The Great Book of
French Impressionism

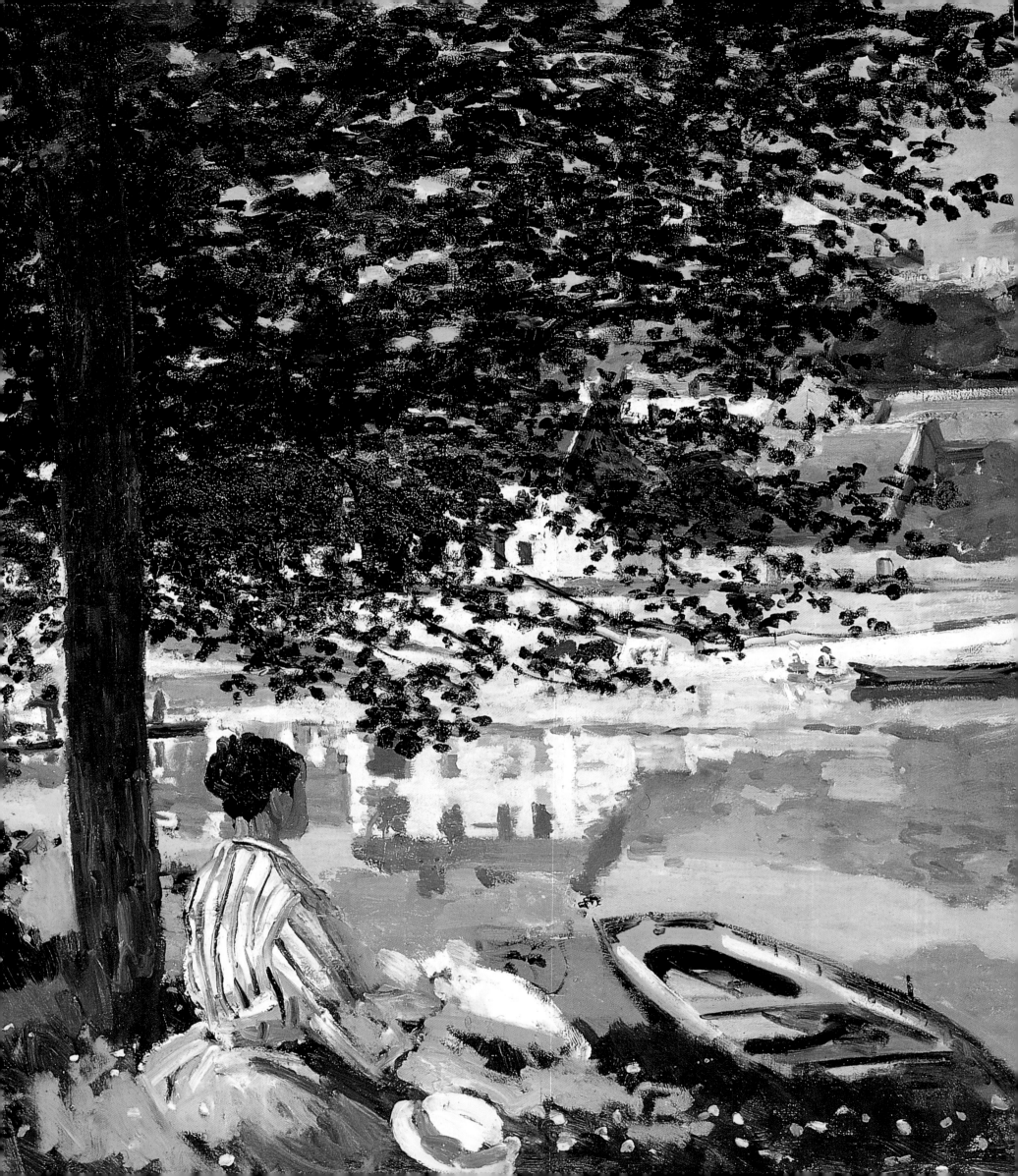

Diane Kelder

The Great Book of
French Impressionism

ARTABRAS

A Division of Abbeville Publishing Group

New York London Paris

Front cover: Detail of plate 180, page 186.
Back cover: See plate 230, page 233.
Frontispiece: Detail of plate 168, page 174.

Designer: Barbara Balch
Production Editor: Meredith Wolf
Production Manager: Lou Bilka

Grateful acknowledgment is made to the following publishers for permission
to reprint previously copyrighted material:

Alfred A. Knopf, Inc.: Excerpts from Ambroise Vollard, *Renoir: An Intimate
Record*, trans. Harold L. Van Doren and Randolph T. Weaver. Copyright © 1925
and renewed 1953 by Alfred A. Knopf, Inc.

The Museum of Modern Art: Excerpts from *The History of Impressionism*, 4th
rev. ed., 1973, and *Post-Impressionism: From van Gogh to Gauguin*, 3d rev. ed.,
1978, both by John Rewald. All rights reserved by The Museum of Modern Art
of New York.

Prentice-Hall, Inc.: Excerpts from Judith Wechsler, *Cézanne in Perspective*,
© 1975, pp. 31, 35, 42. Excerpts from Linda Nochlin, *Impressionism and Post-
Impressionism*, © 1966, pp. 4–7, 101–3, 112–13, 116-18, 157–58, 161. Reprinted
by permission of Prentice-Hall, Inc., Englewood Cliffs, New Jersey.

Second edition

10 9 8 7 6 5 4 3 2 1

Library of Congress Cataloging-in-Publication Data
Kelder, Diane.
 The great book of French impressionism / Diane Kelder. — 2nd ed.
 p. cm.
 Includes bibliographical references and index.
 ISBN 0-089660-074-2
 1. Impressionism (Art)—France. 2. Painting, French.
3. Painting, Modern—19th century—France. I. Title.
ND547.5.I4K43 1997
759.4'09'034—dc20 96-19900
 CIP

Contents

Introduction
7

C h a p t e r 1
Toward a Vision of Modern Life
21

C h a p t e r 2
Edouard Manet: Reluctant Revolutionary
61

C h a p t e r 3
The New Painting
107

C h a p t e r 4
Claude Monet: Impressionist par Excellence
155

C h a p t e r 5
Pierre-Auguste Renoir: The Exuberant Impressionist
201

C h a p t e r 6
Edgar Degas and Henri de Toulouse-Lautrec: The Studied Moment
243

C h a p t e r 7
The Impressionists in 1886
287

C h a p t e r 8
Paul Cézanne and the Legacy of Impressionism
333

Notes 379 *List of Illustrations* 382 *Selected Bibliography* 394 *Index* 396 *Acknowledgments* 400

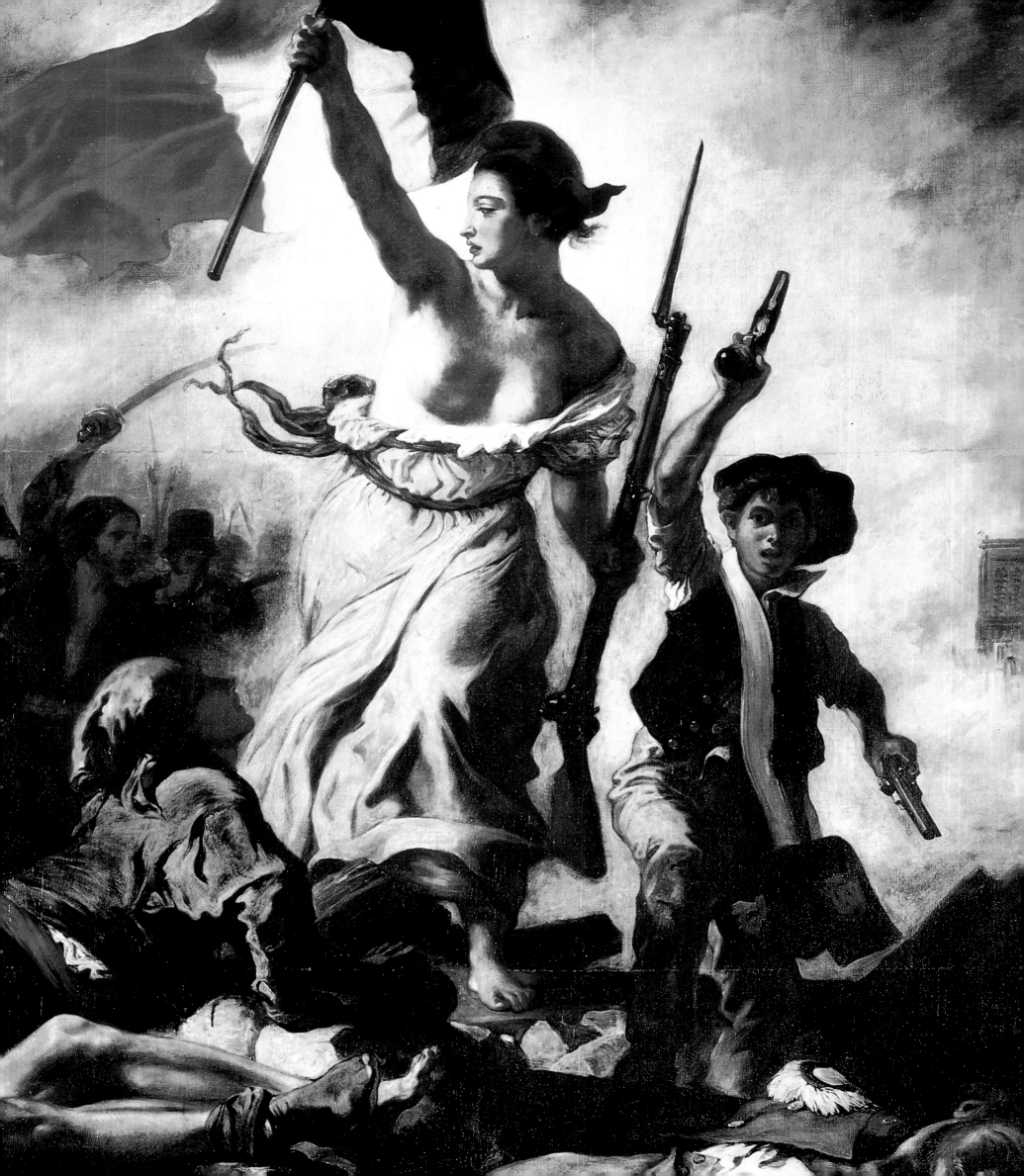

Introduction

More than any other movement in the history of art, Impressionism contained the essential ingredients of popular mythology. Initially misunderstood by the public, reviled by critics, and ignored by all but a few devoted collectors, the small band of painters associated with Impressionism declared themselves free of the constraints of the hierarchical art establishment. They struggled on to achieve both tangible financial success and, in the judgment of posterity, critical vindication. Within an amazingly brief period, they managed to wrest painting from its theoretical and technical moorings in the past.

The Impressionists firmly rejected the notion that an artistic subject had to have intrinsic literary value, that it had to be noble or instructive in order to be worthy of representation. Their commitment to the present made them uniquely conscious of and responsive to the ever-shifting physical reality of the moment, and stimulated them to develop new techniques for capturing its fleeting essence. Instead of painting what they knew, as artists had done before them, they limited themselves to painting what they saw. Like Elstir, the quintessential Impressionist invented by Marcel Proust in *A la recherche du temps perdu*, they made a strenuous effort "to rid [themselves] in the presence of reality, of . . . notions of intelligence." Their pursuit of reality dictated certain innovations: As they came to realize that only direct contact with the subject in open air would produce the effects they sought, they abandoned their studios, adopted smaller-scale canvases that could be carried about easily, and, most important, altered their palette and brushstroke to simulate the rapidly changing atmosphere that they wished to capture.

Today, well over one hundred years after their inaugural exhibition, such canvases as Claude Monet's *Impression, Sunrise* (plate 121) or *Boulevard des Capucines* (plate 120)—which were singled out as particularly egregious examples of ineptness or incompleteness—no longer shock the public. When a rare Impressionist painting now comes up for auction, museums and Maecenases compete furiously to pay an astronomical price for it. While popular interest in Impressionism seems limitless, the critical and historical interest in the movement seems to have risen first in the early 1960s, when its apparent relevance to Abstract Expressionism and color-field painting instigated a reassessment of the movement and of the entire historical context from which it emerged. A more balanced perspective of historical modernism, as well as a clearer picture of the contributions of major and minor artists, has emerged from studies of that intersection of tradition and contemporaneity, *japonisme* and technology, whose impact was first reflected in the work of the Impressionists.

The Impressionists were among the first artists to be motivated by a sense of common purpose. While the individual painters were separated by background and temperament, they were united in their desire to bring their work before the public. Though many of them were born outside of Paris, it was only in the capital that they felt they could make their mark, for the city was not only the center of an empire—that of the ambitious Napoleon III—but also the center of the art world. Napoleon's policies of political expansionism were matched by his vision of Paris as the cultural capital of a French-dominated Europe. One of his major priorities, the physical transformation of Paris from

OPPOSITE

Detail of plate 37

a city of narrow, arbitrarily arranged streets and houses to the very model of a modern metropolis, was accomplished through the genius of the civil engineer Baron Georges Haussmann. His broad, light-filled boulevards literally opened up new vistas and created new subjects for the burgeoning group of young painters.

For most of the Impressionists, the commitment to one's own time presupposed a rejection of the past and all the respectful attitudes associated with tradition and experience, even though there was nothing particularly new in the juxtaposition of past and present, or ancient and modern. Since the seventeenth century, the members of the prestigious Académie Royale de Peinture et de Sculpture (called the Académie des Beaux-Arts after the Revolution) had debated the merits of Rubens versus Poussin, color versus drawing. The artists of the Académie were regarded as the only valid practitioners of high art; predictably, their views were not conducive to the development of independent artistic creativity. Early in the nineteenth century, the rigid academic hierarchy was relaxed somewhat to allow students of landscape painting the privilege of competing for a prestigious fellowship to perfect their craft in Rome, but landscape painting continued to be considered a minor pursuit next to historical or mythological themes.

The ascendance of Jean-Auguste-Dominique Ingres and of the cultivated and eclectic styles of his academic followers reverberated through the halls of the Ecole des Beaux-Arts and the walls of the official Salons, where painters' reputations were made. There, numerous examples of correct drawing and impeccable finish proclaimed the superiority of painting that had *ideas* as its focus. The art of more "liberal" masters such as Eugène Delacroix, the greatest French exponent of color before the Impressionists, was not exempt from this love affair with history and literature. Although Delacroix was capable of responding to contemporary issues, he limited those issues to appropriately significant and heroic themes inspired by national or international crises; and they were enunciated, for the most part, in the visual language of the past.

1.
Eugène Boudin
Approaching Storm
1864

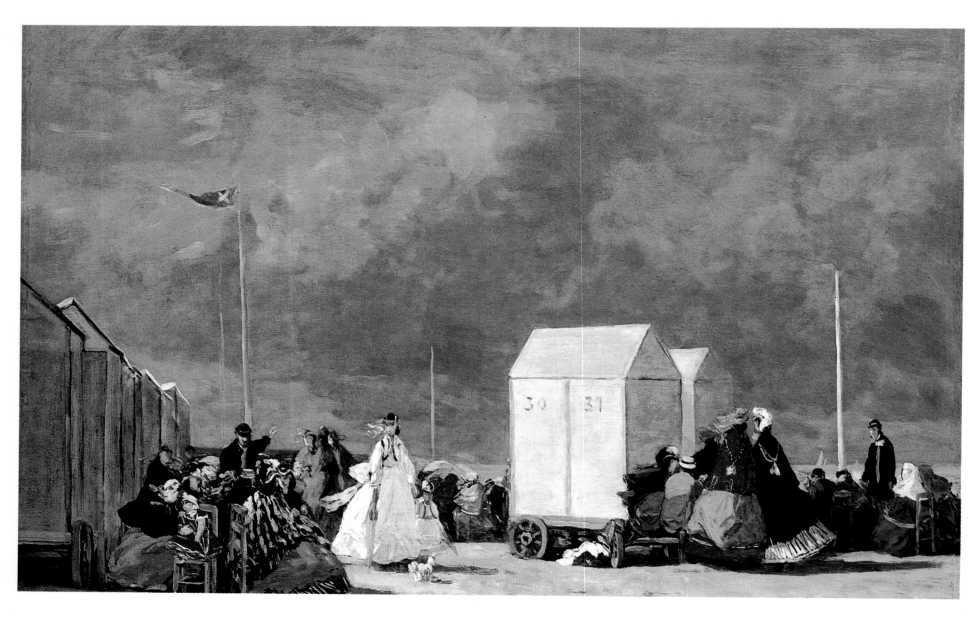

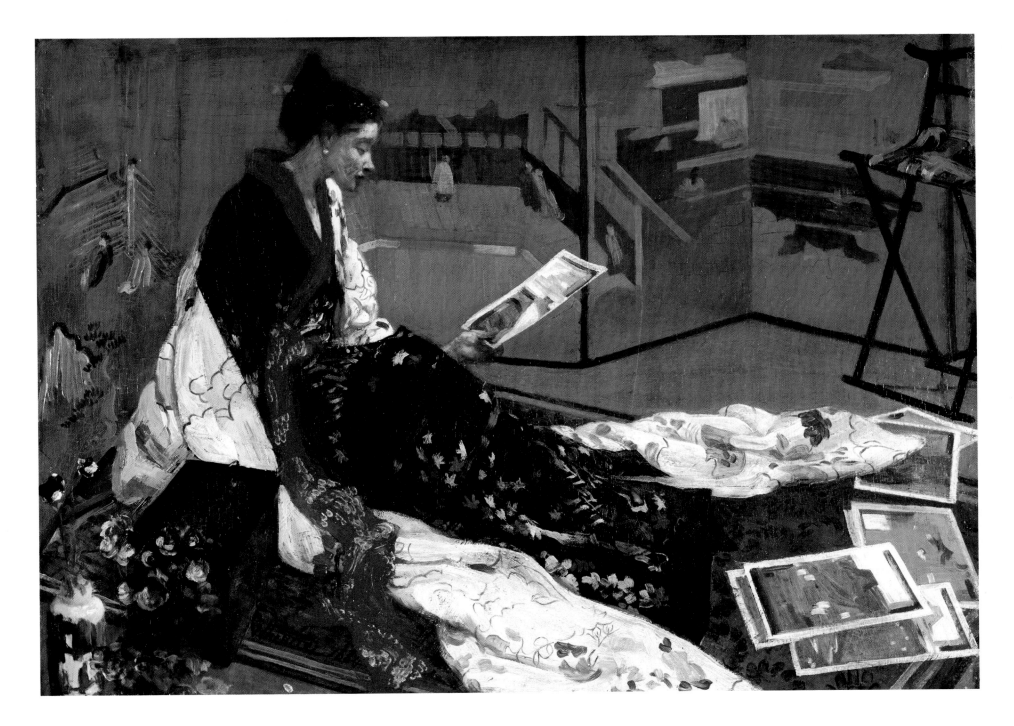

2.
James McNeill Whistler
Caprice in Purple and Gold,
No. 2: The Golden Screen
1864

The American James McNeill Whistler exhibited at the 1863 Salon des Refusés along with Manet and Pissarro, and was considered among the most notorious of all his colleagues. One of the dominant traits of Whistler's art is his interest in japonisme, *seen here not only in the subject matter, but in the overtly two-dimensional quality of the picture. In this elegant, decorative work Whistler has made no effort to depict the deep space of traditional painting. The rug on which the woman lounges appears to tip toward the viewer; her dress and the bright patches of color throughout the picture seem to rest on the surface of the painting.*

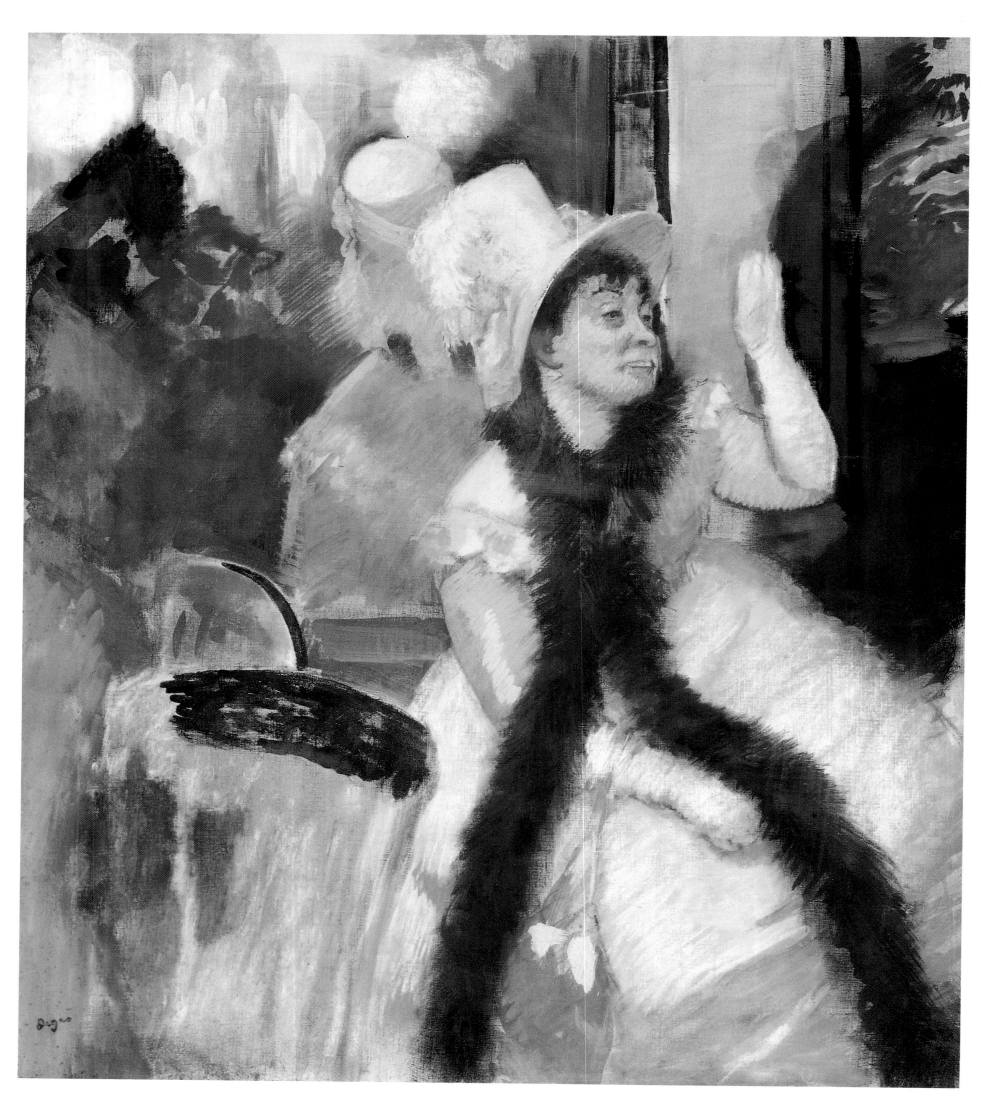

Degas made the study at left for a portrait that, after a great deal of disagreement between the artist and the sitter, was unfortunately never completed. Madame Dietz-Monin is dressed for a party; her lively pose, as well as Degas's rapid line, convey the animation of the festivities to which she is headed (or which she has just left). Her back and head are reflected in a mirror—a device used by many painters, notably in the portraits of Ingres, whom Degas very much admired. Although the furnishings are only sketchily indicated, the figure is quite complete, testifying that this is an advanced study.

It is understandable that Napoleon III, whose political appeal was linked to a nostalgia for the glory of his uncle's empire, should have endorsed a retrospective and eclectic art, and that he should appoint a man of aristocratic tastes, Count Nieuwerkerke, to oversee the academic factories where art products were turned out. The older patrons of this art, if not some branch of the government itself, were the middle and upper middle class. The former, growing steadily in number and influence since the reign of Louis-Philippe (1830–48), took their cue from the Salons and filled their already stuffed townhouses and country châteaux with *grandes machines*—elaborate pastiches of classical, medieval, or Renaissance themes or the acceptable contemporary exoticism, usually depicted in the guise of some Middle Eastern motif.

The exhibition of the Société Anonyme des Artistes, Peintres, Sculpteurs, Graveurs, Etc. (the original name chosen by the artists who exhibited in 1874) was the culmination of a revolt against the art establishment that had been initiated almost twenty years before by Gustave Courbet. His decision to mount a one-man show independent of the official exhibition was to inspire a similar tactic by Edouard Manet twelve years later. Courbet championed a "concrete" art, dealing exclusively with the experience of its own time—an accountable art of physical facts, with common men rather than heroes as its protagonists. Courbet's approach coincided with and was probably conditioned by the rise of scientific materialism and literary Naturalism. It was as much a rebuke to the idealizing aesthetics of official art as the vulgar and mechanical art of photography, whose terrifying capacity to reflect the truth had prompted a

noted painter of the day to proclaim the demise of painting two decades earlier. Indeed, the role played by photography in the evolution of modern vision, particularly that of the Impressionists, was critical to the liberation of painting from traditional formulas and spatial stereotypes.

Just as Impressionism cannot be fully understood without considering the contributions of prominent Realists such as Courbet, the significant achievements of a loosely knit group of landscape painters working in or near Barbizon, a small town on the edge of the forest of Fontainebleau, must be acknowledged. Inspired by the seventeenth-century Dutch masters and by the vivid canvases of their near contemporary the English landscapist John Constable, these French painters sought a close personal identification with nature. In its constant shifting of atmosphere and changing of seasons, they found a perfect mirror for their own moods. Many of the innovations in technique usually associated with the Impressionists, including the practice of working out of doors, were actually anticipated by such members of the group as Charles-François Daubigny. Outstanding among them— though by no means the most typical exponent of that unadorned and rugged atmospheric quality common to the group as a whole—was Camille Corot, whose example was to fire the imagination of Camille Pissarro and of his younger colleagues Claude Monet, Pierre-Auguste Renoir, and Frédéric Bazille.

The lure of Barbizon and its renowned forest proved as irresistible to this small band of former Beaux-Arts students as it had to Corot's generation. In their novel *Manette Salomon*, the Goncourt brothers described the forest of Fontainebleau as "full of impecunious bearded young painters carrying easels."

OPPOSITE

3.

Edgar Degas

Woman in a Rose Hat

1879

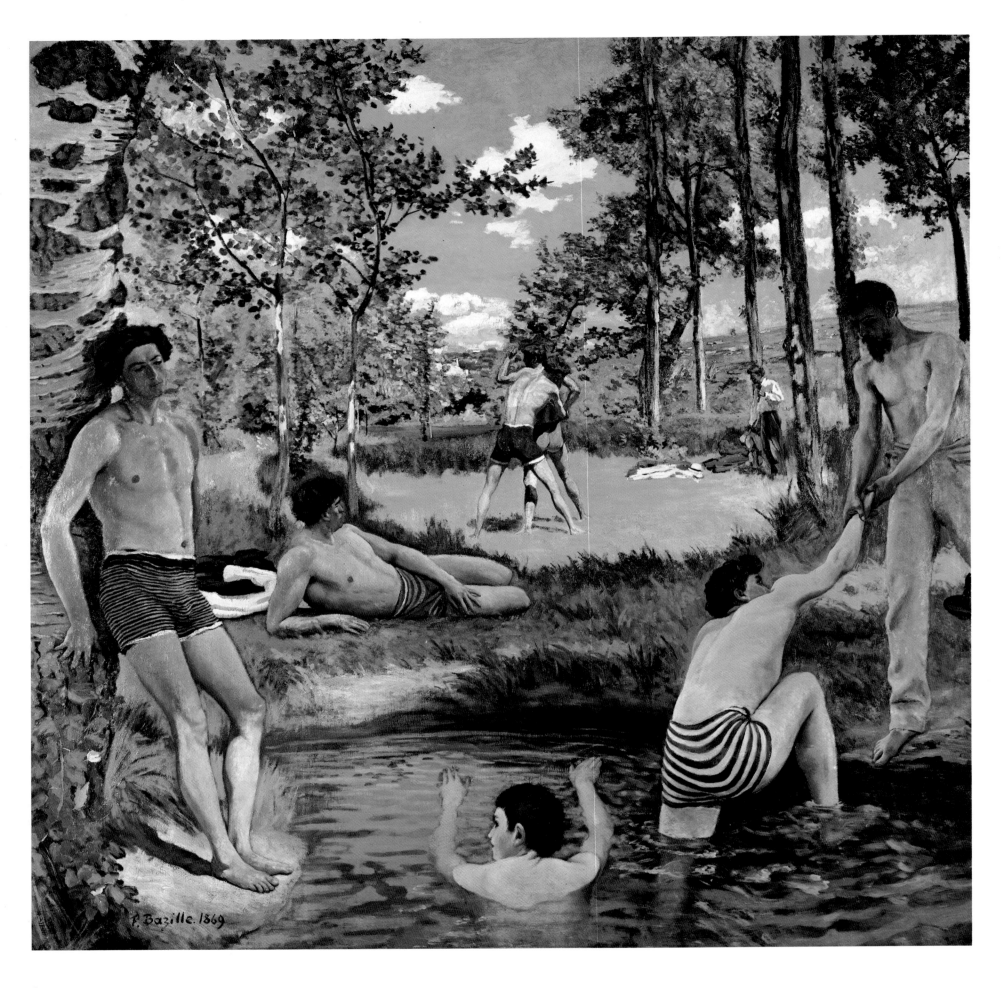

4.
Frédéric Bazille
Bathers (Scene d'Eté)
1869

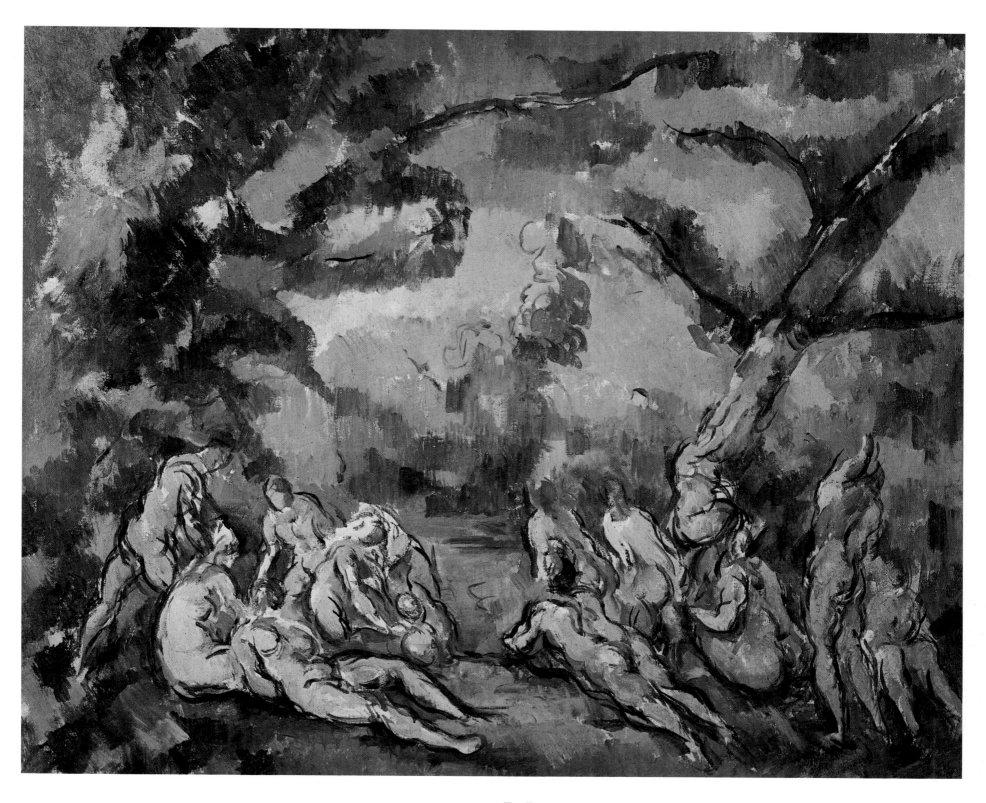

5.
Paul Cézanne
Bathers
1899–1904

*M*anet's Déjeuner sur l'herbe, *which interpreted a classical theme in modern terms, spurred many painters to take up similar subjects. Like Manet, Bazille (opposite) eschews any reference to mythology, concentrating instead on an unambiguous and thoroughly contemporary group of young men. Cézanne's great late series of Bathers, however, depicts anonymous nudes in a timeless setting. These pictures, painted with the undisguised brushstroke and patches of color characteristic of Impressionism, resolve any lingering conflict between the classical subject and the modern technique.*

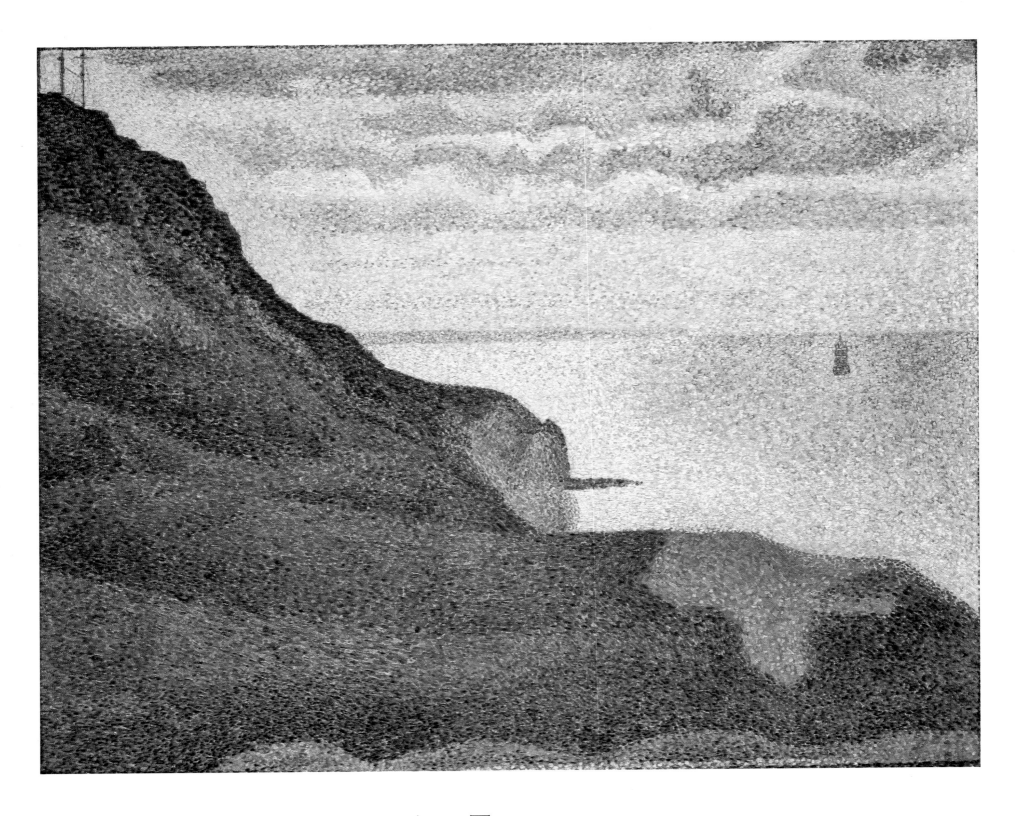

6.

Georges Seurat

Seascape at Port-en-Bessin,
Normandy

1888

The mood of these deserted seascapes is far from that of the Impressionist works of the previous decade. No dashing, spontaneous brushwork here, but rather even, almost mechanical patches of pure color applied to the canvas. Under the guidance of Seurat, the Neoimpressionists sought to transform the directness and spontaneity of Impressionism into something systematic, expressive of their "scientific" era. They adopted a system of coloration based on the latest theories of color and optics, and regularized the sketchy forms of Impressionism into simple, often decorative shapes, much like the clouds in Seurat's painting.

But Barbizon was only one of many new locales that attracted the future Impressionists. The wide beaches of Normandy first painted by Eugène Boudin also provided new sensations of light and opened their eyes to the fascinating properties of water and sky.

While innovations in landscape painting provoked either disapproval or indifference in official circles, the dissatisfaction with the selection process for the Salons, which had largely been a personal affair, achieved the dimensions of a genuine popular protest when more than half of the works submitted to the Salon of 1863 were rejected. The uproar was so great that Napoleon III, ignoring the objections of the Académie, authorized the creation of a separate exhibition in the same building that housed the official Salon. From the first day, the Salon des Refusés over-shadowed the prestigious exhibit next door. A mixture of old and new, bad and good, this unprecedented assemblage of paintings alternately amused and offended the curious visitors who streamed in. While some of the exhibitors—Pissarro, Henri Fantin-Latour, Paul Cézanne, and the American James McNeill Whistler—would later achieve prominence within the history of Impression-ism or, more generally, of modernism, it was a work by Edouard Manet, *Déjeuner sur l'herbe* (plate 75), that came to symbolize the audacious presumption of the new breed of painters. Henceforth, *refusé* was synonymous with revolutionary; and in the public's mind, Manet was the arch-revolutionary.

While Manet's unorthodox juxtaposition of the traditional and the contemporary provoked moral outrage, his technical innovations stirred up a critical hornet's nest that buzzed for more than a decade. Younger artists such as Monet and Bazille immedi-ately took up the challenge of placing life-size figures in a land-scape, imbuing their canvases with a straightforward modernity in the process. The persistence of the picnic and bather themes, which were combined in Manet's epochal work, constitutes one of the most significant chapters in the history of modern paint-ing, culminating in Cézanne's great series, wherein the essential clash of subject and technique, of tradition and innovation first acknowledged in Manet's work was resolved in works that are at once classical and proto-abstract.

Although Manet's work and his decision to organize a one-man show at the 1867 Exposition Universelle in Paris met with the approval of the artists who would later form the nucleus of the Impressionists, he can be considered at best only the godfather of the movement rather than a bona fide member. At the time of Manet's exhibition, Monet, Renoir, Pissarro, and Alfred Sisley were already seriously pursuing landscape. The sense of the fugitive and the momentary that they sought was purely physical, not social or psychological in implication as in the work of Manet. No longer satisfied with motifs provided by the parks or gardens of Paris, the group of young artists moved into rural suburbs or more distant villages. There, in their images of the Seine and the adjacent landscape, they gradually eliminated all human references in order to concentrate on the seemingly inexhaustible variety of atmospheric effects produced by the volatile climate.

While the painting styles of Monet and Renoir, especially, seemed to converge in those years preceding the first Impres-sionist exhibition, the group was heterogeneous enough to accommodate independents like Edgar Degas, whose interest in interior subjects and portraiture set him apart from the mainstream. For Degas, the tyranny of the moment—what Monet called the search for instantaneity—was a serious impediment to the realization of pictorial structure. His initial reservations about landscape painting and the technical and compositional changes it had wrought were later to be shared by Renoir and even by Pissarro, generally considered the most loyal Impressionist of them all. Never comfortable with the label "Impressionist," which had been imposed on the group by a hostile critic, Degas nonetheless accommodated the group in its larger mission of exhibiting work that might otherwise have gone unseen. Renoir, on the other hand, broke completely with his former colleagues when he began to realize that their pre-occupation with those spontaneous and random elements that emerged from a direct but finite contact with his subject were antithetical to his true interests, the unification of firm design and sensuous color.

Impressionism as a group phenomenon was already beset by dissension when it reached its fifth birthday, and by its tenth, the artists who had once been its heart and soul were dispersed in both location and philosophy. Of the eight exhibitions held between 1874 and 1886, only one artist—Pissarro—took part in all; Degas showed in seven; Monet participated in five; Renoir, four; and Cézanne, just two. When the final group exhibition was held, it was not the few remaining older Impressionists who claimed the attention of the critics, but younger artists such as Georges Seurat. His major canvas, *A Sunday Afternoon on the Island of La Grande Jatte* (plate 313), seemed to be in the tradition of plein-air painting, but actually proclaimed a highly program-matic and theoretical reform of the direct, intuitive, and largely individualized approach to painting that had evolved in the pre-vious two decades. Ironically, Seurat's contribution of a genuine system to organize the pure color of the Impressionists into a coherent pictorial structure actually resulted in a schematization of art in symbolic and decorative terms, which was as antithetical to the Impressionists' methods and objectives as the art they had initially defied.

The crisis of Impressionism, exemplified in the emergence of a vigorous reforming "Neoimpressionism," was not limited to dissatisfaction with its technique, but also its unresponsiveness to the mind and soul. The manifesto of Symbolism published in 1886 gave concrete expression to a widespread defection from literary and artistic naturalism, which some of the Impressionists had in one way or another already acknowledged. Vincent van

Gogh, who had never exhibited with the Impressionists, and Paul Gauguin, who had joined them on five occasions, both moved beyond the use of color for the transcription of physical effects to a realization of its emotional, expressive, and ultimately decorative potential. With them and their heirs, the Nabis and the Fauves, color and line were to achieve a final independence from physical stimuli, anticipating the various forms of color abstraction that have been part of the art of this century.

The obsession with time that began to manifest itself in the early years of Impressionism adumbrated the unique development of Monet, who symbolized for many the Impressionist par excellence. From a relatively straightforward concern with capturing the appearance of a sun-filled street or a rainy beach, he moved to a more dramatic awareness of the vitality of time, returning again and again to a subject in order to realize more completely its changing identity. Later, this determination to capture the instant caused him to work on several paintings at a time, switching from one to the other, stopping, resuming in a maddened effort to seize the very essence of time.

Not until the last decade of the century, some five years after the last Impressionist exhibition, did Monet discover the technique that would carry him further than any of his colleagues in his study of time. The "series" paintings of haystacks (now identified more accurately as grain stacks), poplars, and cathedral facades made him conscious as never before of the continuum of time and of its distinct expressions. As he worked on the many versions of these themes over hours, days, and months, that objectivity that had once characterized his approach to landscape was transformed into a subjective, even autobiographical record of his reactions to the motif. In the last twenty-five years of his life, with nearly all of his old friends long dead, Monet's world was defined by the physical limitation of the carefully designed gardens of his home at Giverny. Prolonged contemplation of these gardens, especially the lily pond, made him aware of the continuity of physical life and time; the water garden came to represent a synthesis of being and becoming. The timelessness and infinitude that emanate from his Nymphéas, or Water Lilies,

transport us beyond the world of simple events to a magical and remote environment, whose full identity only begins to emerge when one sees it unfold through the entire body of eight canvases he executed for two specially constructed oval rooms in the Orangerie.

The year Monet began his first Water Lilies, Cézanne embarked on a canvas that was to occupy him, on and off, for six of his last seven years. *Large Bathers* (plate 383) was the most complex version of a theme he had painted since his years as a sometime member of the Impressionist group. Even then, his frustrations with the limits of Impressionist technique had led him to seek a new way of uniting their lighter, pure colors and direct observation of the world with that innate sense of structure that he perceived in nature. Through his brushwork, land, water, and sky were given a palpable and homogeneous identity as the painter realized his dream of making Impressionism "solid and durable like the art of the museums." As with Manet, tradition was to play a paradoxically important role in Cézanne's turning away from Impressionism to a more transcendent and ultimately modern vision of painting. His late Bathers, landscapes, and still-life paintings invite comparison with that sense of architectural form glimpsed in the historical and mythological subjects of Nicolas Poussin and the still lifes of Jean-Baptiste-Siméon Chardin.

Yet it is precisely in confrontation with the past that the impact of Cézanne's new approach can be appreciated. More than any other member of the Impressionist group, Cézanne identified the character of early modern painting. Rigorously analytic, lacking totally the lightness and charm associated with the earlier history of the movement, his grave works would have looked odd indeed at either the Salon or the Impressionist shows. But when they were exhibited at a great memorial show in 1907, their irregular, ponderous forms and ambiguous space spoke to Georges Braque and Pablo Picasso, the engineers of yet another aesthetic revolution, Cubism, which was to alter the course of Western art.

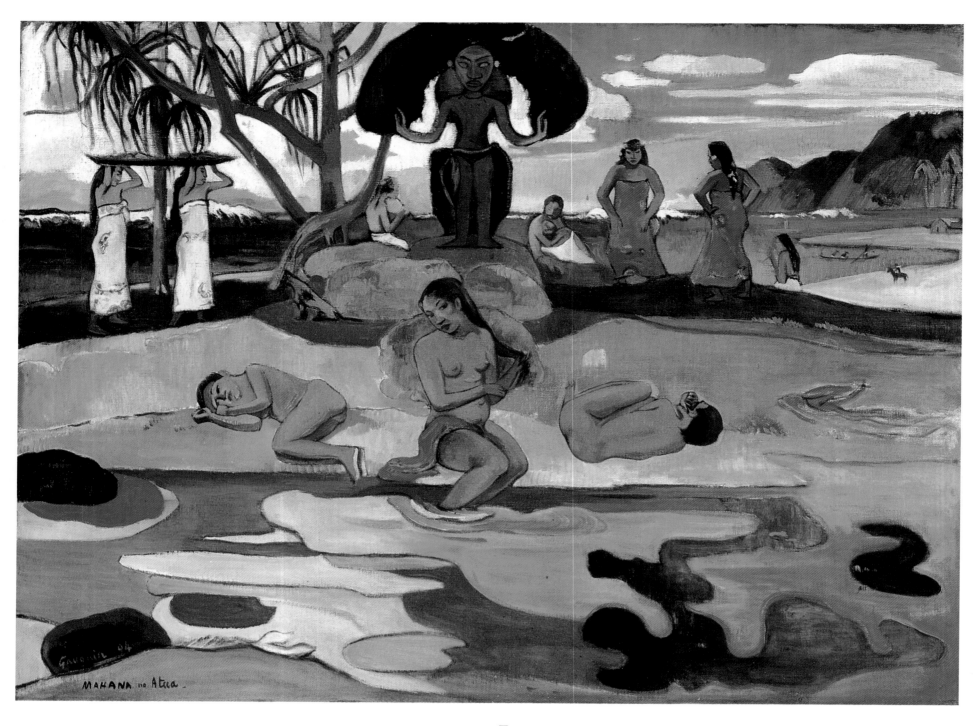

8.
Paul Gauguin
The Day of the God (Mahana No Atua)
1894

In the 1880s the objective transcription of modern life ceased to be the preoccupation of avant-garde artists. Painting was now to be imbued with an expressiveness that went beyond the cool, matter-of-fact viewpoint of the Impressionists. Gauguin actually turned his back on modern Western civilization and went as far as the South Seas in his search for an unspoiled way of life. In The Day of the God, *he depicts a mysterious religious ceremony remote from Western Christianity. His simplified forms and large areas of unmodulated color give the whole an iconic and decorative quality.*

Maurice Denis, a member of the Nabi group, carried even further the stylization of forms and use of lyrical, exotic color initiated by Gauguin. In April, the undulating curves of the path, stream, and foliage are arrested by the linear objects of civilization: the fence and the bridge in the distance. While the content of the painting seems traditional, the radical simplification of color and shape anticipate much of the abstraction of twentieth-century art, as did his admonition: "Remember that a picture—before being a warhorse, a nude woman or some anecdote—is essentially a flat surface covered with colors arranged in a certain order."

9.
Maurice Denis
April
1892

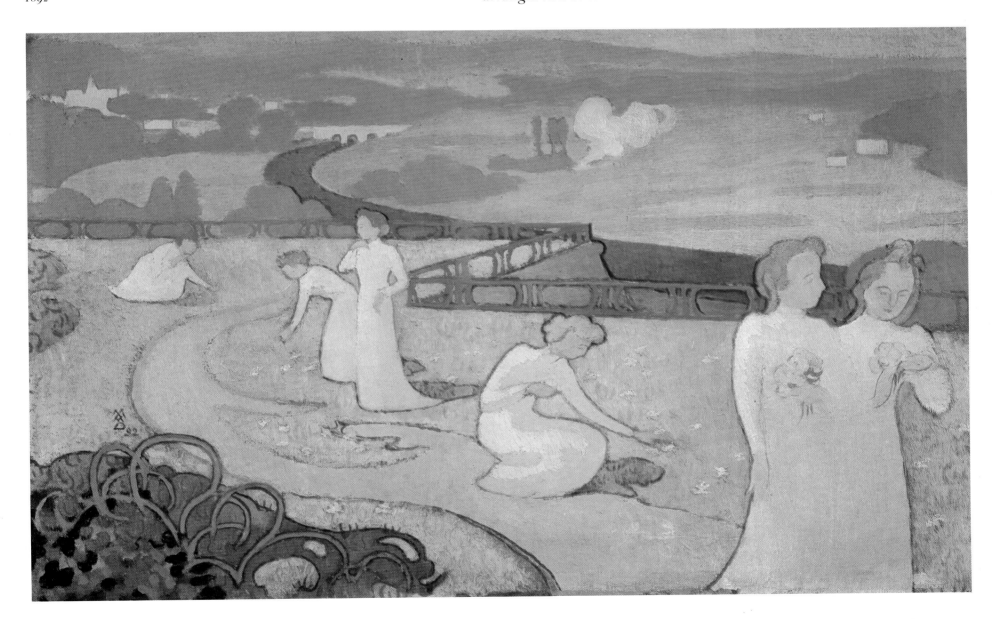

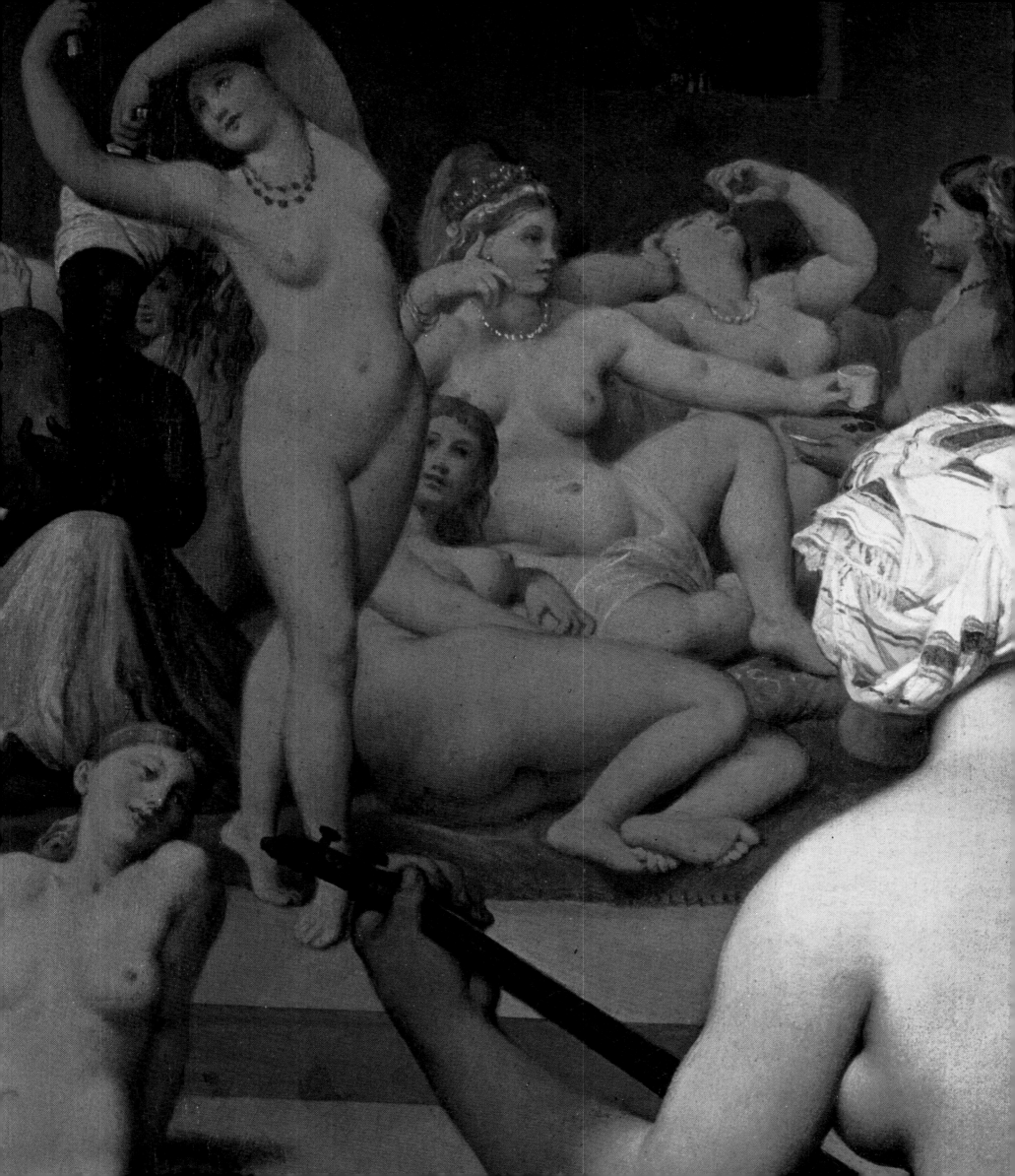

Chapter 1

Toward a Vision of Modern Life

It is true that the great tradition is lost, and that the new one is not yet established. But what was that great tradition, if not the habitual idealization of ancient life. . . . Since all centuries and all peoples have their own forms of beauty, so inevitably we have ours.

CHARLES BAUDELAIRE

The great Exposition Universelle, or World's Fair, of 1855—designed to publicize France's industrial and technological achievements and to promote the cultural prestige of the recently established Second Empire of Napoleon III—contained a large structure devoted to an international art exhibition of a scale and scope never before imagined. Artists from twenty-eight nations had been invited to contribute to what one newspaper described as "the most remarkable collection of paintings and sculpture ever brought within the walls of one building." Over five thousand paintings, hanging frame to frame on the walls of the Palais des Beaux-Arts, testified both to the grandiose ambition of the exhibition and to its dazzling variety of styles and genres. Two giants dominated the event. The classicist Jean-Auguste-Dominique Ingres, who had ignored the official Salon for twenty years, calling it a mere "picture shop," exhibited over forty of his celebrated canvases, as well as a number of drawings, in a special gallery; his aesthetic adversary, Eugène Delacroix, was represented by a selection of thirty-five paintings that highlighted various aspects of his evolution.

While the work of Ingres and of artists more or less closely associated with him, such as Jean-Léon Gérôme, Alexandre Cabanel, Henri Lehmann, and Thomas Couture, garnered most of the honors and prizes in the exhibition, that of such distinguished landscapists as Camille Corot, Jean-François Millet, and Charles-François Daubigny was hardly acknowledged by the official art establishment of teachers and critics, who still regarded landscape as inferior in content to historical or reli-

gious themes, which were viewed as more ennobling and therefore estimable.

It would be difficult to find a more bureaucratic and hierarchic system than the one that tyrannized France in the nineteenth century. The Académie des Beaux-Arts, a part of the Institut de France, provided the teachers for the officially sanctioned Ecole des Beaux-Arts and also supplied the directors for the Académie de France in Rome. To an ambitious artist, attendance at the Ecole offered at least the promise, if not the guarantee, of professional advancement comparable to that of attendance at the best naval and military schools. Moreover, the Académie des Beaux-Arts selected from the ranks of its professors the juries for the biannual (later annual) Salons, the official exhibitions which purported to offer the public the finest examples of contemporary painting and sculpture. Prizes or even honorable mentions from the Salon jury often stimulated purchases and commissions from the government or private patrons.

In the studios of the Ecole des Beaux-Arts, the teachings of Ingres were perpetuated mindlessly by his pupils. Exalting in the role of drawing or line over color, advocating endless copying of the Old Masters, and rejecting the present in favor of an arbitrary amalgam of historical "pasts," they created a style redolent of pseudoliterary anecdote, a style of slick and deadly finish that delighted a public long accustomed to "reading" paintings. Spontaneity, directness, and, above all, passion were qualities conspicuously absent from the large classrooms of the Ecole. The architect Eugène-Emmanuel Viollet-le-Duc provided

OPPOSITE

Detail of plate 39

21

RIGHT
10.
Jean-Auguste-Dominique Ingres
Bather
1808

FAR RIGHT
11.
Edgar Degas
Sketch after Ingres's "Bather"
1855

BELOW
12.
Jean-Auguste-Dominique Ingres
Odalisque in Grisaille
1814–46

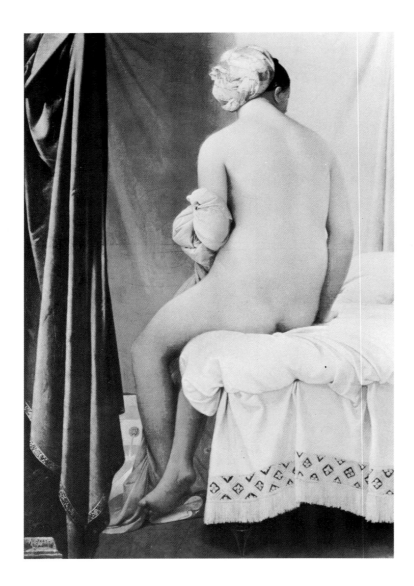

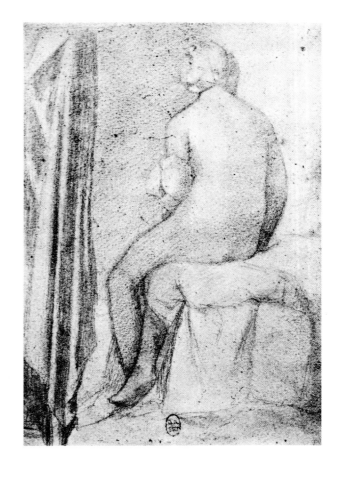

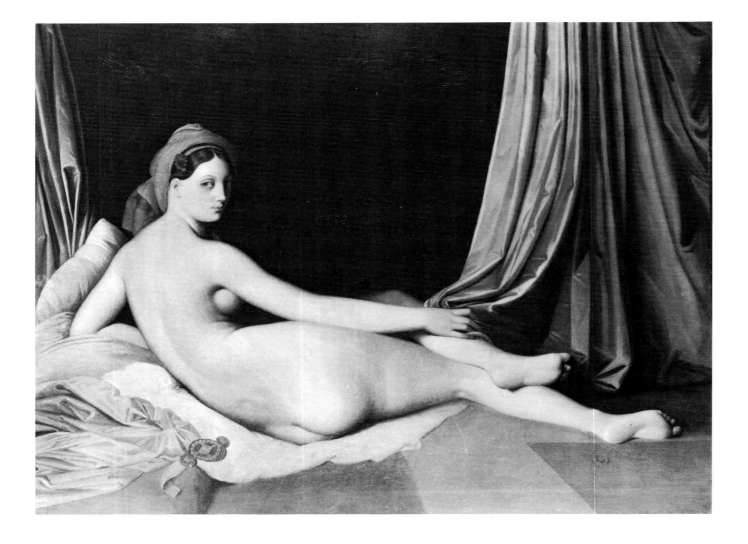

A student of Ingres recalled that the master deplored the prescribed study of anatomy and preferred the more idealized concept of nature offered by ancient and Renaissance art. This may account for the apparent distortions of the human form evident in this austere variation on the theme of the orientalized Venus. By eschewing color in favor of grisaille (black, gray, and white), Ingres was also giving a practical demonstration of his oft-cited credo: "Drawing is the probity of art."

a harsh but accurate appraisal of this system and of the dilemma it created for the would-be artist:

> *The young artist enters the Ecole, he gets medals . . . but at what price? Upon condition of keeping precisely and without any deviation within the limits imposed by the corporation of professors, of following the beaten track submissively, of having only exactly the ideas permitted by the corporation and above all of not indicating the presumption of having any of his own. . . . We observe besides that the student body naturally includes more mediocrities than talented people, that, the majority always itself on the side of routine, there is no ridicule sufficient for the person who shows some inclination toward originality.[1]*

Ingres's personal hostility to Romanticism, and to Delacroix as its champion, was in large measure the reason for the latter's six-time rejection when he presented himself as a candidate for membership in the Académie. Had Delacroix been accepted earlier, his presence might have had a salutary, liberating effect, but that was not the case, and the sharply drawn battle lines of Ingres and Delacroix were more exaggerated than ever when the two were singled out for special distinction in the Exposition Universelle.

Charles Baudelaire

Unlike the art journalists who wrote for the popular press and who worked hand in glove with the academicians, Charles Baudelaire, a poet and the most astute critic of the day, minimized the accomplishments of Ingres and his followers, whom he described as "sad specialists, workers, makers of academic figures, of fruits, of animals,"[2] whereas he considered Delacroix "an epic poet," "the most evocative of all painters," and "the head of the modern school."[3] For Baudelaire, what was central to Delacroix's genius was his sense of artistic imagination, his ability to transport the viewer beyond the familiar and academic. The most passionate and subjective of critics, Baudelaire was drawn to Delacroix's painting by a sense of energy and, above all, temperament, which he equated with poetic genius. He believed that Delacroix, like the great masters of the past, sought to communicate with men's souls. In *Eugène Delacroix, His Life and Work* (1863), he wrote: "What is that mysterious *je ne sais quoi* which Delacroix, to the glory of our century, has transmitted better than any other artist? It is the invisible, the impalpable, it is the dream, the senses, the soul."[4] Baudelaire shared the artist's view that color was crucial to the vitality of his paintings. Delacroix himself had argued:

> *Painters who are not colorists produce illumination and not painting. All painting worthy of the name must include the*

idea of color as one of its necessary supports, in the same way that it includes chiaroscuro and proportion and perspective. Color gives the appearance of life The colorists, the men who unite all the phases of painting, have to establish, at once and from the beginning, everything that is proper and essential to their art. They have to mass things in with color, even as the sculptor does with clay, marble, or stone; their sketch, like that of the sculptor, must also render proportion, perspective, effect, and color.[5]

13.
Felicien Myrbach-Rheinfeld
Candidates for Admission to the Paris Salon
N.D.

While Delacroix studied the great colorists of the past, such as Peter Paul Rubens, he also was enthusiastic about the work of contemporaries—especially the English landscapists Richard Parkes Bonington, Joseph Mallord William Turner, and John Constable, whose *The Hay Wain* (plate 42) was one of the most talked about paintings in the Salon of 1824. Of Constable's color, Delacroix wrote in his journal: "[He] says that the superiority of green in his meadows stems from the fact that it consists of a host of different greens. The error of intensity and of life in the greenness painted by the average landscape artist is the result of his usually employing a uniform tone. What he says here about the green of the meadows can be applied to every tone."[6]

Having seen the principle of the separation of colors at work in the paintings of Constable, Delacroix was eager to achieve greater luminosity in his own paintings, and so he applied himself to a thorough study of color. He was particularly interested in a book written in 1839 by the chief chemist at the Gobelin Tapestry Works, M.-E. Chevreul, entitled *Principle of Harmony and Contrast of Colors and Their Application to the Arts*. Absorbing Chevreul's theories, Delacroix attempted to divide his colors with greater effect, utilizing longer, thinner brushstrokes

*W*hile this painting earned the twenty-seven-year-old
Delacroix a second-class medal and a purchase by the Musée
de Luxembourg, its critical reception was mixed. Antoine-
Jean Gros, whom Delacroix worshiped, labeled it "the
massacre of painting," and the novelist Stendhal criticized it
for being excessively macabre and for having been painted
from newspaper reports rather than from actual observation.
Inspired by the horrible slaughter of nearly one hundred
thousand Greeks by their Turkish overlords, the composition
exudes that combination of suffering and sensuality that was
among the principal ingredients of Romanticism.

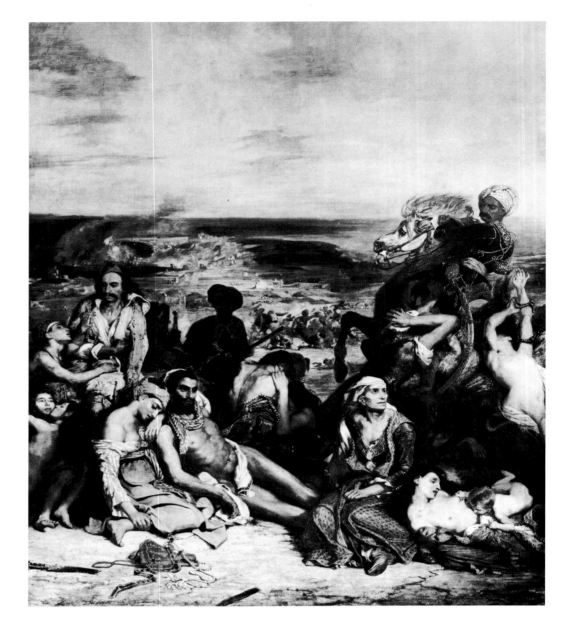

15.
Eugène Delacroix
Massacre at Chios
1824

14.
Henri Fantin-Latour
Homage to Delacroix
1864

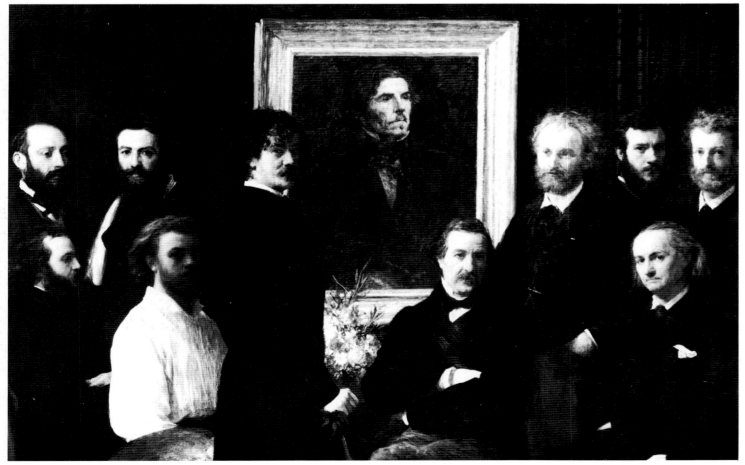

to achieve the optical combinations or mixes he desired. Looking at his painting, Baudelaire was prompted to observe, "This color thinks by itself independently of the object it clothes";[7] and indeed, examination of the painter's work in the 1830s and 1840s reveals how the separation of tones enables the eye to mix them in a way that seems to anticipate Impressionism and Neoimpressionism.

Despite his commitment to a fresh approach to color and an attempt to respond to the moral and political issues of his day, Delacroix was not really drawn to contemporary themes. Although he might admire the English landscapists for their pioneering work in color, he showed relatively little interest in landscape itself, regarding it as a banal form of art that merely copied nature. He continued to paint the literary, historical, mythological, and religious themes that in the hands of another artist would have been the hallmarks of artistic conservatism.

Corot and the Development of Landscape Painting

Landscape painting was to suffer from the stigma of inferiority to history painting well into the nineteenth century. While the establishment in 1816 of a Prix de Rome for landscape painting—an award reserved for the most accomplished students at the Ecole des Beaux-Arts—signaled official recognition of the genre, the majority of the young artists who traveled to Italy to complete their education produced nostalgic visions of classical ruins with picturesque peasants or animals of the type that had become popular with collectors in the eighteenth century.

16.
Richard Parkes Bonington
Normandy Coast
1823–24

17.
John Constable
Cloud Study
1822

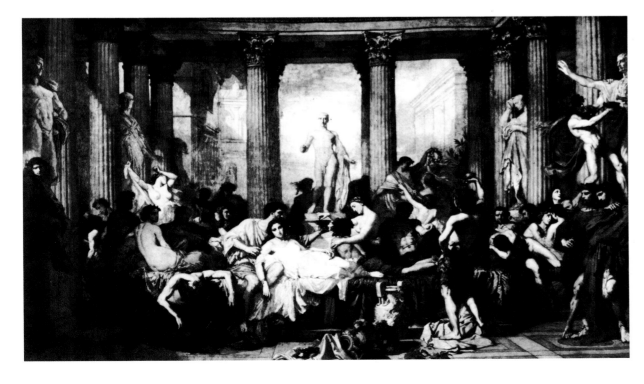

In its theatricality and glossy finish, this painting by Manet's teacher exemplifies the academic work that dominated the official Salons in France. Couture achieved prominence with this moralizing painting, the very model of the meticulously engineered history-machine. He inscribed it with lines from the historian Juvenal: "Crueler than arms, lust descended upon Rome and avenged the conquered world."

18.
Thomas Couture
The Romans of the Decadence
1847

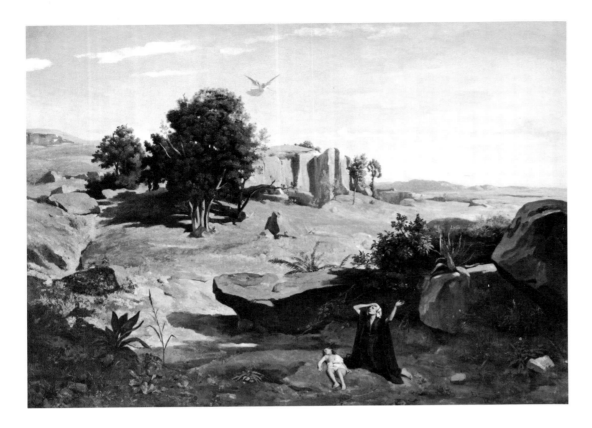

TOP

19.

Camille Corot

Hagar in the Wilderness

1835

BOTTOM

20.

Camille Corot

The Bridge at Mantes

1868–70

One of the many foreign painters working in Rome in the 1820s was Jean-Baptiste-Camille Corot. Nearly thirty years old when he arrived there, the painter was struck by the intensity of light in the sky that compelled him to render forms with a new freshness of color and clarity of shape. "For a beginner," he observed, "hardness is better than softness," and in the many small paintings and hundreds of drawings he produced of Rome, the Campagna, and Umbria, he practiced what he preached. These small works are imbued with an austere, almost monumental grandeur. There are almost no nuances of color in his palette, which at times foreshadows Cézanne's: strong greens, rich ochers, deep blues. Corot's vision of nature, his sense of form—doubtless nourished by the classical language of French seventeenth-century architecture and by the landscape tradition of Nicolas Poussin and Claude Lorrain—grew to maturity in Rome.

Returning to France after nearly three years in Rome, Corot experienced anew the light of the north, a hazy light that renders space more uniform, in contrast to the more articulating, insistent light of the south. Nonetheless, works like *The House and Factory of Monsieur Henry* (plate 45) echo that concern with light as a giver of form and that pureness of color that characterized his Italian pictures. Later, his approach to color would change dramatically, moving Baudelaire, who likened him to the great masters, to say "he is more a harmonist than a colorist."

In the 1830s Corot produced many paintings, such as *Hagar in the Wilderness* (plate 19), that respected the venerable tradition of the narrative or historical landscape referring to religious or mythological subjects. These works stand between the more emphatic confrontation with light and form that characterized his Italian paintings and the lyrical and melancholy poetry of his later pure landscapes, in which any narrative intention is abandoned. Yet the common denominator in all of Corot's landscape paintings is the sense of sincere emotion they exude. A lifelong bachelor who lived with his family well into middle age, Corot loved nature as passionately as any mistress. After the death of his parents in the 1850s, he spent much time visiting relatives and friends in the countryside of the Ile-de-France. Ville d'Avray, Mantes, Beauvais, Mortefontaine—these were the spots he immortalized in his paintings during the 1860s and 1870s. *The Bridge at Mantes* (plate 20) and *Boatman of Mortefontaine* (plate 46) painted when he was nearly seventy, testify to the vigor of his constitution and the firmness of his aesthetic vision.

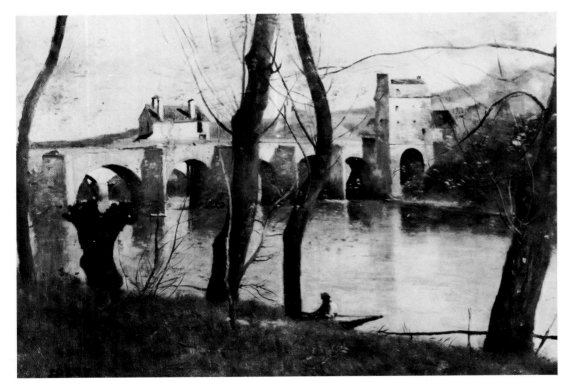

It is tempting to link Corot's painting of figures in a landscape to the work of an earlier French artist, Claude Lorrain. Both were interested in light and its capacity to imbue a scene with physical and emotional properties, and each of them frequently turned to religious or mythological themes. Yet Corot's interpretations of such themes are highly individualized; he is less concerned with narrating a story than with conveying, through his slightly vaporous forms, its spiritual or emotional connotations.

21.
Jean-François Millet
The Angelus
1867

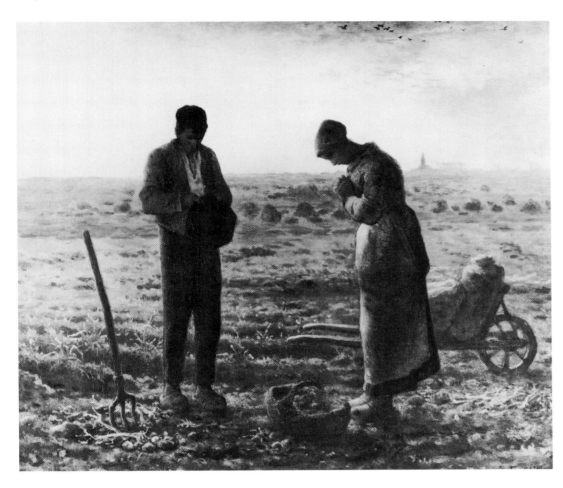

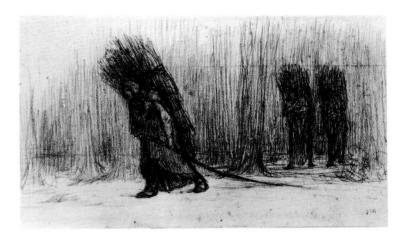

22.
Jean-François Millet
Faggot Carriers
1852–54

23.
Narcisse-Virgile Diaz
de la Peña
Forest of Fontainebleau
1841

Corot had few friends among the literati, and his retiring temperament did not incline him toward politics and the pressing social issues of the day. He did not achieve real success until very late in his career. In fact, he only sold his first picture in 1847, when he was fifty-one years old and had been painting more than half his life. Yet he was celebrated for his generosity to artists less fortunate than he. His charity was so legendary that a priest who knew him well called him the "Saint Vincent de Paul of painting."

Modest as well as generous, he was once asked his opinion of the great Delacroix, who had proposed him for a First Class Medal at the Exposition Universelle. He exclaimed: "That is an eagle, and I am only a lark. I murmur my little song in the gray clouds."

The Barbizon School

There was a closely knit group of painters who worked in the vicinity of the village of Barbizon, near the forest of Fontaine-bleau, from the 1830s on. Inspired in part by the example of the English landscapists and by the gentle and reflective landscapes of Corot, they had a common interest in exploring the particular look and atmosphere of a given locale. Théodore Rousseau had been the first to settle permanently in Barbizon when he became discouraged by his lack of success in the Paris art world. He was

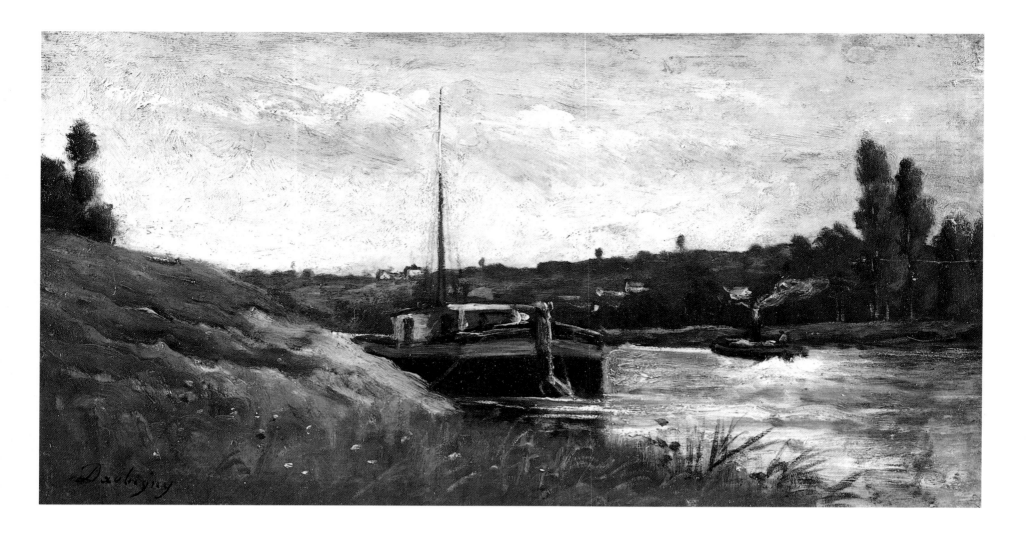

24.
Charles-François Daubigny
Barge on the River
c. 1865–70

25.
Charles-François Daubigny
Gobelle's Mill at Optevoz
c. 1857

Daubigny never tired of painting the Oise, a tributary of the Seine near Barbizon. Not content to sit on its banks, the painter had a boat outfitted so that he could work on the river, which enabled him to find new vantage points and motifs. This direct contact with his subject matter anticipated one of the most significant developments in Impressionist technique.

soon joined by Narcisse-Virgile Diaz de la Peña, Jean-François Millet, and from time to time Charles Daubigny and Corot. With its rustic inns, small cottages, and the nearby dense forest, the area offered artists tranquility and inspiration at a reasonable distance from Paris.

The various painters who came to be known as the "Barbizon School" or "Group" shared a dedication to nature and a wish to be sincere in their representation of nature's many faces. If there was a common element that linked them, it was a striking subjectivism that permitted each to respond to the stimulus of a given scene according to his own sensibilities. They ultimately evolved a direct, unlabored visual language that led many conservative critics to dismiss their work as uninspired or unfinished, lacking those didactic or picturesque pretensions that were considered prerequisites of the finished landscape.

In comparing individual works by members of the group, one sees that Rousseau's renderings of trees and ponds are painted in relatively low-keyed colors, presenting a harmonious and reflective whole while still conveying an individual or particular quality. Diaz's work generally focuses on sharp, dramatic contrasts of light and dark, projected through generously applied paint. Corot, rejecting some of the clarity that had characterized his Roman and earlier French work, sought to capture those nuances of misty light that envelop forms at dawn and dusk, causing outlines of objects to blur and colors to soften. Millet, who settled in Barbizon in 1849, also strove for overall tonal harmony in his works, but these differed from the vast majority of Barbizon painters in their emphasis on specific themes associated with landscape, namely, the daily activities of the farm laborers.

Before moving on to Barbizon, Millet had worked in his native Normandy and on the outskirts of Paris. It took time for him to capture the particular look of this new location, with its long, rough plains and the nearby edge of the forest. The workers of this land, who have been characterized as "the proletariat of the woods,"[8] soon became the subjects of sketches and paintings in which Millet documented their attempts to eke out an existence through such marginal activities as gleaning and faggot gathering (plate 22). The strong drawing and dark palette of these works were admired by Vincent van Gogh, who also shared his sympathy (though not his political awareness) for the plight of the peasants, remarking that they seemed to be painted with the earth they toiled.

Paintings such as *The Gleaners* (plate 48) and *The Angelus* (plate 21) offered such powerful testimony of this grim life that they disturbed and angered bourgeois Parisian art collectors. Napoleon III's minister of fine arts, Count Nieuwerkerke, haughtily observed: "One would think Millet produced art for ruffians."[9] In order to survive, Millet was compelled to paint pseudoclassical themes with a pronounced erotic flavor that found a ready market.

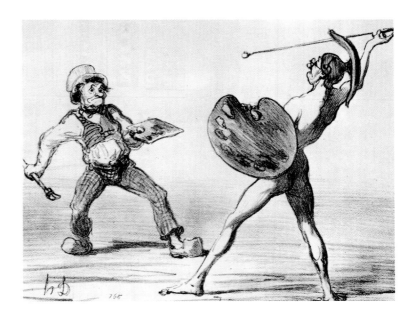

26.
Honoré Daumier
Battle of the Schools
c. 1855

While it might be argued that the Barbizon School contained the seeds of Impressionism in the artists' concern with light and atmosphere, their more direct approach to painting, and their habit of painting out of doors or *en plein air*, it should be remembered that all the artists mentioned still returned to their studios to finish their work. Nonetheless, there were other important links between the two styles. Corot never ceased to remind young students like Berthe Morisot to return again and again to the subject so as not to forget the first impression, and Daubigny was so fascinated with the effects of light on the nearby Oise River that he had a barge constructed in 1857 so he could work directly on the water—anticipating by some fifteen years the floating studio of Claude Monet.

Beyond their involvement with a specific locale and their individual experiments with the painting of water, the real contribution of the Barbizon painters lies in their attitude toward the completion of a painting. Robert Herbert has observed that they were the "first to narrow the gap between the direct sketch and the finished studio picture."[10] Certainly this issue was at the heart of the critical resistance to Impressionism in the 1860s and 1870s. In his *Salon of 1845*, Baudelaire had praised Corot for distinguishing between a *finished* painting and a *complete* one, but it was the exceptional critic who was perceptive enough to recognize the meaning of this change of concept and process. For the most part, critics and public alike railed against the carelessness and lack of design in the landscapes of the Barbizon painters—objections that would persist and indeed intensify by 1874, the year of the first Impressionist exhibition. In a caustic review of that show, Louis Leroy accused Corot of having provided the bad example for the young exhibitors: "Oh, Corot, Corot, what crimes are committed in your name! It was you who brought into fashion this messy composition, these thin washes, these mud-splashes in front of which the art lover has been rebelling for thirty years."[11]

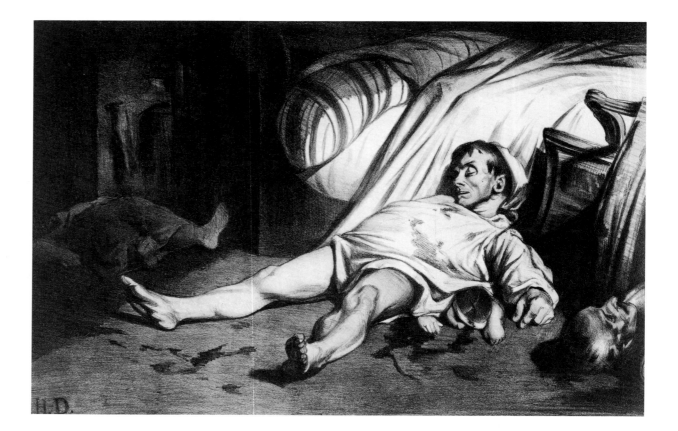

27.
Honoré Daumier
Rue Transnonain
1834

28.
Honoré Daumier
The Uprising
c. 1849

"To Be of One's Own Time": Honoré Daumier

A cartoon by Honoré Daumier entitled *The Battle of the Schools* appeared in an issue of the satirical publication *Le Charivari* at about the time of the 1855 Exposition Universelle. It portrayed a grubby fellow, dressed as a composite of the urban and rural working classes and armed with a short, thick brush and small palette, confronting a tall, skinny, helmeted nude who brandishes a maulstick and shieldlike palette. While the feisty comportment of the top-hatted gladiator resembles that of a bricklayer, the attitude of the nude warrior is unquestionably adapted from Jacques-Louis David's *The Sabines* (1799), one of the most venerated monuments of Neoclassicism. The cartoon is a humorous comment on the rejection by some contemporary artists of the retrospective aesthetics of the Academy in favor of a vigorous commitment to their own time. Yet apart from the topical polemics of the cartoon, in which the Realist sympathies of the artist are not concealed, its comic parodies of anatomy and character ring true. Daumier was unquestionably one of the most inspired draftsmen in the history of art, despite the fact that he was largely self-taught. Baudelaire, who was among the first to appreciate his satirical genius, observed that Daumier "drew because he had to—it was his ineluctable vocation."

The son of a picture framer and glass worker who was also an amateur poet, Daumier was earning a living by the time he was ten years old. He worked initially as a messenger for lawyers, serving writs on the tradespeople who were later to furnish the subject matter for the more than four thousand lithographs he produced in his long career. Daumier never forgot the lessons of his boyhood, honing his vision on daily experience and perfecting his knowledge of the countless representatives of the middle- and lower-middle-class Parisian society he had come to know so well. Despite his limited formal instruction in drawing

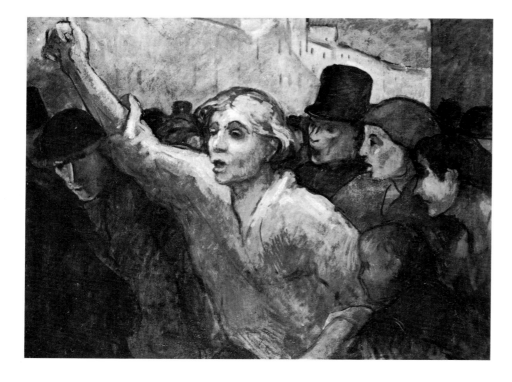

Seventeen years after the revolution that brought Louis-Philippe to the throne and the middle class to real political power, France was rocked by another struggle in which the bourgeoisie was pitted against the working class. Daumier's sympathy then, as earlier, was with the people, and he fashioned a composition as appropriate to the symbolic aspirations of the Socialist movement as his lithographic broadside Rue Transnonain *had been to the events of 1834. The generalized forms, broadly modeled yet vigorously drawn, convey the raw energy of this group of urban guerillas in a style that speaks out as unequivocally as a recruiting poster.*

and printmaking (he trained himself by copying works of art in the Louvre), he was able to find employment as a commercial artist, producing prints for popular consumption.

In 1834 there were riots in Paris against the government of Louis-Philippe, the constitutional monarch who had come to power with the overwhelming support of the bourgeoisie. The troops of the Garde Civile broke into a tenement in a populous quarter inhabited by workers who were suspected of taking part in the revolt. Shooting indiscriminately, they killed many people, including women and children. Daumier, who had been imprisoned two years earlier for his satirical attacks on the king, responded with his most powerful political statement, *Rue Transnonain* (plate 27), named after the street where the massacre had taken place. The lithograph quickly became rare as the government confiscated and destroyed as many copies as it could. Its terse and awful language, conveyed in the limited but dramatic tonalities of black and white, testifies to the enormous strength of Daumier's draftsmanship. Baudelaire, aware that he was dealing with a work that transcended political satire, termed it "history, reality, both trivial and terrible." The simplicity of the humble bedroom, the proletarian intimacy of the dead father in his nightshirt, sprawled across the body of his murdered child, and the random placement of the other corpses underscore the pathetic ordinariness of the death scene. In trying to convey the almost casual nature of violence, Daumier avoided grandiloquence and idealization, and relied instead on the directness and immediacy of his composition. His keyhole view grips the spectator more effectively than the rhetoric of story painting.

Although Daumier achieved fame and even notoriety with his political cartoons and his biting satires of the middle class, the man whom Baudelaire described as "one of the most important men . . . in the whole of modern art" was dogged by poverty throughout his life. He continued to support his family as a cartoonist, but his need to communicate his vision of modern life was too contained by the limited dimensions of that medium; he required the breadth of the canvas to express more fully the sweep and variety of the city and its people.

Daumier probably began painting in the 1840s, but information about his life is scarce. Like other progressives, he was critical of the Salon and its jury system. In 1847 his name appeared in connection with a plan for alternative exhibitions, but the activities of the organizing group were curtailed by the brief and fiery February Revolution of 1848, which resulted in the collapse of Louis-Philippe's government and the establishment of the short-lived Second Republic. Daumier was one of the few artists who attempted to translate the turbulent and ephemeral actions of the Revolution into visual form. Characteristically, he turned to the streets of Paris for his inspiration. In *The Uprising* (plate 28), an unfinished painting, he depicts an orator leading a tidal wave of workers and top-hatted members of the middle

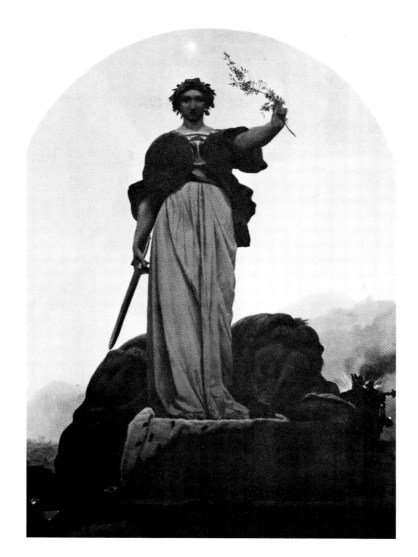

LEFT
29.
Jean-Léon Gérôme
La République
1848

BELOW
30.
Honoré Daumier
The Republic
1848

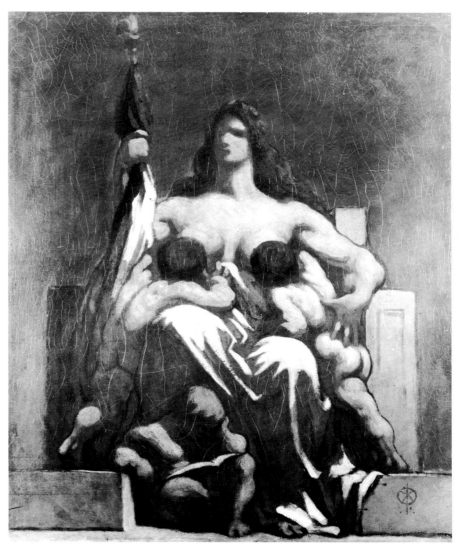

class, a clear reference to the initially wide spectrum of support for the revolt. While the situation is somewhat reminiscent of Delacroix's *Liberty Leading the People* (plate 37), Daumier avoids the literary specificity of the earlier work. The fluid expressiveness of his line and the simple massing of tonal values give the painting the taut intensity of a political poster.

In another work (plate 30), executed in response to a government-sponsored contest for a painting honoring the Republic, Daumier rejects the contemporary in favor of a timeless and monumental icon. His seated personification of the Republic harks back to the symbolic language of the Revolution of 1789, but his harsh outlines, somber color, and crude application of paint are in sharp contrast to the idealized forms and slick execution of Neoclassicism—as one can see by comparing his work with that of Gérôme, who also submitted a painting to the competition.

Daumier painted rather sporadically. He did not date his works and seldom showed them. His watercolors and oils were relatively unknown until a large retrospective exhibition was organized shortly before his death in 1878. The works shown revealed a wide range of interests and subjects—theater, the Bible, classical mythology, Renaissance literature, and, of course, the city. Some paintings reflect the acute political consciousness of his cartoons, while others simply focus on one aspect or another of the life of the ubiquitous worker, moving silently through the metropolis, alone or in the crowd. *The Laundress* (plate 49), a typical painting, is devoid of polemics. The artist did not editorialize; he recorded the commonplace drudgery that was the heritage of the working-class Parisian, in this case a woman and her child, who will eventually assume her place. The visual shorthand of the figures and architecture is informed by that same tonal and structural economy that makes Daumier's cartoons so lively. But the most notable characteristic of his painting is his uncanny ability to project the physical and psychological isolation that seems to have permeated urban living even then. Daumier understood his time and his fellow men as few artists in history have. This remarkable empathy enabled him to extract the essence of reality from even the most commonplace experience.

The Pavillon du Réalisme

Not far from the Palais des Beaux-Arts in the Exposition Universelle of 1855 was a substantial wooden structure that housed nearly fifty paintings by one of the most talked about artists of the day, Gustave Courbet. Because the Salon jury had refused two of the thirteen paintings he submitted, this individualist decided to exhibit in a separate pavilion, constructed at his own expense. The structure came to be known as the "Pavillon du Réalisme," since Courbet was generally regarded as the standard-bearer of Realism after the public's initial exposure to his startling *Burial at Ornans* (plate 33) at the Salon four years earlier. Indeed, Courbet's decision to exhibit independently grew from the rejecting of this work and, above all, of a painting he considered crucial to his development, *The Painter's Studio: A Real Allegory Defining Seven Years of My Artistic Life* (plate 52).

This huge painting was an ambitious attempt to represent some of the visual concepts and individuals who had influenced the artist's creative life. The different social levels of his experience, reflecting his political and philosophical convictions, were acknowledged, somewhat confusedly, in a letter he wrote to his friend and mentor the Realist writer Jules Champfleury:

I have started on an immense painting twenty feet long, twelve feet high. . . . It is the moral and physical history of my studio. . . . it is the world that comes to me to be painted.

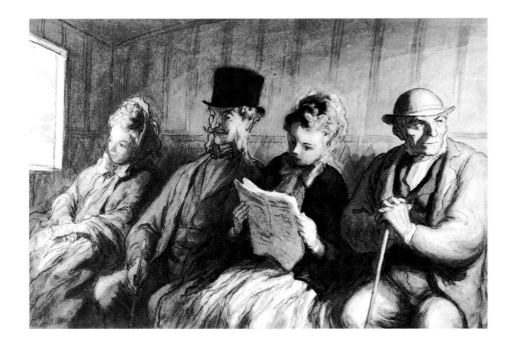

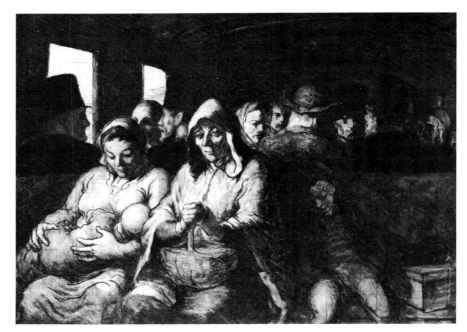

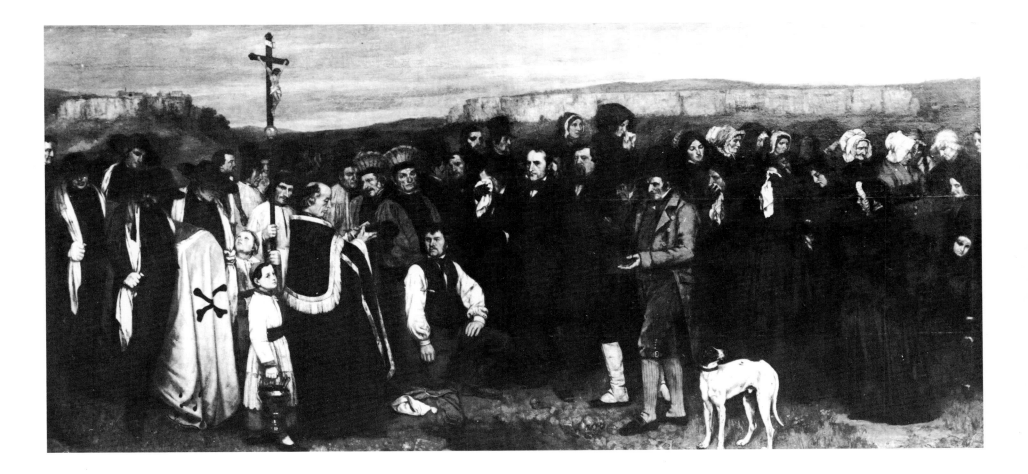

The juxtaposition of low and high life (including portraits of Champfleury, Baudelaire, and the political philosopher Pierre-Joseph Proudhon) resulted in an eccentric and ambiguous composition that the Salon jury found too radical for a public audience long accustomed to the familiar allegory or history associated with the eclectic official style. Courbet's stated intention to create an art that would "interpret the manners, the ideas, the aspect of my time, in terms of my own evaluation—in a word, to produce living art"[13] must have seemed suspicious, if not downright threatening, to minds and eyes conditioned to think in terms of the past and to regard art as separate from life. It was subject matter in itself that continued to obsess the critics and the public and conditioned their judgment in painting. So homogenized were the works that flowed from the Ecole studios into the Salon that Champfleury could justly complain of "the mediocre art of our exhibitions, in which a universal cleverness of hand makes two thousand pictures look as if they have come from the same mold."[14]

Courbet's originality was perceived early on by even the most begrudging of his critics. Théophile Silvestre summed up the prevailing view in an article written in 1861:

Here is an original who, for the past ten years, has made more noise in the streets than twenty celebrities and their coteries. Some regard him as the personification of a new art, like a Caravaggio who sacrifices imagination to reality . . . others take him for a sort of ragpicker of art, scavenging in the streets for truth and throwing it in the face of the romantics and the corridors of the academy: fanatics have placed him above all the artists of our time, and he himself swears resolutely that he had no rival. The public affects disdain for him: critics rage, artists encourage him.[15]

After the initial startled reaction to the *Burial at Ornans* (1849) in the Salon of 1851, Courbet was, as Silvestre asserted, either admired or despised as the main champion of Realism in painting. Paintings such as the *Burial at Ornans* and the *Young Ladies from the Village* (plate 50) represented the people and the landscape of the Franche-Comté. Courbet was enormously attached to his native region, where his family, prosperous landowners, had lived for centuries. He generally spent several months at Ornans, where his family, friends, and neighbors provided the models for his large-scale compositions depicting the daily life of the town and its environs.

For some, the *Burial* was "common, trivial, grotesque." But even a sensitive critic such as Louis de Geffroy had difficulty understanding the work and was compelled to observe that "the funeral of the peasant is not less touching to us than the convoy of Phocion. The important thing is to avoid localizing the subject, and in addition, to emphasize the interesting portions of such a scene."[16] Yet it was precisely the painter's assertion of a common or "localizing" tone that confounded critics and public alike. No emphasis, no focus was provided by Courbet's compositions; only a running, discursive, rather journalistic recording of "facts."

33.
Gustave Courbet
Burial at Ornans
1849

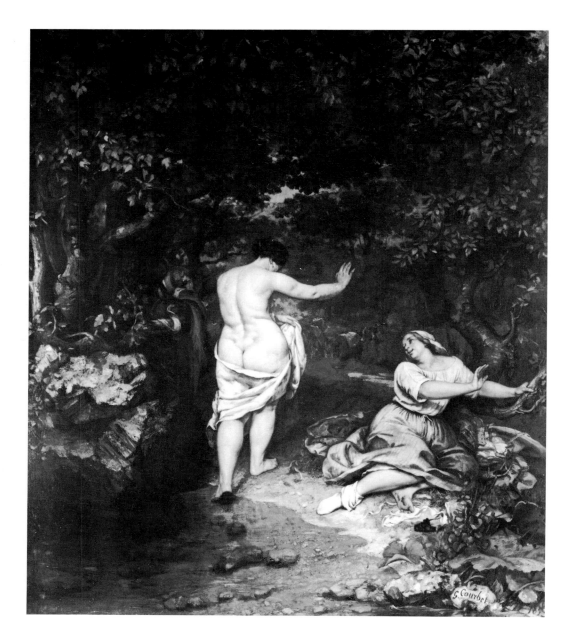

34.
Gustave Courbet
The Bathers
1853

Delacroix's negative reaction to the overt materialism of this canvas was shared by others who had first seen it in the Salon of 1853. One observer characterized the unidealized nude as a "heap of matter, powerfully rendered, cynically turning its back on the beholder."

In a book published in 1860 entitled *Les Amis de la nature*, Champfleury analyzed some of the reasons for the critical and popular rejection of Courbet's Realism. He maintained that "paintings with ideas are not liked" in France, and moreover, that anything that smacked of the proletarian was suspect, if not subversive.[17] Courbet had managed to antagonize the establishment not only by the daring execution of his paintings, but, above all, by the very selection of his subject. In the representation of the everyday, the ordinary, there was the implication of something not merely democratic but profoundly revolutionary, which threatened the official art establishment and its inherited notions of appropriate content and style. Not even Delacroix, with his earlier commitment to more liberal aesthetic and political principles, was able to appreciate fully the consequence of Courbet's aesthetic program. Courbet had introduced rural farmers, workers, middle-class schoolgirls, and intellectual collectors in a new vision of painting. Gone were the heroes, villains, shepherds, nymphs, and all of the picturesque baggage of earlier art; in their place, Courbet offered real people. In the process, he had not so much rejected the traditional concept of subject matter as irreversibly redefined it. Courbet's paintings generated controversy precisely because they appeared in the wake of the upheaval that followed the abortive revolution of 1848, when the bourgeoisie was savoring its defeat of the lower classes. For many, the threat of a socialist takeover was still very real. Moreover, the scale and monumentality of Courbet's works was usually associated with history or allegorical painting, rendering their lack of narrative even more disturbing.

In 1861 Courbet, most likely with the help of his friend the critic Antoine Castagnary, formulated a statement of his personal artistic creed. The document constitutes an informal manifesto of Realist art. Turning away from the notion that an artist must paint the past or some future ideal, Courbet insisted on a commitment to the present and to that which is real: "Painting is an essentially *concrete* art and can only consist of the representation of *real* and *existing* things. It is a completely physical language, the words of which consist of all visible objects. An object which is abstract, not visible, non-existent, is not within the realm of painting."[18]

Courbet's hardheadedness, his insistence on the facts and nothing but the facts, echoes the scientific attitude that permeated the intellectual life of Europe at mid-century. With the collapse of religious and philosophic principles, the natural sciences were regarded by many as the sole means of realizing human happiness and social progress, and their influence pervaded the creative arts. Much of the harsh criticism that greeted Courbet and his literary counterpart, Gustave Flaubert, was aimed at what was perceived as their lack of inspiration of or judicious selectivity. (The writer was in fact likened to a doctor, a clinical technician. In 1857 the critic Charles-Augustin Sainte-Beuve complained of Flaubert's *Madame Bovary*, "He is only there to see

everything, to show everything and to say everything." A similar attack was made on Courbet's *Burial at Ornans*.) Many informed critics, Baudelaire among them, ultimately had difficulty in accepting the all-inclusive aspects of the Realist approach; even the perceptive Baudelaire condemned its "minute description of trivialities." Baudelaire's hero, Delacroix, who visited Courbet's Pavillon du Réalisme, acknowledged his gifts as a painter, but betrayed the dilemma that beset many. In speaking of *The Bathers* (plate 34), which had gained Courbet acceptance in the Salon just two years before, he commented positively on the "vigor" and "relief" of the forms, but went on to indict the "commonness and uselessness" of the subject:

> *What are those two figures doing? A fat bourgeoise is seen from the back, completely nude save for a carelessly painted bit of cloth, covering the lower part of her buttocks; she comes out of a little strip of water which does not seem deep enough even for a foot bath. She makes a gesture which expresses nothing, and another woman, whom one may suppose to be her maid, is seated on the ground, taking off her shoes and stockings. . . . Between these two figures there is an exchange of thoughts which one cannot understand. The landscape is of an extraordinary vigor; but Courbet has done no more than enlarge a study exhibited there, near his large canvas; the conclusion is that the figures were put in afterwards and without connection with their surroundings. This brings up the question of harmony between the accessories and the principal object.*[19]

Delacroix's poetic sensibility was offended by Courbet's banality, but the great Romantic painter was even more perturbed by the lack of physical and psychological coherence in his painting and, finally, by what he understood as Courbet's lack of selectivity or hierarchy of importance. These qualities, all clearly identified as defects, would become in the 1860s the signs of an incipient modernism that was characteristic of the work of Edouard Manet—a painter of enormously different background and temperament, but one who, like Courbet, was deeply committed to his own environment and time.

35.
Gustave Courbet
Proudhon and His Children
1865

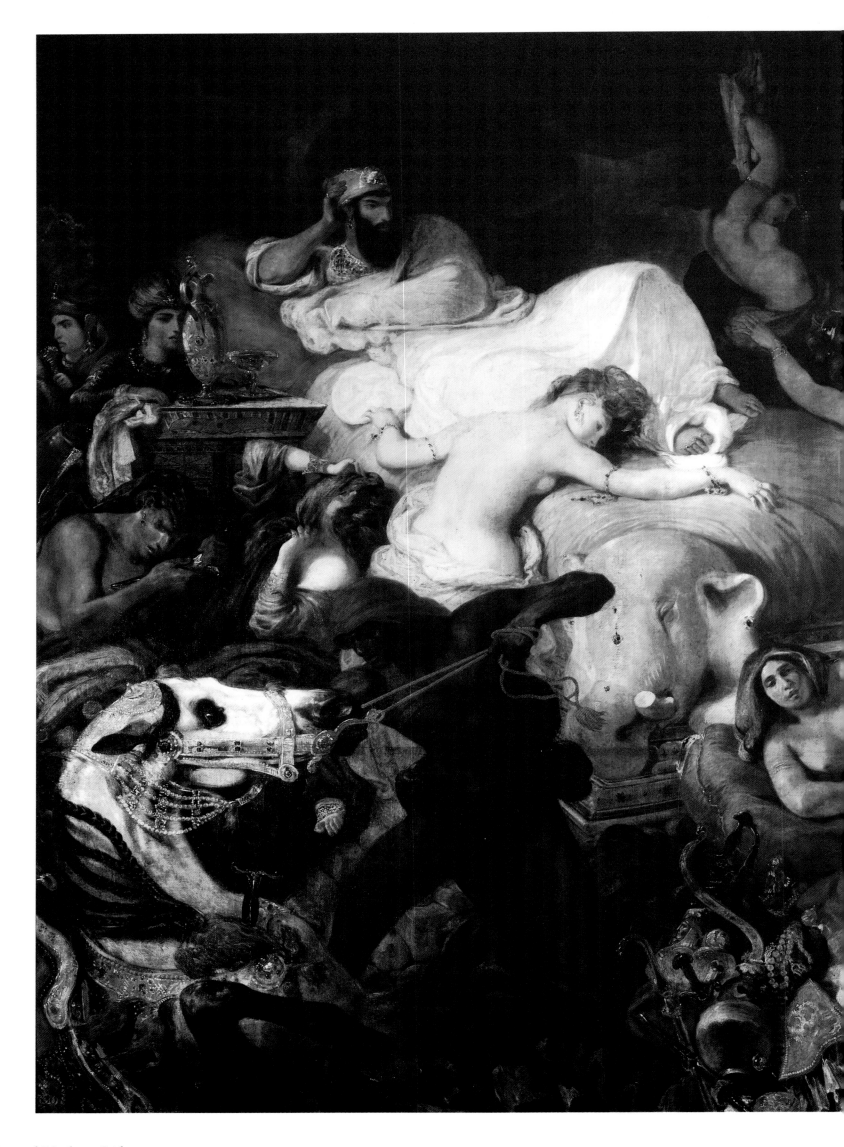

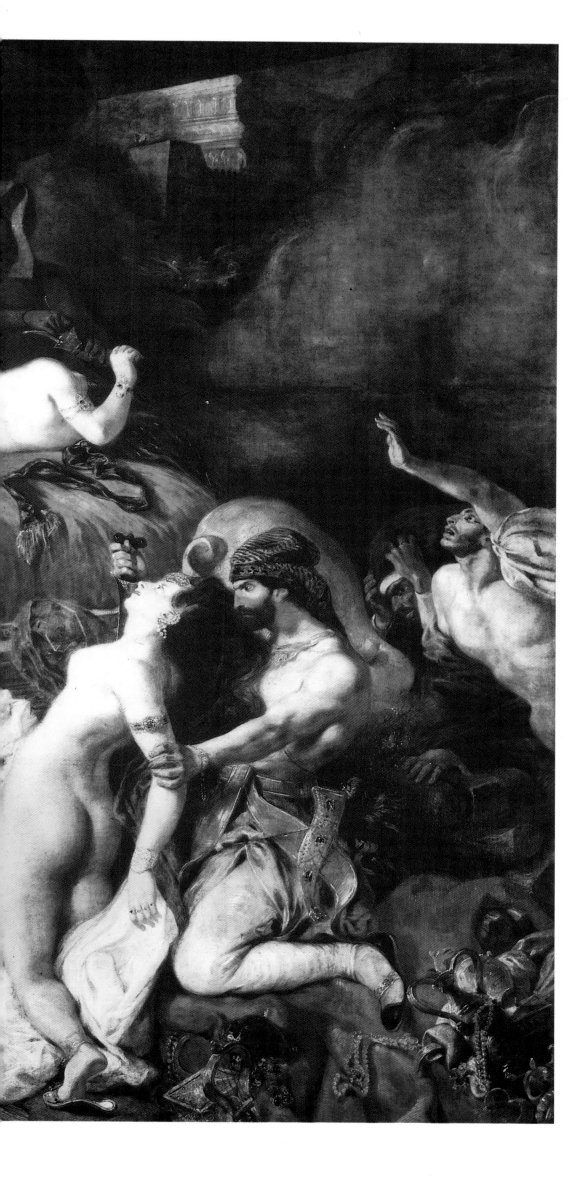

36.
Eugène Delacroix
Death of Sardanapalus
1827

"*There is no picture in the Salon in which color is so sunk in as in the July Revolution by Delacroix. But just this absence of varnish and sheen, with the powder-smoke and dust which covers the figures as with a gray cobweb, and the sun-dried hue which seems to be thirsting for a drop of water, all give the picture a truth, a reality, an originality in which we find the real physiognomy of the days of July.*"

Heinrich Heine: "The Salon:
The Exhibition of Pictures of 1831"

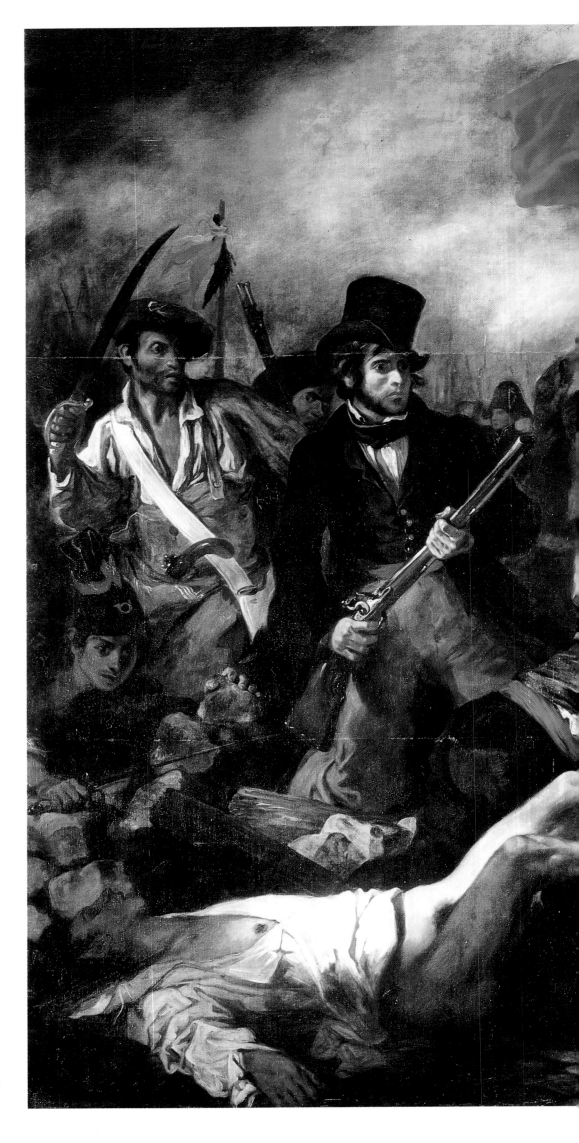

37.
Eugène Delacroix
Liberty Leading the People
1830

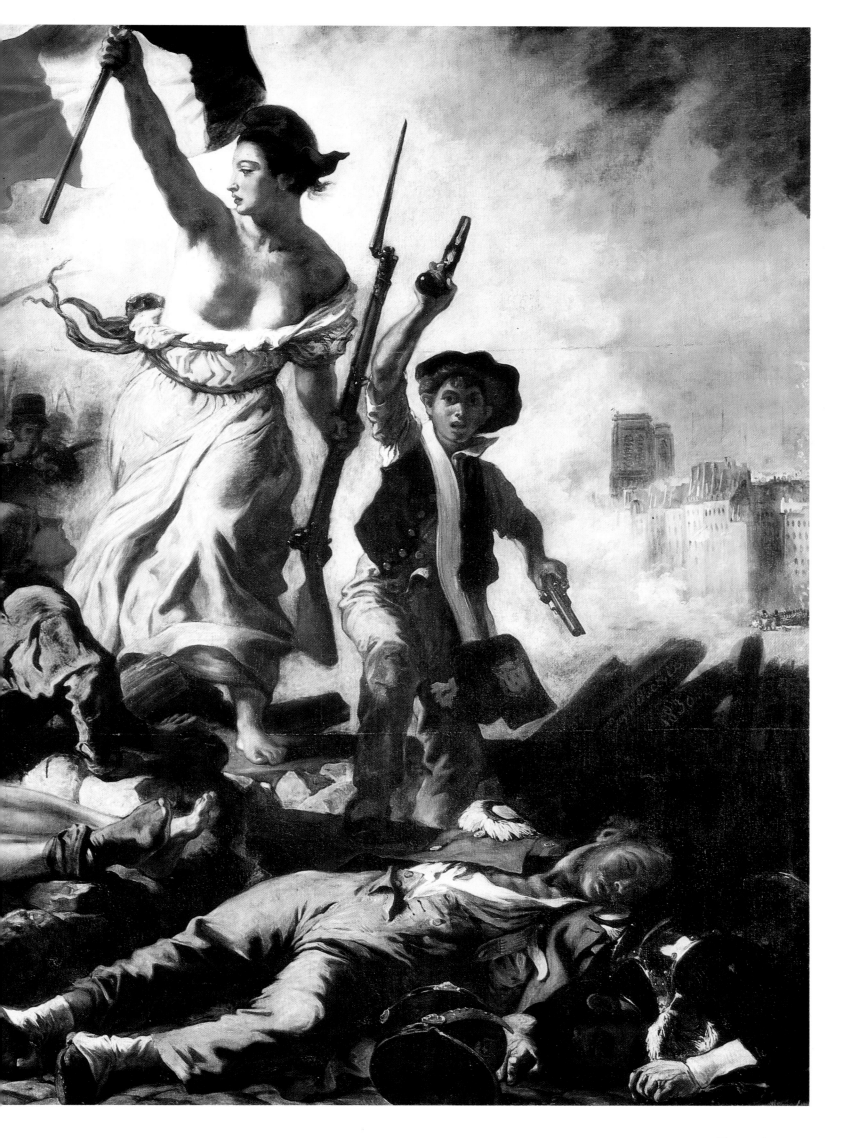

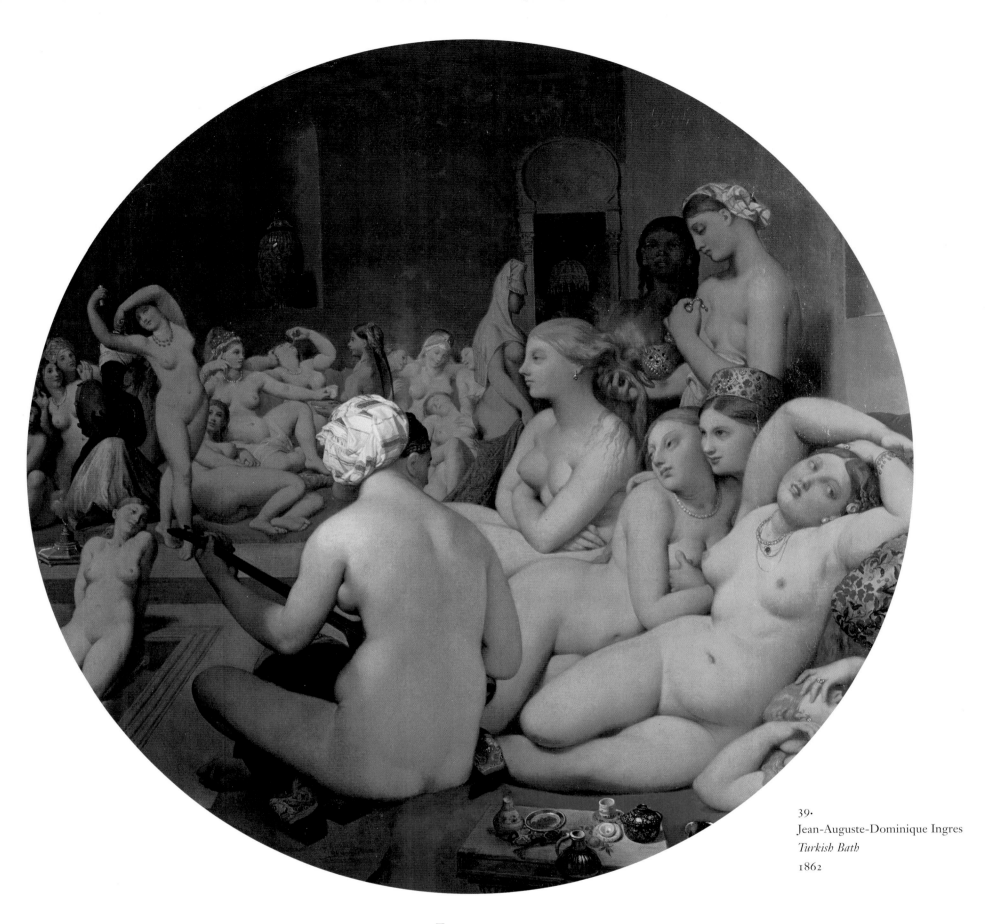

39.
Jean-Auguste-Dominique Ingres
Turkish Bath
1862

OPPOSITE
38.
Eugène Delacroix
The Abduction of Rebecca
1846

*I*ngres's fascination with the motifs of the bather and odalisque persisted throughout his long career. Stimulated by the popularity of orientalizing literary themes, he painted Odalisque and Slave *twice, as he had the theme of the reclining odalisque. In* Turkish Bath *the master quotes liberally from his earlier works, repeating figures and poses such as the slave and principal figure playing the mandolin. The choice of the tondo or round canvas, so popular with fifteenth-century Florentine painters, underlines Ingres's sympathetic response to the decorative flatness of their work.*

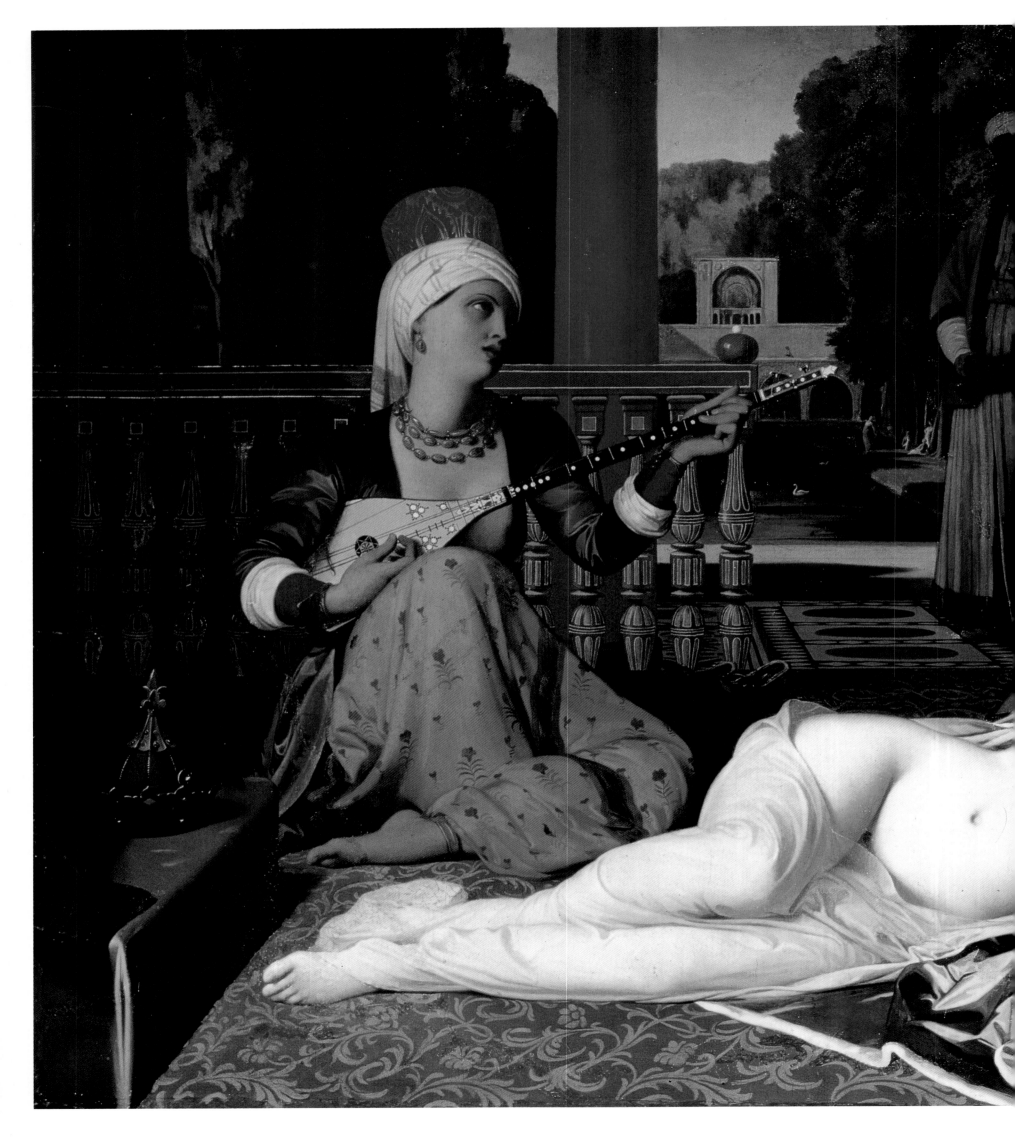

40.
Jean-Auguste-Dominique Ingres
Odalisque and Slave
1842

Detail of plate 41

Constable made a strong impression on the French artists and critics who saw this landscape in the Salon of 1824. The immediacy of the scene and the animated brushwork conveyed that sense of pictorial truth the artist so earnestly pursued. Constable's belief that "the sky is the source of light in nature, and governs everything" led him to a lifelong study of clouds and weather effects. In abandoning traditional tonal values in favor of broken color, he set an example later emulated by Delacroix.

41.
John Constable
Weymouth Bay
c. 1807

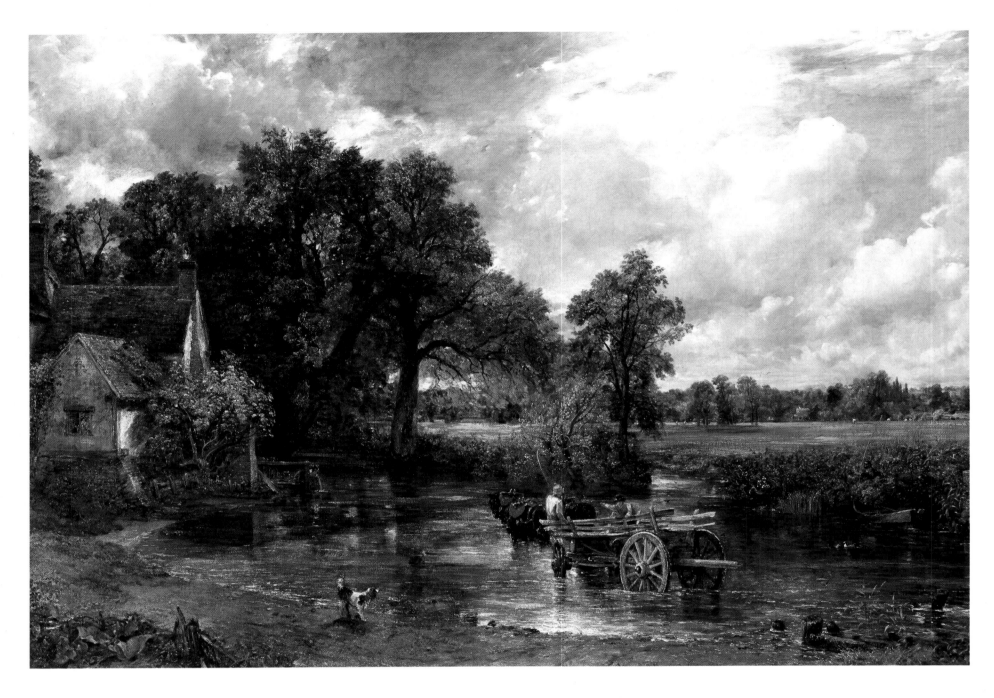

42.
John Constable
The Hay Wain
1821

43.
Joseph Mallord William Turner
Houses of Parliament on Fire
1834

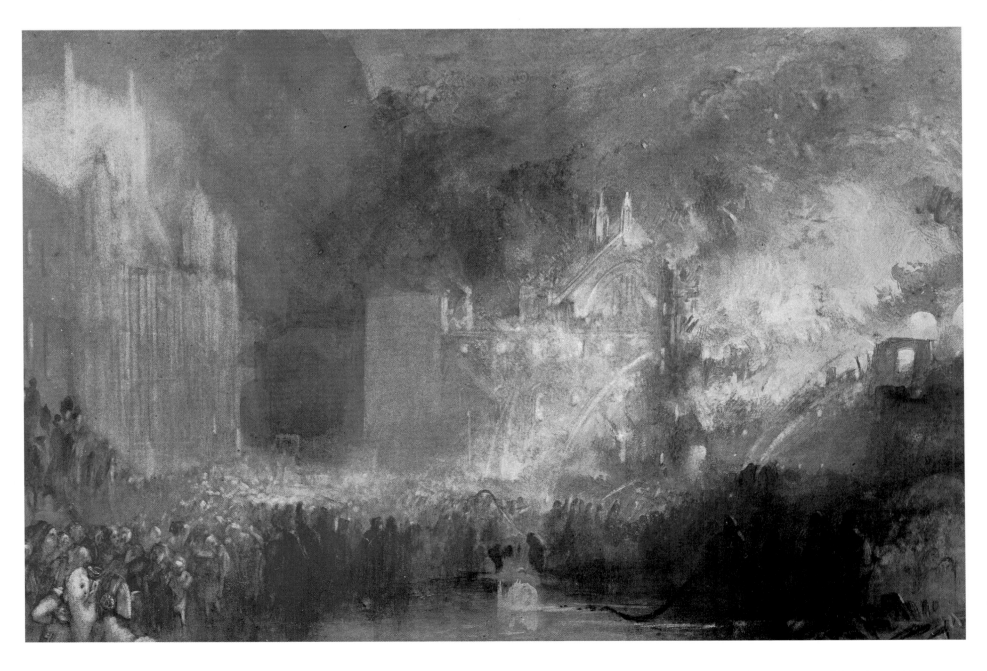

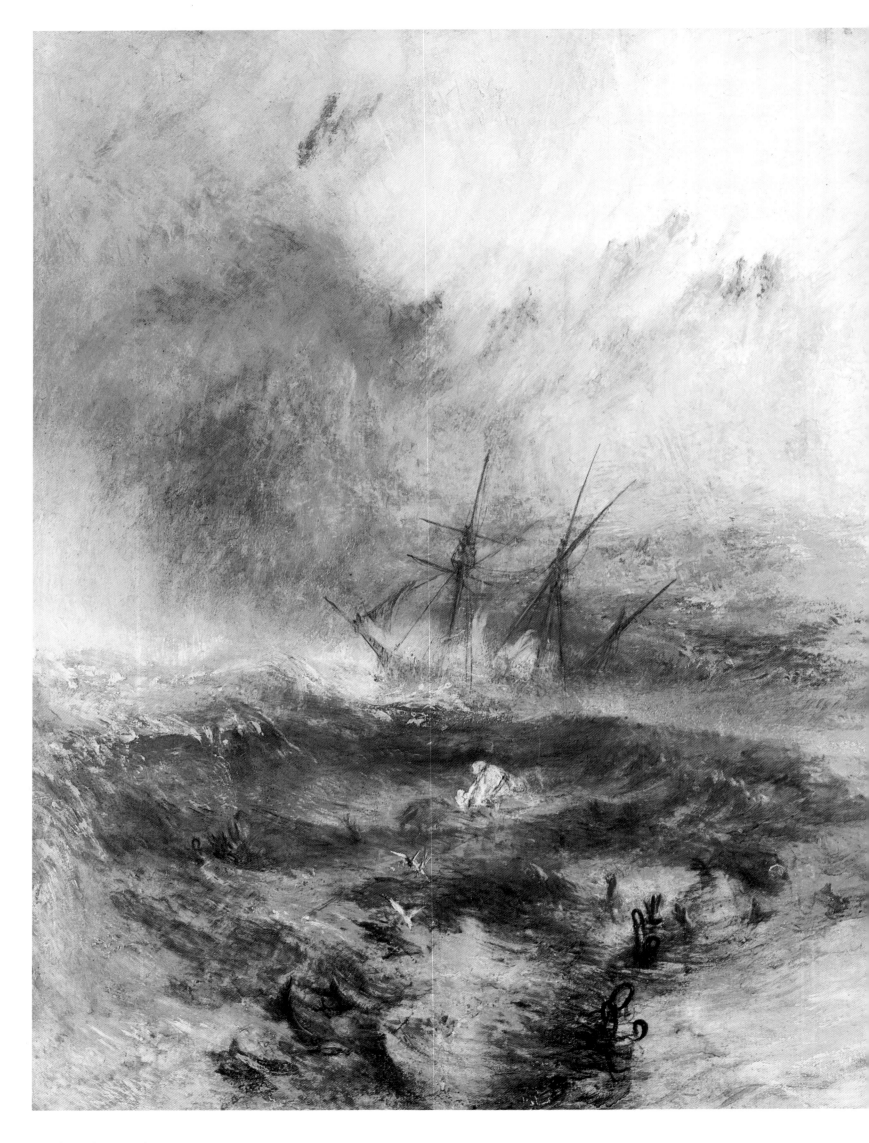

When Turner painted this work, his art was no longer limited by narrative description. Although the painting was inspired by eyewitness accounts of the inhuman conditions and frequent sinkings of the vessels that brought slaves from Africa to America, the painter eschews narration for an expressive symbolism that uses color to convey the brute force of nature. Gustave Geffroy related that when Monet and Pissarro first discovered Turner's paintings, they were thrilled to see the embodiment of an aesthetic they thought they alone had been seeking.

44.
Joseph Mallord William Turner
The Slave Ship
c. 1840

45.
Camille Corot
The House and Factory
of Monsieur Henry
1833

*C*orot spent years studying the ruins of Rome and the surrounding countryside, and the experience made him a keenly sensitive interpreter of light and its capacity to clarify form. Years later, he turned his eyes on the clear sky that illuminated the discrete space and unpretentious shapes of the home and adjacent factory of an early industrialist. Deft brushwork and firm design were combined to produce a lucid composition that conveys both the immediate physical atmosphere and the more enduring structure of forms in nature.

Detail of plate 45

46.
Camille Corot
Boatman of Mortefontaine
1865–70

Like the seventeenth-century landscapist Claude Lorrain, Corot had a genius for conveying the lyric aspect of nature. The soft, slightly blurred focus and silvery tones of his forms create a visual equivalent for contemporary Romantic poetry. Both project the aura of gentle melancholy that comes from the contemplation of nature's fleeting charms.

47.
Charles-François Daubigny
Soleil couchant
1865

48.
Jean-François Millet
The Gleaners
1857

50.
Gustave Courbet
Young Ladies from the Village
(Demoiselles du Village)
1852

*C*ourbet used his own sisters as the models for this modern updating of a traditional charity theme, giving alms to the poor. When the painting was shown in the Salon of 1852, its unconvincing integration of figures and landscape opened it to some ridicule, but the public was even more irked by the painter's conscious renunciation of charm, his avoidance of the picturesque detail usually associated with rural subjects, and his preempting of the large scale that was considered appropriate only for historical or mythological subjects.

51.
Gustave Courbet
Woman with a Parrot
1866

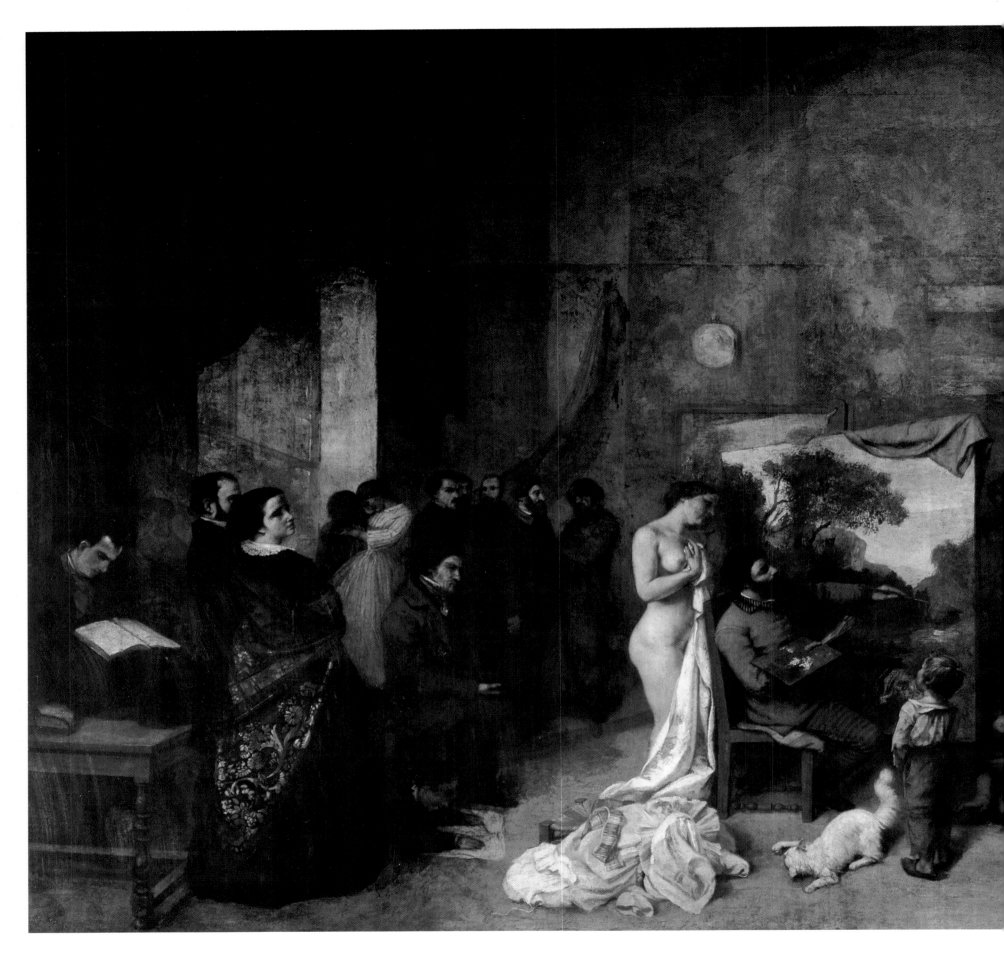

52.
Gustave Courbet
The Painter's Studio
1855

The rejection of this monumental canvas by the jury for the exhibition at the Paris Exposition Universelle of 1855 triggered Courbet's decision to hold a one-man show in a separate pavilion. Subtitled "A real allegory, summarizing seven years of my life as an artist," the painting documents Courbet's growing dedication to painting from his own experience. Grouped respectively to the right and left of the artist at work are Courbet's friends and patrons from the literary and art worlds of Paris (including Baudelaire, featured in the detail below), and peasants from his hometown—clearly separated into the "haves" and the "have-nots."

Detail of plate 52

Edouard Manet:
Reluctant Revolutionary

I cannot repeat too often that in order to understand and savor his talent, we must forget a thousand things. . . . The artist is painting neither history nor his soul. What is termed "composition" does not exist for him . . . he should be judged neither as a moralist nor as a literary man. He should be judged simply as a painter.

EMILE ZOLA

Born to a distinguished Parisian family, Edouard Manet was more at home in the fashionable cafés of the Batignolles quarter than in the noisy, popular brasseries where Courbet and his fellow Realists socialized. Paradoxically, he was an independent who nonetheless believed that he could realize his artistic aspirations only within the framework of the establishment. Although his work repeatedly provoked controversy, Manet persisted in his conviction that the public would come to accept it through prolonged exposure. Never happy in the role of polemicist or revolutionary, he longed for the official recognition that in fact came only after his death in 1883.

Recognizing that his son was not destined to follow the family tradition of law and government service, Manet's magistrate father permitted him to join the crowded studio of Thomas Couture in 1850. He remained for the next six years. Doubtless Manet's father believed that Couture, who enjoyed a considerable reputation as a history painter, was the sort of teacher who would point his son in the direction of official fame and fortune. But the younger painter demonstrated an independent spirit, expressing a preference for drawing ordinary models in contemporary clothing rather than the heroic and more academically acceptable nude. With the other pupils, struggling to find a style, he confronted the art of the past, copying the Old Masters in the Louvre for hours. While he admired Titian, Tintoretto, Rembrandt, and François Boucher, Manet was especially drawn to the paintings of Diego Velázquez and even made a loose copy of the Spanish master's *Little Cavaliers* in 1859. That same year, he painted another work, *The Absinthe Drinker* (plate 53), which owes a debt to Velázquez even though the subject was directly inspired by a contemporary of Manet's, a ragpicker who worked

near the Louvre. When the young artist showed his composition to his former teacher, Couture reportedly objected to its dissoluteness, exclaiming, "My poor friend, you are the absinthe drinker"—an allusion to the power of the beverage to destroy the brain. Apparently the Salon jury agreed with Couture's appraisal, for they rejected the work. Undaunted, Manet submitted two paintings to the next jury: a portrait of his parents and a work entitled *The Guitar Player* (plate 54). The latter, like *The Absinthe Drinker*, offered a combination of past and present, of Spain and Paris, in the person of an itinerant entertainer. In contrast to the earlier work, *The Guitar Player* garnered some favorable critical attention, and the jury awarded Manet an honorable mention for what they considered a successful translation of a traditional, picturesque subject into a modern idiom. Critics such as Théophile Gautier, Zacharie Astruc, and Antoine Castagnary praised the color and the lively execution of the work, while fellow painters Henri Fantin-Latour and Félix Bracquemond were so curious about his work that they visited Manet's studio. Couture's former pupil suddenly found himself in the artistic limelight after a relatively short time in the profession.

Having thus evolved a working formula for his paintings, Manet used it repeatedly in the 1860s, exploiting in particular the newly fashionable Spanish motifs. Sometimes members of the visiting ballet company of the Royal Theatre of Madrid posed for paintings, but Manet also dressed up Parisian acquaintances as pages or matadors. After being long ignored, Spanish art and culture had begun to attract great attention in France in the 1840s. There were two principal reasons for the new popularity: Louis-Philippe's collection of works by Francisco Zurbarán, Bartolomé Esteban Murillo, and Velázquez had been opened to

OPPOSITE

Detail of plate 80

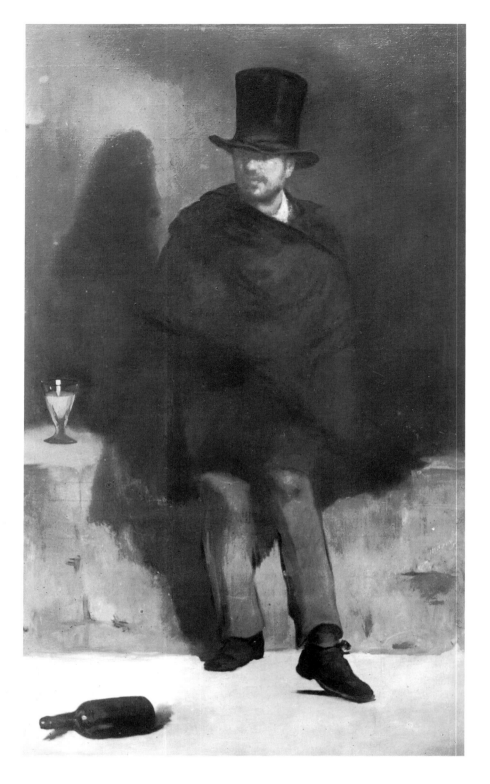

the inhabitants of a slum near the painter's studio.[1] Although the reaction to his *Absinthe Drinker* of a few years earlier had been negative, Manet provocatively "quotes" the subject on the right, raising questions about the figure's identity in such an unlikely context.

The impact of *The Old Musician*, with its flat forms, sharp tonal contrasts, and splintered narrative, is that of an enigmatic pastiche or dumb show. Manet never reveals the identities of either his strolling player or the members of his audience. The Realist and Romantic elements in the painting neutralize one another; the resulting mood of perplexing melancholy that permeates the work angered Manet's contemporaries and prompted them to view his compositional devices as the products of affectation or ineptness. But far from attempting to disguise any inherent weakness of design in his early work, Manet was actually calling attention to it by insisting on a new sense of casualness or informality of structure. The virtual absence of conventional perspective and the abrupt changes in scale that pervade his early compositions are often accompanied by passages of remarkable freshness and skill, yielding curiously uneven compositions.

At times, Manet was so dissatisfied with the results of his work that he cut up his canvases into separate paintings. When he exhibited *An Incident in the Bullring* in the Salon of 1864, the critics panned it mercilessly, calling attention to the arbitrary scale of the figures and the overall lack of spatial coherence. They dubbed the painter "Manet y Courbetos y Zurbaran de las Batignollas"—ridiculing his predilection for Spanish themes and his presumed affinity for Courbet, the Realist. Shortly after the exhibition, Manet cut the work up, retaining its two principal motifs: the bullfight scene and the figure of the fallen matador, known as *The Dead Toreador* (plate 78).

The Painter of Modern Life

About a year after Manet's initial success in the Salon of 1861, Baudelaire published an article in which he praised the painter for combining "a decided taste for modern truth . . . [with] a vivid and ample, sensitive, daring imagination without which all the better faculties are but servants without a master."[2] Lamenting the lack of significant art in the 1840s and 1850s, Baudelaire urged contemporary artists "to be of their own time." The essence of modernity was to him "transitoriness, the fugitive, the accidental."[3]

Temperament was the essential component in Baudelaire's definition of artistic greatness, and the temperament of the painter of modern life was that of the dandy, the elegant *flâneur*, or stroller, who observes life with detached interest. Certainly Manet's temperament was that of the flaneur; and a dedication to the transitory image was one of the major concerns of his art

the public, and Napoleon III's marriage in 1853 to the beauteous Eugénie de Montijo engendered a wave of Hispanophilia. Although Manet certainly shared in this enthusiasm for Spanish themes, the local color or topical picturesqueness one usually associates with such subjects is conspicuously absent from his paintings. A case in point is *The Old Musician* (plate 76), the largest and most ambitious of these early paintings, which combines copied and directly observed motifs. The central figure, posed for by an indigent musician, is also a composite of two art sources from the past: a principal figure in Velázquez's *Los Borrachos* (*The Topers*, plate 55), and a Roman version of a portrait bust of a Greek philosopher in the Louvre. The figures on the left recall the paintings of peasant children by the seventeenth-century Le Nain brothers, while others are said to be studies of

in the early 1860s and surfaced again in the late 1870s. This attitude was first expressed in his large, daring *Music in the Tuileries* (plate 80). The work, which reflects an important stage in Manet's evolving interest in subjects drawn from contemporary life, is autobiographical, containing portraits of himself, his brother Eugène, and many of his new friends—Baudelaire, Astruc, Gautier, even Jacques Offenbach, the composer.[4] While the composition has some affinity with earlier watercolors and prints of fashionable Parisian society, the painting is unique in its lack of anecdote. This literal and spontaneous "record" of a crowd provoked another critical storm. Writers well disposed to Manet were troubled by the disorganized and spatially oppressive *horror vacui* of his composition, with its drastically limited palette of black, white, red, and blue. One even described the palette as "the caricature of color and not color itself."[5] Indeed, the harsh contrasts of black and white, lack of modeling, and incipient flatness that had characterized Manet's early pictures were even more evident in this unfocused assembly of top-hatted dandies and elegant ladies.

A true son of Paris who preferred its parks and gardens to the forest of Fontainebleau or the banks of the Seine, Manet manifested his delight with the city and its inhabitants in his careful choice of subjects. While the Impressionists would later discover the wide, straight boulevards created by Baron Georges Haussmann in the 1850s and paint broad, panoramic views, Manet tended to concentrate on isolated figures and incidents representative of urban life: his paintings function as self-contained visual metaphors of modernity, rather than descriptions of moments. One of the more remarkable illustrations of this capacity to capture a contemporary ambiance is *The Street Singer* (plate 79), which shows a woman (actually Manet's favorite model, Victorine Meurend) exiting from a drab café, raising some cherries to her lips. The slight awkwardness of her pose, the fragmented and vague background, and, above all, the unfinished quality of the physical setting produce a psychological sense of incompleteness. The viewer is overwhelmed by the immediate presence of the woman, almost as if she were a passerby. As one art historian observed, "She is so very present that she is only present."

What a contemporary critic indicated in this work as "nothing more . . . than the shattering discord of chalky tones with black ones"[6] was produced in large measure by Manet's rejection of halftones, but it was also the result of a conscious effort to acknowledge the two-dimensional surface of the canvas. The broad, simplified forms are similar to those found in Japanese prints, which Parisians had been admiring since they were first introduced at the Exposition Universelle of 1855. These prints inspired a technique that, when combined with unmixed color and more spontaneous handling of paint, allowed Manet to relinquish traditional space and evolve a sense of decorative unity in his composition that would serve him for years to come.

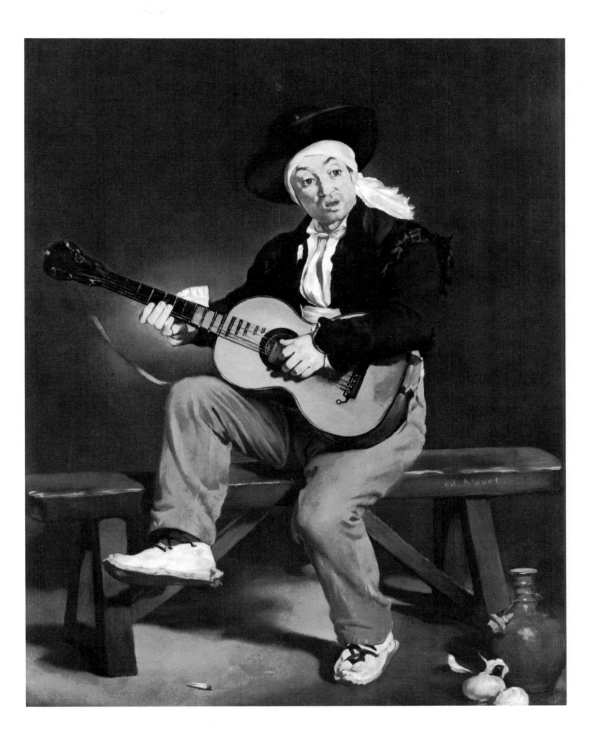

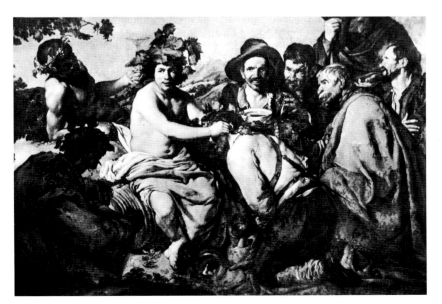

ABOVE

54.
Edouard Manet
*The Spanish Singer
(The Guitar Player)*
1860

LEFT

55.
Diego Velázquez
*Los Borrachos (The
Topers)*
c. 1626–28

56.
Edouard Manet
The Races
1864–65

The Salon des Refusés and Its Aftermath

Like other progressive painters of his time, Manet was eager to put his work before the public. Since inclusion in the Salon was essential for sales, the matter of being accepted involved more than pride. As the time for the selection of the paintings for the Salon of 1863 drew near, pressure from the painters to change some of the conditions of exhibition grew. A ruling that allowed artists to exhibit only three works each created further discontent, and a group of artists led by Manet and Gustave Doré presented a petition to the minister of state to redress the situation. The petition was virtually ignored. To make matters worse, the Salon jury was particularly harsh in its selection; many painters who had encountered no obstacles in the past were rejected. The jury deliberated for about ten days before announcing the official results: of the five thousand or so paintings submitted by about three thousand artists, they had accepted only two thousand. Reaction on the part of artists was swift and predictably emotional. Appeals were sent again to the minister of state. Napoleon III personally reviewed the rejected works and then summoned Count Nieuwerkerke, who was the

president of the jury. On April 24, 1863, he announced his epoch-making decision:

> *Numerous complaints have reached the Emperor on the subject of works of art that have been refused by the jury of the exhibition. His Majesty, wishing to let the public judge the legitimacy of these complaints, has decided that the rejected works of art are to be exhibited in another part of the Palais de l'Industrie. The exhibition will be elective and the artists who may not want to take part need only to inform the administration, which will hasten to return their works to them. This exhibition will open on May 15 [the Salon was scheduled for May 1]. Artists have until May 7 to withdraw their works. Beyond this limit, their pictures will be considered not withdrawn and will be placed in the galleries.*

The emperor's extraordinary action engendered euphoria in some quarters and created a crisis in others. The decision of whether or not to exhibit under conditions that amounted to a total lack of selection was an extremely difficult one for ambitious artists like Manet, who had already received an honorable

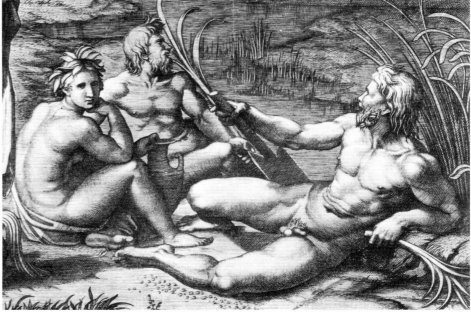

Like other students of Couture, Manet copied paintings in the Louvre. He used Giorgione's celebrated Concert champêtre *and an engraving of a lost painting by Raphael as sources for his most infamous work,* Déjeuner sur l'herbe *(plate 75).*

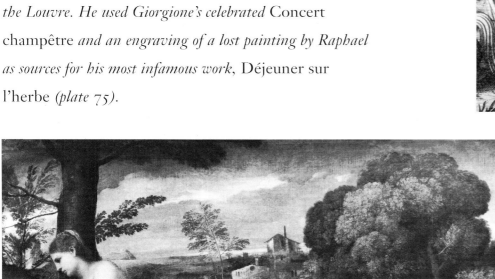

ABOVE
57.
Marcantonio Raimondi
The Judgment of Paris
C. 1520

LEFT
58.
Giorgione
Concert champêtre
C. 1505

59.
Constantin Guys
Coaching
C. 1860

Guys's spirited vignettes of Parisian high society had inspired Baudelaire to characterize him as a painter of modern life. Manet's own zest for living led him to investigate similarly pleasurable themes, but he avoided the fashionable qualities exploited by Guys in favor of bold execution and direct formal expression. These are vividly illustrated in the terse language of his black-and-white lithograph of a horse race.

mention in the previous Salon. The sensitive critic Castagnary, who had been a friend to the Realists, identified the artistic dilemma:

> To exhibit means to decide, to one's detriment perhaps, the issue that has been raised; it means to deliver oneself to the mocking public if the work is judged definitely bad: it means testing the impartiality of the commission siding with the Institut not only for the present but for the future. Not to exhibit means to condemn oneself, to admit one's lack of ability or weakness: it means also, from another approach, to accomplish a glorification of the jury.[8]

Manet and his friends decided to accept the "Salon des Refusés," as the exhibition came to be called. Unlike Courbet, Manet did not regard himself as the center of a rebellion. While he believed that the Salon offered the best opportunity for showing an artist's work, he was willing to accommodate alternatives. The important thing was to show and to show frequently.

The government provided no help in organizing the Salon des Refusés, and the effort was characterized by a certain amount of accident, since some artists could not be reached before the deadline for voluntary withdrawal. Of those who exhibited, Johan Barthold Jongkind, James McNeill Whistler, Fantin-Latour, Camille Pissarro, Alphonse Legros, Bracquemond, and Paul Cézanne—the twenty-four-year-old from Aix-en-Provence who had failed the entrance examination to the Ecole des Beaux-Arts—are the best known.

From the very first day, the Salon des Refusés attracted crowds. On certain Sundays nearly four thousand visitors were registered—far more than attended the official Salon. Manet exhibited three paintings, including two with Spanish themes: *Young Man in the Costume of a Majo* and *Mademoiselle Victorine in the Costume of an Espada* (plate 74). He was the center of the Salon and the focus of the continuing controversy it generated. His large painting (seven by nine feet), originally called *The Bath*, but subsequently known as *Déjeuner sur l'herbe* or *Luncheon on the Grass* (plate 75), was the *succès de scandale* of the exhibition. The popular press had a field day with the Salon des Refusés, particularly with Manet's composition, which they pronounced risqué and vulgar. The English critic Philip Hamerton wrote:

> I ought not to omit a remarkable picture of the realist school, a translation of a thought of Giorgione into a modern French. Giorgione had conceived the happy idea of a fête champêtre in which, although the gentlemen were dressed, the ladies were not, but the doubtful morality of the picture is pardoned for the sake of its fine color. . . . Now some wretched Frenchman has translated this into modern French realism, on a much larger scale, and with the horrible modern French costume instead of the graceful Venetian one. Yes,

> there they are, under the trees, the principal lady entirely undressed . . . another female in a chemise coming out of a little stream that runs hard by, and two Frenchmen in wide-awakes sitting on the very green grass with a stupid look of bliss. There are other pictures of the same class, which lead to the inference that the nude, when painted by vulgar men, is inevitably indecent.[9]

While Hamerton was quick to recognize Manet's quotation of Giorgione's painting in the Louvre, he did not mention the fact that the three principal figures represented, above all, a close transcription of a motif in Marcantonio Raimondi's engraved copy of a lost *Judgment of Paris* (plate 57) by the High Renaissance master Raphael.[10] Thus had Manet invoked the great tradition. What angered Hamerton and other conservatives was not the fact of borrowing from this tradition, but the artist's seeming lack of reverence for it. The public, on the other hand, was outraged because it recognized the protagonists of Manet's painting: his brother Gustave, the sculptor Ferdinand Leenhoff (his future brother-in-law), and the model Victorine Meurend.

Manet's *Déjeuner sur l'herbe* provoked criticism and polemic precisely because its sources were easily identifiable and because its traditional format served to launch a revolutionary technique. In his adaptation of such classical subject matter, incorporating elements of allegory, mythology, and the *fête galante*, the painter had reconstituted that subject matter to the point where it lost virtually all literary significance. If this was objectionable, the accompanying transformation of technique—summary brushstrokes, acid color, abrupt contrasts, and renunciation of traditional tonal value, with its resultant lack of that conventional, slick finish cherished by the academicians—was subject to even greater critical attack. The sensuous poetry of Giorgione's haunting landscape and the rhetorical classicism of Raphael's had been replaced by a brash materialism.

In retrospect, we can acknowledge that the painting is more problematic than successful. Manet barely attempted to integrate his figures with the landscape setting, thus reinforcing the sense of physical and psychological isolation that emanates from this and other works. The spatial ambiguity of this technique would become a critical hallmark of his style.

While the controversy generated by his *Déjeuner sur l'herbe* raised Manet's stature among such critics as Emile Zola and younger painters such as Pissarro, Cézanne, and Frédéric Bazille, the public preferred the smooth surface and cosmetic charms of Cabanel's *Birth of Venus* (plate 61), lauded as *chef d'oeuvre* of the official Salon. Unlike Manet's nude, this blandly sensual image was regarded as charming and in perfectly good taste. Indeed, Cabanel was praised for offering an up-to-date Venus who was "more French than Greek," and more alluring and accessible than cold and distant. Cabanel's canvas not only was purchased by the emperor—who had found Manet's com-

position immodest—but brought the artist the Legion of Honor and election to the prestigious Institut de France.

The closing of the Salon des Refusés did not signal the end of a movement for change and reform. While the majority of the public and critics obviously had agreed with the jury in its rejection of Manet and the others, the jury's stranglehold had been broken. For some, the very existence of an alternative exhibition had proven salutary. Moreover, the commission appointed by the emperor to scrutinize existing rules and regulations presented its findings, and while these did not constitute a drastic reform, some significant changes were made: an annual rather than a biannual Salon was established, and the ratio of elected jurists to appointed ones was enlarged. More significantly, the Institut's supervision over the Ecole des Beaux-Arts and its right to appoint professors was abolished. Among the new professors were the academicians Cabanel and Gérôme, while Couture, Manet's beleaguered teacher, retired in 1864, as did Charles Gleyre, prompting his small group of students—Monet, Bazille, Pierre-Auguste Renoir, and Alfred Sisley—to strike out on their own. Despite the notorious *Déjeuner*, Manet had two paintings accepted in the next Salon, as did several of Gleyre's former students. Manet's canvases, especially his *Olympia* (plate 81), were greeted with scorn. One critic described them as "shams thrown to the crowd, jokes or parodies,"[11] anticipating an attack on Manet's sincerity that would be made repeatedly by critics who were unsympathetic to or uncomprehending of his approach. Gautier, who once had been in the vanguard of the fight against conservatism, complained:

> Manet is by no means negligible; he has a school, he has admirers and even enthusiasts: his influence extends further than you think. Manet has the distinction of being a danger. Olympia can be understood from no point of view, even if you take it for what it is, a puny model stretched out on a sheet. The color of the flesh is dirty, the modeling non-existent. The shadows are indicated by more or less large smears of blacking . . . We would still forgive the ugliness, were it only truthful, carefully studied, heightened by some splendid effect of color.

> The least beautiful woman has bones, muscles, skin, and some sort of color. Here is nothing, we are sorry to say, but the desire to attract attention at any price.[12]

In *Olympia* (which Manet always regarded as his masterpiece), tradition and innovation were juxtaposed even more aggressively than in the *Déjeuner*. The theme was one of the most venerable in the history of post-Renaissance painting, and Manet was well aware of the provocation his painting represented. He had copied Titian's celebrated *Venus of Urbino* in the mid-fifties, and *Olympia* retained the compositional elements of that paradigm of Venetian painting. Once more, the public was confronted with what it perceived as a parody of an unassailable work of art; once more it was forced to suffer the "brazen" nakedness of the model. No bather, odalisque, or Venus, Olympia was resolutely contemporary. As John Richardson has remarked, she was "just the sort of Parisienne . . . many a Salon visitor kept hidden from his wife."[13] In titling his work, Manet invoked a principal character in Alexandre Dumas's popular novel and play *La Dame aux camélias*, whose name was synonymous with heartlessness and inconstancy. As a further provocation, the artist had inscribed on the frame lines from a poem by his friend Astruc that proclaimed the charms of Olympia in verses that celebrate her sensuous appetite.[14]

It was not simply the outrageous or shameless deformation of idealized subject matter that aroused furious reaction, but the accompanying technical innovations. In *Olympia*, there was even greater limitation of color and simplification of design than in the *Déjeuner*; all intermediate values were suppressed in favor of sharp contrasts, creating a composition of such insistent flatness that even Courbet derisively pronounced the figure "the Queen of Spades . . . just after her bath." The controversy surrounding *Olympia* was so heated that Edgar Degas jokingly remarked to his friend, "You're as famous as Garibaldi now." Given Manet's temperament, his ambition, and his own perception of what he was doing, these words hardly could have provided consolation. Baudelaire, upon hearing of Manet's predicament, wrote to him from Belgium, encouraging him to

Manet depicts Zola, his friend and supporter, at work in an ambiance that is full of visual references to the new painting and to Manet as its major exponent. The frame on the wall contains images that refer to the artist and to the bond that linked the two men: dominated by a reproduction of Olympia, *so vigorously defended by the critic, it also contains a print of a Velázquez painting and a Japanese woodcut, knowing and explicit documentations of Manet's complex aesthetic.*

62.
Edouard Manet
Portrait of Emile Zola
1868

persevere in his pursuit of a new artistic vision. Nonetheless, Manet did not paint the nude again for nearly a decade, and when he did, he treated the problem very differently, eschewing any reference to earlier art.

It may have been the brouhaha over *Olympia* that prompted Manet to undertake a trip to Spain in 1866; or possibly it was the wish to gratify a passion that had consumed the painter since the years in Couture's studio when he first studied Velázquez and Francisco de Goya. His short stay confirmed his opinion of the seventeenth-century painter's greatness, and he dubbed Velázquez "the painter of painters." Yet the opportunity to examine at first hand, and in depth, the work of countless Spanish artists had a curiously liberating effect on Manet, enabling him to leave behind the more obvious motifs of Spanish art for a more profound grasp of its technical message, handling of paint, and sense of ambiance. Nearly two years after his return from Spain, Manet utilized his experience in connection with a large painting

inspired by the death in 1867 of the Archduke Maximilian, who had been encouraged by Napoleon III to pursue his claim to the throne of Mexico and then abandoned by him to face death at the hands of a firing squad. The event, which compromised France's prestige in the eyes of most European powers, provoked sentiments of outrage, horror, and pity; yet nowhere are these qualities evident in the several versions of the subject that Manet painted (plates 63 and 83). While the various treatments suggest Goya's stirring *Third of May, 1808* (plate 64) as a point of departure for the general placement of executioners and victims, the similarity ends here. In the terse visual language of Manet's canvases, all traces of narrative are expunged; the only drama is that of brushstroke and pigment.

The critics had been quick to accuse Courbet of producing paintings that were emotionally as well as formally incoherent, and they attacked Manet on similar grounds, likening his figure paintings to still lifes and describing them as "dumb. They pose

immobile—don't ask them to show any feeling, or to express an opinion. . . . They are examples of painting in which the sole interest lies in the technical questions they raise."[15] Because its subject matter was embarrassing to the regime, Manet was not permitted to exhibit his work—a fact that seems singularly ironic in view of its lack of polemic or propaganda, but which again calls attention to the general misapprehension of his artistic statements.

Manet's One-Man Show

The opening of the official Salon of 1867 coincided with another Exposition Universelle in Paris. This time, paintings submitted by Manet, Monet, Cézanne, Sisley, Bazille, Pissarro, and Renoir were rejected, while Degas, Whistler, Berthe Morisot, and Fantin-Latour gained entry. Manet, apparently fed up with repeated rejection, made an important decision: instead of sending work to the jury, he would follow the example of Courbet and exhibit in his own pavilion. Since the older artist decided to repeat his own experiment, the pavilions of the two became the principal points of artistic interest at the exposition. Manet showed fifty paintings. In an explanatory pamphlet written with the help of his friend Astruc, the artist tried to answer past criticism and to clarify his intentions for the general public:

Since 1861, M. Manet has been exhibiting or attempting to exhibit. This year he decided to offer directly to the public a collection of his works. . . . The artist does not say . . . "Come and look at works without fault," but: "Come and look at sincere works." It is sincerity which endows works of art with a character that makes them resemble a protest, although the painter has only intended to convey his impression.—M. Manet has never desired to protest. On the contrary, it has been against him, who did not expect it, that there has been a protest, because there exists a traditional teaching about forms, methods, aspects, painting, because those brought up on these principles don't admit any other. . . . To exhibit is the vital question . . . for the artist, because it happens that after several examinations people become familiar with what surprised them and, if you will, shocked them.[16]

Manet's exhibition was not the success he had hoped it would be. Even close friends were unsympathetic or unappreciative of his work. Monet, for one, had deep reservations about Manet's progress, or lack of it; and Courbet, the erstwhile revolutionary, did not even bother to visit the younger painter's pavilion, protesting that he didn't "understand anything about his painting" and wished not to be rude.

Yet the example of Courbet and Manet seems to have inspired young artists who had been rejected by the Salon to think of an alternative to the official exhibition. Bazille, writing to his family, summed up his position and that of his friends Monet, Renoir, and Sisley:

I shan't send anything more to the jury. It is far too ridiculous. . . . What I say here, a dozen young people of talent think along with me. We have therefore decided to rent each year a large studio where we'll exhibit as many of our works as we wish. We shall invite painters whom we like to send us pictures. Courbet, Corot, Diaz, Daubigny, and many others whom you perhaps do not know have promised to send pictures and very much approve of our idea. With these people, and Monet, who is stronger than all of them, we are sure to succeed. You shall see that we'll be talked about.[17]

This was the embryo of an idea that was finally to emerge in 1874. But financial problems forced the group (which included Pissarro, Cézanne, Fantin-Latour, Morisot, and Degas) to abandon their plan for the time being. Fortunately, most of them succeeded in getting paintings accepted in the Salon of the following year, largely through the influence of Daubigny, who was a member of the jury. Zola, whose portrait Manet had submitted to the Salon, wrote long articles on him and on Pissarro, referring to the young artists who were to change the direction of painting as "les Naturalistes." He stated prophetically: "They form a group which grows every day. They are at the head of the movement in art, and tomorrow one will have to reckon with them."[18]

While Manet was denied the critical recognition he sought, he could console himself with the attention, indeed adulation, of a sizable group of artists and writers who recognized his genius and hailed him as their leader. Among these were Monet, Renoir, Bazille, and the critics Astruc and Zola. Their meeting place was the Café Guerbois near Manet's studio in the Batignolles quarter, where various members of the loosely knit group would gather on Thursday evenings to exchange ideas. Slightly older than the others, quick with a witty or cutting remark, Manet dominated the often heated conversations. His only close "rival" was Degas, who joined the group from time to time. Just two years younger than Manet, he shared a common social background and, more important, possessed a kindred artistic temperament.

The group often discussed the subject of light and the advantages or disadvantages of working *en plein air*. For the landscape painters—notably Monet, Sisley, and Pissarro—this practice was crucial to their development, as it permitted them to experience light and color more directly; whereas Manet and Degas eschewed outdoor painting, because their aesthetic interests lay elsewhere. They were primarily figure painters, and never totally accepted pure landscape.

Though they may have differed in background and in individual objectives, the artists who gathered at the Café Guerbois were united in their common rejection of the old formulas of

63.
Edouard Manet
*Execution of
the Emperor
Maximilian*
1867

In June of 1867, Mexico's Emperor Maximilian and his loyal generals Miramon and Mejia were executed by republican troops. Moved by the story, Manet painted several canvases depicting the event. Though he was largely inspired by Goya's Third of May, 1808, *a stirring depiction of political executions in Madrid, Manet's cool, laconic scenes (also see plate 83) are much more detached than their dramatic prototype.*

64.
Francisco de Goya
Third of May, 1808
1814–15

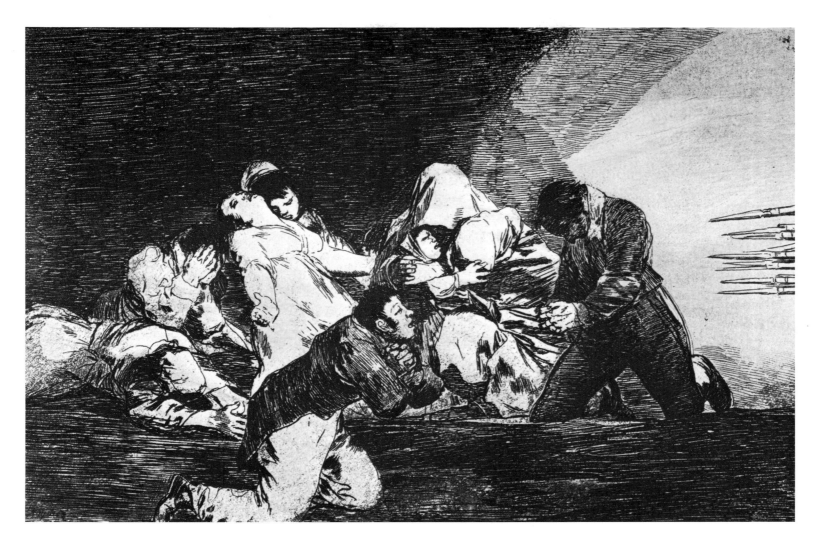

65.
Francisco de Goya
"One Can't Bear to Look"
from *Disasters of War*
c. 1814

the Académie and in their resolve to find new ways of recording the truth of modern life. While they were referred to by the more informal word group rather than school, Manet's position as their symbolic mentor was acknowledged. Fantin-Latour, always a more conservative painter but nonetheless an early admirer of Manet, paid homage to the innovators in *A Studio in the Batignolles Quarter* (plate 66), which he exhibited in the Salon of 1870. Surrounding Manet, who is seated at his easel, are Zola and Astruc, the painters Renoir, Bazille, Monet, and Otto Scholderer, and a musician friend, Edmond Maître. Yet even the elegantly furnished studio, the sober clothing of the painters, and their generally bourgeois demeanor were not enough to persuade the public that Manet and his friends were not revolutionaries.

Throughout his career, Manet repeatedly proclaimed his belief that the Salon was a painter's real testing ground. Yet despite the slight liberalization of the procedure for electing the jury, it was still extremely difficult for Manet and other progressives to gain entry. In 1869 he managed to get two works accepted. One of these, his enigmatic *The Balcony* (plate 82), was a group portrait of the painters Morisot and Antoine Guillemet and the violinist Jenny Claus. While the immediate stimulus for the painting was doubtless provided by a visual memory of a group of acquaintances, its composition recalled a work formerly attributed to Goya, *Majas on the Balcony* (plate 67), a charming and provocative quartet of romantically mysterious *Madrileños*. As usual, the critics were less than enchanted with

Manet's utilization of the earlier motif. Even those who had expressed some appreciation for his previous work complained: "Just as Manet assembles, for the mere pleasure of astonishing, objects which should be mutually incompatible, in the same fashion he arranges his people at random without any reason or meaning for the composition."[19]

Morisot, the great-grandniece of Jean-Honoré Fragonard and sometime pupil of Corot, clearly admired Manet, and gave an ambivalent appraisal of his work: "His paintings . . . give the impression of strange, or even unripe, fruit. To me they are far from unpleasant. In *The Balcony* I am more odd than ugly."[20]

Manet had spent the summer of 1868 on the Channel at Boulogne, and was so delighted that he returned the next year. Turning to the beach and the port for inspiration, he produced haunting souvenirs of the activities around him. The brightness of Manet's palette and the looseness of his brushstroke convey an energy, rapidity of execution, and immediacy of vision that are significantly different from the technique of the more studied and larger studio pieces of previous years. The painter was evolving a method of capturing the movement of masses in light, intensifying color by reducing shadows and eliminating half-tones. The abbreviated sketchiness of *Departure of the Folkestone Boat* (plate 86), painted from the artist's hotel window above the dock, signals a new freedom of composition and a renewed commitment to contemporary subjects that would intensify in the 1870s.

Manet utilized another work, long thought to be by Goya, as a point of departure for The Balcony *(plate 90). Yet his debt to this dashing and romantic painting by the Spanish master is a superficial one; provocatively devoid of anecdote or mystery, Manet's composition concentrates instead on the formal properties of his figures.*

ABOVE, LEFT

66.

Henri Fantin-Latour

A Studio in the Batignolles Quarter

1870

ABOVE, RIGHT

67.

Formerly attributed to Francisco de Goya

Majas on a Balcony

C. 1810

The Seventies: New Prospects and Old Frustrations

The decade began ominously with the outbreak of war between France and Prussia in July of 1870, which was quickly followed by the collapse of the Second Empire and the siege of Paris. Many artists and their families fled the city, but Manet remained, even enlisting in the National Guard, which defended the capital. There he witnessed the incredible suffering that marked the siege and the violence of the civil insurrection that followed in May of 1871, and saw the establishment of the short-lived Commune. The events took their toll on the painter, whose health was already fragile and whose spirits were low. He had been exhibiting for more than a decade, with little to show for his efforts apart from notoriety. Fewer than a dozen paintings had

been sold from his crowded studio. Even the satisfaction he might have drawn from critical, as opposed to popular, recognition was tainted with confusion: supporters and detractors often used the same adjectives in speaking of his work.

Late in 1872 Manet's career took an unexpected turn for the better, when the astute young dealer Paul Durand-Ruel, who had established something of a reputation as a specialist in contemporary landscape painting, visited Manet's studio and purchased twenty-two paintings, among which were *The Absinthe Drinker, The Guitar Player, Mademoiselle Victorine in the Costume of an Espada,* and *The Dead Toreador.* Purchases by other dealers and collectors followed, and Manet must have been encouraged anew to persuade critics of his serious intentions. After a brief visit to Holland, he painted *Bon Bock*—literally, "a good beer"— a work whose robust subject and broad execution suggested the seventeenth-century Dutch genre painters. It achieved a surpris-

ing popularity with critics and the public at the Salon of 1873. Yet, the following year, two of the four paintings Manet submitted to the Salon jury were again refused; one of the two accepted, *Le Chemin de Fer (The Railway)*, provoked the familiar outrage of conservative critics for its compositional innovations.

In *Gare Saint-Lazare* (plate 90), as the painting is now called, Manet seizes one of the ordinary moments of modern life and transfixes it. It is precisely the ordinariness of the moment, removed from any historical or dramatic significance, that established its modernity. The seated woman and the child, linked forever in Manet's work, were not even related. The latter was the daughter of an artist friend in whose garden much of the picture had been painted, and the "mother" was Victorine Meurend, who had posed so scandalously for the *Déjeuner* and *Olympia* a decade earlier. The combination of poses—one figure gazing at the viewer, the other with her back turned—creates a delicate visual and psychological balance that eluded many of the critics. The deceptive informality and decorative two-dimensionality of the composition were informed by Manet's study of contemporary photography and Japanese woodcuts.

While Manet was prepared to suffer humiliation from the jury in order to achieve exposure in the official Salon, his young friends from the Café Guerbois chose a different course, preferring to organize an independent exhibition. The prime mover in setting up the exhibition was Monet, but Renoir and Sisley also actively recruited artists who, like themselves, were tired of habitual rejection by the Salon juries. Manet was invited to join

the group, which met regularly during the winter of 1873, but he refused, underscoring the sense of independence and ambiguity always associated with his character. Despite a progressive lightening of his palette in the early seventies, and an occasional flirtation with plein-air subjects, Manet's unwillingness to do pure landscapes, his reluctance to break color into its components, and his refusal to renounce black as a tone continued to separate him from the group that had ironically been nicknamed "*la bande à Manet*"—Manet's gang. To make matters worse, Manet and Monet were often confused by careless critics.

In the summer of 1874 Manet and Renoir worked briefly with Monet at Argenteuil on the Seine. There Manet painted Monet seated in his floating studio, working on one of his many studies of the water. He also executed *Boating* and *Argenteuil* (plates 87 and 88), entering the latter in the Salon of the next

BELOW
68.
Edouard Manet
Les Chats
1868–69
(detail)

*I*nspired by the example of the Japanese master Hokusai, whose famed album of woodcuts, The Manga, *contained many studies of animals in characteristic poses, Manet celebrated the elegant languor of cats in the etching below. In a perfect synthesis of description and expression, he utilized cross-hatching to establish the thick texture of the animals' fur. The stark economy of black ink and white paper has rarely been so sensitively exploited by a Western artist.*

year. In both paintings, the subject matter virtually dictates the bright palette, so evocative of summer light. The informal composition and more summary brushwork are superficially reminiscent of pictures by Renoir and Monet, but close comparison of these works with similar ones done by the Impressionists reveals their fundamental differences.

In *Boating*, for example, there is a firm sense of silhouette in the principal figure and in the contours of the boat that once more calls to mind Japanese prints. Indeed, the odd perspective (we see the work from above) and arbitrary fragmentation are also typical of formal devices employed in the Ukiyo-e or "floating world" woodcuts that were so popular with Manet's contemporaries. In *Argenteuil*, where we encounter the same gentleman (possibly Manet's brother-in-law or a sportsman friend), the generally light palette occasionally darkens arbitrarily and unexpectedly—on the left side of the painting and in details of the woman's dress and hat, for example—producing a solidity uncharacteristic of an Impressionist composition.

After a few years of experimenting with landscapes, Manet returned to the painting of figures in an interior toward the end of the decade, often finding his subject matter in the cafés he and his friends continued to frequent. Works such as *The Plum* (plate 99), *At the Café* (plate 89), and his last masterpiece, *A Bar at the Folies-Bergère* (plate 93), reveal Manet's unique gift for capturing the essence of the contemporary experience. In these and other paintings produced during the last five years of his life, he seems more than ever to fulfill Baudelaire's prescription for the painter of modern life. The poet exhorted artists to see "private subjects . . . the pageant of fashionable life, and the thousands of floating existences—criminals and kept women—that drift

In these lithographs, Manet has stressed the brutal impersonality of war. The focus of Civil War *is a dead soldier; the feet in the corner are a piercing reminder that he is but one of thousands. In* La Barricade *the artist depicts an anonymous execution; the only visible face is that of the victim.*

ABOVE
69.
Edouard Manet
La Barricade
1871

LEFT
70.
Edouard Manet
Civil War
1871

LEFT
71.
Edouard Manet
Café, place du Théâtre Français
c. 1881

BELOW
72.
Edouard Manet
A Café Interior
1869

about in the underworld of a great city." The subject of *The Plum* was a model seated at a table in the Café de la Nouvelle Athènes. She projects that aura of distraction or ennui, so often found in public places, that appealed to Degas as well—indeed, the latter had painted a similar subject, *L'Absinthe* (plate 137), only a year earlier.

In these vignettes of modern life, Manet manages to capture time itself. Although Degas and, later, Henri de Toulouse-Lautrec would haunt the cafés of Paris for subject matter, no other painter of his generation was as skilled in distilling what the Symbolist poet Stéphane Mallarmé called "the aspect" of life.

By 1880 Manet had become more daring in his pictorial construction, more innovative in his use of color, and more inspired in his choice of subject matter. He could take some satisfaction in the gradual critical acceptance of his novel vision, but an extremely painful illness drastically restricted his work, so that at times he painted only small still lifes. A dramatic exception was his masterly canvas, *A Bar at the Folies-Bergère*, which he began in 1881 and completed a year later. It is his last great work, both a culmination and a recapitulation of his controversial career.

A deliberate work that was the result of careful notes and of watercolor and oil sketches, *A Bar at the Folies-Bergère* is also a technical tour-de-force. Manet's shimmering color and controlled brushwork evoke the ephemeral atmosphere of a gaslit popular café. The provocative composition can only be understood as a series of fragments, isolated visual moments assembled by the painter. The large, daringly distorted mirror behind the blond barmaid provides most of the visual information and serves as a constant point of reference for the viewer. Whereas the silhouette of the girl facing the viewer is clear, her reflected silhouette is both blurred and displaced, contradicting our expectation of the mirror image. The top-hatted man whom the

*M*anet's rapid line conveys a momentary quality, evoking the lively, often heated discussions among the painters and critics who gathered at the Café Guerbois. These men are quite at home in the café: even the waiter, who plays a dominant role in the composition, seems to be included in the group. The hat on the stand next to the table is of the type worn by dandies in many of Manet's paintings.

Baudelaire had urged artists to find new subject matter for the life of Paris, with its "thousands of floating existences—criminals and kept women—which drift about in the underworld of a great city." In Nana, *Manet's inspiration is drawn not from contemporary life but from literature, as he depicts the socially ambitious heroine of Zola's novel of the same name. The boldness and intimacy of the scene—fully dressed admirer and sexually provocative deshabillé of the coquette—offended the sensibilities of the Salon jury of 1877.*

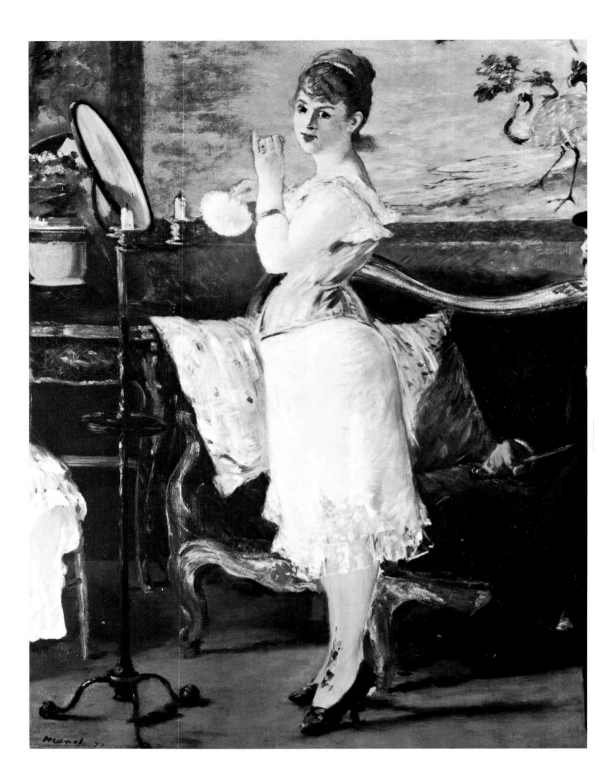

73.
Edouard Manet
Nana
1877

OPPOSITE

74.
Edouard Manet
Mademoiselle Victorine in the Costume of an Espada
1862

young woman serves is introduced arbitrarily as an uncomfortable fragment in the upper right-hand corner, yet in no other sense is his physical or psychological presence conveyed. Manet is constantly forcing the viewer's eye to adjust to different visual messages: from the clarity of the barmaid, one moves restlessly over the canvas's surface to the unfocused images in the mirror's reflection and then, again, to the distractingly beautiful still life on the counter. One "reads" the painting as if one were a visitor to the bar looking for a familiar face. The extraordinary variety of the painted surface—thick, thin, slick, and summary—metaphorically projects the experience of the crowded gaslit ambiance and the shifting perspectives of the presumed visitor. Yet despite the fugitive theme and its at times purely gestural sense of painterliness, an insistent structure of strong verticals and horizontals dominates the work, suggesting that Manet was still experimenting, still striving to create a pictorial synthesis that would permit him to render both the ephemeral and the eternal.

Manet died in April 1883. He was only fifty-one, and it is tempting to speculate about the direction his art might have taken had he enjoyed a longer life. The extraordinary color and vigorous design of *A Bar at the Folies-Bergère* suggest that he was on the edge of a more novel and multifaceted type of modern painting. Within a year after his death, a perceptible change had taken place in both the critical and public reception to his work, and with a fitting irony that would have pleased the artist, a memorial exhibition was organized in the Ecole des Beaux-Arts. Félix Fénéon, a young man of letters who would emerge as one of the most effective spokesmen for modernist art in the 1880s, observed of the Manet exhibition: "If I had to give any advice to the public which today . . . opens wide and blissfully its bovine eyes, I should incite it to check a little its tardy admiration and to endeavor conscientiously to understand the paintings of those artists who drew inspiration from Manet without copying him. . . . I refer to the gallant clan of Impressionists."[21]

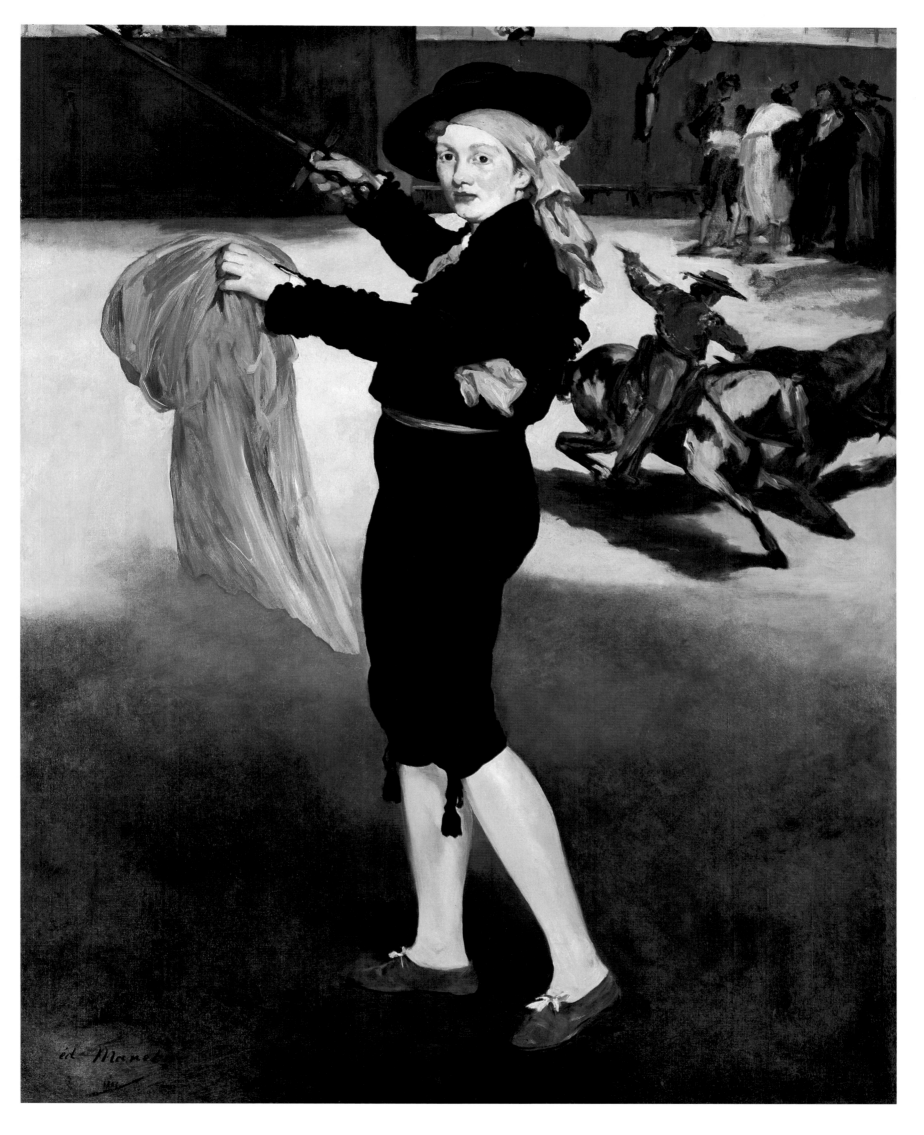

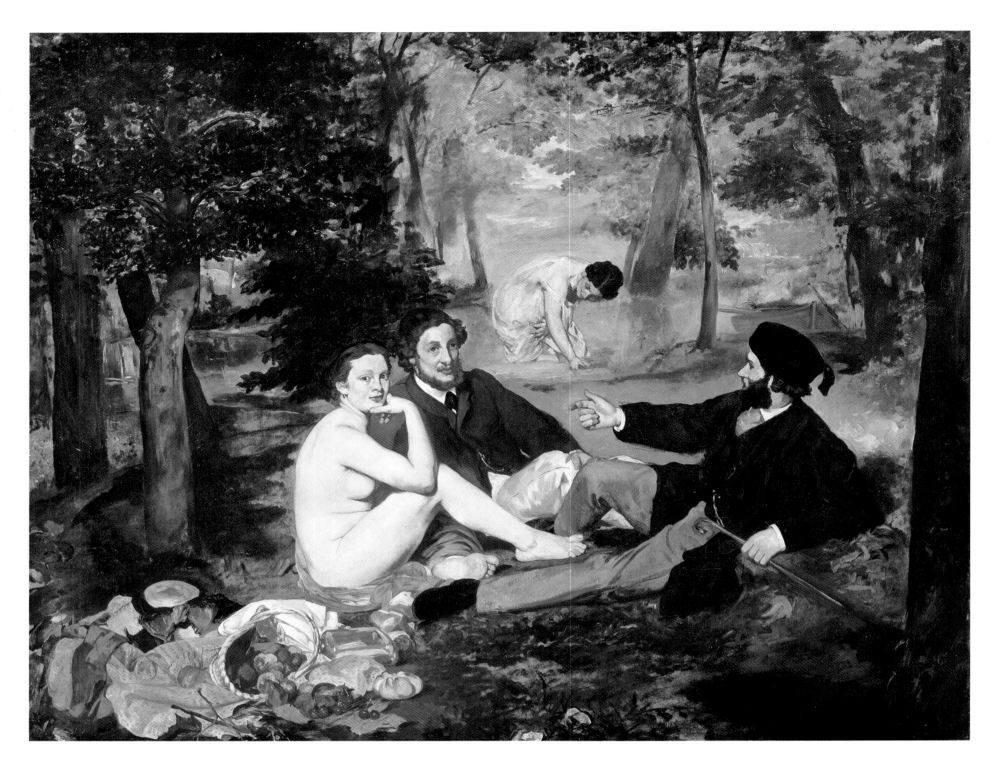

75.
Edouard Manet
Déjeuner sur l'herbe
(Luncheon on the Grass)
1863

"French art, as it is seen in the rejected work, seems to begin all over again. It is odd and crude, yet sometimes exactly right, even profound. The subjects are no longer the same as those in the official galleries: very little mythology or history; contemporary life, especially among the common people Things are as they are, beautiful or ugly, distinguished or ordinary, and in a technique entirely different from those sanctioned by the long domination of Italian art."

Théophile Thoré, review of the Salon des Refusés

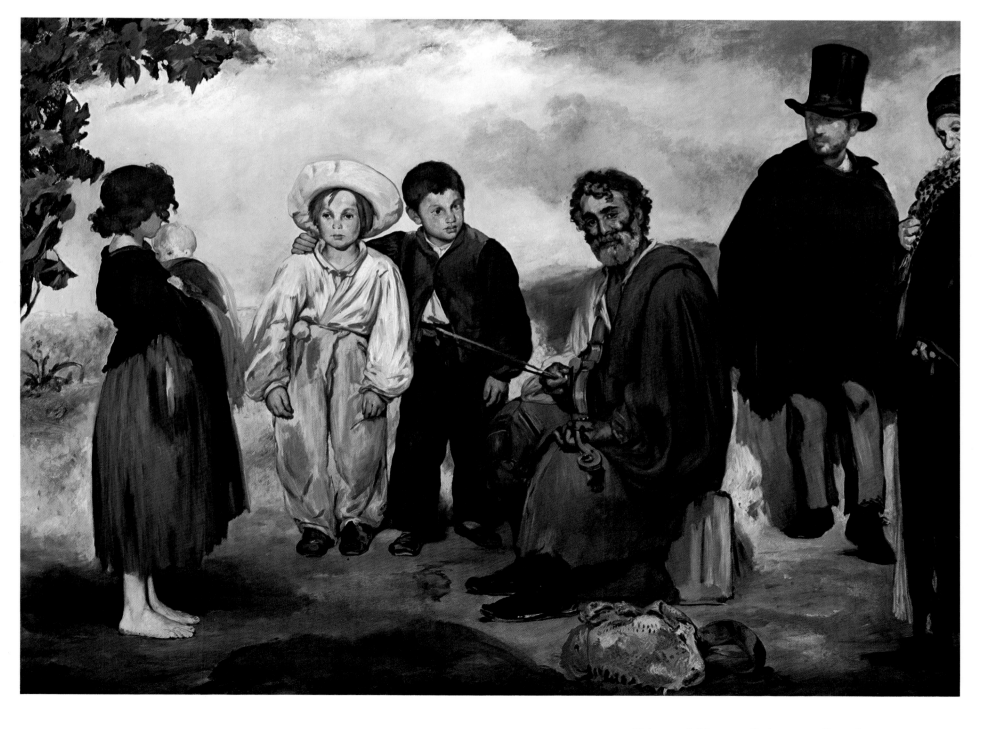

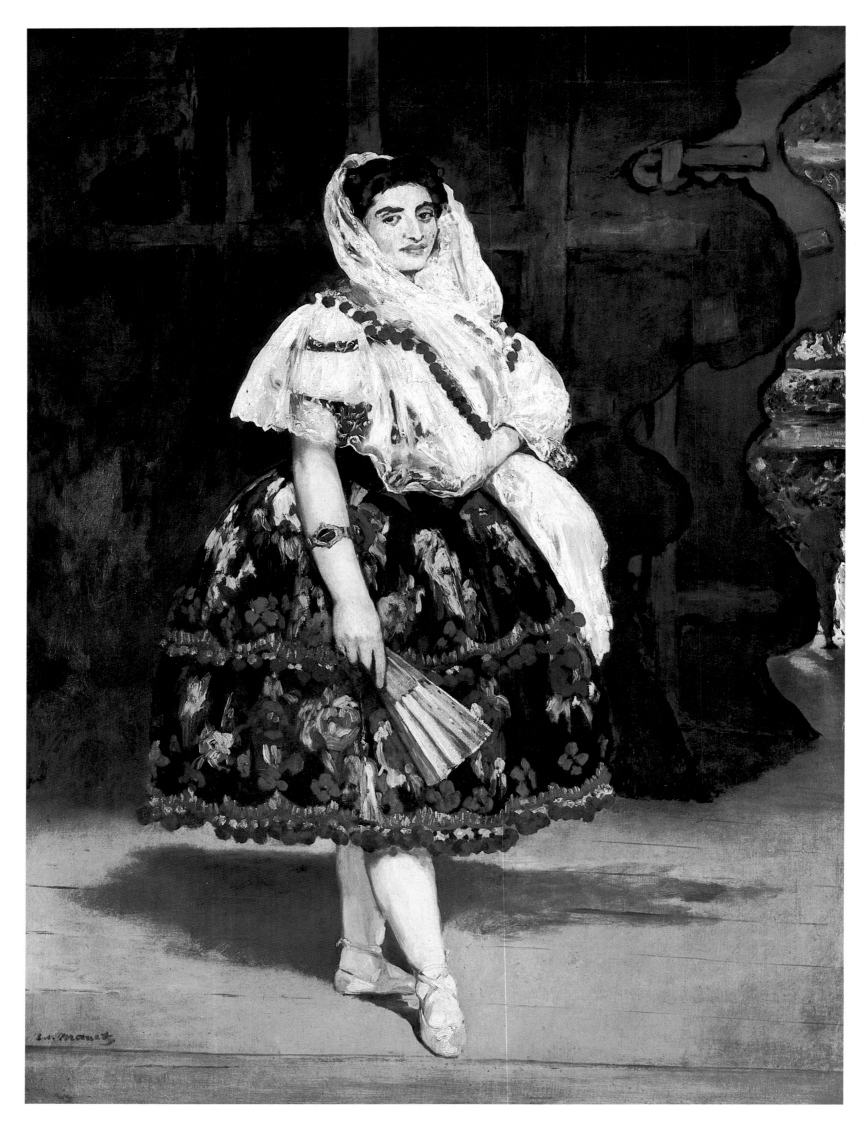

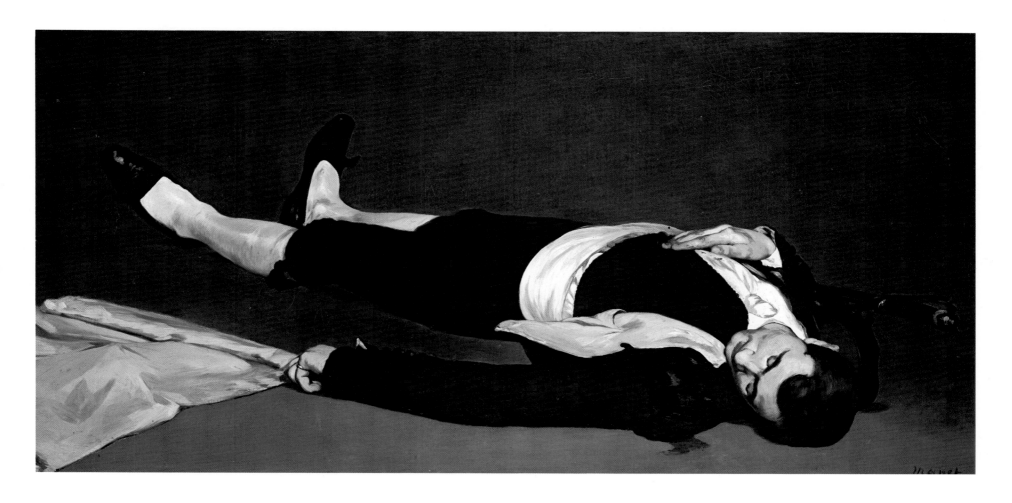

Manet's love of Spanish subjects and his strong handling of paint led one critic to call him the Velázquez of the boulevards, a Spaniard in Paris. But the painter was so dissatisfied with his Incident in the Bullring *that he cut it up, retaining this dramatically foreshortened and stunningly painted fragment of a fallen toreador.*

OPPOSITE

77.
Edouard Manet
Lola de Valence
1862

ABOVE

78.
Edouard Manet
The Dead Toreador
1864

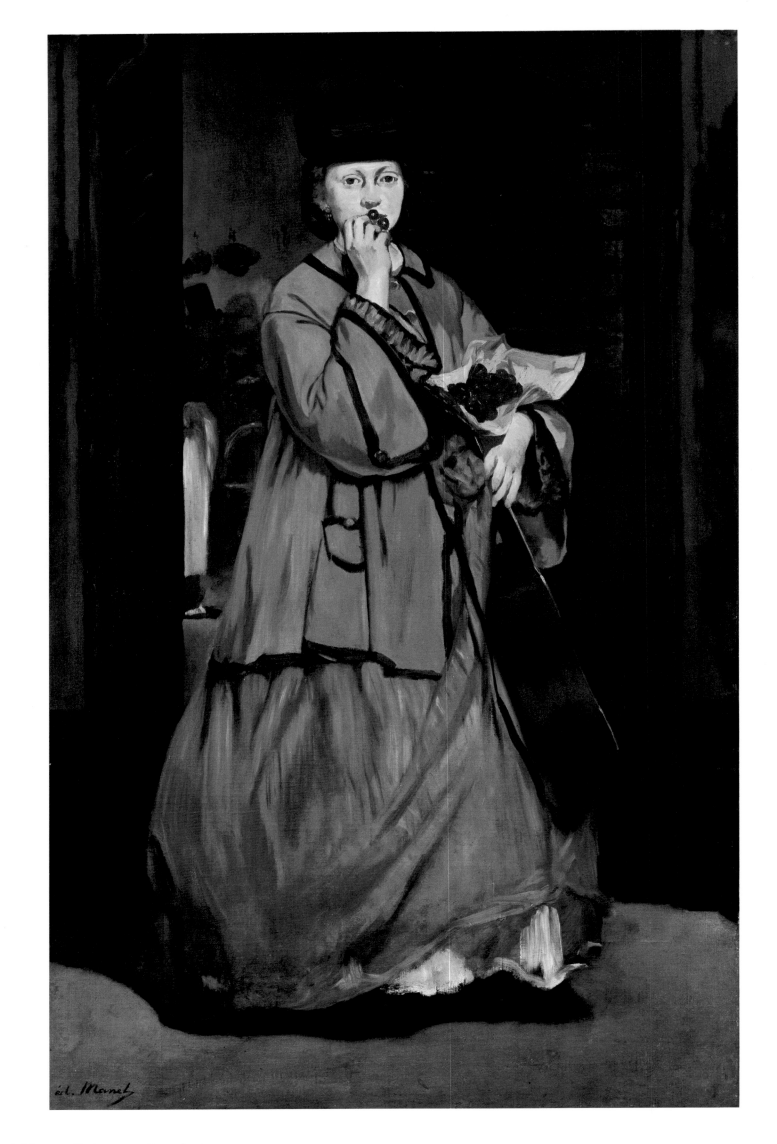

Although this work is related to eighteenth-century prints of elegant society, these fashionable Parisian concertgoers are very much of their own time. Manet has kept to a severely limited palette dominated by grays, black, and white, with a few brilliant dashes of color, such as the red sash on the little girl in the foreground. The entire canvas is painted with the spontaneous, undisguised brushstroke that shocked Manet's academic contemporaries. The crowded composition, relieved only by an open patch of sky, also drew harsh criticism.

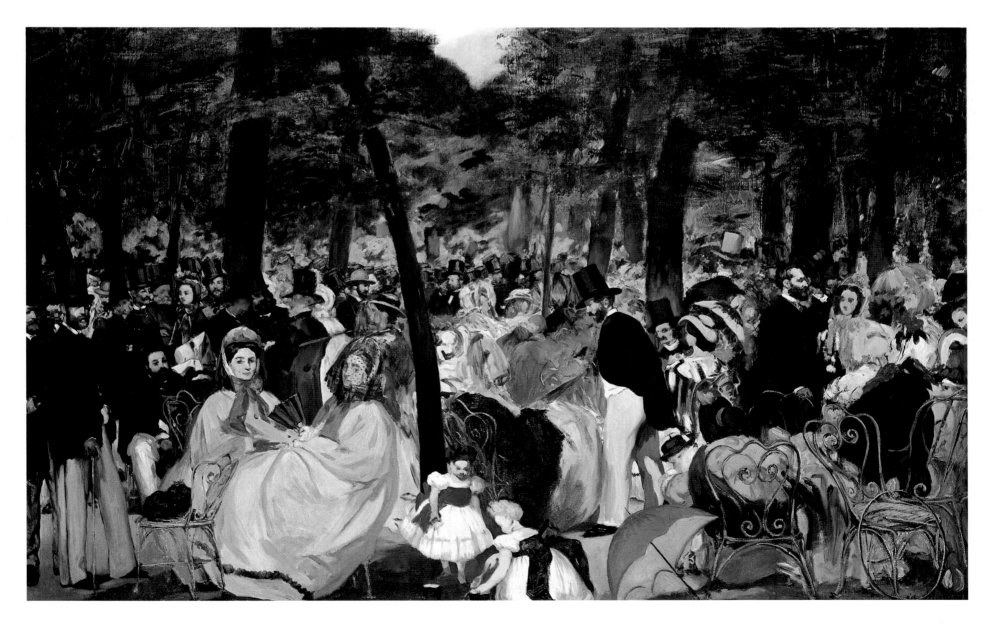

80.
Edouard Manet
Music in the Tuileries
1862

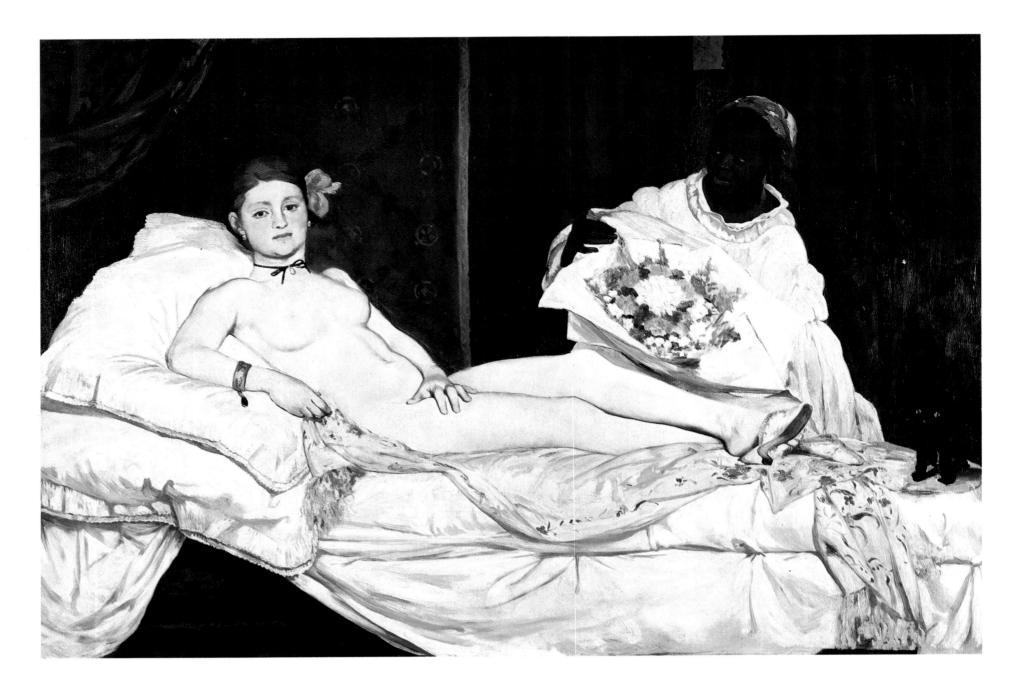

"*At first glance you distinguish only two tones in the painting, two strong tones played off against each other. . . details have disappeared. Look at the head . . . the lips are two narrow pink lines, the eyes are reduced to a few black strokes. Now look at the bouquet. Some patches of pink, blue, and green. Everything is simplified and if you wish to reconstruct reality you must step back a bit. Then a curious thing happens. Each object falls into its proper plane An accurate eye and a direct hand performed this miracle. The painter worked as nature works, in simple masses and large areas of light, and his work has the somewhat rude and austere appearance of nature itself When other artists correct nature by painting Venus they lie. Manet asked himself why he should lie He has introduced us to Olympia, a girl of our own times.*"

Emile Zola, Edouard Manet

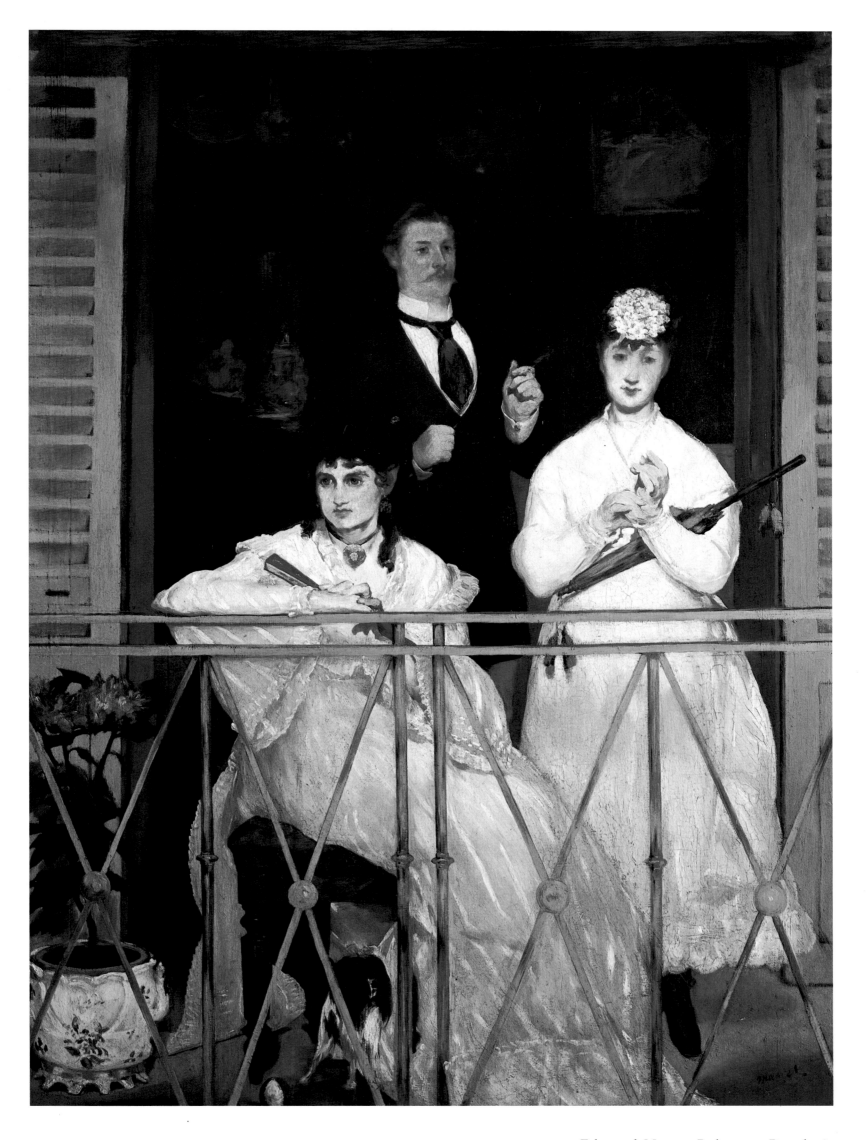

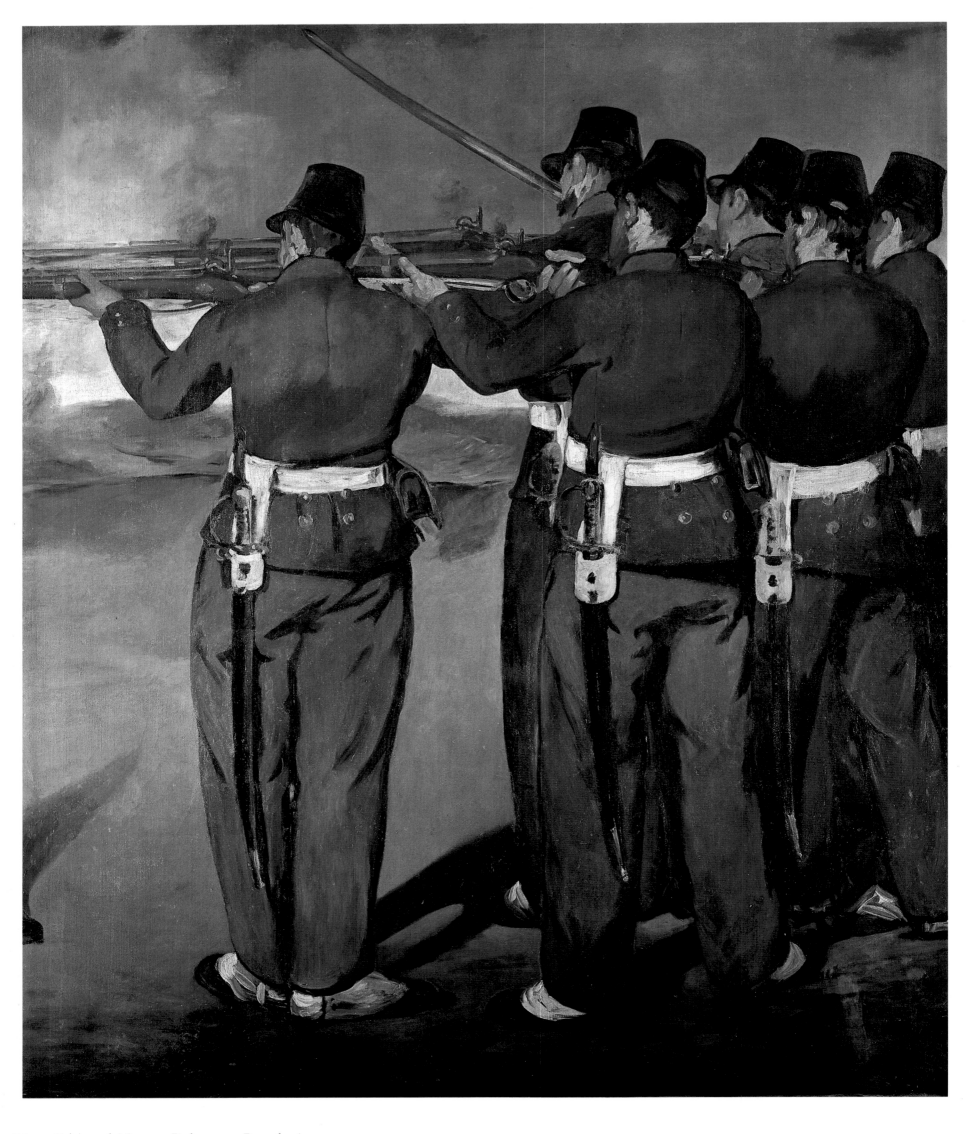

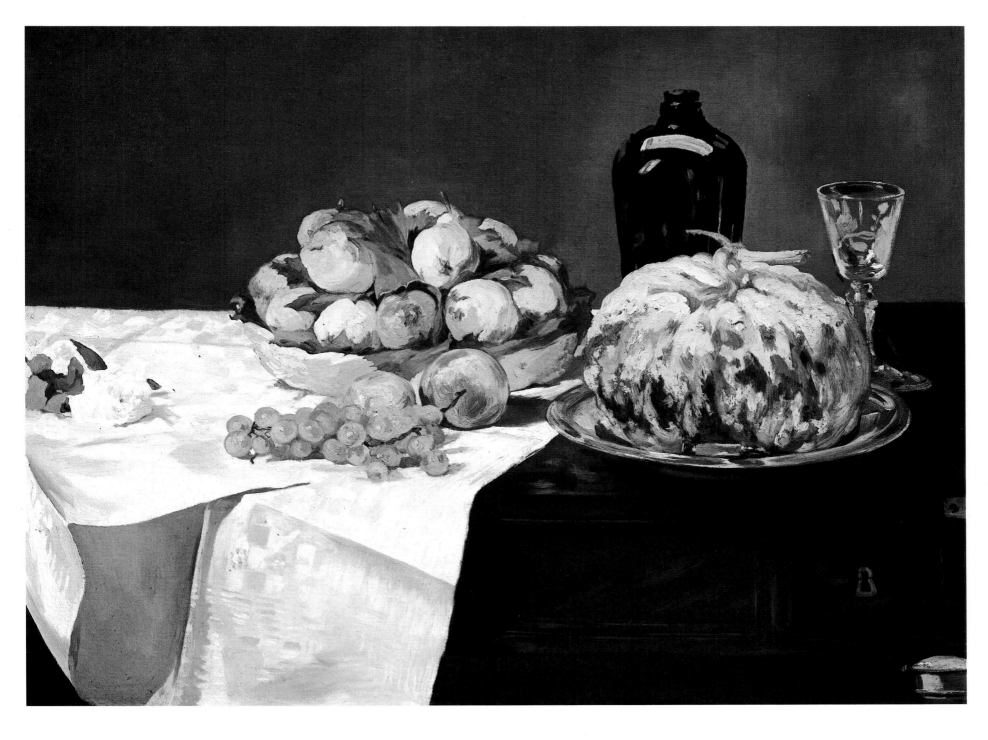

The rich color and subtle texture of fruits, glass, and damask challenged Manet's capacity to evoke tactile as well as visual sensations. Drawn to still life throughout his career, he called the genre "the touchstone of painting."

OPPOSITE
83.
Edouard Manet
Execution of the Emperor Maximilian
1867

ABOVE
84.
Edouard Manet
Still Life with Melon and Peaches
1866

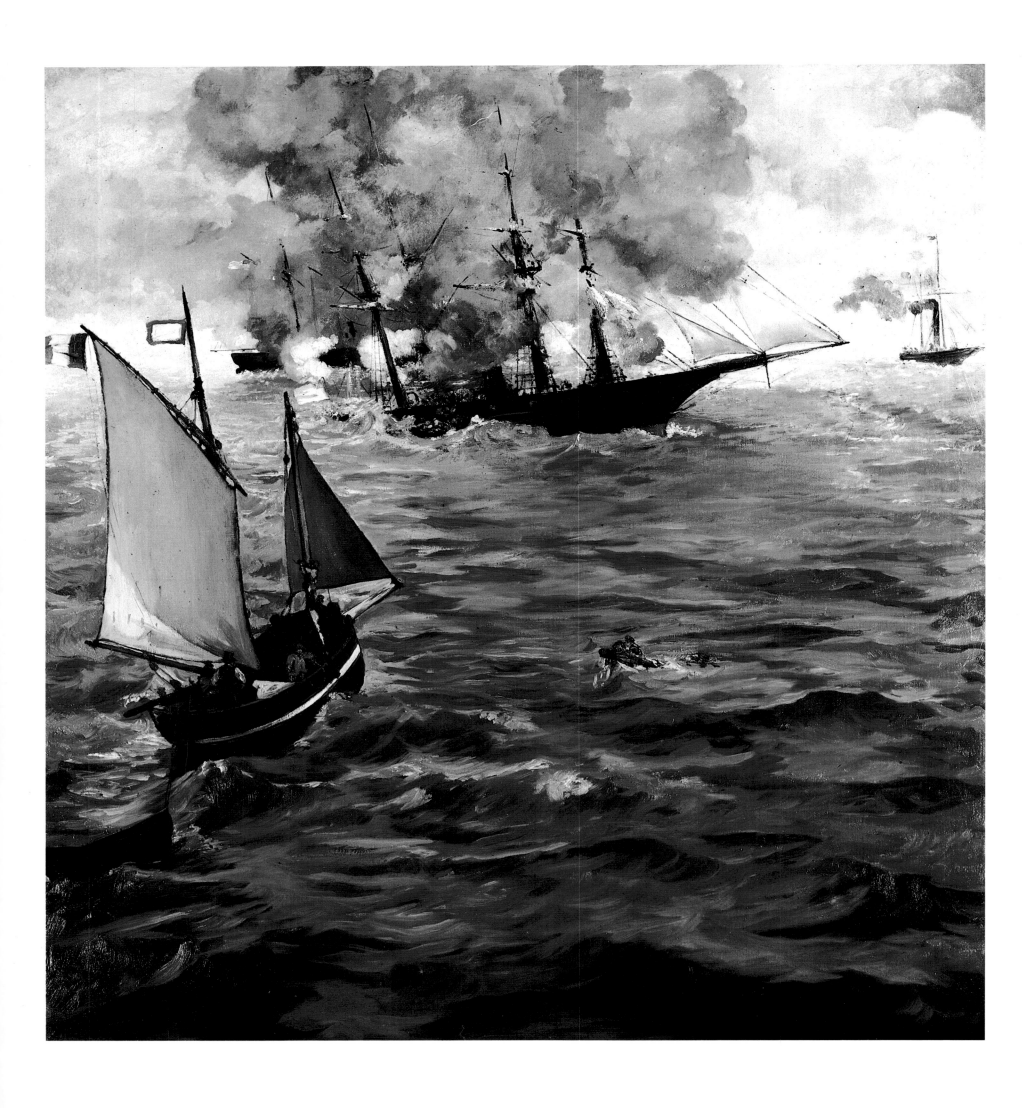

Manet's unconventional depiction of a naval battle between the Union frigate
Kearsarge and the Confederate vessel Alabama off the Normandy coast drew
mixed reviews. Some complained of the lack of clarity in presenting the opposing
vessels; others found the arbitrarily high vantage point and wide expanse of
water disconcerting; most deplored the painting's lack of drama. One critic, Barbey
d'Aurevilley, took exception to this criticism, praising the painter's unusual
placement of the ships and his daring emphasis on the surging "turgid-green"
sea as a means of conveying the upheaval of battle.

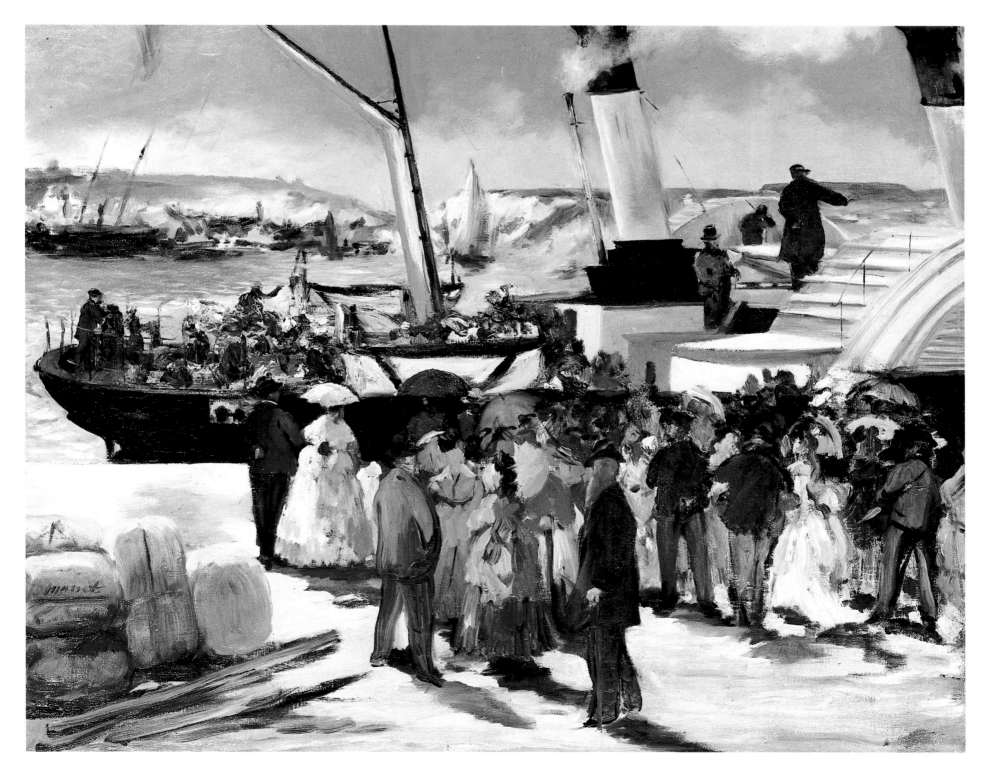

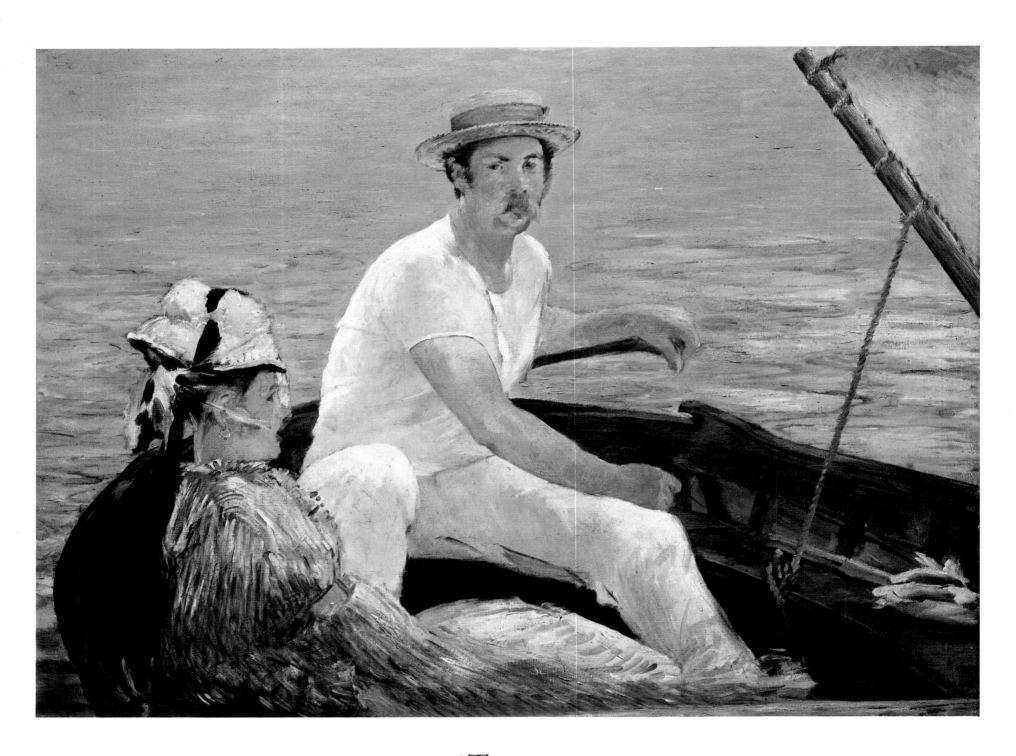

ABOVE
87.
Edouard Manet
Boating
c. 1874

OPPOSITE
88.
Edouard Manet
Argenteuil
1874

"The bright blue water continues to exasperate a number of people: Manet has never, thank heavens, known those prejudices stupidly maintained in the academies. He paints, by abbreviations, nature as it is and as he sees it. The woman, dressed in blue, seated in a boat cut off by the frame as in certain Japanese prints, is well placed, in broad daylight, and her figure energetically stands out against the oarsman dressed in white, against the vivid blue of the water. These are indeed pictures the like of which, alas, we shall rarely find in this tedious Salon."

Joris Karl Huysmans, *L'Art moderne*

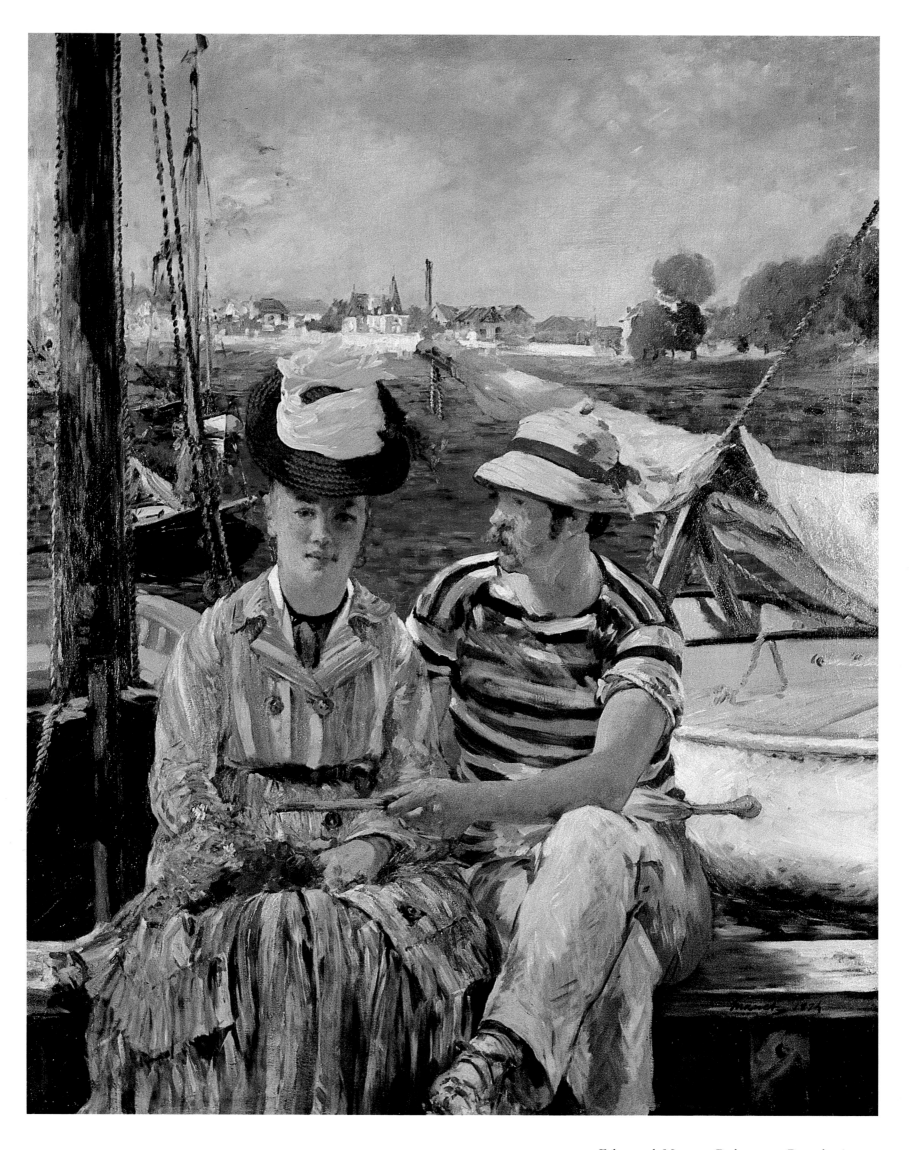

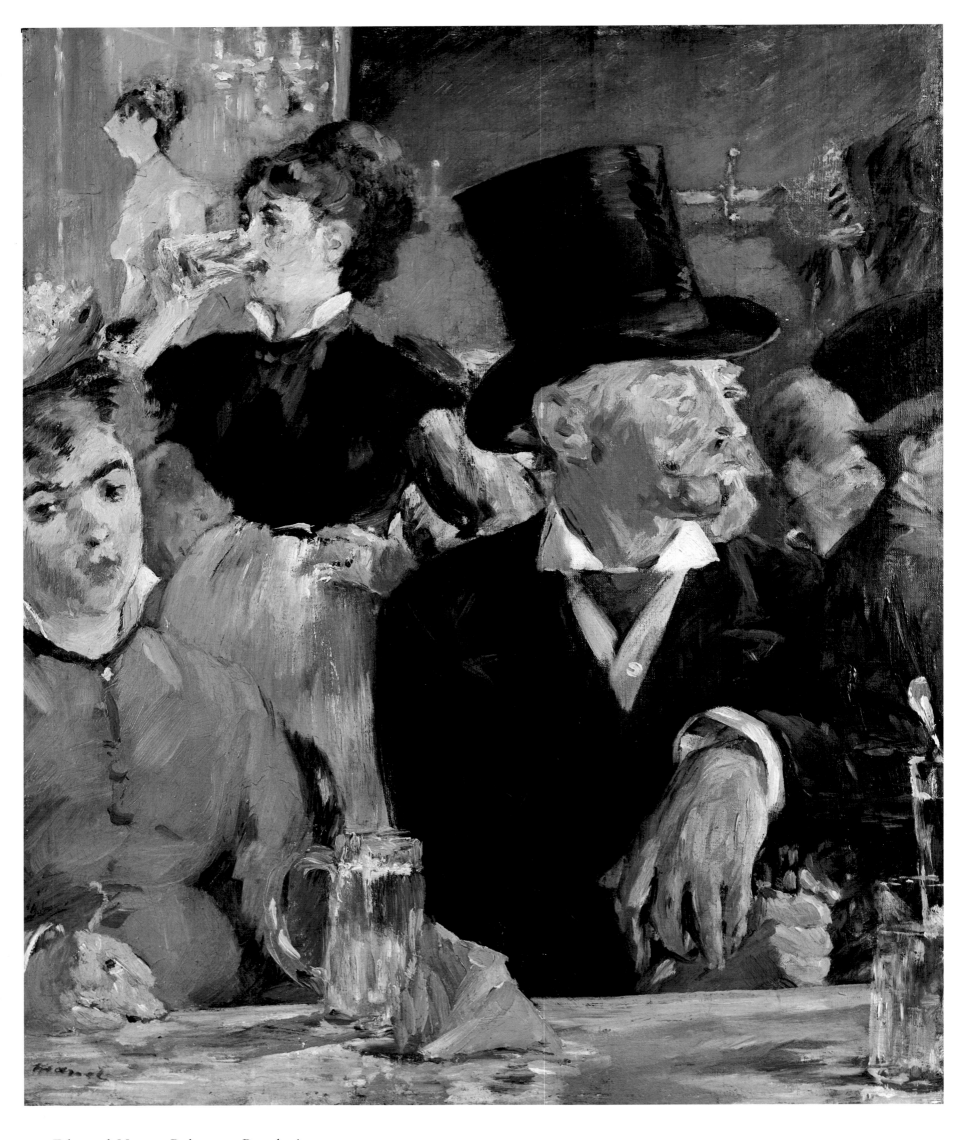

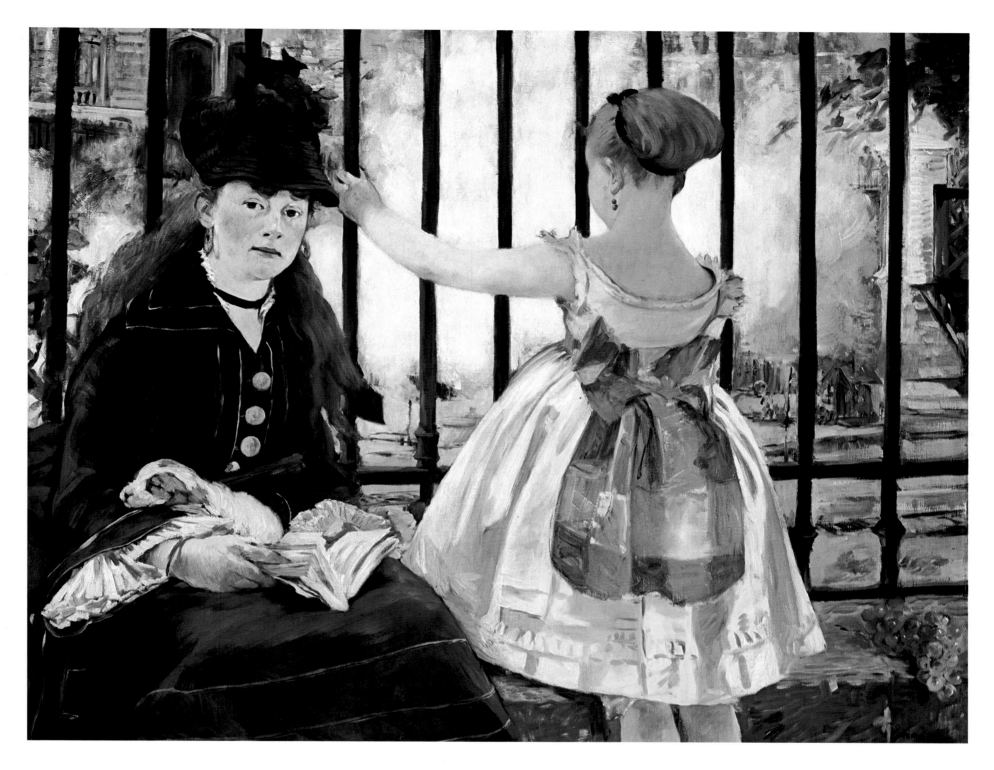

90.
Edouard Manet
Gare Saint-Lazare (Le Chemin de Fer)
1873

OPPOSITE
89.
Edouard Manet
At the Café
1878

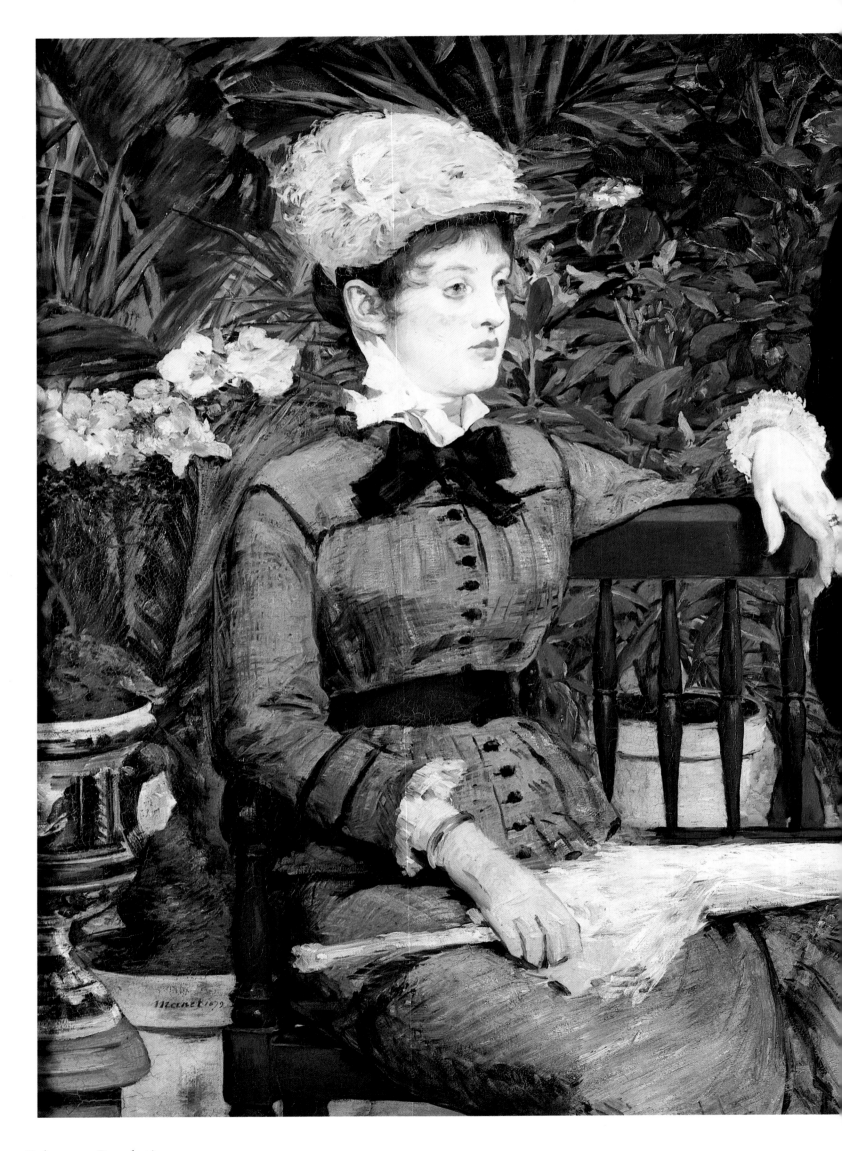

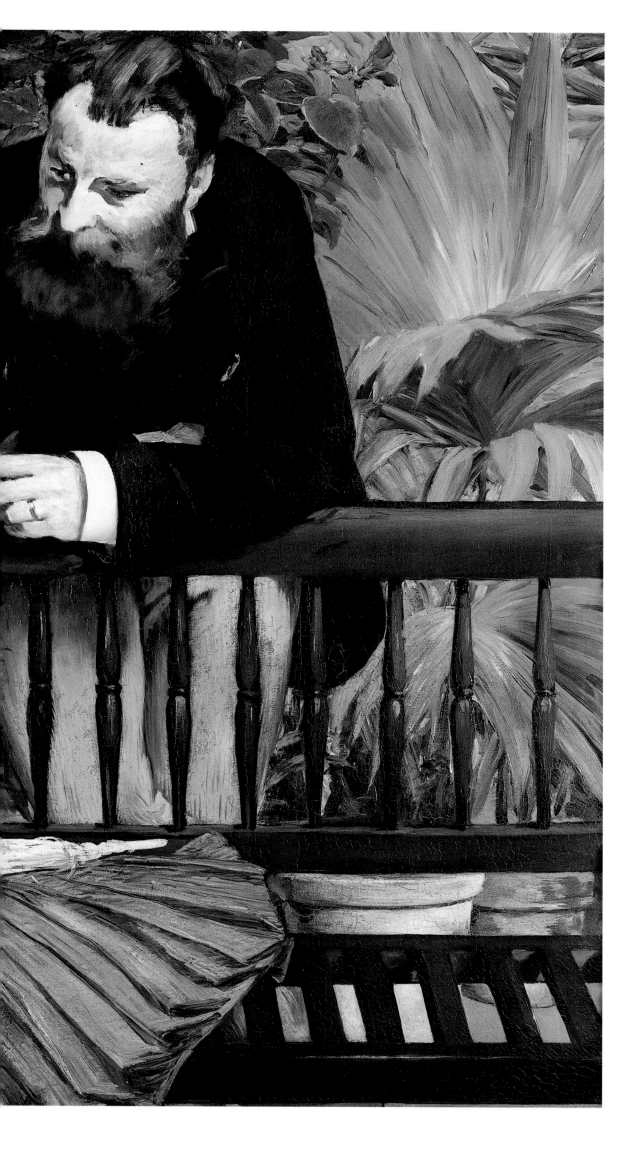

*Manet was the master of the glimpse—
the passing vision of a woman poised
distractedly in a doorway, the reflected
reality of a café mirror, the momentary
pause in an intimate conversation between
husband and wife. As was commonly his
practice, Manet here used a couple he
knew as models, expanding the traditional
concept of portraiture by introducing them
into informal situations.*

91.
Edouard Manet
In the Conservatory
1879

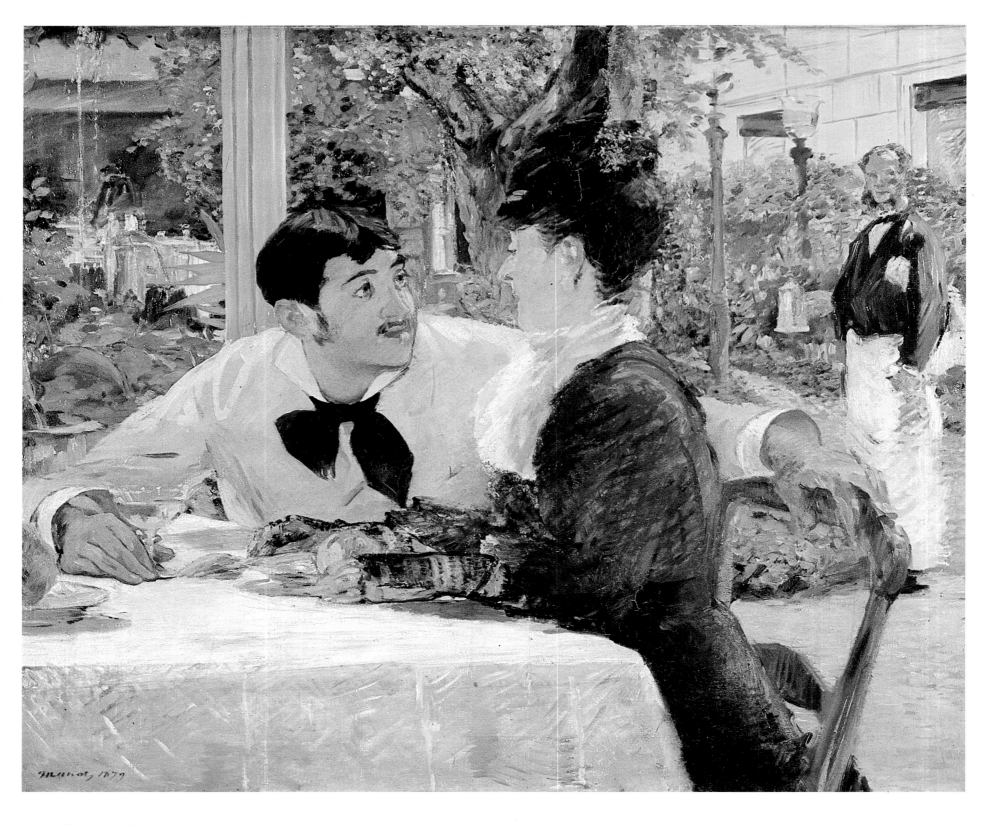

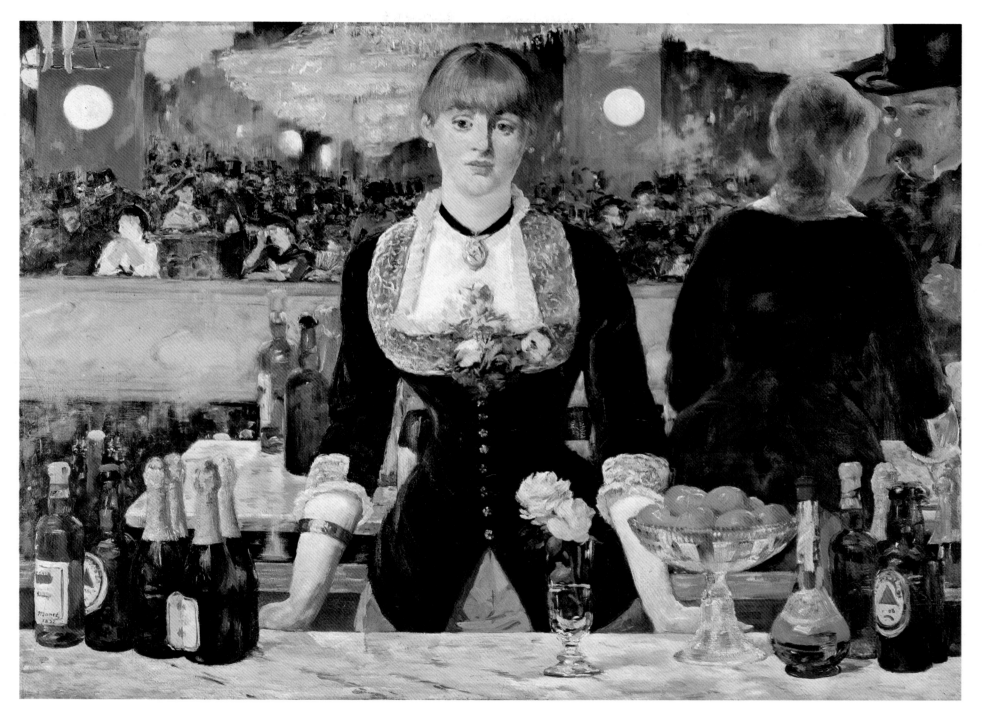

93.
Edouard Manet
A Bar at the Folies-Bergère
1882

The essence of modern life was captured in the impersonal but infectious excitement of crowds. Manet watched them and was part of them as he made his way through noisy cafés, elegant balls, and fashionable boulevards of Paris. Few painters could rival the acuteness with which he fixed these fleeting realities, and none came as close to fulfilling Baudelaire's prescription for "the painter of modern life."

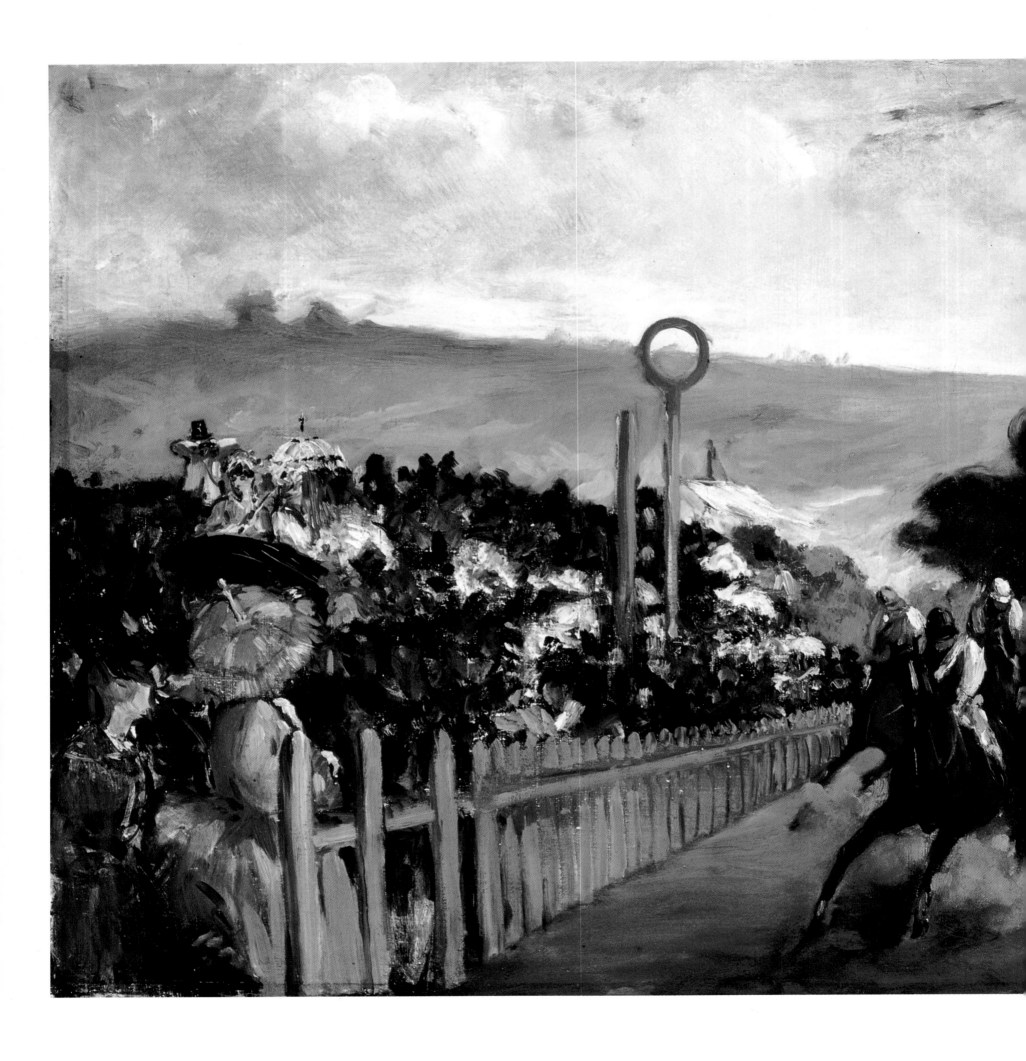

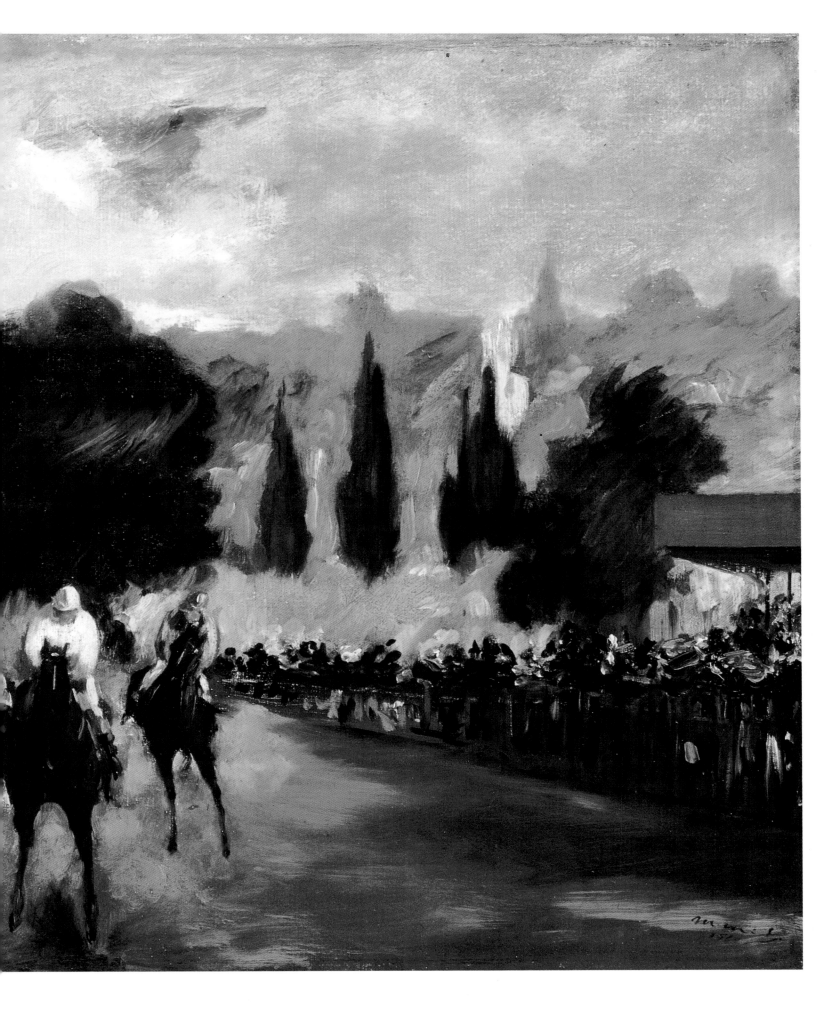

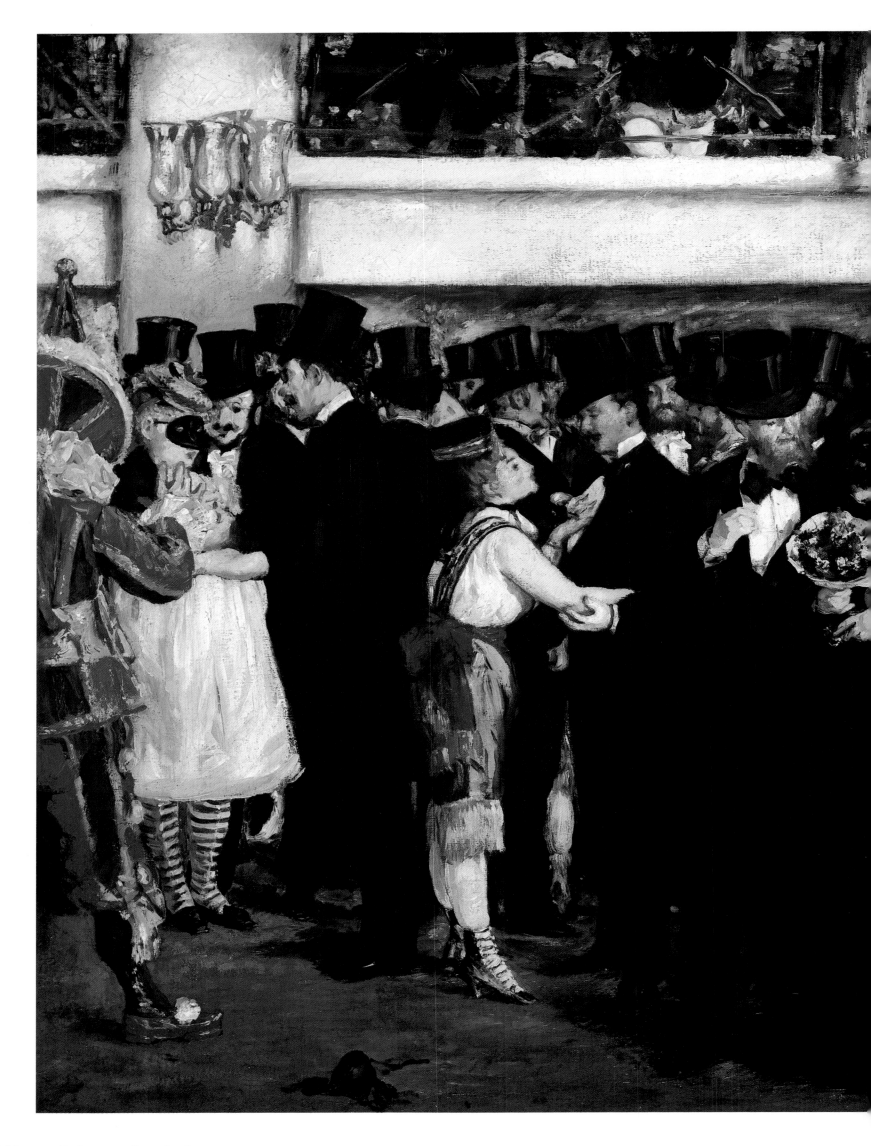

Le Bal de l'Opéra *conveys the tumult of a much livelier scene. The foyer of the opera house is crowded with women in fancy clothes and masks and their companions in evening dress and top hats. According to the critic Théodore Duret, who was a model for the painting, Manet took great pains to recreate the sense of variety and the incidental present in the original visual experience. Particularly striking—because of the color contrast it offers to the largely black and white patterns of the coquettes and their gallants—is the delightful yet fragmented figure of Punchinello, a* commedia dell'arte *character for whom Manet evidently had great affection.*

Manet had painted both the high and low life of Paris in some startling subjects of the 1860s, but toward the end of the 1870s he did a number of paintings that addressed specific aspects of Parisian life. The Plum depicts a nameless young woman whom Manet probably encountered at the café he and his friends frequented; it suggests that quality of detachment so often found in the waiting rooms of train stations or in popular eating and drinking places in large urban centers.

OPPOSITE
98.
Edouard Manet
Flowers in a Crystal Vase
C. 1882

LEFT
99.
Edouard Manet
The Plum
1878

Chapter 3

The New Painting

They have . . . succeeded in breaking down sunlight into its rays, its elements, and to reconstitute its unity by means of the general harmony of spectrum colors which they spread on their canvases. . . . The most learned physicist could find nothing to criticize in their analysis of light.

EDMOND DURANTY

The seed that had been planted in the minds of Bazille, Sisley, and Monet at the time of Manet and Courbet's one-man shows in 1867 bore spectacular fruit seven years later in the first of eight collective exhibitions held in Paris. Frustrated by continued official rejection and the attendant financial burden, Monet and Pissarro decided to bypass the Salon in favor of independent exhibition. While in London, where they and Sisley sought refuge from the Franco-Prussian war, they had met Paul Durand-Ruel, the enterprising Parisian dealer who had opened a gallery on New Bond Street. His exhibition and purchase of their work encouraged them in the belief that it was possible to find recognition outside of the art establishment, and upon their return to Paris, they introduced the dealer to their friends, from whom he immediately began to acquire canvases. They also embarked on a campaign to persuade other artists that a cooperative association would offer them desperately needed opportunities for exhibition and to convince them that renouncing the Salon did not mean oblivion. Not everyone shared their optimism: Manet remained adamant about the need to work through the establishment, and Degas listened attentively to the advice of his friend Théodore Duret not to abandon the Salon before he finally agreed to join the group enterprise.

Hoping to avoid the polemic associated with choosing a name, the artists proclaimed themselves the Société Anonyme des Peintres, Sculpteurs, Graveurs, Etc. (Corporation of painters, sculptors, engravers, etc.), underlining the commercial aspirations of the majority of the membership. A charter dated December 27, 1873, listed the founder-members: Monet, Degas, Pissarro, Renoir, Sisley, Armand Guillaumin, and Morisot. Through their urgings, others joined, including Paul Cézanne, Eugène

Boudin, and Félix Bracquemond, so that the number of artists participating in the inaugural exhibition came to about thirty.

The First Group Exhibition

The problem of where to exhibit was solved when the celebrated photographer Nadar (Gaspard-Félix Tournachon) generously lent the group his studio on the boulevard des Capucines. The exhibition, which opened on April 15, 1874, drew curiosity seekers from the first day; it also sparked a critical controversy that later would result in the publication of two important pamphlets, Edmond Duranty's *La Nouvelle Peinture* (The new painting) in 1876 and Duret's *Les Peintres impressionnistes* of 1878.

No one could have predicted the vehemence of the popular press's adverse reaction to the works. The radical and audacious nature of an independent exhibition made it fair game for humorous magazines such as *Le Charivari*, whose critic Louis Leroy poked fun at virtually all the exhibitors, saving his sharpest barbs for Cézanne and Monet. The latter's *Impression, Sunrise* (plate 121), a misty view of the port of Le Havre, elicited this sarcastic response from Leroy's purported companion at the exhibition, an award-winning academician: "Impressionism—I was certain of it. I was just telling myself that, since I was impressed, there had to be some impression in it . . . and what freedom, what ease of workmanship! Wallpaper in its embryonic state is more finished than that seascape."[1]

The term *impressionism*, coined in derision by Leroy, was taken up nonetheless by sensitive critics as well. Actually, the word had been employed for some time by some artists and

OPPOSITE

Detail of plate 125

The paintings hung on the wall and stacked on the floor, as well as the chair and sofa, are presences almost as strong as the figures themselves in Bazille's representation of his large studio on the rue de la Condamine. Bazille has depicted his friends and colleagues in an easy, casual grouping. After the artist portrayed Zola, Renoir, Manet, Monet, and Maître, Manet painted Bazille's portrait to complete the group.

ABOVE, RIGHT

100.

Frédéric Bazille

The Artist's Studio

1870

RIGHT

101.

Honoré Daumier

Nadar Raising

Photography to the Level

of Art

1862

critics to designate quick studies of atmospheric effects. Armand Silvestre, who, the year before, had written a preface to accompany a collection of etchings after paintings published by the Galerie Durand-Ruel, described Monet's, Sisley's, and Pissarro's "vision of things . . . as above all *decorative*. Its sole aim is to record an *impression*, leaving the concern with *expression* to those concerned with line."[2] Other critics, while voicing enthusiasm for the new subject matter, expressed reservations about the limitations of the new techniques. Antoine Castagnary, Manet's friend and an ardent champion of naturalism, maintained that the common aim of the exhibitors was to seize the essence of a subject: "Once the impression is captured, they declare their role terminated. If one wants to characterize them with a single word that explains their efforts, one would have to create the new term of impressionists."[3] Personally, Castagnary found the sketchiness of the young painters insufficient, and cautioned them to perfect their drawing lest their art become "too superficial." He also correctly predicted that the members of the group would follow separate paths.

Claude Monet

At the time of their epochal show, most of the founder-members of the group were still in their early thirties; only Degas and Pissarro were slightly older. The latter, at forty-three, was an almost patriarchal figure for some of the younger artists. Yet it was Claude Monet whose artistic personality dominated the group and the critical issues associated with it. The twelve paintings he exhibited in the first show revealed the considerable range of his talents and documented the significant changes

that were taking place, both in terms of how artists perceived a subject and in the related questions of appropriate execution and scale. One of the few paintings accorded a moderately favorable reception, *The Luncheon* (plate 171), had been rejected by the Salon jury four years earlier. The work was typical of Monet's carefully constructed compositions that contrasted so markedly with the small, thinly worked *Impression, Sunrise*. *Boulevard des Capucines* (plate 120), one of two views painted from the windows of Nadar's studio, stood somewhere between these extremes. With its curious vantage point and blurred figures (Leroy called them "black tongue lickings"), it seemed to some the epitome of the fragmentation and slapdash execution they would attribute to Impressionism. Only a few critics recognized in that superficial disorder a new basis for pictorial structure and the springboard for the re-creation of "the elusive, the fleeting, the instantaneity of movement . . . in its incredible flux."[4]

Monet continued to show one or two large, more finished paintings with a number of smaller ones throughout the decade. The latter category, painted for the most part entirely out of doors, occupied him more and more. In fact, the varying concepts of scale and execution in the artist's painting signaled a persistent conflict that would be resolved only much later in his career, when he relinquished the spontaneity he had been so enamored of in order to cultivate consciously decorative qualities that emerged only when a painting was worked on over a long period of time.

Painters of the Seine

Among the landscapists who made up the Barbizon group, only Corot and Daubigny had been drawn to the rendition of fluid environments. In this they anticipated the Impressionists' extraordinary preoccupation with water as a repository of nature's most evanescent effects. No exponent of the new painting was more fascinated by water than Monet, whose lifelong study of its interaction with the other elements already had begun in the late 1860s, when he and Renoir worked together near the boating and bathing spot on the Seine known as Le Grenouillère. Each artist produced three sets of pictures of the floating café and its patrons. Comparison of the works (plates 124 and 125) reveals that while their personal styles were extremely close, there were fundamental differences of facture (brushstroke) and color between them. Monet's palette is darkish; his emphatic brushstrokes impose a sense of pattern that amplifies the tight structure of the composition, whereas Renoir's concern with communicating the flickering light of a summer day drew him to brighter colors applied in looser brushstrokes. Renoir made a conscious effort to integrate the figures with their physical environment to create a new pictorial unity, while Monet tended to isolate them much as he isolated other compositional motifs such as the barge, the footbridge, and the boats, thereby dispersing the viewer's focus.

Zola was quick to appreciate Monet's gift of capturing not only the many appearances, but the very energy of water: "With him, water is alive, deep, above all it is real. It laps against the boats with little greenish ripples cut across with white flashes: it spreads out in glaucous pools, suddenly ruffled by a breeze, it lengthens the masts reflected on its surface by breaking up their image, it has dull and lambent tints lit up by broken gleams of light."[5]

Both Monet and Renoir regarded their small views of La Grenouillère as preparatory studies for larger, more complete works to be submitted to the Salon jury. Yet within a few years, their approach to landscape painting had changed significantly.

TOP
102.
Edouard Manet
Monet in His Studio Boat
1874

BOTTOM
103.
Edgar Degas
Portrait of Duranty
1879

Their decision to exhibit small, spontaneous works in the group shows amounted to a declaration of war on the Salon's notion of what constituted a finished painting.

After his return to Paris in 1871, Monet moved to Argenteuil, a popular spot on the Seine just west of Paris. During the early 1870s, Sisley and Renoir joined him there periodically, and even Manet, that dyed-in-the-wool flaneur, deserted the boulevards and cafés of Paris for a brief stint as a plein-air painter. In his specially outfitted "floating studio," Monet made trips along the river near Argenteuil, recording its different faces—the quiet roads, small towns, and the tall chimneys of low-slung factories that within a decade were to transform the character of the area from rural and agricultural to industrial. Of all the paintings executed in the five years that Monet lived in Argenteuil, those usually regarded as the most quintessentially Impressionist are his many images of boats, some moored, some gliding along the river, their sails billowing in the wind that ripples on its reflective surface. These sparkling canvases exude that sense of joie de vivre and exuberance popularly associated with Impressionism. Their bright color, simplified pictorial organization, and wide range of brushstrokes enliven the surface of the canvas and produce an energy so palpable that it serves as a metaphor for the experience rather than a description of it.

The Auction at the Hôtel Drouot

While the exhibition at Nadar's studio had provoked a good deal of controversy, it had not generated the sales the organizers desperately needed. Some of the founders—Morisot and Degas—had sold nothing at all, while the few works of Renoir, Sisley, and others that were sold totaled only thirty-six hundred francs. The bourgeoisie clearly was not in the mood to buy art; the country's economy had not recovered from the devastating cost of the recent war, and the government was forced to pay heavy indemnities to the victorious Prussians. Inflation, unemployment, and the fears of revolution unleashed anew by the experience of the Commune created a climate unconducive to the flourishing of an art market. In view of this, and because of their particularly dire straits, Renoir persuaded Monet and Sisley that their only recourse was to offer a number of paintings at public auction under government supervision. Accordingly, a sale of seventy-three works—twenty-one by Sisley, twenty each by Monet and Renoir, and twelve by Morisot—took place at the Hôtel Drouot on March 24, 1875.

Durand-Ruel once more proved himself a good friend to the artists, lending his services at the auction. Later, he reminisced about the extraordinary public abuse heaped on the clerks who showed the paintings to the potential bidders. Catcalls and insults greeted each work, and finally the atmosphere became so belligerent that the police were summoned to maintain order. A newspaper account of the auction provides some sense of the general mood: "We had good fun with the purple landscapes, red flowers, black rivers, yellow and green women, and blue children which the pontiffs of the new school of painting presented."[6] Far more damaging than the insults hurled at the Impressionists were the contemptuously low prices bid for their work: the highest prices were obtained by Morisot, with an average of 250 francs (150 dollars) bid for oils, while Monet, Sisley, and Renoir averaged somewhat less.

Among the few brave souls who acquired paintings at the auction were Ernest Hoschedé, a department store executive and amateur critic; the critic Ernest Chesneau; and an unknown official in the customs ministry, Victor Chocquet, who for years had quietly but passionately collected Delacroix. Chocquet was especially drawn to the paintings of Renoir, and the two soon became friends. Renoir introduced his new patron to Cézanne and Monet, and the customs official/collector became one of the Impressionists' most enthusiastic supporters in the difficult years following their first exhibition. Indeed, Chocquet's taste for the new painting turned his Paris apartment into a virtual museum of Impressionism.[7]

The Second Group Exhibition

While Chocquet's patronage could offer the Impressionists some consolation for the public indignities and financial disappointments they had suffered from the auction, they had to postpone plans for another group show until the following year. The number of participants in the exhibition that opened at Durand-Ruel's gallery in April 1876 was reduced by one-third to twenty. Some artists were still licking the wounds inflicted by the press at the previous showing and simply did not wish to risk another skirmish; others still preferred to submit their works to the Salon jury, even in the face of almost certain rejection. Despite significant defections, there were a few new members: Marcellin Desboutin (who had posed for Degas's L'Absinthe, plate 137), Alphonse Legros, and Gustave Caillebotte, a former law student and Sunday painter who had befriended Monet and Renoir at Argenteuil and was to become a major collector of their works.

Once more the popular press was unsparing in its attacks on the enterprise. Albert Wolff's vituperative appraisal is representative: "At Durand-Ruel's there has just opened an exhibition of so-called painting . . . five or six lunatics—among them a woman—a group of unfortunate creatures stricken with the mania of ambition have met there to exhibit their works. . . . Those self-styled artists give themselves the title of non-compromisers, impressionists; they take up canvas, paint and brush, throw on a few tones haphazardly and sign the whole thing."[8] So angered was Berthe Morisot's husband, Eugène Manet, that he considered challenging Wolff to a duel.

This scene is in Marlotte, a hamlet near the forest of Fontainebleau where Renoir and Sisley both lived and painted. The simplicity of village life is evoked by Sisley's direct method of painting and by the blocklike architecture. These sturdy forms may also signify the endurance of the hardworking residents, one of whom is seen chopping wood at the right.

104.
Alfred Sisley
Village Street in Marlotte
1866

The popular press repeatedly echoed the notion that the Impressionists were madmen whose peculiarly colored works induced infectiously erratic behavior. A few critics came to their defense, including Georges Rivière, a writer and friend of Renoir, who mounted a counterattack and even published a short-lived review, *L'Impressionniste*, in which he indicted Wolff's superficiality and claimed: "The public . . . seeing how insistent these painters were in the pursuit of their experiments, looked at their works more closely, and the Impressionists emerged stronger from this second trial, supported by a large number of remarkable men."

One of these remarkable men was Edmond Duranty, a novelist and friend of Courbet's who had founded a periodical called *Le Réalisme* some twenty years earlier. An active participant in the discussions at the Café Guerbois in the late sixties, Duranty had developed views similar to Degas's on painting and the importance of carefully observing modern life in realizing new pictorial forms. Avoiding the controversial term "impressionism," which Degas and Renoir both abhorred, Duranty set out to defend what he called "the new painting" against the frequently leveled charge that its exponents had no roots in tradition. He cited the notable examples of Courbet, Corot, Manet, and Jongkind, among others, as precursors of their interest in nature, and noted the innovative concern of the artists in the group "with that fine play of colors which . . . contrast with or penetrate one another. Their discovery actually consists in having recognized that full light de-colors tones, that the sun reflected by objects tends (because of its brightness) to bring them back to that luminous unity which melts its seven prismatic rays into a single colorless radiance: light."[9]

105.
Alfred Sisley
The Flood at Port Marly
1876

These pictures were painted in Pontoise, where Pissarro moved after the Franco-Prussian war. The artist not only depicts the play of light on the water and the ground, but the life of the townspeople as well. Below, the weight of the water carrier's burden is vividly conveyed by his posture as he makes his way into the village. In the later picture, at right, the wood gatherer seems to be absorbed into the surrounding landscape.

ABOVE
106.
Camille Pissarro
Banks of the Oise, near Pontoise, Drab Weather
1878

RIGHT
107.
Camille Pissarro
Bords de l'Oise (Le Porteur d'eau)
1874

Defending plein-air painting, Duranty maintained that it was time for "the painter to leave his sky-lighted cell, his cloister." Yet even as he acknowledged the Impressionists' passion for the instantaneous, and their determination to "render the trembling of leaves, the shivering of water, and the vibration of air inundated with light,"[10] Duranty expressed reservations about the unevenness of talent in the group, which he characterized as "eccentric and ingenuous characters, visionaries alongside profound observers, naive ignoramuses"[11] and he wondered whether their achievements would survive the test of time.

Painters of the Ile-de-France: Sisley and Pissarro

Despite limited sales and only occasional enthusiasm for their work, the Impressionists were busier than ever in 1876. Alfred Sisley, who had moved to Marly on the outskirts of Paris, produced some of his finest work in this year. The floods that periodically inundated the banks of the Seine provided the artist with a theme for a group of paintings that vividly record the volatile and shimmering surfaces of the river and its interaction with the turbulent sky. In the face of this evanescent atmosphere, the houses and trees possess a contrasting sturdiness that would remain a characteristic of Sisley's unobtrusive style. Although the painter had been very close to Monet and Renoir (all three were students of Gleyre at the Ecole des Beaux-Arts until 1864), his sensibility was profoundly affected by the landscapes of Daubigny and Corot. Never as confident or successful as his

The strong composition of The Balcony *(right) marks Morisot as a member of the new generation of artists. The diagonal of the balcony contrasts with the angle of the view beyond. Furthermore, the seemingly arbitrary cropping of the pedestal and vase of flowers at the right gives the impression of a random view, a feeling reinforced by the casual pose of the woman and child.*

two friends, his concern with form as evidenced in the more precise brushwork of *The Bridge at Villeneuve-la-Garenne* (plate 126) and *The Flood at Port-Marly* (plate 105) separates him from them, as does his more traditional rendering of space. While Monet and Renoir tended to concentrate of sun-filled subjects, Sisley was the master of the troubled sky, and his studies of the effects of snow are among the most stunning achievements of Impressionist landscape painting in the 1870s.

Another painter of the countryside of the Ile-de-France, Camille Pissarro had been with Monet and Sisley in London in 1870–71. He returned to his studio in Louvenciennes, outside of Paris, to find that virtually all of the work he had produced before the war had been lost during the German occupation. Moving to the nearby town of Pontoise, where he remained for twenty years, Pissarro persuaded Cézanne to join him and was largely responsible for the younger artist's gradual conversion to plein-air painting and its attendant lighter palette. Esteemed by all the members of the group as a generous friend and a wise counselor, Pissarro exerted an influence on such artists as Cézanne and Paul Gauguin that seems almost as important as his painted oeuvre. Indeed, Cézanne generously acknowledged the crucial role played by the artist when he declared, "Perhaps we all . . . derive from Pissarro."

Pissarro was particularly drawn to the beauty of the French countryside and of the people who toiled it. While Monet would exhort young painters to forget what they were looking at and see only the effects produced by light, Pissarro strove to impart the essential look of a place. His works of the 1860s already display simplified forms, a generous use of the palette knife to apply paint, and an interest in optical effects, all of which anticipate many of the principal qualities of Impressionism in the early 1870s. Paintings such as *Orchard in Bloom, Louveciennes* (plate 128) and *Entrée des voisins* (plate 130) document Pissarro's attempts to reconcile the recording of momentary climatic effects with an evolving awareness of the inherent organization in nature. Perhaps it was the painters's dedicated effort to integrate the two that led him in the mid-1880s to adopt the more controlled brushwork and more systematic color theories associated with Georges Seurat and Neoimpressionism.

At the time of the exhibition at Nadar's studio, Armand Silvestre had called Pissarro the "most real and most naive member" of the group. His work expressed the same quiet dignity, sincerity, and durability that distinguished his person. He was the only Impressionist to participate in all the group exhibitions; no member of the group did more to mediate the internecine disputes that threatened at times to break it apart, and no one was a more diligent proselytizer of the new painting.

108.
Berthe Morisot
The Balcony
1872

Berthe Morisot

Berthe Morisot had met Edouard Manet in 1868 and posed for him in *The Balcony* (plate 82) the following year. The two had much in common: wealthy backgrounds and a tradition of family service to government; within five years they would be joined by stronger bonds when Morisot married Manet's brother Eugène. Both Berthe and her sister Edma were given drawing lessons, and in 1860 Berthe began working on landscape painting under Corot's guidance. From 1864 to 1873 she exhibited at the Salon. Her decision to join the Impressionists in 1874 was especially courageous because she had a reasonably good expectation of being accepted by the Salon jury that year.

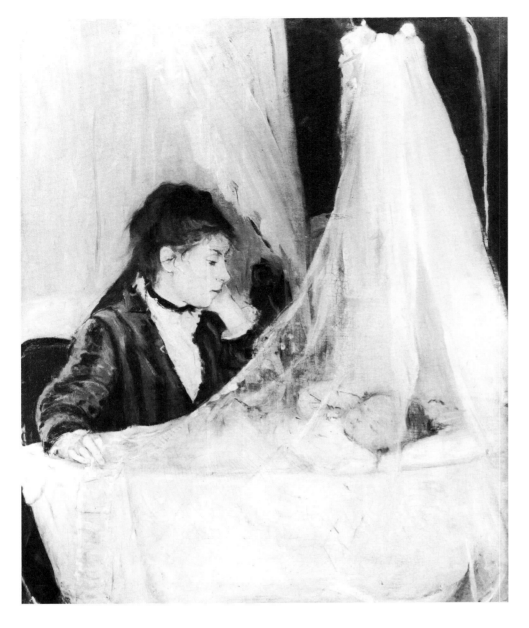

Although her family's wealth protected her from the terrible financial pressures that beset most of her colleagues, Morisot's strong personal convictions about the future of art compelled her to remain in the group despite the advice of Manet and others. The freshness of color and charming design that characterized her *Harbor at Lorient* (plate 132) in the first group exhibition were gradually replaced by a more emphatic sense of color and brushwork in works such as *The Balcony* (plate 108), whose modern subject and somewhat detached execution compare favorably with Manet's *Gare Saint-Lazare* (plate 90).

The poet and critic Paul Valéry said that Morisot lived her painting and painted her life. Her models—as those of another female member of the group, Mary Cassatt—were frequently close relatives. *The Cradle* (plate 109), exhibited in the first Impressionist show, depicts the artist's sister and infant niece. Despite the distinctive design and remarkable subtlety of mood, the work did not meet with unqualified approval. Louis Leroy took sarcastic exception to the free handling of the paint: "Now take Mlle Morisot! That young lady is not interested in reproducing trifling details. When she has a hand to paint, she makes exactly as many brushstrokes lengthwise as there are fingers, and the business is done."[12]

The birth of a daughter in 1878 kept Morisot from participating in the Impressionist show of that year, and it may also have led to her growing preference for domestic scenes. The home of Morisot and Eugène Manet was a frequent meeting place for the Impressionists in the late seventies. Among the painters in

Like other female members of the Impressionist group, Morisot frequently painted themes associated with motherhood and family. Here, in a canvas that was included in the historic group exhibition of 1874, the model is her sister, and the infant is presumably her tiny niece. Although the delicate brushwork and shimmering, silvery tone convey some of the lyric reverie associated with the mother and child tradition, the firm sense of structure precludes any trace of sentimentality.

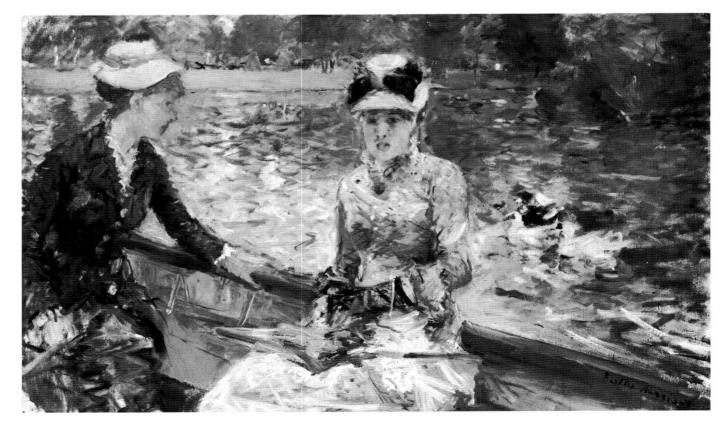

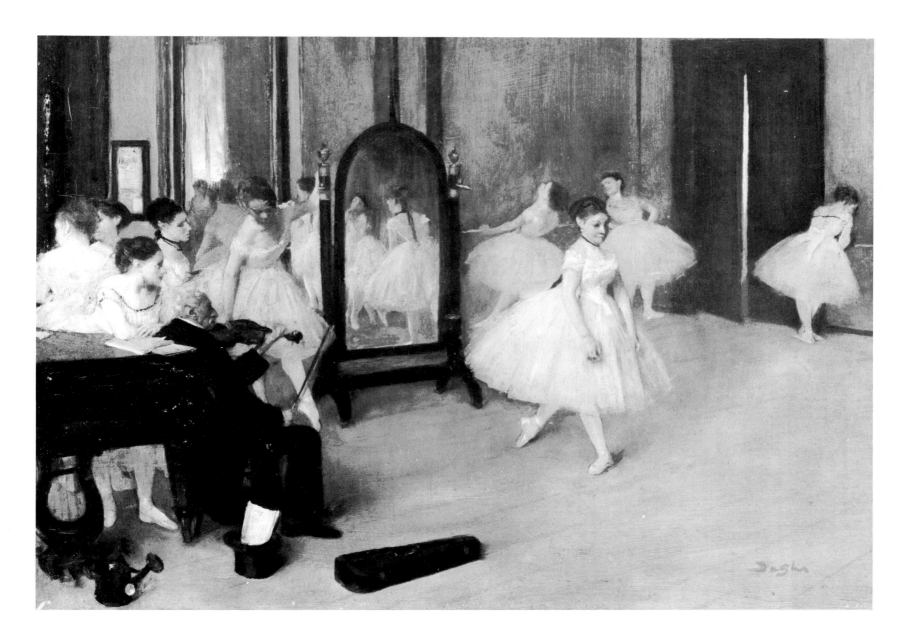

the group, Morisot was drawn increasingly to Renoir, and the changes in her style over the next decade—richer coloring, more sketchily defined form, and more generous paint surface—can at least partially be explained by their close contact.

Edgar Degas

In the discussions that occurred regularly at the Café de la Nouvelle Athènes in the Place Pigalle, which had replaced the Café Guerbois as a regular meeting place for artists and writers, Edgar Degas was an animated, even brilliant advocate of the need to cultivate the mind as opposed to the eye. Never comfortable in the role of plein-air painter, Degas was committed to a certain type of urban subject matter, and his favorite milieux were popular spots such as cafés, theaters, and the circus. Distinguishing himself from his landscapist colleagues with the observation: "You need natural life, I, artificial life," he began in the late 1860s to haunt the Paris Opéra. There he discovered a range of new themes involving musicians, performers, and spectators and also developed a particular passion for ballet. He visited the classes where the young dancers were trained, accumulating a wealth

of sketches and training his keen memory to retain the motifs that would provide a point of departure for numerous paintings in the 1870s and 1880s. Unlike so many of his colleagues who finished their paintings in situ, Degas believed that the immediate impression had to be modified, transformed into something more valid by reflection. He claimed: "It is very well to copy what one sees, it's much better to draw what one has retained in one's memory. It is a transformation in which imagination collaborates with memory. One reproduces only that which is striking; that is to say necessary. Thus, one's recollections and inventions are liberated from the tyranny which nature exerts."[13]

Indeed, Degas remained adamant in his aversion to the term *impressionism*, even after the word had been more or less accepted by the other members of the group. Because of his persistent objection, the name "Group of Independent Artists" was used instead for the exhibition of 1879.

A sense of wonderful informality pervades Degas's vignettes of dancers from the early seventies. Starting with paintings such as *Foyer de la Danse (The Dancing Class)*, he began to tackle the challenging problem of disposing a large number of figures within an interior space. The role of color is consciously limited in these pictures; the primary contrast is between light and dark.

OPPOSITE, TOP

109.

Berthe Morisot

The Cradle

1873

OPPOSITE, BOTTOM

110.

Berthe Morisot

Eté (Summer)

c. 1879

THIS PAGE, ABOVE

111.

Edgar Degas

Foyer de la Danse
(The Dancing Class)

1871

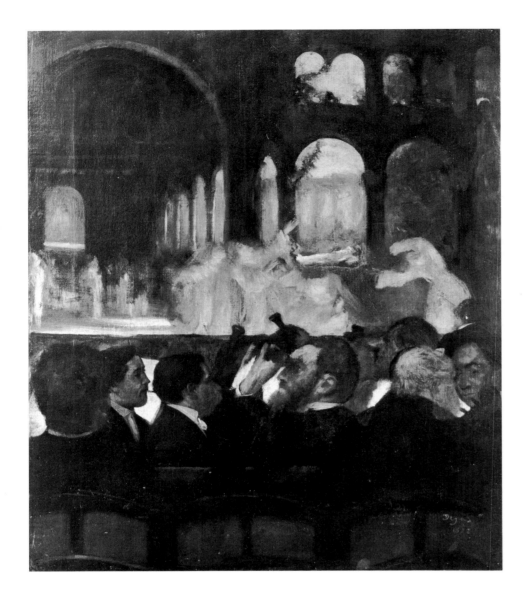

112.
Edgar Degas
The Ballet from "Robert le Diable"
1872

Carriage at the Races (plate 134), which depicted the family of the artist's friend Paul Valpinçon. Borrowing some compositional devices from the Japanese woodcuts that he and many other Impressionists enthusiastically collected, Degas created a design of elegant and simplified two-dimensionality that compels the viewer to experience the carriage, its inhabitants, and the distant riders as colored shapes. The arbitrary cropping of the scene and the constantly shifting focal points are reminiscent of Manet's work, but are free of the contradictions that often abound in his paintings. Degas's friend Duranty acknowledged his decorative reordering of idealized perspective in *La Nouvelle Peinture:*

> *Views of people and things have a thousand ways of being unexpected in reality. Our point of view is not always in the center of a room with two lateral walls receding toward . . . the rear; it does not always gather together the lines and angles of cornices with a mathematical regularity and symmetry. Nor is it always free to suppress the great swellings of the ground and of the floor in the foreground; it is sometimes very high, sometimes very low.*[15]

These words could just as easily apply to *Portraits in an Office: The Cotton Exchange, New Orleans* (plate 135), a souvenir of Degas's visit to relatives in America. The artist depicts his uncle, top-hatted, looking at some cotton, and his brothers René, reading a newspaper, and Achille, slouching against a window, while the other figures are partners or employees of the uncle. The precedents for such a group portrait are clearly the corporation pictures of such seventeenth-century Dutch masters as Hals and Rembrandt; yet the subdued color and randomness of the composition were radically new and disturbed many critics. In a letter from New Orleans to his painter friend James (Jacques-Joseph) Tissot, Degas described this work as "a painting of a vernacular subject, if there is such a thing." Actually, it is precisely the haphazard, unposed quality of the composition that identifies its modernity. Apparently, Degas intended to send the painting to a dealer in London, hoping that he in turn would sell it to a textile manufacturer, but this never happened, and it ended up among the twenty-four works Degas sent to the second Impressionist exhibition.

Pierre-Auguste Renoir

At the time of the first exhibition, Pierre-Auguste Renoir was living in Montmartre, where the purchase of some paintings by Durand-Ruel had enabled him to take a large studio. While Monet, Sisley, and Pissarro were beguiled by the countryside, Renoir loved the energy of the capital, with its crowded and fashionable boulevards, parks, and other gathering places. Renting a room above a café that faced the Pont Neuf, he set

The painter also introduces mirrors and doorways, a favorite device which calls the viewer's attention to the complicated and ambiguous spatiality of the work and, more generally, underlines the paradoxical nature of painting as both a reflection of reality and a finite, two-dimensional medium.

In 1874 the novelist and critic Edmond de Goncourt observed that Degas's interest in dancers was part of a more generalized interest in specific occupations that involved his perceiving their distinct physical attitudes and fixing them in appropriate images. Later, speaking of Degas's dancers, Paul Valéry noted perceptively: "He defines them. . . . He is like a writer striving to attain the utmost precision of form, drafting and redrafting, canceling, advancing by endless recapitulation, never admitting that his work has reached its final stage."[14] Indeed, like the Naturalists, his literary counterparts, Degas constantly accumulated information about people and things. He would hoard this information, taking his sketches and refining what had been accidental or casual into designs of such premeditated clarity that they projected the illusion of effortless spontaneity we associate with the Impressionists.

Degas's extraordinary concern with a given milieu—rehearsal room, café, or race course—led to remarkable new concepts of portraiture. One of his most innovative compositions was a group portrait submitted to the 1874 exhibition called

about capturing the movement of the traffic on a particularly bright day in 1872. *Pont Neuf, Paris* (plate 140) projects both the general panorama and the specific attitudes of the pedestrians who stop to greet friends, smoke a cigarette, or look down the river. Above all, it conveys a palpable exuberance and *joie de vivre* that were essential components of Renoir's approach to painting.

Since many of his painter friends were living in or near Argenteuil, Renoir often left Paris to visit with them. There, as he had in the late 1860s, Renoir worked closely with Monet. Such radiant, sun-filled themes as *Monet Working in His Garden at Argenteuil* or *Sailboats at Argenteuil* (plate 220) document the evolution of his style and already point to the more pronounced concern with pleasure that would become his special hallmark. The latter painting, which can be compared with an identical scene by Monet, reveals—as had their views of La Grenouillère some five years before—both their affinities and their temperamental differences. While Monet's execution is matter-of-fact, essential in its detail, and devoted to the recording of the instant, Renoir's brushstroke almost caresses the canvas, providing a tactile component for the visual experience.

After the disastrous auction of 1875, Renoir turned to the study of the nude—an unusual interest for a professed plein-air painter—and to portraiture, which was essential to his livelihood. One of the few paintings that fetched a decent price at the auction was acquired by the publisher Georges Charpentier, whose patronage was to sustain Renoir for some time.

Renoir's studio in Montmartre had a garden in which he painted two works, *A Nude in the Sun* (1875) and *La Balançoire* (plate 113). In these paintings, the human figures become receptive objects onto which are projected myriad patterns of highly mobile light. In his review of the second Impressionist show, Albert Wolff complained, "Try to explain to M. Renoir that a woman's torso is not a mass of flesh in the process of decomposition with green and violet spots."[16] Undaunted, Renoir continued to devote himself to such studies of light filtered through trees, expanding his subject from the single figure to complex groups. The most ambitious of his group studies was *Dancing at the Moulin de la Galette* (plate 139), which was shown the following year in the third Impressionist exhibition. While it provoked some sarcastic criticism, the large painting did elicit a sensitive response from a few writers.

The organization of such a large number of figures, many of them depicted in motion, may have necessitated the loose, somewhat circular pattern of the work, which may also have been inspired by such related earlier works as Rubens's *Kermesse* or Watteau's *Embarkation for Cythera* (plate 196). The exuberance of Renoir's composition, its sparkling light and sensuous surface, captivated the public when it was reexhibited at Durand-Ruel's in 1883. Acquired by Caillebotte, it was part of the painter's bequest to the Musée du Luxembourg in 1894. Indeed, the large canvas—departing from the smaller-scale paintings done by

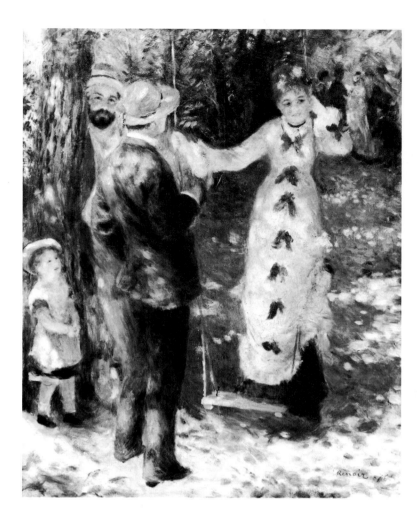

113.
Pierre-Auguste Renoir
La Balançoire
1876

many of the Impressionists and painted in situ rather than in the studio—can be regarded as a milestone in the evolution of Renoir and of Impressionism.

Paul Cézanne

Paul Cézanne, whose submissions to the official Salon met with uniform rejection, was admitted to the Société at the invitation of Pissarro. For two years the rough Provençal painter had worked closely with Pissarro, first at Pontoise and subsequently at Auvers, where he was given hospitality by Dr. Paul Gachet, a physician and amateur engraver who befriended a number of the Impressionists (he later treated Vincent van Gogh in the last months of his life). In the first group exhibition, Cézanne showed two landscapes and a composition entitled *A Modern Olympia* (plate 340), a strange work that seemed like little more than a disrespectful parody of Manet's infamous painting. With its loose paint quality and peculiar subject matter, this work came under sharp attack from critics. It certainly did not typify the kind of painting Cézanne later produced at Auvers. There he gradually abandoned the literary subject matter, darker palette, and pseudo-Baroque brushwork characteristic of his

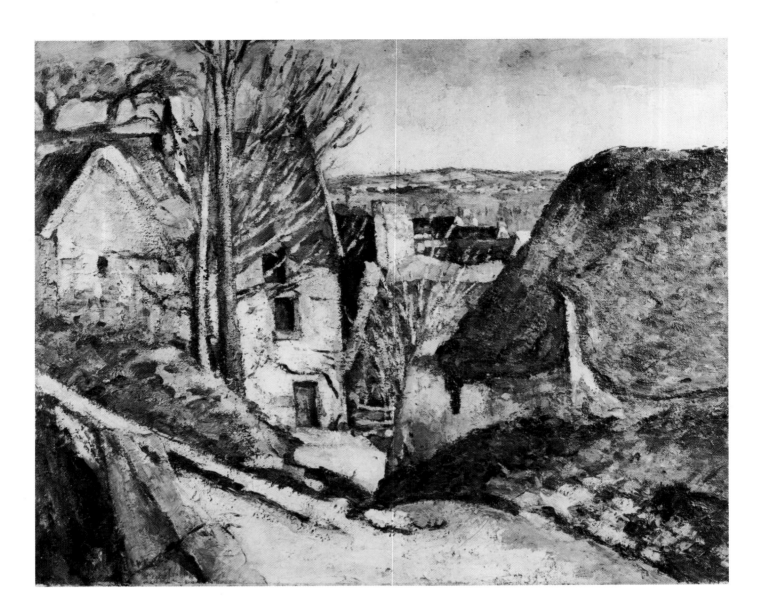

114.
Paul Cézanne
House of the Hanged Man
c. 1873

previous works, although he never lost his respect for the tradition of history or mythological painting incorporating figures in landscape.

Two landscapes from this first period of Cézanne's close association with Pissarro reveal the ongoing changes in the problematic young painter's work. *The House of Père Lacroix* (plate 138) and *The House of the Hanged Man* (plate 114) especially show his debt to the older Impressionist in his selection of the unpretentious farm houses as the basis for his composition. Cézanne concentrates on the essential structure, the clarity of its geometric statement, whether man-made or a natural form. In both paintings the surface is thick with paint, which is applied at times with a palette knife rather than a brush.

A slow worker who constantly strove for visual truth, Cézanne sought to capture the effects of light through pure color, but he did not share the Impressionists' concern with the ephemeral in nature. His landscapes project a sense of order and monumentality that are atypical of Impressionism. Emile Bernard, a poet and painter who corresponded with Cézanne over a number of years, appraised his encounter with the movement: "He had met Monet who dreamed of nothing but sun and light, and he succumbed in turn to the charms of great brightness; but he recovered little by little his calm and his ponderation."[17]

The House of the Hanged Man was one of a few vital sales Cézanne made after the closing of the first Impressionist exhibition. Later it was acquired by Chocquet, and after a subsequent

sale it was bequeathed to the Louvre in 1911. While the painting displays certain affinities with the Impressionists—particularly evident in the bright colors and vigorous brushstrokes that evoke the strong cool light of the area around Auvers—the carefully formulated geometry of the walls, rooftops, and sloping hills reveals a fundamentally different pictorial organization.

After the exhibition at Nadar's studio, Cézanne divided his time between Paris and the south. He did not participate in the second group show, but instead submitted works to the Salon jury, which rejected them. Cézanne spent part of the summer of 1876 at L'Estaque on the bay of Marseilles, where he painted the first of many landscapes. The intense light of Provence engrossed him in projecting an arbitrarily shallow picture space. Abandoning traditional modeling and perspective, he minimized the contrast between near and distant objects, rendering their texture in a virtually uniform fashion.

In 1877 Cézanne exhibited with seventeen other members in the group's third exhibition, held at Durand-Ruel's gallery. Among the dozen paintings that he labeled "studies from nature," he showed several landscapes, a portrait of his patron, Chocquet, and an 1875–76 study of bathers, one of many he made throughout his life. In these monumental works Cézanne liberated himself from the mythological subjects he had experimented with in his early years.

Predictably, Cézanne's work met with little critical approval. His schoolfriend Zola came to his support, citing his abilities as

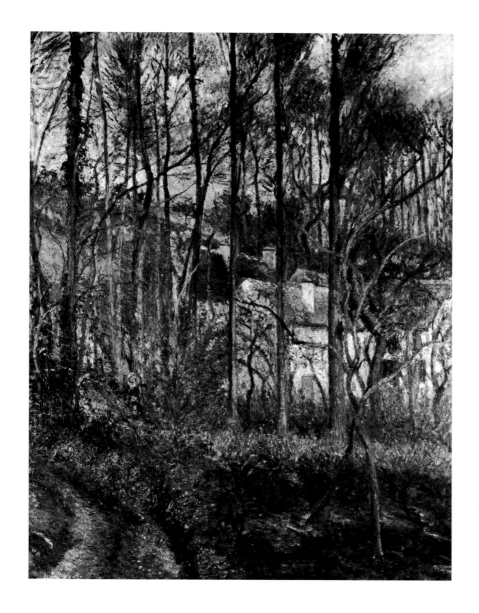

*C*aillebotte's rather large canvas, below, was the first to be executed of three Paris street subjects that the artist included in the Impressionist exhibition of 1877. The common theme in all three paintings is the architectural innovations of Baron Haussmann—in this case, the newly constructed bridge over the tracks leading to the Gare Saint-Lazare. Though Caillebotte's subject matter is as contemporary as that of his colleagues, the sharply focused imagery, the vortexlike space, and the evident concern with even the most casual of details underscores basic and crucial differences that would continue to set this highly independent young painter apart from the mainstream of Impressionism.

115.
Camille Pissarro
La Côte des Boeufs à Pontoise
1877

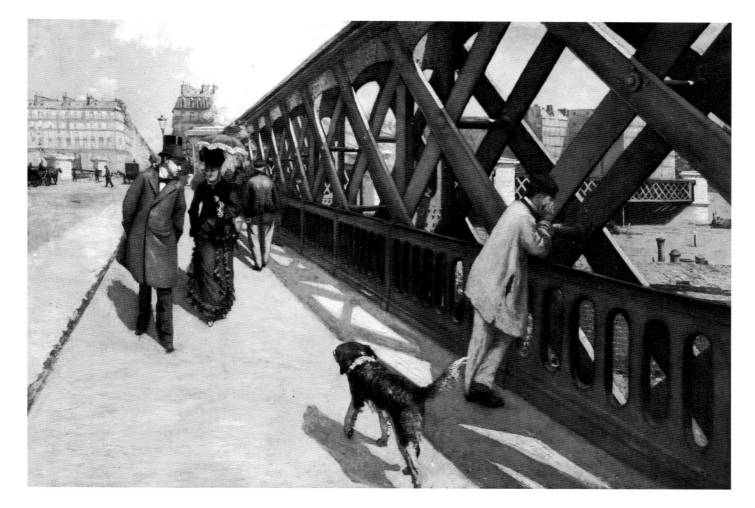

116.
Gustave Caillebotte
Le Pont de l'Europe
1876

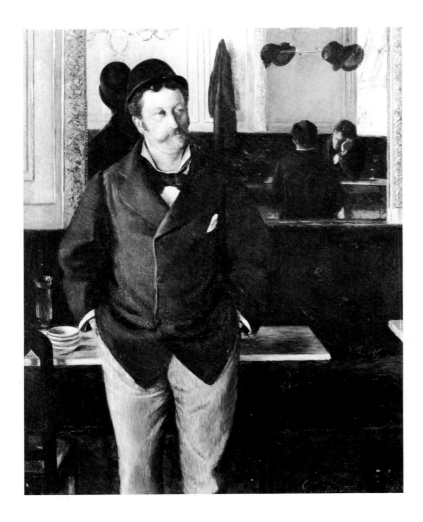

117.
Gustave Caillebotte
Au Café
1880

a colorist, chiding the simplistic incomprehension of the public, and praising his recent work: "There are . . . some Provençal landscapes of his which have a splendid character. The canvases of this painter, so strong and so deeply felt, may cause the bourgeois to smile, but they nevertheless contain the makings of a great artist."

While many of the Impressionists frequented the Café de la Nouvelle Athènes, Cézanne, something of a loner, paid only occasional visits. When he did, his unorthodox attire—overalls, paint-spotted jacket, boots, and old hat—provoked ridicule and misunderstanding, which reinforced his feeling that Paris was an inhospitable environment and that his future lay elsewhere. While he spent another year working closely with Pissarro, he gradually came to the conclusion that only in his native Aix could he find the physical conditions—a harsh countryside and southern light—that would enable him to pursue his study of forms, moving beyond the lessons learned with Pissarro to a more profound search for structure and order in nature.

Gustave Caillebotte

As the decade drew to a close, failing to produce either a decisive change in critical attitudes toward the new painting or a substantial body of collectors, virtually the only comfort to the original members of the Société was their capacity to attract new members. Gustave Caillebotte, who participated in the second exhibition, became a fervent proselytizer for the cause.

Apart from his generous patronage of fellow artists, he played a crucial role in organizing subsequent exhibitions, finding and even paying for space, helping with the hanging, and handling countless related details. It is no exaggeration to say that Caillebotte's participation was indispensable to the group in these difficult years.

Like other affluent young men of his generation, Caillebotte had prepared for a law career, but he was drawn to painting and encountered no parental objections when he decided to pursue it seriously. He entered the Ecole des Beaux-Arts in 1873 and within just two years submitted a painting to the Salon jury, which turned it down. His meeting with Degas in 1874 was decisive: the older painter introduced him to the members of the Société and invited him to join in their exhibitions. In fact, Caillebotte's contribution to the second group show at Durand-Ruel's—entitled *The Floor Scrapers*—revealed an interest in work subjects and a fascination with the intricacies of space that sparked comparison with Degas and gained Caillebotte instant notoriety with critics.

Free of the financial strains that plagued many of his colleagues, Caillebotte could indulge his interest in a particular type of urban subject on a grand scale that echoed the sweep and breadth of the great thoroughfares designed by Baron Haussmann. *Street in Paris, a Rainy Day* (plate 141), which he exhibited along with two other city views in the group show of 1877, is Caillebotte's most ambitious and original work. If only on the basis of its size (it measures about seven by ten feet, or two by three meters), the work is unique in a decade when the Impressionists had all but abandoned large pictures. Its panoramic monumentality is matched by a complex vision and precise execution. The forms, etched in cool gray tones, have a visual clarity and sense of order that contrasts dramatically with the bustling informality and fragmented color of the street scenes done by Monet, Renoir, and Pissarro. The tight structure of the composition, the result of careful observation and a painstaking synthesis of numerous preparatory drawings and oil studies, seems the antithesis of Impressionist spontaneity. While precedents for the curious dual perspective of the work can be found in contemporaneous panoramic photographs, none conveys that extraordinarily vivid sense of proximity and distance Caillebotte has captured, nor does any other Impressionist painting communicate as eloquently both the specifics and the anonymity of the great city.

Notwithstanding his sizable output, including more typically Impressionist landscapes and boating scenes, Caillebotte's historical importance as a painter has been overshadowed until recently by his role as an enlightened patron and enthusiastic promoter of the new painting. His bequest to the French state of sixty paintings, including works by Manet, Monet, Degas, Cézanne, Pissarro, and Sisley, formed the basis of the collection of Impressionist works at the Musée d'Orsay.

Mary Cassatt

Like Caillebotte, Pennsylvania-born Mary Cassatt came from a wealthy family (her father was a banker; her brother became president of the Pennsylvania Railroad). Arriving in Europe at the age of twenty-four, she studied with an academic painter and then traveled extensively in Italy and Spain before settling in Paris. She exhibited works in the Salons of 1872 and 1874, and it was in the latter that her painting caught the eye of Degas. After a visit to her studio, Degas became Cassatt's lifelong friend, and his works soon replaced those of Courbet and Manet as her sources of inspiration. He invited her to join the Impressionists, and she exhibited with the group from 1879 through 1886.

While she hardly could be described as a pupil of Degas, Mary Cassatt's subject matter and her execution often closely parallel his. She shared Degas's commitment to sure draftsmanship and his awareness of painting's decorative potential. Cassatt, too, was enthusiastic about Japanese woodcuts, and her later graphic works constitute the most sensitive assimilation of their formal simplifications of any member of the group. Her fascination with the theater, its particular quality of light, and the vivid color and unfocused excitement of an audience also rivaled Degas's. In *Woman in Black at the Opera* (plate 142), painted the year after her first exhibition with the Impressionists,

LEFT
118.
Mary Cassatt
The Coiffure
1891

BELOW
119.
Paul Gauguin
Seine in Paris, Winter
1875

This winter view of the Seine was painted just a few years after Gauguin married and accepted a position with a Paris brokerage firm. While he formed a friendship with Pissarro at about the time this canvas was done, the somber, darkish tones of the work suggest that he may have been inspired by the sturdy harbor views of Johan Barthold Jongkind, who earlier had influenced Monet's adoption of water themes.

and *The Loge* (plate 143), her fragmented forms and near-pastel colors come very close to Degas's. The heads of the principal figures are more sharply focused than the more distant, summarily rendered areas. As other Impressionists had done, Cassatt demonstrated that concentration on one subject or area causes blurring of the peripheral areas. This preoccupation with optical sensation was one of the most consistent features of Impressionist naturalism and exemplifies its scientific bent. In Cassatt's case, the results hardly constitute traditional portraits; the physical characteristics of the principals are clearly subordinated to formal concerns, expressed through a limited range of colors and a rigorous command of shapes.

While closely associated with the scandalous Impressionists, this transplanted Pennsylvanian scarcely conformed to the bohemian stereotype. She recognized this herself when she proclaimed vehemently, "I am an American, definitely and frankly American." Proper, steadfast, strongly committed to the Protestant work ethic, she brought a discipline to her work that matched her energy. She was devoted to her family and friends and frequently used them as models in her paintings, as Bazille and Caillebotte had done. She possessed a discerning eye, advising visiting American friends to purchase Impressionist works and thus functioning as a curator for some of this country's finest private and public collections of the new painting.

Paul Gauguin

Another newcomer to the group in this period of shifting allegiances was Paul Gauguin, a successful stockbroker who had begun to paint in the early 1870s. He had doubtless followed the progress of the Impressionist exhibitions, for he had assembled a small collection of works by Monet, Renoir, Manet, Sisley, Guillaumin, Jongkind, Cézanne, and Pissarro by the end of the decade. In 1876, at the age of twenty-eight, he had a landscape accepted at the Salon, and he also met the ever-helpful Pissarro, who became his mentor, exposing him to a more profound study of nature as they worked closely at Pontoise. It was Pissarro who introduced Gauguin to Degas and Cézanne, and who invited the young broker to participate in the fourth group exhibition in 1879.

The aggravated financial plight of some members, the defection of Renoir, and the absence of Sisley, Morisot, and Cézanne demoralized the group and shrank the number of exhibitors from the previous show. Long-standing philosophic and political differences within the group threatened to polarize its members further when Degas insisted that the name "Impressionists" be dropped. The term "Independents" was adopted again, prompting Armand Silvestre to describe the event as a "funeral service, procession and interment of the Impressionists."[18]

Renoir, whose *Madame Charpentier with Her Children* (plate 231) enjoyed a success at the Salon, had begun to make a reputation (and a fortune) as a painter of society women and their offspring. He opted for regular appearances at the official exhibition and defended his action by maintaining:

> I have just been trying to explain . . . why I send pictures to the Salon. There are in Paris scarcely fifteen art-lovers capable of liking a painting without Salon approval. There are 80,000 who won't buy so much as a nose from a painter who is not hung at the Salon. That's why I send in two portraits every year. . . . Furthermore, I don't want to descend to the foolishness that anything is good or bad according to the place where it is hung.[19]

Monet, originally at the center of the group, began to show the strain of the campaigns and gradually withdrew from the organization of the shows. Beset even more than usual by money problems and depressed by the difficult pregnancy and ensuing fatal illness of his wife, he remained secluded at Vétheuil, where he had moved in search of peace and a more rural landscape. After years of steadfastly refusing to lose his faith in the future of independent exhibition, in spite of overwhelming evidence to the contrary, Monet was confronted with a crucial choice: continue to adhere to his principles and court further insult, or relent in the hope that admission to the next Salon might provide the critical recognition and financial security that had so far eluded him. He, too, submitted to the Salon, and in so doing provoked Degas to accuse him of "desertion." Of the founder members, only Degas, Morisot, and Pissarro remained strongly committed to the group as the new decade began.

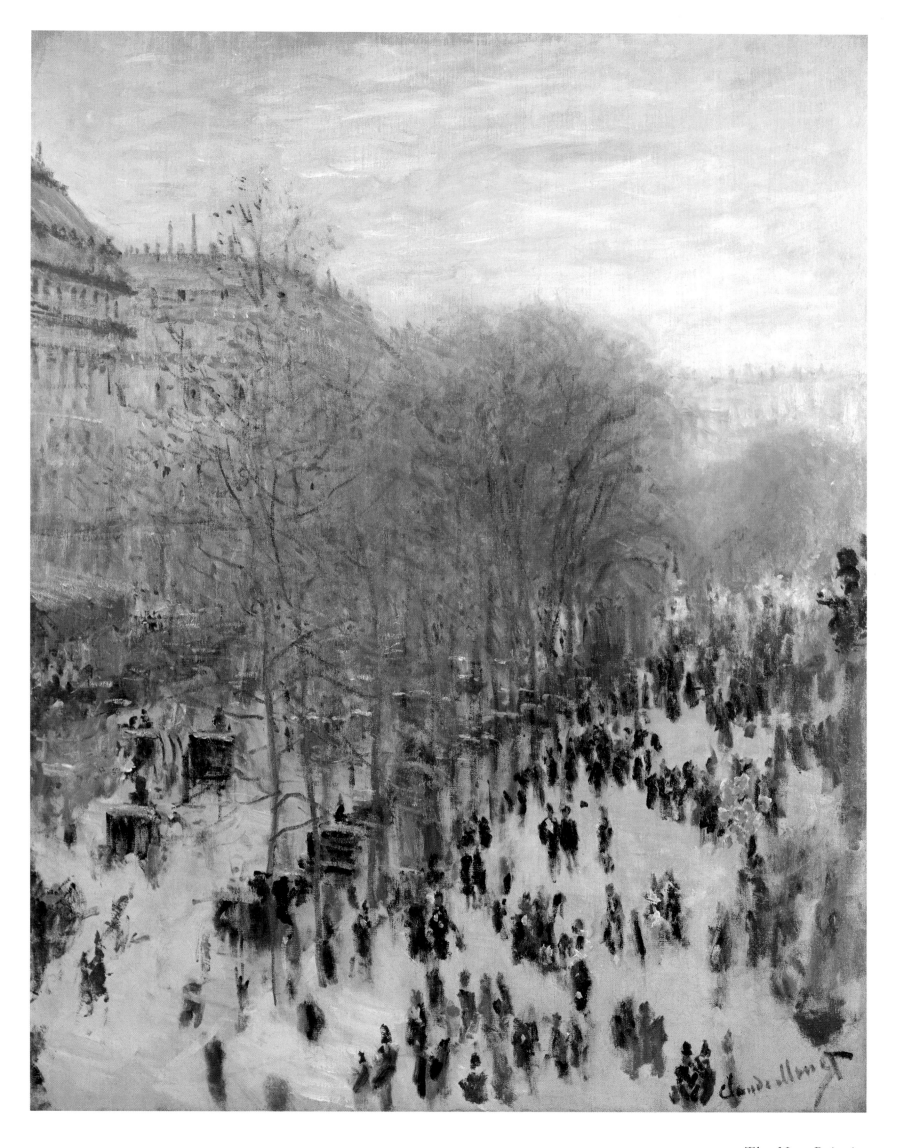

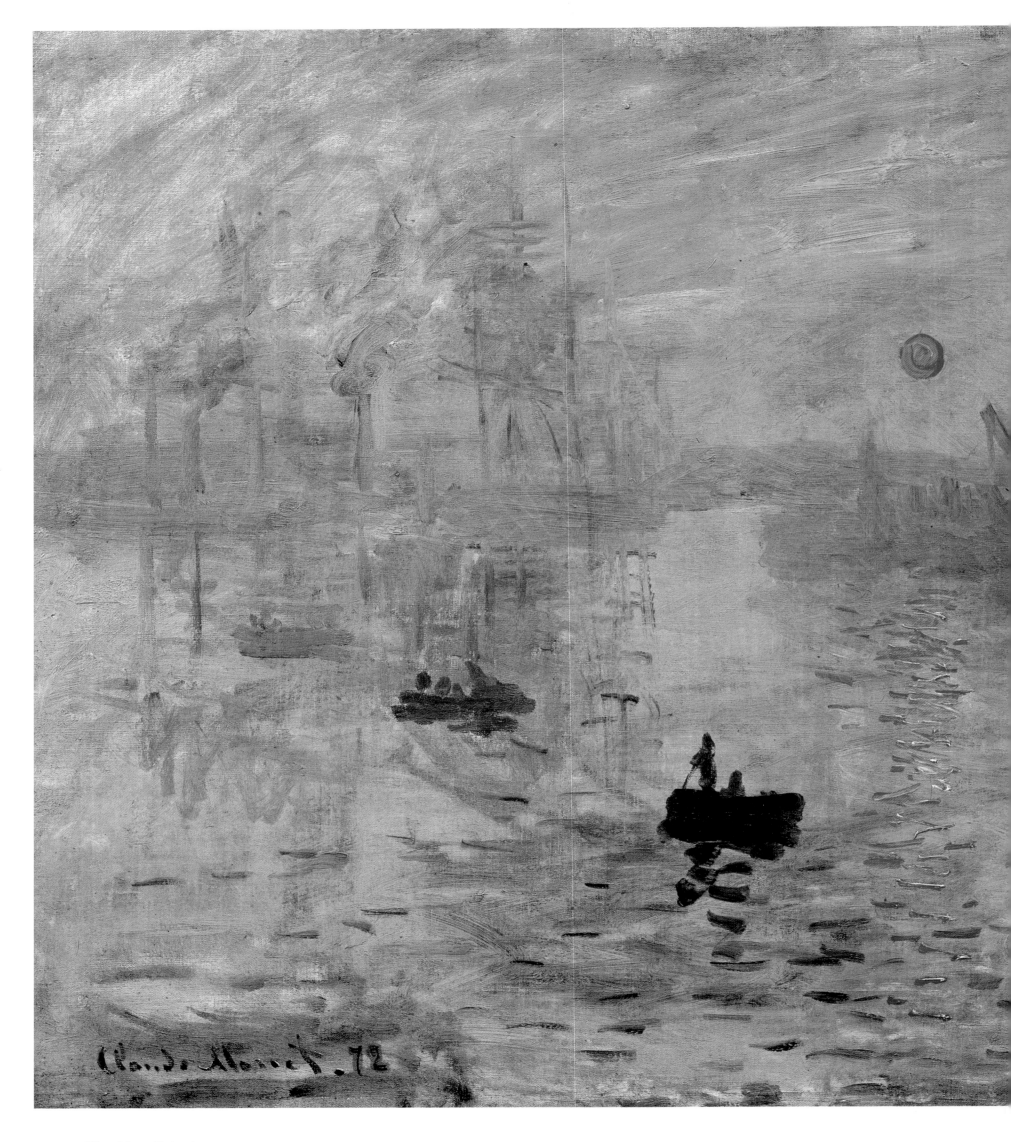

*A*lmost twenty-five years after this painting shocked the public at the first Impressionist exhibition, Monet recalled: "I had something I painted from my window in Le Havre: the sun in the fog and in the foreground some masts sticking up. They wanted to know its title for the catalogue; [because] it couldn't really pass for a view of Le Havre I replied, 'Use Impression.' Someone derived 'Impressionism' from it and that's when the fun began."

121.
Claude Monet
Impression, Sunrise
c. 1872

In the early 1870s Monet and Renoir resumed their practice of working together, painting side by side near Monet's new home in the riverside village of Argenteuil. Like their earlier views of La Grenouillère, these regatta scenes reflect the aesthetic differences between the artists as strongly as their affinities. Whereas Renoir places greater emphasis on the social aspects of the scene, focusing the viewer's eye on the procession of people down to the mistily rendered boats, Monet's view is much more detached. A strong horizontal axis divides the areas of sky and water almost evenly, providing a point of reference for the viewer as one attempts to decipher the relation between the perceived objects—sailboats, houses, and foliage—and their flickering reflections.

122.
Claude Monet
Regatta at Argenteuil
1872

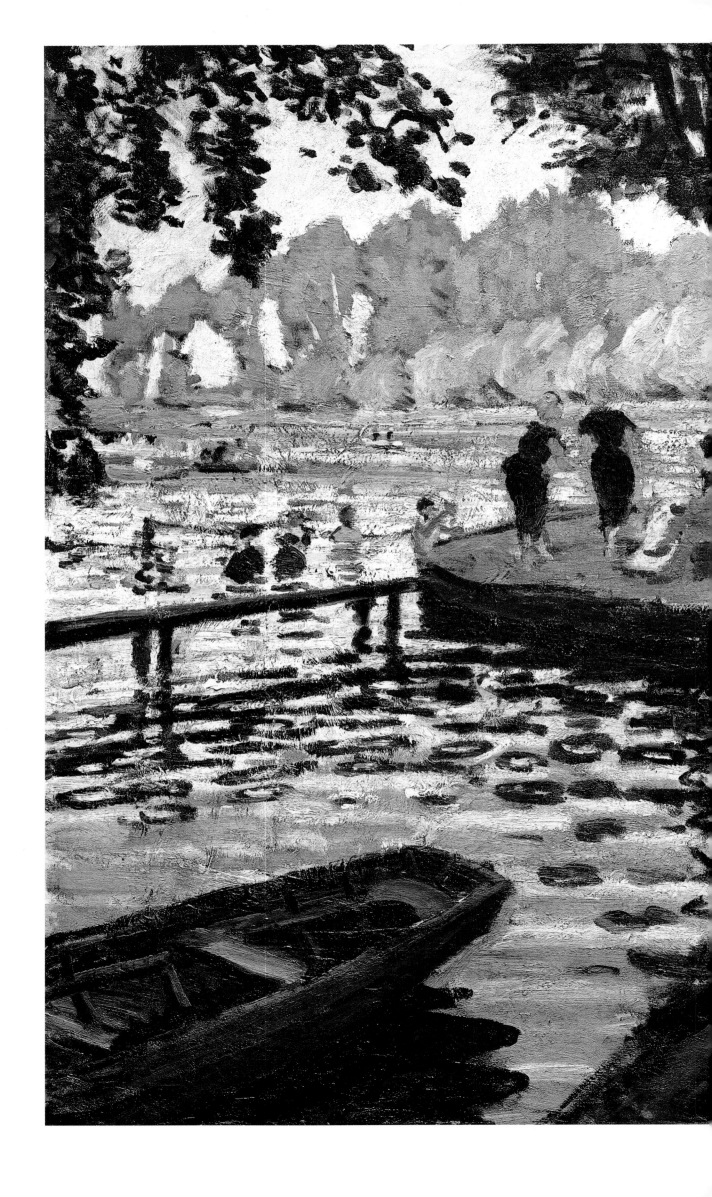

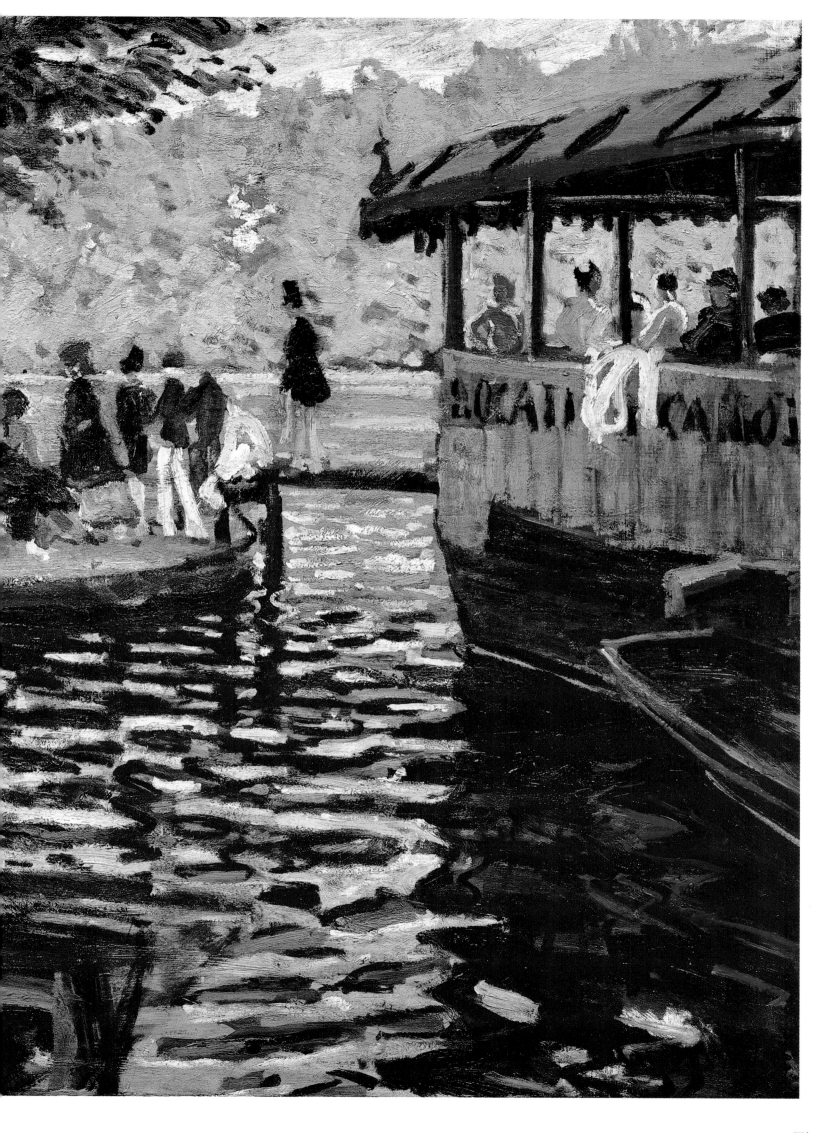

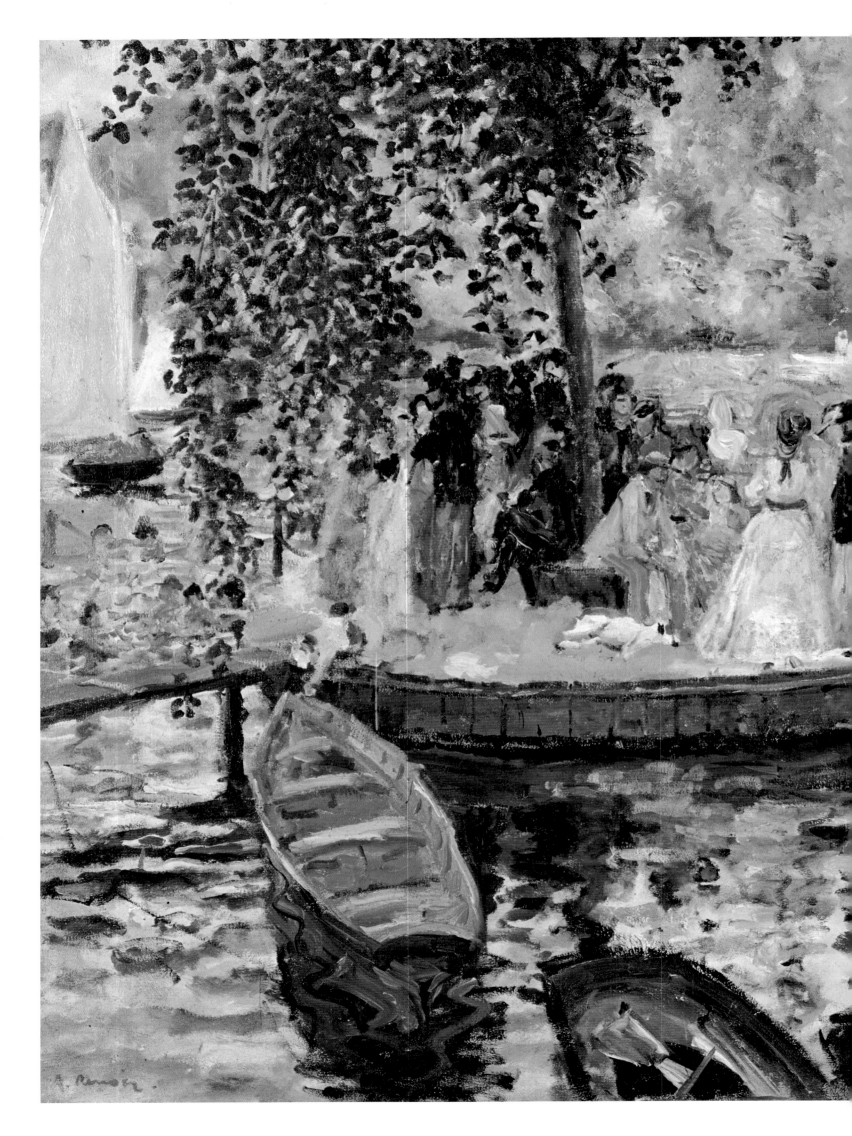

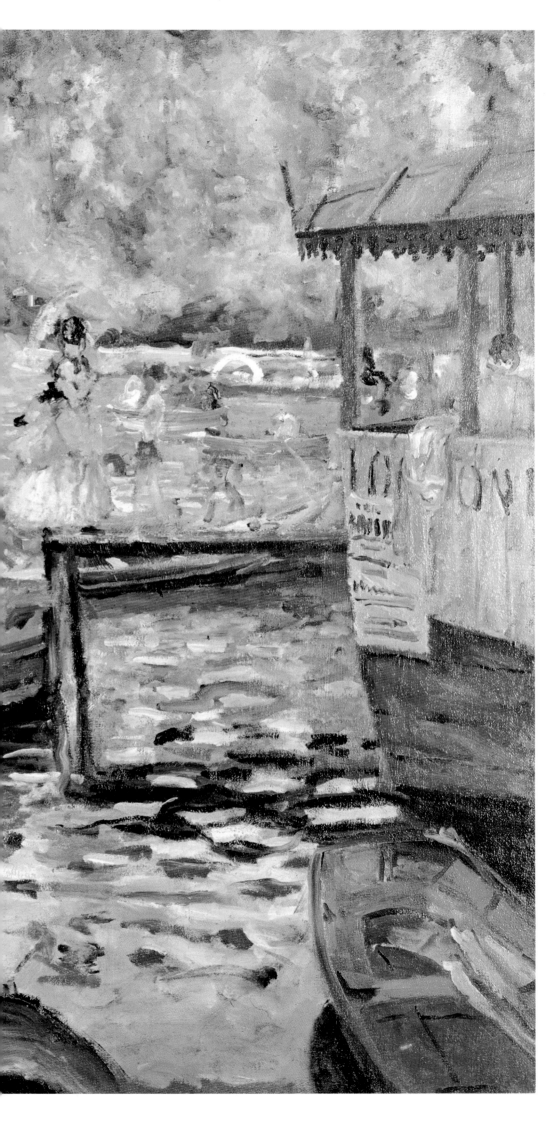

Monet's and Renoir's views of *La Grenouillère* are almost identical in size and vantage point, but far apart in feeling. The darker color of Monet's work (plate 124) is matched by an almost brutal application of paint; the brushstrokes call attention to the agitated surface of the water and make us aware of the various sections of the painting, rather than concentrating on the unified whole, as Renoir had done. What the painters of the Académie would have considered imperfect preparatory sketches became for Monet and Renoir ends in themselves, a necessary corollary to their objective of seizing the atmosphere of a given place instead of just its topography.

125.
Pierre-Auguste Renoir
La Grenouillère
1869

126.
Alfred Sisley
The Bridge at Villeneuve-la-Garenne
1872

127.
Claude Monet
The Bridge at Argenteuil
1874

*M*onet's Argenteuil paintings exhibit that revolutionary bright palette and summary brushstroke that provoked critical scorn and accusations of sloppiness at the first Impressionist exhibition. In The Bridge at Argenteuil, *the changing light of a highly mobile sky is translated into patches of pure color that confront the eye like pieces in a jigsaw puzzle. The structure of the painting is quite simple: the strong horizontal edge of the shore separates the water from the trees and sky, while the emphatic diagonal of the bridge encloses the sailboats and also serves as a dark color contrast to the light-saturated water and the complementary blue of the sky.*

*B*y 1872, Pissarro was mixing color directly on his canvas. The bright clear sky and simple, sturdy forms in this picture of an orchard emphasize the element of the commonplace that was so typical of his style. While other Impressionists were fascinated by the effects of light on water, Pissarro sought meaning in the humble farms and villages of the countryside surrounding Paris.

LEFT
128.
Camille Pissarro
Orchard in Bloom, Louveciennes
1872

ABOVE
129.
Alfred Sisley
Early Snow at Louveciennes
1874

130.
Camille Pissarro
Entrée des voisins
1872

131.
Camille Pissarro
Jallais Hill, Pontoise
1867

132.
Berthe Morisot
The Harbor at Lorient
1869

Morisot had exhibited in the Salons for nine years before she joined the Impressionists. Rich, well-born, and female, she was a favorite target for the vituperative criticism and personal ridicule that the group exhibitions engendered. Yet her elegant manner and reserved exterior concealed a resoluteness and dedication to the new painting that made her one of the group's staunchest supporters. The critic Paul Mantz singled out her special qualities: "Her painting has all the freshness of improvisation; it is truly the impression, registered by a sincere eye, and loyally rendered by a hand which does not cheat."

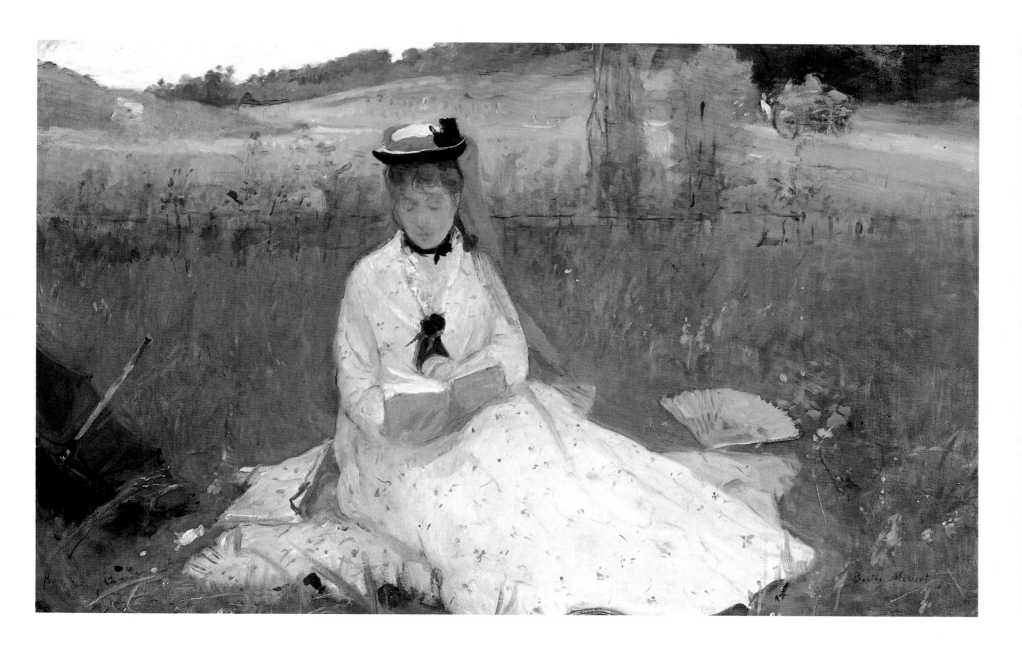

133.
Berthe Morisot
The Artist's Sister, Madame
Pontillon, Seated on Grass
1873

Carriage at the Races, *which focuses on the family of Degas's friend Paul Valpinçon, is rather eccentric both as a portrait and as a racetrack scene. The flat forms and limited color reflect Degas's sensitive response to Japanese woodcuts, whereas the unusual placement of the family within the carriage unit and against the larger context of the landscape suggests an ambitious amplification of his experiments with asymmetrical composition in earlier portraits.*

134.
Edgar Degas
Carriage at the Races
1869

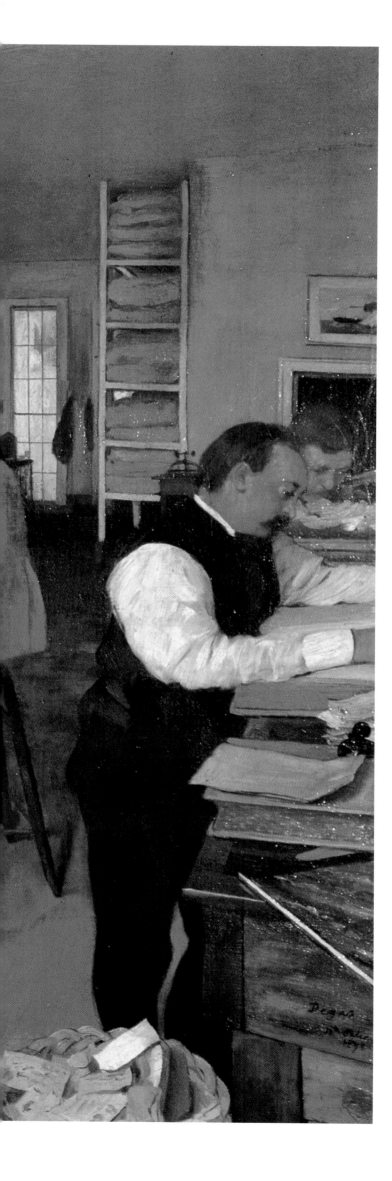

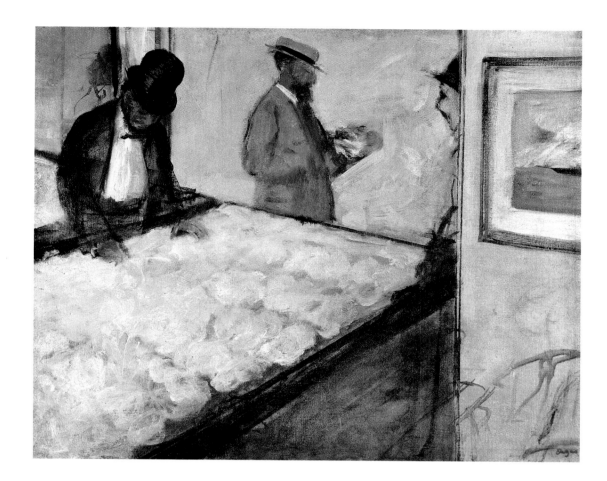

*D*egas spent four months visiting relatives in New Orleans. While he complained of the climate, the local obsession with cotton, and his inability to work in that atmosphere, he nevertheless produced an elaborate composition that is both a family portrait and a social document. The artist's uncle is seated in the foreground examining a piece of cotton, while his brothers are shown reading a newspaper and casually leaning against the windowsill. Degas found the subject sufficiently interesting to undertake another version of the theme "less complicated and more surprising . . . in which everyone is in summer dress, the walls white, and a sea of cotton on the tables." The small oil sketch above may have been a preparatory study for that second painting.

LEFT
135.
Edgar Degas
Portraits in an Office: The Cotton Exchange, New Orleans
1873

ABOVE
136.
Edgar Degas
Cotton Merchants
1873

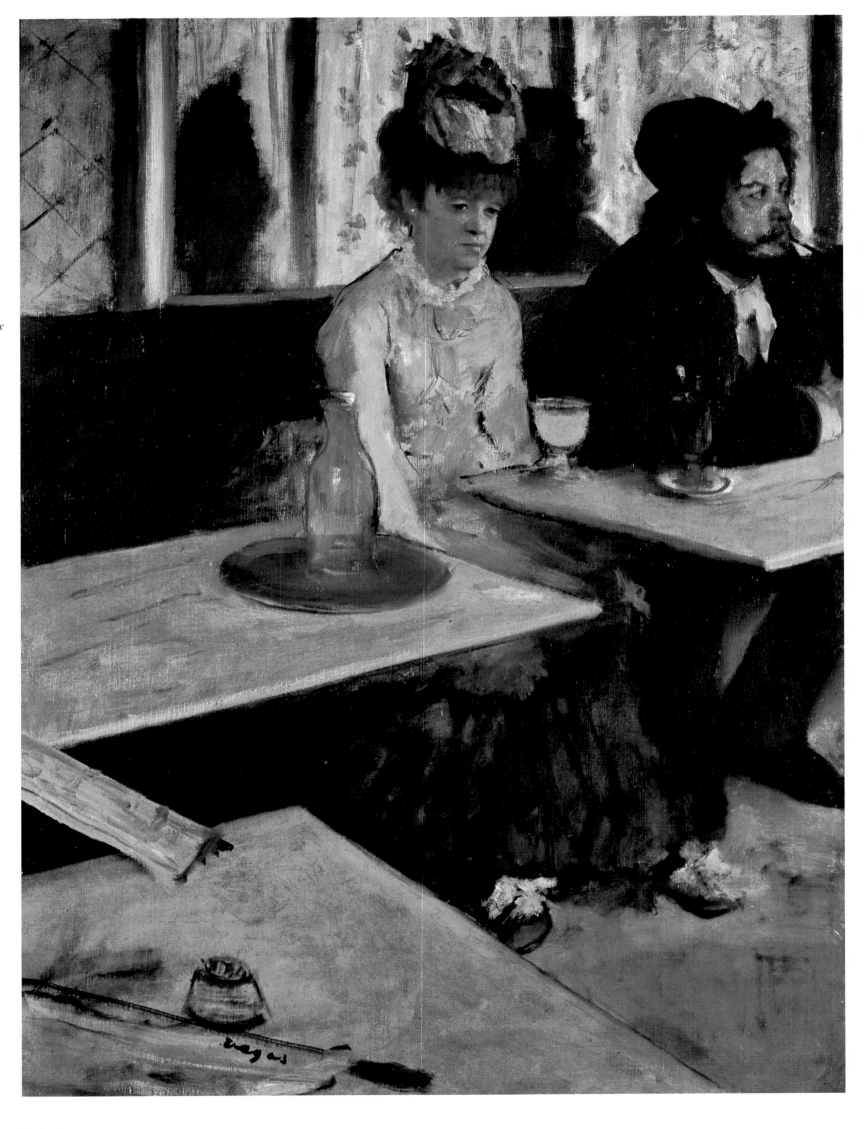

RIGHT
137.
Edgar Degas
L'Absinthe
1876

OPPOSITE
138.
Paul Cézanne
House of Père Lacroix
1873

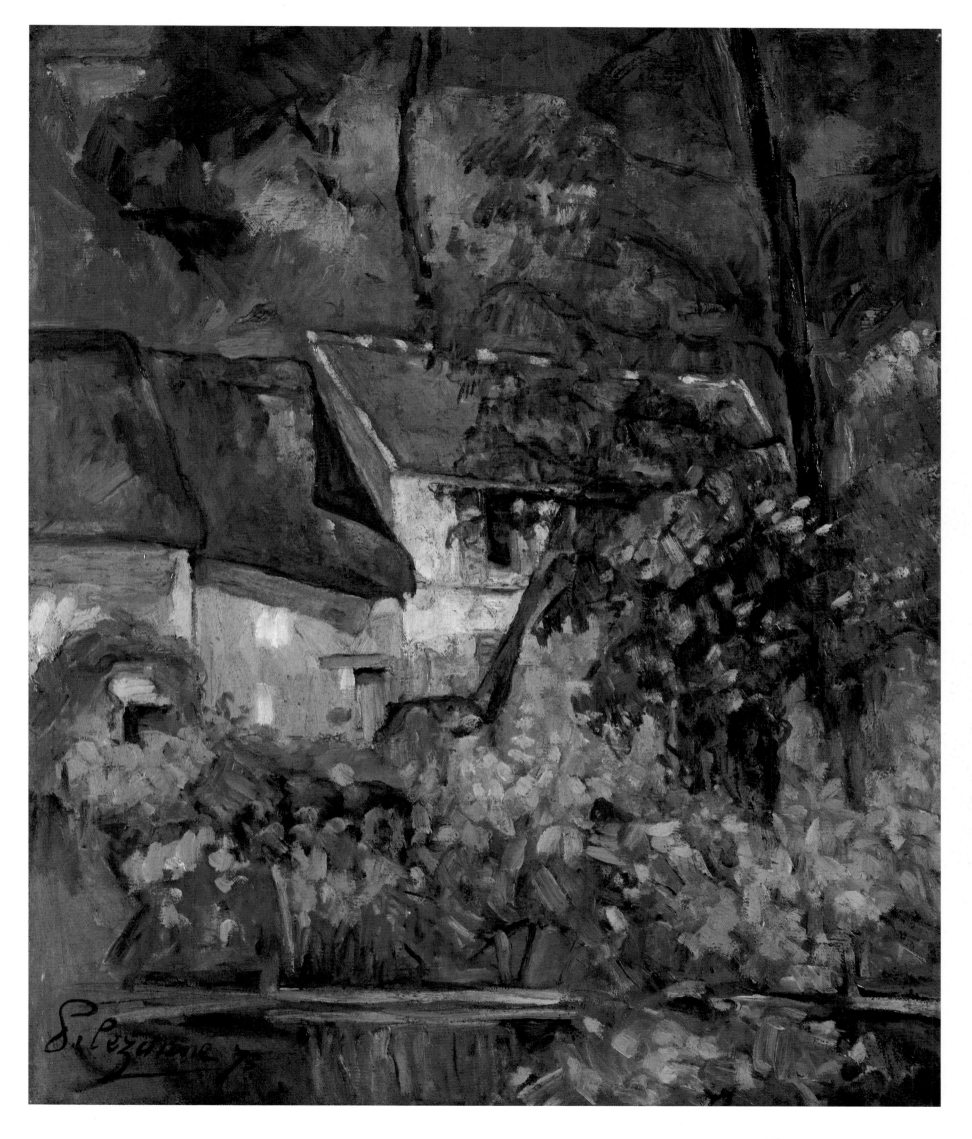

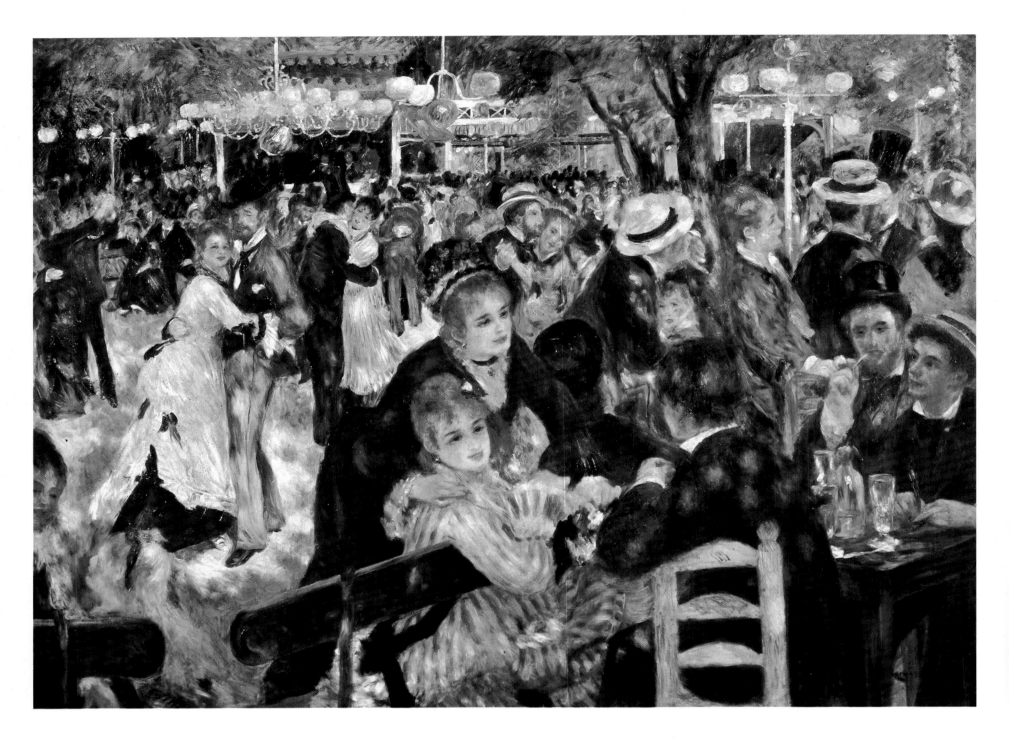

139.
Pierre-Auguste Renoir
Dancing at the Moulin de la Galette
1876

*N*oise, laughter, movement, sunshine, in an atmosphere of youth": such was Georges Rivière's characterization of this huge work when it was shown in the third Impressionist exhibition in 1877. The composition expands the ambition of Renoir's earlier studies of strong light filtering through a screen of leaves and falling on one or more figures. A close friend of the painter's and a staunch defender of the Impressionists, Rivière (seen seated at the table) maintained that the large canvas was painted entirely out of doors at the Montmartre dancing spot, which enjoyed the patronage of the working-class residents of the neighborhood and the painters who worked nearby.

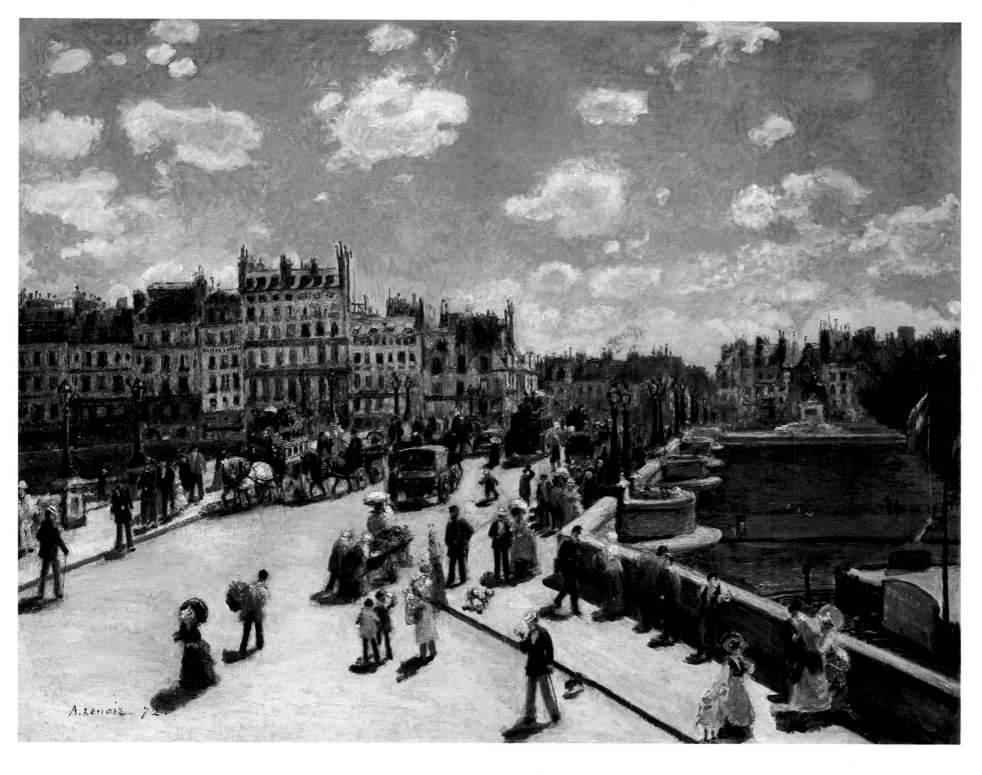

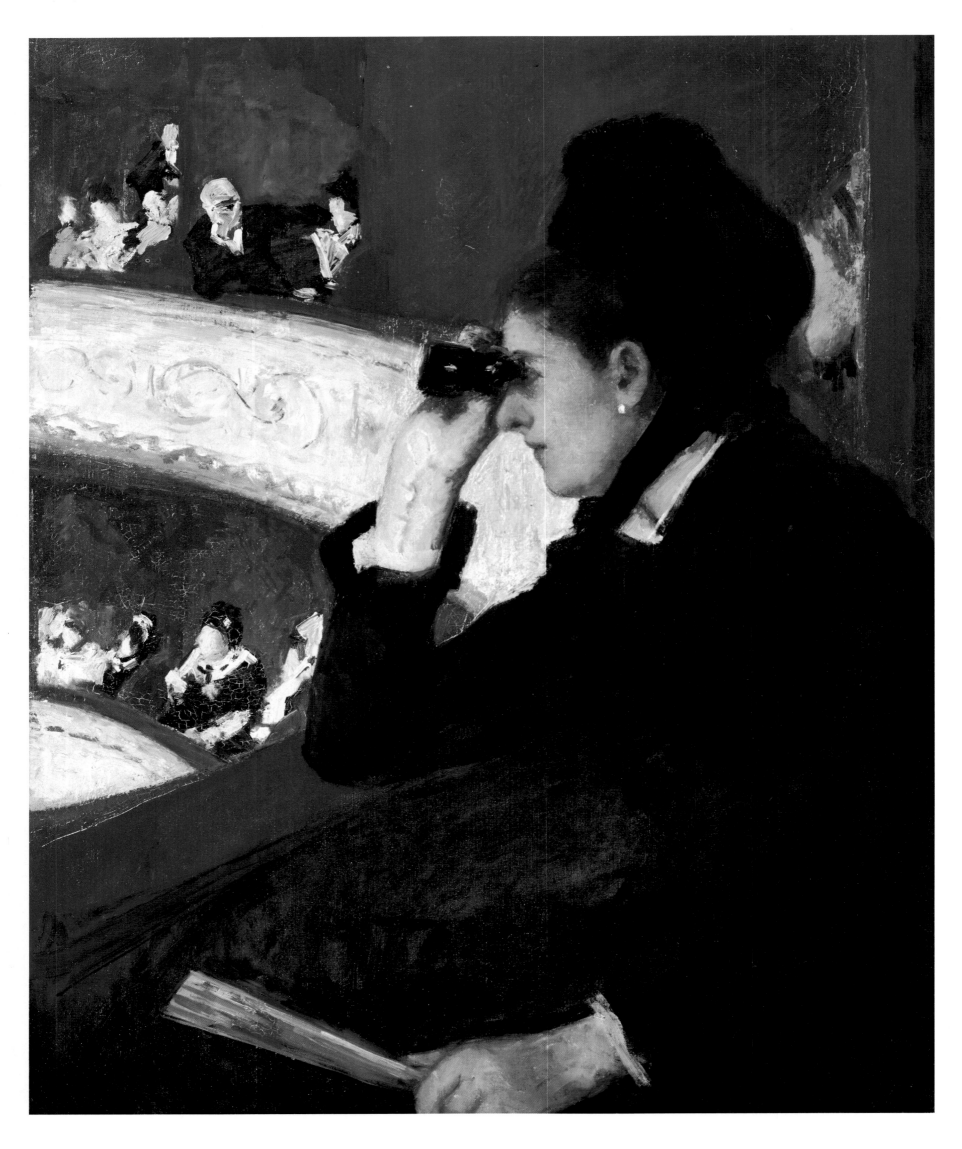

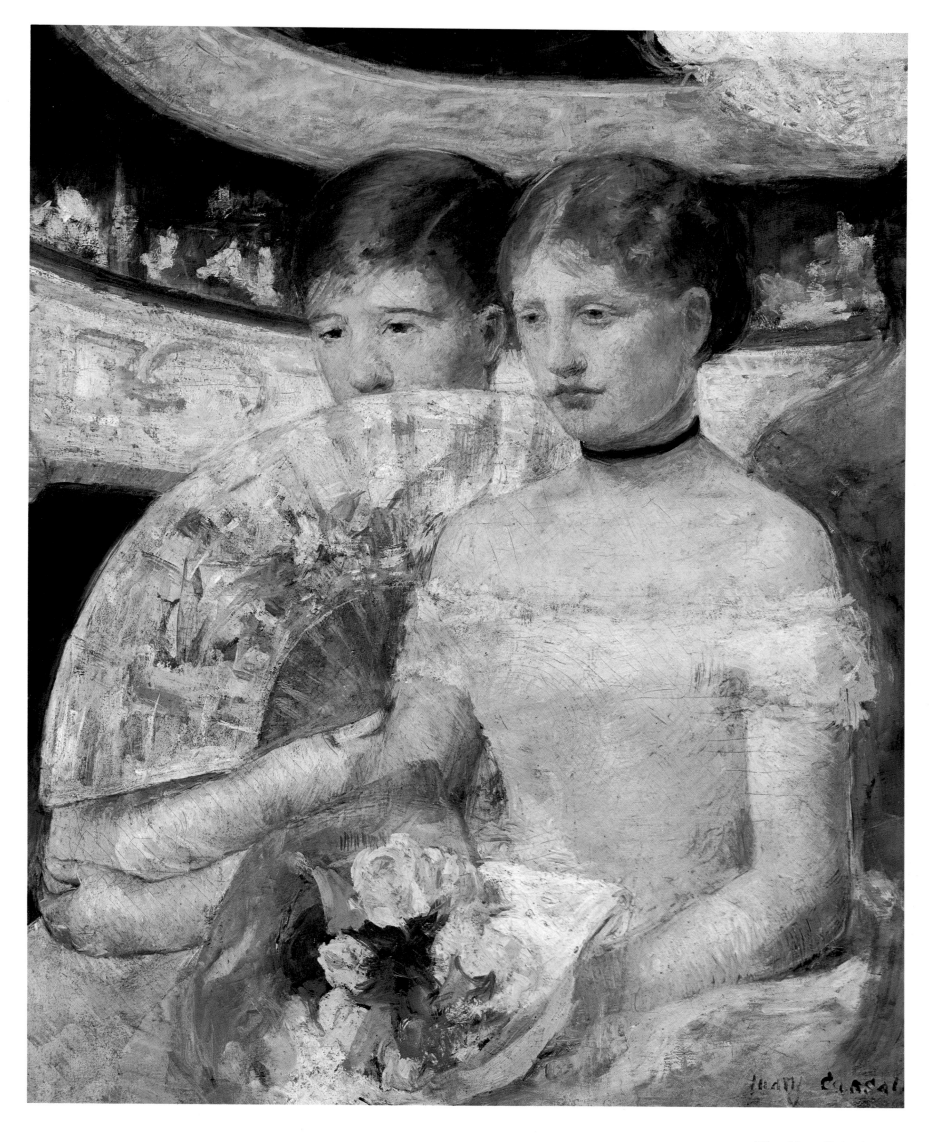

OPPOSITE
144.
Mary Cassatt
Lady at the Tea Table
1885

ABOVE
145.
Mary Cassatt
The Boating Party
1893–94

Cassatt repeatedly painted images of women—alone in their parlors or boudoirs, with companions or female relatives, and with their children. Yet she never married herself and died, nearly blind and alone, in a château in France far from her native Pennsylvania. While The Boating Party *can be seen as a typical plein-air Impressionist subject, it displays certain qualities that are unmistakably personal. Cassatt pays strict attention to the shapes of her figures and to the sweeping curve of the boat, partially echoed in the sail. The essential flatness of the canvas reflects the influence of Japanese prints. The inclusion of the chubby and slightly uncomfortable child introduces a sense of familiarity that is rather different from the chic or elegance of the French.*

Claude Monet:
Impressionist par Excellence

If the word "Impressionist" was . . . definitely accepted to designate a group of painters, it is certainly the particular qualities of Claude Monet's painting that first suggested it. Monet is the Impressionist par excellence. . . . Monet has succeeded in setting down the fleeting impressions which his predecessors had neglected or considered impossible to render with the brush.

THÉODORE DURET

By the time he was sixteen years old, Claude Monet was quite a celebrity in his hometown of Le Havre, where his irreverent and amusing caricatures of its citizens caught the eye of the local landscape painter Eugène Boudin. This artist, the son of a sea captain, had already begun to explore the ports and beaches dotting the Channel coast, earning himself a reputation as a specialist in the painting of clouds and other atmospheric effects. Boudin can be considered Monet's first mentor; it was he who encouraged the young man's interest in plein-air painting and persuaded him, against the strenuous objections of his family, to visit Paris. Monet remained in the city for about a year, frequenting the Académie Suisse, before his stay was curtailed when he was drafted into the army in 1861. An illness contracted in Algeria brought him home to Le Havre the following year and persuaded his father to buy him out of the service. During his recuperation, Monet won his father's grudging permission to return to Paris, but only on the condition that he enter the studio of an established painter.

In the fall of 1862 Monet became a pupil of Gleyre, who was also the teacher of the future Impressionists Bazille, Renoir, and Sisley. Yet it was not Gleyre who inspired him, but rather Jongkind, whom Monet had met during the summer in Le Havre. Later, he claimed that Jongkind opened his eyes to marine painting, and it was two seascapes—painted only a year or so after his meeting with Jongkind—that brought Monet his first critical attention in 1865, when they were accepted by the Salon.

Monet's family had a house on the beach at Sainte-Adresse, not far from Le Havre, and from here the young artist set out to discover new motifs along the coast. In a letter to his friend Bazille he expressed enthusiasm for the new work and impatience with the limited realization of his objectives:

Every day I discover more and more beautiful things; it's enough to drive one mad; I have such a desire to do everything, my head is bursting with it! . . . I am fairly well satisfied with my stay here although my sketches are far from what I should like; it is indeed frightfully difficult to make a thing complete in all aspects. . . . Well, my good friend, I intend to struggle, scrape off, begin again, because one can produce what one sees and what one understands . . . It is on the strength of observation and reflection that one finds it.[1]

Monet produced a number of studies as the basis for the two paintings he submitted to the Salon of 1865. One of the finished works, *The Estuary of the Seine at Honfleur*, was reproduced in the souvenir album of the Salon and was admired as "the most original and most supple seascape, the most solid and harmonious painting exhibited in a long time."[2] Paul Mantz, an influential critic of the day, also praised the young artist for "the taste of his harmonious colorations" and cited his talent as a marine painter, an appraisal that others echoed.

Monet and the Monumental Landscape

Before the opening of the Salon, Monet had gone to stay in the village of Chailly near the forest of Fontainebleau. There he conceived the idea for the most ambitious and most ill-fated of his early works, a canvas twenty feet (six meters) long whose title, *Déjeuner sur l'herbe (Luncheon on the Grass)* (plate 149), suggests a critique of or reply to Manet's infamous painting of two years earlier. Monet was probably bolstered in this enterprise by his

OPPOSITE
Detail of plate 165

RIGHT

146.

Eugène Boudin

The Beach at Trouville

1864

BELOW

147.

Johan Barthold Jongkind

Entrance to the Port of Honfleur

1864

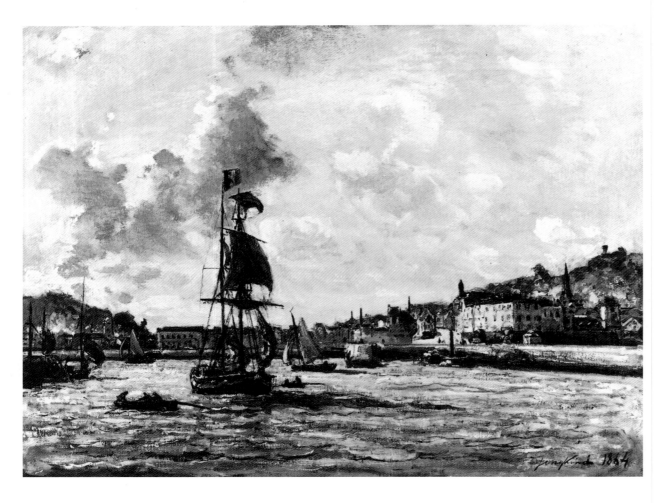

BELOW

148.

Claude Monet

Caricature of Rufus Croutinelli

1856–58

The painter Jongkind had a deep influence on several Impressionists. Although his palette and direct brushwork were in accord with the new painting, this scene is rather traditional. Reminiscent of classical marine painting, it points to Jongkind's Dutch heritage.

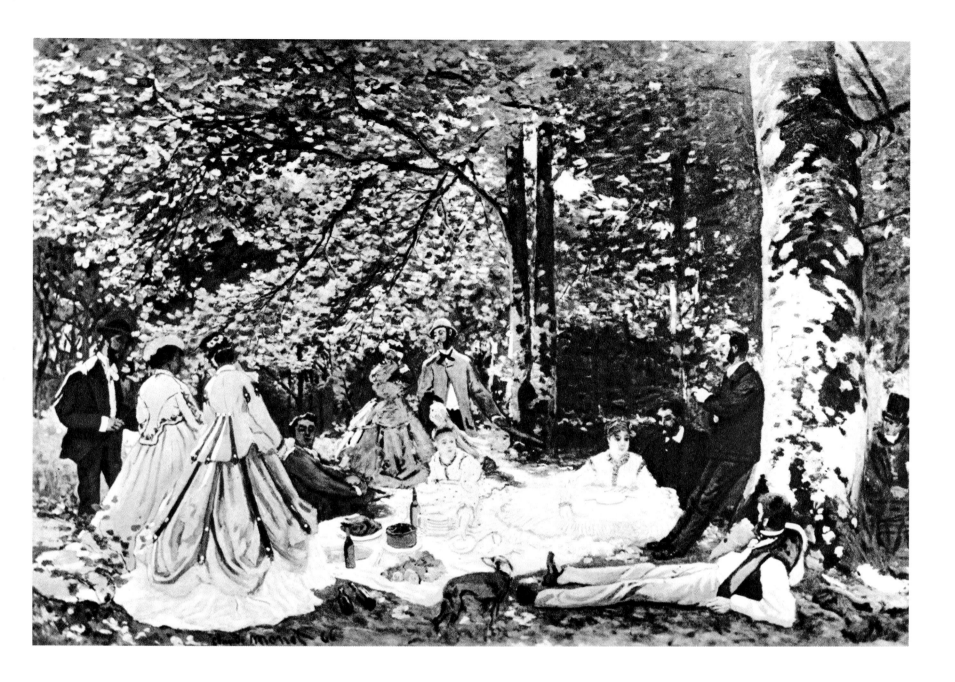

critical success in the Salon. He was surely challenged, as Manet had been, by the historical tradition of placing figures within a landscape, but his choice of a straightforward picnic scene, rather than an ambiguous mélange of the contemporary with allegory or mythology, rejects Manet's modus operandi in favor of the unexceptional and the familiar. Linda Nochlin has described Monet's *Déjeuner* as "a paradigm of presentness, of immediate experience, executed on the vast scale usually associated with . . . Salon painting";[3] certainly its provocative monumentality rendered it especially vulnerable to critical comparison.

Letters and reminiscences provide an insight into the development of the painting, which has survived only in a fragmented state. It is clear from these fragments and from surviving preparatory sketches such as *Bazille and Camille* (plate 164) that the informal composition, bright color, and more vigorous brushwork emphatically distinguish it from the darker palette and more eclectic poses of Manet's *Déjeuner* (plate 75). Although he worked on drawings and oil sketches directly from nature, Monet subsequently integrated the various motifs into a finished composition in his studio. Recruiting Camille Doncieux and Bazille as his models, he placed them in varying poses that are as persuasively casual as any in the repertoire of Impressionism. While Monet's study of light was still in

its earliest stages, the vitality of its interaction with the various forms already hints at the radical new direction his art would take later in the decade.

Monet returned to Paris in the fall and presumably continued to work on the large canvas, as he planned to offer it to the Salon of 1866. Yet dissatisfaction with the painting prompted him to abandon it, only to salvage later a few fragments of the deteriorating canvas. Critics receptive to new ideas—such as Castagnary and Zola—responded to the naturalism of Monet's vision, which the former described as "idéaliste et réaliste." Even those who were not particularly enthusiastic about his landscapes were struck by the originality of the life-size portrait of Camille (plate 153) that he submitted to the Salon of 1867, with its boldly executed dress and simplicity of design.

Despite his setback with *Déjeuner sur l'herbe*, Monet did not abandon the hope of creating monumental landscapes with figures in contemporary situations. Whereas he had previously worked with small sketches and studies made from nature and amplified in the studio, he now resolved to execute a large-scale painting entirely out of doors. Indeed, the scale of *Women in the Garden* (plate 165)—more than eight feet (two and a half meters) in height—forced him to dig a trench in order to accommodate it. Camille, his future wife, was again the model, posing succes-

149.
Claude Monet
Déjeuner sur l'herbe
(Luncheon on the Grass)
1866

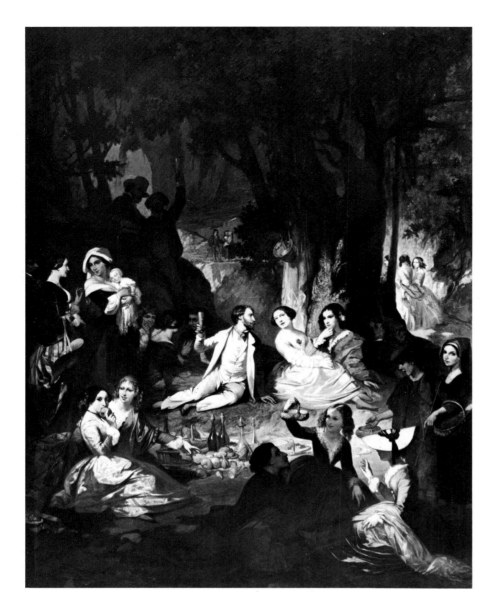

150.
Auguste-Barthélémy Glaize
Picnic
c. 1850

there is no trace of intimacy or emotional connection to the theme. An emphasis on the purely formal qualities of the motif, which Monet himself likened to Oriental art, prefigures his developing concern with the hows of seeing and painting rather than the whats, though the choice of family-related themes parallels the contemporaneous work of his friend and colleague Bazille.

Despite an enormously active painting campaign on the coast and the award of a silver medal at the International Maritime Exhibition in Le Havre, Monet was dogged by financial problems that would persist for another fifteen years. His submissions to the Salon of 1869 were turned down, and he was forced to approach his friends for aid. Bazille supplied him with paint, and Renoir, who was only slightly better off himself, shared his bread with Monet on frequent visits to Bougival, the Parisian suburb where Monet lived. A nearby restaurant and boating spot on the Seine called La Grenouillère provided both Renoir and Monet with inspiration for a series of pictures that served as working precedents for the later river studies executed at Argenteuil.

Rejection by successive Salon juries in 1869 and 1870 may have convinced Monet that it was useless to seek recognition within the framework of the art establishment. In any event, he did not attempt to exhibit again at the Salon until 1880, and did so then only out of financial desperation. Instead, he turned to private dealers, exhibiting works here and there, and turned over in his mind the idea of finding a serious alternative to the official exhibition. As Kermit Champa has observed, "Once the Salon jury had forced (or left) Monet to go it alone, the breach between academic and avant-garde painting in France was complete. The avant-garde proceeded to develop along lines which it defined for itself."[5]

In July of 1870, just after their marriage, Monet and Camille were vacationing with their infant son Jean at Trouville when France suddenly declared war on Prussia. To avoid conscription Monet escaped by boat to England where he remained—separated from his family—for several months. Monet was particularly attracted to the large public parks of London. He painted a couple of curious, wide-angle views that relinquish traditional perspective and focus in favor of more random and surface qualities, so as to convey a sense of restless searching or scanning of a broad expanse. When he wasn't busy working on these park views or painting the Thames, Monet visited museums. Later, Pissarro, who also spent the war period in London, would claim that while he and Monet had been impressed by the paintings and watercolors of Turner and Constable, they especially admired the work of such near contemporaries as George Frederic Watts or Dante Gabriel Rossetti, "who shared more in our aim with regard to plein-air, light and fugitive effects."[6] Monet even went so far as to decry "the exuberant romanticism of his [Turner's] fancy."[7] and, indeed, the dullish tones of his London

sively for each of the four female figures. Their somewhat frozen character was influenced by contemporary fashion illustrations, whose decorative properties coincided with Monet's impulse toward compression of pictorial space and simplification of design. Predictably, the radical flattening of form and generally loose execution of the painting were deemed unacceptable by the Salon jury in 1867. Among the critics, only Zola admired the audacity of its author: "To dare to do something like that—to cut in two the material of the dresses with light and shade and to rightly place these women in a carefully kept flower garden— one must have a particular fondness for one's period."[4]

The difficulties he experienced in painting *Déjeuner sur l'herbe* and *Women in the Garden* may have convinced Monet that working out of doors on a large scale was impractical. Thereafter, he confined his monumental compositions to themes that could be executed in the studio and began to produce numerous smaller plein-air studies such as the view of his family's *Terrace at Sainte-Adresse* (plate 166), a work that signals the maturing of his artistic vision and a major advance toward the conquest of light and atmosphere that was to become the common objective of Impressionism in the 1870s. Although the small figures depicted were relatives (Monet's father is seen in the chair to the right, and the seated woman with the parasol may be the artist's aunt),

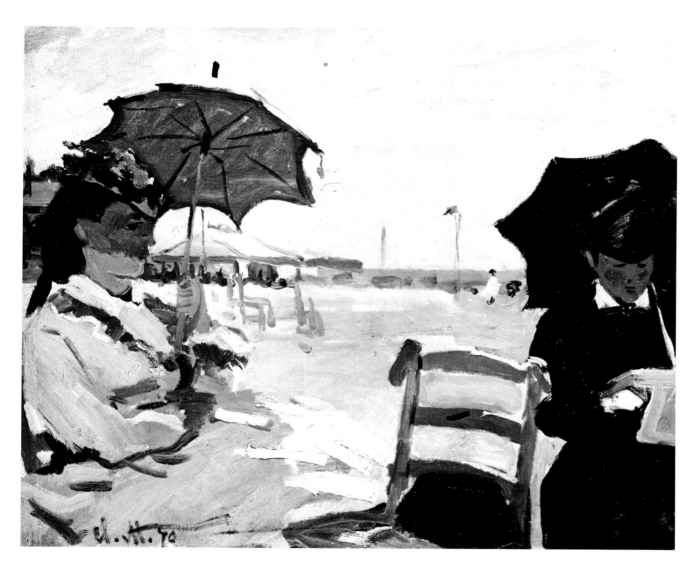

In the summer of 1870 Monet resumed painting with his old friend and onetime mentor, Eugène Boudin, along the Channel coast. The unusual close-up view and terse paint handling of The Beach at Trouville *convey an extraordinary sense of immediacy and suggest that Monet, along with Manet and Degas, was experimenting with a new type of composition that they probably discussed together. The contrast of the young woman in white at the left (possibly Camille, the painter's recently legitimized wife) and the enigmatic figure in black at the right, and the odd placement of the empty chair, invite speculation about the relationship between the otherwise unconnected figures.*

151.
Claude Monet
The Beach at Trouville
1870

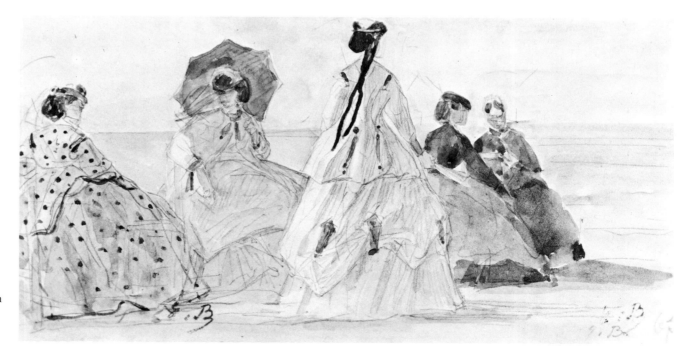

152.
Eugène Boudin
Beach Scene
1865

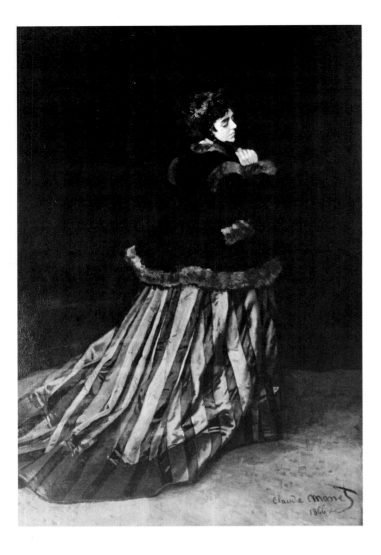

This life-size painting of Monet's future wife was exhibited at the Salon of 1866. Camille is hardly posed as for a traditional portrait; rather, she appears to be walking away, trailing her striped skirt and tying or adjusting the ribbon of her hat as she goes. Emile Zola was among the admirers of this modern depiction of a modern woman, and Monet also drew praise from many quarters on the virtuoso rendering of the silk fabric.

Contentment best describes the mood of Monet's languid scene. In a beautiful, light-filled garden, his young son Jean plays on the ground, next to the table at which the family has recently finished lunch. The mother, Camille, strolls with a companion in the background. Even the hat suspended from a branch evokes a sense of ease and relaxation.

ABOVE

153.
Claude Monet
Camille: Woman in a Green Dress
1866

RIGHT

154.
Claude Monet
The Luncheon
1872

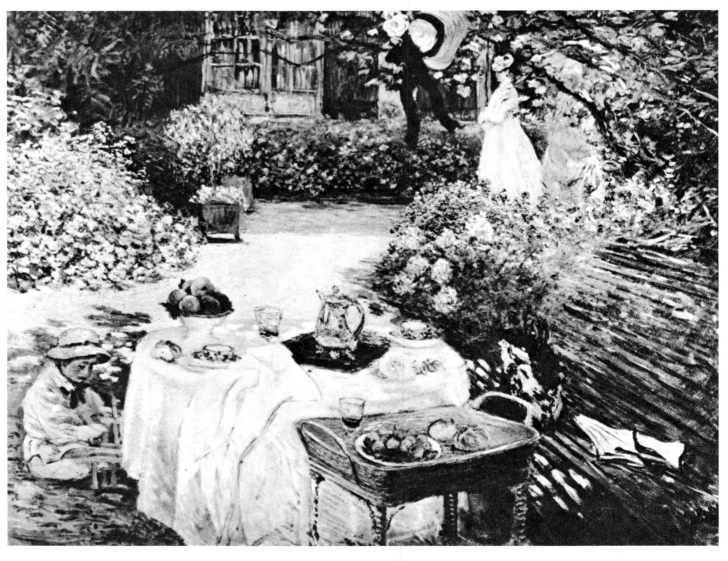

pictures seem to reject the sensuous color and gestural theatricality of Turner's sea themes. Rather, it was the mystery of fog and the quiescence of the river that remained in Monet's mind, compelling him to return again to the city between 1899 and 1904, long after his numerous studies of the Seine and the initiation of the Giverny water garden had turned his concern with water into a nearly single-minded obsession.

The terrible war, which culminated in a humiliating surrender to the Prussians and engendered a civil conflict in Paris, was to take its toll in France for years. In the climate of social and economic uncertainty that followed, patronage of art was hardly a priority. Thus, the friendship of Paul Durand-Ruel, a dealer specializing in landscape painting who had aided Monet and Pissarro in London, was especially important when the artists returned home in 1871. Reminiscing later about their association, which proved to be a lasting one, Durand-Ruel characterized Monet as "a solid and durable man, who, it seemed to me, would paint tirelessly for more years than I had given myself to live." His estimate proved accurate, as the painter outlived him by four years.

Toward the end of 1871 Monet and his family found a small house with a garden at Argenteuil, a riverside suburb of Paris, where they remained until 1876. These years, certainly among the most momentous for the history of French painting, were full of hardship and struggle for Monet, but they were also enormously productive. Argenteuil became the Barbizon of the 1870s as artists were drawn there by Monet's example. Sisley visited in 1872; Renoir again worked side by side with his friend in 1873 and 1874; and even Manet, confirmed urbanite that he was, ventured out and documented Monet's working methods in a view of the painter's specially outfitted floating studio (plate 102).

It was from this odd-looking vessel, which allowed him to work in direct proximity to his motifs, that Monet painted those numerous small works that have shaped the public's image of the exuberant, pleasure-filled world of the Impressionists. From these river excursions, a new persona emerged in the paintings of Monet and his colleagues: smaller scale, brighter color, and more summary brushstroke. The majority of critics were oblivious or hostile to this change; but a few, such as the Symbolist poet Jules Laforgue, recognized that a genuine visual revolution was taking place: "Where the academic painter sees only white light . . . the Impressionist sees it bathing everything not with a dead whiteness, but with a thousand vibrant clashings, with rich prismatic decompositions. Where the academic sees only the outline binding the modeling, he [the Impressionist] sees the real, living lines, not taking geometric form but built up with a thousand irregular touches which, from a distance, convey life."[8]

While river views claimed much of Monet's energy in the Argenteuil years, he also found time to explore the town, especially the area around his home. Friends and family continued

to be models for his untiring investigations of light. Despite the financial hardship endured by the small family, these works reflect, as had *The Luncheon* (plate 154), a sense of domestic well-being, not so much described as implied. However, in *Field of Poppies* (plate 175), for which his wife and small son posed, the family relationship seems of little importance. Employing the same brushstroke for figures and landscape, Monet eschews charming particulars in favor of a lively and spontaneous immediacy. The seemingly random splashes of bright red paint jump to the surface of the canvas, establishing their independence from the intense yellow-green of the sun-saturated field. Gustave Geffroy, Monet's friend and biographer, described the peculiarly equalizing intensity of his "transparent atmosphere . . . [in which] everything is illuminated and quivers under the waves of light propagated in space."

In *Woman with a Parasol: Madame Monet and Her Son* (plate 174), the figures of Camille and Jean are inseparable from the physical atmosphere that envelops them. This surprising view from below conveys through a range of brushstrokes both the quick turning movement of the woman and the agitation of the wind that whips through the grass and catches her skirts and veil. The quick and free execution, which evolved from the artist's desire to capture time and light, was perceived as sloppiness by critics unresponsive to his innovations.

The paintings Monet produced at Argenteuil documented important changes in his attitude to color. Previously moderate tones gave way to more intense, vibrant hues that tended to diminish awareness of form and composition. As time went on, Monet further liberated color and brushstroke from their traditional function as he sought to transcribe physical facts into their purely pictorial components. His views of Paris streets and parks, executed between 1876 and 1878, place increasing emphasis on the physical properties of paint itself. In *La Rue Saint-Denis, fête du 30 juin 1878* (plate 180), for example, as the artist moves consciously from a descriptive approach to an almost abstract one, the pulsating color of the dazzling flags is matched by an almost frenzied brushstroke, conveying an excitement equivalent to the mood of the holiday that inspired it.

In the fall of 1876, Monet moved back into Paris and with money provided by Caillebotte set up a studio near the Gare Saint-Lazare. This huge structure of glass and steel, its vast network of tracks, and the constant movement of trains and passengers offered a fascinating panorama of modern life and an aesthetic challenge that Monet found irresistible. He applied for and received permission to work in and around the station, and ultimately showed seven of the many views he painted (plates 177, 178, and 179) in the Impressionist exhibition of 1877. Although Monet's Saint-Lazare canvases mark a significant development in his working method, namely, the tendency to create multiple views of the same motif (anticipating such later series paintings as the Grain Stacks, Poplars, and Venice groups),

155.
Claude Monet
*Camille Monet on
Her Deathbed*
1879

a spectacle in a perpetual state of flux. Commenting on Monet's attachment to the theme, John Rewald maintained: "He found in the railroad station a pretext rather than an end in itself; he discovered and probed the pictorial aspects of machinery but did not comment upon its ugliness or usefulness or beauty, nor upon its relationship to man."[9]

Strained Relations with the Impressionist Group

When Monet left Paris to move to Vétheuil, a village along the Seine some fifty miles west of Paris, his personal problems were worse than ever. Although he claimed that the move was prompted by a search for new landscape motifs, the more immediate reason was that the failure of the group exhibitions to generate any significant sales had exacerbated his precarious financial condition, and life was somewhat cheaper in the country. He wrote a pitiful letter to a patron, complaining: "I am no longer a beginner, and it is sad to be in such a situation at my age, always obliged to beg, to solicit buyers."[10] To make matters worse, the health of his wife, always fragile, declined dramatically after the birth of a second son, and she required constant care that he could ill afford. Camille's death in 1879 was a terrible blow, and in his mood of bleak demoralization Monet resolved not to show with his friends, who were preparing another exhibition. Instead, he submitted two paintings to the Salon of 1880, suffering a humiliating disappointment when only one of these, a fairly large view of the Seine at Lavacourt was accepted and then hung so high that it was barely visible.

Monet had little luck with the critics who reviewed the Salon. Zola, in a double-edged compliment, called him "an incomparable landscapist" and lauded "the clarity and truth of his superb tones" while indicting his "facility" and urging him to devote himself to "important canvases."[11] As an exponent of the Naturalist approach in writing, Zola was committed to careful and often lengthy observation; Monet's vaunted spontaneity must have struck him as superficial indeed. Other critics voiced their familiar reservations about the lack of finish and decried the new attempts to create tones through the juxtaposition of pure colors.

Monet may have been provoked by these critical attacks into offering a more cohesive statement of his artistic position in the form of a one-man exhibition. In 1880 he mounted a show of eighteen paintings at the offices of *La Vie moderne*, a weekly magazine devoted to contemporary art, literature, and social issues. For the occasion, Théodore Duret, one of his few staunch defenders, prepared a catalog essay in which he cited Monet's pioneering plein-air techniques as the most original contributions to French landscape painting since the emergence of Corot.

the idea of doing a railroad theme was hardly without precedent. Three years earlier Manet, who also had a studio in the area, had painted *Gare Saint-Lazare (Le Chemin de Fer)* (plate 90), a new type of modern portrait that incorporated a section of the steam-filled trainyard as a backdrop for the figures of a middle-class woman and child. Earlier in 1876 Caillebotte had done several oils of the Pont de l'Europe, the enormous steel structure that spanned the tracks; indeed, visitors to the Impressionist show of the following year could compare Monet's and Caillebotte's treatments of a distinctively modern subject.

Long before the Impressionists, the imagery of the railroad had inspired both Joseph Mallord William Turner and Honoré Daumier, who saw it, respectively, as a symbol of the technological age and a microcosm of society. But Monet's attraction to the theme did not stem from a developed social consciousness or a related desire to polemicize about the quality of urban life. While he may have been drawn to the inherent impersonality of the railroad station, Monet was primarily intrigued by the wide variety of material or physical conditions he found in the building. Its large, sloping roof imposed a curtainlike grid against which the steam and the constantly moving engines formed an evanescent counterpoint. Even less material than the water he had painted at Argenteuil, the smoky air of the station challenged Monet's ability to capture the essence of

156.
Claude Monet
The Manneporte, Etretat (I)
1883

At the time of the exhibition, much was made of Monet's defection from the ranks of the Impressionists, and the painter protested in an interview that appeared in *La Vie moderne*: "I am still and I always intend to be an Impressionist . . . but I see only very rarely the men and women who are my colleagues. The little clique has become a great club which opens its doors to the first-come dauber."[12] While the remark hardly improved his strained relations with his friends, Monet did return to exhibit with them one final time in 1882. His fortunes changed the following year when he entered into a regular arrangement with Durand-Ruel, who subsequently introduced his works to collectors in the United States.

The Search for New Themes

In the early 1880s in Vétheuil and later at nearby Giverny, where Monet would live for the rest of his life, he found many new visual paths. Painting numerous views of the river under a wide range of atmospheric conditions—hazy morning sun, the frosty chill of winter—he continued to explore a familiar theme while searching for new ones. Indeed, a certain impatience with his work in 1883 seems to have prompted the first of many trips

(in this case to the Côte d'Azur) in search of new subjects to paint. More and more, Monet's physical separation from the now dispersed members of the group was matched by a psychological distance. Occasionally, the old friends would meet at prearranged dinners in Paris, but the magical sense of community that had marked their artistic endeavors in the early years was gone.

Monet began to paint regularly again along the Channel coast, where the writer Guy de Maupassant recalled seeing him:

> He was no longer a painter, in truth, but a hunter. He proceeded, followed by children who carried his canvases, five or six canvases representing the same subject at different times of day and with different effects. He took them up and put them aside in turn, according to the changes in the sky. Before his subject, the painter lay in wait for the sun and shadows, capturing in a few brushstrokes the ray that fell or the cloud that passed. . . . I have seen him thus seize a glittering shower of light on the white cliff and fix it in a flood of yellow tones, which, strangely, rendered the surprising and fugitive effect of that unseizable and dazzling brilliance. On another occasion he took a downpour beating on the sea in his hands and dashed it on the canvas—and indeed it was the rain that he had thus painted.[13]

The Serial Paintings

The move to Giverny, even further from Paris than Vétheuil, reflected Monet's determination to remove himself from the controversies and crises of a movement that seemed to have lost its direction and its esprit de corps. Renoir and Pissarro, his former colleagues, had already begun themselves to question the very foundations of the Impressionist vision, echoing—either consciously or unconsciously—the very same objections to its superficiality or lack of finish that had been voiced repeatedly by critics during the 1870s. Each was to turn from the freedom and spontaneity of Impressionism to a more structured or programmatic way of painting, while Monet, instead of renouncing his earlier work, drew on his enormous experience as a plein-air painter to expand the varieties of expression inherent in a single motif.

By 1886, the year of the last Impressionist group show, Monet was beginning to reap the financial benefits of his association with Durand-Ruel, who included fifty of his paintings in a New York exhibition along with those of Pissarro, Renoir, Degas, and Sisley. He was able to purchase his house at Giverny and live there in domestic comfort with Alice Hoschedé, whom he married in 1892 following the death of her estranged husband. Released at last from the enormous financial cares that had shadowed his career, he was able to focus his energies on his painting, and in the decade that followed, he concentrated on the development of specific themes in series. The practice had really been initiated as early as the 1860s, when he had begun to do several paintings based on the same motif, and was carried through in the seventies and eighties with the Gare Saint-Lazare paintings and some of the Channel views, which were done at least five or six times. Monet's exhibition of the Saint-Lazare paintings at the group show in 1877 may have anticipated his later showing of series based on grain stacks, trees, and Rouen Cathedral, but there was a significant difference. Whereas the earlier works explored the varieties within a single theme, the new series works sought a fundamental unity. By 1890, the year he embarked on the Grain Stacks (plates 184, 185, and 186), Monet had moved away from the objectives of uniqueness and spontaneity that had been the raison d'être for earlier paintings, deciding that the justification of the individual works in the new series lay in their cumulative effect. When a group of fifteen Grain Stacks paintings was exhibited in 1891, he remarked that they only acquired "their value by the comparison and the succession of the entire series."[15]

Monet maintained that he originally had intended to do only two canvases of grain stacks, one in gray weather and one in sunshine, but had discovered that the immense variety of the light inspired him to do more. He wrote, "The further I go, the more I see how hard I must work to render what I am trying for, that "instantaneity," above all the outer surface, the same light

157.
Claude Monet
Beach at Sainte-Adresse
1867

In these works and in others made later, when he returned to work again at Bordighera and Antibes, Monet was pushing the limits of his evolving technique in an effort to demonstrate that no aspect of nature was too ephemeral or too overwhelming to be captured by the plein-air painter. In order to realize his objectives, he constantly tailored his method to the special conditions of his subject. Confronting the spectacular light of the Mediterranean, he despaired at the limitations of his pigments. To his friend Duret he wrote, "One needs a palette of diamonds and precious stones";[14] and yet in the canvases he painted in 1884 at Bordighera and later at Antibes (plates 182 and 183), he succeeded in capturing the iridescence of that soft and "enchanted" color. Although in the seventies Monet had occasionally abandoned the intense color favored in his Argenteuil and Paris pictures for the more subtle or delicate tones dictated by a morning haze on the river near Vétheuil, he now appeared more consistently sensitive to the poetics of pastel.

Increasingly in the late eighties, Monet tended to paint canvases with more unified tonalities and relied on the rhythms of the brushstroke to activate the surface, so that they are more tactile and more consciously decorative than the paintings of the 1870s. Moreover, Monet was under some pressure to "finish" his pictures from Durand-Ruel, who thus echoed a persistent criticism about the incompleteness of his technique. In the calm of his studio, Monet now often filled in the edges of the swiftly executed canvases and eventually began to emphasize elements of color or brushwork that gave his work a more homogeneous character.

Monet's paintings of the awesome rocks and sea at Belle-Ile are among his most dramatic works. The artist spent three months on the small island, painting what he called its "somber and terrible aspect." Here the rough waves, painted with a thick impasto, crash violently against the menacing rocks, one of which forcefully juts into the sea like a great hammerhead. While the artist had painted equally fantastic rock formations at Etretat, it is at Belle-Ile that his sea paintings reach their emotional climax.

spread everywhere, and more than ever the things which come easily disgust me."[16]

Geffroy, who wrote the preface for the catalog that accompanied the Grain Stacks exhibition, described the painter's virtual obsession with the motif:

> *There he is stopping on the road on a late summer's evening, glancing at the field with its haystacks. . . . He remained at the edge of the field that day and returned the following day and the day after, and every day until autumn, during the entire season and at the beginning of winter. If the haystacks had not been removed, he would have been able to continue, go there during the entire year, renew the seasons, reveal the infinite changes of time on the eternal phase of nature.*[17]

Geffroy correctly saw that the paintings functioned as an ensemble that "would provide a single record both of the change itself and of the process of its pictorial registration."[18]

Not all the critics were as enthusiastic as Geffroy, but the exhibition enjoyed a tremendous popular success; indeed, the entire group of paintings was sold in a few days. Apparently, the effects of repeated exposure over twenty years had finally overcome the public's hostility to Monet's work. The following year, he exhibited fifteen canvases of poplars at Durand-Ruel's. While the Grain Stacks had reflected change over the seasons, the Poplars series (plates 187 and 188) restricted the range of light and atmosphere to a single day. The graceful silhouette of

the trees inspired the unusual decorative quality that emerges from the paintings, and their monumental lyric poetry seems, in retrospect, to prefigure the studies of water lilies.

The Poplars series and the Rouen Cathedral series (plates 189 and 190) that followed, so subtle in color and lyrical in mood, were a far cry from the bright and literal paintings of the 1870s that had made Impressionism synonymous with Monet. Even more than the other series, the rendering of the cathedral's facade demanded the artist's relentless attention. In order to work in close proximity to his motif, Monet rented a room opposite the cathedral, setting up several easels by the windows and moving from canvas to canvas as he sought to capture the look of the facade at different hours of the day. After three months of work he had produced twenty canvases, which were enthusiastically received when they were shown by Durand-Ruel. The concavities and projections in the cathedral's surface made it particularly receptive to the play of light, and Monet pursued its abstract effects with a single-minded dedication, divorcing his work from any subjective associations with the cathedral. Later, he elaborated this approach to a young admirer: "When you go out to paint, try to forget what objects you have before you—a tree, a house, a field, or whatever. Merely think, here is a little square of blue, here an oblong of pink, here a streak of yellow, and paint it just as it looks to you, the exact color and shape, until it gives your own naive impression of the scene before you."[19]

The cathedral itself loses its objective identity as its sculp-

158.
Claude Monet
Rocks at Belle-Ile
1886

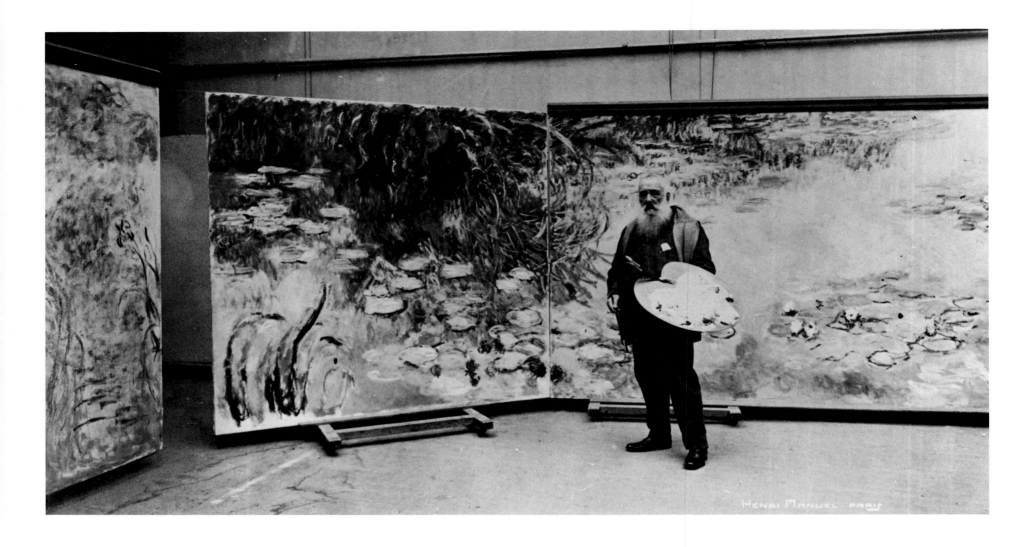

159.
Monet in his large mural
studio
c. 1920

tural bulk is translated into the heavily impastoed surface of colors. Joel Isaacson has pointed out that Monet's own sensibility emerges as the real subject of these paintings as the cathedral's "objective structure [is] taken as a foil for recording the history of the experience of a single individual."[20]

The critical reaction to the serial works, though resoundingly positive, was by no means unanimous in its understanding of their significance. Two writers closely associated with Monet may be singled out for their penetrating, though slightly differing perceptions. Gustave Geffroy, who had been an art critic for Georges Clemenceau's newspaper, *La Justice*, saw the peculiar poetry of Monet's work and its aim as a kind of decorative synthesis, whereas Clemenceau saw them as "an analytical tool for the decomposition of a single object into its constituent temporal aspects."[21] What mattered most to Geffroy was that delicate balance between the subject and the artist's perception of it; to Clemenceau, the artist's eye—virtually mechanical in its registration of the very process of seeing—was most important. Yet despite his emphasis on the scientific aspects of Monet's serial paintings, Clemenceau was not immune to the clearly premeditated and emphatically decorative coherence of the group. He was dismayed to learn that collectors could acquire single paintings, thus destroying "the harmony of their whole." Clemenceau proposed that the state acquire the entire group, anticipating the creation of a permanent installation of a group of Water Lilies canvases some thirty-five years later in the Orangerie (now at the Musée d'Orsay).

Later Years at Giverny

During the second half of the decade, Monet traveled from his home to work briefly in Norway and then along the seacoast of Normandy. There he reexplored earlier themes that allowed him to measure his current objectives against the achievements of the past. The results underline the change in Monet's work from an art initially rooted in naturalistic transcription to one of aesthetic determinism.

Monet's move to Giverny in 1883 brought a measure of tranquility and comfort that his struggle-filled life had previously lacked. He had always enjoyed the pleasures of a garden, and with the acquisition of some additional property in 1893, he was able to indulge his taste on a grand scale. The piece of land was a marshy plot with a stream that would provide the raw material for his water garden: a pond whose sluice gates gave him control over the current and the temperature of the water and allowed the introduction of exotic aquatic plants, including *nymphéas* (water lilies). To the existing poplars nearby, he added willows, gingkos, and Japanese cherry trees, and he erected a small arched bridge, such as were seen in Japanese gardens, over the narrow end of the pond. The initial arrangement, expanded and embellished in later years, was the subject for a group of paintings he undertook in 1899, the first of hundreds based on the lily pond. Utilizing the arch of the bridge as his compositional mainstay, Monet exploited the delicate relationship between the atmospheric depth of the motif and its potential translation into surface

*M*onet was enamored of country life, and the acquisition of his property at Giverny must have brought him rare pleasure. Stimulated by a motif he may have seen in certain Japanese woodcuts, he constructed a small arched bridge to span the narrow end of the pond, and this ensemble inspired some of the first views of the garden he painted in 1899.

ABOVE
160.
Monet's water garden at Giverny

RIGHT
161.
Claude Monet
Water Lilies I
1905

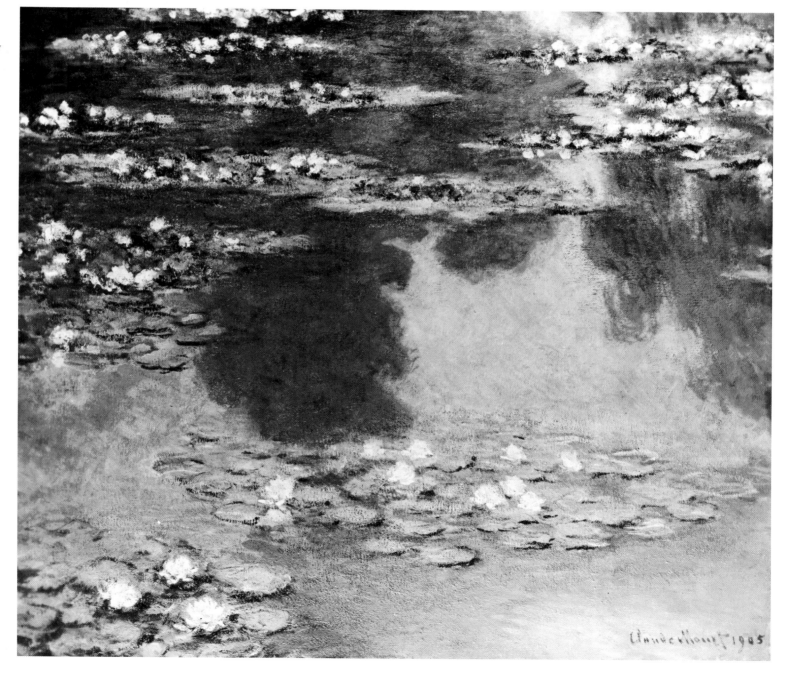

162.
Claude Monet
*The Palazzo Ducale
Seen from San Giorgio*
1908

design. The extraordinary symmetry and balance of the first *Water Lilies* produce an equilibrium of the visual and the tactile, and project an aura of serene and planned order that was to resonate throughout the many series he made of this subject.

Although Monet found time to work again in London in 1903, and executed a large group of canvases he had begun during visits to Venice in 1908 and 1909, his water garden occupied more and more of his time and declining energies. After the death of his second wife in 1911, followed by the loss of his elder son just three years later, Monet was plunged into mourning from which he never recovered. His life centered more and more on his work, and the water garden became the surrogate for his loved ones, providing a world whose finite dimensions never bored or confined him. The very nature of this garden—hermetic, even secretive—was conducive to loving meditation. He lavished attention on it, engaging a gardener whose sole duty was to maintain the pristine clarity of its reflective surface. Alien weeds or insects were removed, and the lilies were "bathed" daily to maintain the luster of their pads. The protective isolation of the water garden complemented the increasingly withdrawn character of its creator, who spent whole days searching its environs for propitious motifs. The garden was a virtual microcosm of the elements that had engaged the painter's curiosity from the very beginning. If now the fragmented character of the canvases seems divorced from any but an implied decorative context, it is worth recalling that the paintings combine themes, such as flowers and water, to which Monet consistently had been drawn.

An examination of the nature of painting was a principal aim of Monet's art in particular and of Impressionism in general. This conscious relationship between the description of visual experience and the making of a painting, which was central to the development of Monet's serial paintings, heightened dramatically between the first of the Water Lilies canvases, done in 1899, and the last ones, painted a quarter of a century later. The exhibition of forty-eight paintings in 1909 under the title *Nymphéas, série de paysages d'eau* (Water lilies: a series of water landscapes) vindicated the concept of the exhibition as a cumulative work of art (rather than an assemblage of individual canvases), and prompted public recognition that only through a vast and permanent ensemble could the full impact and intention of Monet's later art be revealed. The critic Claude Roger-Marx invented a conversation in which he attributed to the painter a scheme for the decoration of a salon: "Carried along the walls, its unity, unfolding through all the panels, would have given the illusion of an endless whole, of water without horizon or bank; nerves tense from work would be relaxed there . . . and to him who lived in the room it would have offered the refuge of a peaceable meditation in the center of a flowering aquarium."[22]

The Nymphéas series made a distinct break with the earlier group of paintings that had focused on the footbridge. Eliminating any view of the edges of the pond, Monet produced entirely self-referential compositions without boundaries or limits. A critic described one of the canvases as "a liquid surface, a mirror without a frame," and observed that the painter had provided no landmarks by which the viewer could orient himself. He called it "a painting turned upside down."[23]

As work on the water garden continued, Monet gradually enlarged the size and altered the shapes of the paintings, occasionally combining canvases to create diptychs or triptychs. The more monumental scale enabled him to pursue pictorial effects

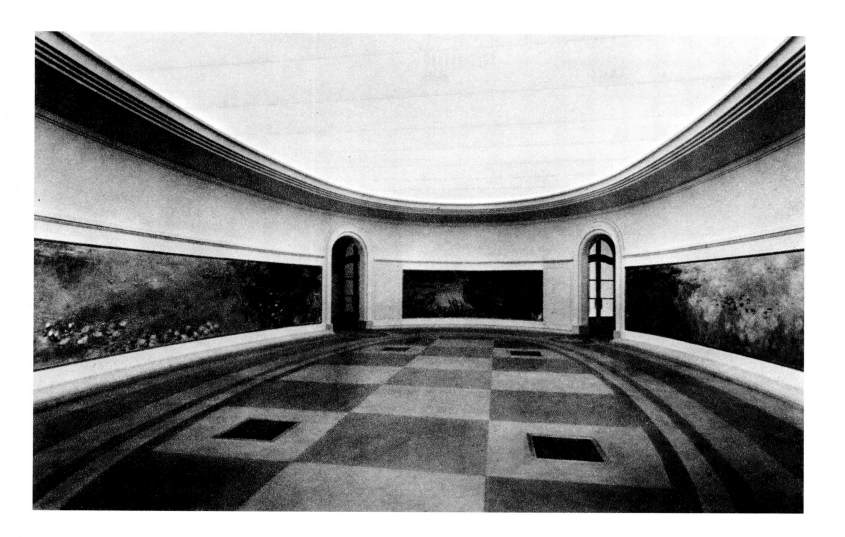

that he had explored only tentatively in the earlier paintings, and insinuated an expansiveness, a feeling of ongoing and ever-unfolding flux, which he described:

> *The flowers themselves are far from being the whole scene; really they are just the accompaniment. The essence of the motif is the mirror of water whose appearance alters at every moment, thanks to the patches of sky that are reflected in it, and which give it light and movement. The passing cloud, the refreshing breeze, the light growing dim and bright again . . . transform the coloring and distort the plane of water. One needs to have five or six canvases that one is working on at the same time, and to pass from one to the next, and hastily back to the first as soon as the original, interrupted effect has returned.*

In the later, larger Water Lilies (plates 193 and 194), Monet virtually abandoned any efforts at formal composition. The paintings have no conventional focal point; rather, the eye moves at random over the painted forms much as it might meander along the surface of the pond itself. The most striking quality of these canvases is the degree to which they compel the viewer's participation. Looking at these grand fragments, one gradually becomes aware of their larger spatial and temporal framework, which emerges only as one stands in their cumulative presence. Not simply a device for avoiding the anguish of searching for new themes, the serial paintings of his later years clearly grew out of Monet's obsession with time and his growing awareness of the limitless possibilities of seemingly finite themes. The inherent fascination of the water lilies as subjects was the very open-endedness of their fragmented lives, which permitted the artist to create an infinite number of contexts in which to experience them.

When he executed these paintings, Monet had been suffering for several years from deteriorating vision, which would require a cataract operation in 1922. He could no longer distinguish the particulars of form or color, but his sensitivity to light and atmosphere remained. Forced to fall back on a lifetime of visual experience and the resources of his inner eye, he tended to stress nuances of color, soft, blurred shapes, and a homogeneous texture. The immediacy of his earlier work was replaced by a remoteness both physical and psychological. Looking at these canvases, one feels that the painter has penetrated beyond the surface of his subject to its inner being by sheer force of concentration. Noting this magical quality, Monet's dealers observed, "We seem to be present at one of the first hours in the birth of the world."[24]

Monet's friend, the statesman and art lover Clemenceau, helped him to realize his dream of creating a permanent, comprehensive exhibition, comprising some of the Water Lilies canvases, as a peace memorial. From 1914, shortly after the death of his son, to 1923, Monet labored over the paintings, which were destined for the Orangerie of the Tuileries. Ironically, in order to execute these epic works, Monet was forced to work between the water garden and a new, large studio which he had built at the end of his garden. Thus he returned to the painting process of his earliest large work, the *Déjeuner sur l'herbe*. The eight huge Water Lilies canvases were ultimately installed in 1927, about a year after the artist's death, in two oval-shaped rooms that have been called the Sistine Chapel of Impressionism.

163.
Claude Monet
Water Landscapes
1919–26

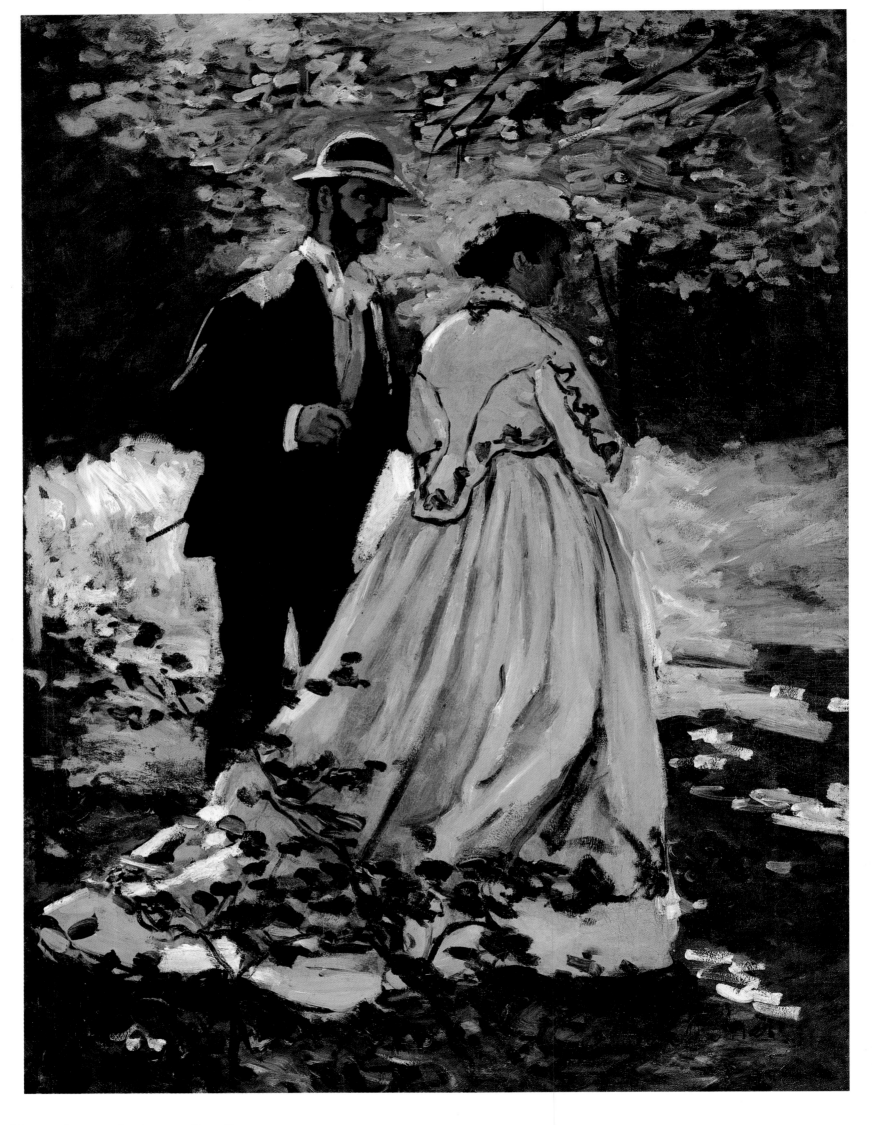

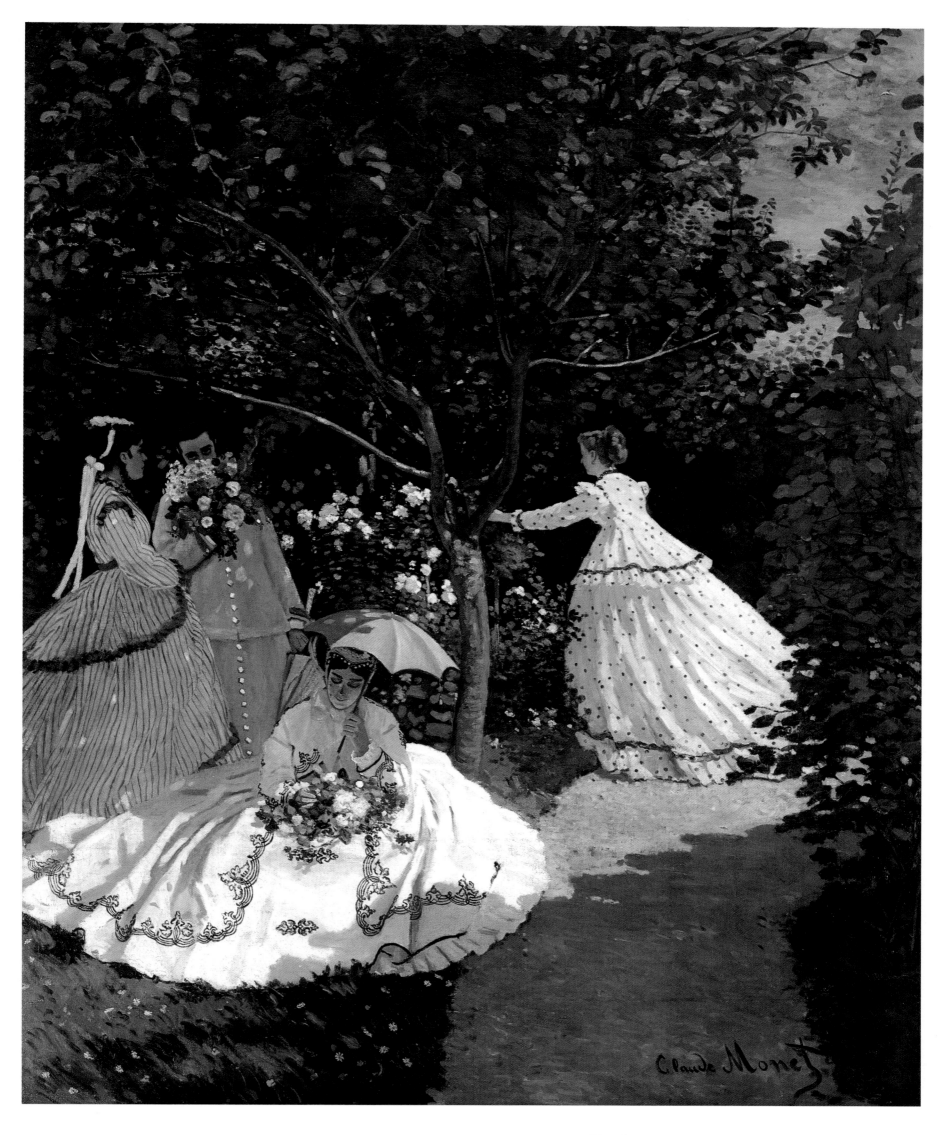

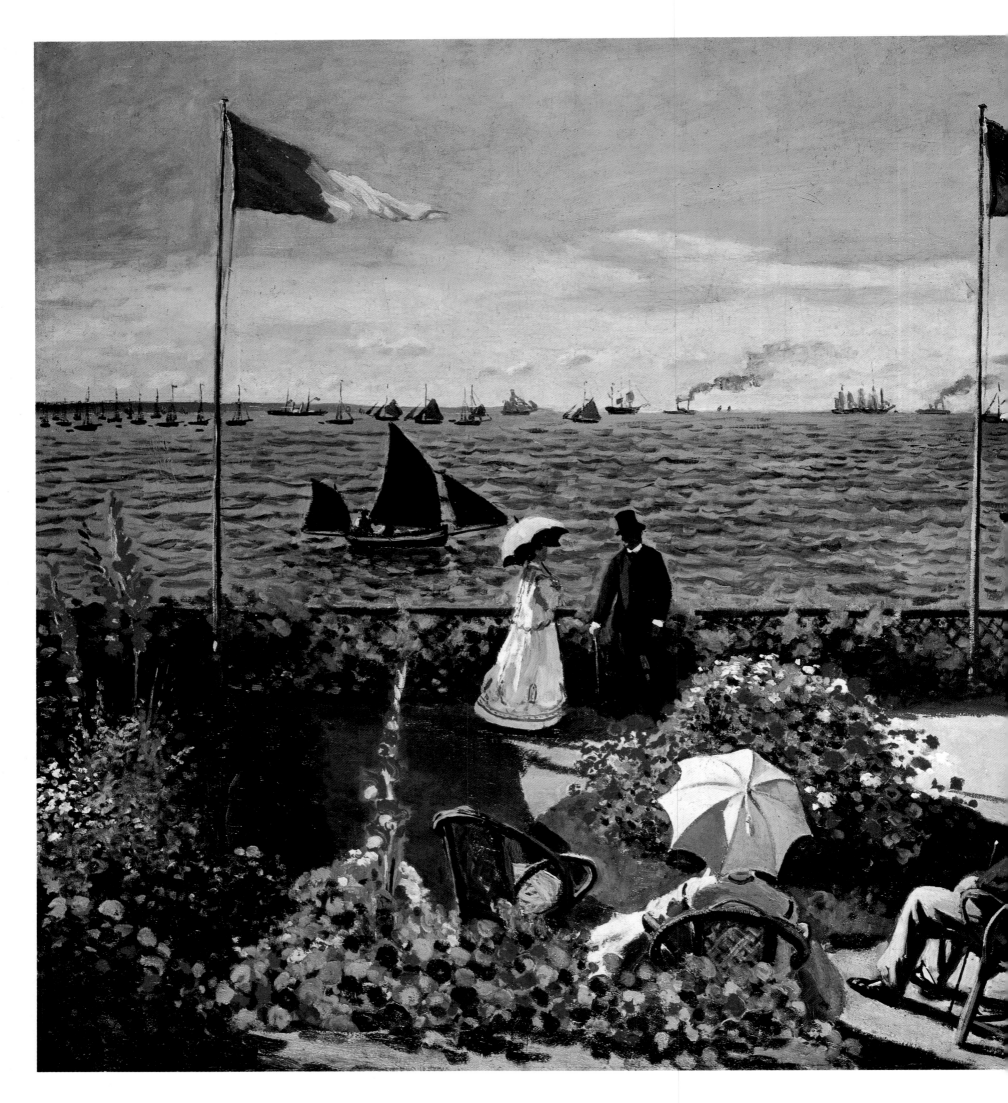

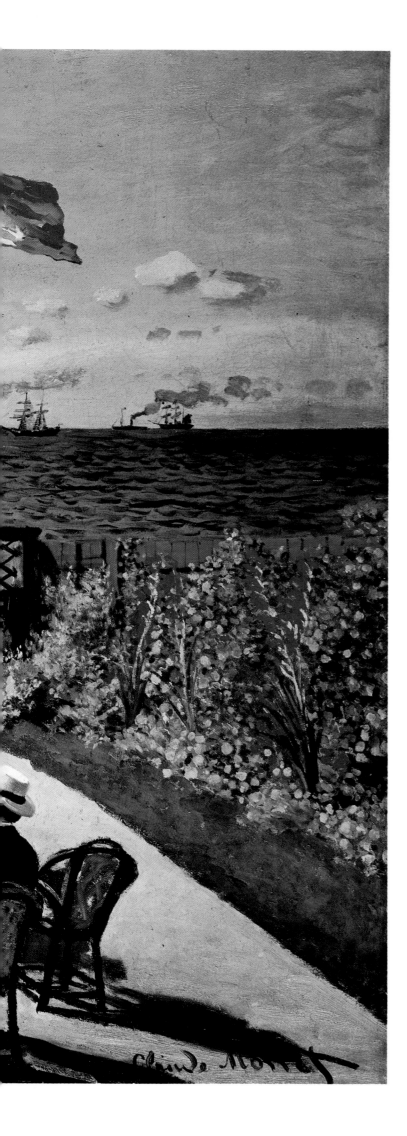

*M*onet first attracted attention to the Salon with marine paintings like the one below. The local seascapist Boudin had first opened his eyes to the atmospheric possibilities inherent in seacoast motifs. Although these sea views are close in actual size and employ a similarly high vantage point, the later picture (left) presents a sun-filled atmosphere of brilliant color and a composition that seems very formal compared to the dark palette and casual organization of the earlier one.

LEFT
166.
Claude Monet
Terrace at Sainte-Adresse
1866–67

BELOW
167.
Claude Monet
Pointe de la Hève at Low Tide
1865

168.
Claude Monet
The River
1868

During the spring of 1868, Monet lived with his mistress, Camille, and their infant son in a small village on the Seine, where he furthered his study of water first begun on the beaches of Normandy. The River focuses on light and its effect on masses in nature—houses, trees, hills—and on the shimmering and ever-changing surface of the river. The figure of Camille is treated democratically, dematerialized in such a way that she loses human interest and becomes an immobile form, not unlike the light-saturated trees and boat adjacent to her.

169.
Claude Monet
Red Boats at Argenteuil
1875

Red Boats at Argenteuil *documents Monet's continuing interest in themes inspired by the Seine. Today a visitor to the area would search in vain for the pleasure craft depicted here, for Argenteuil is now part of the dreary industrial periphery of Paris; but when Monet and his friends worked there it still retained its bucolic charm.*

170.
Claude Monet
Jean Monet on His Wooden Horse
1872

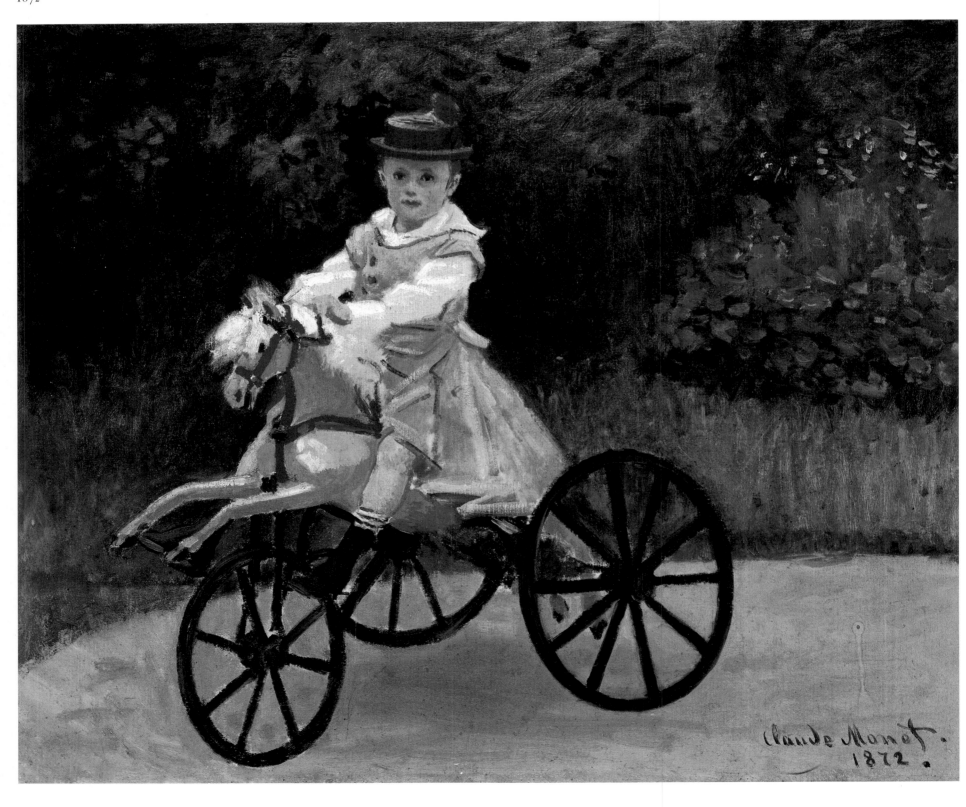

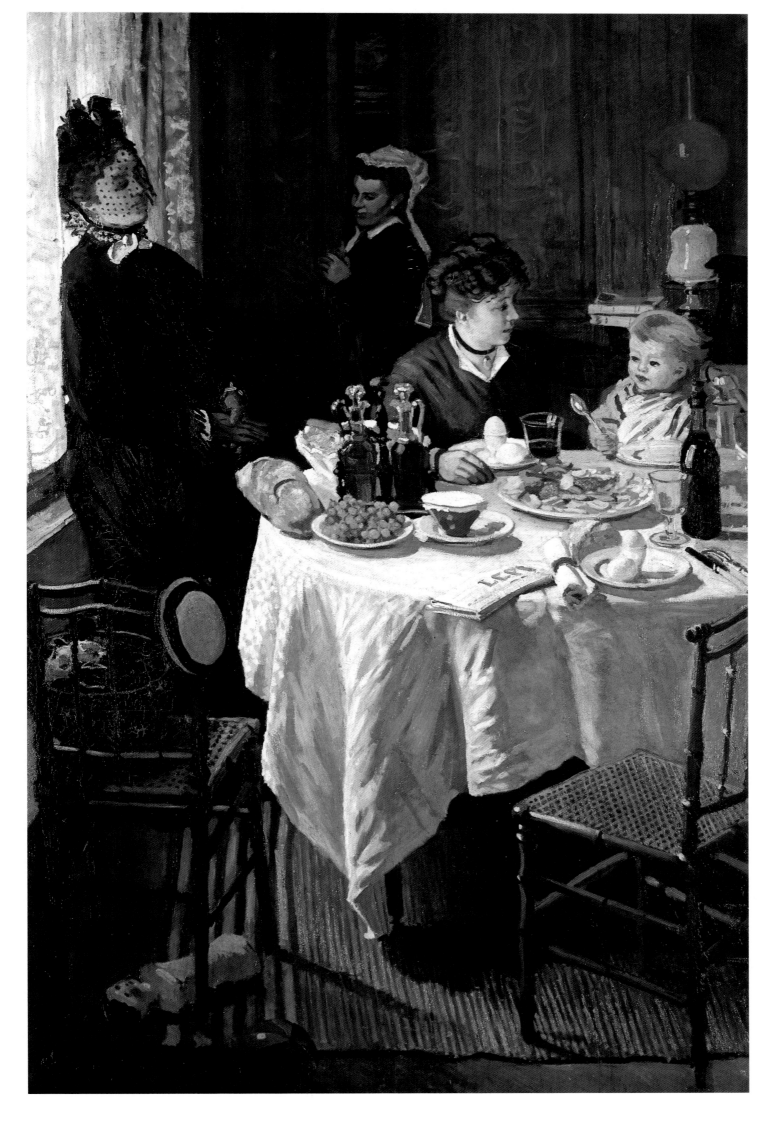

171.
Claude Monet
The Luncheon
1868

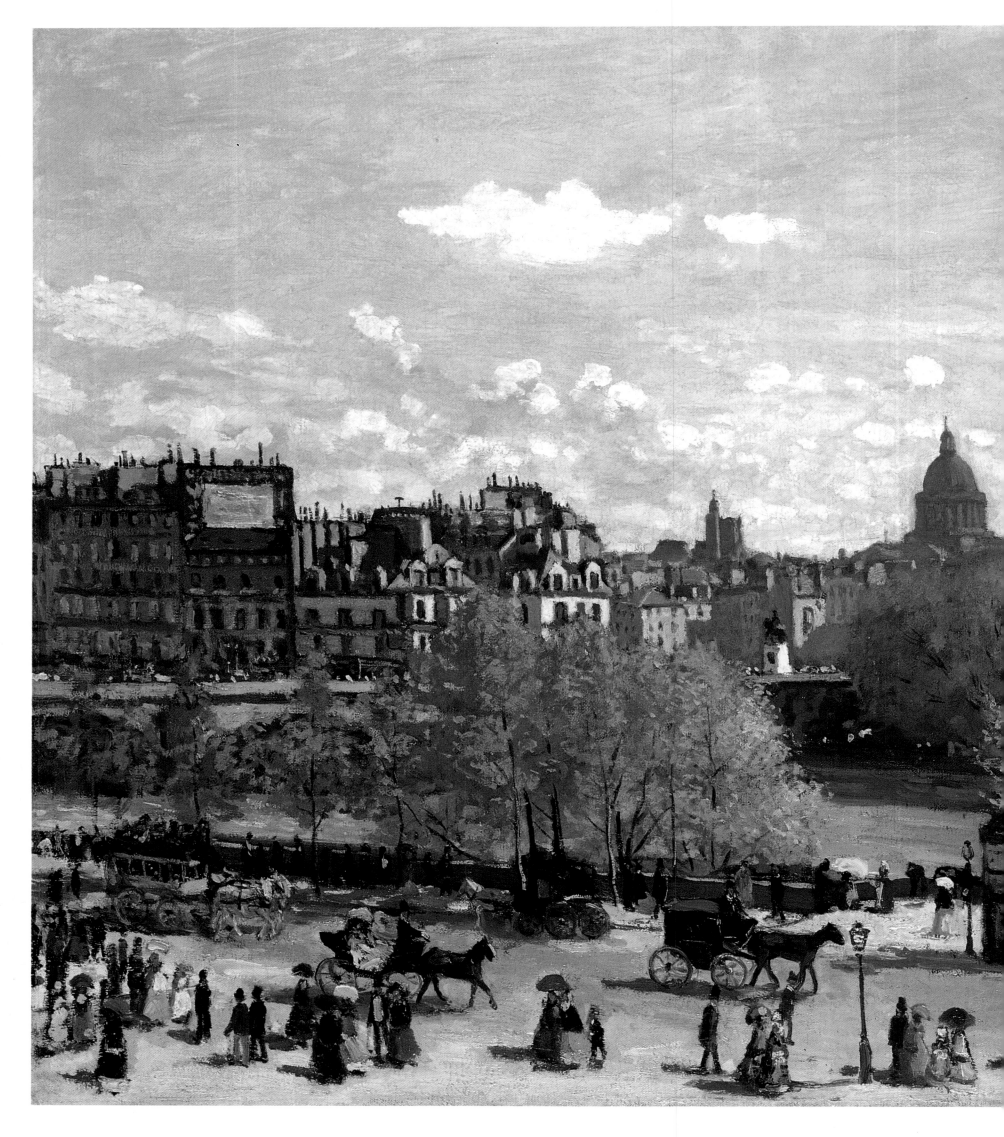

In response to Baudelaire's exhortation to paint themes from contemporary life, Monet turned in 1867 to a study of three Parisian scenes, all visible from his perch on a balcony on the east facade of the Louvre. This view of the Quai du Louvre *(at right) is similar in scale and vantage point to another urban subject, the* Boulevard des Capucines *of 1873 (plate 120); but the sharp lighting and crisp forms are still fairly conventional compared to the loose, hasty execution of the later painting.*

172.
Claude Monet
Quai du Louvre
1867

RIGHT

173.
Claude Monet
La Japonaise
1876

OPPOSITE

174.
Claude Monet
Woman with a Parasol:
Madame Monet and Her Son
1875

Field of Poppies *was probably among the twelve works Monet included in the first Impressionist exhibition. As in so many other paintings done in or around Argenteuil, his wife and son appear as small, somewhat dematerialized and almost abstract elements of the composition. No trace of anecdote or sentimentality is permitted to interfere with the projection of the all-pervasive light—the real subject of the painting.*

LEFT
175.
Claude Monet
Field of Poppies
1873

BELOW
176.
Claude Monet
Parisians Enjoying the Parc Monceau
1878

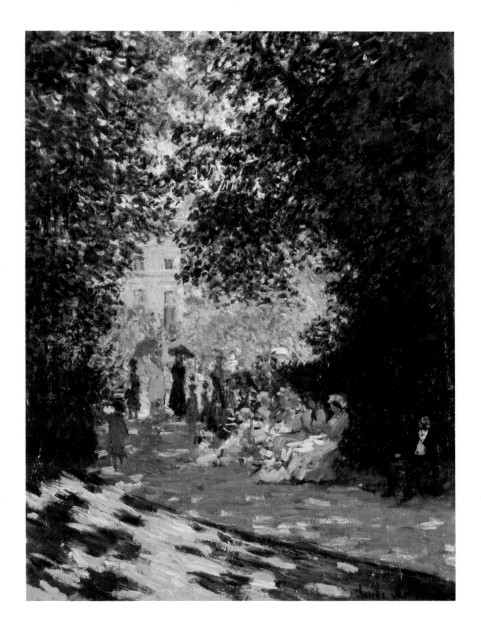

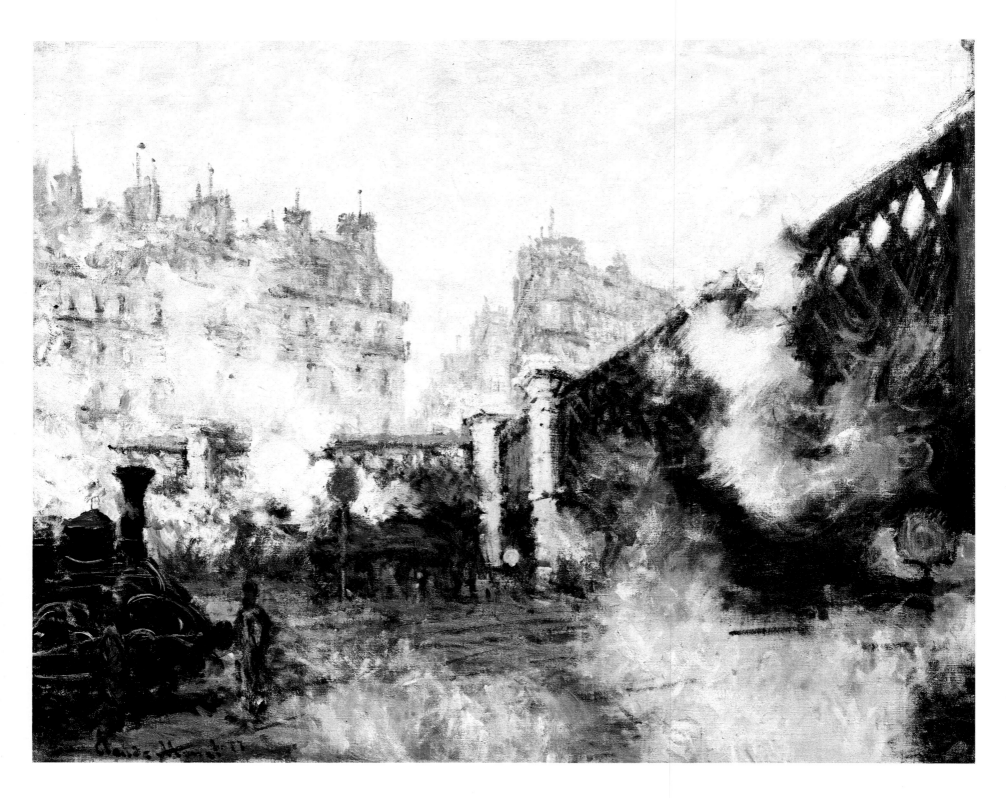

177.
Claude Monet
Le Pont de l'Europe
1877

During the winter of 1876–77, Monet did numerous studies of the Gare Saint-Lazare, the huge terminus for the railway that had taken him to Paris some twenty years earlier. Rather than constituting a carefully interrelated series of the sort he later undertook, these canvases are more properly understood as multiple views of a single theme, comparable to the paintings of the river and bridge at Argenteuil done about two years earlier.

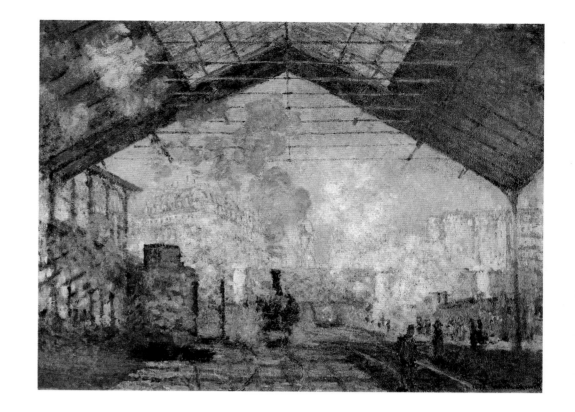

RIGHT
178.
Claude Monet
Gare Saint-Lazare
1877

BELOW
179.
Claude Monet
*Saint-Lazare Station: The Arrival
of the Train from Normandy*
1877

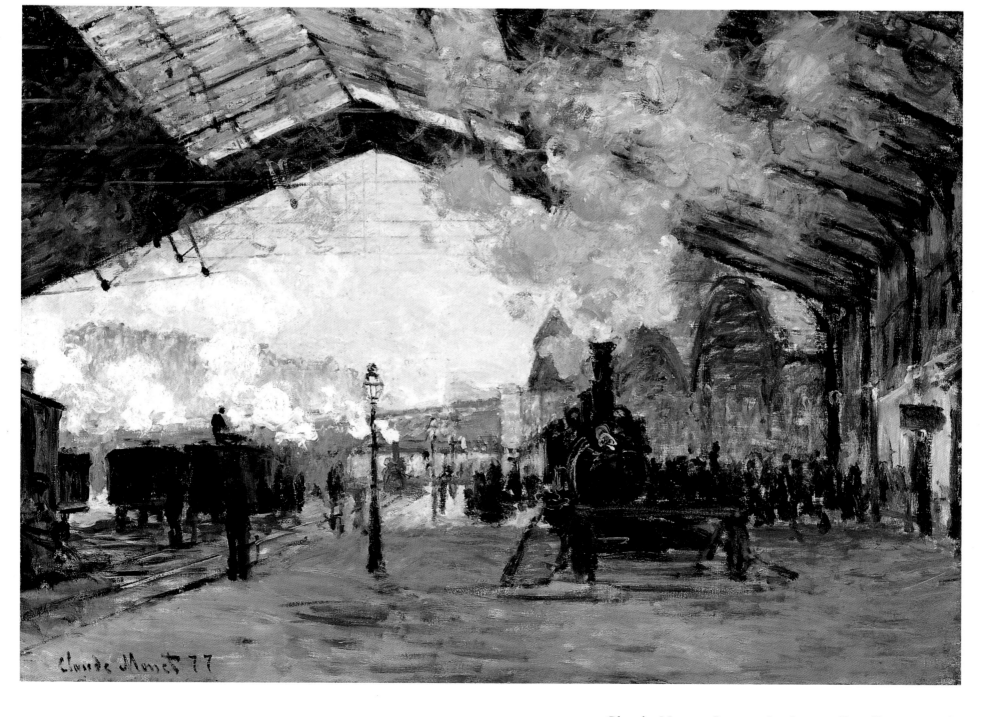

RIGHT
180.
Claude Monet
La Rue Saint-Denis, fête du 30 juin 1878
1878

OPPOSITE
181.
Claude Monet
The Artist's Garden at Vétheuil
1880

182.
Claude Monet
Bordighera
1884

183.
Claude Monet
Bordighera
1884

In January of 1884 Monet journeyed to the Mediterranean coast, which he had visited the previous year with Renoir. It was his first trip to the area since he had been stationed in North Africa during his military service, and he was enthralled by its sparkling blue water and luminous skies. In Bordighera, on the Italian Riviera, he painted the villa and gardens of a friend from Marseilles, responding to the rich and exotic vegetation of the area by alternately lightening and intensifying his color.

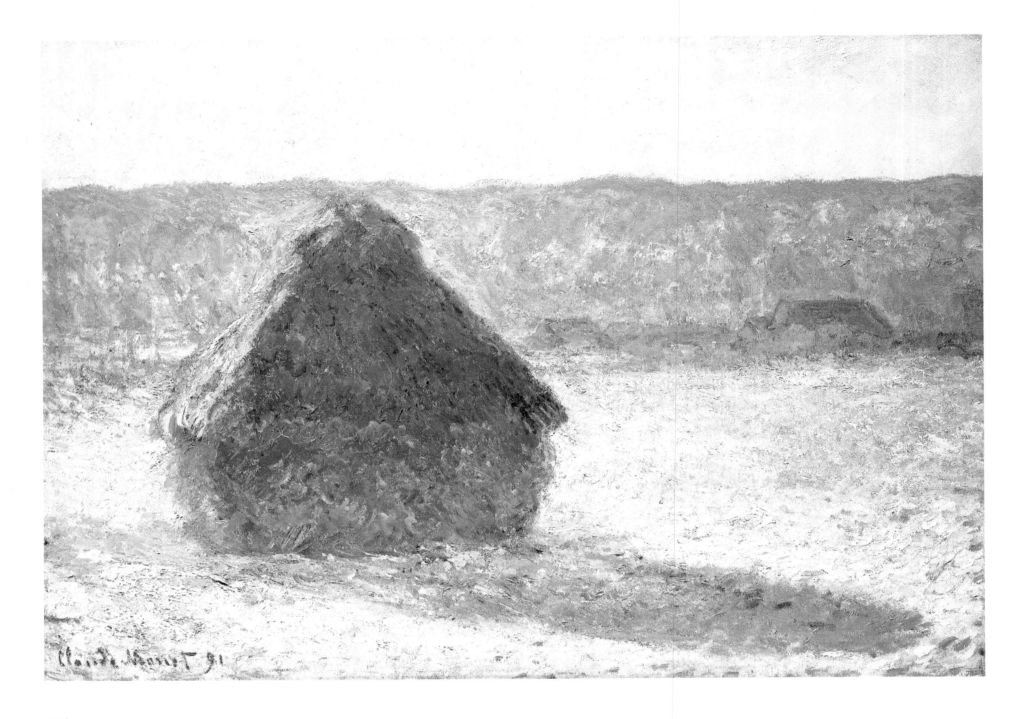

These paintings represent different aspects of the Grain Stacks series: at various times Monet shows a single stack from close range and somewhat trimmed, a single stack seen from a fair distance and more centered, two stacks close together or overlapping, and stacks seen separately. Whether they are solitary or in somber pairs, Monet endows the grain stacks with an iconic presence. The rich yet controlled range of pastels and the dense network of pigment create a variegated and highly tactile surface; the colors are as iridescent as any Monet ever painted.

184.
Claude Monet
Grain Stack in Winter
1891

RIGHT
185.
Claude Monet
Grain Stack at Sunset near Giverny
1891

BELOW
186.
Claude Monet
Two Grain Stacks
1891

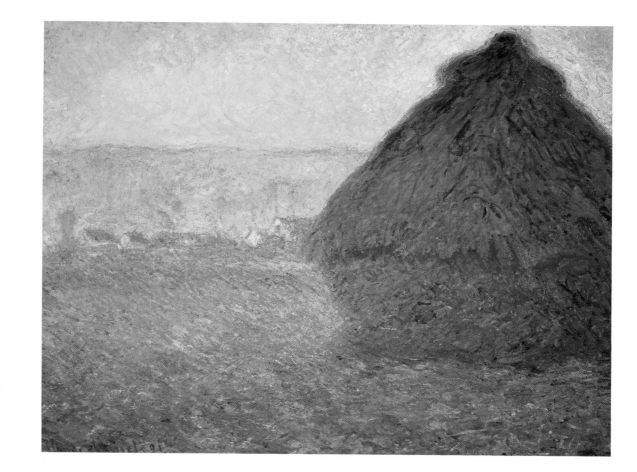

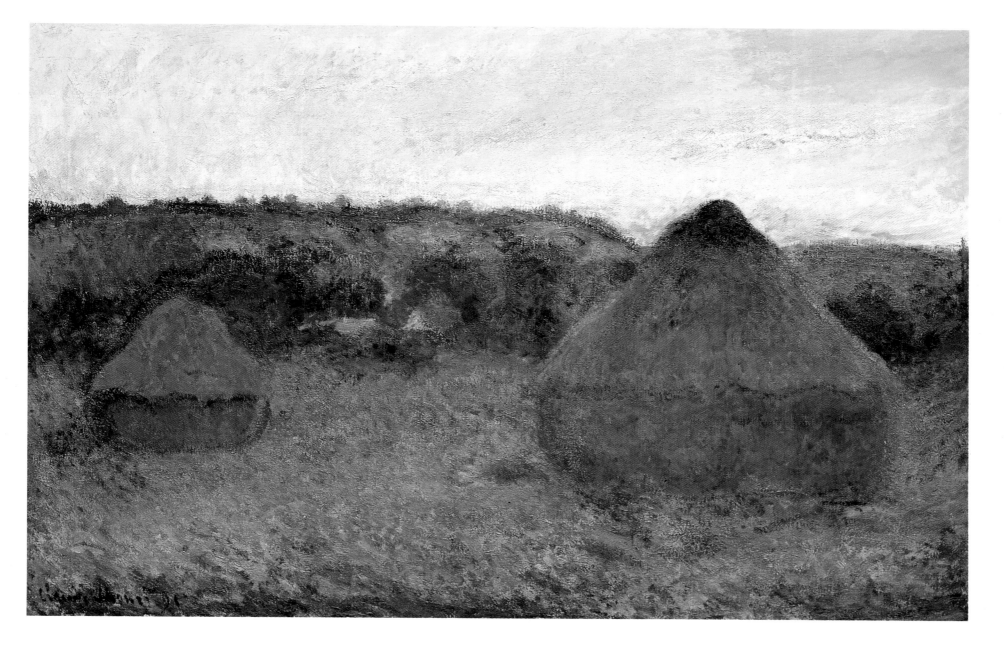

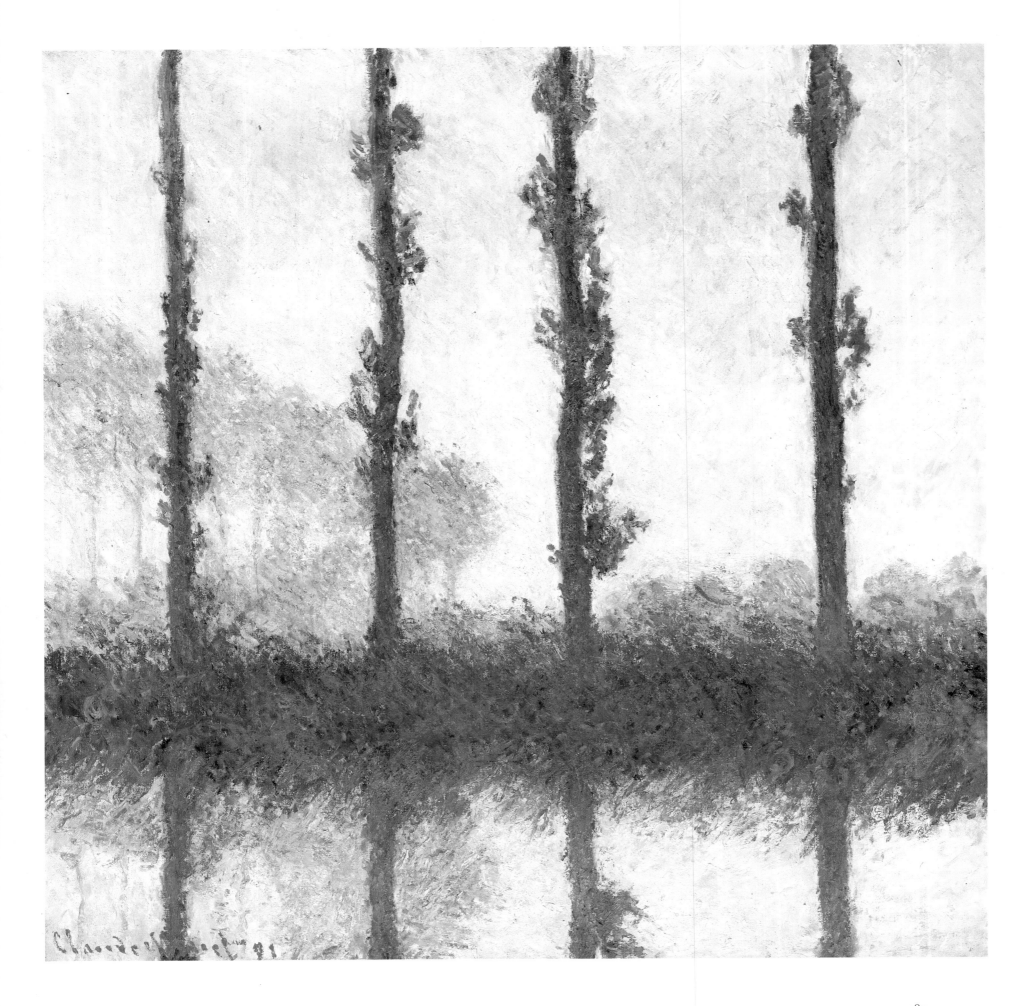

187.
Claude Monet
The Poplars
1891

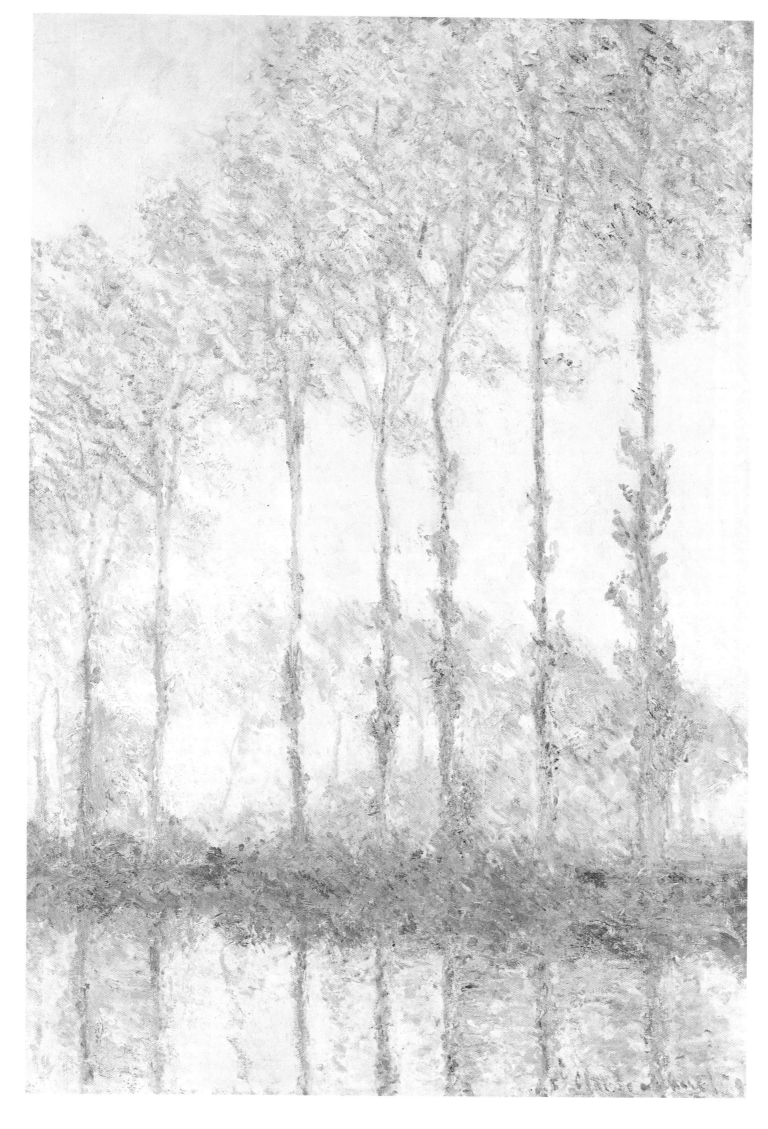

188.
Claude Monet
*Poplars on the Bank of
the Epte River*
1891

189.
Claude Monet
Rouen Cathedral, Portal and
Albane Tower
1894

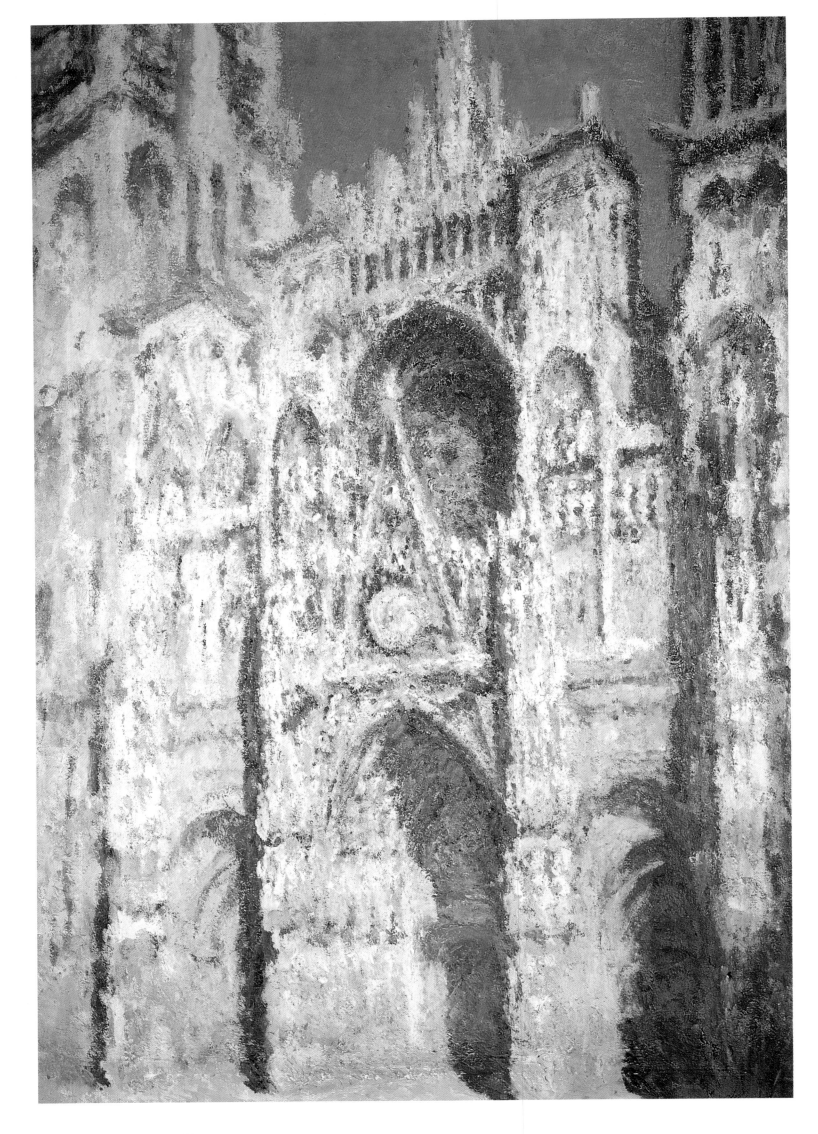

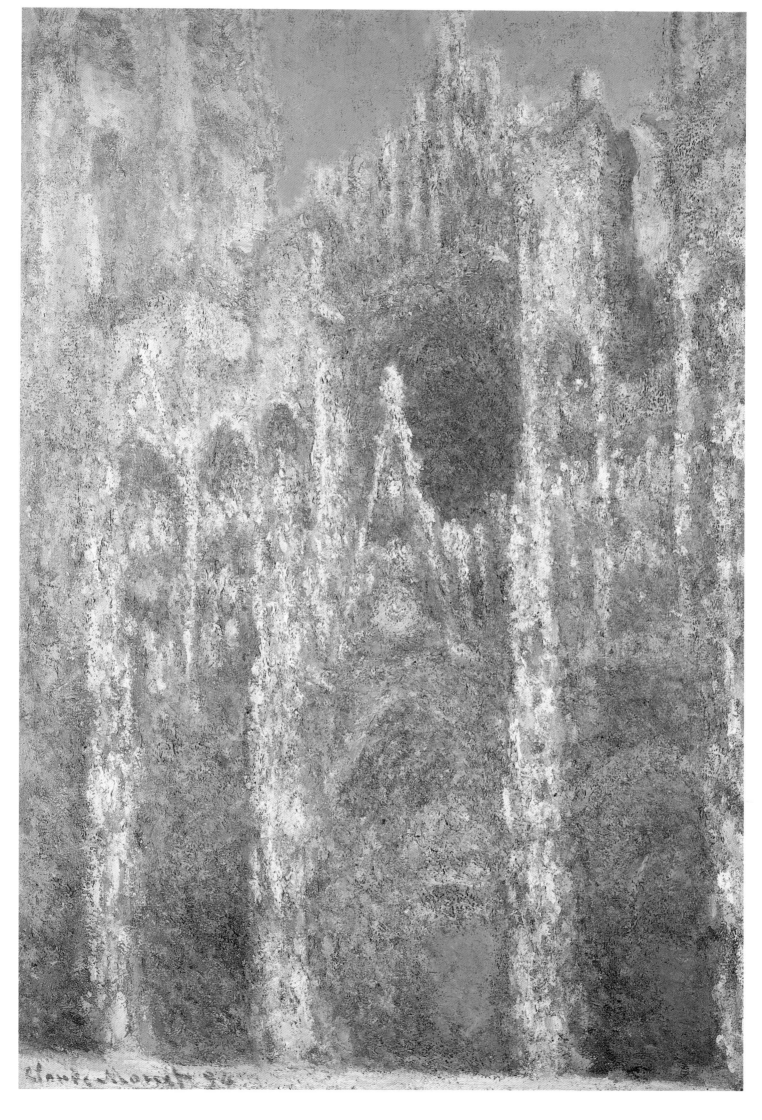

190.
Claude Monet
Rouen Cathedral, Sunset
1894

191.
Claude Monet
The Japanese Footbridge and
the Water Lily Pond, Giverny
1899

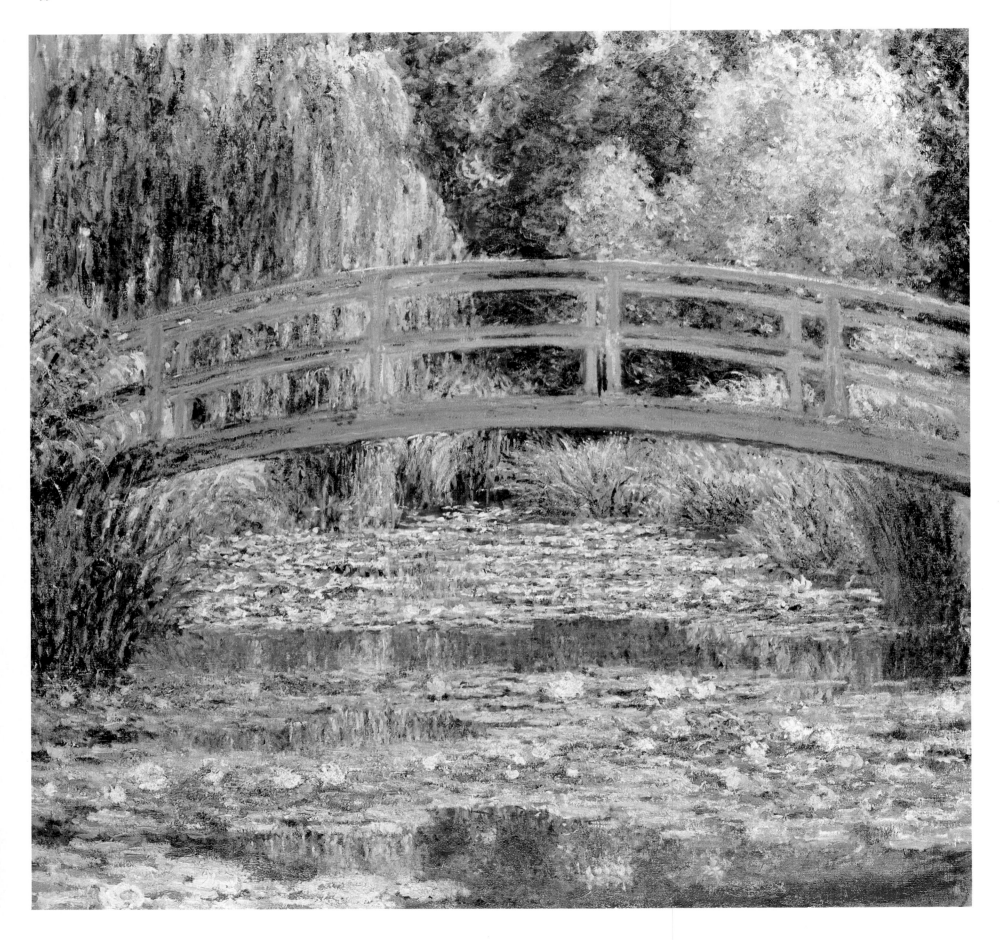

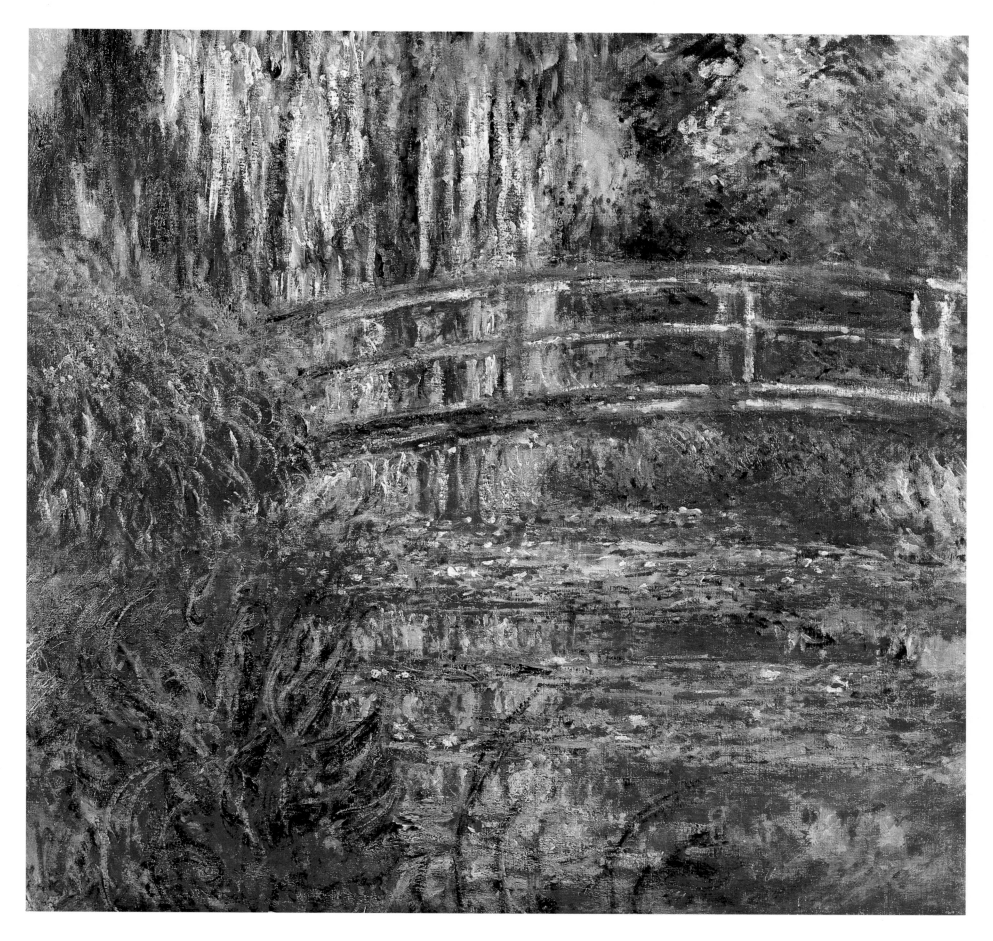

192.
Claude Monet
Water Garden and Japanese
Footbridge
1900

*M*onet's series of paintings of the Japanese footbridge that spanned his water garden at Giverny exhibit an almost tropical richness and density of color and texture. One stares at them with that particular fascination reserved for the myriad colored threads of worn oriental carpets or tapestries. Though some variation occurs throughout the series, the formal, even iconic, presence of the curvilinear bridge is a pictorial constant, moving the viewer's eye from one edge of the canvas to the other, asserting the flatness of the surface and at the same time rendering the optical and tactile properties of the work more immediate.

Claude Monet: Impressionist par Excellence • 197

ABOVE
193.
Claude Monet
Water Lilies
1916–22

RIGHT
194.
Claude Monet
Water Lilies
1919–22

Monet's water garden on his estate at Giverny sustained the painter through failing health and personal tragedy, and it was the source of some of the most poetic, ethereal paintings he ever produced. In these pictures the exquisite, delicate colors and their soft, fluid shapes create a dreamlike world into which we are invited to lose ourselves in personal meditation. Yet like so much of Monet's painting, the simplicity of the work is deceptive. It is in actuality the concentration on the tiniest details that renders the broad, expansive world of the Nymphéas.

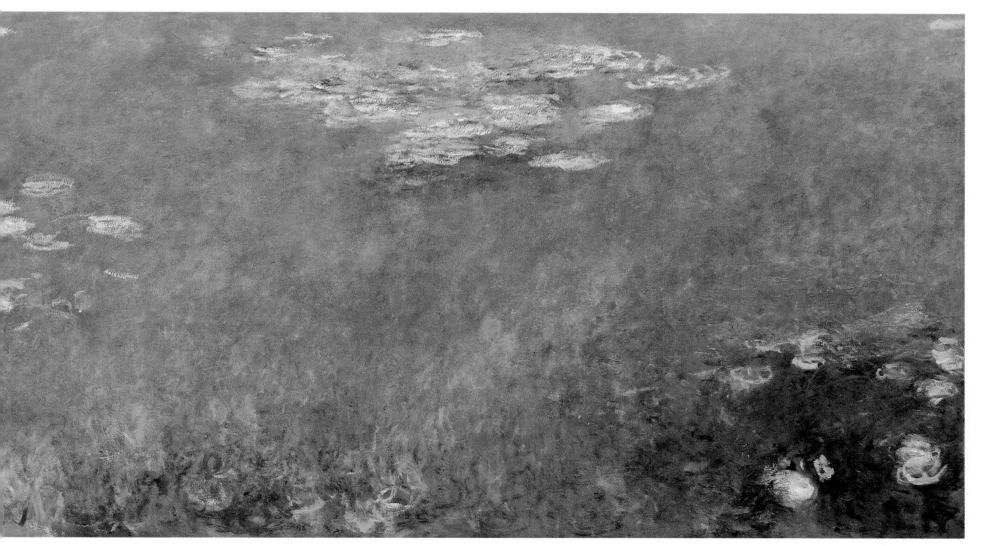

Pierre-Auguste Renoir: The Exuberant Impressionist

I like beautiful materials, rich brocades, diamonds flashing in the light, but I would have had a horror of wearing such things myself. I am grateful to those who do wear them, provided they allow me to paint them. On the other hand, I would just as soon paint glass trinkets and cotton goods costing two sous a yard. It is the artist who makes the model.

PIERRE-AUGUSTE RENOIR

Today, the name Renoir conjures up images of elegantly dressed women, smiling children, laughing boaters, and their healthy buxom companions, lounging in sun-drenched gardens or taking their pleasure in inviting riverside restaurants. Pierre-Auguste Renoir's splendid, shimmering color and lithe brushwork evoke the intoxicating energy of a life that fairly bursts with well-being. Along with his friend Monet, with whom he shared early poverty and a common professional destiny, Renoir has come to represent the quintessential Impressionist. Yet there is ample evidence to dispute this claim and to make us wonder whether he really ought to be considered an Impressionist at all.

From the very beginning to the end of his long career, Renoir's most profound convictions about art and his deepest objectives were often at variance with those of Monet and the other Impressionists. In an interview with the critic C. L. de Moncade in 1904, he observed:

My existence has been exactly the opposite of what it should have been, and it's certainly the most comical thing in the world that I am depicted as a revolutionary, because I am the worst old fogey there is among painters.

Moreover, the misunderstanding began when I was at the Ecole des Beaux-Arts. I was an extremely hard-working student; I ground away at academic painting; I studied the classics, but I did not obtain the least honorable mention, and my professors were unanimous in finding my painting execrable.[1]

The elderly painter is clearly indulging in a bit of good-natured irony at his own expense, but his words nevertheless provide a valuable insight into his approach to art. For Renoir was obsessed with history and clearly thought himself in the mainstream of Western painting. Unlike Monet, Pissarro, and Sisley, who were completely absorbed by their own researches into the fleeting appearances of reality, he was constantly measuring himself against "the classics."

The Youthful Years

The son of a tailor, Renoir was born in 1841 at Limoges but moved to Paris with his family when he was four. From an early age he showed a passion for drawing, and his father, coming as he did from a city famous for its porcelain, decided to apprentice him to a china manufacturer. Many years later, Renoir told Ambroise Vollard: "At thirteen I was earning my own living. The work consisted of painting little bouquets on a white background. . . . When I was a little more sure of myself I was promoted from bouquets to portraits, always at starvation wages. I remember that the profile of Marie-Antoinette brought me 8 sous."[2]

When he was seventeen, however, the factory went out of business; machine-decorated china had just been introduced, and the public preferred it to hand-painted ware.

So I began decorating fans with copies of Watteau, Lancret, and Boucher. I even used Watteau's Embarkation for Cythera! *I was brought up, you see, on the eighteenth-century French masters.*

To be more precise, Boucher's Diana at the Bath *was the first picture that took my fancy, and I have clung to it all my life as one does to one's first love. I have been told many a time*

OPPOSITE

Detail of plate 221

195.
Pierre-Auguste Renoir
Lise with a Parasol
1867

that I ought not to like Boucher, because "he is only a decorator." As if being a decorator made any difference. Why, Boucher is one of the painters who best understood the female body. What fresh, youthful buttocks he painted, with the most enchanting little dimples! . . . A painter who has the feel for breasts and buttocks is saved![3]

Renoir's early experiences in copying the sensuous and romantic works of the Rococo conditioned his sensibility and produced, especially in his mature years, a taste for themes that seem decidedly retrospective by comparison with those of his Impressionist colleagues. One commentator wryly called him "a great eighteenth-century painter born a hundred years late."[4]

Though in later life Renoir liked to joke about his beginnings as a commercial artist, that period had in fact been crucial to his development. For the rest of his life, he was to take himself more seriously as a craftsman—as a "decorator," even—than as a theoretician; and the delicate touch he acquired as a painter of plates and fans remained an essential element of his style.

The Group at Gleyre's Studio

Eventually some friends persuaded Renoir to take the plunge as a "serious" artist, and in 1862 he enrolled at the Ecole des Beaux-Arts. He entered Gleyre's studio, where Bazille, Monet, and Sisley were among his classmates. Gleyre was not a particularly inspiring master. Examining a canvas of Renoir's, he said, "You paint for your own amusement, I suppose?" "Well, of course! If it didn't amuse me," Renoir answered, "I assure you that I wouldn't paint at all."[5] The exchange sheds light on the character of both teacher and pupil. Gleyre, essentially a history painter committed to the teachings of Ingres, viewed painting as serious and didactic; whereas for Renoir it was also a source of pleasure.

More important than the training he received with Gleyre, Renoir formed friendships with gifted and ambitious artists of his own age. Monet, who had already embarked on his lifelong investigation of atmosphere and light, especially acted as a catalyst for Renoir's own deeper examination of the art of his own century. Delacroix's color and emotion also attracted him, as did Courbet's Realism; and the gentle poetry of the Barbizon landscapists opened his eyes to natural light and color. Later grumblings to the contrary, Renoir did not do at all badly as the fledgling academic artist. As early as 1864 he exhibited a romantic subject called *La Esmeralda* (which he later destroyed) at the Salon.

Early Successes and Failures

Mademoiselle Sicot (plate 226), a carefully drawn work of 1865, is a fine example of Renoir's early style. The colors are Manet's, but the stately composure of the figure recalls the portraits of Ingres. The lovely *Spring Bouquet* (plate 198), painted the following year, is a conventional enough flower-piece, but shows a great deal more freedom in its quick, impetuous brushwork. Renoir once told his friend Georges Rivière: "I just let my brain rest when I paint flowers. I don't experience the same tension as I do when confronted by the model. When I am painting flowers, I establish the tones, I study the values carefully, without worrying about losing the picture. I don't dare do this with a figure piece for fear of ruining it. The experience which I gain in these works, I eventually apply to my [figure] pictures."[6]

Of the early influences on Renoir's style, it was primarily Courbet who determined not only his move to Realism but also his conversion to contemporary themes; the mythological subject matter and difficult *contrapposto* composition of *Diana* (plate 214) derive from Renoir's unsuccessful attempt to court the Salon

When Renoir was unable to paint nature en plein air, he brought nature into his studio. These just-picked flowers are not formally arranged but rather overflow the vase in their hearty abundance. Renoir has rendered them with all the freshness and vitality he brought to his large outdoor compositions.

Though superficially similar to Monet's slightly earlier Field of Poppies *(plate 175), this small landscape is less radical in its objectives. Renoir seems far less interested in the saturating property of light than Monet. In place of the randomness that emanates from his friend's canvas, he has retained a relatively modulated, homogenized color scheme and composition whose appeal is more conventionally decorative.*

ABOVE

199.
Pierre-Auguste Renoir
Path Through High Grass
c. 1876–78

RIGHT

200.
Pierre-Auguste Renoir
Victor Chocquet
1876

jury. Yet, the unidealized materialism of Diana, more French working-class girl than classical deity, indicates a new concern with translating traditional themes into modern language that also reflects the impact of Manet's *Déjeuner sur l'herbe* and *Olympia* (plates 75 and 80). For the twenty-three-year-old art student, Manet's work signaled a "new era of painting," a directness of approach and innovativeness with color that was infectious for Renoir and his friends.

Despite the bright flesh tones and absence of conventional shading that characterize Diana and its outdoor setting, reminiscent of both Courbet and Manet, the work remains a typical studio picture. But in the months following its execution, Renoir seriously took up Monet's practice of working en plein air. He made a number of outdoor studies of Lise Tréhot, his mistress and favorite model. In 1868 an elegant portrait of her, *Lise with a Parasol* (plate 195), was accepted by the Salon. It was Renoir's first real critical success.

Kermit Champa has made the interesting suggestion that Renoir was inspired here by the English tradition of monumental portraiture, in which aristocratic figures are frequently represented in a landscape.[7] Yet the painter concentrates not on the noble character or physical charms of his sitter, but rather on the particulars of atmosphere. Lise, in a subtle play of colors, appears partly in sunlight and partly in the shadow of the trees and of her parasol; the background, dark but speckled with sunlight, ties the composition together admirably.

Renoir's Emerging Impressionism

In August 1869 Renoir joined Monet at La Grenouillère, the popular pleasure spot on the Seine not far from Paris. Years later he told Vollard that at La Grenouillère "life was a perpetual holiday. The world knew how to laugh in those days! Machinery had not absorbed all of life; you had leisure for enjoyment and no one was the worse for it."[8]

In somewhat ironic contrast, both Renoir and Monet were so poor in those days that at times they had to interrupt work because they could not afford to buy paints. During their weeks at La Grenouillère, working side by side, they produced three pairs of identical views. Renoir's Grenouillère paintings are his first in a recognizably Impressionist style, derived directly from Monet's juxtaposition of broad, rapid strokes of color, but they are distinguishable by Renoir's preference for pastel tones and a more detailed treatment of the human figures, which are not swallowed up (as they tend to be with Monet) in the overall visual effect.

Renoir was always susceptible to new enthusiasms, and his development may therefore strike us as erratic. In 1870, a year after the Grenouillère paintings, he produced a portrait of Lise as an Algerian odalisque (plate 213) which can only be described as an homage to Delacroix—specifically, to the sumptuous color and languid eroticism of *Women of Algiers*, which Renoir always regarded as one of the masterpieces of painting. Yet *Odalisque* reminds us too of Manet's habit of dressing up Parisian models, for Renoir's subject is not some remote oriental love object but a decidedly accessible, full-blooded woman. The painter's friend and patron, the critic Duret, characterized this accessibility of Renoir's women in the following way: "With their delicate flesh, their sexual charm and their seductiveness [they] appear on canvas as pretty human beings, although in so representing them Renoir obeyed no preconceived aesthetic. His perception was spontaneous, and his brush rendered the direct sensations he felt when he looked at a woman and touched her."[9]

Renoir's endeavors, like those of most French artists, were completely disrupted by the Franco-Prussian War. He served in the army, though he did not see active duty; in March 1871, during the Commune, he came back to Paris, but soon left to join his mother at Louveciennes. After the fall of the Commune he returned permanently to Paris. During the early 1870s, together with Monet, he began to attract the attention of important patrons and dealers such as Duret, Caillebotte, and Durand-Ruel. Of the latter, who was widely known to be a political conservative, he remarked, "We needed a reactionary to defend our painting, which the Salon crowd said was revolutionary. He was one person at any rate who didn't run the risk of being shot as a Communard!"[10] Sales came in slowly but regularly, permitting Renoir to rent a huge studio in the rue Saint-Georges. The decade following 1871 was, beyond any doubt, the most creative one of his career.

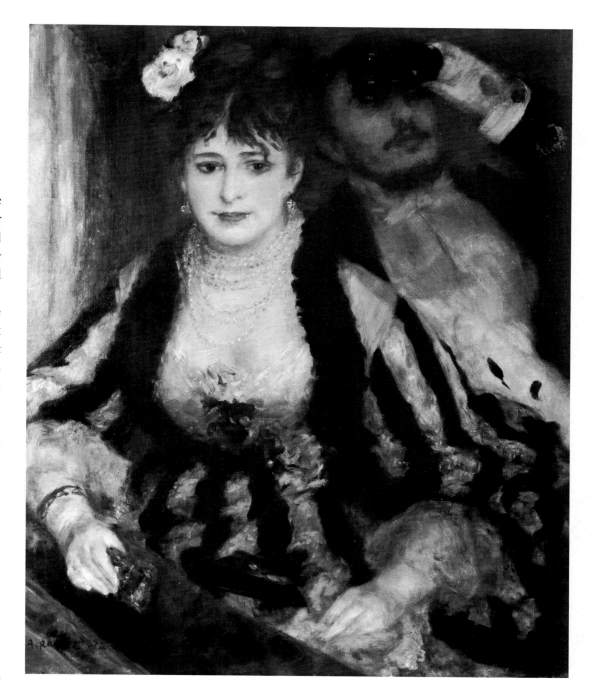

201.
Pierre-Auguste Renoir
La Loge
1874

When the first Impressionist exhibition opened at Nadar's studio on April 15, 1874, Renoir showed seven pictures, including *La Loge* (plate 201), which some consider his best work of that period. It is not a particularly "Impressionist" painting, but rather a carefully composed studio picture, posed for by Renoir's brother Edmond and a model new to Renoir named Nini. Its unifying principle is the dramatic contrast of purest black (a color which was, or was soon to become, anathema to the other Impressionists) with whites that are saturated with every other color and with delicately modulated flesh tones. The most exciting and distinctive feature of the work is not the play of light but rather the extraordinarily immediate presence of the woman and the man. The painting's elegance bespeaks the luxurious society of the Second Empire rather than the relatively hard times that followed the Franco-Prussian War, as if the artist were indulging in a bit of nostalgia for a way of life that had been threatened and was gradually disappearing. But *La Loge* also gives a preview of the style that would emerge in the late 1870s and would ultimately introduce the artist into a world of beautiful and wealthy people—a world he found irresistibly attractive and which, in turn, embraced him as its flattering interpreter.

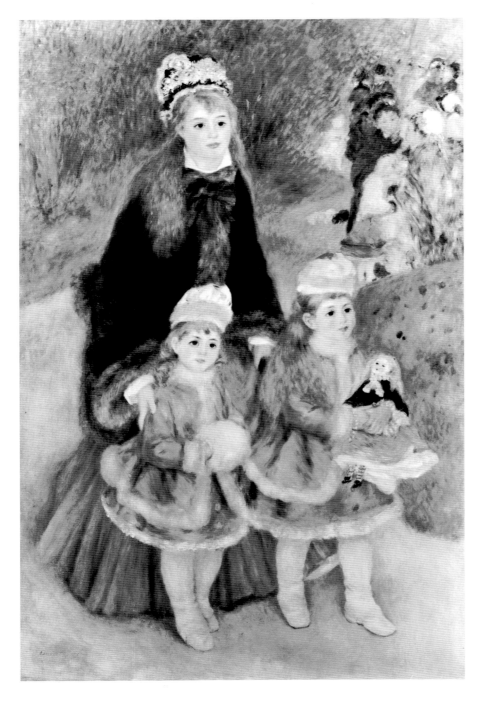

202.
Pierre-August Renoir
Mother and Children
c. 1874–76

New Plein-Air Themes

Between 1872 and 1874, Renoir frequently visited Monet at Argenteuil, where the two friends again painted the same views, side by side, as they had done a few years before at La Grenouillère. Renoir's Argenteuil paintings represent his most purely Impressionist manner, with entire scenes dissolved in shimmering light. His *Sailboats at Argenteuil* (plate 220) is virtually identical in composition to Monet's version.

Renoir's *Madame Monet and Her Son in Their Garden* (plate 219) dates from a visit to Argenteuil in 1874. Manet, who was also there, painted the same subject at the same time. An apocryphal story relates that Manet, after a look at Renoir's work, whispered to Monet, "He has no talent at all, that boy! You, who are his friend, tell him please to give up painting."[11]

In 1875 Renoir, without giving up his studio in the rue Saint-Georges, also rented a small house with a large garden in

Montmartre. He painted a number of pictures in this garden, including *La Balançoire*, or *The Swing* (plate 113), which takes up—and carries a good deal further—the essential idea of *Lise with a Parasol*: the human figure seen in light and in half-shadow, under trees. In this later work, the men, the woman, and the little girl, without entirely losing their substantiality, entirely lack Lise's monumental presence. They are clearly subordinated to the overall play of dappled light, in a manner which comes as close to Monet's work as had Renoir's Grenouillère paintings of a decade earlier.

Renoir's paintings of his Montmartre years often contain autobiographical elements. He often depicts his associates: patrons such as Georges Rivière, the champion of Impressionism; musicians; and young painter friends like Pissarro's son Lucien, who accompanied him on expeditions through the gay neighborhood and often went with him to the Moulin de la Galette. The Moulin was an old rustic establishment where the young people of working-class Montmartre came together on Sundays to eat, dance, and make merry. Renoir was enchanted with the vitality of the place, and painted several pictures there on the spot. His *Dancing at the Moulin de la Galette* (plate 139) goes further than any other to justify the oft-repeated claim that it was Renoir who extended the Impressionist style from landscape to all aspects of life. Impressionist elements are of course crucial here, from the quick, summary brushwork in certain (but not all) passages to the vivid palette and the concern with different aspects of light. But the essential purpose of the painting is Realist, not Impressionist: to communicate to the viewer the atmosphere of a certain social milieu at a given time—not to record, as did Monet, the optical reality of a particular view at a specific moment.

Despite the financial disappointments the Impressionists suffered at the Hôtel Drouot auction in 1875, Renoir was busier than ever in the late 1870s. He began to attract a circle of admirers, such as Victor Chocquet, whose reverence for Delacroix may have predisposed him to appreciate the richness of Renoir's color. The painter produced a portrait of Chocquet, and also one of the collector's wife. Indeed, portraiture was rapidly claiming more of Renoir's time, although he still explored popular themes such as café life and the theater, much as Manet and Degas were doing.

In 1876 Renoir painted the picture usually known as *La Première Sortie* or *Her First Evening Out* (plate 203), though its original title seems to have been simply *Le Café-Concert*. Like *La Loge* of two or three years earlier, it shows the interior of a theater box, but this time the technique is thoroughly Impressionist. Details of the girl's dress, her bouquet, and the members of the audience seen in the "background" (there is actually little attempt to suggest depth) are wonderfully noted with brushstrokes at once bold and delicate. The picture is also characterized by a conscious sentimentality—something new in Renoir—

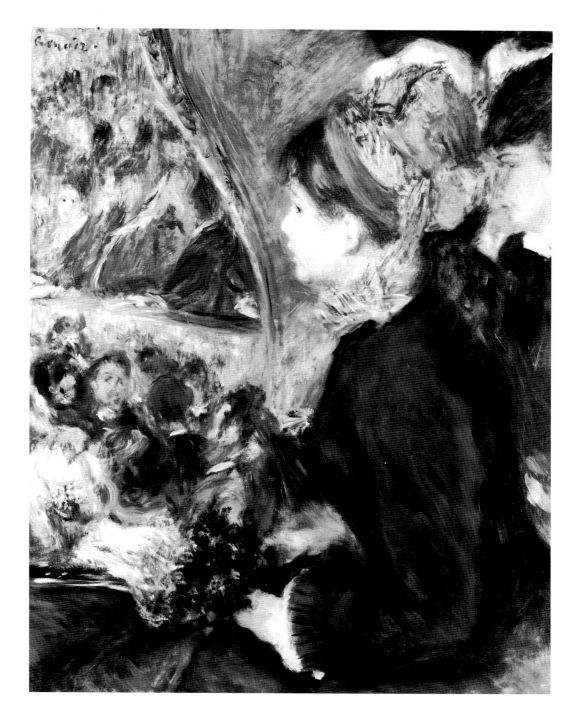

Renoir often painted members of the fashionable bourgeoisie. The slight self-consciousness of the elegant mother and children out for an afternoon stroll (opposite page) robs the scene of some of the verve of La Première Sortie (left). This young debutante's alert, straight-backed posture and wide-eyed expression convey the excitement of her evening as she watches the swirling scene before her.

203.
Pierre-Auguste Renoir
La Première Sortie (Her First Evening Out)
c. 1876–77

which removes it, by light-years, from the grandiose *La Loge*. The contemporary *Girl with a Watering Can* (plate 229) perhaps suffers from the same defect—an all-too-deliberate pleasingness—though this is more understandable in portraits of children. Renoir was absolutely without equal in his ability to capture in paint the freshness, innocence, and fragility of a small child; but this viewpoint began to pervade his treatment of all subjects indiscriminately in his later years.

The Society Portrait

During the mid-1870s the tailor's son from Limoges was taken up by some rather grand members of Parisian society. In 1875 the publisher Georges Charpentier bought one of his pictures, and not long thereafter Renoir began to frequent Madame Charpentier's salon, where he met the great political and literary figures of the Third Republic, as well as the most fashionable women of the time. Madame Charpentier, he told Vollard, "did not stop at inviting artists to her soirées; she got her husband to start a magazine for the defense of Impressionist art, called *La Vie moderne*. We all collaborated. We were to be paid out of the earnings; in other words, none of us got a single sou."[12]

This amusing self-depreciation had a touch of ingratitude to it, since Renoir's association with the Charpentiers provided him with financial advantages as well as artistic stimulation. He painted a number of his fellow guests and, on more than one occasion, the hostess herself. The large *Madame Charpentier with Her Children* of 1878 (plate 231) was an ambitious undertaking for which more than forty sittings were required. When Marcel Proust saw the finished portrait in the Charpentier house, he was enchanted with it and spoke knowingly of the benefits an artist could reap by associating with "people somewhat richer than he, in whose homes he will meet what he does not have in his

studio . . . : a salon with furniture upholstered in antique silks, many lamps, lovely flowers, beautiful fruit, attractive dresses."[13]

Madame Charpentier with Her Children contains a number of exquisite details—the still-life arrangement in the background, for instance—and the doll-like children are full of charm; but it is, in the final analysis, a conventional portrayal of an eminently self-satisfied bourgeois household. The Salon of 1879 accepted it largely because, in the artist's own words, his patroness "knew the members of the jury, whom she lobbied vigorously."[14] It was a huge success with public and critics alike, and made Renoir's reputation; for the rest of his life his portraits and other works were in constant demand.

The Break with Impressionism

With *Oarsmen at Chatou* (plate 222), painted during the summer of 1879, Renoir pursued further the Impressionist technique that he had perfected at Argenteuil, particularly in the use of bold, short brushstrokes to break up the surface of the water into a myriad of reflected colors. But the hues themselves are more vivid now, less subordinate to an overall unity of light, and—as in pictures such as *Dancing at the Moulin de la Galette*—the emphasis is on the human subjects and their delight in a concrete situation.

Despite his seeming adherence to plein-air themes, Renoir was becoming increasingly disenchanted with the broken color and ephemeral immediacy of Impressionism. His last masterpiece in the genre, and perhaps the most successful celebration of friendship, summertime, and joie de vivre in all of art, is *The Luncheon of the Boating Party* (plate 221). It was painted in 1881 at one of his favorite haunts, the Restaurant Fournaise on the Seine at Chatou. Bathed in golden light filtered through a striped awning, the artist's companions are lingering over the remains of their lunch. The man standing to the left is the proprietor, Père Fournaise, and the girl leaning on the railing in the middle distance is his daughter Alphonsine. At the table in the foreground are Renoir's future wife, Aline Charigot, with her little dog; Gustave Caillebotte; and the actress Ellen Andrée, who is chatting with a journalist called Maggiolo. At the other table are Baron Barbier, seen from behind and apparently talking to Alphonsine, and the model Angèle, draining a last glass of wine.

Behind Maggiolo we see Renoir's good friends Eugène-Pierre Lestringuez (in the felt hat) and Paul Lhote (in the straw hat); Lhote has his arm around the waist of Jeanne Samary, a famous actress whom Renoir had met at Mme Charpentier's and whom he had already painted in *La Balançoire* and other works. The gentleman in the top hat is the banker Charles Ephrussi, and the young man with the cap is probably Alphonse Fournaise. Renoir uses Impressionist techniques with consummate skill in this painting, but the scene is more anecdotal and the personalities more highly individualized than in the *Moulin de la Galette*.

There is, moreover, a much stronger indication of depth; the figures have far more volume and the composition is more carefully constructed.

This *Luncheon* coincides with a crisis in Renoir's own development as well as with the general crisis of the Impressionist movement. Like Monet, Sisley, and Cézanne, Renoir had decided not to participate in the fifth Impressionist exhibition in 1880. Even sympathetic critics and artists were beginning to call attention to the very real limits of Impressionism. Zola, who had previously championed Monet and the others, now accused them of failing to fulfill their promise; and the Symbolist artist Odilon Redon wrote in his diary that Impressionism "is a very legitimate mode of painting when applied mainly to the representation of external objects under the open sky. However, I do not believe that all which palpitates under the brow of a man who meditates and listens to his inner voices . . . can gain much from his tendency of observing only what happens outside of our walls. On the contrary, the expression of life can appear but in *chiaroscuro*."[15]

Perhaps Renoir did not spend a great deal of time "listening to his inner voices," but the "expression of life" was his principal concern, and he began to feel a genuine revulsion for the Impressionist tendency to reduce reality to optics. Years later, Vollard tried to draw him out on the subject of Impressionist theory, and it is clear from his remarks that he had never had much patience with it. Vollard began by quoting a recent critic: "The only innovation of Impressionism, so far as technique is concerned, is the elimination of black, the non-color," to which Renoir replied: "Black a non-color? Where on earth did you get that? Why, black is the queen of colors!" Further on, Vollard quoted again: "Manet died before he was able to take advantage of the luminosity derived from the division of tones." "He was lucky to have died in time," retorted Renoir.[16]

Renoir in Italy

In the autumn of 1881 the painter went to Venice, where he was particularly drawn, in his words, to "Carpaccio, with his fresh and gay colors. He was one of the first who dared to paint people actually walking in a street."[17] Subsequent visits to Florence and Rome inspired Renoir's profound appreciation for the masters of the High Renaissance, especially Raphael: "I must confess that my greatest joy was Raphael. Especially at Florence. . . . I can't begin to tell you how I felt when I first saw the *Virgin of the Chair!* I expected to have a good laugh; but I found the freest, the most solid, the most marvelously simple and living kind of painting that it is possible to imagine. The arms and legs were of real flesh! And what a touching expression of maternal tenderness!"[18] Of Raphael's frescoes in Rome, he wrote to Durand-Ruel: "I should have seen them before. They are full of knowledge and

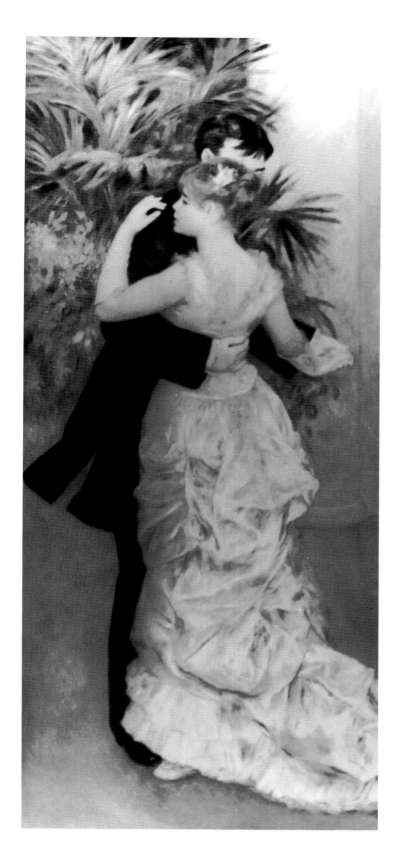

*In these pendant pictures, Renoir contrasts city and
country amusements. In* Dance in the City *the potted
palm, the column, and the elegant dress of the dancers add
up to a picture of Parisian sophistication.* Dance in the
Country *creates a mood of rustic pleasure with the straw
hat on the floor, the untidy table, and the forthright look
on the woman's face.*

ABOVE
204.
Pierre-Auguste Renoir
Dance in the City
1883

RIGHT
205.
Pierre-Auguste Renoir
Dance in the Country
1883

RIGHT
207.
François Boucher
The Bath of Diana
1742

wisdom. Unlike me, he did not seek the impossible."[19] From Rome, Renoir journeyed to Naples and Pompeii, where the "simplicity of workmanship" in the ancient frescoes reminded him of Corot.[20] In Palermo Richard Wagner sat for a portrait: "I was very nervous and I regret that I am not Ingres," the painter wrote to a friend.[21]

The upshot of Renoir's disenchantment with Impressionism and his newfound enthusiasm for the art of the past was

> *a sort of break [that] came in my work about 1883. I had wrung Impressionism dry, and I finally came to the conclusion that I knew neither how to paint nor draw. In a word, Impressionism was a blind alley, as far as I was concerned Out of doors there is a greater variety of light than in the studio, where, to all intents and purposes, it is constant; but, for just that reason, light plays too great a part outdoors; you have no time to work out the composition; you can't see what you are doing If a painter works directly from Nature, he ultimately looks for nothing but momentary effects; he does not try to compose, and soon he gets monotonous.*[22]

So it was back to the studio, and back to the study of academic techniques. During this year Renoir by chance came across Cennino Cennini's *Il libro dell'arte*, a manual for painters written in the fifteenth century. He found it full of useful advice, and immediately began to apply it to his work.

Renoir's Dry Period

The five years or so from 1883 on are known as Renoir's "dry" (or "harsh" or "sour") period, but it was not unrelievedly arid. To 1883 belong the pendant pictures he painted for Durand-Ruel, *Dance in the City* and *Dance in the Country*. Paul Lhote and Suzanne Valadon, one of Renoir's favorite models, posed for the former, Lhote and Aline for the latter. *Dance in the City* (plate 204) is a cool, spare composition, all elegance and sophistication; a noble column and some potted vegetation provide the decor, and Renoir has lavished some of his most delicate brushwork on the lady's white satin gown. *Dance in the Country* (plate 205), on the other hand, is definitely plebeian in tone. Aline is enjoy-

Renoir's trip to Italy in 1882 had profound consequences for the development of his painting. His admiration for Raphael, coupled with an innate love for the human figure, led him away from Impressionist technique and plein-air themes. Confronting the past, he took on the time-revered bather theme with an energy that was now matched by the discipline of design. This chalk study (right) for the monumental canvas of Bathers *(plate 236) projects an almost Ingres-like firmness of contour; which was only slightly modified in the finished painting.*

209.
Pierre-Auguste Renoir
Nude (Study for "Bathers")
c. 1884–85

208.
Pierre-August Renoir
Bather Arranging Her Hair
1885

ing herself thoroughly, and looks as though she might even be perspiring. The composition is fussier, the colors brighter, and Impressionist touches still linger, as in the table in the background. Quite apart from their painterly merits, the very conception of the two pictures indicates Renoir's eagerness to accommodate bourgeois taste at this time.

In 1884 the anti-theoretician Renoir proclaimed a theory of his own, "Irregularism":

> *Nature abhors a vacuum, say the physicists; they might complete their axiom by adding that she abhors regularity no less. . . . The two eyes of the most beautiful face will always be slightly unlike; no nose is placed exactly above the center of the mouth; the quarters of an orange, the leaves of a tree, the petals of a flower are never identical; it thus seems that every kind of beauty draws its charm from this diversity. . . . One can thus state, without fear of being wrong, that every truly artistic production has been conceived and executed according to the principle of irregularity; in short, to use a neologism which expresses our thought more completely, it is always the work of an irregularist.*
>
> *At a time when our French art, until the beginning of this century still so full of penetrating charm and exquisite imagination, is about to perish of regularity and dryness, . . . it is the duty of all men of sensitivity and taste to gather together without delay, no matter how repugnant they may otherwise find combat and protest. An association is therefore necessary It will be called the Society of Irregularists Its aim will be to organize as quickly as possible architects, goldsmiths, embroiderers, etc., who have irregularity as their aesthetic principle. . . . No work containing copies of details or of a whole taken from other works will be accepted.[23]*

The project, fortunately, came to nothing; however, its muddled philosophy gives us a good idea of the intellectual turmoil that beset the ordinarily complacent Renoir (the declared admirer of the most "regular" of all painters, Raphael and Ingres) throughout most of the 1880s.

Renoir and the Grand Tradition

The principal monument of Renoir's "dry" period is the *Bathers* (plate 236), now in the Philadelphia Museum of Art. Renoir seems to have begun work on this large canvas in 1884 and finished it three years later. It is thoroughly academic in conception, despite Renoir's recent polemic. Its composition is adapted from an iron bas-relief in the gardens of Versailles, the *Bathing Nymphs* of 1668–70, by François Girardon. It also recalls the artist's "first love," Boucher's *Bath of Diana* (plate 207), and—as Barbara Ehrlich White has pointed out[24]—Raphael's *Galatea* fresco, which Renoir had so much admired when he visited the Farnesina in Rome. In fact, Renoir first exhibited the *Bathers* as an *essai de peinture décorative*, from which "we may assume that he meant it to be seen in relation to the great murals of the past."[25]

Nineteen preparatory studies, in various media, have survived, and the final drawings seem to have been transferred to the canvas by means of tracing paper. The two huge nudes to the left (for which Suzanne Valadon and Aline posed) and the crisply drawn trees behind them take up two-thirds of the canvas. The meticulous contours and ivory-like skin of the large figures seem almost to parody Ingres, whereas the girls in the water and the background landscape in the right-hand third of the composition are softer and more impressionistic. Perhaps, as White suggests, the contradictions within this unsatisfactory painting can be explained by Renoir's "Irregularist" credo.[26]

By the end of the 1880s, Renoir had begun to overcome his obsession with Ingres-like outline, and settled into a serviceable kind of late style. He sought, in a not entirely successful blend, to harmonize academic composition and drawing, the soft edges and high colors of Impressionism, and the bourgeois-sentimental subject matter that had occupied him in the seventies and early eighties. Color came first, at least in his intentions. In a 1912 interview with the American painter Walter Pach, Renoir stated:

I arrange my subject as I want it, then go ahead and paint it, like a child. I want a red to be sonorous, to sound, like a bell; if it doesn't turn out that way, I put more reds and others colors till I get it. I am no cleverer than that. I have no rules and no methods; anyone can look over my materials or watch how I paint—he will see I have no secrets. I look at a nude, there are myriads of tiny tints. I must find the ones that will make the flesh on my canvas live and quiver.[27]

212.
Pierre-Auguste Renoir
The Bather
c. 1917–18

In 1904, the year in which he moved from Paris to the Mediterranean town of Cagnes-sur-Mer, Renoir was struck with rheumatoid arthritis. The disease progressed rapidly, and left him crippled to a large degree. After 1912 he had to paint with his brushes tied to his fingers. But his zest for iife was unimpaired; he went on painting—preferring female nudes—practically to the end. Not long before his death from pneumonia in 1919, he was heard to murmur, "I am beginning to show promise."

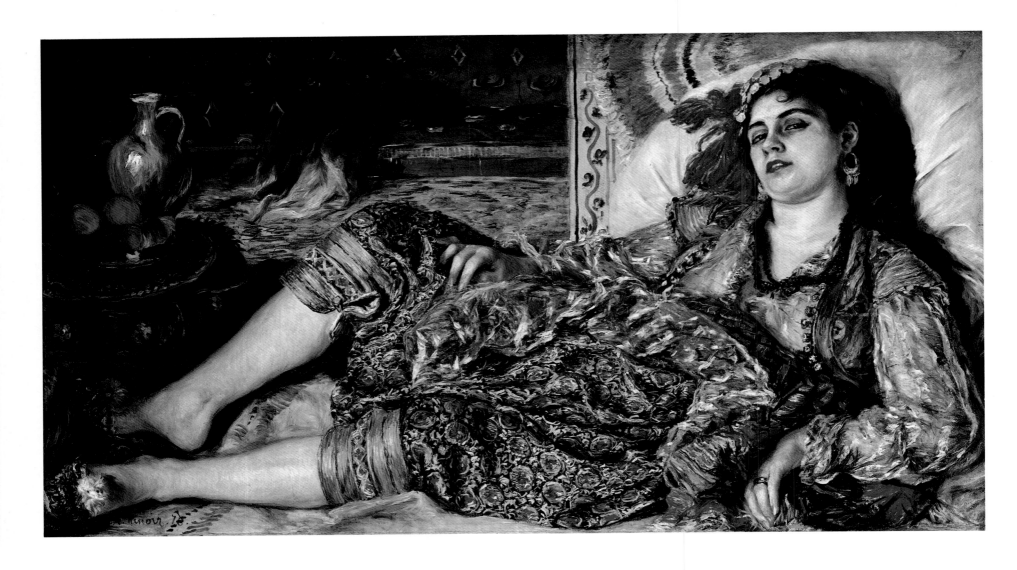

213.
Pierre-August Renoir
Odalisque
1870

Although Renoir later recalled him as "a second-rate schoolmaster but a good man," Gleyre considered his young pupil extremely promising. He cautioned him, however, against succumbing to the "cult of color." In early figure compositions such as Diana *(opposite), Renoir did limit the role of color, opting for a clarity and materialism that owe much to Courbet; but his conversion to the "cult" is clearly evident in this odalisque, an imaginative variation on the oriental love slave theme long associated with Delacroix.*

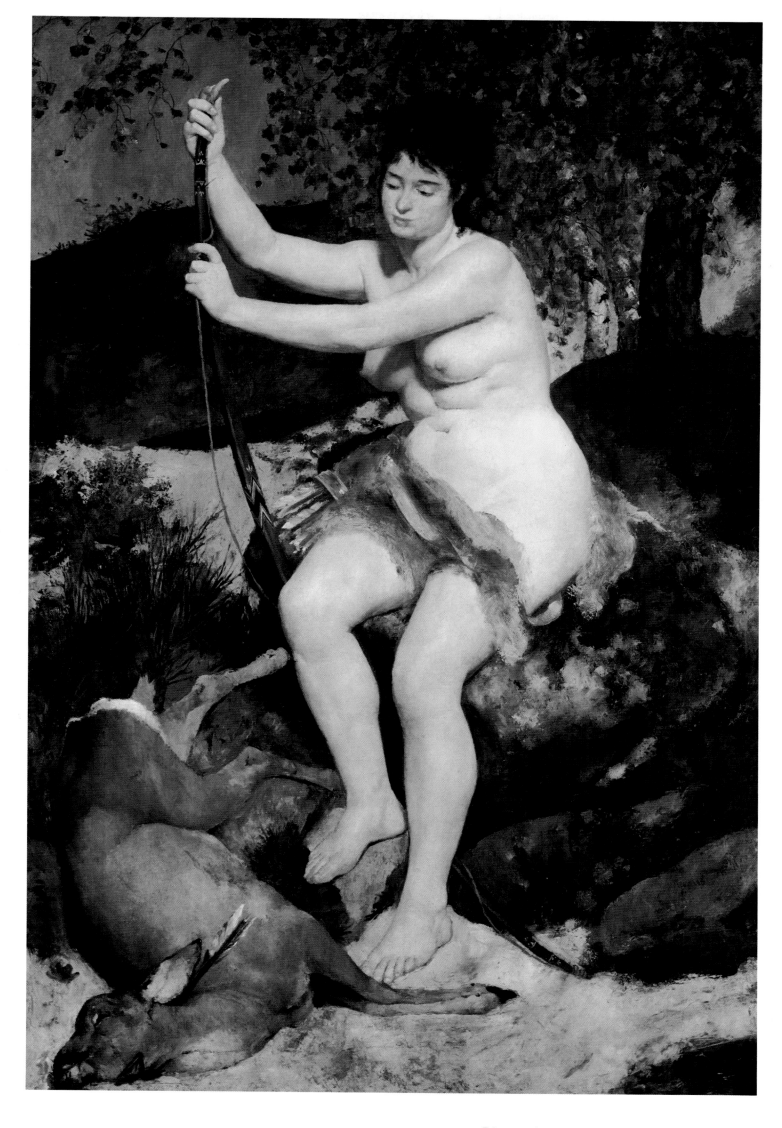

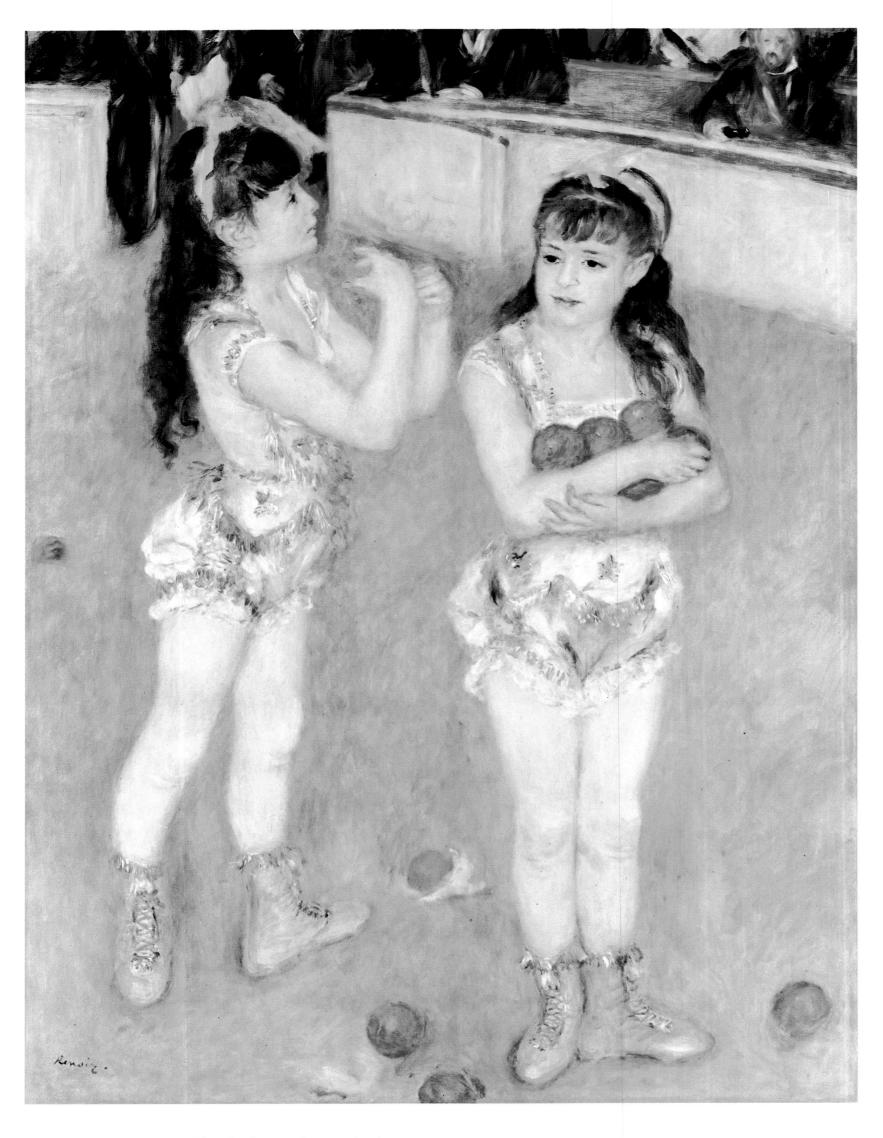

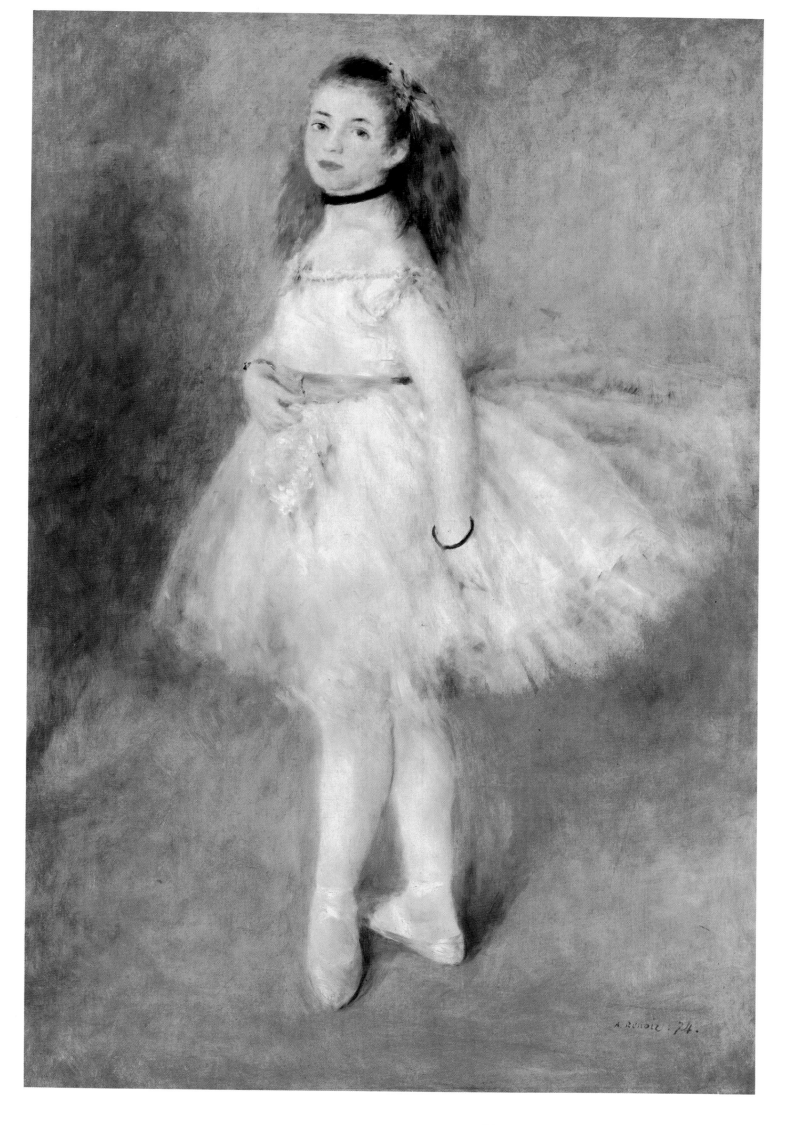

OPPOSITE
215.
Pierre-August Renoir
Two Little Circus Girls
1879

LEFT
216.
Pierre-August Renoir
The Dancer
1874

For Renoir, painting was first and foremost a source of pleasure, and he sought to transmit to the viewer his delight in a subject. With fresh color and deft brushwork he enlivened the components of an otherwise commonplace view. The artist held that painting "should be something pleasant, cheerful and pretty, yes pretty!"

FAR LEFT
217.
Pierre-August Renoir
Picking Flowers
1875

LEFT
218.
Pierre-August Renoir
Woman in a Park
1870

219.
Pierre-August Renoir
*Madame Monet and Her Son
in Their Garden*
1874

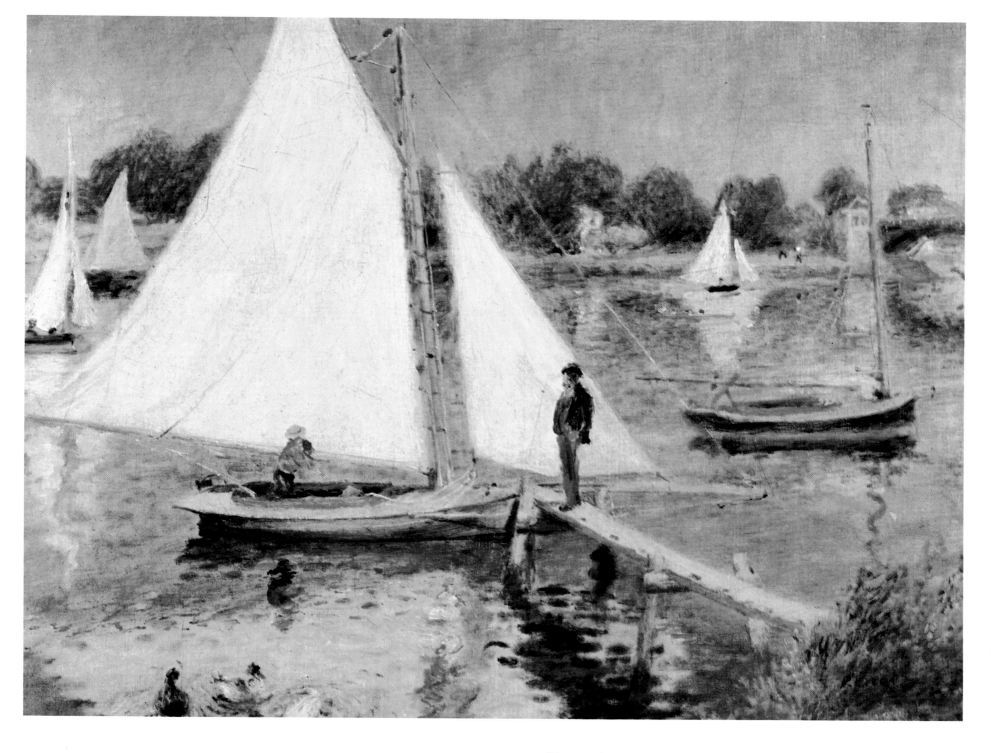

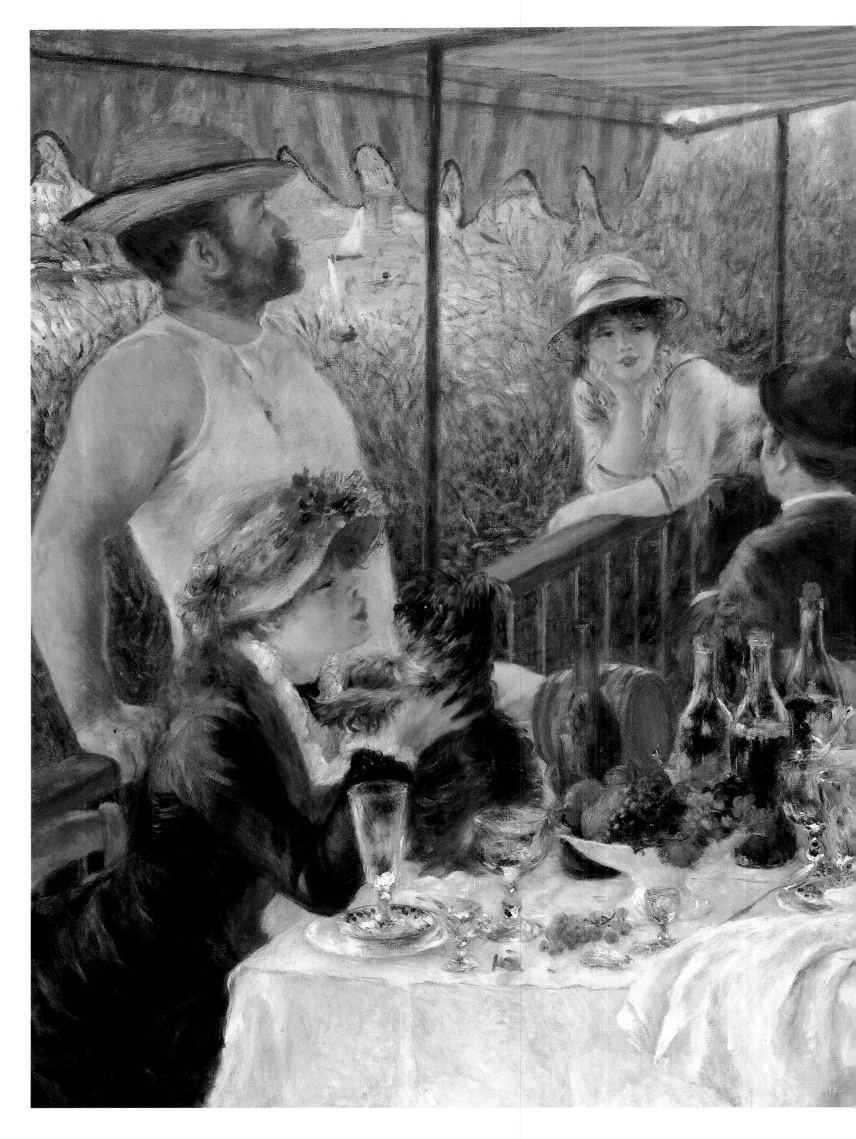

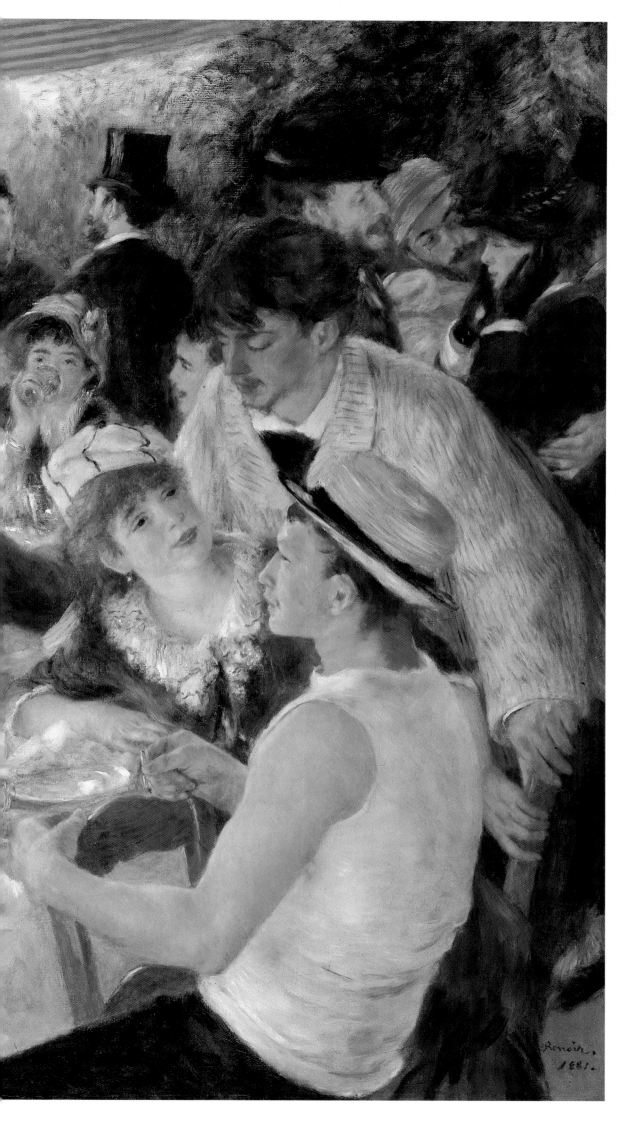

Representations of men and women feasting on fruit and wine date from classical antiquity. Yet Renoir's scene is not mythological—his is a very modern bacchanal. The luncheon takes place at the Fournaise, a restaurant on the island of Chatou, and the boaters are real-life friends of the painter. Renoir's sheer love of painting is conveyed in the rich and sensual coloring and in the delicate light which, filtered through the leaves surrounding the terrace, dances on the fruit, the glass, and the boaters' rosy skin. The slightly tipsy expressions on some of the faces tell us that they too share in Renoir's delight.

221.
Pierre-August Renoir
The Luncheon of the Boating Party
1881

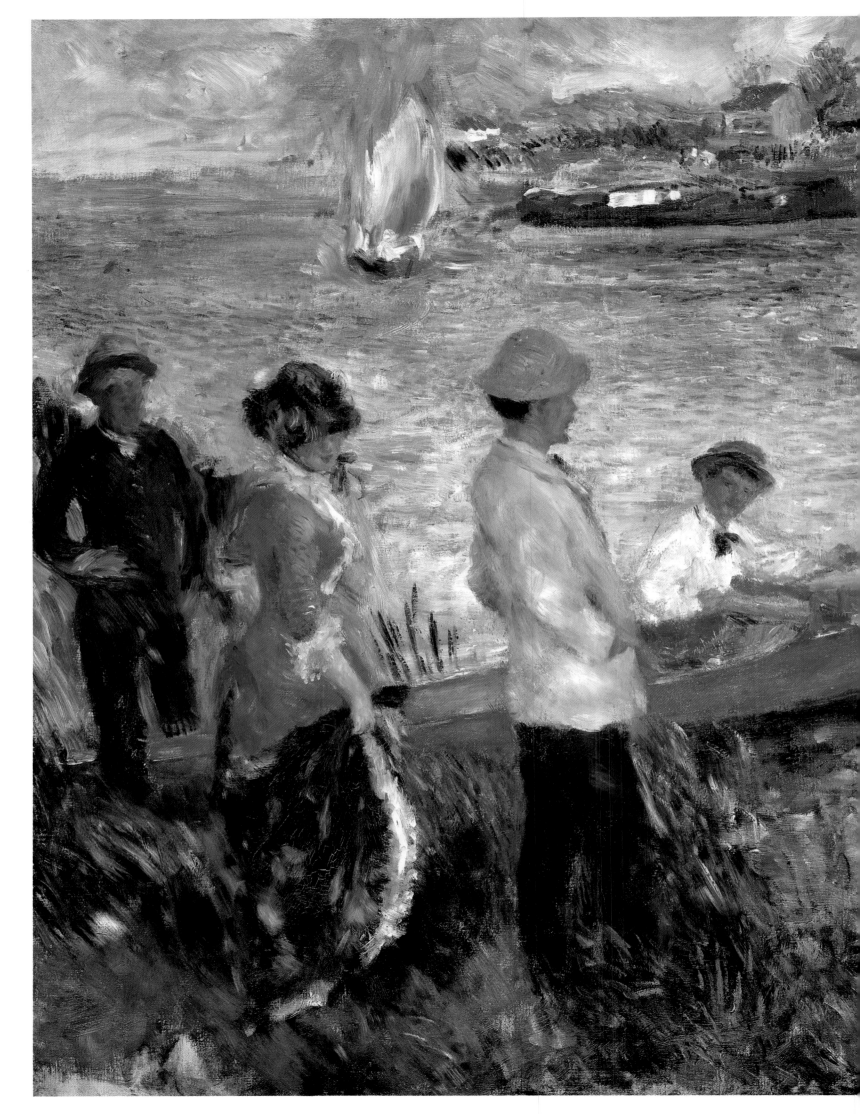

224 • Pierre-Auguste Renoir: The Exuberant Impressionist

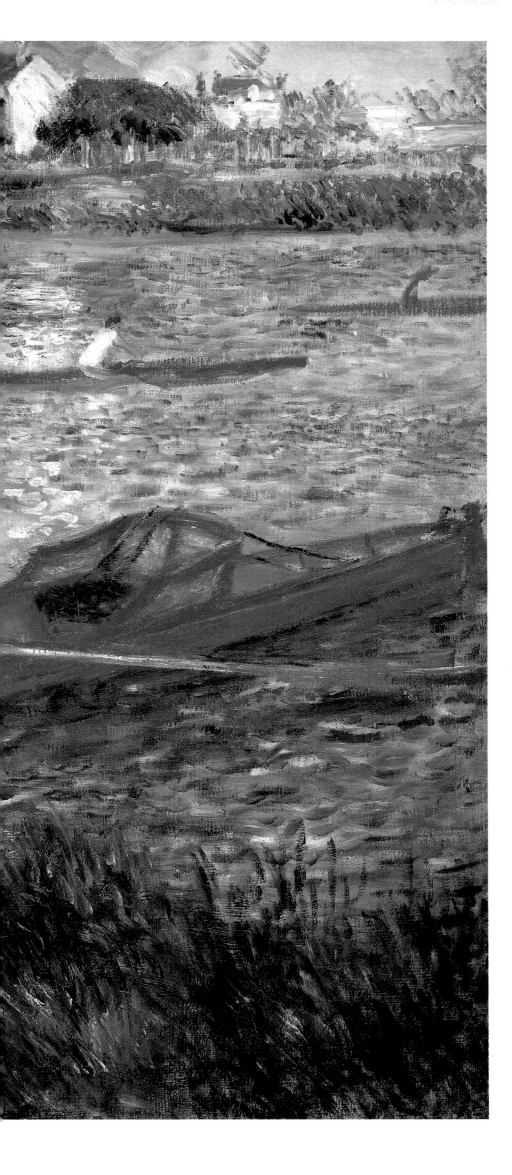

If the pleasures of Bougival, Chatou, and the other boating spots frequented by fun-loving young Parisians made them the Cytheras of their time, then Renoir was the ideal Watteau to immortalize them. In this view, he consciously juxtaposes opulent reds and oranges against the overall blue that shimmers off the surface of the river and reverberates through the figures and patches of grass and flowers.

PAGE 226
223.
Pierre-August Renoir
Le Déjeuner
1879

PAGE 227
224.
Pierre-August Renoir
Portrait of Alfred Sisley
1874

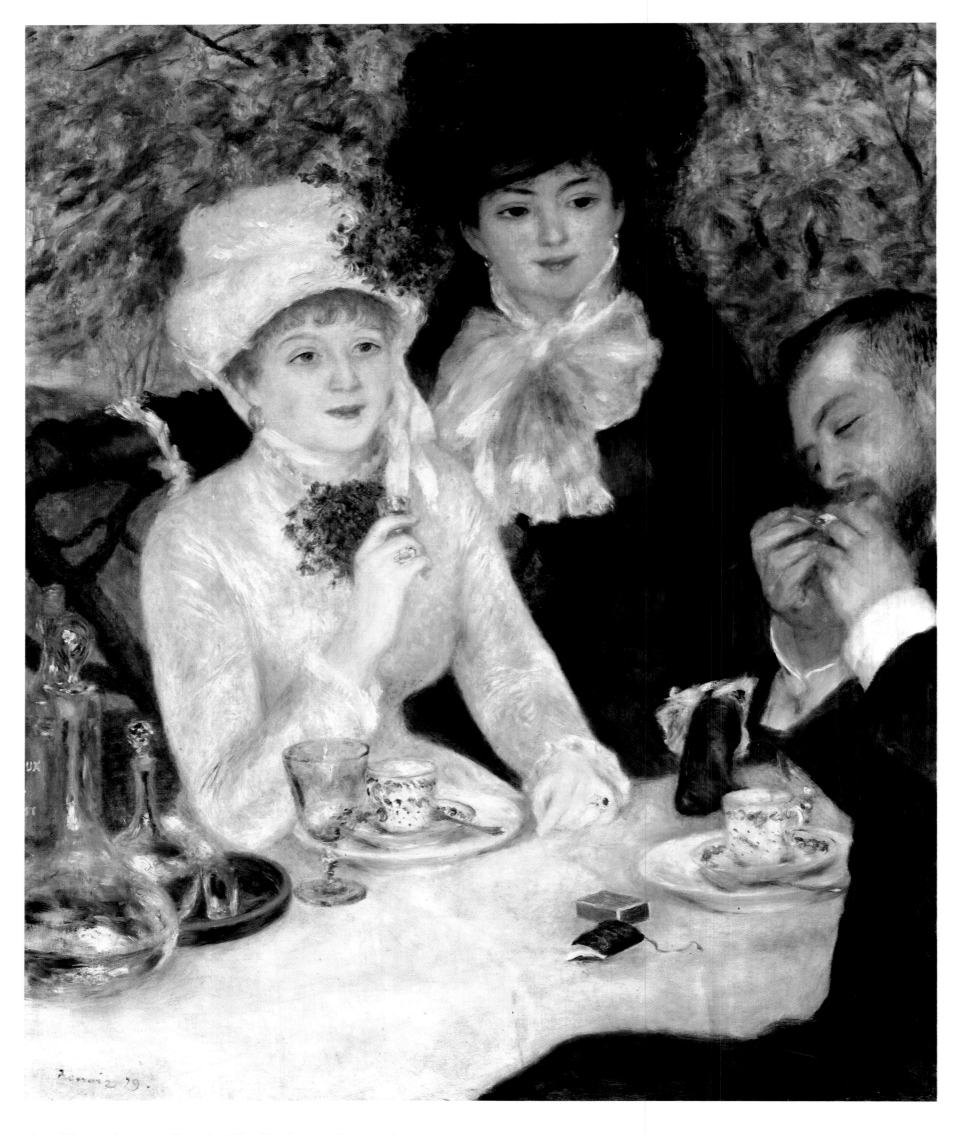

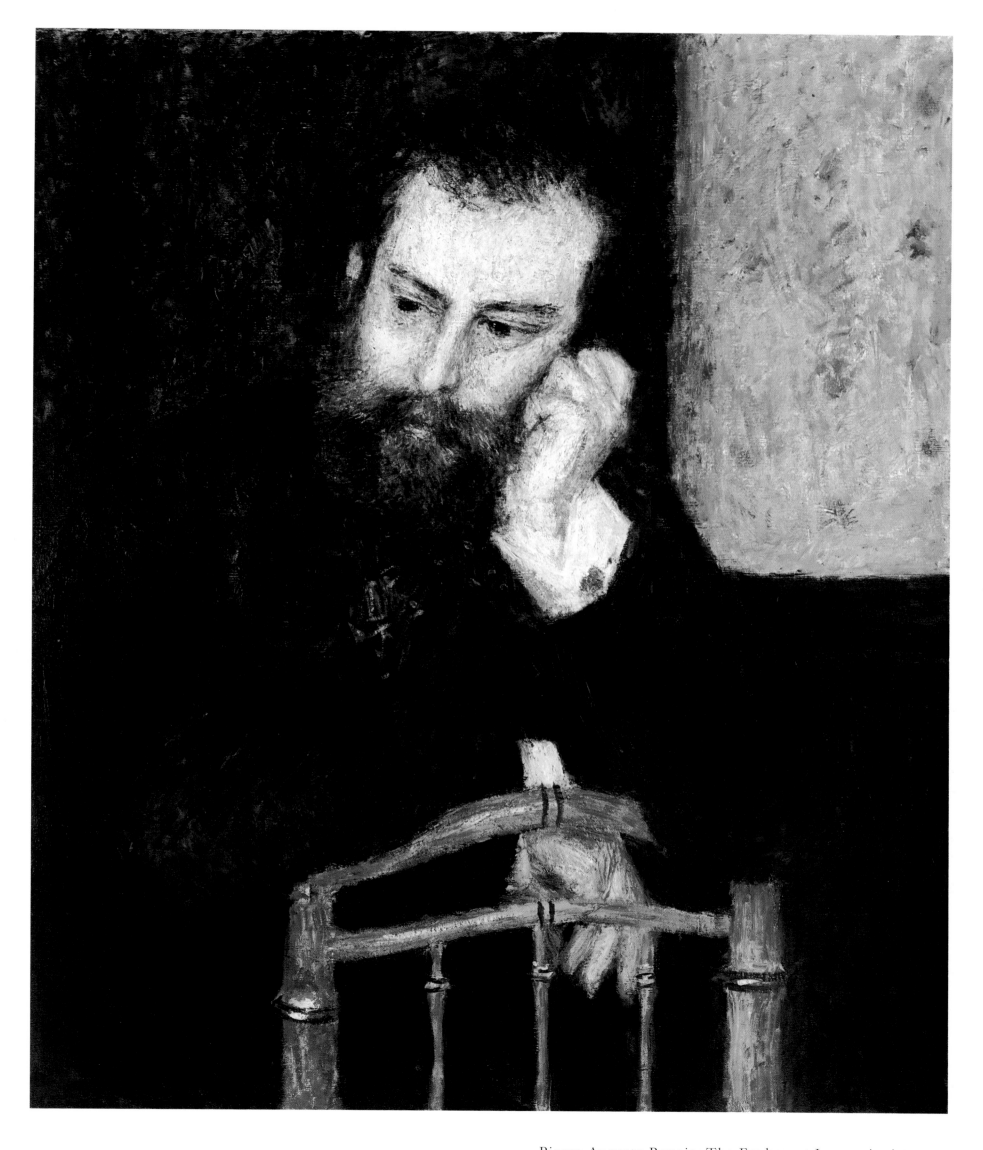

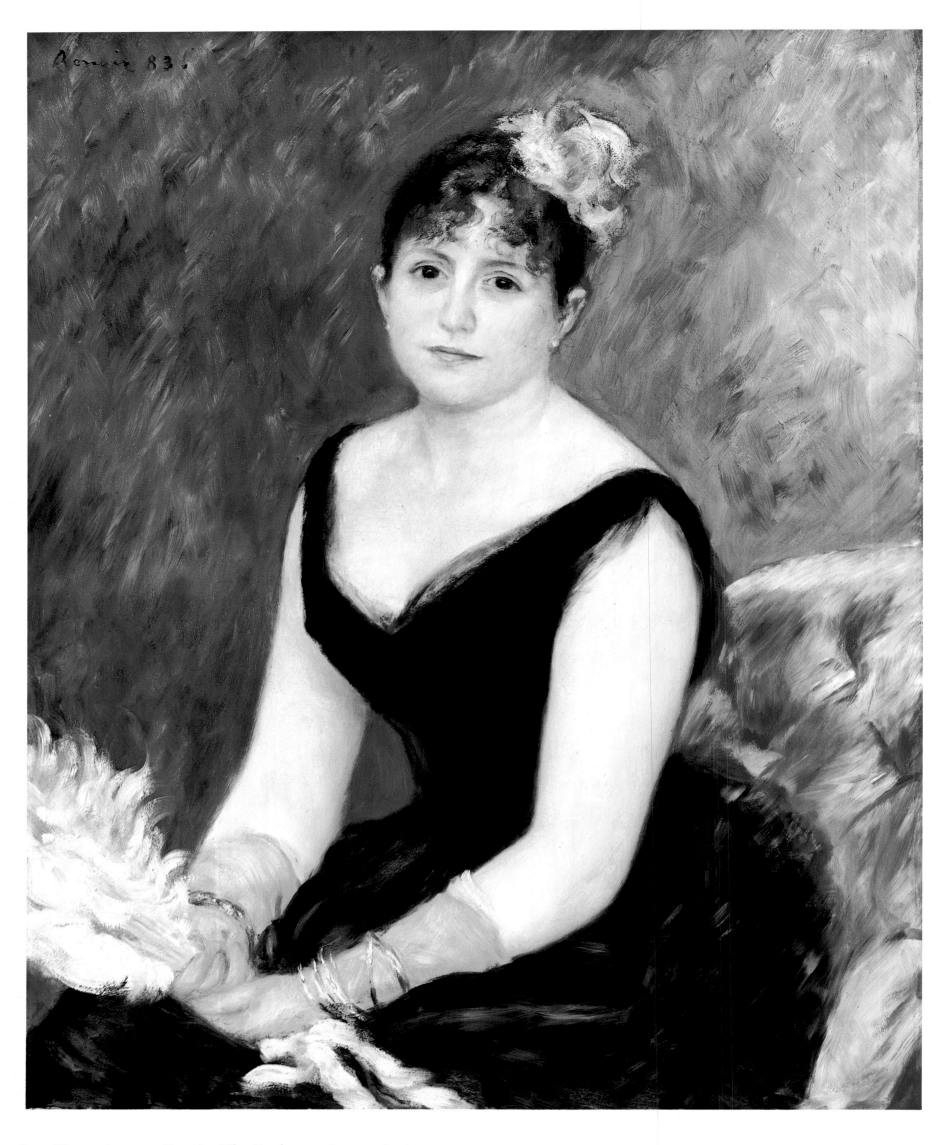

OPPOSITE

225.

Pierre-August Renoir

Madame Clapisson (Lady with a Fan)

1883

RIGHT

226.

Pierre-August Renoir

Mademoiselle Sicot

1865

PAGE 230

227.

Pierre-August Renoir

Woman with a Cat

C. 1875

PAGE 231

228.

Pierre-August Renoir

Lady at the Piano

C. 1875–76

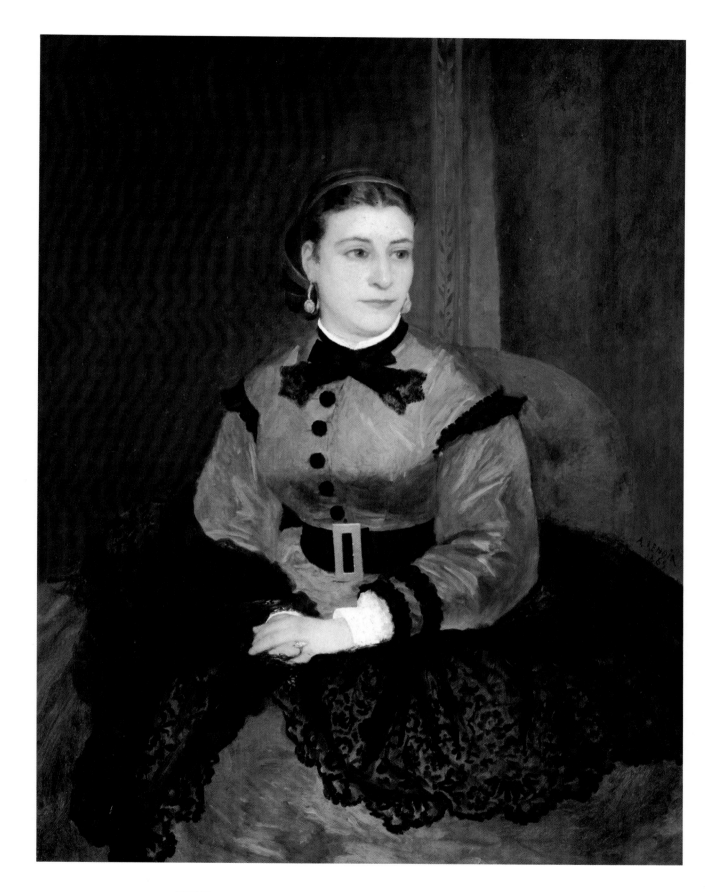

When he painted Mademoiselle Sicot, *Renoir was a young beginner just out of Gleyre's studio; still, the marvelous feeling for color and texture evidenced in this early portrait gives some hint of the mastery he would achieve. It reminds us of his unabashed delight in the sensual beauty of women—such as the beautiful socialite he painted some twenty years later.*

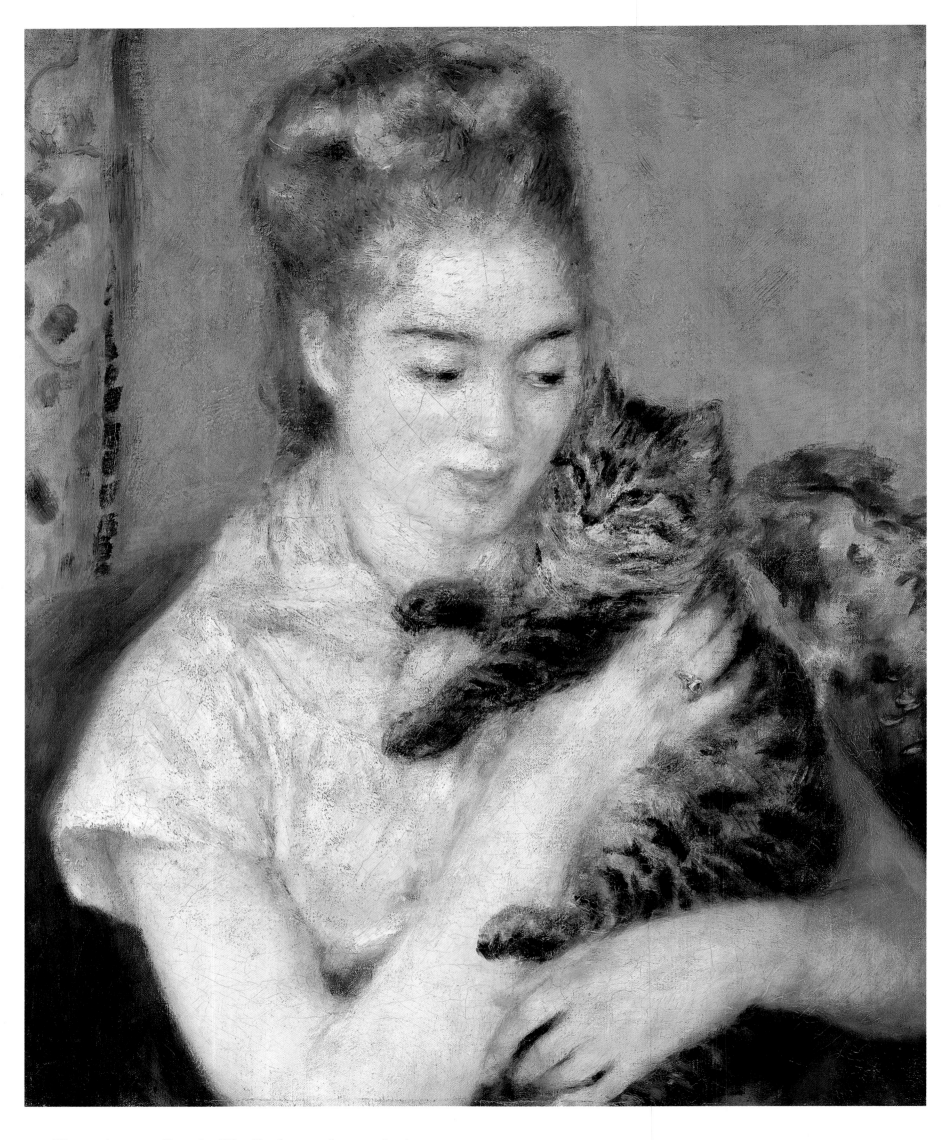

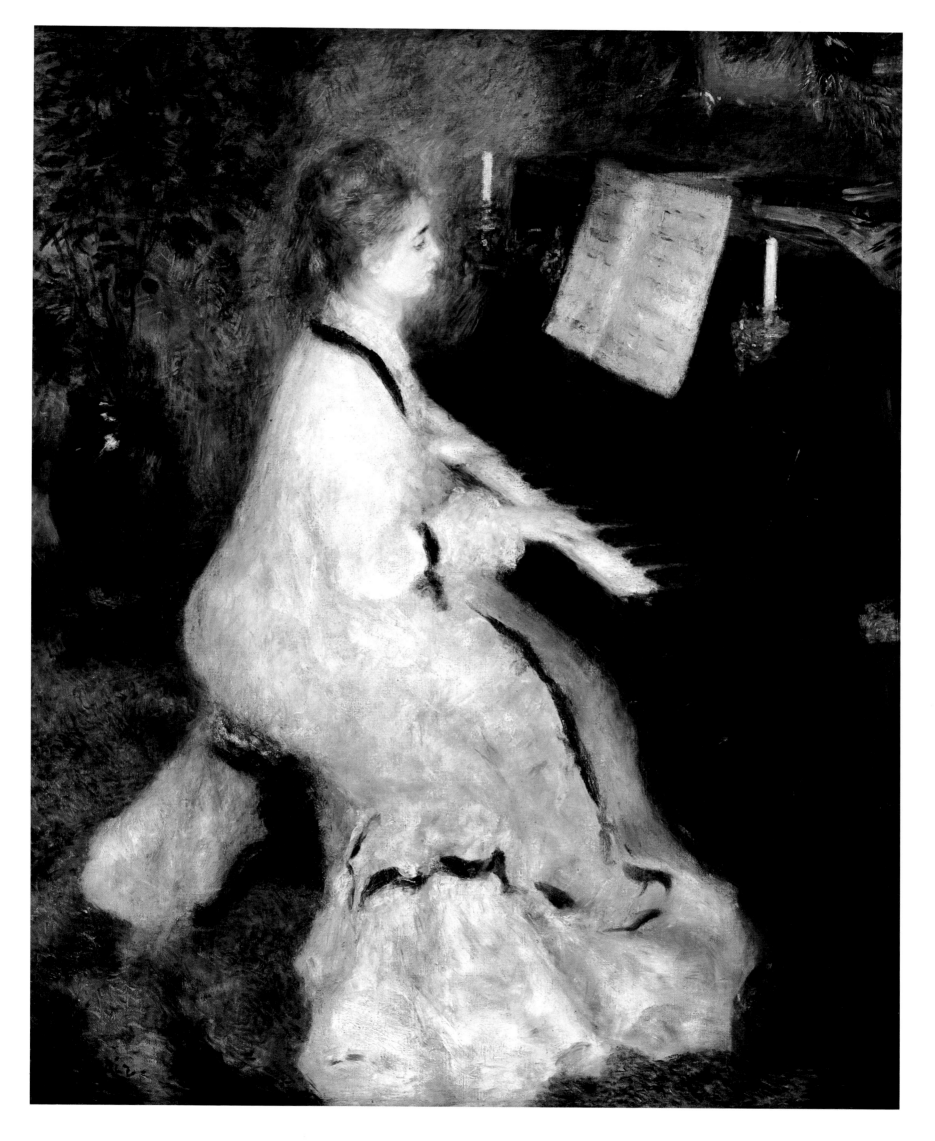

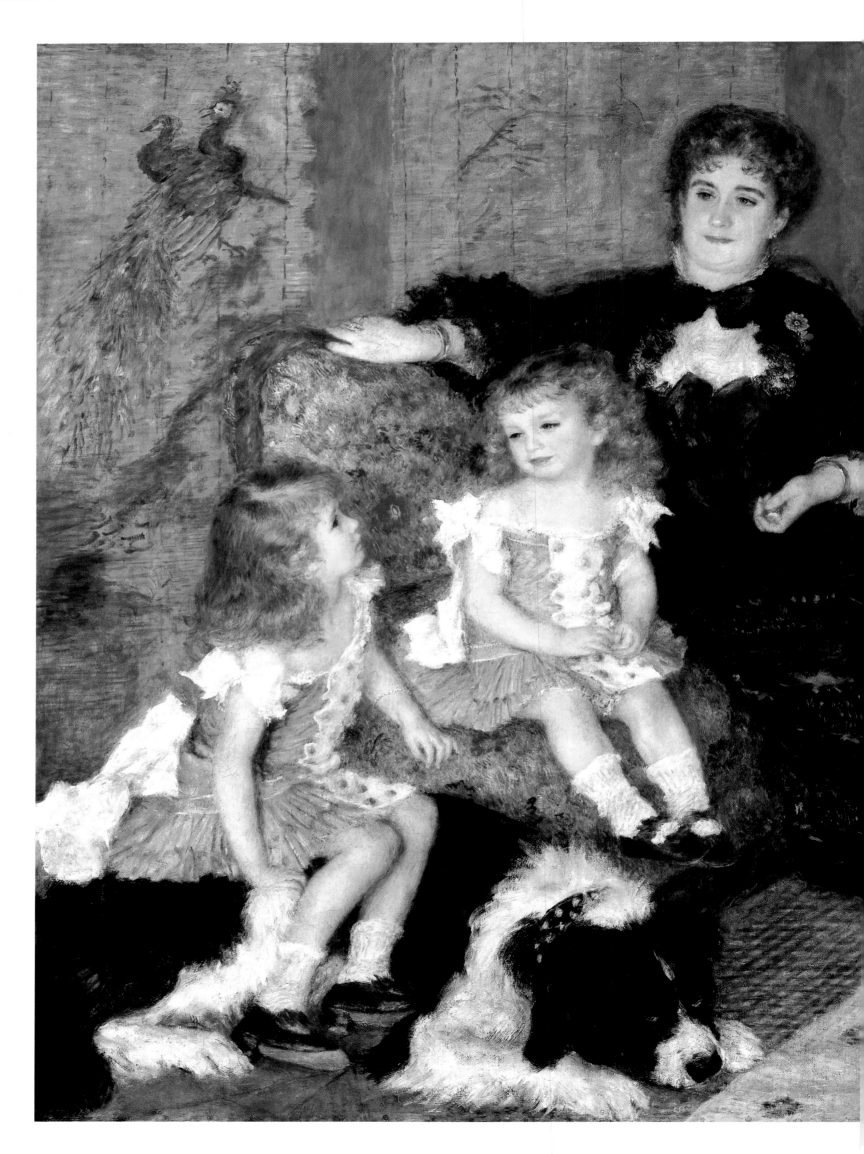

In 1879 Renoir deserted the Impressionists for the Salon, where he exhibited a huge portrait of the handsome wife and children of Georges Charpentier, the publisher of Zola and Maupassant. The painting was an instant success, and the social position enjoyed by Madame Charpentier worked as a magnet to attract prestigious patrons to Renoir. Even though the work was obviously a commission, Renoir did not shortchange his own interest in sumptuous detail. The rich and fashionably orientalized interior, sensuously defined by the red and gold passages, serves as a marvelous foil for the blues, whites, and blacks of the human and animal sitters.

LEFT
231.
Pierre-August Renoir
Madame Charpentier with Her Children, Georgette and Paul
1878

PAGE 236
232.
Pierre-August Renoir
Young Woman Sewing
1879

PAGE 237
233.
Pierre-August Renoir
In the Meadow
C. 1890

Pierre-Auguste Renoir: The Exuberant Impressionist • 235

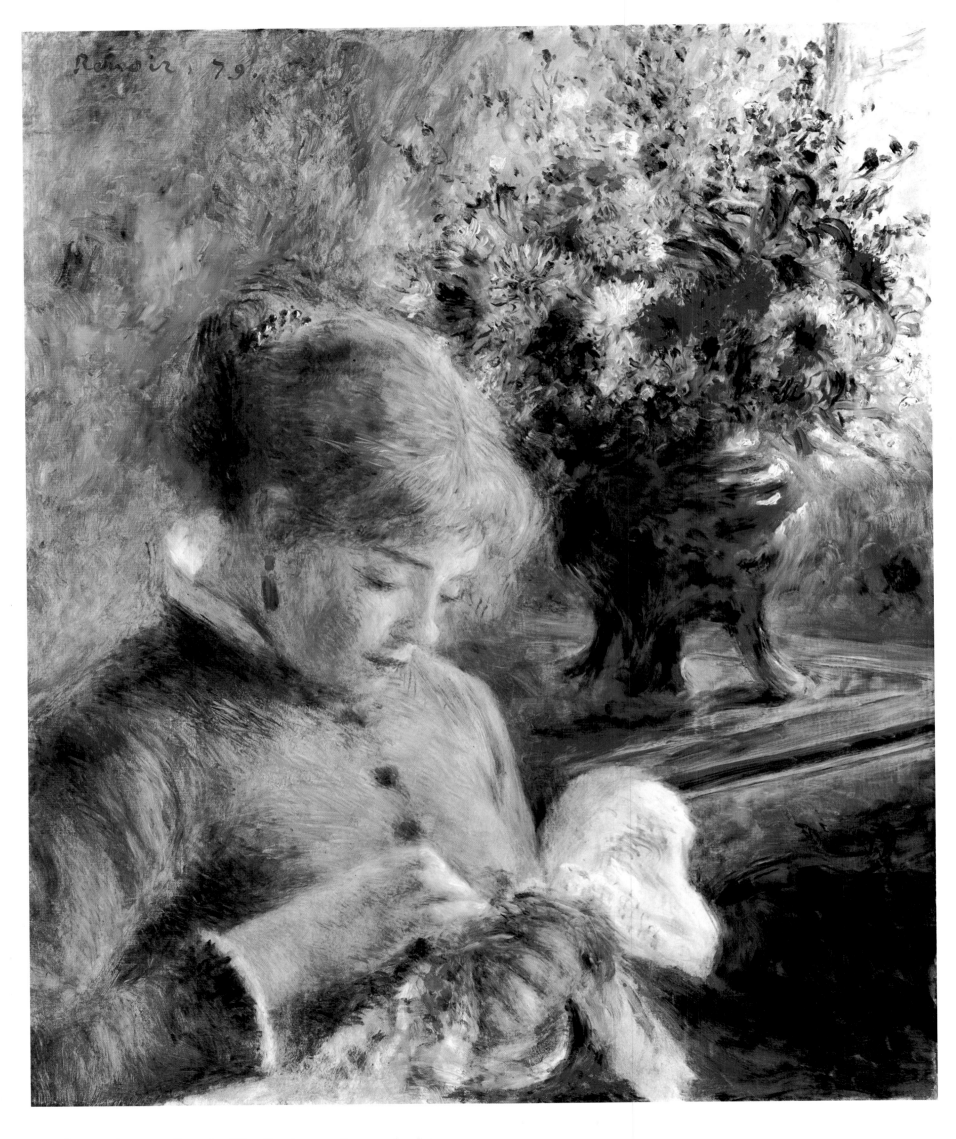

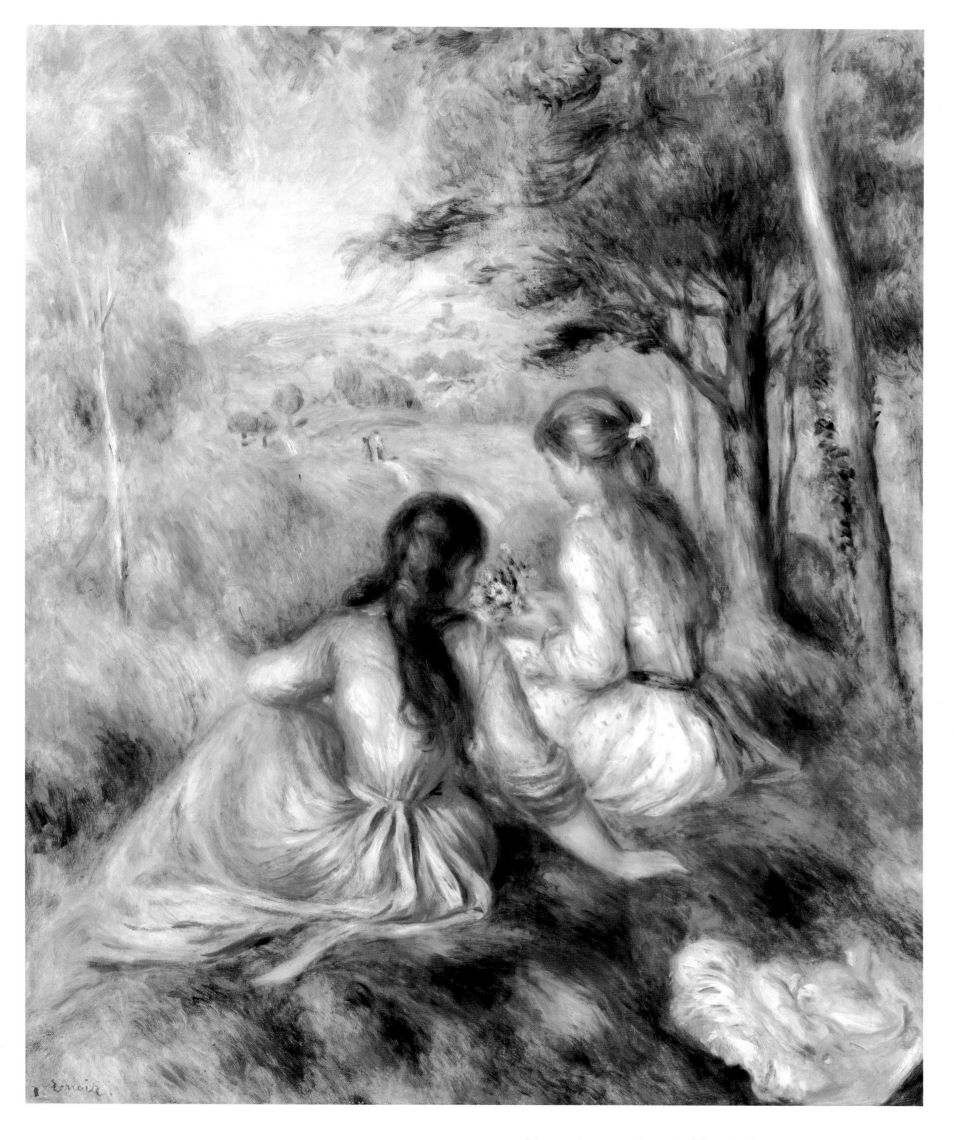

RIGHT

234.

Pierre-August Renoir

Girl with a Hoop

1885

OPPOSITE

235.

Pierre-August Renoir

Bather Arranging Her Hair

1893

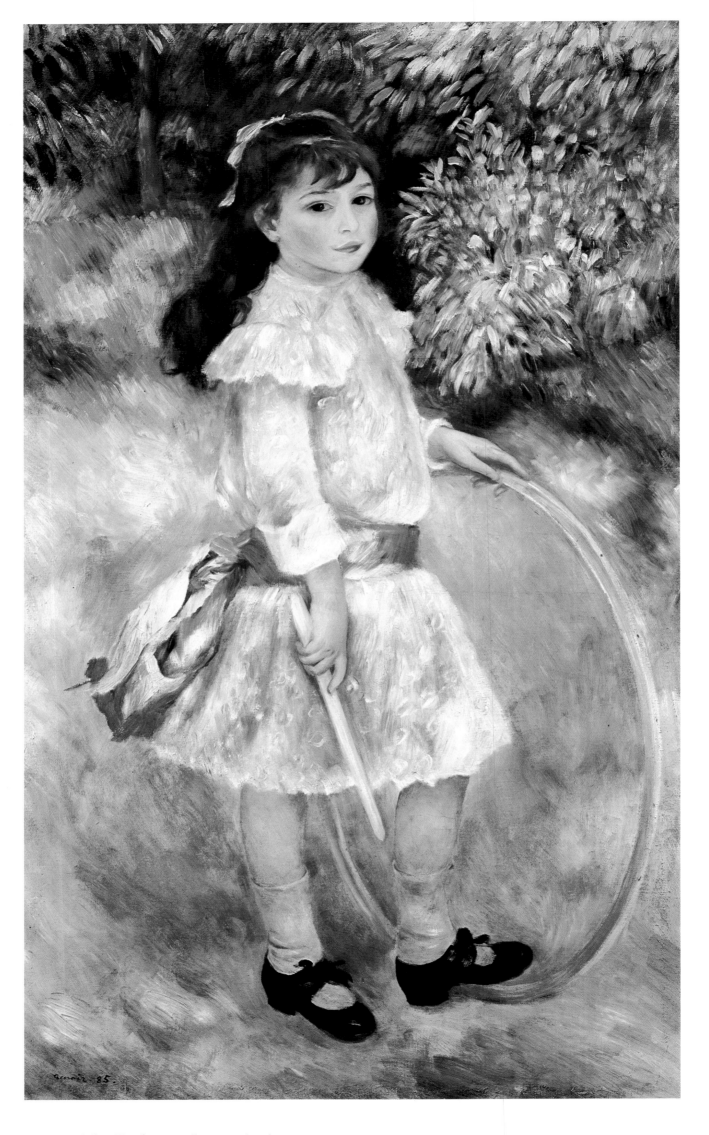

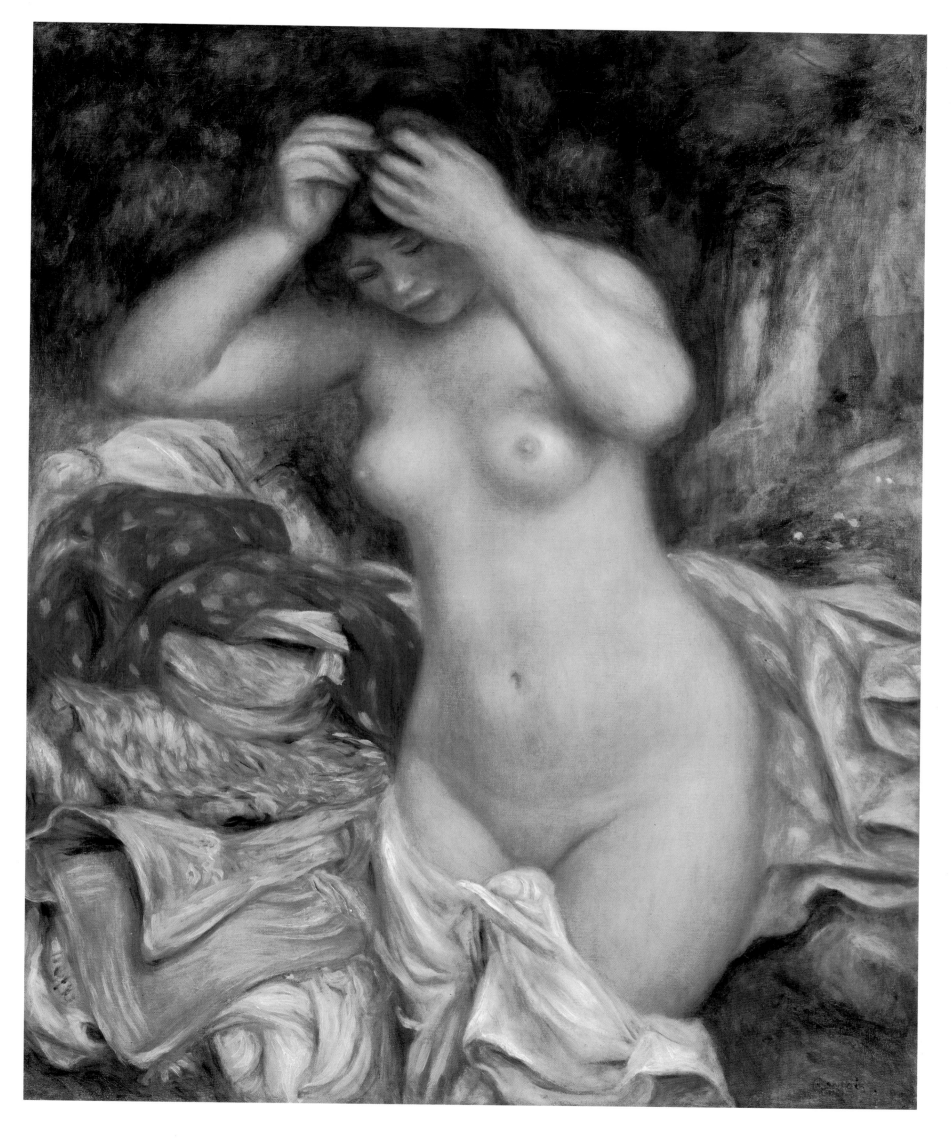

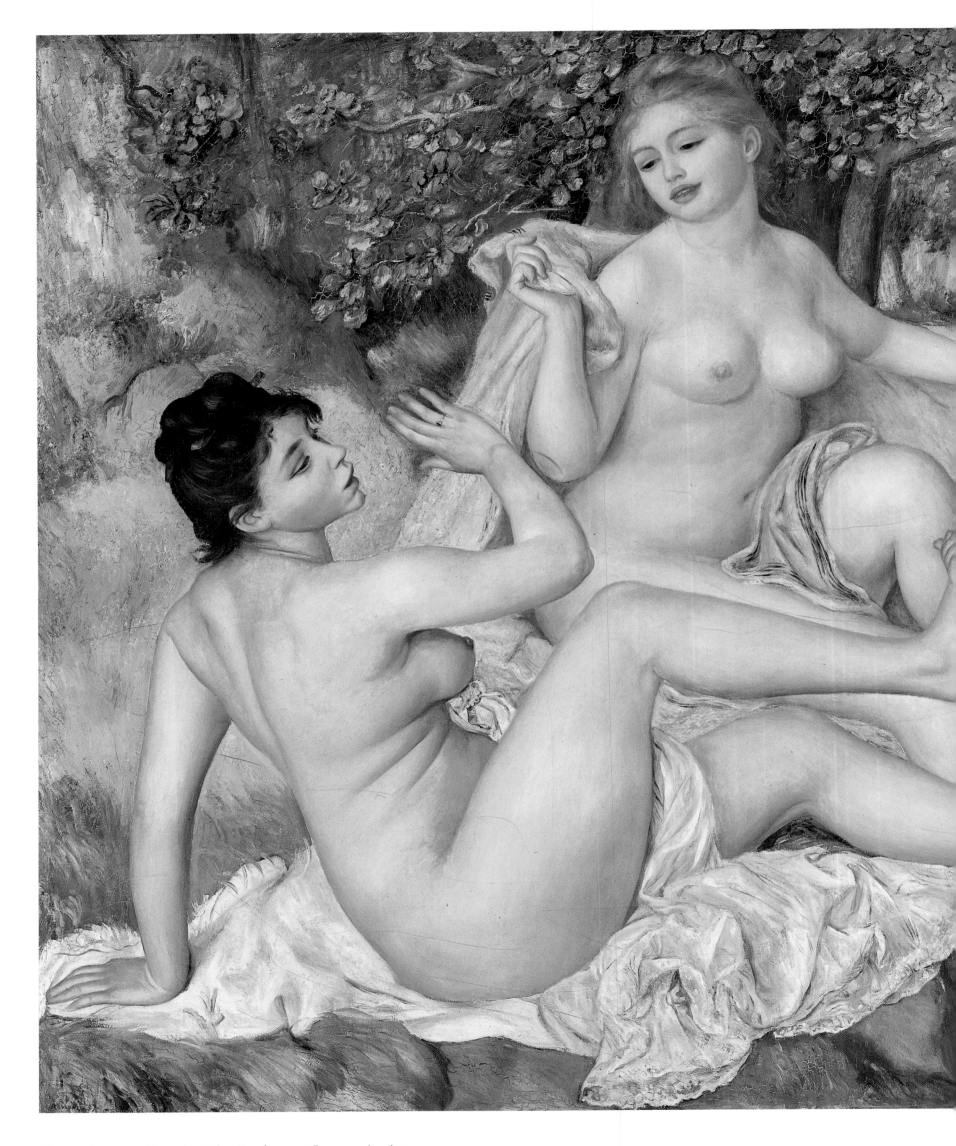

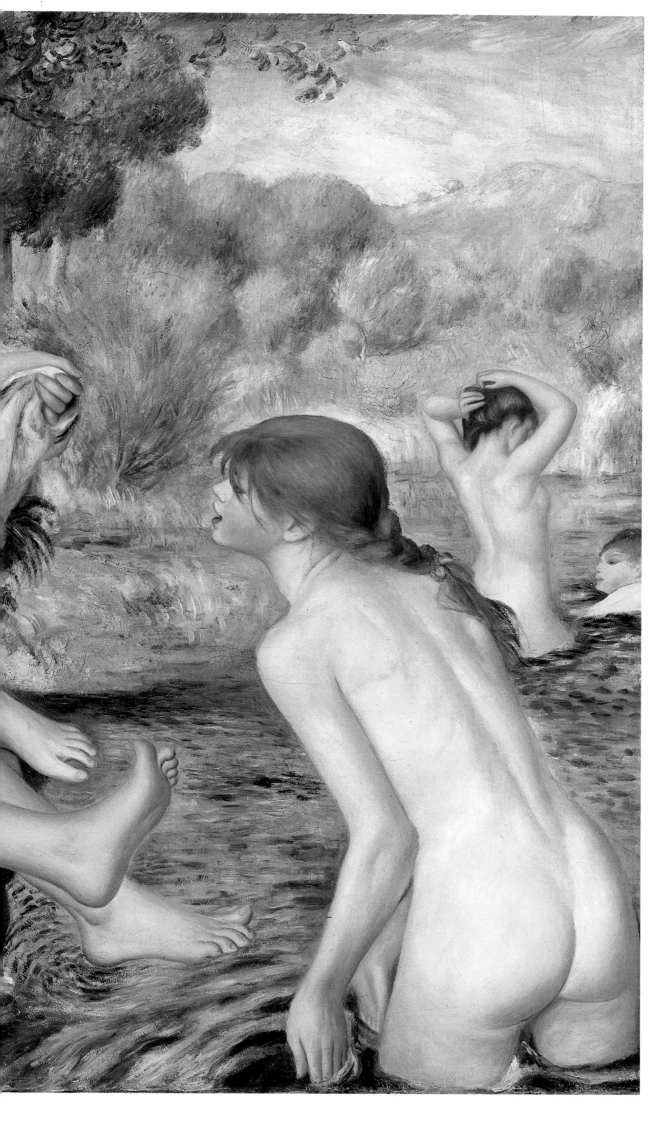

The beginning of Renoir's so-called dry period can be traced to his prolonged study of the work of the Italian Renaissance, in particular Raphael, during the winter of 1881–82. He came more and more to value those formal qualities that emerged from careful drawing, and began almost to despise the summary and spontaneous effects he had sought as an Impressionist. His early reverence for Boucher's nudes was now matched by an enthusiasm for Ingres as he sought to synthesize more delicate color with firm contours. Here he flatly rejects the contemporaneity of his colleagues in favor of the timeless look of traditional mythological painting.

236.
Pierre-August Renoir
Bathers
1887

Edgar Degas and Henri de Toulouse-Lautrec: The Studied Moment

Farewell to the human body treated like a vase with decorative, swinging curves; farewell to the uniform monotony of the framework, the flayed figure jutting out beneath the nude; what we need is the particular note of the modern individual, in his clothing, in the midst of his social habits, at home or in the street.

<div align="right">EDMUND DURANTY</div>

In the group of artists exhibiting at Nadar's photography studio in 1874, Edgar-Hilaire-Germain Degas stood out not only as an independent, but as a supremely aloof and inaccessible man. Although he had thrown in his lot with Monet, Sisley, Pissarro, and the other painters for whom Louis Leroy coined the term "Impressionist" by participating in all but one of the group exhibitions, Degas abhorred the label and preferred to think of himself as a Realist. In the intense discussions at the Café Guerbois, which had focused on landscape painting, the importance of capturing immediate sensations, and the desirability of spontaneity, Degas played the role of dissident. He had studied painting with Louis Lamothe, a pupil of Ingres, and he never relinquished his belief that an artist could only learn about art from art.

For the supremacy of the eye, Degas substituted the supremacy of the mind. While he believed in the value of studying nature, he insisted that the crucial factor in painting was the artist's mediating intelligence. The exuberance, immediacy of vision, and casual execution that we associate with the paintings of Monet or Renoir contrast sharply with the calculated and highly refined form and content of Degas's oeuvre. Degas himself proudly underscored this difference when he maintained: "No art was ever less spontaneous than mine. What I do is the result of reflection and study of the great masters; of inspiration, spontaneity, temperament, I know nothing."[1]

Unlike most of his colleagues, whose origins were solidly middle or lower class, Degas was descended from aristocracy. His roots were more cosmopolitan than most: his banker father had been born in Naples and his mother came from a French family that had emigrated to Louisiana. Like his friend Manet, with whom he shared a common social background as well as a

reverence for the Old Masters, Degas had turned to painting from the study of law. Copying at the Louvre and spending long hours of tireless study in the print room of the Bibliothèque Nationale only stimulated his appetite for the art of the past and his desire to see these works in their native surroundings. With the promise of hospitality from relatives, he undertook several trips to Italy in the late 1850s, filling sketchbooks with drawings of the masterpieces he admired in Naples, Rome, and Florence. Often he would intersperse well-known works of art with the likenesses of relatives and friends he met in his travels, a practice that suggests he was already attracted to portraiture.

Degas did not neglect the heroes of his own generation. He admired both Ingres and Delacroix; and at the time of the organization of their one-man shows at the Exposition Universelle in 1855, he interceded with a family friend, Edouard Valpinçon, who owned Ingres's *Bather* (plate 10), to lend the painting to the master's retrospective. Later, he met Ingres, who admonished him to "draw lines, young man, many lines; whether from nature or from memory." Degas was doubtless also encouraged by Ingres in his decision to become a history painter, and he persisted in the late 1850s and early 1860s in painting the prescribed large historical and biblical subjects, such as *Jephthah's Daughter* (plate 238), that were supposed to gain him entry into the Salon.

Early Family Portraits

It is unclear precisely what factors combined to lure Degas away from traditional and historical subjects to an involvement with modern life. Perhaps it was shifting tastes and a gradual

OPPOSITE

Detail of plate 271

appreciation of the work of Honoré Daumier; or possibly that portraiture, especially the depiction of loved ones or close friends, began to exercise a greater pull on his interests. His first mature painting, and the largest and most complex of his portraits, is the penetrating *The Bellelli Family* (plate 262), begun in Florence in 1858 and finished seven years later in Paris. The sitters were his aunt Laura; her husband, Baron Gennaro Bellelli, an Italian nationalist; and their two daughters. The colors of the portrait—somber, formal black contrasting with white, gold, and a vibrant blue—recall those of Mannerist portraits, particularly Hans Holbein's and Lucas Cranach's.

Notebooks, sketches, and letters document the progress of Degas's work and reveal the painstaking process of transcribing individual motifs and combining them within a careful structure of verticals and horizontals. But Degas's emphasis on structure goes beyond his highly original sense of design and even beyond his wish to capture the way people disperse themselves around a room in reality; he uses the arrangement of the sitters and the furnishings that back them up to underscore the family's polarized relationships. The isolation of the father in the triangular space of the mantelpiece and armchair creates a horizontal accent that is overcome by the dominant vertical unit of the baroness and her daughters. This contrapuntal composition gives off a tension

ABOVE

237.
Edgar Degas
Standing Nude Youth
1856

RIGHT

238.
Edgar Degas
Jephthah's Daughter
1859–61

239.
Edgar Degas
Sulking
c. 1871

not usually present in contemporary family portraits, which put a greater emphasis on the harmony of the parts and thus expressed the stability of the group.

Degas's extended study of the sixteenth-century Florentine and Venetian portrait traditions may have stimulated his awareness of the importance of gesture and of "body language" in defining social status, personal character, and interpersonal relations. But his skill in organizing and communicating all of these elements was also sharpened by constant observation, a habit that linked him with certain Naturalist writers such as Zola and Duranty. Degas's unfinished portrait of his younger sister and her titled Italian husband, *Edmondo and Thérèse Morbilli* (plate 265), projects a daring contrast of formality with casualness and finality with incompleteness. Significant passages of the work were either left unfinished or painted over, suggesting that the artist was not entirely satisfied with what he had done. Yet the painting provides refreshing insights into character: Thérèse's oval face and large eyes gaze out shyly from above the summarily sketched dress, whereas the nonchalant grace of Edmondo's pose conveys the composure and security of the born aristocrat. His ease, bordering on arrogance, recalls the elegant sitters in portraits by Pontormo or Bronzino. As he had done in *The Bellelli Family*, Degas here crops the view of the room, so that the viewer must integrate the implied continuity of its space with its observed fragmentation. In so doing, Degas appears to be appropriating for fine art the arbitrary cropping, sharp outlines, and accidental blurs found in contemporaneous photography, a medium he subsequently took up himself.

The Modern Portrait

In later portraits involving two figures, Degas further exploited contrast, particularly of age or mood, as in the depiction of his elderly uncle and young niece (plate 266), which involves sitters actually related to each other, or *Sulking* (plate 239), in which his friend Duranty and an anonymous female model posed as a disaffected couple, simulating the domestic conflict that gives the painting its name. Like Manet, Degas was often intrigued by a visual experience into recreating the situation by means of artful deception.

A measure of just how far Degas had moved away from traditional portrait conventions is revealed by a comparison of his *Woman with Chrysanthemums* (plate 240) with one of Ingres's most celebrated portraits, *Comtesse d'Haussonville* (plate 241). Gone is the meticulous definition of the shape and texture of the objects that surround the sitter; even more significant is the change in distribution of visual emphasis, as the human figure vies with the floral motif for our attention. X-rays of the painting reveal two dates, 1858 and 1865, hinting that Degas added the figure to a preexisting study of flowers. Whether he altered a finished work or simply did the painting in stages, the resulting asymmetry, both physical and psychological, is quite daring, even by comparison with such advanced painters as Manet.

In the next decade Degas continued to experiment with unusual placement and with different and unexpected types of lighting effects. In his portrait of Madame Camus, the wife of a

Many of the portraits of women shown in this chapter employ mirrors, a favorite device of painters from the fifteenth century on for both physically and psychically amplifying the space of their subject and for commenting on the illusionistic intent of their craft. Earlier in the nineteenth century, Ingres had exploited the reflective image of the mirror to underline the two-dimensionality of the canvas; Degas made the mirror a repository of incomplete sensations and impressions of color that confuse rather than elucidate the physical identity of the setting.

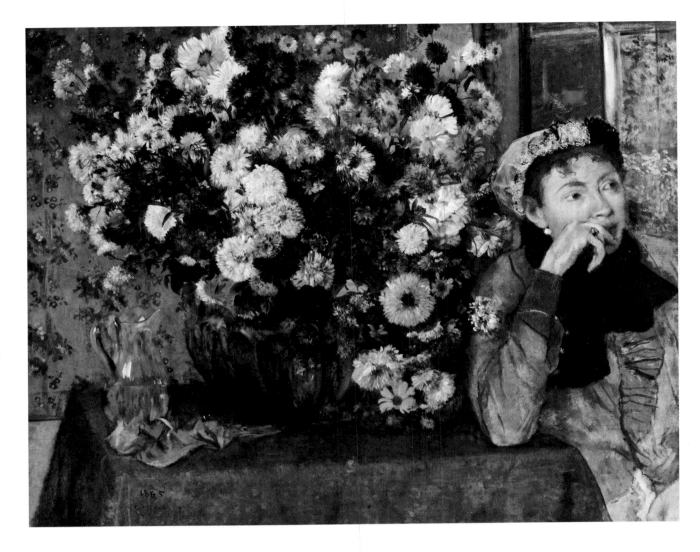

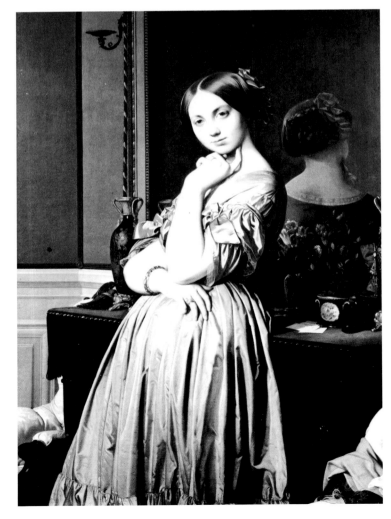

ABOVE
240.
Edgar Degas
Woman with Chrysanthemums
1865

RIGHT
241.
Jean-Auguste-Dominique Ingres
Comtesse d'Haussonville
1845

physician friend and an accomplished amateur musician (plate 267), the artist subordinates his sitter to the total physical ambiance; she never emerges as more than a shadowy profile against the red wall. The critic Edmond Duranty, who shared many of the painter's views on aesthetics and was generally sympathetic to his compositional innovations, complained that Madame Camus was overwhelmed by the background, though he did acknowledge the visual truth that this and other portraits proclaimed:

> If one now considers the person, whether in a room or in the street, he is not always to be found situated on a straight line at an equal distance from two parallel objects; he is more confined on the one side than on the other by space. In short, he is never in the center of the canvas, in the center of the setting. He is not always seen as a whole: sometimes he appears cut off. . . . At other times, the eye takes him in from close up, at full height, and throws all the rest of a crowd in the street or groups gathered in a public place back into the small scale of the distance.[2]

Degas's portraits of his artist friends James (Jacques-Joseph) Tissot and Diego Martelli (plates 242 and 244) may have been shown together in the fourth Impressionist exhibition. They document the considerable changes that had occurred in his approach to composition and to color. The earlier painting is far more formal in its attention to detail and in the precise pose

of the sitter, whereas the Martelli portrait, through its looseness of execution and odd figure placement, conveys something of the disorganization and rumpled informality of this Florentine champion of Impressionism.

Like Manet's portrait of Zola, the Tissot painting enumerates the interests of both the sitter and the artist who painted the work. A portrait by a follower of Cranach occupies the crucial center of the canvas, where it engages in an unexpected dialogue with Tissot, whose head is placed slightly off center. Other works that appear in the painting have been identified by Theodore Reff as Degas's free improvisations based on works by Tissot, a Japanese artist, an unidentified Impressionist, and possibly a Venetian. Tissot holds a pointer in his hand as though he were being interrupted in the middle of a discourse; Reff contends that he is deliberately shown in an equivocal situation, "neither actively at work in his own studio nor clearly a visitor to another artist's."[3]

As part of his ongoing experimentation with figure placement, Degas had advocated doing portraits from every conceivable vantage point; here he has painted Martelli as if working from a stepladder. Such an unorthodox angle gives the viewer a sense of unexpected and privileged intimacy. Seated on a rather impractical—certainly uncomfortable—Florentine folding chair, Martelli unselfconsciously folds his arms, closes his eyes, and assumes the attitude of one either concentrating or meditating.

LEFT
242.
Edgar Degas
Jacques-Joseph Tissot
c. 1868

BELOW, LEFT
243.
Edgar Degas
Manet at the Races
c. 1864

BELOW, RIGHT
244.
Edgar Degas
Diego Martelli
1879

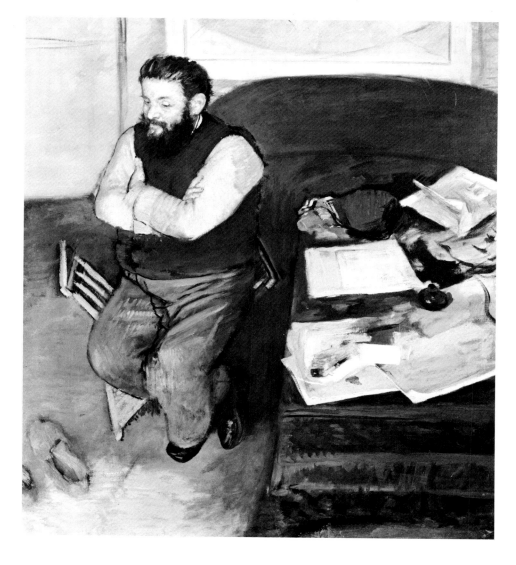

Edgar Degas and Henri de Toulouse-Lautrec: The Studied Moment · 247

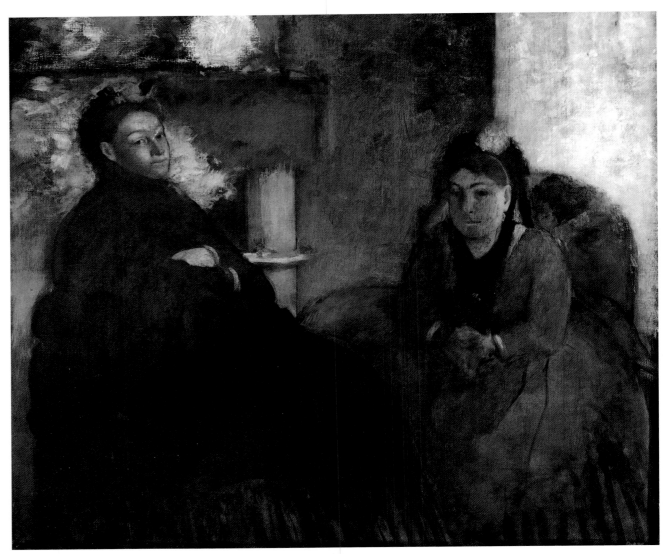

245.
Edgar Degas
*Madame Lisle and Madame
Loubens*
1869–70

Further Themes from Modern Life

Degas's interest in subjects from modern life and his resolve to capture men and women in their natural environments, performing familiar tasks or in repose, were stimulated by his friendships with Duranty and Manet. Like the first, who argued that all aspects of contemporary experience were worthy of investigation, and the second, who was one of the first artists to fashion suitable metaphors of urban reality, Degas was drawn to particular places and themes: the modish cafés that all three men frequented, the theater, and the racetrack, where members of the upper classes congregated to see and be seen. Degas's approach to subject matter was surely conditioned by personal character and social habit, but probably also reflected an innate reservation or fastidious disdain for certain aspects of contemporary life. He is reported to have contrasted the age of Louis XIV with his own, maintaining, "They were dirty, but they were distinguished; we are clean, but we are common." Yet, in his own way, he came to accommodate the ordinary, making it beautiful by faithful examination, even if he never plunged himself into the boulevards and railway stations of Paris as some of his Impressionist colleagues did.

Some of Degas's most "casual" paintings were actually quite calculated works, as for example *L'Absinthe* (plate 137). The spiritless and isolated couple were posed by two good friends of the painter: the actress Ellen Andrée and a fellow

Impressionist, Marcellin Desboutin. Although the painting was criticized many years later for celebrating a licentious lifestyle, it is as unpolemical in its recording of existential ennui as Manet's *The Plum* (plate 97). In painting *L'Absinthe*, Degas bothered little about the personal or social problems associated with the overconsumption of the infamous beverage; what mattered was the challenge of creating a composition that would project just the right aura of truth while, at the same time, conveying through its unorthodox and paradoxical space painting's implicit lie: its pretense to three-dimensionality. Appropriately, Degas's composition was set at the Café de la Nouvelle Athènes, which had been the locus for so many important discussions about the nature of painting in the early years of Impressionism.

Not far from the café was the Circus Fernando, a popular entertainment spot that provided new motifs for both Degas and Renoir. The two artists probably attended performances there together in 1879, and each responded to its range of performers in terms of his emerging aesthetic interests. Renoir was drawn to a charming pair of child jugglers (plate 215), while Degas preferred the more daring athletic feats of Miss Lala, the circus's star trapeze artist, whose act he watched on at least four occasions. Following what was by now his established practice, Degas made numerous sketches and a pastel, capturing the shifting figure against different aspects of the building. In the final oil (plate 269), he selected the most unusual of Miss Lala's positions, showing her being hoisted upward by her teeth toward the ornate

Degas and the Dance

roof of the circus. While Renoir concentrated on the personalities of the circus girls to the virtual exclusion of their surroundings (a choice at least partially determined by his execution of the painting in the studio), Degas pointedly recreated both the physical position of the performer against the background and the fragmented perspective of the spectator's view.

High-spirited horses, circus athletes, and dancers—movement both natural and stylized—formed the core of Degas's increasingly restricted subject matter in the 1870s and 1880s. Despite the variety of themes, these works reflect a unity of aesthetic intention. Seldom narrative or documentary, they provide the raw material for a synthesis of motion and setting that occupied Degas more and more as he economized the functions of line and color in later works. Central to this synthesis was an exhaustive analysis of human and animal structure, and the painter filled his notebooks with a veritable encyclopedia of attitudes and shapes. Inspired by the Renaissance masters, particularly Leonardo, Degas was motivated by an ideal of perfect design: a balance of the elements of painting, a union of form and content. He believed it was possible to reconcile the appearance of spontaneity with the sense of inevitably correct expression that came from doing a subject "again and again, ten times, a hundred times. Nothing in art should seem accidental, not even a moment."[4]

More than any other painter in history, Degas is associated with ballet. If art was Degas's mistress, he reserved a special passion for dance, which for more than forty years inspired his most unforgettable studies of the human body in motion and repose. For other members of his social class, opera and ballet were simply appropriately cultivated and therefore fashionable forms of entertainment. Degas, however, had inherited from his father a deep love of music and theater and a respect for the craft and skill of musicians, actors, and dancers. He sought to represent not only the professional image of the performer, but also the long hours of arduous preparation and accompanying fatigue.

Degas first began to frequent dance classes and rehearsal halls in the early 1870s. A work now known as *The Dancing Class*, but originally exhibited in the first Impressionist show as *Foyer de la Danse* (plate 111), may well be his first depiction of the theme. Like other early works, it is rich in detail and generally warm in tone, similar in both color and casually unfolding structure to the slightly later *Portraits in an Office: The Cotton Exchange, New Orleans* (plate 135). In both cases, Degas exploited the ambiguous architectural effects produced by mirrors. According to Reff, this technique served to create pictures within

ABOVE, LEFT
246.
Edgar Degas
A Dancer Posing
C. 1874

ABOVE, RIGHT
247.
Edgar Degas
Au Théâtre
pastel
1880

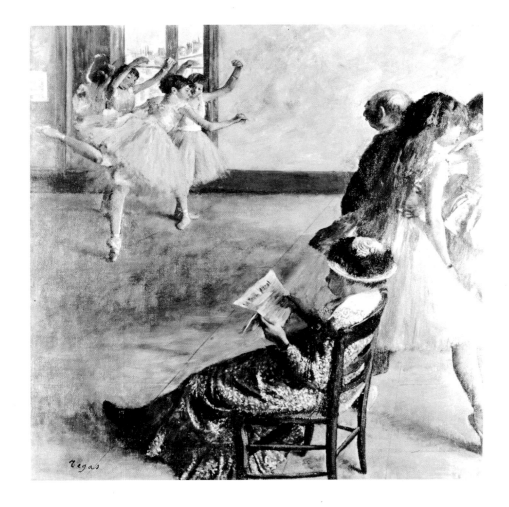

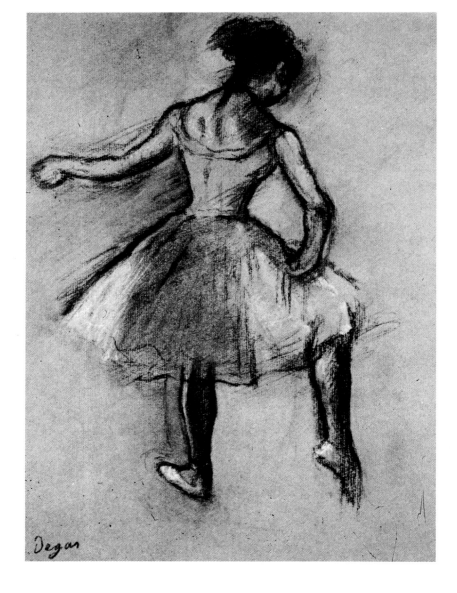

pictures and "call attention to the artificial aspects of the picture in which [it] occurs, reminding us . . . of the artist's mind and hand."[5] In later works such as *Dancers at the Old Opera House* (plate 270), Degas drastically reduced the number of figures and elements, preferring a more summary and fluid expressiveness.

Degas was scrupulously attentive to dance steps and positions, recording them in innumerable drawings such as *A Dancer Posing* (plate 246). The painter's notations on the drawings about the type of exercise or the name of the position indicate his familiarity with dance terminology and technique. These drawings were not necessarily executed in connection with paintings, but rather as part of a process of eye education. In his notebooks he wrote, "Of a dancer do either the arms or the legs or the back." These words are eminently applicable to the late painting *Four Dancers* (plate 271), in which the curved or outstretched arms create casual yet insistent curvilinear patterns that echo or counter other shapes in the painting. Degas uses the curved edge of the scenery to confine the figures within the lower left corner, which then seems to press out of the fragmented space of the canvas. While still retaining the ambiguous vantage point and cropping of forms associated with Impressionism, the pastel's firm sense of design reaffirms Degas's enduring commitment to the principles of Ingres.

Degas's Women

Although Degas neither married nor ever came close to it, he had many women friends—dancers like Mademoiselle Malo; actresses such as Ellen Andrée, whom he depicted in several works; and his American Impressionist colleague Mary Cassatt, whom he represented in a series of etchings and who probably posed for *At the Milliner's* (plate 273). Apparently Degas often accompanied female friends when they shopped for hats or other accessories. His numerous studies of middle- or upper-class women, executed in the increasingly popular medium of pastel, employ myriad vantage points and unexpected spatial devices. The mirror in *At the Milliner's* effectively hides the identity of the saleswoman and emphasizes the two-dimensionality of the canvas through the introduction of a strong vertical shape. Its inspiration clearly was Japanese woodcuts, which also provided the precedent for the high viewpoint Degas often employed in other millinery pictures. In a similar subject of the same year (plate 275), Degas demonstrates his extraordinary sensitivity to color and shape as he creates with a descriptive economy a most unusual still life, fully as compelling as the bouquets that filled the portraits of the 1860s. Paul Valéry, who had singled out Degas's talent for capturing the essence of dance movement, also praised his ability

> to elicit the one line which determines a figure, but that figure
> as found in life, in the street, at the opera, at the milliner's . . .
> that figure surprised in its own peculiar habits, at a particular

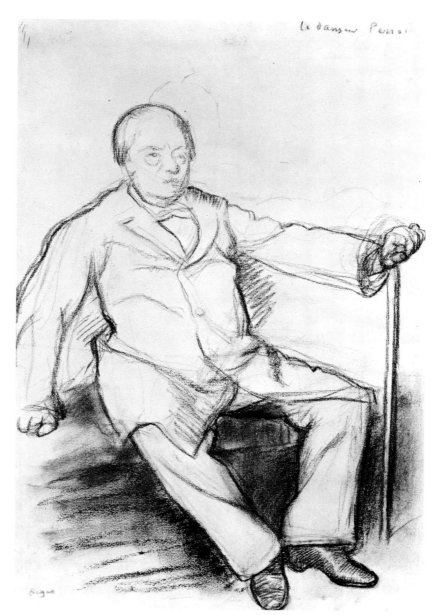

le danseur Perrot

FAR LEFT
250.
Edgar Degas
Dancer Putting on Her Shoe
1880

LEFT
251.
Edgar Degas
The Dancing Master, Perrot
C. 1875

BELOW
252.
Edgar Degas
Ballet Rehearsal
C. 1891

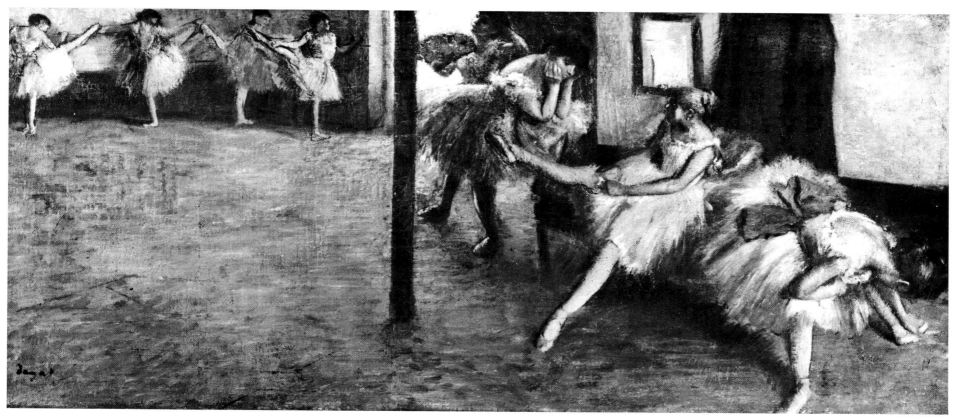

moment, never without action, always expressive—this, for me, somehow sums up Degas. He ventured to combine, he dared to combine, the snapshot and the infinite toil in the studio, to enclose the impression in an elaborate study and the immediacy of things in the continuance of reflective will.[6]

Paintings of women constitute the vast majority of Degas's works. From portraits of relatives and social acquaintances, he moved on to the more categorical investigation of women's work, which was to embrace laundresses as well as ballerinas, prostitutes as well as socialites, in what Edmond de Goncourt termed their "expert, specialized worlds." Visiting Degas's studio, de Goncourt recalled: "He showed me, in their various poses and their graceful foreshortenings, washerwoman after washerwoman . . . speaking their language, explaining to us in technical terms the applied stroke of the iron, the circular stroke."[7] Degas's paintings of laundresses expanded the genre of urban work pictures that had been developed by Legros and Daumier. Degas admired the latter's work, especially his lithographs, of which he had an impressive collection. His evolving interest in laundresses was most likely stimulated by Daumier's painting of that subject (plate 49), which was included in the retrospective organized to honor the Realist artist in 1878. Unlike his predecessor, however, Degas did not view his subject as a symbol of social and economic oppression. In *Woman Ironing* (plate 274) Degas employs a broad, simplified design and rather dark color against a light ground. The sense of contour is firm, the identity of every object clear. The woman's face is a shadowy profile, curtailing any speculation about her age or physical features. The viewer is forced to concentrate on the specific objects and movements that define her class and occupation.

Late Nudes

The two overriding concerns that dominated Degas's career—his admiration for the classical tradition and his interest in modern life—converged in the 1880s when he concentrated more and more on the female nude. At the last group exhibition of the Impressionists in 1886, he showed a group of pastels described in the catalog as "a series of nudes of women bathing, washing, drying, rubbing down, combing their hair or having it combed." *The Tub* (plate 277) continues Degas's use of an unusually high vantage point which, when combined with the aggressive cropping of the space above the crouching figure, forces on the viewer an almost clinical awareness of the formal similarities between the woman's body and the vessel from which she emerges. This and countless other works relinquish the icy perfection of Ingres's Bather or the self-conscious inappropriateness of Manet's *Déjeuner sur l'herbe* or *Olympia* for a distinctly modern intimacy. Degas, who was so absorbed in the bather as a

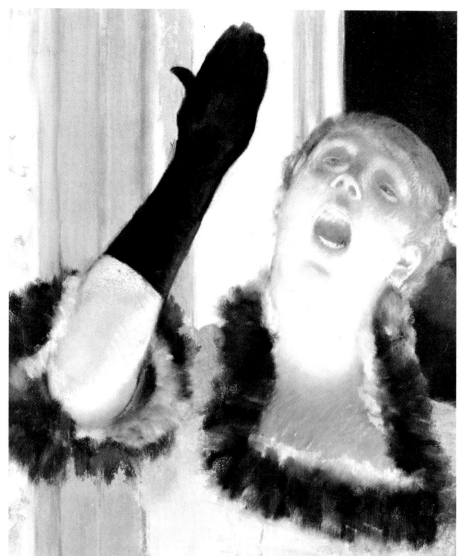

subject that he had a tin bathtub installed in his studio, was aware of this peculiar quality: "The nude has always been represented in poses which presupposed an audience, but these women of mine are honest, simple folk, unconcerned by any other interests than those involved in their physical condition."[8] Some of his contemporaries took exception to Degas's obsessive cataloging of the models' unidealized nakedness, suggesting that it sprang from an antipathy or even loathing for women. Félix Fénéon complained: "Monsieur Degas pursues the female body with an old animosity which is like a grievance; he dishonors it with animal analogies."[9] His remark was probably a reaction to Degas's own allusion to one of the pastels: "This is the human animal cleaning itself, a cat licking itself."

While sharpening his powers of observation through focused concentration on the human body, Degas was also simplifying his drawing and heightening contrasts of color. Unlike his friend Renoir, who also turned to studies of the nude in the eighties, Degas did not paint inherently sensuous women. The poses are often not simply awkward but downright unappealing; the skin tones are not gratuitously voluptuous. Rather the artist tended increasingly to emphasize the rough grain of the pastel, the medium that served him so well in later years when his poor vision worsened to almost total blindness.

OPPOSITE PAGE, TOP

253.

Edgar Degas

At the Milliner's

C. 1882

OPPOSITE PAGE, BELOW

254.

Edgar Degas

Portrait of Madame Jeantaud

1875

LEFT

255.

Edgar Degas

Mary Cassatt at the Louvre

1879–80

ABOVE, RIGHT

256.

Edgar Degas

Chanteuse au Gant

1878

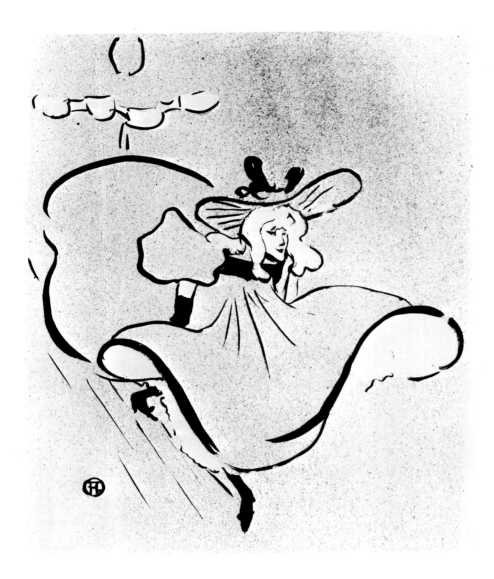

257.
Henri de Toulouse-Lautrec
Jane Avril,
from Café-Concert series
1893

into a phobia in later life. His reputation for a savage wit and quick temper and his railings against progress and the increasing ugliness of modern civilization fed the legend of the "terrible M. Degas." Yet the misanthrope was also a loving uncle to his numerous nieces and nephews and a close friend to those few companions who still frequented his home. While his rigorous standards had made him impatient with mediocrity in others, he was always hardest on himself. Late in life, in a letter to a painter friend, he apologized for any offenses:

I was or I seemed to be hard with everyone through a sort of passion for brutality, which came from my uncertainty and my bad humor. I felt myself so badly made, so badly equipped, so weak, whereas it seemed to me that my calculations on art were so right. I brooded against the whole world and against myself. I ask your pardon sincerely, if beneath the pretext of this damned art, I have wounded your very intelligent and fine mind, perhaps even your heart.[10]

Like those other stalwarts of the Impressionist group Renoir and Monet, Degas had a long life; and as in theirs, a shadow of tragedy fell over his later years. Although he struggled, Degas could not overcome the handicap of deteriorating eyesight. By the 1890s he was wholly blind in one eye, and he found it impossible to work on any but a large scale. He turned with greater frequency to sculptures of the human figure or horses, which he could model with his hands. The drawings or pastels that he produced during this period banish elegant contour and nuance in favor of heavy line and broad, rough color. Though his sight was failing, these works still convey that visual order fixed so clearly in his mind's eye.

After 1893 Degas refused either to exhibit his paintings or to sell them; to hold onto his own work had become an obsession. Compensating perhaps for his growing inability to paint as he wished, he collected the works of others, notably Ingres, Delacroix, Corot, Manet, and Cézanne; and, of course, Japanese prints.

For the last ten years of his life Degas, who had dedicated himself totally to art, was forced to relinquish it. A hint of what he might have done is provided by the thirteen notebooks he left behind at his death in 1917. The drawings and statements in them reveal plans for a wide range of portraits, new types of still-life painting, and studies of musicians and of innumerable subjects related to Paris, its people, and its monuments. The keen intellect that formulated these unrealized projects must have been immensely frustrated by the failure of the body. How often he had occasion, in those last blank years, to reflect on his years of activity. Making his way through the streets of Paris, once teeming with tantalizing motifs, now only filled with the sounds of unseen automobiles, he must have longed for the past he had so often celebrated in art and epigram.

Pastel united drawing with color, leading Degas to remark: "I am a colorist in line." Nowhere is this fusion more evident than in *The Bathers* (plate 278). The large pastel study testifies once again to the inordinate popularity of this time-honored theme. In keeping with the formal dictates of the tradition, Degas places four figures within a vaguely defined landscape setting. Although he was already hampered by his failing vision, the work displays a sure sense of design and placement of forms, along with a bold new sense of rhythm. Moreover, the composition daringly introduces two collaged or attached strips to the top and bottom of the paper. These additions draw attention to the physical limitations of the central motif and also underscore the decorative role and color in the overall work.

By the time he finished *The Bathers*, Degas had parted company with nearly all of the Impressionists. Manet had been dead for more than ten years, and he no longer saw Monet or Renoir. His sharp tongue and his fundamental resistance to the attitudes and techniques of Impressionism alienated him from many former colleagues. When the Dreyfus affair polarized French society in the 1890s, Degas, a political conservative, refused to join in the condemnation of anti-Semitism engendered by the incident, thus offending even Pissarro, with whom he had maintained contact during the last years of the group's activity.

From the very beginning, Degas had expressed reservations about exhibiting with the Impressionists. His inclination to standoffishness, already pronounced in his youth, developed

Beyond Naturalism: Toulouse-Lautrec

Although Henri de Toulouse-Lautrec cannot be considered an Impressionist in the strict sense of the term, his work is linked with that of the earlier artists by its dedication to contemporaneity and its intent to capture the essential atmosphere of a time and a place in a cogent distillation of color and shape. If Lautrec has an affinity with any one member of the group, it is Degas, whose emphasis on line and respect for design were already at odds with the aspirations of Impressionism.

Born Count Henri-Marie-Raymond de Toulouse-Lautrec Monfa, he might have become nothing more than another titled Sunday painter had he not sustained two accidents that kept his legs from growing and prevented him from fulfilling the duties of the provincial aristocrat. At the age of eighteen, Lautrec left Albi, his ancestral home, and went to Paris. There he was admitted to the prestigious atelier of Léon Bonnat, a portraitist and the very model of the successful academician. The traditional teaching of the Ecole des Beaux-Arts was rigorously observed by Bonnat, and Lautrec sketched plaster casts and the nude model for long hours, striving to assimilate the cold and perfect draftsmanship that stifled his own natural and immediate sense of form.

After about a year of suffering, Lautrec and his fellow students were liberated when Bonnat accepted an appointment as professor of the Ecole. Félix Cormon, celebrated as a painter of biblical subjects, now became Lautrec's mentor. A warm and eminently approachable man, Cormon allowed his students great freedom. In a letter to his uncle, Lautrec described the new atmosphere at the studio: "Cormon's criticisms are much milder than Bonnat's. He looks at everything you show him and encourages you heartily. You will be very much surprised, but I don't like that as well. In fact, my former master's raps put ginger into me, and I didn't spare myself. Here I feel rather relaxed and find it an effort to make a conscientious drawing when something not quite as good would do just as well."[11] Although he tried hard to follow Cormon's admonition that students copy the model, Lautrec appears to have allowed irresistible exaggerations or distortions to creep into his studies, leading his master to regard him essentially as a gifted caricaturist.

Portraiture and the human body were the focus and continuing inspiration of Lautrec's artistic vision. Maturing in the 1880s when Impressionism and the plein-air subjects associated with it were under constant assault, Lautrec had the figure painter's contempt for landscape. He maintained that it counted for "nothing, but an accessory; the painter of pure landscape is an idiot. Landscape should be used to make the character of the figure more intelligible."[12]

Lautrec's strong opinions, youthful exuberance, and restless creative energies could not be contained by the formulas and discipline of academic art. After just three years with Cormon,

he had acquired sufficient polish to realize that his artistic future lay outside the confines of official art; it was time for him to move on. He exchanged the comforts of his family circle for the rough and bawdy world of Montmartre, that citadel of bohemian license and indulgence. His companions there were the inhabitants of the quarter: dancers, singers, sportsmen, small-time criminals. Lautrec threw himself into their lifestyle with an enthusiasm usually reserved for religious or political converts.

Lautrec and Degas

One of his fellow students noted that Lautrec's fascination with physical activity was perhaps in compensation for his own deformity. Lautrec's attraction to wrestlers and acrobats drew him to places of popular entertainment such as the circus. In 1888, just two years before Seurat painted a similar motif, Lautrec executed *In the Circus Fernando: The Ringmaster* (plate 279), a work that establishes a particular affinity to Degas in its concise design and color and its somewhat caustic summary of gesture and movement. Although the daring composition, with its abrupt cropping at the top and on the left side, pays homage to Degas, Lautrec's limited color and strenuously flattened forms make his work more stylized than that of the older painter.

258.
Henri de Toulouse-Lautrec
Au Salon de la rue des Moulins
1894

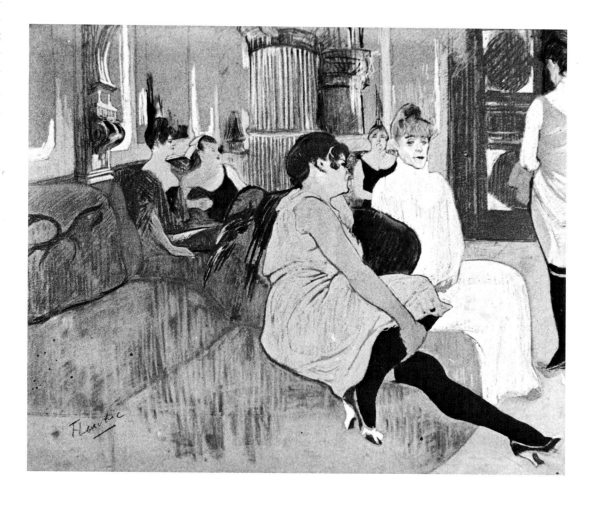

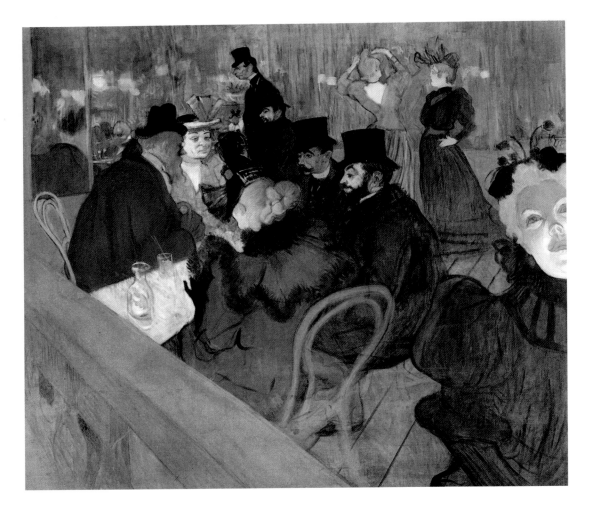

Just a year before he painted *In the Circus Fernando*, Lautrec had moved into an apartment across the street from Degas, and it is more than likely that the two exchanged views about drawing. The young man also shared Degas's enthusiasm for Japanese art. His bizarre apartment was cluttered with screens and exotic objects, and on more than one occasion the self-satirizing painter had a friend photograph him in Japanese costume (plate 261). His interest in Oriental art was further sharpened after 1896, when a friend who had assumed the management of the Montmartre branch of the art gallery Goupil's acquired from Théodore Duret some splendid albums of Japanese woodcuts. Lautrec bought and undertook a serious study of these prints, which helped him effect the dramatic simplification of forms that found its most eloquent expression in his lithographs and posters.

Like Degas, Lautrec was interested in combining materials and media, and he worked extensively in pastel, watercolor, and gouache. *A la Mie*, or *At the Crumb* (plate 280), is a gouache superficially reminiscent of *L'Absinthe*, though its caricature of sleaziness or meanness is a far cry from the reserved objectivity of Degas's work. Lautrec also adopted Degas's practice of using acquaintances as models (the slouching male patron of the bar where the picture is set was Maurice Guibert, a champagne salesman and infamous roué). Lautrec's conscious search for something low and sinister was very different, however, from Degas's categorical approach. While the latter consistently sought out representatives of the upper or lower classes, Lautrec was drawn to those on the edge of society.

Such paintings as *A Corner of the Moulin de la Galette* (plate 281) invite further comparison with Degas and Manet, both in combining rigorous shapes within a distinctly two-dimensional composition and in evoking the mood of isolation so often characteristic of café or dance hall subjects. In another painting, *The Englishman at the Moulin Rouge* (plate 283), Lautrec used the double vantage point and strong oblique accent found in many of Degas's works. Unlike the more homogeneous lower-class atmosphere of the Moulin de la Galette, the Moulin Rouge offered a wide range of patrons: its clientele on a given night might include both workers and visiting gentry from at home and abroad. Lautrec loved the Moulin Rouge and the singers and dancers who entertained there. He had been a regular since the place opened in 1889, and he enjoyed inviting friends—such as the group we see at the table—to join him there, where his own grotesqueness could be assimilated. Still, it would be a mistake to see Lautrec as simply a titled freak forced to seek refuge in a more tolerant milieu because of rejection by his own social group. While socializing with prostitutes, thieves, and entertainers claimed much of his limited energy, he also enjoyed the company of the most creative minds of his generation. He was a good friend of Misia Natanson, the ebullient wife of the founder of *La Revue blanche*, one of the most influential art and

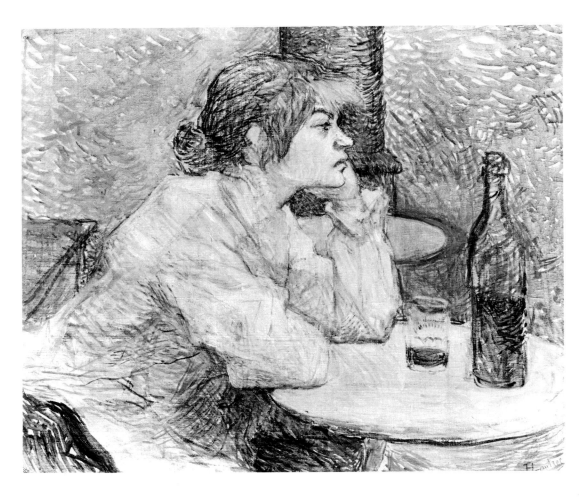

literary magazines of the decade, and he was a frequent guest at soirées that included the poets Mallarmé and Valéry and the composer Claude Debussy.

Whether depicting the denizens of the dance halls or the bored prostitutes who await their customers in a local brothel frequented by the painter, Lautrec immediately established a firm element of design, a principal focal point against which he offered a counterpoint of secondary figures or fragments of the architectural setting. Like Degas, he produced hundreds of drawings, which he then altered to suit the needs of his theme. Indeed, his work might more correctly be described as painted or colored drawing. In *Alfred la Guigne* (plate 282), a composition inspired by an underworld character in a popular novel about Montmartre low-life, he exploited the natural color and the texture of the cardboard as an effective contrast for the limited passages of bright color.

Prints and Posters

Lautrec was comfortable working with paper and used it for both drawing and painting. He exploited its potential as few other artists had when he turned early in the decade to the technique of color lithography, producing over three hundred lithographs within a period of only five or six years. These lithographs, especially the posters he designed, are almost more startling in their formal innovations than his painted oeuvre, and through them the artist achieved considerable fame. Most of the posters advertised the music hall performers who also populated his paintings. Lautrec was particularly friendly with Jane Avril (plate 257), a signer at the Moulin Rouge who introduced him to the English dancer May Milton. Photographs document the ungainly demeanor of Miss Milton, who, it seems, was "a little clownish, reminding one of a bulldog." Lautrec found her caricature of a face especially appealing and did a portrait of her; but it is the brilliant poster he produced for an American tour (plate 287) that has forever fixed her image. Using the white of the page as a foil for the deep blue background and her reddish blond hair as a contrasting intermediary, Lautrec captures the mincing choreography of her comic dance. At the same time, the lettering combines with the subject to create a design of such integrated economy that it establishes Lautrec as possibly the most sophisticated japonist of them all.

Lautrec exhibited regularly at the Salon des Indépendants and with an avant-garde group in Brussels called Les XX (Les Vingt, or The Twenty). He was friendly with Emile Bernard, whom he knew from his student days, and later also with Paul Sérusier, Maurice Denis, and Pierre Bonnard, painters associated with the Symbolist movement; but his aesthetic interests did not really coincide with theirs. Interviewed by a journalist on the occasion of his participation in an exhibition entitled *Impression-*

OPPOSITE PAGE, TOP

259.
Henri de Toulouse-Lautrec
At the Moulin Rouge
1892

OPPOSITE PAGE, BOTTOM

260.
Henri de Toulouse-Lautrec
La Buveuse
1889

261.
Toulouse-Lautrec in samurai costume
1889

nistes et Symbolistes, he disavowed an affiliation with any group: "I don't belong to any school. I work in my corner. I admire Degas and Forain."

During Lautrec's last year as a student in Cormon's studio, Impressionism had passed from a living force in painting to a chapter in its history. Just fifteen years later, in 1901, Lautrec himself—exhausted by the strain of his life and by long bouts with alcoholism and syphilis—died and became a part of that history. In the interim, the issues raised by Impressionism had already been confronted by three painters with very different personalities: Georges Seurat, Vincent van Gogh, and Paul Gauguin. Their responses to these issues would radically alter the direction of painting in the next century.

"*I am busy on a portrait of my aunt and my two cousins . . . I've got to do it well because I want to leave it as a memento. . . . My two young cousins look good enough to eat. The older one is really a lovely little thing, the younger one has the devil in her as well as the kindness of an angel. I'm doing them with their black dresses and little white pinafores, which suit them delightfully. I have ideas for the picture's background in my head. I would like a certain natural gracefulness with a nobleness of feeling that I don't know how to describe.*"

—Letter of Edgar Degas to Gustave Moreau, Florence, November 27, 1858

262.
Edgar Degas
The Bellelli Family
1858–65

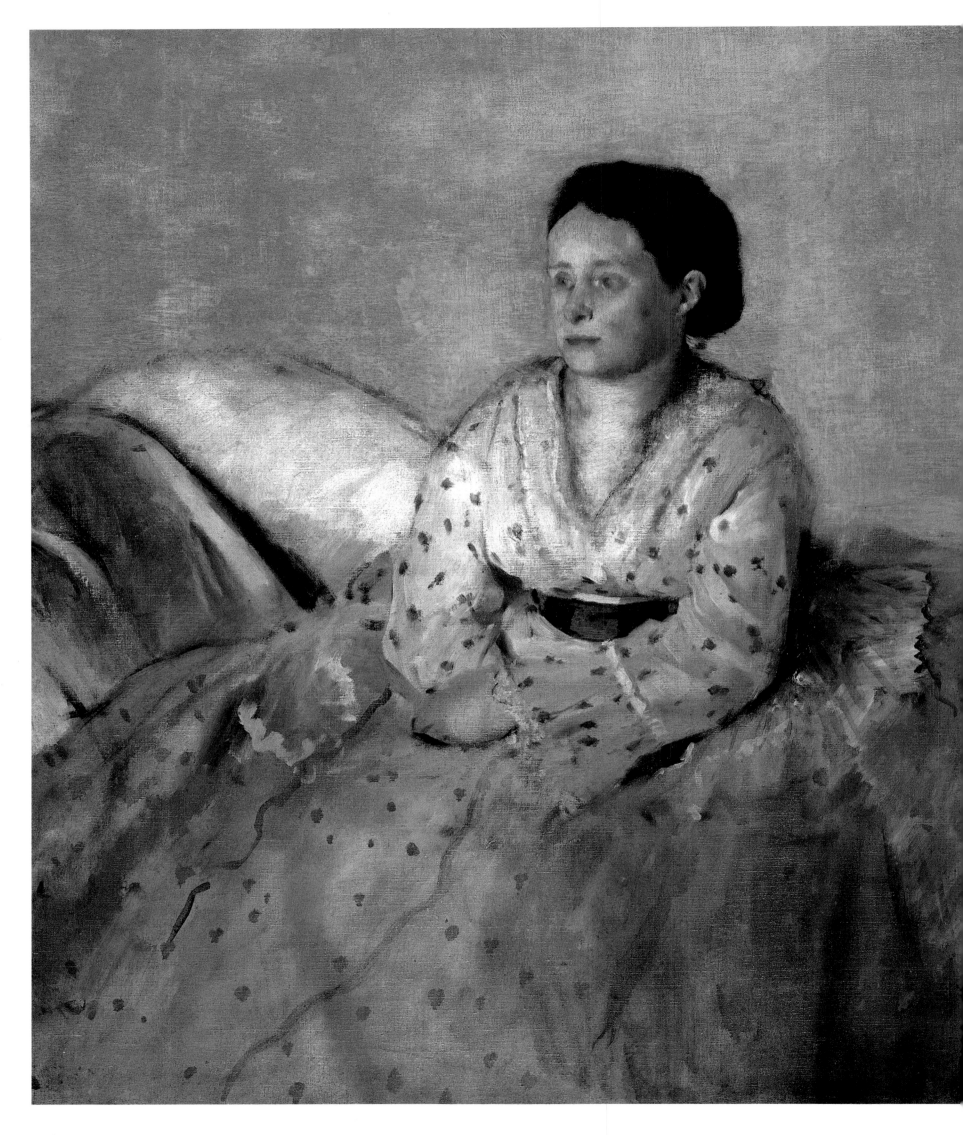

Fifteen years separate these portraits of the artist's brother and sister-in-law. The cool elegance, subdued color scheme, and clearcut silhouette of the young cadet imbue his likeness with a classic austerity that contrasts markedly with the later work. In Madame René de Gas, Degas uses delicately applied shades of blue, pink, and white to suggest the gentle, refined character of the blind sitter. The warm light that illuminates her sightless face contrasts with the predominantly silvery tone of the dress and chaise, evoking qualities of vulnerability and introspection.

LEFT
263.
Edgar Degas
Madame René de Gas
1872–73

264.
Edgar Degas
Achille de Gas in the Uniform of a Cadet
1856–57

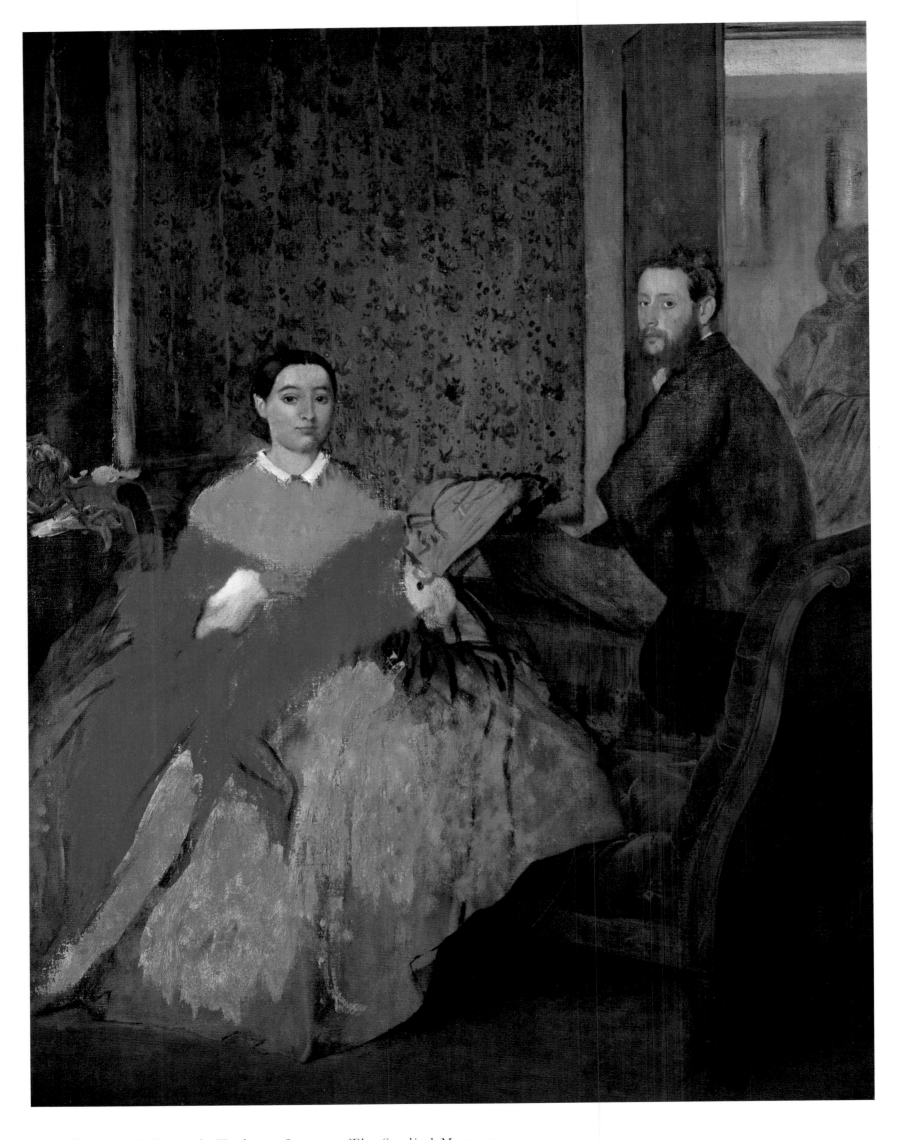

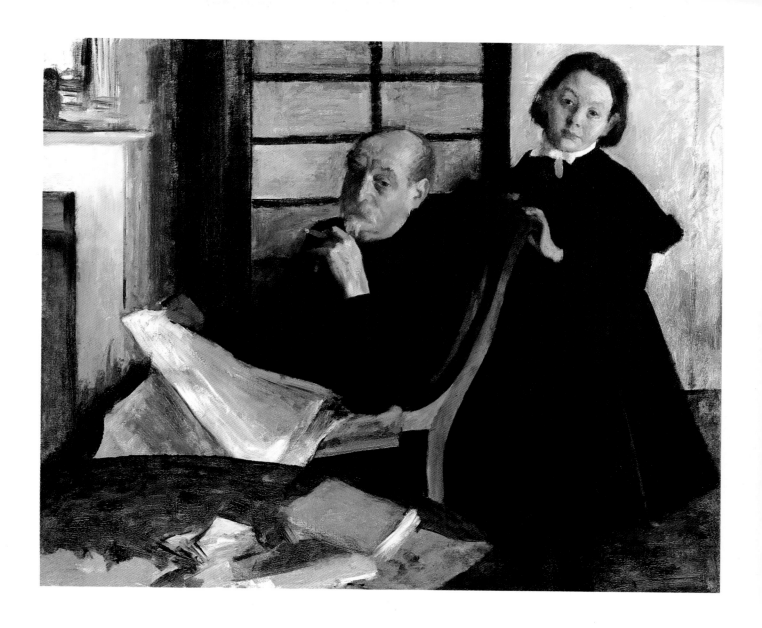

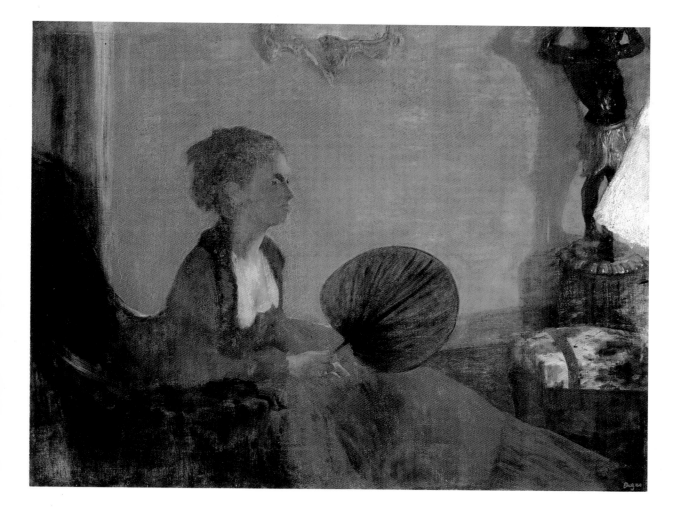

OPPOSITE PAGE
265.
Edgar Degas
Edmondo and Thérèse Morbilli
c. 1865

ABOVE
266.
Edgar Degas
Uncle and Niece
(Portrait of Henri and Lucy de Gas)
c. 1876

LEFT
267.
Edgar Degas
Madame Camus
1869–70

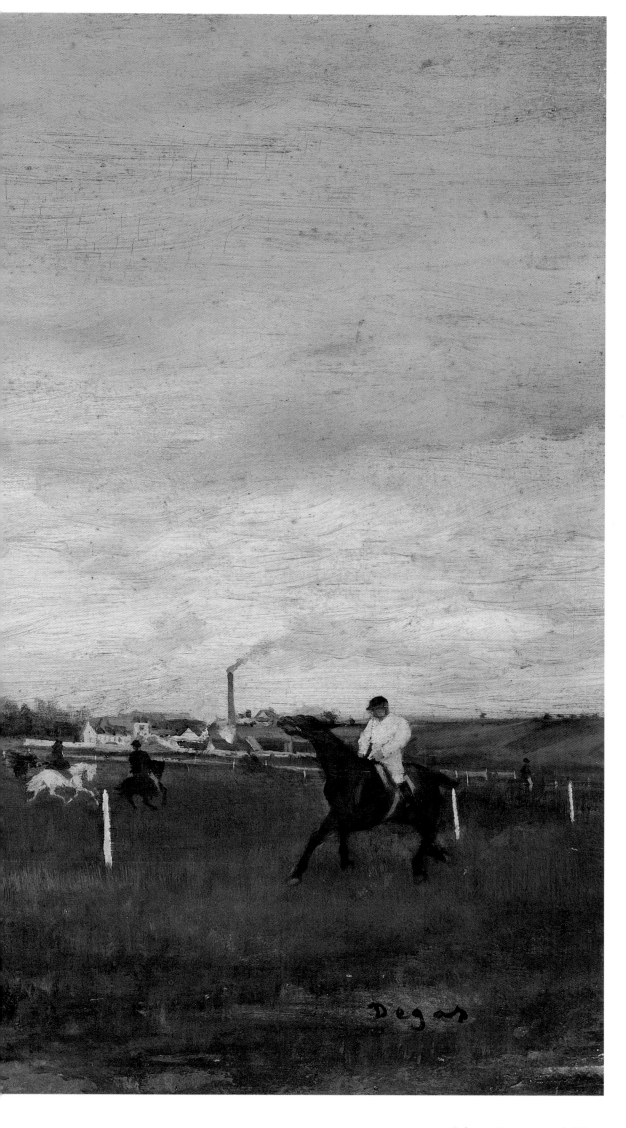

Unlike most of the artists in the Impressionist group, Degas cared little for landscape painting. The significant exceptions were his studies of horses and racetracks. Degas was attracted to the races because of his love of the animals and his fascination with movement. Avoiding the typical moments usually depicted in popular prints, he often focused on the preparation for a race or its aftermath. He was interested in the casualness or randomness of racetrack motifs, yet felt hampered by the limitations of the plein-air technique. He preferred to incorporate the many visual fragments accumulated in a day's sketching into more carefully "composed" works that nonetheless conveyed the impression of truth.

268.
Edgar Degas
The Races
c. 1873

OPPOSITE
272.
Edgar Degas
Dancers, Pink and Green
C. 1890

Like his racing scenes, Degas's studies of the ballet are rarely documents of actual events. Only occasionally is the theater or the particular rehearsal space recognizable, and hardly ever does the artist depict celebrated ballerinas. Degas permitted himself unparalleled freedom in composing these works, inventing the scenery and the lighting and choosing unusual vantage points in order to condition the viewer's response to the motif. Yet despite this artifice, such works as Four Dancers *always drew on Degas's meticulous observation of actual situations, which the painter stored for later use.*

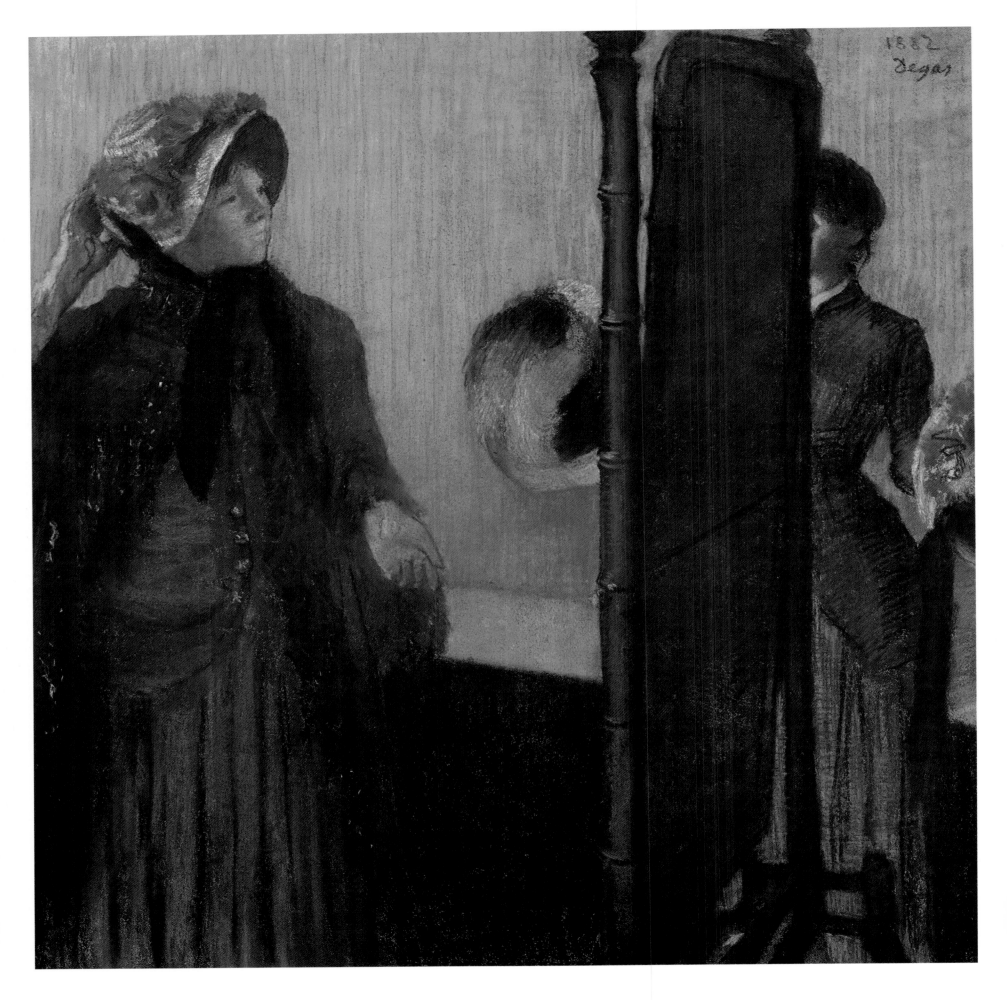

ABOVE

273.
Edgar Degas
At the Milliner's
1882

OPPOSITE

274.
Edgar Degas
Woman Ironing
1882

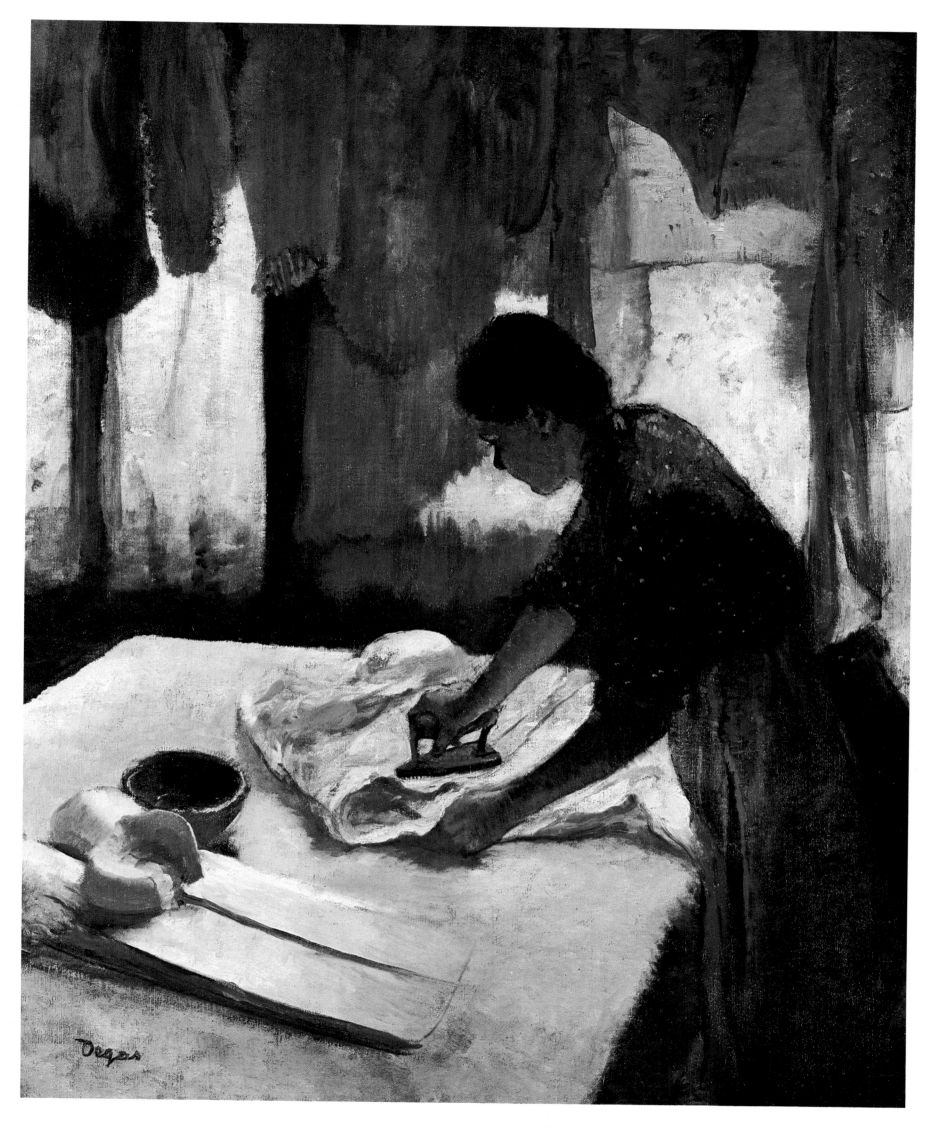

275.
Edgar Degas
The Millinery Shop
c. 1882

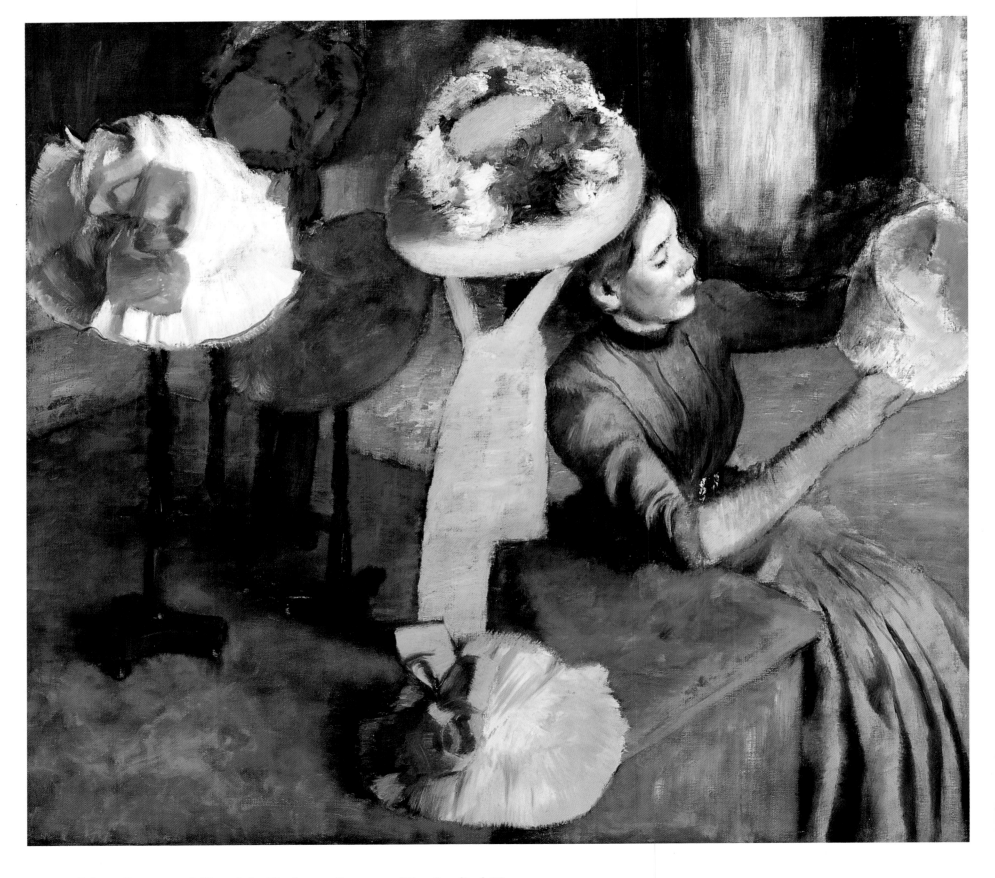

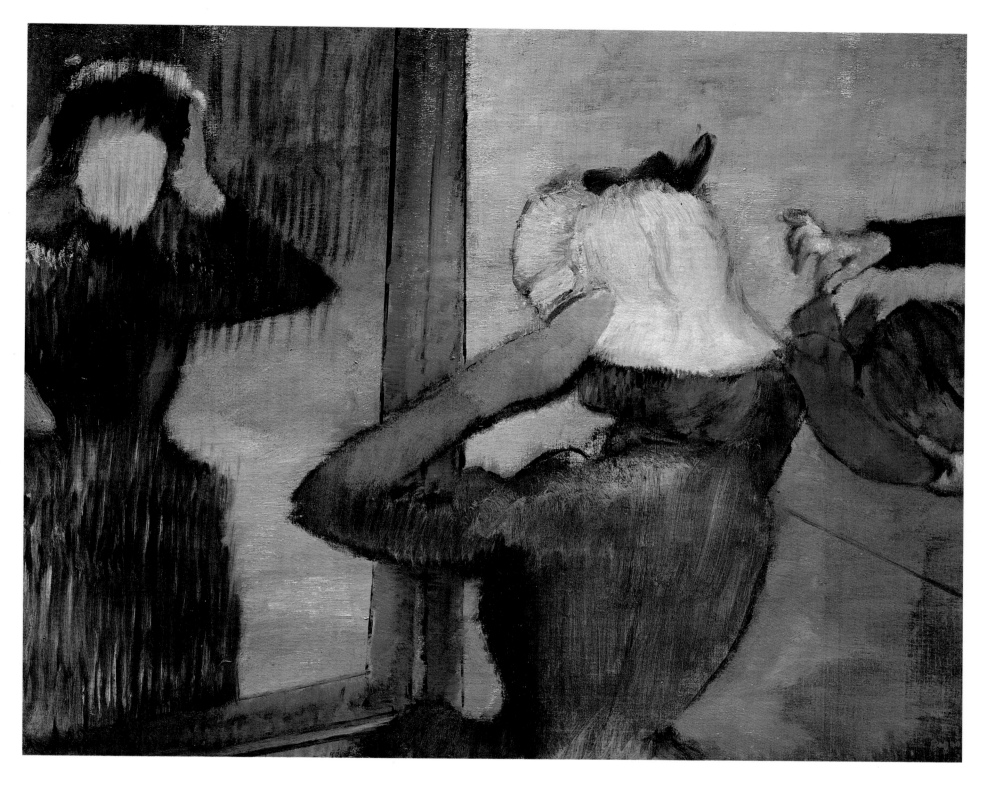

276.
Edgar Degas
At the Milliner's
1882–85

Degas's expanding interest in documenting different aspects of contemporary life led him to places most men of his social class never knew. Like Emile Zola, the great Naturalist writer who immersed himself in the sweltering and steam-filled shops of laundresses while he was writing L'Assommoir, *Degas spent hours studying the equipment and learning the techniques and movements of women washing and ironing (see plate 274) in order to impart the accent of truth to his work.*

* While Degas's laundresses are warmly embraced by their environment, the pastels and oils of millinery shop scenes he executed in the 1880s are cool and terse. The prominence of the client in* At the Milliner's *is accentuated by the placement of the mirror, which effectively obscures the saleswoman and converts her into an object or accessory rather than a human being.*

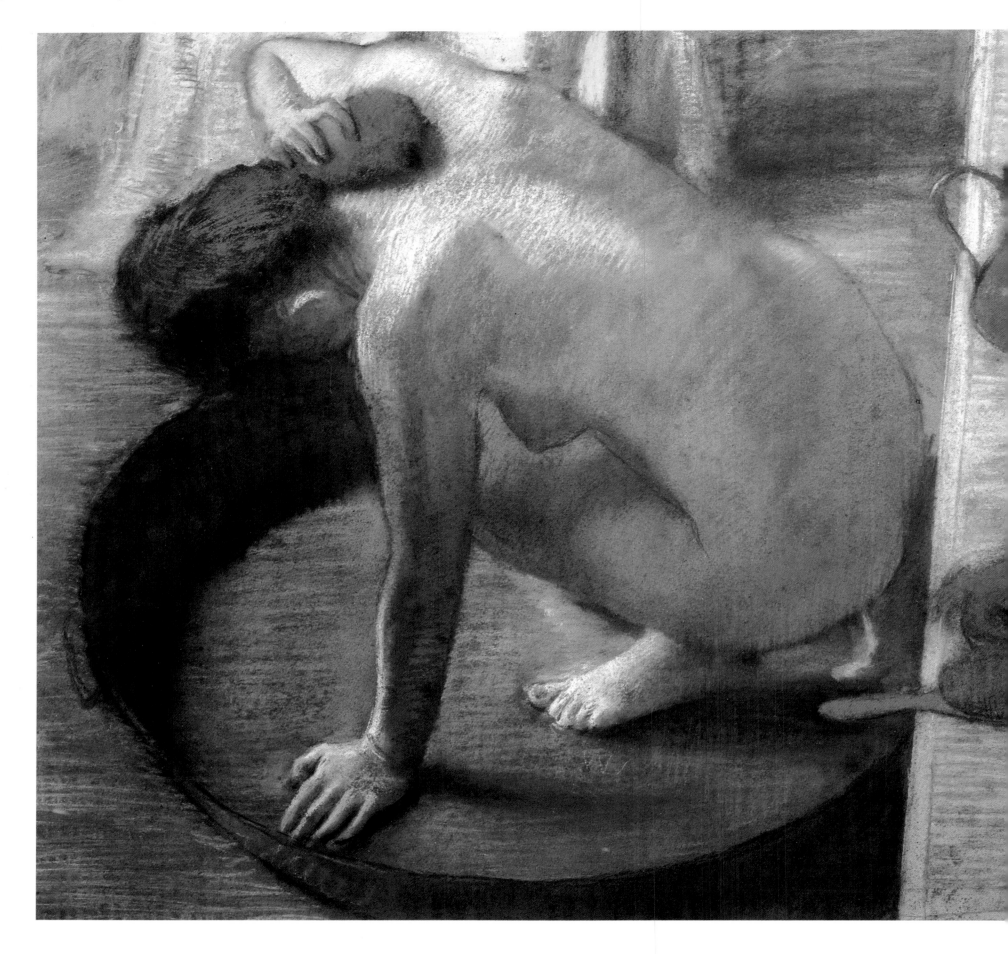

277.
Edgar Degas
The Tub
1886

The asymmetrical composition and momentary pose of this woman at her toilette (left) gives the impression of a casual, random glimpse into the woman's room, such as one might see in passing by the open door. Yet the pastel is actually artfully contrived. The woman's torso completes the circle of the tub, which is itself confined in a square. Moreover, the shelf to the right, which is almost parallel to the flat plane of the picture, contrasts with the three-dimensionality of the left side of the canvas. The hairbrush, precariously balanced in the foreground, both links the left and right halves of the picture and adds to the instability and momentary quality of the whole.

278.
Edgar Degas
The Bathers
1890–95

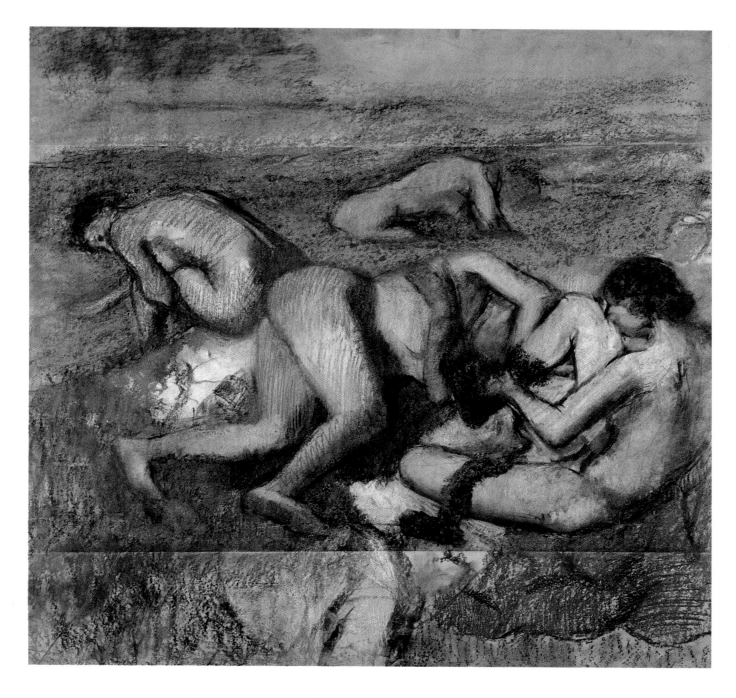

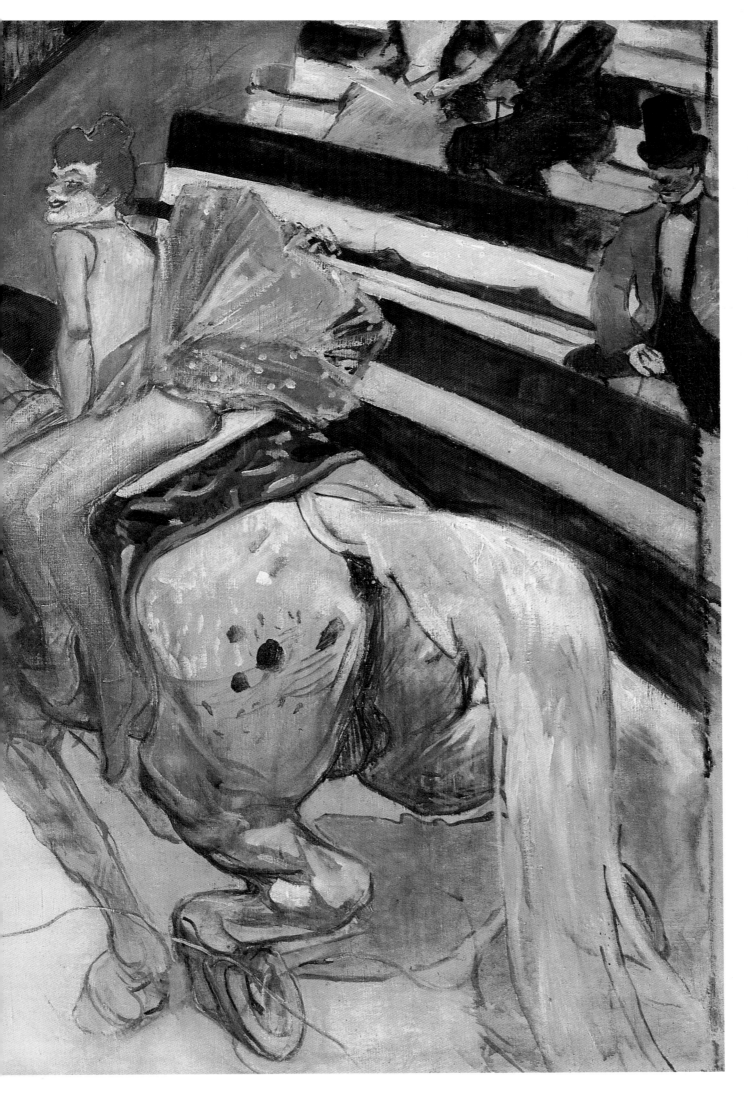

*L*ike Degas, Lautrec was attracted by the vigorous, exaggerated movements of circus performers and dancers and by the artificial light that illuminated them. Yet there is none of the studied elegance of Degas in Lautrec's drawing; rather, it projects an inclination to stylization or caricature. This is clearly evident here in the exaggerated flatness of the composition, the emphasis on simplified shapes, and pronounced contrasts of color.

279.
Henri de Toulouse-Lautrec
In the Circus Fernando: The Ringmaster
1888

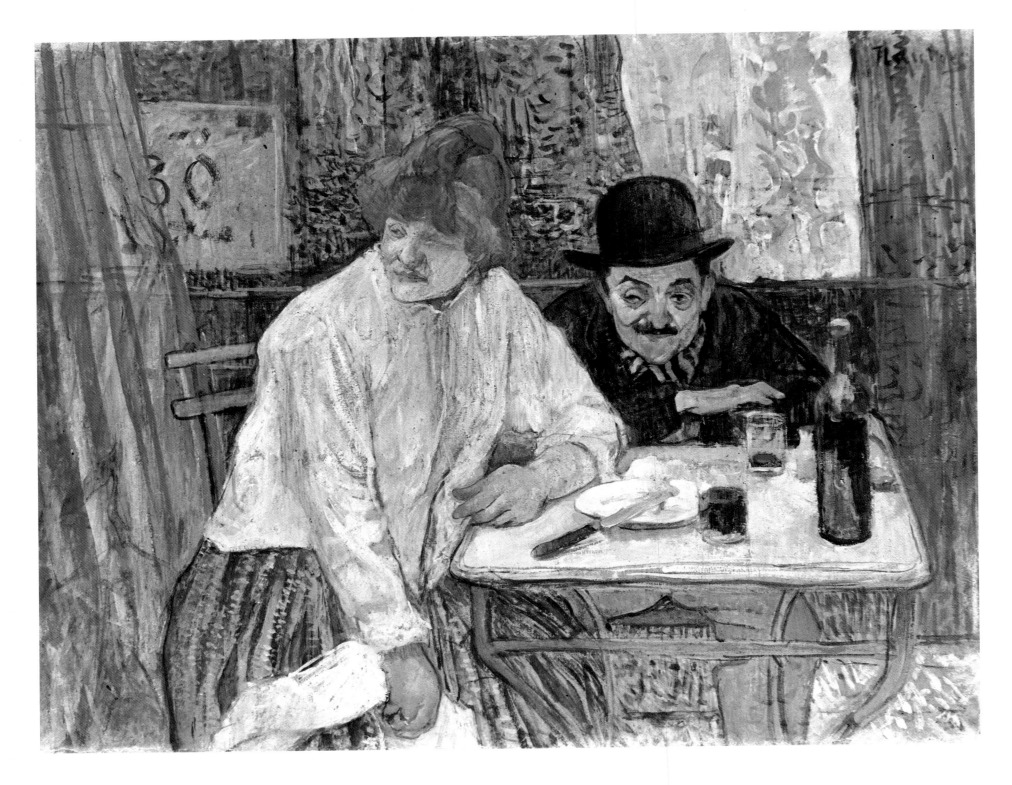

ABOVE
280.
Henri de Toulouse-Lautrec
A la Mie
1891

OPPOSITE
281.
Henri de Toulouse-Lautrec
A Corner of the Moulin de la Galette
1892

The cafés, dance halls, and brothels of Montmartre offered a fascinating if sometimes squalid visual panorama for Toulouse-Lautrec. The artist's keenly journalistic eye moved restlessly over singers and their aristocratic admirers, prostitutes and poets, sportsmen and small-time gangsters, recording their casual encounters and translating them into decorative syntheses that seem as vivid today as they were then. The Moulin de la Galette was one of Lautrec's favorite spots and provided him with the inspiration for many of his finest paintings. With his telling line, the artist could convey the crisp outline of a sleeve, the knowing "come-on" of a prostitute's gaze, and the sense of isolation and loneliness that separates the characters.

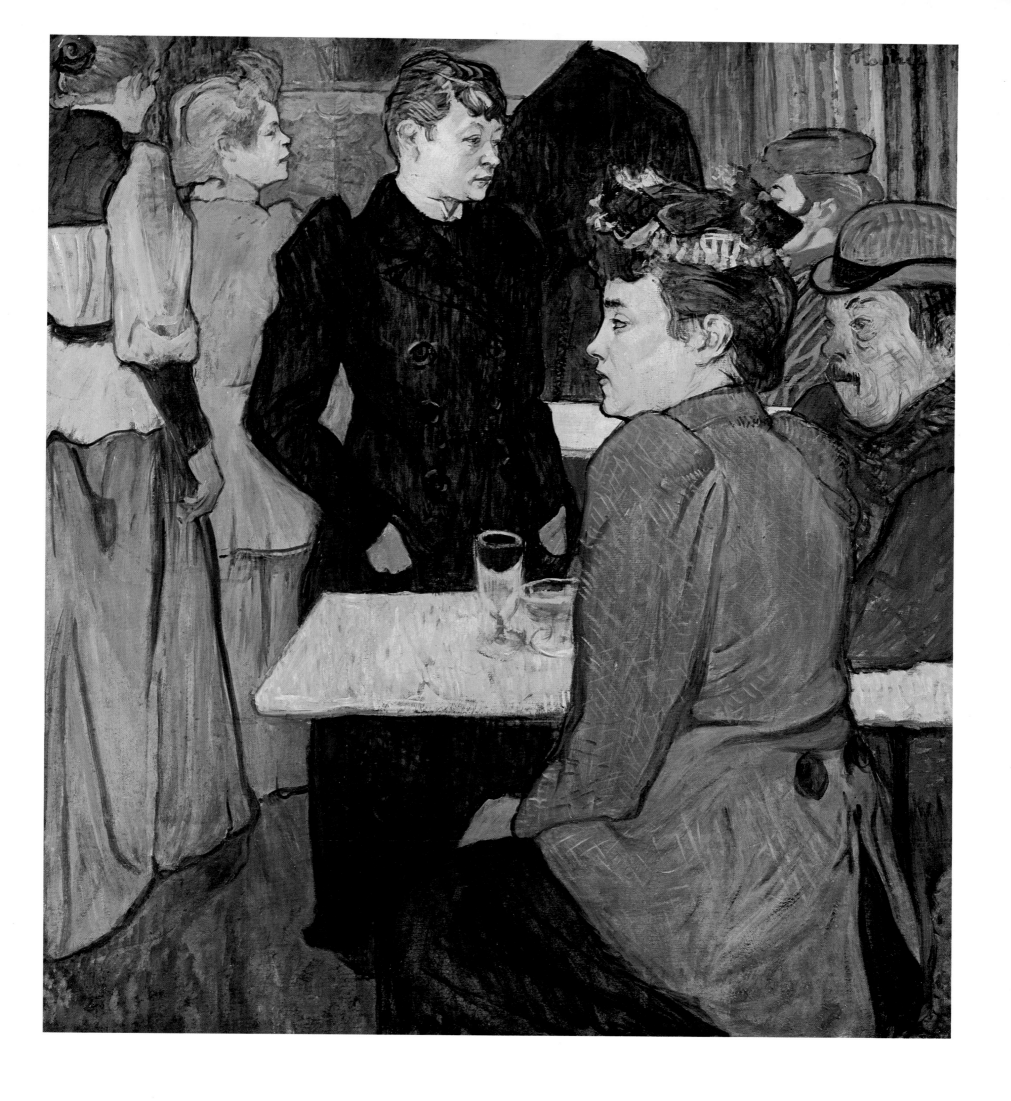

RIGHT
282.
Henri de Toulouse-Lautrec
Alfred la Guigne
1894

OPPOSITE
283.
Henri de Toulouse-Lautrec
*The Englishman at the
Moulin Rouge*
1892

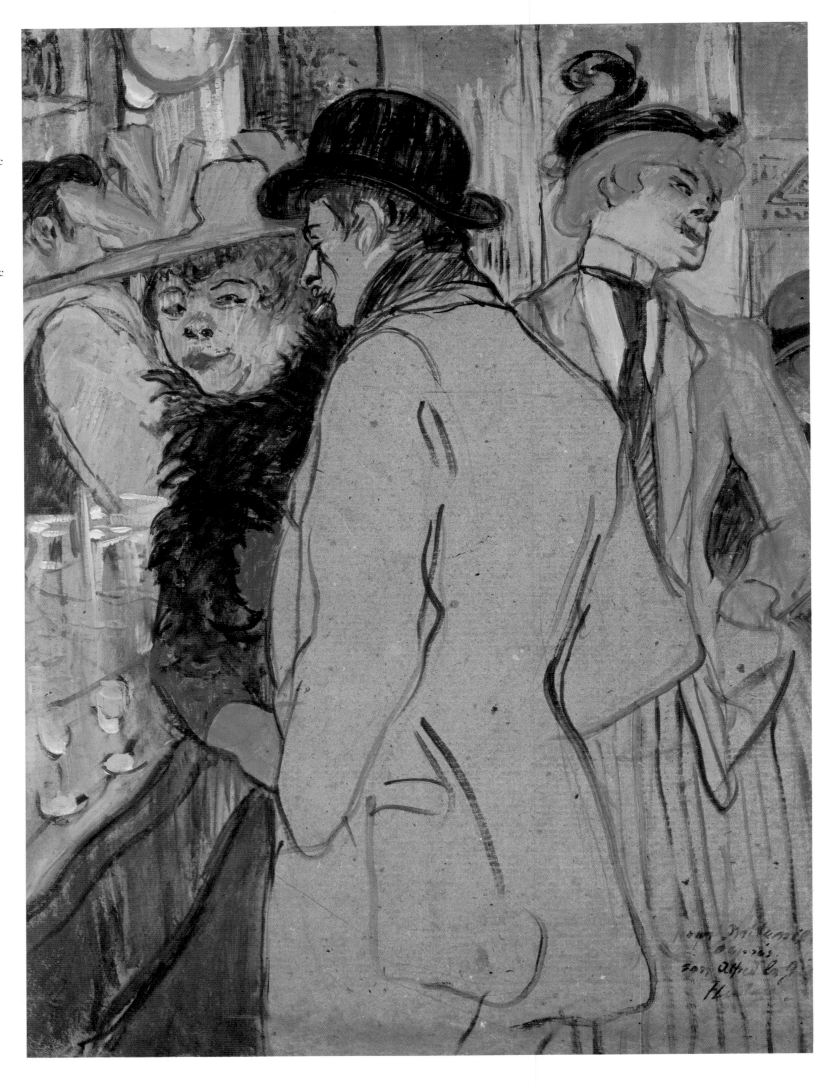

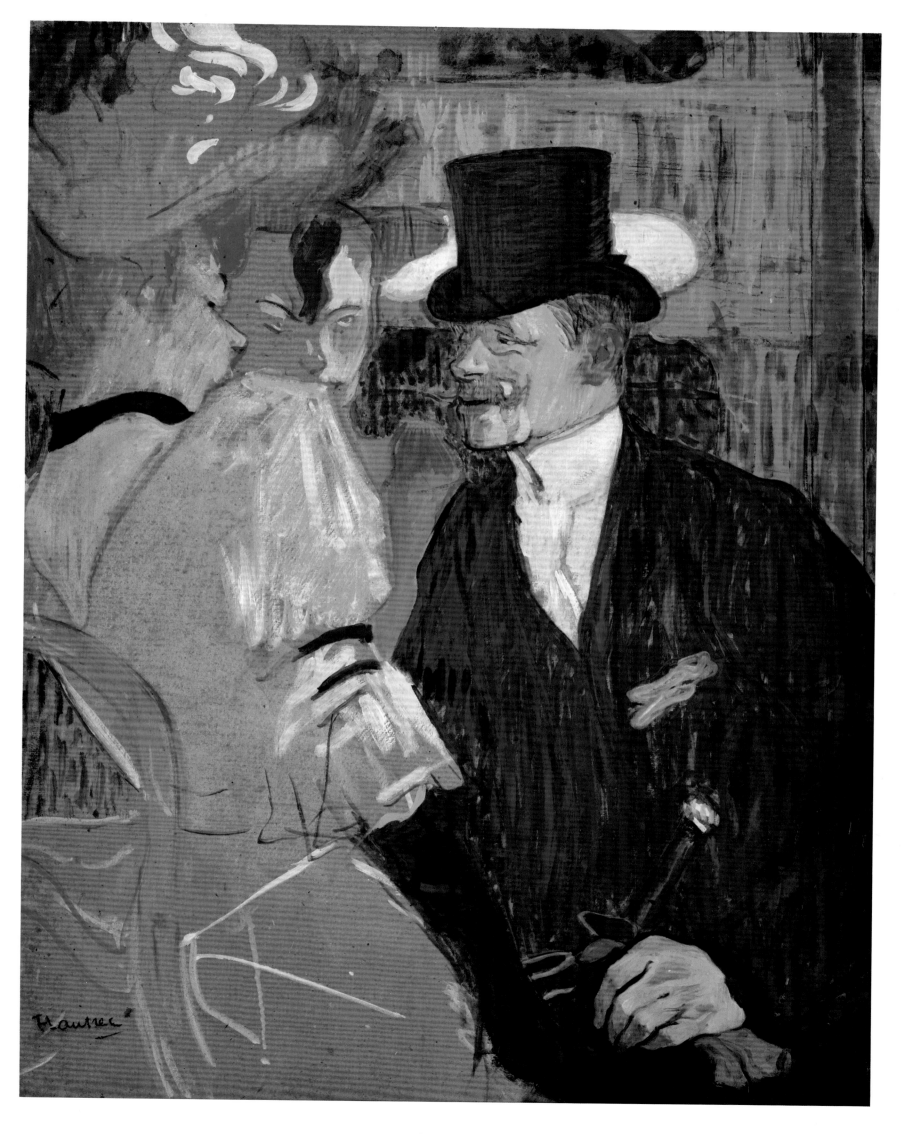

RIGHT
284.
Henri de Toulouse-
Lautrec
*Quadrille at the
Moulin Rouge*
892

OPPOSITE
285.
Henri de Toulouse-
Lautrec
La Toilette
1896

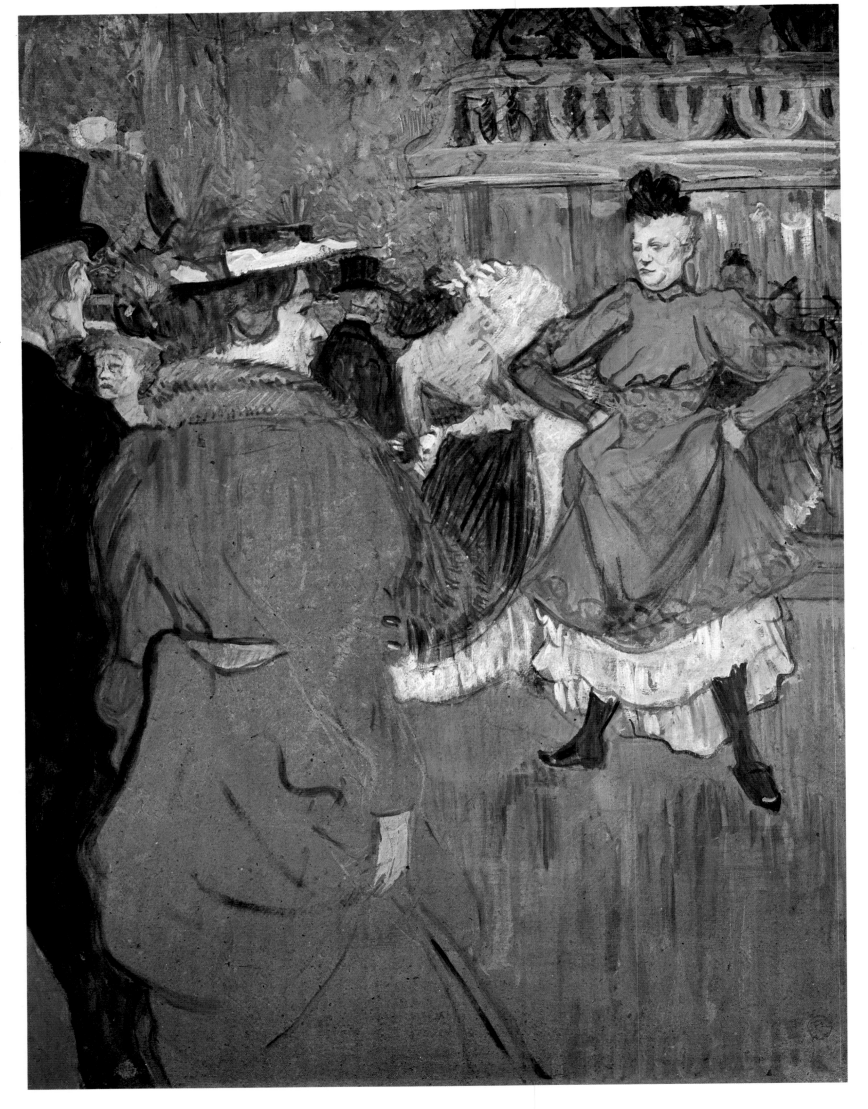

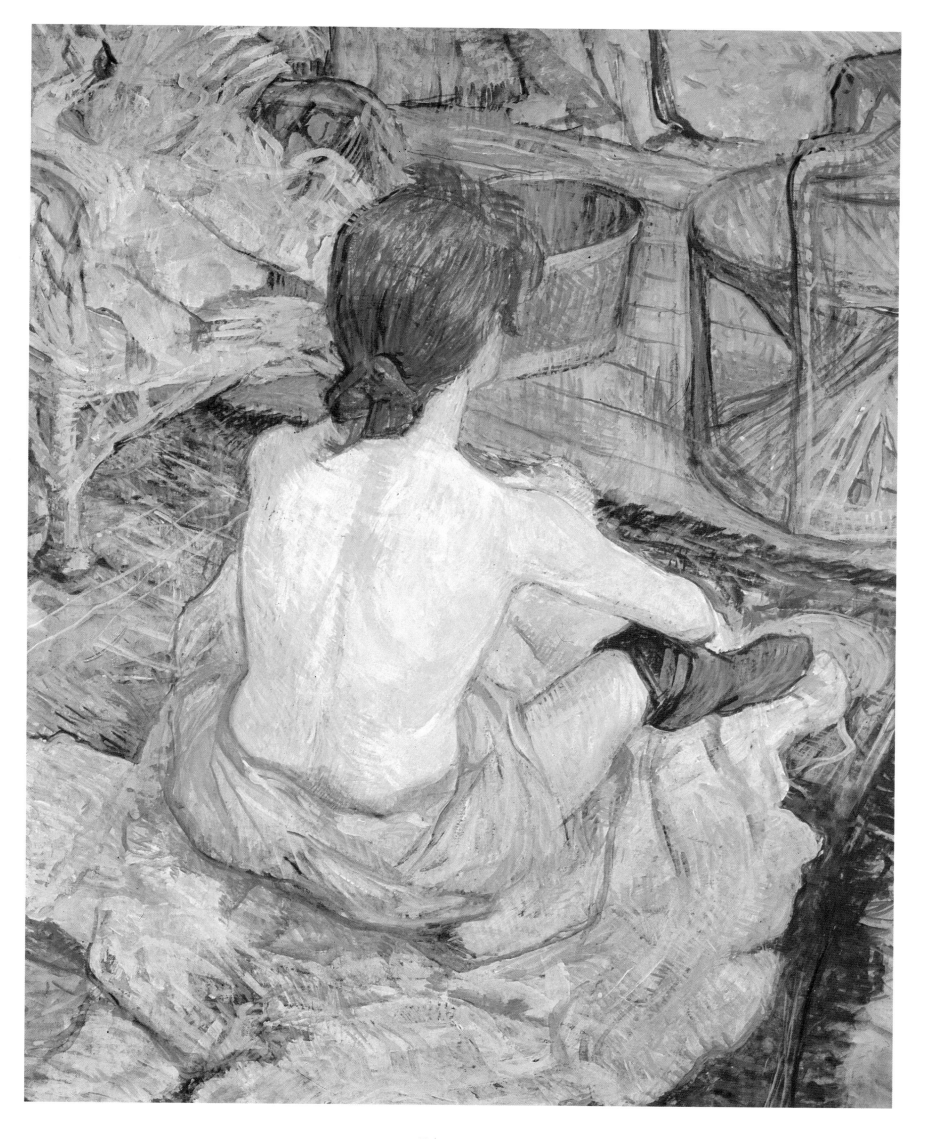

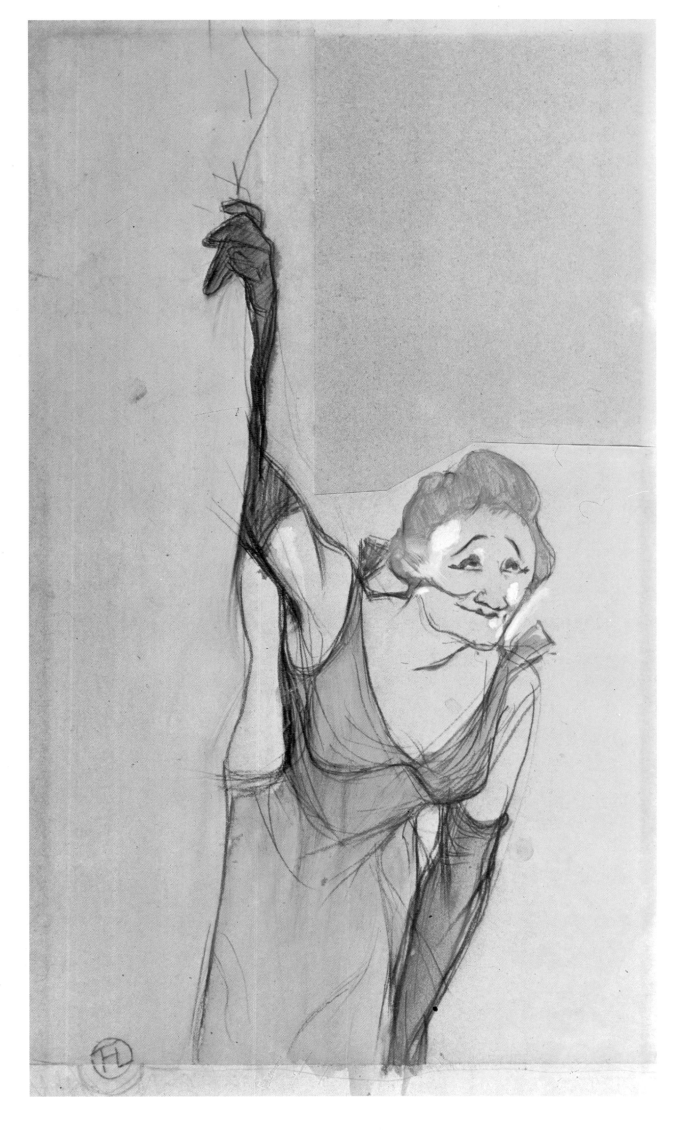

Lautrec's close friendships with the performers at the Moulin Rouge inspired many personal works, such as this vibrant study of the famed comic singer Yvette Guilbert, whom he sketched at curtain call. A few telling exaggerations—the hair color, the mouth, and the large made-up eyes—were all he needed to capture her essence.

May Milton *reflects more formal influences—particularly the decorative flatness of Japanese prints, which Lautrec assimilated in his color lithographs. No other Western artist so closely rivaled the Japanese in producing concise and expressive abstractions of the human figure.*

LEFT
286.
Henri de Toulouse-Lautrec
Yvette Guilbert Taking a Curtain Call
1894

OPPOSITE
287.
Henri de Toulouse-Lautrec
May Milton
1895

The Impressionists in 1886

The Impressionist works presented themselves with an air of improvisation.
The technique was summary, brutal, and hit-or-miss. . . . Since 1884–1885,
Impressionism has come into possession of [a] rigorous technique, M. Georges
Seurat was its instigator The innovation of M. Seurat . . . is based on
the scientific division of the tone.

FÉLIX FÉNÉON

In 1886 the eighth and last Impressionist exhibition was held. Four years had elapsed since the previous one, and of the original group, only Degas, Pissarro, and Morisot had continued to participate regularly in the last four group shows. Major differences of opinion about strategy and personal doubts had gradually polarized the members; Renoir's declaration in 1885 that he had "reached the end of Impressionism" typified the problem of many painters who were finding the style a "blind alley." The nature of this blind alley was not illuminated by the shifting roster of exhibitors in the later group shows, whose on-again-off-again participation indicated their weakening commitment to the group's original goals.

The 1886 exhibition took place without the participation of the pivotal Impressionists Monet, Renoir, Sisley, and Caillebotte. Indeed, it was only through Pissarro's untiring efforts that the event was undertaken at all, and he seems to have been motivated chiefly by his encounter the previous year with two young painters, Paul Signac and Georges Seurat. With the reluctant support of Degas, Pissarro petitioned to have them included in the exhibition. The work of the young newcomers was shown in one room along with that of their sponsor and his son, Lucien. This group of paintings—particularly Seurat's *A Sunday Afternoon on the Island of La Grande Jatte* (plate 313), whose authority provided the works with a pictorial manifesto—served both to identify the crisis that had befallen Impressionism and to offer a way through it.

Seurat's *Grande Jatte* documents, as had many Impressionist paintings, the ritual of the promenade. But unlike the Impressionists, Seurat rejected everything fleeting, transitional, and accidental. Instead of the reality of a particular moment, he constructed an ideal time, logical and clear as Pythagorean space. Seurat's canvas is not a celebration of middle-class leisure such as the earlier Impressionists painted, depicting situations the artists moved in freely themselves and often using their actual families or friends as models. Seurat does not identify with his subjects; his study is more remote than personal, more formal than documentary. Unlike the Impressionists, he was not interested in the "contemporary," the truth of the moment per se. Rather, he seems to have had a broader, more intellectual grasp of modernity.

The *Grande Jatte* may be understood as a complex summary of the numerous plein air gatherings, picnics, and promenades that had occupied the pioneer Impressionists in the previous two decades. Its monumental scale (almost seven by ten feet, or two by three meters), a necessary corollary of its all-inclusive content, invites comparison with Manet's and Monet's *Déjeuner* canvases, and underscores more acutely the latter's failures. The critic Gustave Kahn quoted Seurat's comment on the painting: "Phidias' Panathenaea was a procession. I want to show the moderns moving about on friezes in the same way, stripped to their essentials, to place them in paintings arranged in harmonies of colors . . . in harmonies of lines." [1] Seurat's exaggeration and stylization of the social ceremonies of the period is also a stylization of the spontaneity of earlier Impressionist painting. In fact, the challenge of the *Grande Jatte* resided precisely in its choice of a familiar plein-air theme as the point of departure for an entirely new method of applying color, the technique that Seurat and Signac called "Divisionism."

OPPOSITE
Detail

ABOVE, LEFT
288.
Georges Seurat
Seated Boy with Straw Hat
1883–84

ABOVE, RIGHT
289.
Georges Seurat
Head of a Woman Sewing
(Head of Woman with a Hat)
1884

Seurat used a special, highly textured paper for his Conté crayon drawings, so that when he rubbed the soft, chalklike pencil along the surface of the page it did not penetrate all the indentations, but left some of the white of the paper showing through. This marriage of paper and pencil is largely responsible for the soft, poetic light which seems to illuminate the figures from all sides. The two drawings at the left are studies for Bathers at Asnières *(plate 314).*

RIGHT
290.
Georges Seurat
L'Echo
1882–83

291.
Georges Seurat
The River Banks
c. 1883

The Emergence of Neoimpressionism

A seminal article by Félix Fénéon entitled "The Impressionists in 1886" analyzed the paintings of the new group, which the critic termed "Neoimpressionist." At the heart of Fénéon's argument was the belief that the "essential aim of [the] art is to objectify the subjective . . . instead of subjectifying the objective (nature seen through the eyes of a temperament)."[2] Fénéon's invocation of the term Neoimpressionism makes it clear that Seurat and his group conceived of themselves as "reformers of a casual, informal, instinctive Impressionism by means of the more rigorous disciples of modern science, rather than as the creators of a completely new and imposing style."[3]

Concern with artistic theory was certainly one development that differentiated the painters of the 1880s from those of the previous decade, but it was neither scientific method nor increased objectivity per se that ultimately distinguished Neoimpressionism from its stylistic predecessor. The reaction against Impressionism was not simply directed against the evident limitations of its method. Even before the emergence of Seurat, thoughtful artists like Pierre Puvis de Chavannes had gained the attention of a wide range of younger painters by endowing the historical, religious, and mythological themes he painted with a firm sense of design. In projecting the simplified language of basic forms, Puvis de Chavannes anticipated the more abstract concept of decorative art that would emerge with Paul Gauguin. Seurat was one of Puvis's young admirers; both critics and supporters made comparisons between the *Grande Jatte* and the work of the academic painter. For Fénéon, Seurat was a "modernizing Puvis," while an unsympathetic critic dubbed him a "false Puvis." What Seurat did share with the older artist was a dedication to clarity of design and, above all, to a harmonious arrangement of forms which left no room for incompleteness or equivocation.

Early Influences on Seurat

At the time his *Grande Jatte* thrust him into the limelight of the Paris art world, Seurat was just twenty-six years old. A few years before, he had studied at the Ecole des Beaux-Arts under Henri Lehmann, a pupil of Ingres. Sketches he made as a student reveal a profound respect for the role of drawing in painting—a respect doubtless encouraged by the type of teaching perpetuated since the Neoclassicists had come to dominate the Ecole some fifty years earlier. An avid reader, Seurat carefully studied the writings of such prolific artists as Delacroix, and he also made copious notes on the *Grammaire des arts de dessin*, a book published in 1867 by Charles Blanc, the librarian of the Ecole. This work, which included résumés and analyses of both Chevreul's and Delacroix's ideas about color, influenced the thinking of a wide variety of progressive late-nineteenth- and early-twentieth-century artists. Its emphasis on technical questions and relative indifference to subject matter both influenced and advanced the new focus on objectivity. Blanc's insistence that "color is controlled by fixed laws which 'can be taught like music'"[4] attracted Seurat. So did the scientific premises of textbooks such as that of American physicist Ogden Rood, whose *Modern Chromatics* taught Seurat a new formula for achieving greater luminosity through selective juxtaposition of color.

During his student years, the Louvre was Seurat's laboratory for testing the art of the past against his developing theories. He pursued the study of black and white as carefully as he had

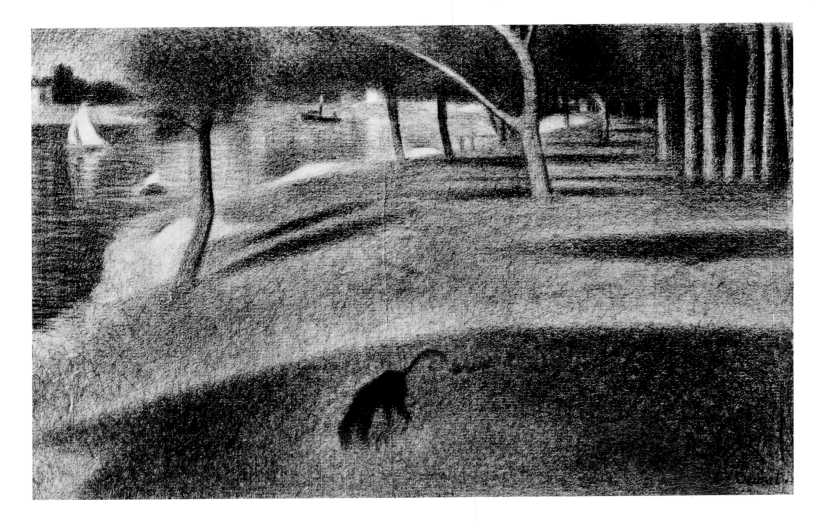

examined the role of color, producing hundreds of drawings in soft Conté crayon in which he concentrated on defining the character of a form through gradations of light and shadow instead of line. These drawings, like Seurat's early paintings, reveal a preoccupation with light—especially with its ability to penetrate objects.

Seurat was only twenty-three years old when he began work on his first great canvas, *Bathers at Asnières* (plate 314). This serene and majestic work, as large as the later *Grande Jatte*, was rejected by the Salon jury in 1884 but included in an exhibition organized by the Société des Artistes Indépendants,

a group in which Seurat was quite active. While preparing the final version of *Bathers at Asnières*, Seurat produced countless drawings and many small oil sketches of the various motifs that were ultimately included. This methodical process of prolonged analysis and selection contrasted dramatically with the more immediate and spontaneous technique developed by the Impressionists of the previous decade.

Even the choice of locale was a move into unfamiliar territory. Located near the island of La Grande Jatte, Asnières was an industrial suburb, flat and somewhat barren. The working-class men depicted in the painting are implicitly linked to the factories visible in the distance. Yet there is no written evidence to suggest that Seurat was motivated by the kind of socialism that appealed to his friends Pissarro and Signac. His choice, rather, lent itself to the depiction of coolly treated forms subordinated in a carefully engineered disposition of the whole and its constituent parts; vertical and horizontal elements throughout articulate the pictorial structure. The color is fairly subdued, with the result that no simple physical aspect of the painting takes precedence over another. Despite its modern setting, the painting projects an aura of idyllic timelessness usually associated with more patently arcadian themes.

Collaboration with Signac

Paul Signac, a slightly younger painter who had been instrumental in the founding of the Indépendants, saw *Bathers at Asnières* when it was exhibited in 1884 and sought out its creator. At the time, Signac employed the bright colors associated with Monet, whom he greatly admired, though he favored a choppy, more uniform brushstroke. He was attracted by the orderly air of Seurat's canvases, and within a short time he and his new friend began to pool their intellectual energies with mutually beneficial results. Signac applied himself to a more profound study of color theory and optics, even going so far as to interview the ninety-eight-year-old Chevreul, while Seurat, at his friend's urging, added passages of bright color to sections of *Bathers at Asnières*.

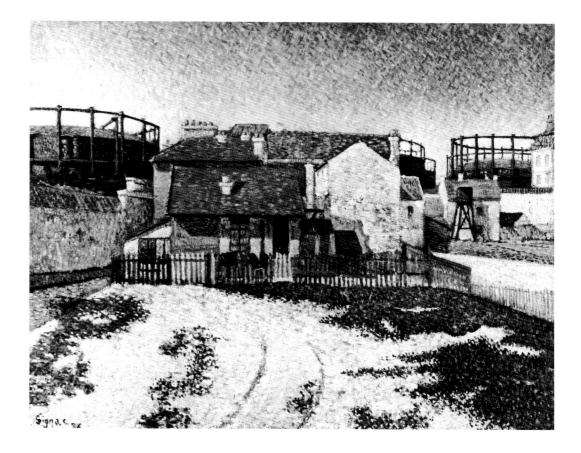

Four years younger than Seurat, Paul Signac became his principal spokesman and the official theoretician-historian for the Neoimpressionist position, responsible for its assuming the dimension of an international movement. Attracted to progressivist ideas in science as well as politics, Signac was a sympathizer with the socialist-anarchist movement who saw beauty in the new industrial landscape—the environment of the urban proletariat seen in this highly formularized view of a Parisian suburb.

297.
Paul Gauguin
Locusts and the Ants
1889

Their increasingly scientific approach to the study of color and light resulted in the development of the formula and technique for applying the pigments that the artists termed "Divisionism." Signac, a highly articulate spokesman and effective proselytizer for the new theories, later codified the tenets of Neoimpressionism in a book entitled *From Eugène Delacroix to Neoimpressionism* (1899). Responding to the frequent and erroneous observation that the Neoimpressionists simply covered their canvases with little dots, Signac insisted that they had introduced a much more precise procedure:

> *The Neoimpressionist does not* dot, *he divides.*
> *Now, to divide is:*
> *To assure oneself of all the benefits of luminosity, of coloring, and of harmony, by:*
> *1.* The optical mixture of solely pure pigments . . .
> *2.* The separation of the different elements . . .
> *3.* The equilibration of these elements and their proportions (*according to the laws of contrast, of gradation, and of irradiation*);
> *4.* the choice of a brushstroke commensurate with the dimensions of the painting.[5]

Fénéon termed Signac's paintings "exemplary specimens of a highly decorative art, which sacrifices the anecdote to the arabesque, nomenclature to synthesis, the fugitive to the per-

manent, and confers on nature—weary at last of its precarious reality—an authentic reality." More of a socialist than Seurat, Signac was attracted to the ideas of a young scientist, Charles Henry, and may have collaborated on the latter's *Education of the Spirit of Forms* and *Education of the Spirit of Colors*, books which Signac felt would create an aesthetic consciousness among the working classes.

The Growth of Neoimpressionism

The controversy generated at the last Impressionist exhibition by Seurat's *Grande Jatte* was extended beyond Paris in the next year, when the artist was invited to participate in a Brussels exhibition by the independent group Les XX. Seurat sent his huge canvas along with six seascapes to the exhibition, where the technique of small dots of color was alternately praised and damned by critics. Its impact on such younger Belgian painters as Henry van de Velde and Theo van Rysselberghe demonstrated its enormous power to seduce artists searching for a coherent new pictorial language.

Back in Paris, the nucleus of the Divisionist group drew in new members, including Charles Angrand, Maximilian Luce, and Henri-Edmond Cross, another of the founders of the Société. While Pissarro and Signac regarded the sudden enthusiasm for Divisionism as proof of its validity, Seurat was suspicious. He expressed increasing concern that the popularity of his theories among painters would compromise the integrity of his achievements. Although Signac and Fénéon attempted to dispel his fears by suggesting that the technique was accessible only to really serious painters, Seurat continued to be reticent about his ongoing discoveries.

One of Seurat's innovations, already noted by Fénéon in his article "The Impressionists in 1886," was the abandonment of the traditional gold frame in favor of a white one (preferred also by the Impressionists) and the subsequent coloring of the frame itself. From there, Seurat went on to paint directly on the canvas a border whose colors complemented those of the picture surface next to it. The effectiveness of this technique is clearly evident in such works as *Invitation to the Sideshow (La Parade)* (plate 315), *Le Chahut* (plate 317), and *Woman Powdering Herself* (plate 316), a stylized portrait of the painter's mistress.

These paintings chart the course of Seurat's remarkable development after the *Grande Jatte*. The assemblage of figures in a broad landscape viewed under natural light had been the culmination of Seurat's earlier studies. In *Invitation to the Sideshow*, *Le Chahut*, and *The Circus* (plate 318), he turned to figures in artificial light—the gaslight of the street theater or the footlights of a café cabaret. The predominant tones of the paintings, alternating monotones of brown-green or yellow-orange, project moods of gloom or gaiety. The figures and objects of *Invitation*

298.
Paul Gauguin
Portrait of van Gogh
1888

*T*he title of this work suggests Gauguin's identification with the principal character of Victor Hugo's novel: Jean Valjean, a reformed thief. The design of the canvas betrays a tendency toward abstraction that is matched by the conscious decorativism of the wallpaper and the carefully juxtaposed colors. In the upper right hand corner Gauguin has included a schematized portrait of Emile Bernard, a close friend of both van Gogh and Gauguin.

299.
Paul Gauguin
Les Misérables
1888

to the Sideshow are tightly aligned to the vertical and horizontal axes that dominate the composition and underline their rigid and stylized shapes. The three-dimensionality of his earlier landscape has been replaced by an emphatically two-dimensional canvas, whose flatness is reiterated by rectangular veils of color.

Rejecting the casual approach of the Impressionists, Seurat made a critical attempt to see each subject anew and to imbue it with intrinsic meaning. Years later, reminiscing about his experiences as a Neoimpressionist, Henry van de Velde described Seurat's efforts as a "return to style," the conscious outgrowth of his experiments with technique that had led "inevitably" to stylization.

In his last works Seurat strove to integrate an increasingly complex calligraphy into his color schemes. His unfinished *Circus*, exhibited at the Indépendants only weeks before his sudden death from an influenza-like disease, presents a caricature of movement and gesture, as had *Le Chahut*. The figures of the horse and its acrobatic rider seem to have been influenced by commercial art; the impersonal uniformity of the urban poster may have attracted Seurat, just as the naive or "primitive" *Images d'Epinal*—popular French woodcuts with historical or moralizing subjects—served as inspirations for the archaicizing mythic form and content of Gauguin.

Only in the last year or so of his life did Seurat provide any written summary of his evolving theories of painting. In a letter written to a friend, he offered an outline of his credo: "Art is Harmony. Harmony is the analogy of contrary and of similar elements of *tone*, of *color*; and of *line*, considered according to their dominants and under the influence of light in gay, calm, or sad combinations."[6]

Van Gogh and Gauguin

The eventful year of 1886 not only marked the last Impressionist exhibition and the official birth of Neoimpressionism, but also saw the publication of a manifesto of Symbolism, the first and most controversial of the late-nineteenth-century avant-garde movements, by the poet Jean Moréas. Coincidentally, it was also the year in which Vincent van Gogh and Paul Gauguin met for the first time. During the next few years the intersection of Neoimpressionism and Symbolism was to create a tension between opposing theories that van Gogh's and Gauguin's work, in different ways, sought to resolve.

At the time of their meeting, Gauguin had only been painting seriously for about ten years, and it was just within the last three that he had given up his promising career as a banker to devote himself to painting full-time. The paintings he produced before 1886 were still essentially conservative works that contrasted sharply with the flamboyant character of their creator. Headstrong and self-indulgent with a streak of cruelty, Gauguin

was to provide the model for the popular notion of the artist as a bohemian with little or no sense of domestic or family responsibility. Brought into the Impressionist group by Pissarro, he participated in five of the exhibitions, with nineteen paintings in the last show alone. The money Gauguin had earned as a businessman permitted him to buy works of art, and he already had amassed a sizable collection of works by Manet, Monet, Renoir, Sisley, and Pissarro when he met the last named. Under Pissarro's selfless guidance, the younger artist began to concentrate on landscape painting.

Gauguin's enthusiasm for plein air painting soon gave way to a dissatisfaction that seems to have beset virtually all the adherents of Impressionism. He was increasingly drawn to the contemplative character of Cézanne's work, which he had seen at the shop of the paint grinder Père Tanguy, as well as to the broad patterns and simplified colors of Puvis de Chavannes. In the face of estrangement from his family, hardship, and ill health, he persevered in his desire to fashion an art that would be responsive to the emotions and the senses and still convey the logic and order that he believed intrinsic to all great art. In a letter written in 1885 to a friend and a former broker who, like him, had sacrificed comfort and professional success to

devote himself to painting, Gauguin articulated his seemingly paradoxical belief that "the greatest artist is synonymous with the greatest intelligence; he is the vehicle of the most delicate, the most invisible emotions of the brain."[7] The reconciliation of seemingly antithetical intellectual and emotional elements occupied Gauguin in the years between the last Impressionist exhibition and his first trip to the South Pacific in 1891. During this remarkably brief interval, he formulated many of the influential theories that would shape the development of modernism in the next century.

Van Gogh and Impressionism

When Vincent van Gogh, the son of a Dutch minister, arrived in Paris early in 1886, he was largely ignorant of the development of Impressionism; but with the peculiar urgency that marked both his personal life and his career as a painter, he quickly began to assimilate the essence of the movement. He viewed Impressionism through the perspective of the last exhibition, challenged as it was in the work of such men as Seurat and Pissarro. His own taste in painting had been formed by his experience in Holland,

OPPOSITE, TOP

300.

Vincent van Gogh
Still Life with the Bible
1885

OPPOSITE, BOTTOM

301.

Vincent van Gogh
*People Coming Out of Church
at Nuenen*
1884

ABOVE

302.

Vincent van Gogh
The Potato Eaters
1885

In the course of his tormented life, van Gogh made thirty copies or adaptations of Millet's The Sower. *The lean and sinewy line employed in this drawing conveys some of the same directness as Millet's own drawings of rural workers (plate 22).*

where two of his uncles were successful art dealers with international connections. Van Gogh worked in their firm, Goupil and Company, for about five years before he decided to enter the ministry, continuing a family tradition of service to the church.

An unfocused humanitarianism impelled van Gogh to a vocation which he could fulfill neither emotionally nor intellectually. He entered a theological seminary, intending to follow in his father's footsteps, but despite his earnest struggle, he failed the examinations, and took a position as a lay religious worker in the desperately gloomy mining region of Belgium. There, amid the lacerating poverty of the miners and their families, he took up painting. Inspired by the moving spectacle of their resignation and dignity, van Gogh sought to express a pictorial equivalent for the deep sincerity and truth of their experience. In a letter to his brother Theo, who was working as an art dealer in Paris, he expressed his aim in painting *The Potato Eaters* (plate 302), the most ambitious of his early pictures: "I have tried to emphasize that these people, eating their potatoes in the lamplight, have dug the earth with those very hands they put in the dish, and so it speaks of manual labor, and how they have honestly earned their food. I have wanted to give the impression of a way of life quite different from that of civilized people. Therefore, I am not at all anxious for everyone to like or admire it."[8]

When he wrote these lines, van Gogh had been painting for about five years. Although he had spent time at art schools in The Hague and in Antwerp, he was largely self-taught, which may partially account for the crude but powerful quality that emanates from this dark and moving painting and from the many crayon or charcoal studies of this period. He greatly admired Delacroix; but it was the Barbizon School, and especially the work of Millet, that had represented modern art for van Gogh until his arrival in Paris. His reverence for Millet's empathy with the condition of the rural poor expressed itself directly in his copies of the older painter's motifs, but a more profound influence is to be seen in van Gogh's shared conviction: "Painting peasant life is a serious thing, and I should reproach myself if I did not try to make pictures which will rouse serious thoughts in those who think seriously about art and about life."[9]

Van Gogh's decision to go to Paris was sudden but had been influenced no doubt by the enthusiastic letters of his brother, Theo. When he arrived, he was consumed with a passion to see everything and especially to learn all about the new theories of color that were so heatedly being discussed. His intensity often intimidated those with whom he came into contact, so that he made few friends among his fellow students in the studio of Félix Cormon, where he worked for about a year. Perhaps his age and his tragic inability to communicate easily with his fellow man—a manifestation of the psychological fragility all too evident in his early hesitations and failures—predisposed him to go it alone in Paris and, later, persuaded him to search for a new life and a new air in the south of France.

Van Gogh's initial contact with the Impressionists was disappointing. While he began to lighten his palette and change his subject matter, he was especially critical of their sloppiness, indicting them for bad drawing. Characteristically, it was Pissarro who patiently explained the technique and intent of his own paintings to van Gogh, inducing him to adopt the Neoimpressionist approach that is superficially evident in *Restaurant Interior* (plate 319). Later, Pissarro recalled his intuition that the novice "would either go mad or leave the Impressionists far behind." While striving more consciously for the brighter color and greater luminosity of Neoimpressionism, van Gogh began to explore, as had many Impressionists before him, the clarity, sharpness of contour, emphatic color contrasts, and distinctive spatial homogeneity of Japanese woodcuts. His highly original implementation of the message of Japanese art is already evident in his vivid portrait of Père Tanguy (plate 327), the paint seller who befriended van Gogh and remained a faithful collector of his work. Indeed, when van Gogh left Paris for Arles in February of the next year, he did so not only out of nervous exhaustion and a need for a complete change of environment, but also because he believed that he had developed a more "Japanese" eye and that Arles would be more like Japan.

Van Gogh's meeting with Gauguin in November 1866 engendered a curious friendship. Despite their radically different characters, each artist saw himself outside the framework of Impressionist art. Gauguin had openly broken with the group, causing Pissarro profound sadness and disappointment; while, for his part, van Gogh professed disapproval of the self-interest and pettiness of the Impressionists' squabbles. His own idealistic dreams of artists working in close community were fed by his vision of the south, much as Gauguin's desire to find new subjects had been stimulated by trips to Panama and Martinique. For both van Gogh and Gauguin, physical removal from Paris was to become crucial to the transformation of their styles.

Van Gogh's Move to Arles

The first months of van Gogh's stay in Arles in 1888 were marked by high spirits and feverish activity. A small allowance from his brother enabled him to find a little house, which afforded him a measure of stability that his life had previously lacked. Describing himself as a "painting locomotive," he undertook hundreds of new motifs—landscapes, still lifes, interiors, portraits—imbuing them with an almost unbearable energy. Emphatically rejecting Impressionism and Neoimpressionism, he attempted instead to capture in works such as *Drawbridge near Arles* (plate 320) and *Haystacks in Provence* (plate 321) the rhythmic vitality and dynamics of nature. He wrote, "Instead of trying to reproduce exactly what I have before my eyes, I use color more arbitrarily so as to express myself vigorously."[10]

The key elements of the style he was forging were saturated, evocative color and a vigorously calligraphic style of drawing. From his correspondence with Theo, which sheds light on the painters's passionately poetic theories on art, we learn that van Gogh identified specific emotions with certain colors. Yellow, for example, was for him the color of friendship and love. Thus the intense yellows and oranges of many Arles canvases are not used merely to record the atmosphere of a sun-drenched field, but also as chosen symbols for conveying the exhilaration and love of man that the painter experienced in those moments of closeness with nature.

Although van Gogh steadfastly kept up his confrontation with nature, he sought to simplify form and composition by intensifying his color and brushstroke. This intensification gave his canvases an expressiveness that was interpretive rather than descriptive. The intense blood reds, acid yellows, and lurid greens of *The Night Café* (plate 323), a painting showing a seedy Arles bar, were meant to convey the latent violence van Gogh

felt in "a place where one can ruin oneself, run mad or commit a crime."

Van Gogh seemed close to realizing his dream of artistic collaboration when he finally succeeded in convincing Gauguin to join him in September 1888. It is clear from letters to his brother that van Gogh was emotionally and physically exhausted as he awaited Gauguin's arrival and that he was aware of the frail state of his nerves. Perhaps he sensed the onset of those emotional problems that would come to a head during the other painter's brief but tragic stay.

Gauguin had developed a deep attachment to Brittany, where he had painted for about two years and become the center of a small but devoted circle of painters and poets. His immediate dislike of Arles, which he found dirty, and of van Gogh's housekeeping, which he found disorderly, created tensions between the two men. Gauguin's self-assurance, born of greater experience and a clarity of purpose that expressed itself in both words and paintings, was a rebuke to an artist as basically humble and

BELOW, LEFT
306.
Vincent van Gogh
Cane-Bottomed Chair
1888

BELOW, RIGHT
307.
Vincent van Gogh
Cypresses
1889

insecure as van Gogh, who considered his own canvases "ugly and uncouth" and his aesthetic vision "vulgar" next to that of his sophisticated friend. Gauguin also worked now from memory, whereas van Gogh continued to need direct contact with nature. He made an earnest attempt to adopt Gauguin's practice, but soon found that the "abstraction" required for painting from memory created more dilemmas for him than it resolved.

Whatever the pain suffered by van Gogh or irritations endured by Gauguin, the two months they spent working together provided an unparalleled opportunity for mutual stimulation and challenge that helped to focus the endeavors of both painters. Van Gogh had been working on portraits since his arrival in Arles. In November, just a month before his frustration with Gauguin erupted into the self-inflicted violence that marked the beginning of his first serious mental breakdown, he painted a portrait of a neighbor, Madame Ginoux, called *L'Arlésienne* (plate 328). The juxtaposition of strong colors, purple-black against a yellow background, bespeak a stylization and assimilated orientalism akin to that of Gauguin. The obvious quotations of Japanese art, so boldly if somewhat primitively evident in the Père Tanguy portrait of just a year or so earlier, have been replaced by a surer synthesis of color and shape.

Van Gogh's genius for making objects seem alive, so evident not only in his floral still lifes, but also in his paintings of books and worn-out shoes, suggests his special, highly emotional identification with the concrete world. Although he apparently could not bring himself to paint a direct likeness of Gauguin, he did paint the feelings Gauguin brought out, creating a portrait in absentia, as it were. *Gauguin's Armchair* (plate 330), done just before the mental collapse during which he mutilated his ear, is a brooding, even sinister, evocation of Gauguin's overbearing aura. The chair seems to possess the canvas, while the paper-back novels and candle resting on the straw seat suggest the absorption with literature and commitment to intellectual life that marked Gauguin's aesthetic. As a pendant, van Gogh painted his own chair (plate 329), a rather unprepossessing, homemade piece of furniture, with his pipe and tobacco—altogether unsophisticated by contrast.

Van Gogh's Last Troubled Year

Van Gogh spent long months recovering from his illness, first in a mental hospital near Arles and later under the care of the physician-painter Paul Gachet in Auvers, outside of Paris. The painter's letters from this period provide a unique autobiography as well as a documentation of his aesthetic ideas and working habits. In June 1890, just a few weeks before van Gogh shot himself to death in the wheatfield where he had once painted marauding crows (plate 331), he wrote to his youngest sister about his passion for what he called "the modern portrait," saying that

he wanted to create works that would strike later generations as "apparitions." His numerous self-portraits come close to realizing this ambition, especially those executed after the onset of his illness. The sharp features, more skeletal than ever, and the weary, fixed stare bespeak a haunted man. Any sense of description is superseded by the intense, unhealthy color and jagged brushwork, which suggest a physical assault on the canvas.

Six months before van Gogh's death, the critic G.-A. Aurier had published the first appraisal of his work in the Symbolist magazine *Mercure de France*. Drawn to the painter by his antinaturalist and antiscientific qualities, Aurier lavished praise on his sincerity, his unique and even "neurotic" vision, and the crude but expressive power of his line and color. While his attempt to place van Gogh within the mainstream of Symbolism is not always persuasive, the critic's evaluation of his character is certainly on target: "Vincent van Gogh is not thus merely a great painter . . . he is also a dreamer, a fanatical believer, a devourer of beautiful Utopias, living on ideas and dreams."[11]

308.
Vincent van Gogh
Portrait of Dr. Gachet
(*L'Homme à la Pipe*)
1890

309.
Paul Gauguin
The Yellow Christ
1889

Gauguin was enormously attracted to the folk art of Brittany. In particular, the "rustic grandeur and superstitious simplicity" of the naive religious sculptures that filled the countryside stimulated his imagination and his desire to fashion a new kind of symbolic art. A polychrome wooden crucifix in a village chapel provided the model for this inventive, stylized celebration of Breton piety and religious mystery.

The Symbolist Aesthetic: Gauguin at Pont-Aven

Aurier was the most ambitious and possibly the ablest of the critics who promoted the Symbolist position. His article on Van Gogh, celebrating an art of emotion and sensation, was followed by an equally penetrating one on Gauguin. For Aurier, as for the young painters Paul Sérusier and Maurice Denis, Gauguin was "the initiator of a new art, not in the course of history, but at least in our time."[12] The goal of this art was not to represent objects, but rather to create forms that expressed their essence. For the critic, an essential component of the process of translation was "a necessary simplification of the writing of the sign." His views thus complemented and, in turn, influenced the evolving aesthetic of Gauguin, who was already groping toward a style that rejected illusionism and chose still greater abstraction from nature and a "synthesis of form and color."

Gauguin had put his "synthetism" into practice in works he painted in Pont-Aven, Brittany, where he lived and worked intermittently from 1885 to 1891. The indigenous folk art of the region, especially stone and polychrome wood sculpture, began to exercise an influence on Gauguin, taking its place beside his more cultivated enthusiasm for Degas, Puvis de Chavannes, and the art of the early Italian Renaissance. *Vision after the Sermon: Jacob Wrestling with the Angel* (plate 336) unites objective reality— a group of Breton peasants and a landscape—with the subjective reality of the biblical vision. The intensely compressed space, stylized forms, and strong color contrasts reflect the highly decorative structure of the composition. Gauguin was quite satisfied with this picture and wrote to van Gogh: "I believe I have attained in these figures a great rustic and *superstitious* simplicity. It is all very severe To me . . . the landscape and the struggle exist only in the imagination of these praying people, as a result of the sermon."[13] The biblical theme of the vision was seized by Gauguin as a means of moving away from the dictates of representation that had dominated avant-garde painting from the time of Courbet. Similarly, the costumes of the Bretons, with their localized and traditional characteristics, allowed Gauguin to break away from the contemporaneity that had accompanied the ascendance of Realism.

The Yellow Christ continues the innovations of *Vision after the Sermon*. Posed against the Breton landscape, a group of three peasant women kneel in a semicircle around a devotional sculpture of the crucified Christ. The motif was borrowed from an existing polychrome wood figure, the yellow Christ of the Chapel of Trémalo in Pont-Aven. However, placed before the ordinary contours and incidents of the landscape and enclosed by the devotional and pious introversion of the kneeling figures, the figure in *Yellow Christ* has the quality of an apparition.

The most radically simplified and abstract painting dating

from Gauguin's stay in Brittany is his Symbolist *Self-Portrait with Halo* (plate 333). The painting is broken into two flat fields of red and golden yellow. Out of the mushrooming lower field emerges the truncated head with its halo. The intention of the work is allegorical: the colors signify passion on the one hand and sanctity on the other. Along with the obvious allusions to temptation and sin, the portrait shows the artist caught in the dilemma of good and evil, worldliness and innocence.

Departure for Tahiti

In April 1891 (a few days after Seurat's burial and shortly before the death of Theo van Gogh from an illness brought on by the shock of Vincent's suicide), Gauguin left France for Tahiti. Having raised some money from an auction of his paintings and secured additional funds from the minister of fine arts for a mission to study the customs and scenery of the French colony, he remained there for two years. In this interval he produced, in his own words, "sixty-six more or less good paintings and several extremely savage sculptures."[14] These first Tahitian paintings pursue—through the particular vantage point of the island, its exotic colors, its folklore and myths—the Symbolist style that Gauguin had developed in Brittany. Generally, these canvases are richer in color and simpler in form than the Brittany paintings, and the compositions are more lucid and harmonious—qualities Gauguin came more and more to value. Paintings such as *Ia Orana Maria* (plate 337) have a calm atmosphere and almost classical design. Rather than picturesque anecdote, the painter has fashioned formal equivalents of the innocence and timelessness that westerners associate with the islands. Like the Symbolist poets, he sought analogies between art and music, wishing his canvases to evoke sensations in the way that combinations of notes did: "By the combination of lines and colors, under the pretext of some motif taken from nature, I create symphonies and harmonies which represent nothing absolutely real in the ordinary sense of the word but are intended to give rise to thoughts as music does."[15]

Gauguin returned to Paris in 1893, in poor health but in firm possession of his large group of strange-looking paintings and sculptures, which he showed—unsuccessfully—at Durand-Ruel's. Aurier, who had voiced such enthusiastic support of Gauguin's Symbolist principles, had just died suddenly, leaving him without a champion; so the painter became his own prophet, writing notes in his *Intimate Journal*, which would eventually be published after his death.

Gauguin returned to the South Pacific in 1895 and later moved to the more remote Marquesas Islands. The largest and most philosophical of his canvases, *Where Do We Come From? What Are We? Where Are We Going?* (plate 338), was painted just five years before his death. It sums up his work and his early

310.
Maurice Denis
The Muses
1893

influences, and reflects his profound wish to create a new type of literary or allegorical work. Writing to his friend Daniel de Monfried, Gauguin described his objectives: "I wanted to paint a big canvas which I had in mind By God, it is not made like a Puvis de Chavannes, studied from nature, preparatory cartoon, etc. It is all done in a bold style, directly with the brush, on sackcloth full of knots and wrinkles, so it looks terribly rough."[16]

The landscape is lush and the figures in the work are indeed primitive, compared with the nymphs of Puvis de Chavannes or the orientalized Venuses of Ingres. Yet the painting fits as squarely into the venerable tradition of the nude as do the works of the great academicians.

Whereas van Gogh sought to capture the raw emotion produced by a direct encounter with familiar persons or things, Gauguin rejected the known and tangible. He relinquished the transcription of the physical world to pursue the mysterious and elusive universe of sensations. Van Gogh's expressive use of line and color and Gauguin's cultivation of decorative values were to influence a broad spectrum of painters both within and outside of France. The immediate impact of Gauguin's work on a group of students at the Académie Julien—the self-proclaimed Nabis, or "prophets," such as Sérusier and Denis—was to inspire an elegant art of consummate artificiality which celebrated premeditation and concept, qualities the Impressionists had labored so long to suppress.

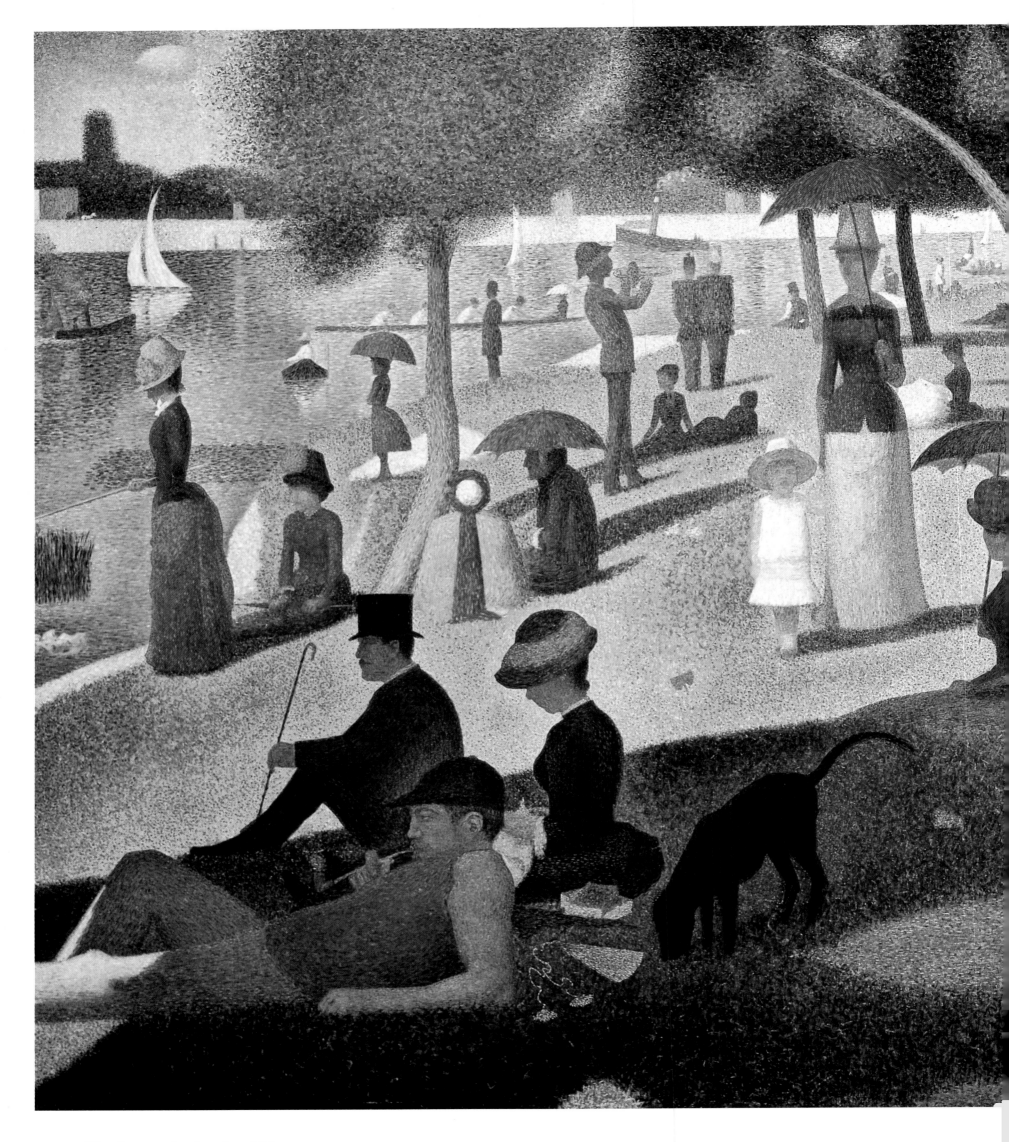

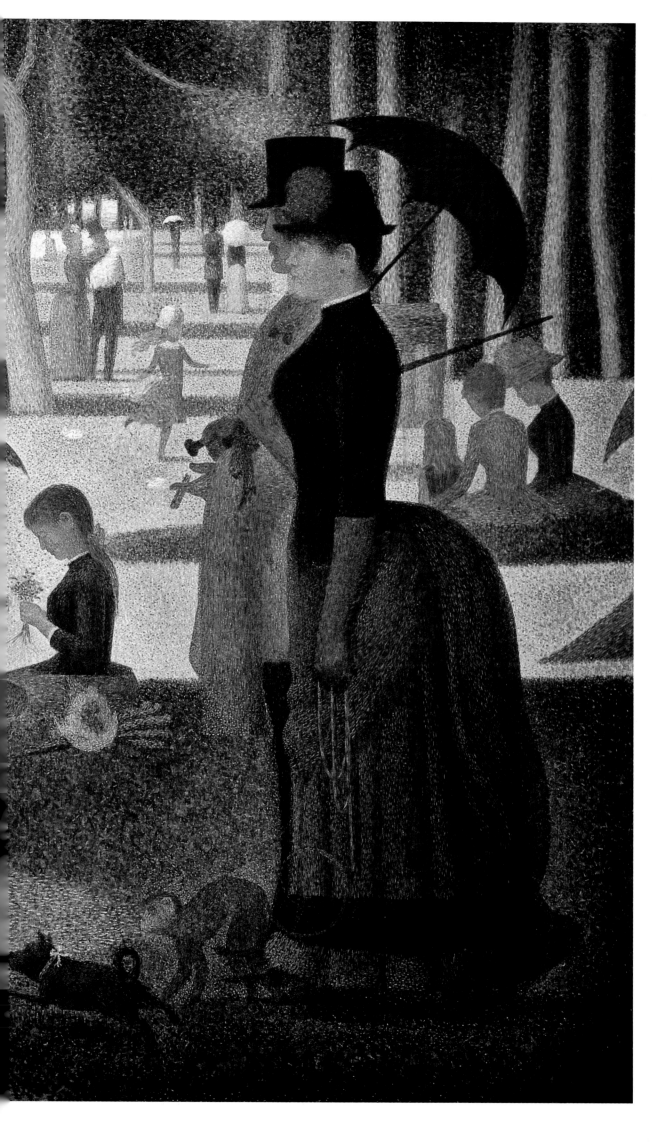

While the subject matter of this huge canvas belongs to the repertoire of Impressionism, the organization of space and controlled application of colors reflect a scientist's temperament and discipline. Seurat has replaced casual composition and haphazard brushstroke with formulas for structure and color that ensure a harmonious work in which all of the parts reflect the whole. There is no room here for the spontaneity or incidental qualities associated with the critical decade of Impressionism; the scene is laid out with the scrupulous precision of a specimen slide prepared for analysis under a microscope.

313.
Georges Seurat
A Sunday Afternoon on the Island of La Grande Jatte
1884–86

Seurat

306 • The Impressionists in 1886

Seurat made at least fourteen preparatory oil sketches on the spot before executing this enormous composition in his studio. The tight vertical-horizontal structure of the finished work, enunciated through the large seated figure, is already implicit in these sketches, which reveal—as do those for the later Grande Jatte—Seurat's steadfast elimination of anything casual or incomplete in favor of an almost hieratic wholeness. Classically calm and studiously anonymous, the world of these bathers is aesthetically remote from the vibrancy and subjective exuberance of comparable themes painted by Impressionists such as Renoir.

314.
Georges Seurat
Bathers at Asnières
1884

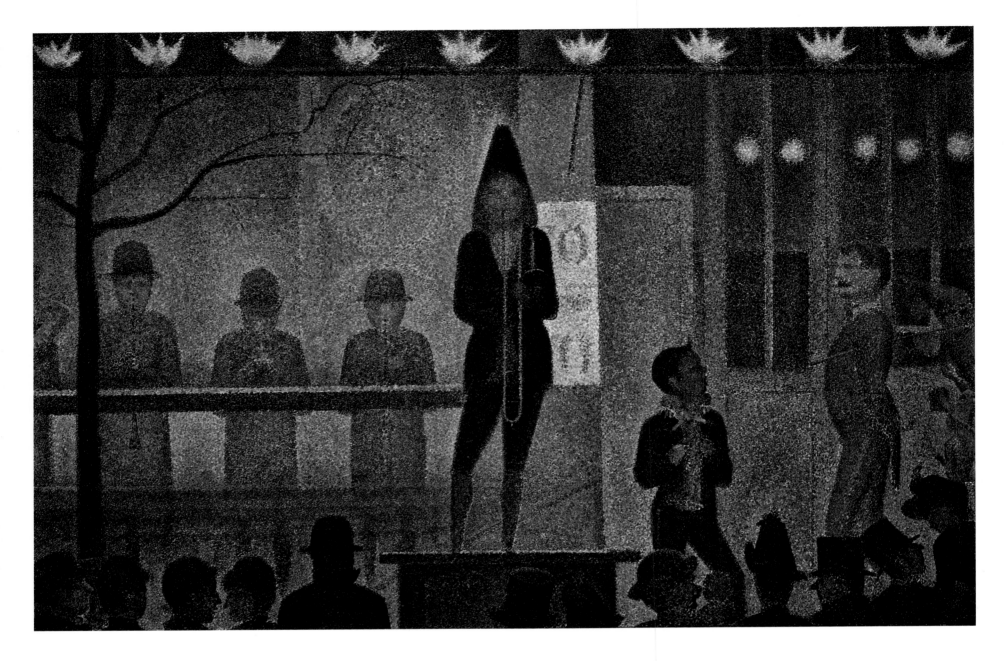

ABOVE
315.
Georges Seurat
Invitation to the Sideshow (La Parade)
1887–88

OPPOSITE
316.
Georges Seurat
Woman Powdering Herself
1889–90

*I*n his late works, Seurat rendered the formalized movements of dancers and circus performers in correspondingly stylized compositions. The precise geometric patterns of the figures project a rhythm that is energetic but almost impersonal in its mechanical repetitiveness. In several of these canvases, Seurat stations a lone figure with his back to the spectator, whose isolation serves as a crucial point of reference in the telescoped space.

PAGE 310
317.
Georges Seurat
Le Chahut
1889–90

PAGE 311
318.
Georges Seurat
The Circus
1891

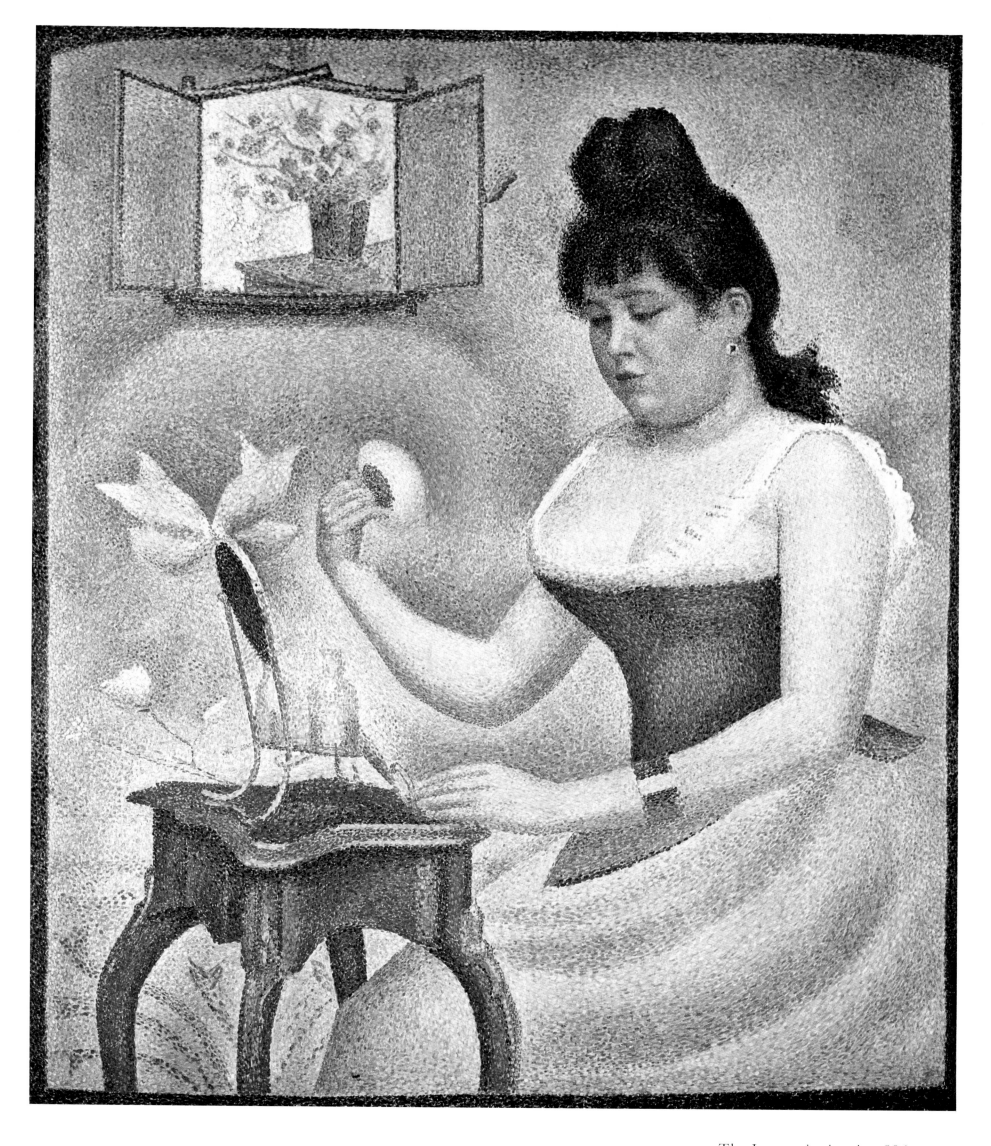

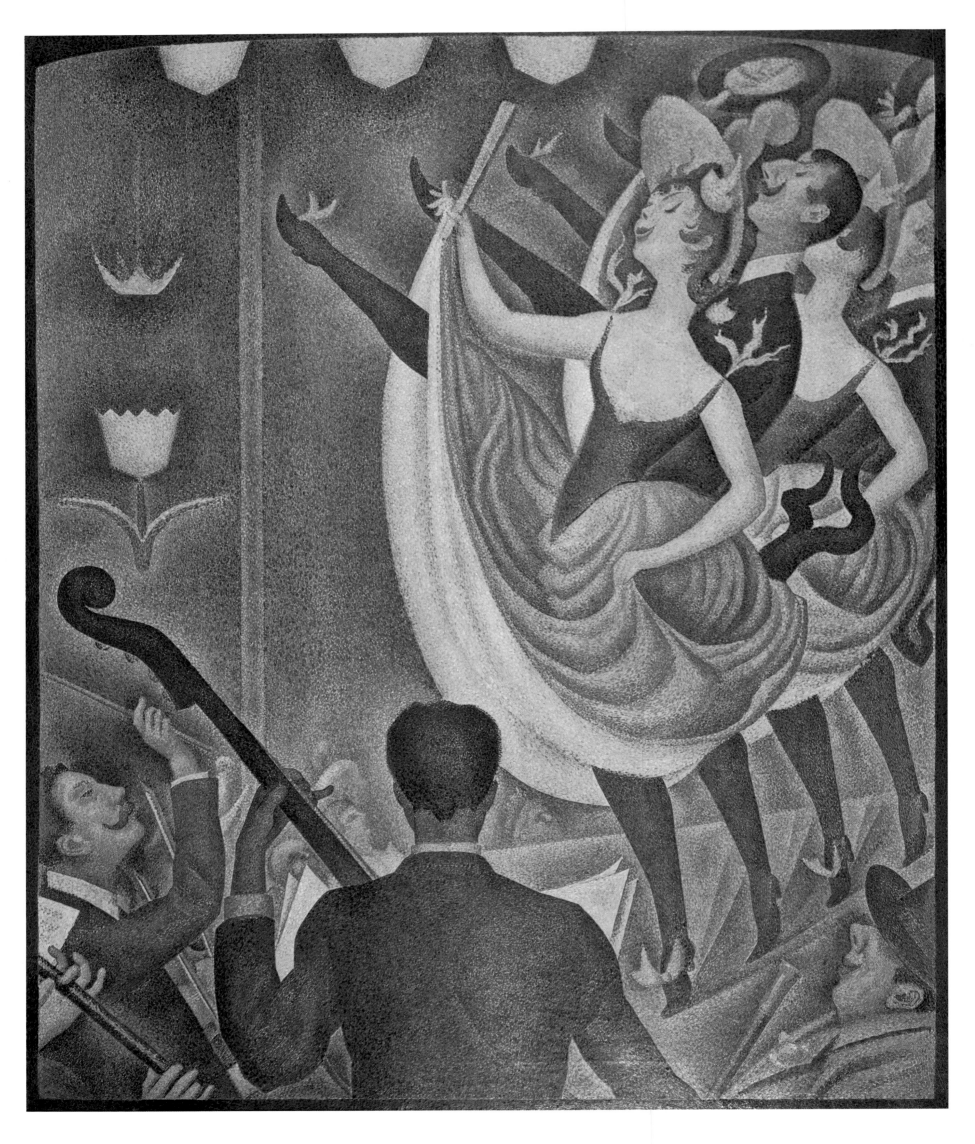

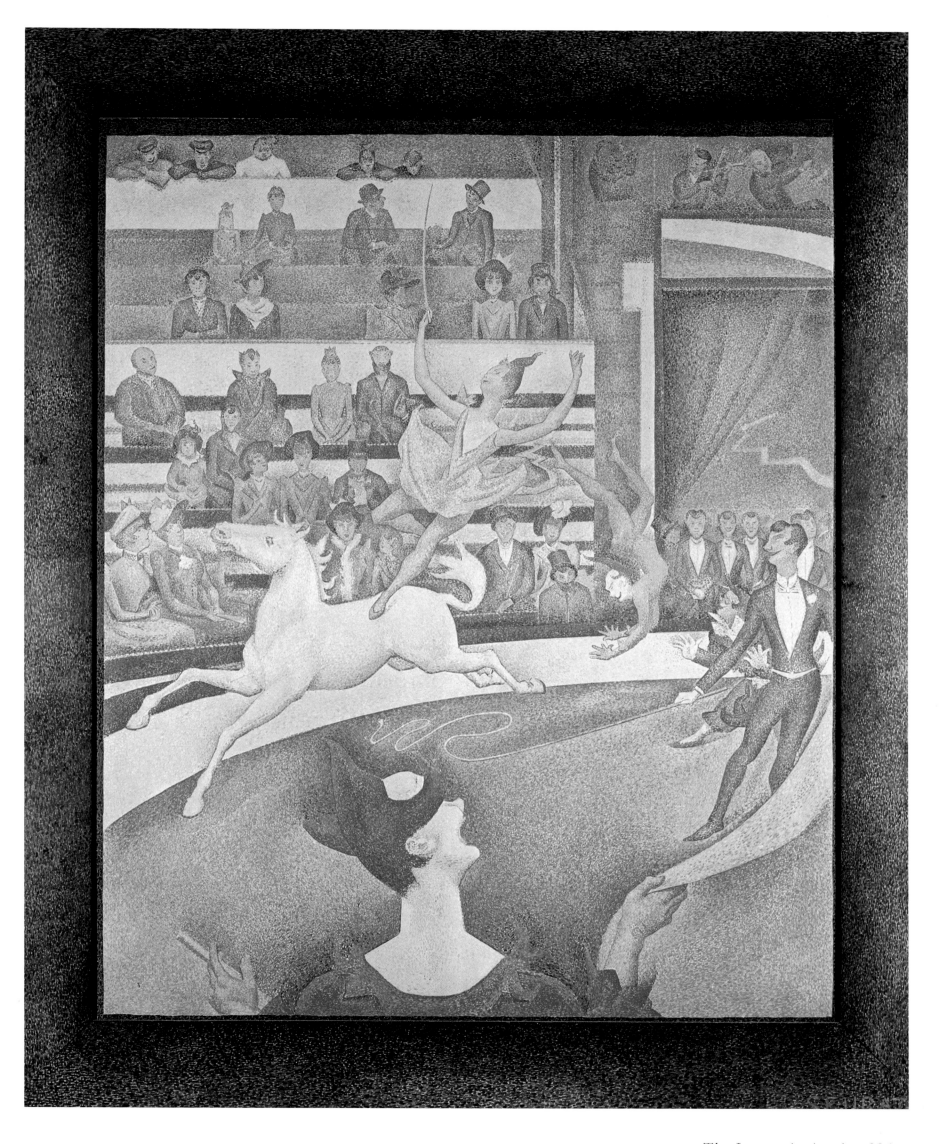

319.
Vincent van Gogh
Restaurant Interior
1887

321.

Vincent van Gogh

Haystacks in Provence

1888

322.
Vincent van Gogh
The Sower
1888

Like Millet, whose Sower *had profoundly impressed him some eight years earlier, van Gogh seems to have identified with some of the qualities personified in the farm laborer: determination, endurance, and a sense of connection to the land. Although this canvas was painted after the artist's arrival in Arles, it does not project the light or the look of the south evident in other works of the period. Rather, the startling contrasts of color and rhythmic stylization of the forms reflect van Gogh's highly personal assimilation of* japonisme.

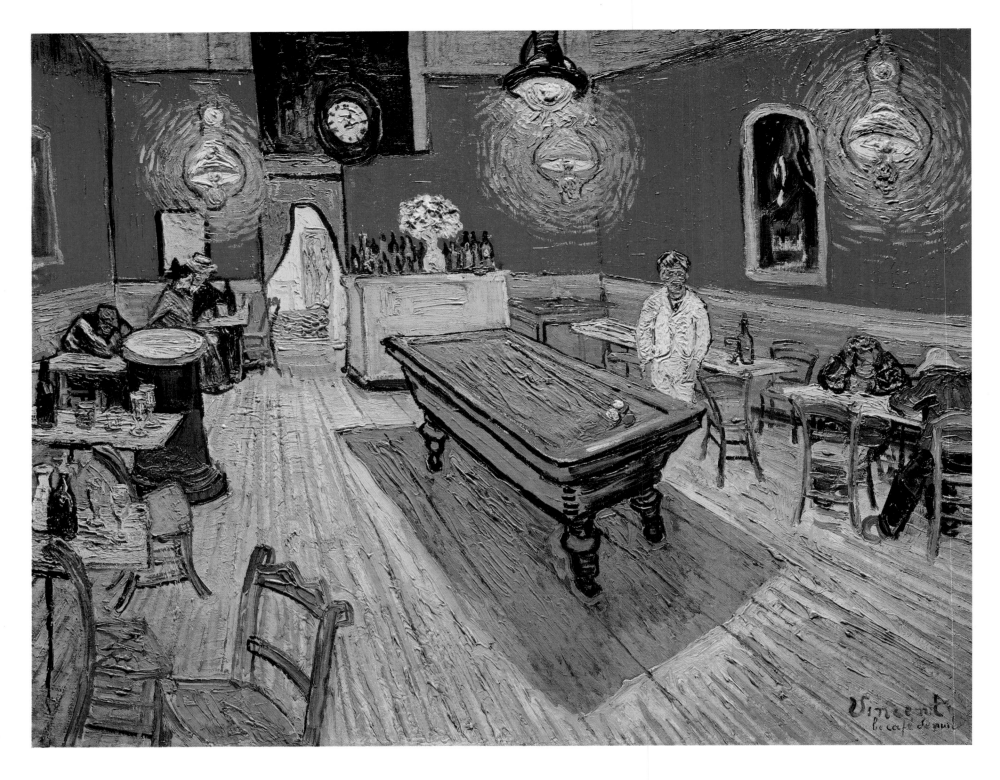

ABOVE

323.

Vincent van Gogh

The Night Café

1888

OPPOSITE

324.

Vincent van Gogh

Sidewalk Café at Night

1888

The Night Café *depicts a disreputable neighborhood bar frequented by prostitutes and other elements of Arles low life. Van Gogh professed to be repelled by the place, yet he must have felt a paradoxical attraction to its evil atmosphere. The seething colors convey the aura of latent violence, while the random disposition of objects and patrons seems analogous to the floating and unstable nature of the relationships formed there.*

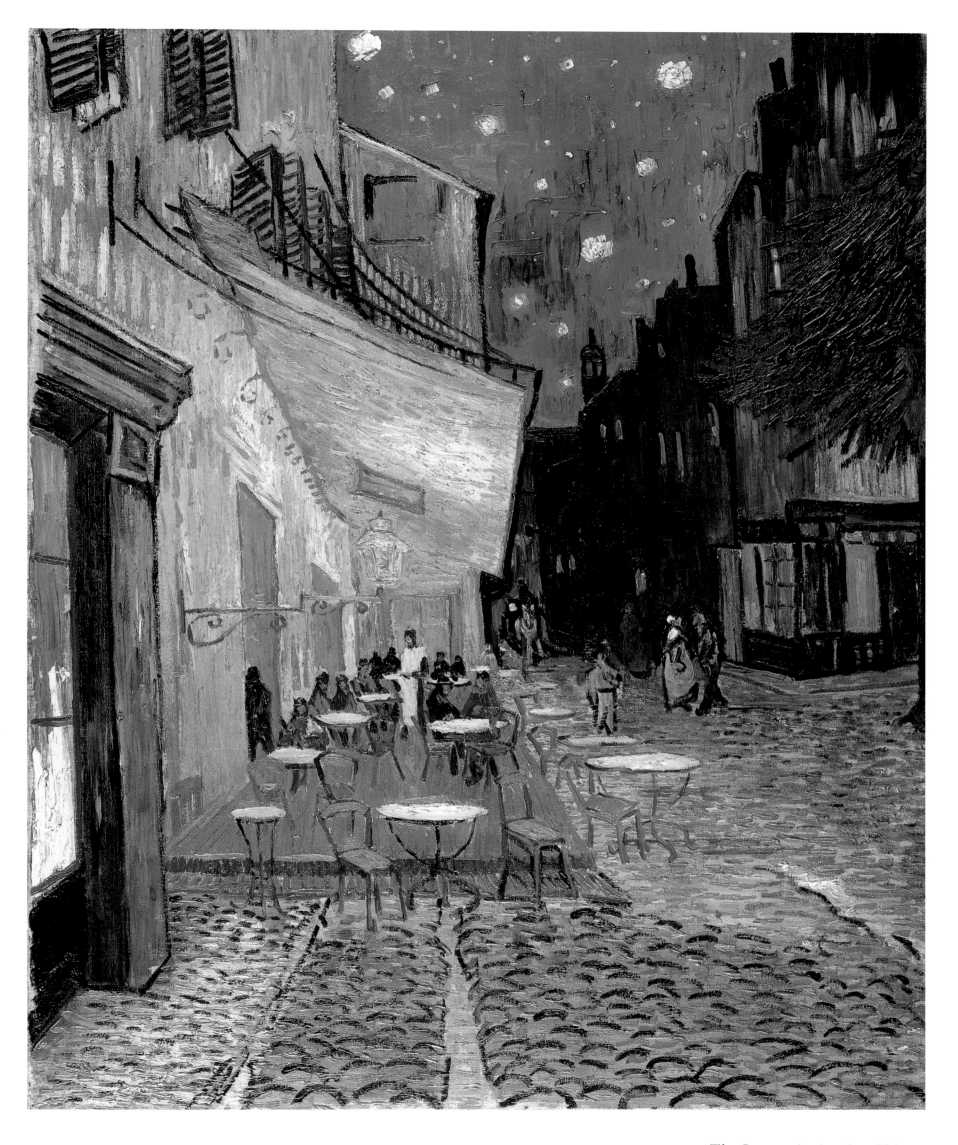

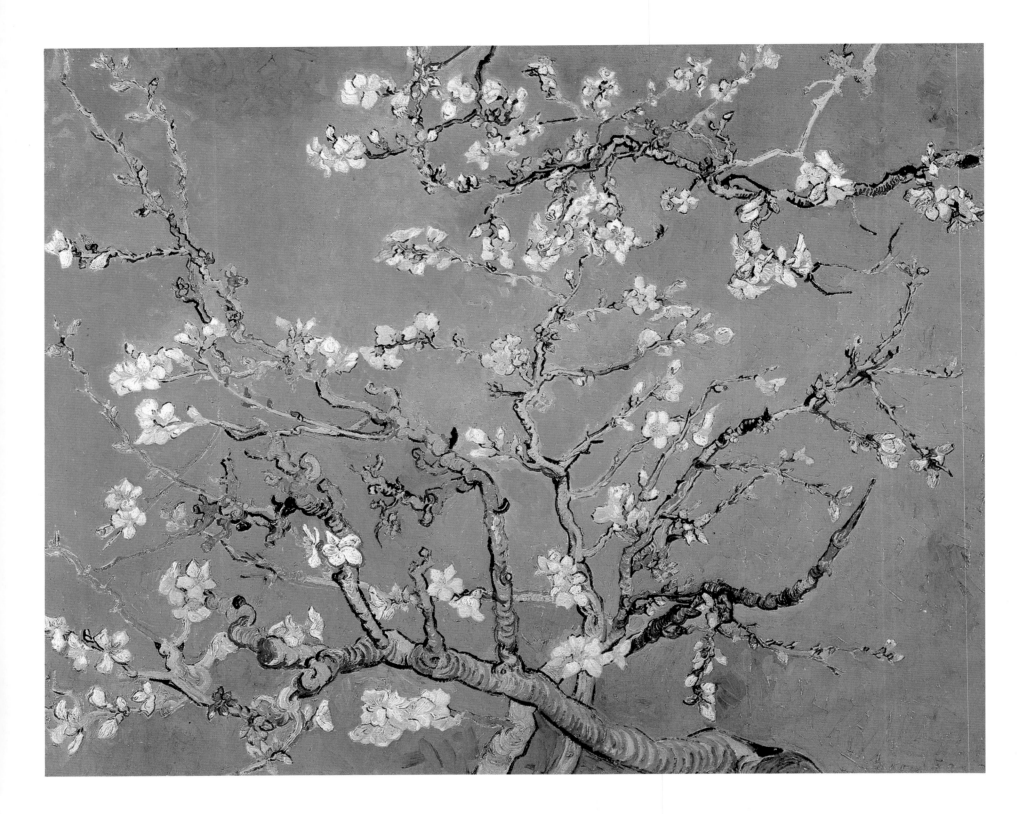

ABOVE
325.
Vincent van Gogh
Flowering Almond Branch
1890

OPPOSITE
326.
Vincent van Gogh
Sunflowers
1888

PAGE 320
327.
Vincent van Gogh
Portrait of Père Tanguy
1887

PAGE 321
328.
Vincent van Gogh
Portrait of Madame Ginoux
(L'Arlésienne)
1888

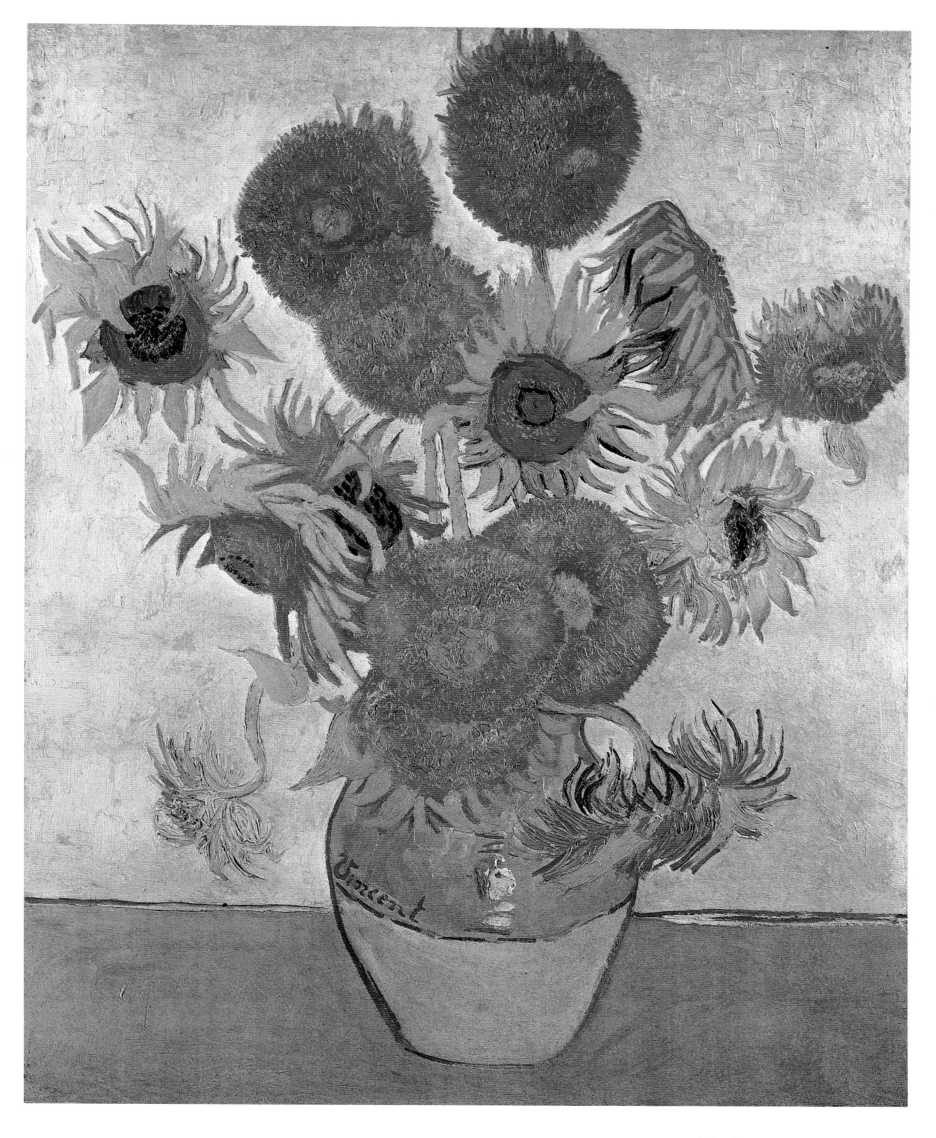

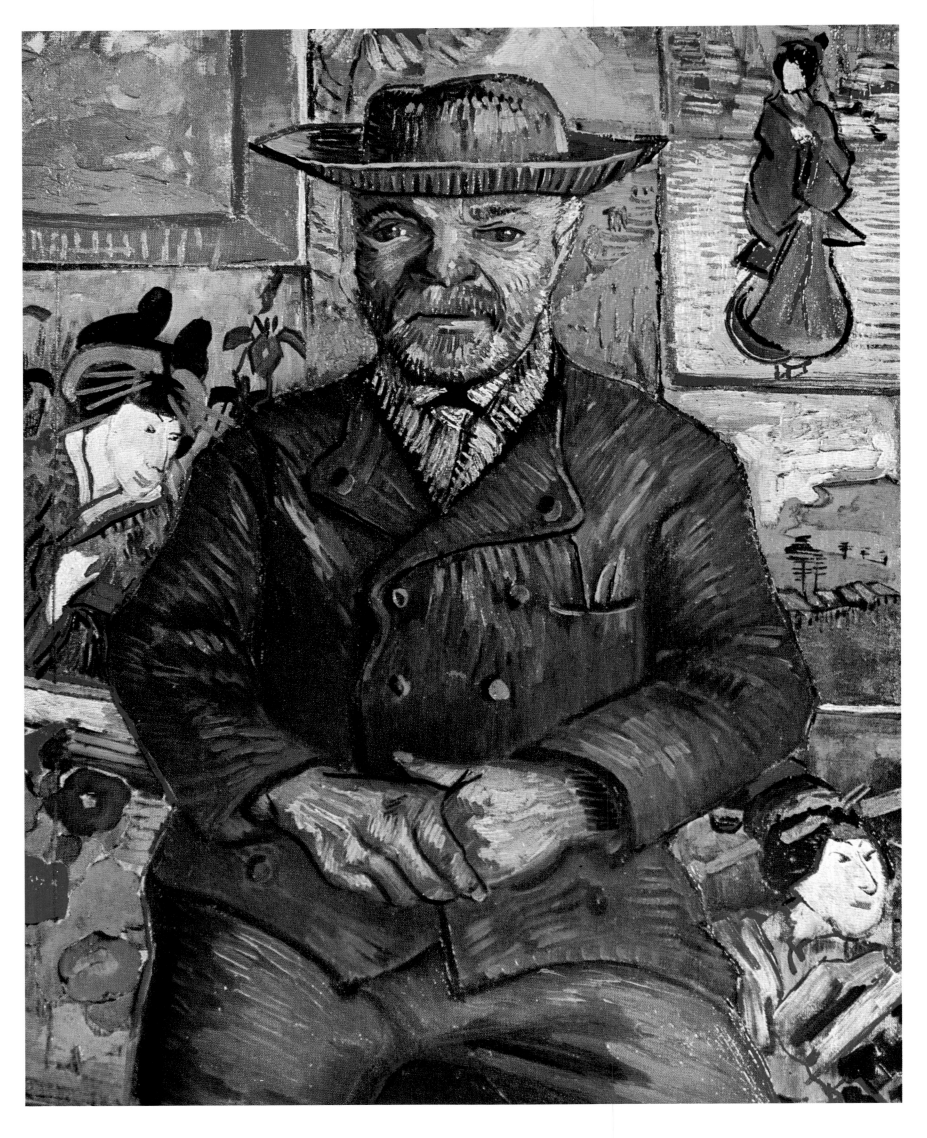

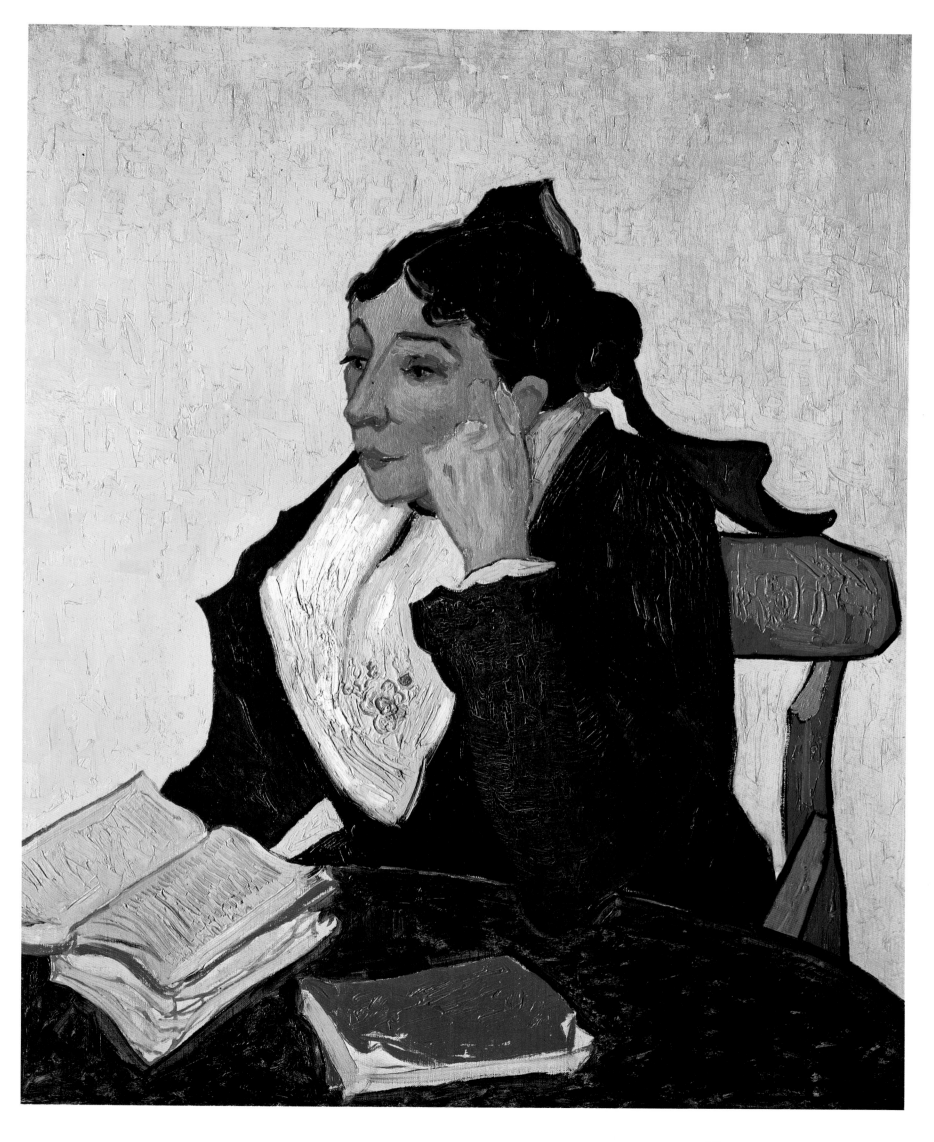

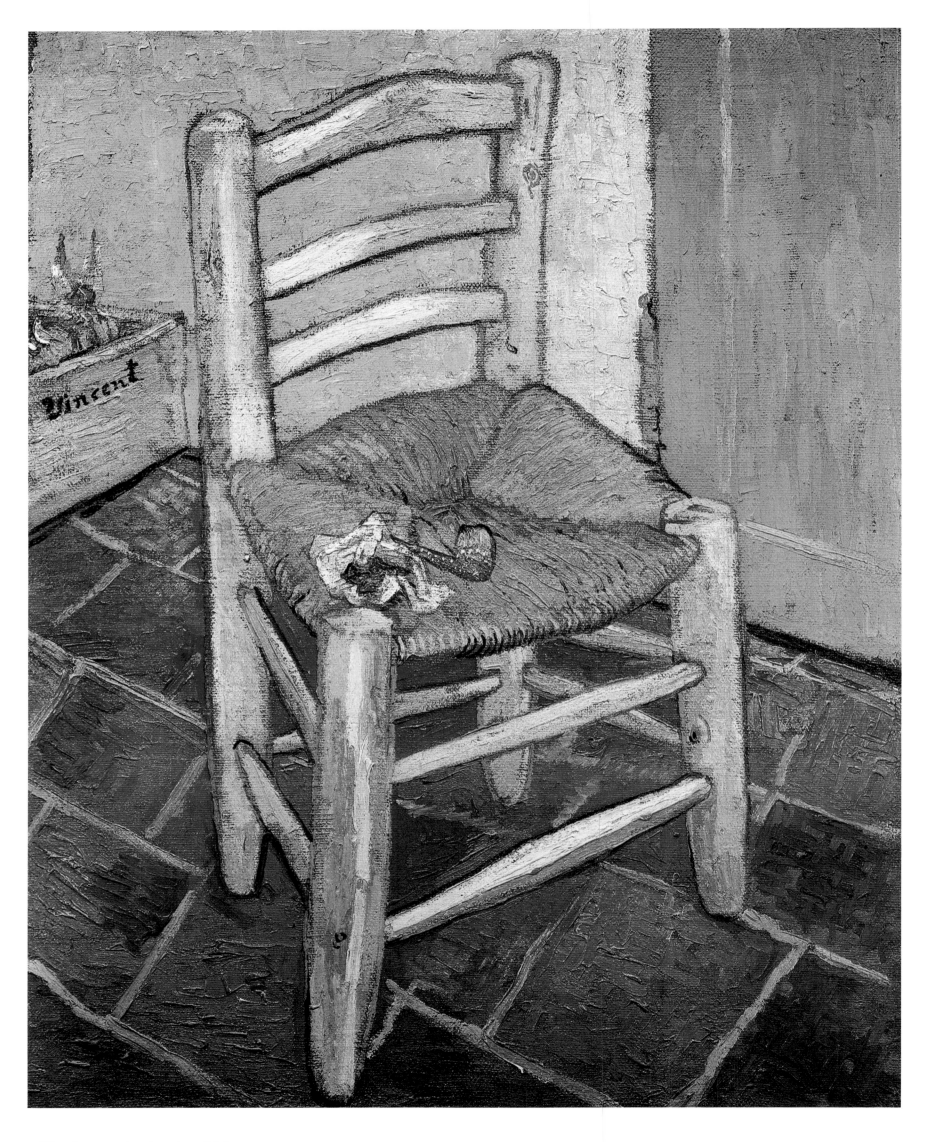

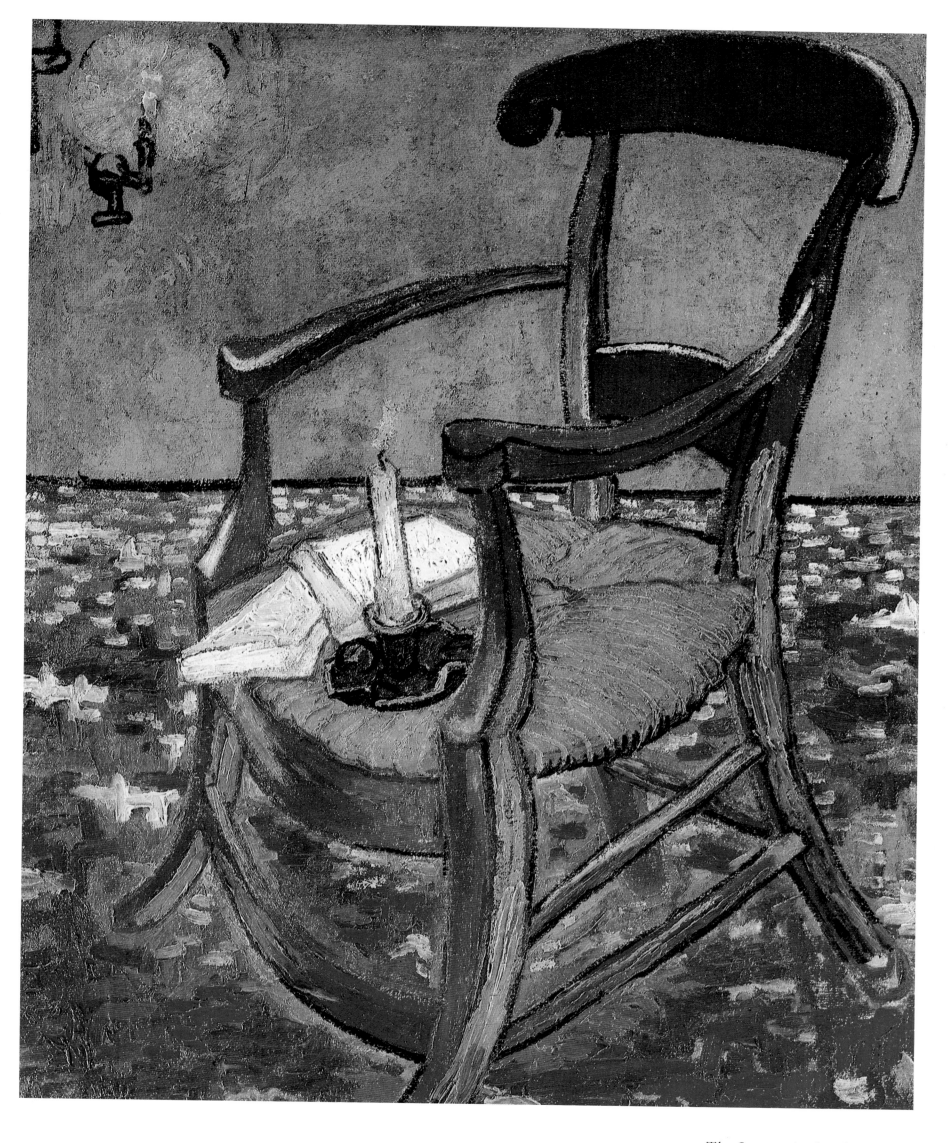

In April 1890, Van Gogh left the south of France to enter the care of Dr. Paul Gachet at Auvers, not far from Paris. He immediately began to paint, producing a number of canvases that depict the crows that scavenged in nearby wheatfields. The lack of perspective or focus in this aggressively gestural and violently colored work poignantly conveys the emotional desperation of the painter, who finally shot himself in just such a field only days after executing this canvas.

PAGE 322

329.
Vincent van Gogh
Van Gogh's Chair and Pipe
1888–89

PAGE 323

330.
Vincent van Gogh
Gauguin's Armchair
1888

331.
Vincent van Gogh
Crows over the Wheatfield
1890

OPPOSITE

332.
Vincent van Gogh
Self-Portrait
1889

333·
Paul Gauguin
Self-Portrait with Halo
1889

334.
Paul Gauguin
*Still Life with Three
Puppies*
1888

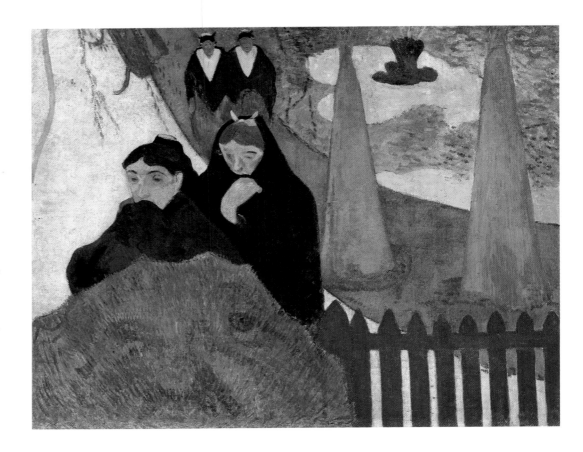

Although Gauguin's pictures of the South Seas are probably his best-known works, he was able to find a sense of mystery of his native France as well. In Vision after the Sermon, the priest on the right has just spoken of the parable of Jacob wrestling with the angel. The biblical scene, still on the minds of the peasant women, is materialized in the area set apart by the tree trunk. In Old Women of Arles, the peasants walk in an enigmatic procession. Gauguin's strong, unmodulated colors and simplified, elemental forms add to the unearthly, magical aura of these works.

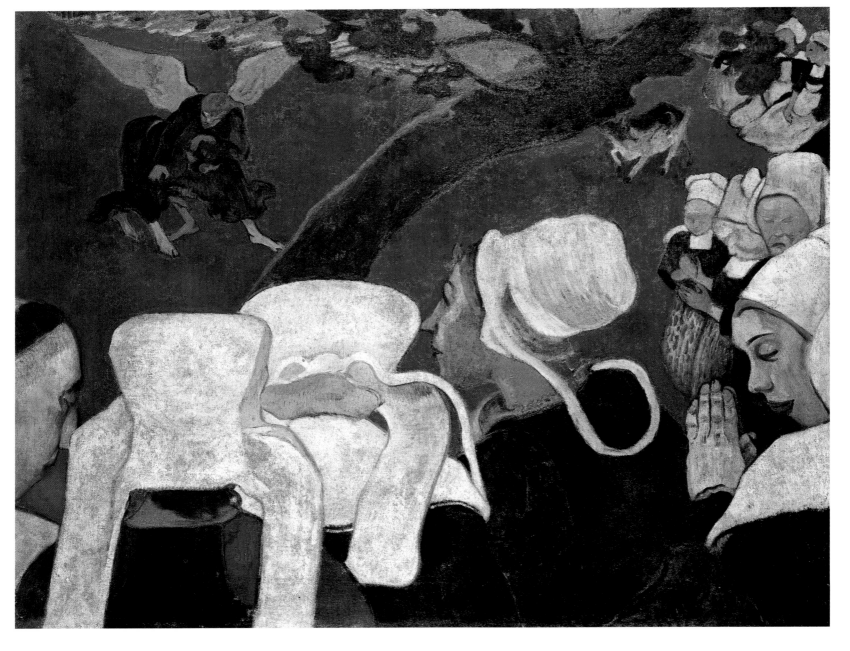

ABOVE
335·
Paul Gauguin
Old Women of Arles
1888

LEFT
336.
Paul Gauguin
*Vision after the Sermon:
Jacob Wrestling with
the Angel*
1888

OPPOSITE
337·
Paul Gauguin
Ia Orana Maria
1891

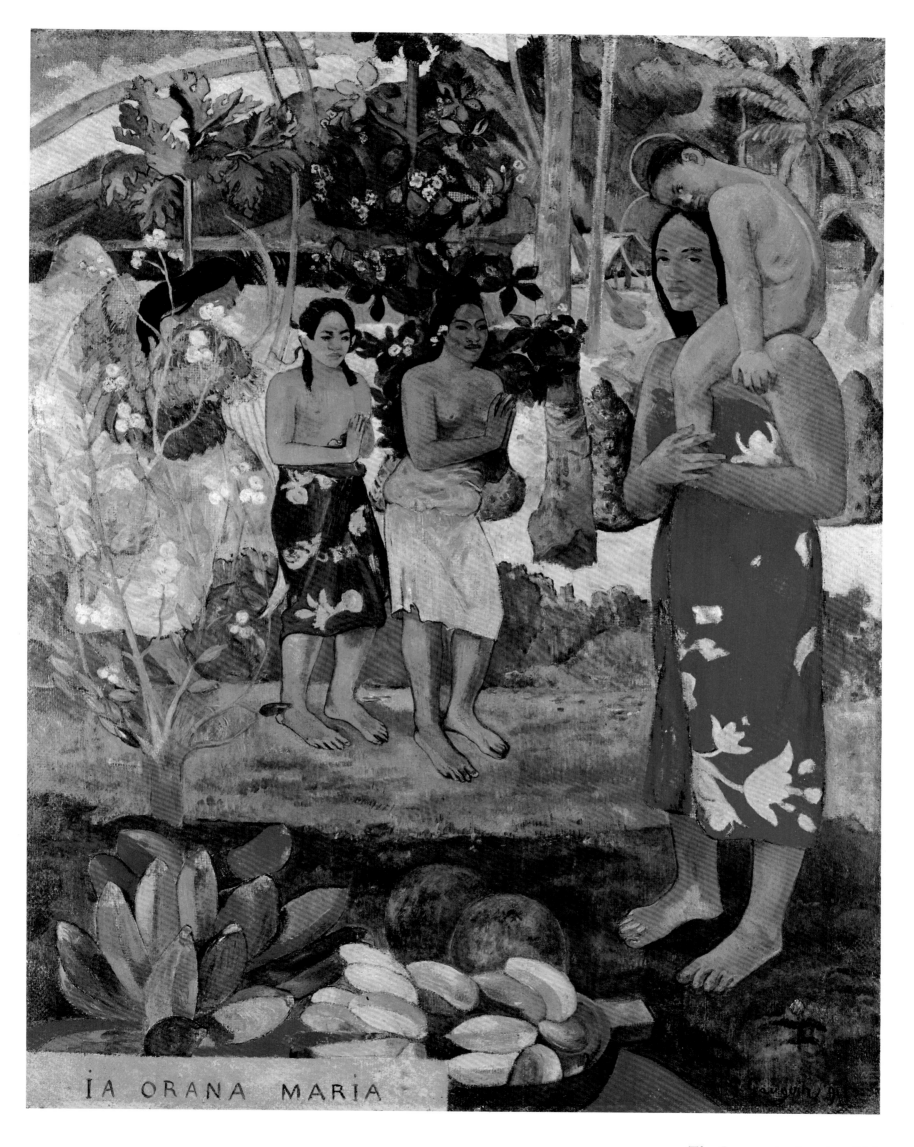

IA ORANA MARIA

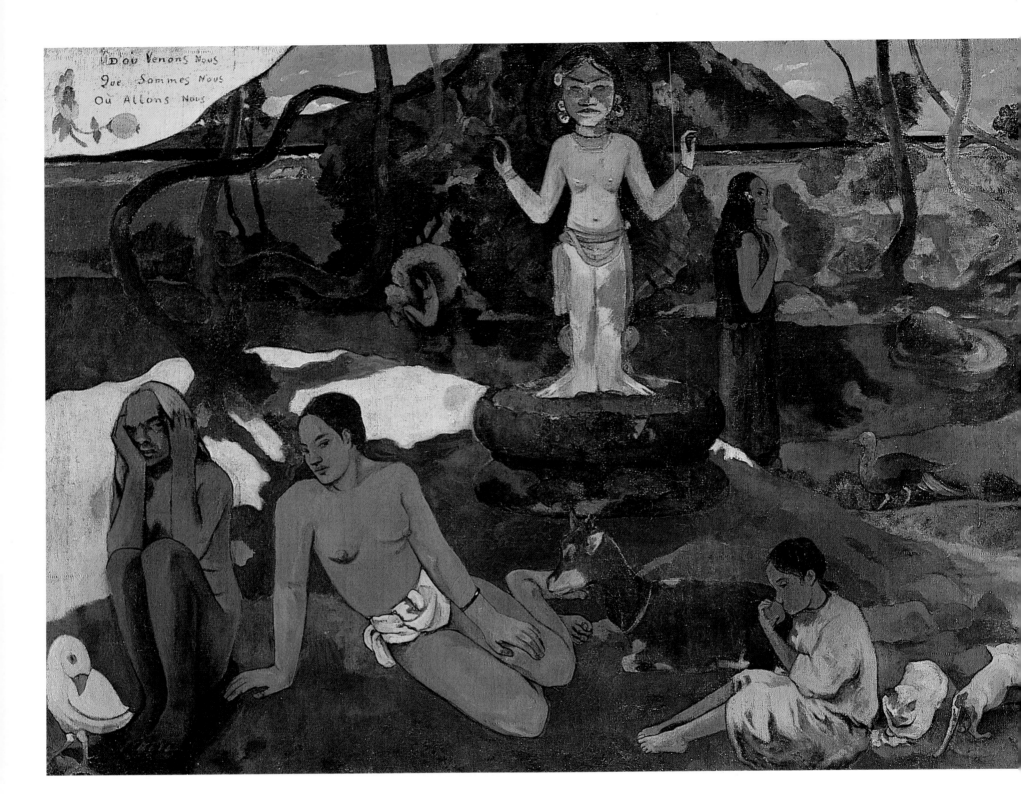

338.
Paul Gauguin
Where Do We Come From? What Are We?
Where Are We Going?
1897

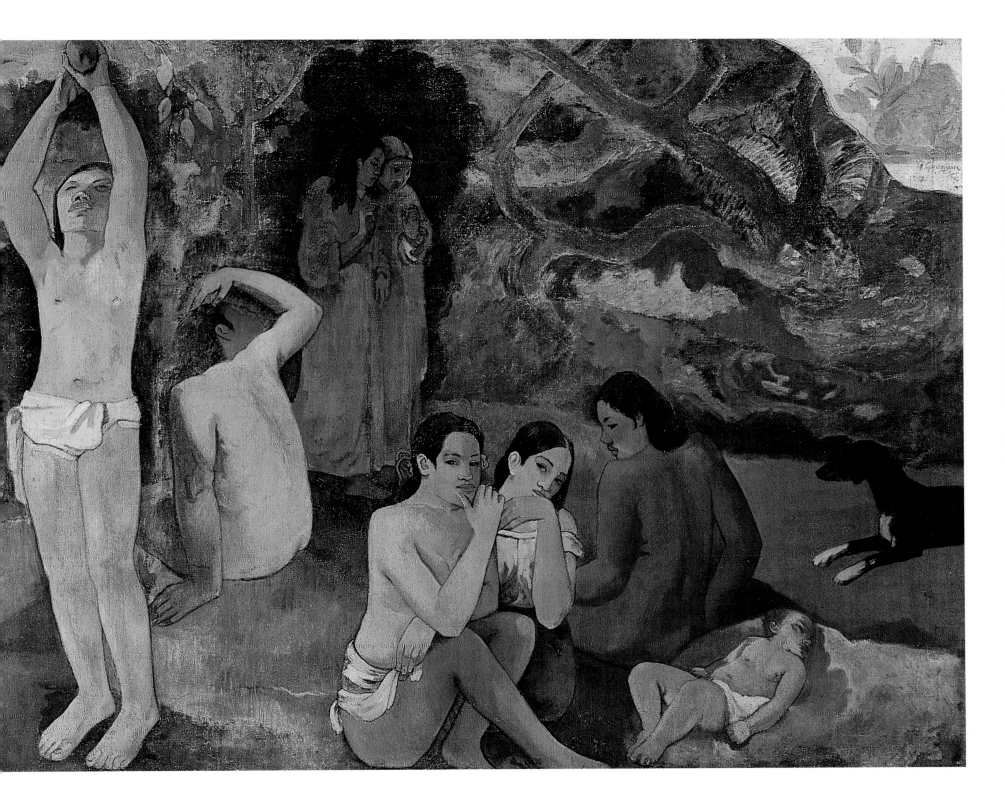

*G*auguin's artistic output in Tahiti and later in the more remote Marquesas Islands was enormous, but there were few buyers for the works he sent back to Paris. Suffering from poverty, malnutrition, and syphilis, he contemplated suicide in 1897. Yet somewhere he found the inspiration and strength to work on this oversized composition, which he clearly viewed as both a personal testament and a new interpretation of the traditional religious and philosophic view of human destiny. Using a rough-textured sackcloth, he created a friezelike composition whose flat but monumental forms and exotic color create visual equivalents of the peace and harmony he had admired among the Polynesian natives.

Paul Cézanne and the Legacy of Impressionism

He never ceased declaring that he was searching for a technique; of that technique, each picture contained a portion successfully applied like a correct phrase of a new language.

ARMAND SILVESTRE

The entry of Paul Cézanne into the Parisian art world in 1861 was hardly auspicious. Neither his person nor his painting augured more than an undisciplined career of eccentric production. His commitment to work was erratic and pervaded by an intense and inexorable self-doubt that persisted through his old age. Zola, his closest boyhood friend and the individual most responsible for convincing Cézanne to pursue his vocation, wrote: "Paul may have the genius of a great painter, but he'll never have the genius to become one. The least obstacle throws him into despair."[1] Not even those close to Cézanne would have predicted that the temperamental young man from Provence would emerge, posthumously, as the "father of modern painting," radically altering both the conceptual framework and the pictorial structure of his chosen medium.

Cézanne and Zola were separated when the latter left their hometown, Aix-en-Provence, to seek his fortune as a writer in Paris. His enthusiastic letters to his painter friend were peppered with vivid descriptions of the city, successfully enticing Cézanne to pressure his father to allow him to give up his law studies and join Zola in the capital. There Cézanne spent hours haunting the Louvre, where he would study and sketch. He concentrated on the art of the past, particularly the works of the Venetian and Spanish masters, of Rubens, and especially, among more modern painters, Delacroix, with whom he seems to have identified. He also frequented the venerable Académie Suisse, which had offered an opportunity to work from live models to two generations of would-be painters. There, he became friends with Antoine Guillemet, Armand Guillaumin, and Pissarro, who later played a decisive role in Cézanne's development as a landscape painter.

Although Louis-Auguste Cézanne had permitted his son the luxury of a trip to Paris, he continued to view his aspirations with hostile suspicion. The descendant of hardworking artisans, Cézanne père was a pragmatic, self-made banker who had spent his life struggling to attain the wealth and position he now enjoyed in Aix. He regarded his son's artistic leanings as symptoms of an incipient and dangerous bohemianism. So strained were relations between the two men that Madame Cézanne had to intervene. She pled with her husband to provide their son with the financial support he needed to maintain himself in Paris.

Louis-Auguste probably felt vindicated when Paul returned home, insecure and humiliated, after just four months in the capital. In an effort to assuage his father's dissatisfaction and forget his own disappointment, Paul accepted a clerical job in the family bank. Even so, he soon covered notebooks and ledgers with sketches and even verses that proclaimed his ambition to paint. His sister recalled a couplet he penned at the time:

*My banker father can't help shuddering to see
Born in his counting-house depths a painter-to-be.*[2]

Finally, after a year in the bank, Cézanne resolved to return to Paris. He overcame his father's objections and even won a modest monthly stipend from him on the condition that he apply to the Ecole des Beaux-Arts. Doubtless because he never hoped to pass the entrance examination, Cézanne agreed to the bargain. The gesture of applying was sufficient to placate Louis-Auguste, who was beginning to resign himself to the futility of trying to alter his son's unorthodox ways.

OPPOSITE

Detail of plate 368

Still life held a particular fascination for Cézanne throughout his career, although figure painting still claimed the bulk of his energy when he painted The Black Clock. *Unlike the turbulent figure studies of the period, this composition projects an awesome calm and grandeur disproportionate to its actual dimensions. It has been suggested that the canvas was executed in Zola's home, a theory substantiated by the fact that Cézanne later gave the work to his writer friend.*

TOP

339.
Paul Cézanne
The Black Clock
1869–71

RIGHT

340.
Paul Cézanne
A Modern Olympia
1872–73

Back in Paris, Cézanne returned to work daily at the Académie Suisse, which, after the predicted failure to gain admittance to the Ecole, provided him with his only formal training. He also found there a sense of camaraderie that must have helped to counteract his brooding insecurity. Still deeply impressed by the work of Delacroix, especially those qualities of "supernatural" color and "epic" drawing celebrated by his great admirer Baudelaire, the young painter was also discovering the work of Courbet and of Manet, the sensation of the Salon des Refusés.

Early Enthusiasms and Influences

The structure and themes of Cézanne's early paintings reflect his struggle to reconcile these competing influences with his own strong temperament. He had probably met Manet shortly after the Salon des Refusés, and was by 1869 an occasional participant in the sophisticated gatherings at the Café Guerbois, where Manet held court to artist and critic friends. One of these was Zola, who had become one of Manet's most ardent defenders, championing such modern subjects as *Déjeuner sur l'herbe* and *Olympia* (plates 75 and 81). Although Cézanne was attracted to the older painter's use of strong contrasts, opaque tones, and his candid execution, he was not in awe of Manet as others were. Cézanne's *Pastoral* (c. 1869–70, private collection) is a critical transposition of Manet's *Déjeuner* into a dreamlike, somewhat sinister context, while *A Modern Olympia* (plate 340) suggests an almost vicious parody of Manet's composition. In addition to the crude drawing and almost savage color, it offers a measure of decidedly autobiographical erotic fantasy, as the seated "client" contemplating the tasty "tart" is clearly the artist himself. Cézanne continued to paint visionary and erotic themes with mythological or religious connections in the later 1860s and 1870s. In these works, the palette is usually dominated by black, a color choice that Cézanne was slow to relinquish. Oppressive and sensuous, the heavy paint surface mimics Rubens almost as directly as does the exaggerated corporeality of the figures.

Although a baroque theatricality typifies some of Cézanne's early work, the painter also produced more subdued still lifes and portraits. Both the large *Portrait of the Artist's Father* (plate 360) and *The Black Clock* (plate 339) have a powerful structure

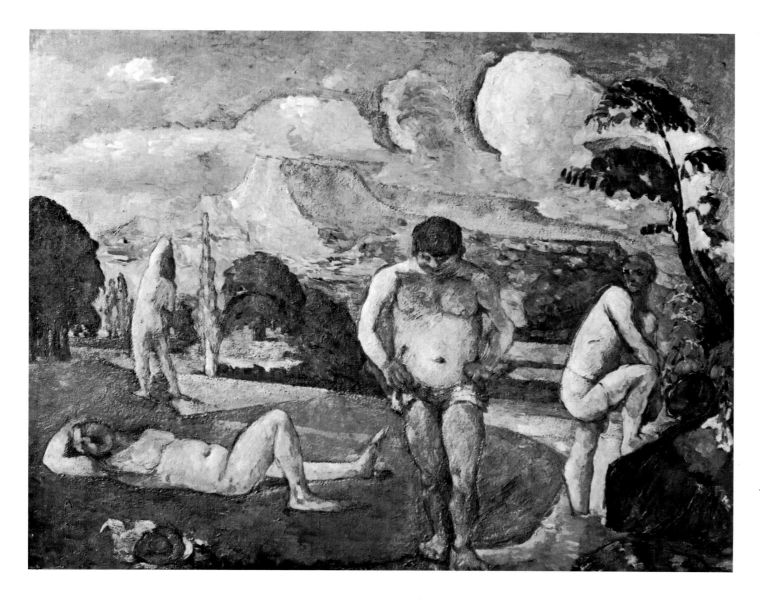

containing weighty objects. The paint in both pictures, sometimes applied with the palette knife, is dense, marked by strong contrasts of black and white. Particularly in the portrait, forms are vigorously if crudely defined, resulting in an image of durable solidity and sober color that conveys the tough, bourgeois strength and simple tastes of the sitter.

Despite its occasionally eccentric subject matter and its uneven execution, Cézanne's early oeuvre clearly demonstrates his enormous energy and the tough-mindedness that would make him a loner throughout his career. While his association with the Impressionists in the 1870s brought him into contact with the most sophisticated artists of the day and helped develop his interest in plein air painting, it was, characteristically, a close personal relationship that had the most profound consequences for his slowly maturing notions about painting.

The Debt to Pissarro

In 1872 Cézanne joined Pissarro at Pontoise and later at Auvers, where he embarked on a serious study of landscape themes in the surrounding countryside. Pissarro proved to be an ideal mentor, for even while communicating his own enthusiasm for nature and dedication to the study of light and color, he recognized and encouraged the younger painter's individuality. He wrote to a mutual acquaintance: "Our friend Cézanne raises our

expectations, and I have seen and have at home a painting of remarkable vigor and power. If, as I hope, he stays some time at Auvers . . . he will astonish a lot of artists who were too hasty in condemning him."[3]

Among the immediate results of Cézanne's apprenticeship with Pissarro were that he virtually abandoned anecdotal and mythological themes; he stopped using the palette knife; he began to juxtapose bright colors and avoid black; and he changed the length and quantity of his brushstrokes. Cézanne developed a greater luminosity without sacrificing the material identity of his objects; indeed, that identity was intensified even as it was linked to a more articulated whole.

The Impressionist exhibitions of 1874 and 1877 afforded Parisian audiences their last opportunity to see a body of Cézanne's work until 1895. On both occasions, his contributions were singled out by the critics as particularly egregious. His *House of the Hanged Man* (plate 114) provoked a shrill reaction in 1874 from the journalist Marc de Montifaud: "M. Cézanne only gives the impression of a kind of madman who paints in delirium tremens." Painted just at the time that Cézanne was beginning to reap the benefits of his work with Pissarro, the canvas was both the most significant accomplishment of his encounter with Impressionism and an adumbration of things to come. The bright colors of the painting convey the sharp spring light of the region, and the choice of a humble village may reflect the influence of Pissarro, who was attracted to similar rural themes.

341.
Paul Cézanne
Bathers at Rest
1875–76

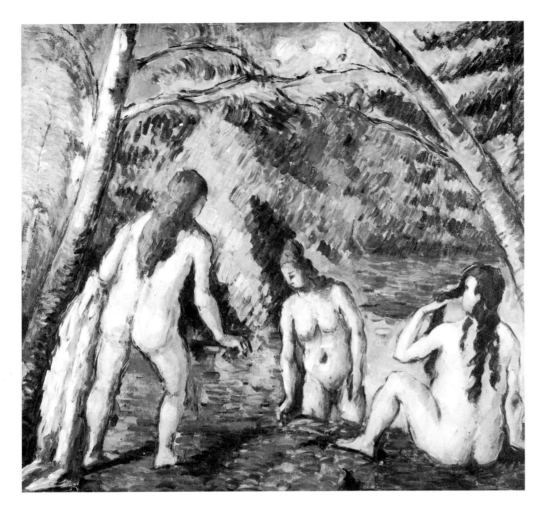

However, the emphasis on structure in the composition, expressed by emphatic drawing and a thickly built up paint surface; the dynamic and challenging apprehension of space projected in the abrupt angles of the turning road; and the firm sense of silhouette clearly separate it from the relatively loose execution and unfocused composition of the mainstream Impressionists.

When he settled in Paris a dozen years earlier, Cézanne had been essentially a Romantic, beset by an almost pathological sense of personal and professional inadequacy. Through his contacts with the Impressionists, he gained a focus for his energy and polished his technical skills. To the light and pleasure-filled visions of his colleagues, he contributed a new dimension of stability, the fruit of his need to clarify and harmonize the seemingly irreconcilable conditions of permanence and change.

The First Bathers

In the third Impressionist exhibition (1877), Cézanne showed sixteen works, including landscapes painted at Pontoise, Auvers, and at L'Estaque near Marseilles, as well as still lifes and portraits. Among these was another prophetic work, *Bathers at Rest* (plate 341), which engendered this critical objection: "M. Cézanne is a veritable intransigent, a chimerical hot-head. In looking at his *Bathers* . . . we have the impression that our view of nature is not the same as that which the artist experiences."[4] This time, however, Cézanne was not without defenders. Georges Rivière,

the young founder of the journal *L'Impressionniste*, made a sympathetic and prescient appraisal of the artist, identifying the classicism that would gradually be associated with his oeuvre: "Cézanne is . . . a Greek of the great period; his canvases have a calm, a heroic serenity of the paintings and terra-cottas of antiquity, and the ignorant who laugh before his *Bathers* for example, impress me as barbarians criticizing the Parthenon."[5]

Bathers at Rest and the slightly later *Three Bathers* (plate 342) both inaugurated a theme and related objective to which Cézanne would return repeatedly: the integration of a group of nudes into a landscape without a loss of the identity of either element. The challenging subject offered an opportunity to reconcile his deep attraction to the monumental art of the past with his new enthusiasm for landscape. His continuing attention to earlier art is demonstrated by the reclining figure at the left, derived from Gérôme's *Greek Interior*, which Cézanne had copied the year before. In addition, the bathers theme touched something deeply nostalgic within Cézanne, evoking carefree boyhood experiences in his native surroundings. The group in *Bathers at Rest* is a friezelike arrangement that echoes the vertical and horizontal disposition of forms throughout the picture. Cézanne repeated the central figure in this group in the *The Bather* (plate 343), a far more cohesive and austere composition in which the bather and his environment are inseparable. The elements of the later canvas reiterate and form analogies with one another, anticipating the mature groupings of bathers that the painter produced in the last decade of his life. No longer

sirens or wood nymphs, the later female *Bathers* signal a change in the depiction of the nude that would reverberate in the early years of the twentieth century in the works of Henri Matisse, Pablo Picasso, and Georges Braque.

Isolation and Exploration

Cézanne had never felt a true affinity with the Impressionists as a group, and when the political and philosophic differences which beset them came to a head at the end of the 1880s, he began more and more to retreat to Provence. There he struggled with the problem that was to be the central focus of his art: form as an absolutely unified and self-sustaining system of representation. He determined "to work in silence until the day when I shall be able to defend in theory the results of my efforts." His rigorous intellect, sense of form, and instinct for challenge found the Impressionist aesthetic too simplistic and at variance with his intense need for solidity and architectural stringency: "Everything we see surely melts away? Nature is always the same but nothing of it endures, so far as we can see. Our art must give a sense of its duration, must make us feel it is eternal."[6]

To the philosophy of Impressionism, with its devaluation of local color, its emphasis on reflexive, spontaneous depiction without the mediation of intellectual analysis, and its denial of structural elements of painting by enveloping objects in a volume-destroying light, Cézanne opposed analysis and contemplation, a "study" of nature through the constructive use of color. His method of contrasting and modulating colors created a light that could be both the product of and ground for the density and clarity of objects. He explained his conception of the painter's role: "There are two things in the painter: the eye and the mind. Each of them should aid the other. It is necessary to work at their mutual development, in the eye by looking at nature, in the mind through the logic of organized sensations which provides the means of expression."[7]

Cézanne thus embarked on what appears at first to be an austere program characterized by constant analysis of the elements of painting and reassessment of their value. *Houses in Provence* (plate 361) illustrates some of these tendencies. The brushstroke—short, abrupt, and enormously varied—creates a rhythmic unity that is enhanced by the geometric limning of the houses, reduced to their essential shapes and portrayed virtually as planes of color. These forms, along with the vigorous, vertical brushstrokes in the foreground, which allow some unpainted canvas to show through, align the painting with the picture plane. The resulting space is not illusionistic in the usual sense: it did not exist a priori, but rather unfolds in terms of the whole canvas. Throughout his career, Cézanne extended and elaborated this experiential concept of space, moving relentlessly toward its formal abstraction. In the 1880s he adopted a new, more regular

ABOVE

344.
Paul Cézanne
Gardanne
1885–86

LEFT

345.
Nicolas Poussin
Burial of Phocion
1648

type of brushwork, organized into parallel strokes which, through their differences of color, imparted a new sense of depth, of advancing and receding planes.

For Cézanne, every painting was a process of exploration in which he tested assumptions about the nature of the visual field before him. The very act of painting forced Cézanne to recognize its unfolding character, for each time he began to render one aspect of the field he became acutely aware of its connection to and bearing on other, uncompleted sections. Each mark on the canvas determined the next, so that the fundamental character of the entire subject was reconstituted in a developing network of lines and colors.

The New Pictorial Space

During the 1880s Cézanne's experience of forms as elementary geometric shapes was repeatedly and forcefully expressed. In the unfinished *Gardanne* (plate 344), a view of a small hill town near Aix, the planes that define trees and buildings are carefully stacked in such a way as to reconstitute the structural verticality of the site into a metaphor of the constructive act of painting. In another contemporaneous work, *The Gulf of Marseilles Seen from L'Estaque* (plate 362), the painter chose a very different type of site, panoramic in its breadth and complex in its spatial character. He had first painted the theme in the summer of 1876, and in a letter written to Pissarro he described his reaction to the locale: "It is like a playing-card. Red roofs over the blue sea The sun here is so tremendous that it seems to me as if the objects were silhouetted not only in black and white, but in blue, red, brown and violet. I may be mistaken, but this seems to me to be the opposite of modeling."[8]

These works signal the painter's developing interest in two-dimensional design and the new role of color in creating pictorial space. One has only to compare this view with a theme by Monet, the much earlier *Terrace at Sainte-Adresse* (plate 166)—which has a similar vantage point and compositional components—to appreciate how dramatically Cézanne broke with the ephemeral world of Impressionism. The clarity of Cézanne's work reflects the painter's search for meaning and order in nature as it moves away from casual record to prolonged analytical meditation. Aerial perspective was foreign to Cézanne; the mountains in the distance are as carefully articulated as the foreground objects, and the texture is uniform throughout. Although the outlines of the houses are well defined as the juncture of two planes of color, the transition unites rather than separates. The emphatic blue plane of the sea intervenes between the intense ocher of the bottom and the more subdued tones of sky and mountain, compelling us to read the composition as a disposition of colored shapes upon a plane.

While acknowledging that photographs document Cézanne's respect for the look of a subject, Meyer Schapiro has argued nonetheless that "the visible world is not simply represented on Cézanne's canvas. It is recreated through strokes of color, among which are many that we cannot identify with an object and yet are necessary for the harmony of the whole."[9]

The Break with Zola

In October 1886 Cézanne's father died at the age of eighty-eight. Paul, then forty-six years old, had been living alone or with his mother and sister at the family's estate, the Jas de Bouffan. Fear of his father had forced the painter for years to deny or hide from him an unhappy liaison with Hortense Fiquet, the mother of his fourteen-year-old son. Yet despite the physical and psychological estrangement between the couple, he succumbed to pressure from his mother and married Hortense six months before Louis-Auguste's death.

Marriage served only to legitimize Cézanne's separation from his wife and son, who continued to reside in Paris. Although liberated from his fear of and financial dependence on his father, Cézanne was now more than ever a prisoner of emotional anguish. His health had begun to deteriorate seriously with the onset of diabetes, increasing his anxiety about his work; and his inclination to melancholy, already pronounced in his youth, further isolated him from former colleagues.

The long-standing friendship between Cézanne and Zola, already strained by the latter's absorption in his brilliant literary career, was ruptured in 1886 with Zola's publication of *L'Oeuvre*, the last novel in the *Rougon-Macquart*, a chronicle of a family's decline. The protagonist of the book, Claude Lantier, characterized by the author as "un Manet, un Cézanne dramatisé, plus pris de Cézanne" ("a Manet, a Cézanne dramatized, taken more from Cézanne"), is an artist who hangs himself in front of the canvas whose completion eludes him. When Cézanne received a copy of the novel, he wrote Zola a note thanking him for the book and for the past. The two never communicated again.

Their friendship had been born of a common need to resist and transcend the stultifying provincialism of their hometown, but their careers had taken very different directions. While Cézanne was working in virtual isolation and anonymity "to make of Impressionism something solid and durable like the art of the museums," his boyhood friend enjoyed the prestige and material rewards of the life of a successful novelist, the doyen and foremost exponent of the school of Naturalism. As his writing earned critical acclaim, Zola achieved wealth, popularity, and status, and grew somewhat complacent; Cézanne remained the rebel and visionary. One artist saw his goals accomplished; the other despaired of ever realizing even a part of his ambition. Cézanne's unpredictable behavior, his outbursts and rude manner, and his unorthodox aesthetic aspirations were ridiculed by the sophisticates who frequented Zola's ostentatious new home in the sub-

ABOVE, LEFT
346.
Paul Cézanne
Portrait d'Ambroise Vollard
1899

ABOVE, RIGHT
347.
Paul Cézanne
Portrait of Gustave Geffroy
1895

urbs of Paris. What had been acceptable to the writer as a young man—indeed, proof of his friend's uniqueness—became in their middle age the occasion for mere tolerance or condescension.

Zola's evaluation of Cézanne was echoed by his onetime disciple, the Symbolist writer Joris-Karl Huysmans. When asked by Pissarro why he had left Cézanne out of a book he had written on the Impressionists, Huysmans made this reply: "He has temperament, he is an artist, but in sum, with the exception of some still lifes, the rest . . . is not likely to live. It is interesting, curiously suggestive in ideas. . . . In my humble opinion, the Cézannes typify the Impressionists who didn't make the grade."[10] Later, Huysmans grudgingly acknowledged that the "exasperated apperception of his sight discovered the preambles of a new art," but nonetheless regarded him as a symbol of "artistic impotence."[11]

Gradual Recognition

As the decade moved toward its end, it seemed likely that Cézanne would never be known outside of a small group of cognoscenti—painters such as Gauguin, Pissarro, and Guillaumin, the paint grinder Père Tanguy, and the collector Victor Chocquet—for whom he was something of a legend. His self-imposed exile from Paris, his ascetic solitude and dark moods, and the prodigious creativity attributed to him were beginning to foster the image of a *monstre sacré*, an object of both curiosity and reverence. In 1889 his *House of the Hanged Man* was represented in an exhibition that was assembled for the Paris Exposition Universelle (apparently thanks to the intervention of Chocquet, who was an important lender); but it was only the third time that Cézanne had exhibited in Paris, and his work attracted little attention. Even his participation in a show organized in Brussels by Les XX produced little more than passing critical mention of his "sincerity."

From the late 1880s on, Cézanne made a concerted effort to develop figure painting, doing numerous portraits as well as group studies of bathers and cardplayers. Taken together, these canvases reflect an emerging constructivism, based on an impersonal and intellectual order. In the several portraits of his wife or son, a new solidity of design subordinates the identity of the sitter to the total composition. The *Portrait of Gustave Geffroy* (plate 347), a writer and critic sympathetic to Cézanne's work, is one of his finest in this genre. A carefully orchestrated play of diagonals across a basically horizontal-vertical grid reflects a variety of viewpoints. The critic's head provides the focus for converging lines from above and below, especially from the crowded shelves of the bookcases, creating a physical space that

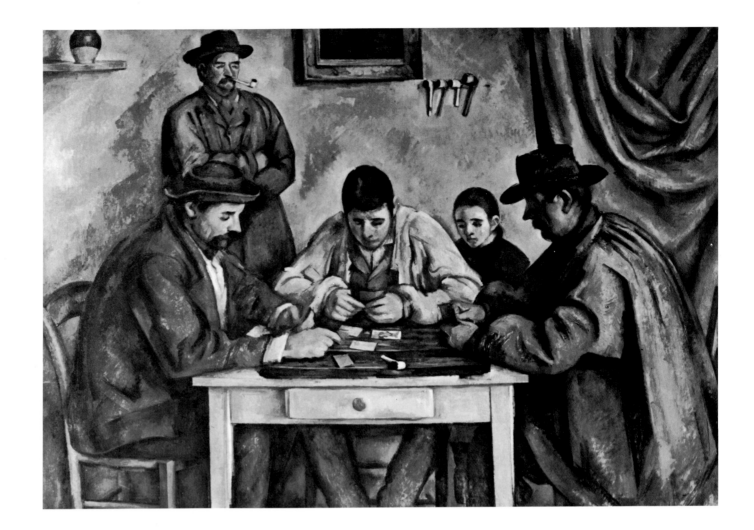

RIGHT
348.
Paul Cézanne
The Cardplayers
1890–92

BELOW
349.
Paul Cézanne
Still Life with Plaster Cupid
c. 1892

Cézanne worked on the five versions of Cardplayers *intermittently during the early 1890s. Using local peasants as his models and varying the number of players from five to two, he created compositions as static and deliberate as any ever painted. Paradoxically, the immutability of these canvases contrasts markedly with their theme, its implications of accident or chance, and its broad allusion to human destiny. Although the elements of the composition are deployed in a semitraditional manner, Cézanne's attention to the spatial intervals between objects—so-called negative space—and his controlled activation of it look ahead to the conscious manipulation of object-space relationships by the Cubists.*

OPPOSITE
351.
Paul Cézanne
Still Life: Apples, Pears, and Pot
1900–4

also refers symbolically to the critic's intellectual life. The portrait necessitated more than eighty sittings over a three-month period, and it took a strenuous effort to maintain the look of Geffroy's study, with its busy worktable and casual furnishings, through the painting's lengthy gestation.

The patience and concentration demanded of both sitter and artist were recounted by Ambroise Vollard, the skillful dealer who organized Cézanne's first one-man show in 1895:

> *Very few people ever had the opportunity to see Cézanne at work, because he could not endure being watched while at his easel. For one who has not seen him paint, it is difficult to imagine how slow and painful his progress was on certain days. . . . In my portrait there are two little spots of canvas on the hand which are not covered. I called Cézanne's attention to them. "If the copy I'm making at the Louvre turns out well . . . perhaps I will be able tomorrow to find the exact tone to cover up those spots. Don't you see, M. Vollard, that if I put something there by guesswork, I might have to paint the whole canvas over starting from that point."*[12]

Between 1890 and 1892, Cézanne further pursued his study of figure composition, striving for a mastery of volume and structure that would convey the monumentality of forms without denying the role of color in projecting space and energy. In the five versions of *Cardplayers*, the peasants who posed for the composition are reduced to their elemental geometric shapes. The rigorously simplified groups of two, three, or more figures

Skulls have long been used in art as a classical allusion to mortality. Yet here Cézanne has removed them from the allegorical context in which they would be found in traditional painting. He has so disarmingly meditated upon the form of the skulls, and arranged them with such care, that they no longer need a narrative to reveal their meaning; the very solemnity, thoughtfulness, and even delicacy with which they are rendered tells us all we need to know about this memento mori.

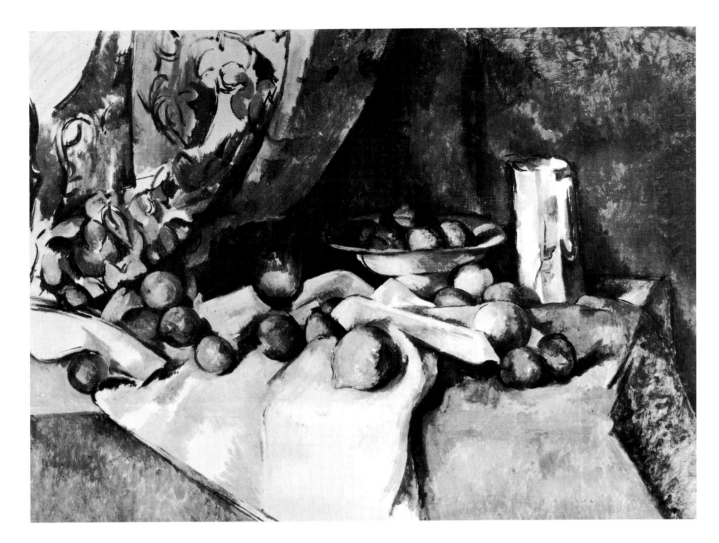

This still life is set as if upon a stage. The curtain to our left opens to reveal a composition of fruit, a coffee pot, and a glass. Every object, including the tablecloth, is infused with a solidity that reveals the artist's prolonged study and thought, and which belies the seemingly casual arrangement.

352.
Paul Cézanne
Still Life with Apples
1895–98

are solid, earthy people, as rooted in their game as they are fixed in the fabric of the painting. Although the theme is traditional, the element of amusing anecdote or narration usually associated with seventeenth-century genre painting is here expunged as the artist seeks to transform conventional storytelling into a more abstract reality of color and shape.

Cézanne turned increasingly to still-life painting in the 1890s, for objects were far more compliant than people and permitted closer and longer scrutiny. He could arrange still-life elements, tilting them, distributing them over the table surface, setting them off against one another until he was satisfied with the organization—which, by virtue of their deceptively casual placement, suggested their potential energy. The impressive range and handling of Cézanne's still lifes stretches from the austerity of *Three Skulls* (plate 350), an obvious allusion to the conventional memento mori, to the luxurious, vibrant color and architectural scale of *Still Life with Apples and Peaches* (plate 367) or *The Basket of Apples* (plate 368). Unlike so many artists of the past who had encouraged the public's sensuous response to the theme, Cézanne sought to move beyond the object's appearance in order to capture its formal essence. Portrayed in a dramatically delimited space, the majestic folds of the drapery cascade forward, terminated abruptly by the tablecloth and strong plane of the table's edge. Constantly creating new sets of formal relationships, Cézanne forced the viewer to acknowledge each shape or color, the weightiness or lightness of the pictorial elements. Though the actual size of the canvases varies only slightly from about two by three feet, the impact is one of transcendent monumentality comparable to that of the landscape paintings.

The Last Years and Final Themes

Eighteen ninety-five was a watershed year for Cézanne: it brought him, at the age of fifty-six, his first major exhibition. One hundred and fifty paintings were shown at Vollard's gallery, provoking a critical reaction comparable to the one aroused by the Impressionists more than two decades earlier. Although he was not without supporters, especially among the younger painters, the plaudits for his work were often couched in the same terms used by his detractors. Even his old friend Pissarro, in an otherwise complimentary letter, referred to him as a "refined savage." Thadée Natanson, editor of the influential literary and art magazine *La Revue blanche*, offered a keener appraisal of his style: "In addition to the purity of his art, which is devoid of any base seduction, another quality of precursors, so essential, proves his mastery: he dares to be unpolished and as it were uncivilized, and only allows himself to be swept along right to the end, to the scorn of all the rest, by the only concern which impels imitators, to create new signs."[13]

Aside from bringing him long overdue attention, Cézanne's one-man exhibition marked the beginning of what has come to be considered his period of greatest achievement, one distinguished by both exploration and synthesis. Almost as if in reaction to the pressure of increased public exposure, Cézanne began to seek out remote and inhospitable places of nature to paint—places where a human presence was lacking or which, more poignantly, had once been sites of social activity but were no longer. The abandoned quarry at Bibémus and the estate of the Château Noir, both near to Aix, became favorite motifs. Maurice Denis explained

The landscape of his native Provence sustained Cézanne throughout his life, providing him with solace and comfort in times of stress. The great Mont Sainte-Victoire, so ubiquitous in the area around Aix, was one of the artist's favorite subjects. He sometimes depicted the mountain as powerful and forbidding, sometimes as an old friend. These watercolor renderings, light and delicate as they are, still convey the enduring solidity of the huge natural form.

Cézanne's crucial choice of locale as "the delicate symphony of juxtaposed gradations, which his eyes discovered at once, but for which at the same moment his reason spontaneously demanded the logical support of composition, of plan, and of architecture."[14]

Bibémus Quarry (plate 369), *Bibémus: Red Rock* (plate 374), and *Le Château Noir* (plate 375) are united by a common structural aspect which allows the viewer only a peculiar and limited access of entry into the interior of the painting. A clear visual path is frustrated, in the first composition, by the restless violence of the overlapping planes formed by the rocks; in the second, by the aggressive jutting of the rock at the framing edge and by the densely grouped, multicolored foliage, which forms another barrier across the road and denies the eye a place to rest; in the third, by the ominously insistent intrusion of the trees and their branches into the line of sight. Any tentative, shallow recessive movement is strongly counterbalanced by the advance of these disruptive forms toward the picture plane. This feeling is heightened by the use of line, especially in the *Château Noir*. As with most of Cézanne's late work, the boundaries are never continuous; the contour of an object is often broken, promoting its fusion with an adjacent form and making the surface of the canvas into a fabric of color.

Perhaps the primary catalyst for Cézanne's innovative formal investigations was his increasing use and mastery of watercolor. The immediacy and fluency demanded by this medium indicates a new sense of confidence unknown in his prior work. In *Pin et Rochers au Château Noir* (plate 378), the diagonal tree is positioned so near the surrounding rock formations that its identity as a tree is virtually erased, and the rocks themselves are but

ABOVE, LEFT

353.
Paul Cézanne
View of Mont Sainte-Victoire
1885–87

ABOVE

354.
Paul Cézanne
*Mont Sainte-Victoire
Seen from Les Lauves*
1902–6

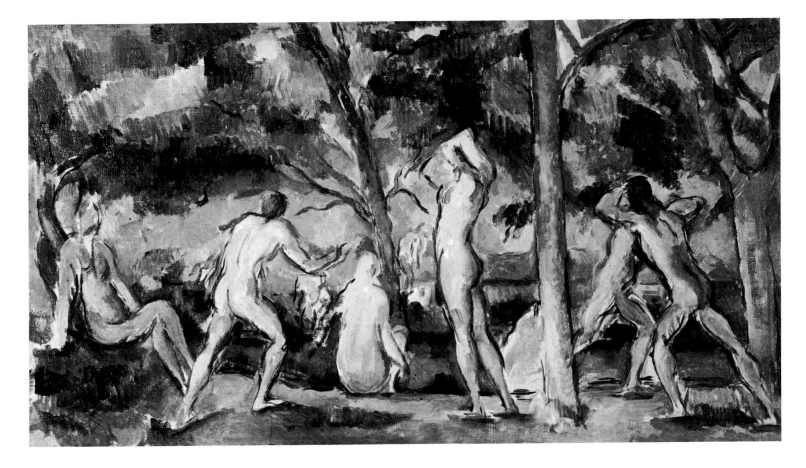

LEFT

355.
Paul Cézanne
Bathers
1895–1900

BELOW

356.
Paul Cézanne
Nudes in Landscape
(Bathers)
1895–1906

Cézanne's periodic return to the bathers theme may have offered him a means of rejuvenation by recalling the experience of his youth in terms of a lyric motif. In fact, he invoked similar imagery in an unfinished poem to his son in the early 1890s. In contrast to the Bathers of the 1870s, whose forms were carefully isolated, these late compositions—painted without live models—link the figures with each other and with the surrounding landscape.

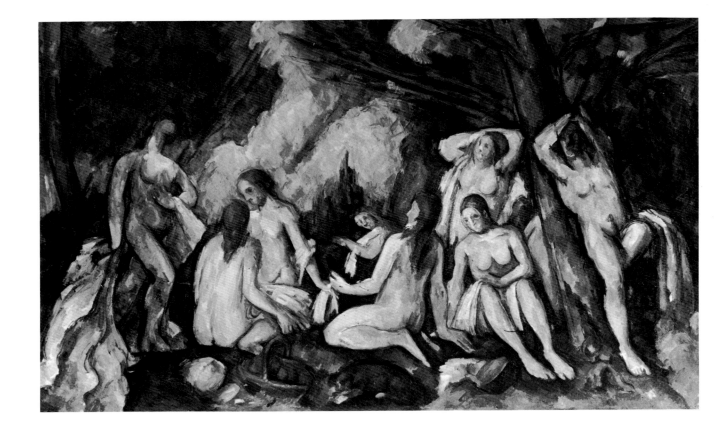

tentatively defined. The absence of a ground plane in the painting leaves abstract lines and planes suspended in a new kind of pictorial space. The structure of the composition takes on a musical character through pauses and repetitions, the mobile lines dancing in and out, up and down across the canvas. The whole is illuminated and unified by both the unpainted areas and the transparent washes applied over the entire surface.

Jardin des Lauves (plate 372) comes quite close to the spirit of the watercolors in the free and energetic distribution of colors along the picture plane and their liberation from verisimilitude. It is also the most abstract work Cézanne would ever execute. The horizontal divisions of the garden and the sky are mere scaffolding, a planar structure supporting the vibrant mosaic-like vertical patches of color ranging from warm yellow-greens to the tones of gray and pink in the sky. In some areas the paint is simply a wash; in others it takes on the thick texture of impasto. The application and handling, the basic processes and operations of painting, are the real subject of the work.

Cézanne's articulation of landscape reached its apogee in his treatment of the theme of Mont Sainte-Victoire, which he drew or painted no fewer than sixty-five times. For him the motif was an inexhaustible source of challenge and inspiration. The views of the late 1880s—measured, stately sequences of receding planes culminating in the solid form of the mountain—recall the stability and architectural sense of Poussin; indeed, Cézanne often described his objectives in landscape as "redoing Poussin according to nature." The late versions of the theme, however, although they retain the stratification so characteristic of the seventeenth-century master, are boldly reduced to the simple elements of earth, mountain, and sky. The canvases are turbulent and violent, but their violence is consecrated to a greater unity, a paradoxical vision: continuity through apparent disjunction.

The Zurich version of *Mont Sainte-Victoire Seen from Les Lauves* (plate 371) is the most exalted one, pervaded by a light never before seen in Western art. The mountain and all the other pictorial elements advance with a grand sweep toward the picture plane. The broken contour of the mountain merges it at points with the sky and at the same time conveys its power and majesty as an autonomous natural form. Despite the suppression of detail, a sense of depth emerges through various connections, contrasts, juxtapositions, and parallels of color and brushstroke. Color carries with it the intrinsic suggestion of changes in plane, giving the surface a slight curvature like that of a shallow bas-relief. Nature is portrayed in the state of becoming; dissonant forces yield to an overall equilibrium and harmony without losing their restless violence and tension.

The Classical Tradition

Large Bathers (plate 383) is the climax of the Bathers compositions. It also represents the culmination of thirty years of thought, practice, and assimilation of a type of painting Cézanne felt a strong attraction to but which for the most part remained outside the circumference of his primary concerns. It is as close as he came to realizing his dream of integrating classicism into a modern idiom. Maurice Denis was the first to recognize this dialogue between the old and the new in Cézanne's sensibility: "He is at once the climax of the classic tradition and the result of the great crisis of liberty and illumination which rejuvenated modern art. He is the Poussin of Impressionism."[15]

Poussin's concept of order, expressed by the stratification of landscape and human beings, finds its fullest expression in this work. Cézanne felt a deep, inner kinship with Poussin, at least in the comprehensiveness of his aspirations, and the painting includes a direct quotation from the work of the earlier artist (the grouping on the right substantially repeats the figures in Poussin's *Bathing Nymphs*, which Cézanne probably knew from an engraving).[16] To execute his work, Cézanne had to rely on photographs, reproductions, and early sketches he had made, because aside from his long-standing personal discomfort with unclothed models, he was unwilling to risk the wrath of public opinion in provincial Aix, where the use of nude models would have intensified the hostility and scandal in which he was already embroiled. In view of how removed from nature these bathers are, it probably would have made little difference in the final result if he had worked from life.

The composition of *Large Bathers* is rather schematic, owing to its unfinished state. It is based on two sets of triangles: one, formed by the standing bathers and trees, that recalls the earlier *Three Bathers*; and two smaller groups of figures flanking the larger one. Parallels and counterparallels are drawn among the arms and postures of the stylized figures. Although the painting is architectonically conceived, the application of paint is so light and delicate that it almost seems a sketch. The semi-transparent pigment, restricted to the tones of ocher, green, and blue and their intermediaries, and the lambent brushstroke create a lively, flickering surface impression clearly influenced by watercolor technique.

While he was working on the Bathers series, Cézanne's diabetes made it extremely painful for him to walk, and the effort of simply getting to the site required enormous commitment. His frequent depressions were intensified by several events of his later years: the failure of his marriage to provide a sympathetic companion; the death of his adored mother, whom he had nursed through a long illness; the sale of the family estate, the Jas de Bouffan, where he had grown up; and the accidental death of Zola, whom he mourned as if there had never been any rancor between them. He had lost his connections to his past; his present was empty; the future held only death. Conversation with his young friends in Aix allayed his sadness to a small degree, but the only dialogues that brought satisfaction were with art and nature. In this vital exchange, he sought and found the communion for which he yearned.

Despite the apparent disparities between the work of 1870–90, with its lucidity of conception, patient and scrupulous brushstroke, and keen attentiveness to the solidity of depicted form, and the complex ambiguities of the late paintings, Cézanne's oeuvre remained coherent, unified by a single objective. Rainer Maria Rilke, the poet, expressed it as "the convincing quality, the becoming a thing, the reality heightened into the indestructible through his own experience of the object."[17] Cézanne, like the artist protagonist of Balzac's *Chef d'oeuvre inconnu*, with whom he identified, strained his capacities to their limits as he attempted to convey the vexing result of his formal investigations: that there are no edges, but only an infinite number of pulsating transitions, and that an object is merely the staging area of transformation and relationship, inextricably involved with all that surrounds it. Cézanne had written in a letter toward the end of his life: "It is all a question of estab-

357.
Georges Braque
Maisons à l'Estaque
1908

lishing as much affinity as possible."[18] He aspired to create a self-reflexive pictorial space parallel to nature that would operate as a matrix—the symbolic equivalent for nature itself.

Cézanne's *The Gardener (Vallier Seated)* of 1905–6 (plate 377), embodies this aspiration. Simultaneously emerging and withdrawing through incessant modulations of color, the glimmering, elusive outlines efface the distinction between subject and environment. It has been suggested that Cézanne saw in Vallier the man he wished to be. Certainly, in his last years, as disease took its physical and mental toll on Cézanne, his relationship with his gardener intensified into one of close identification. Although the artist's numerous paintings of ordinary people testify to his sympathy for them, no other painting is so imbued with strength; none offers a subject so fixed in the center of a world of shifting realities.

The Legacy of Cézanne

In the last seven years of his life Cézanne's work developed a truly international reputation. Seven of his paintings were shown in the Secession group exhibition in Vienna, and he had one-man shows in Brussels and in Berlin in 1904. That same year, one room at the Salon d'Automne in Paris was devoted to his work. The year after his death in 1906, a memorial exhibition comprising fifty-six oils was mounted at the Salon d'Automne, and seventy-nine watercolors were shown at the Galeries Bern-

heim-Jeune. Only then did Parisians have an opportunity to assess his achievements. Ironically, the importance of the memorial exhibition as a summary of the painter's life's work was overshadowed by its significance as a catalyst for the creation of a new plastic vocabulary. Cézanne himself had anticipated the prophetic dimension of his art when he wrote to Vollard: "I am working doggedly, for I am beginning to see the promised land. Shall I be like the great Hebrew or shall I be able to enter?"[19]

If Cézanne was Moses, then he had not one but two Joshuas in Braque and Picasso. Stimulated by his example, their work would ultimately lead the art of the twentieth century to a land where Cézanne, with his deep commitment to the natural world, never would have wished to dwell.

To the intense emotionalism and emphasis on decorative symbolism that dominated Post-Impressionism, Cézanne offered a constructivist alternative. Picasso had begun to absorb the message of Cézanne's work in such paintings as *Boy with a Horse*, executed in 1902 after he had studied some of Cézanne's canvases at Vollard's. Unlike Braque, who would approach Cézanne by radically expanding the nature of his new spatiality, Picasso used the older master's example in combination with such wide-ranging sources as Iberian, Egyptian, and black African sculpture. His *Demoiselles d'Avignon* (plate 381), painted in 1906–7, may have begun as a form of tribute to Cézanne's Bathers, but its harsh color and distorted forms signal a crucial break with the classical and humanistic tradition in which that theme was rooted.

The bulk of Cézanne's work has a strongly vertical cast, with high horizons, shallow backgrounds, and distant objects portrayed with the same clarity and integrity as those in the foreground. Most important for his younger followers, Cézanne eliminated the privilege of single-view perspective. Many of his paintings were executed as if seen from several eye levels and different standpoints. This was a result of Cézanne's idea of construction, which demanded a new sense of a painting—temporal as well as spatial. He realized that one saw elements of a painting successively as well as simultaneously; the viewer could, as it were, see around an object. These multiple foci were unified by Cézanne's conception of the total painting in which every element—solid and void—is tied to every other. Combined with his use of distortion and the "passage" of one plane into another, this motion opened up an enormous freedom and potentiality in the distribution of forms upon the canvas, and led, ultimately, to Picasso's epochal work.

In an interview, Picasso generously acknowledged Cézanne's influence: "As if I didn't know Cézanne! He was my one and only master! Don't you think I looked at his pictures? I spent years studying them. . . . It was the same with all of us—he was like our father."[20] *Les Demoiselles d'Avignon* assimilates Cézanne's daringly fluid point of view. The figures, partly derived from late studies for Bathers, are seen on the ground plane and from below. Heads, noses, and eyes are seen both in profile and

This still life, like those of Cézanne, is set in a shallow, stagelike space; but Picasso's intensified analysis of the forms magnifies their inherent abstract properties. Even more than with Cézanne, the objects here are subjectively deformed in order to achieve a sense of palpability and monumentality.

358.
Pablo Picasso
Bread and Fruit Dish on a Table
1909

straight on. The table and the bowl of fruit are tipped toward the spectator, and the stylized bodies of the women seem to be unfolded and cut up into their constituent planes, which are undifferentiated from the planes of the surrounding area. The same effect is observable in Braque's *Nude* of the same year.

Braque's absorption of Cézanne's visual legacy led him literally to trace the steps of the master in Provence. In 1907–8, he painted a group of landscapes there, further reducing the natural and man-made forms to essential geometric shapes. In *Road near L'Estaque* (plate 379), he energized space by giving the same importance to the intervals between objects as he does to the objects themselves. Using a high horizon and flattening the topographical features, Braque established the verticality of the composition. By the strong thrust of the road and its abrupt dropping off, he gave the impression not of recession but of a flow down and out into the space of the spectator. When his paintings were rejected by the Salon jury of 1908, Braque decided to show them at the gallery of Daniel-Henry Kahnweiler, who would later become the major dealer for the new art that he and Picasso were creating. On viewing them there, the critic Louis Vauxcelles pronounced them to be like cubes.

Two other concerns of Cézanne that were major elements in the formative years of Cubism were his reduction of objects to their rudimentary geometrical shapes and the "non-finite" dimension of some of the last paintings. Both are present in Picasso's *Bread and Fruit Dish on a Table* (plate 358), as is the use of the high horizon, which aligns the table with the picture frame. Cézanne never tired of repeating, "Everything in nature is modeled on the sphere, the cone, the cylinder. One must learn to paint from these simple forms."[21] He never followed this dictum, but the statement gained currency in avant-garde circles early in the century and wielded considerable authority (although it was adhered to more in spirit than in actual practice).

Cézanne regarded the unfinished aspect of some of his late paintings as incompletion and failure to "realize": "Now being old, nearly seventy years, the sensations of color, which give light, are for me the reason for the abstractions that do not allow me to cover my canvas entirely or to pursue the delimitation of objects where their points of contact are fine and delicate; from which it results that my image or picture is incomplete."[22] In 1906 Jean Royère wrote, "This painter who analyzed nature to the point of decomposing colors, tones and lights, aspired to so exalted a synthesis that it was impossible for him."[23] By leaving many canvases with unfinished areas, Cézanne drew attention to the process of painting, an idea that strongly appealed to Picasso. He identified with Cézanne's anxiety about his ability to express his vision fully, and went one step further by incorporating and systematizing this idea as part of the process of painting. Of the three loaves of bread in *Bread and Fruit Dish on a Table*, one is smoothly finished, one roughly modeled, and the third only has its underpainting.

Cézanne's willingness to leave his canvases unfinished is one aspect of a larger matter that occupied the early Cubists. In their repudiation of representation, they gradually shifted the subject of painting from nature to procedural and technical artistic questions. The poet Guillaume Apollinaire described this subject matter as "new structures [painted from] elements borrowed not from visual reality, but from the reality of intellectual knowledge." They announce the existence of a realm of abstraction far removed from the agonized and passionate dialogue Paul Cézanne carried on with the natural world for forty years.

359.
Paul Cézanne
Cardplayers
1890–92

This picture is marked by none of the animation one might expect of Provençal peasants playing cards. Nor are there any anecdotal details. Rather Cézanne has endowed his figures with a dignified and monumental solidity that makes them heroic. The figures and objects consist of simplified shapes, made three-dimensional by the patches of color. Every object is palpable and weighty. Yet despite the literal heaviness of these cardplayers (and the serious looks on their faces), the austerity of this picture is not unrelieved; the brilliant red of the card and the standing figure's scarf, as well as the four pipes on the wall, enliven the scene.

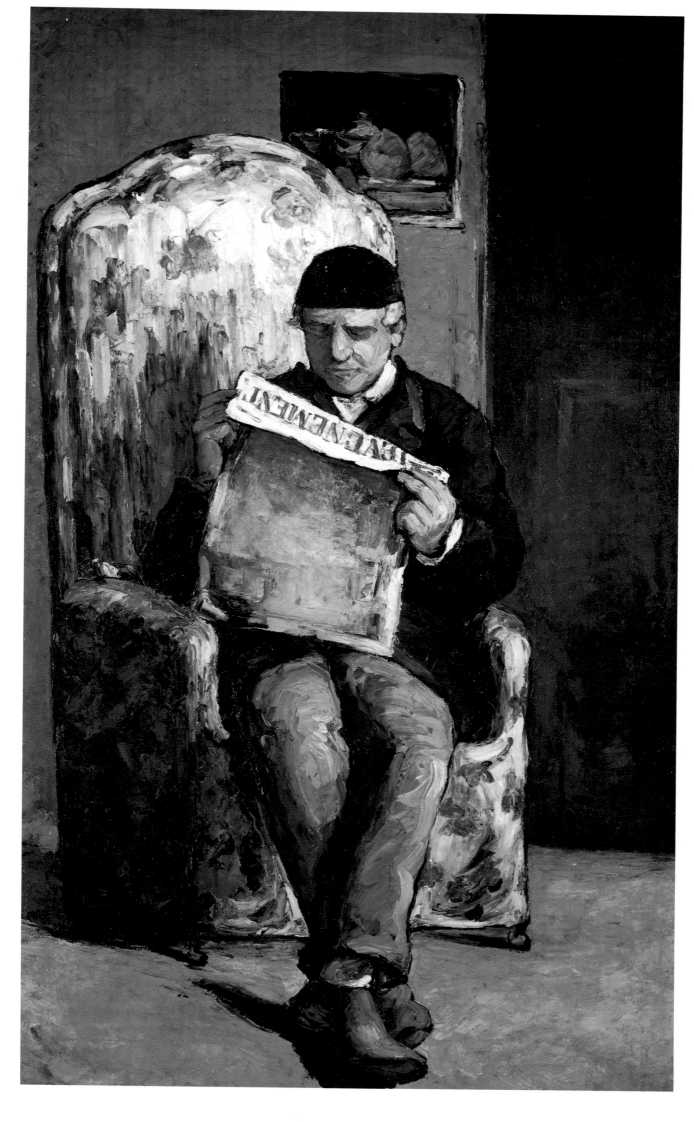

360.
Paul Cézanne
Portrait of the Artist's Father
1866

361.
Paul Cézanne
Houses in Provence
1880

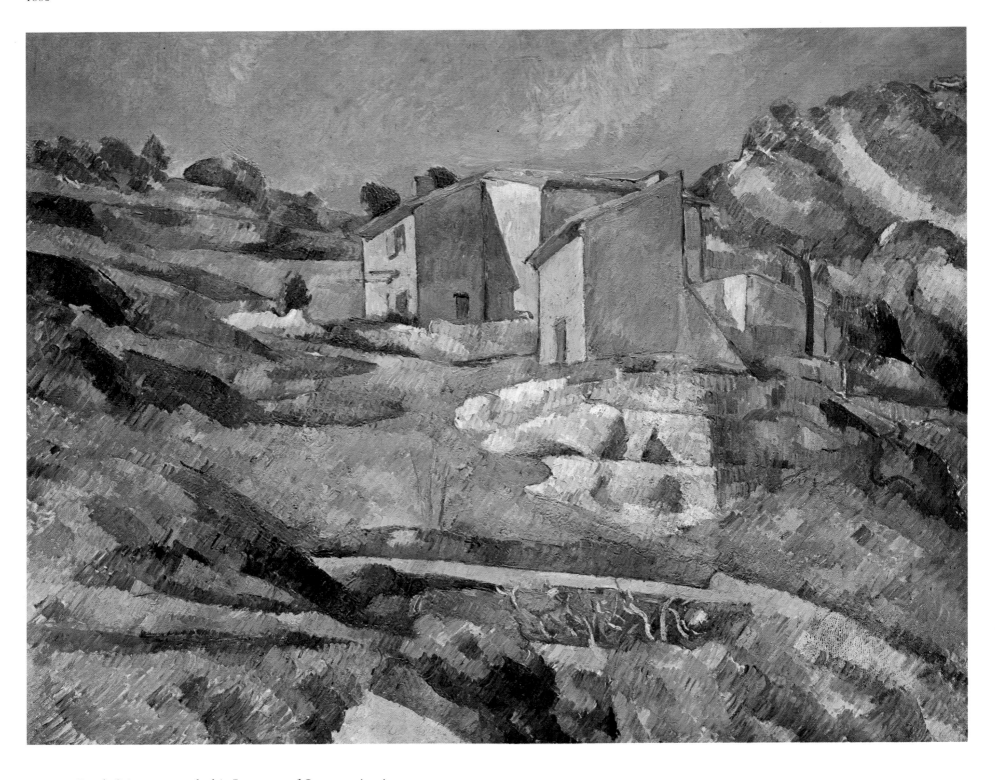

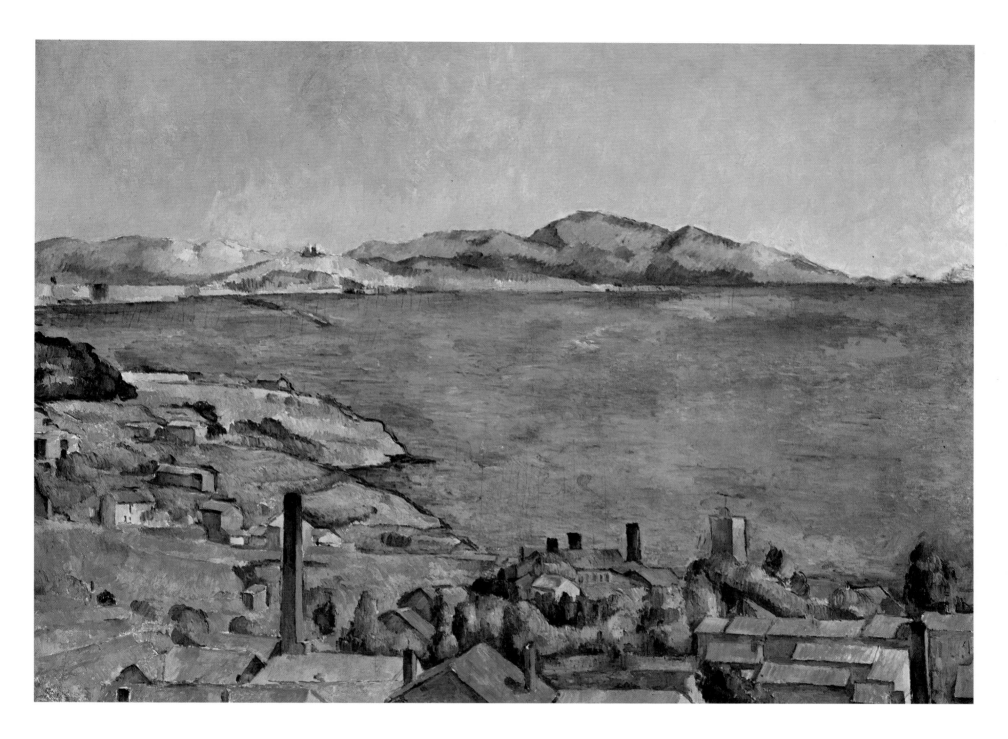

362.
Paul Cézanne
The Gulf of Marseilles Seen from l'Estaque
c. 1884–86

Cézanne's desire to replace "traditional modeling and perspective by the study of color tones" was matched by an abiding concern with clarity and structure. Long hours spent scrutinizing a motif made him sensitive to the essential geometry of the man-made houses in the surrounding natural landscape. His interest in light stemmed from its ability to illuminate these forms and not from its manifestation of atmosphere or climate. As a result, his works exude a sense of timelessness and solidity that are the antithesis of Impressionism.

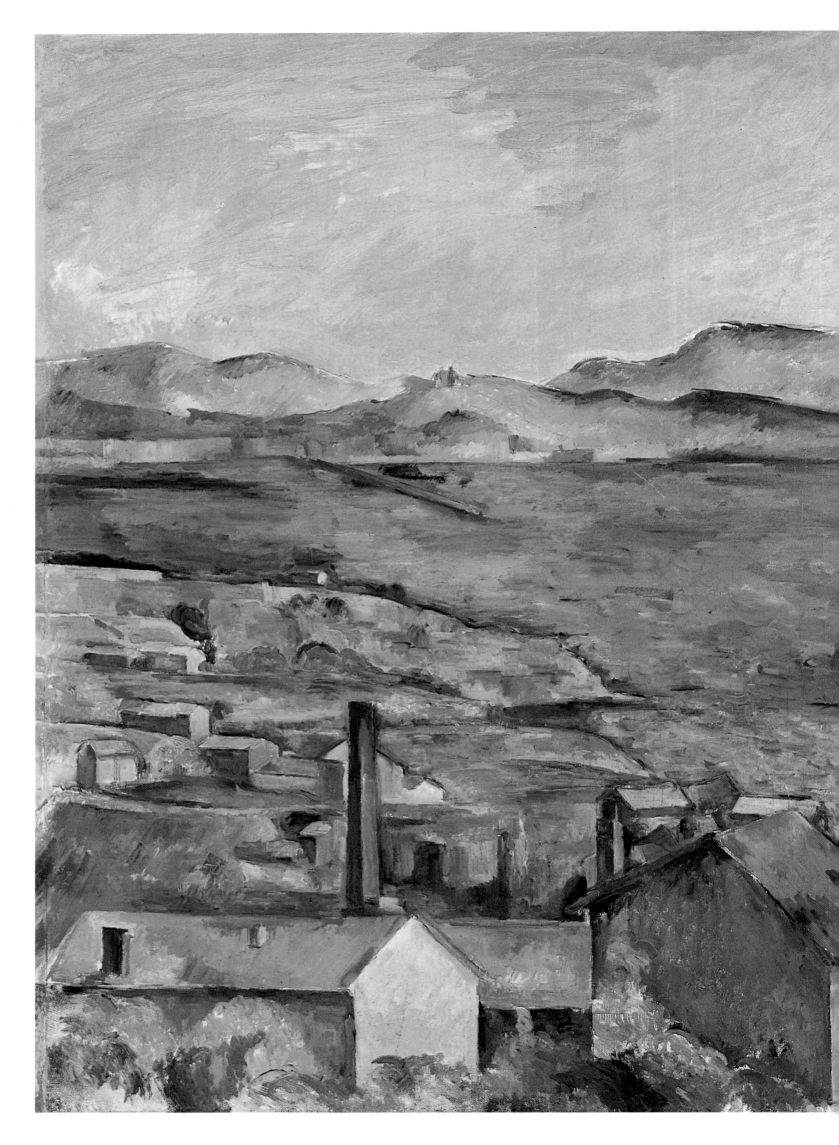

363.
Paul Cézanne
Marseilles, Seen from l'Estaque
1886–90

PAGE 354
364.
Paul Cézanne
The Artist's Son, Paul
1885–90

PAGE 355
365.
Paul Cézanne
Madame Cézanne in a Red Armchair
C. 1877

366.
Paul Cézanne
Still Life with Peppermint Bottle
c. 1894

Unlike the still-life painters of the past, who sought to gratify the public's sensuous response to objects, Cézanne sought a more profound sense of reality. Although Still Life with Peppermint Bottle *pays a debt to Chardin, the purposeful distortion of the forms in relation to themselves and each other is uniquely Cézanne's. The gravity and scale of the arrangement and the sober colors impart a sense of monumentality more commonly associated with landscapes than still lifes.*

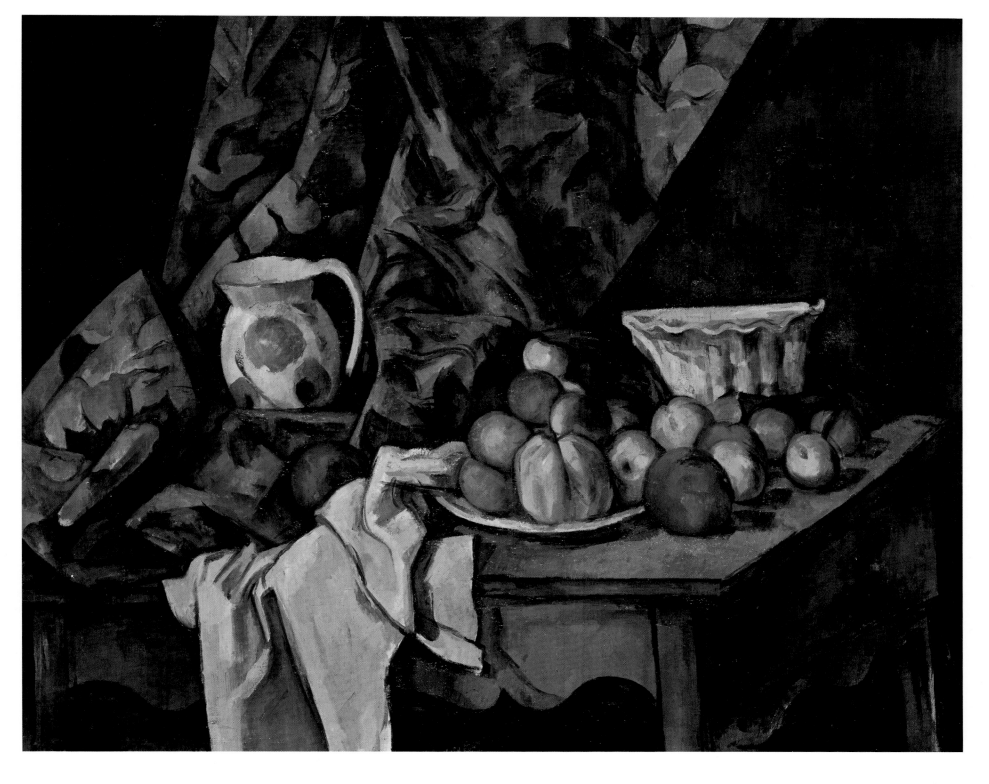

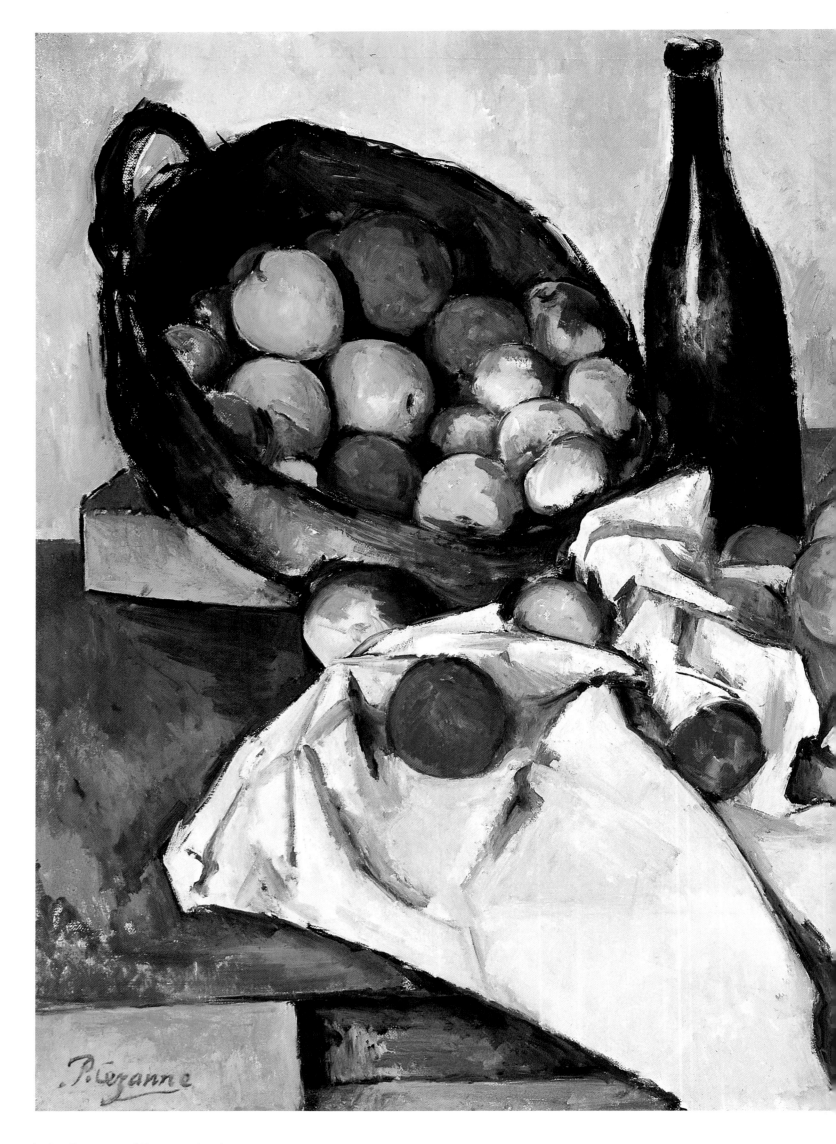

Still-life painting was more important to Cézanne than to any of the other artists associated with Impressionism. For a painter as dedicated as he to the close and prolonged study of objects, it offered an unparalleled opportunity for formal analysis within a fixed and controlled space. The few familiar objects represented in the still lifes produced during Cézanne's last decade may belong to the traditional repertoire of the genre; but the artist ignores their visual and tactile properties in order to concentrate on their formal essence. One would never look on these apples as something to eat.

368.
Paul Cézanne
The Basket of Apples
c. 1895

Paul Cézanne and the Legacy of Impressionism · 359

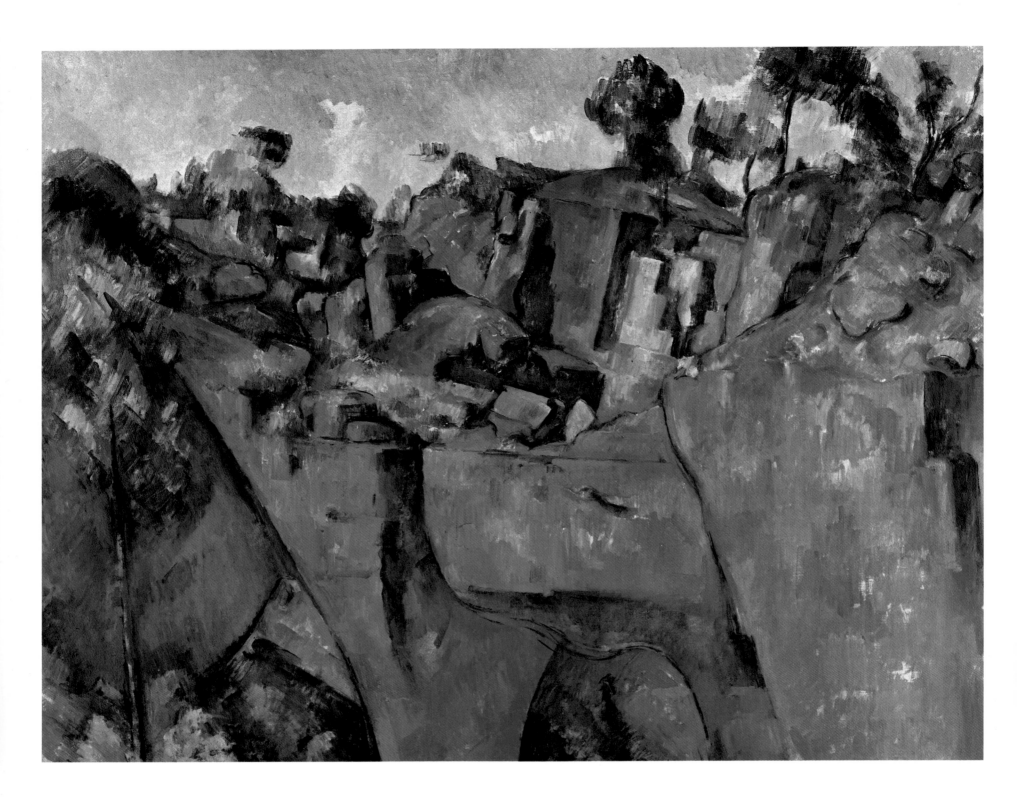

369.
Paul Cézanne
Bibémus Quarry
c. 1895

370.
Paul Cézanne
*Mont Sainte-Victoire Seen from
Bibémus Quarry*
c. 1898–1906

While the Impressionists had concentrated on plein air themes that were determined by ephemeral atmospheric conditions and therefore required rapid execution, Cézanne was convinced that the "truth" of a visual experience could only emerge after prolonged contemplation. The relatively cloudless skies and strong, even light of the south of France were more conducive to establishing that equilibrium of perceptual and conceptual structure than the fast-moving, dramatic light of the north. Again and again, Cézanne returned to study Mont Sainte-Victoire near his native Aix, moving his vantage point, altering the character of space and the objects that populate it, so that each canvas seems to move through time itself.

371.
Paul Cézanne
Mont Sainte-Victoire Seen from Les Lauves
1902–6

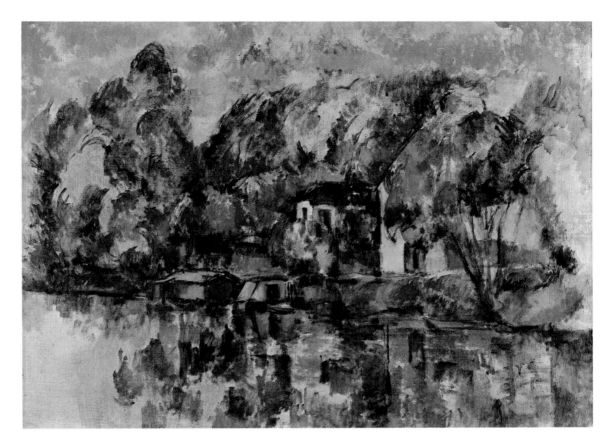

*T*he development of Cézanne's painting was marked by
constant internal struggle as he sought to reconcile seemingly
contradictory elements: energy and repose, mutation and
permanence. For him, colors and lines created weight and
materiality; they were the building blocks that, through their
intersection, overlapping, or separation, created sensations of
recession or advancement in a highly active surface pattern.

LEFT

372.
Paul Cézanne
Jardin des Lauves
1906

ABOVE

373.
Paul Cézanne
At the Water's Edge
c. 1890

374·
Paul Cézanne
*Bibémus: Red
Rock*
1897

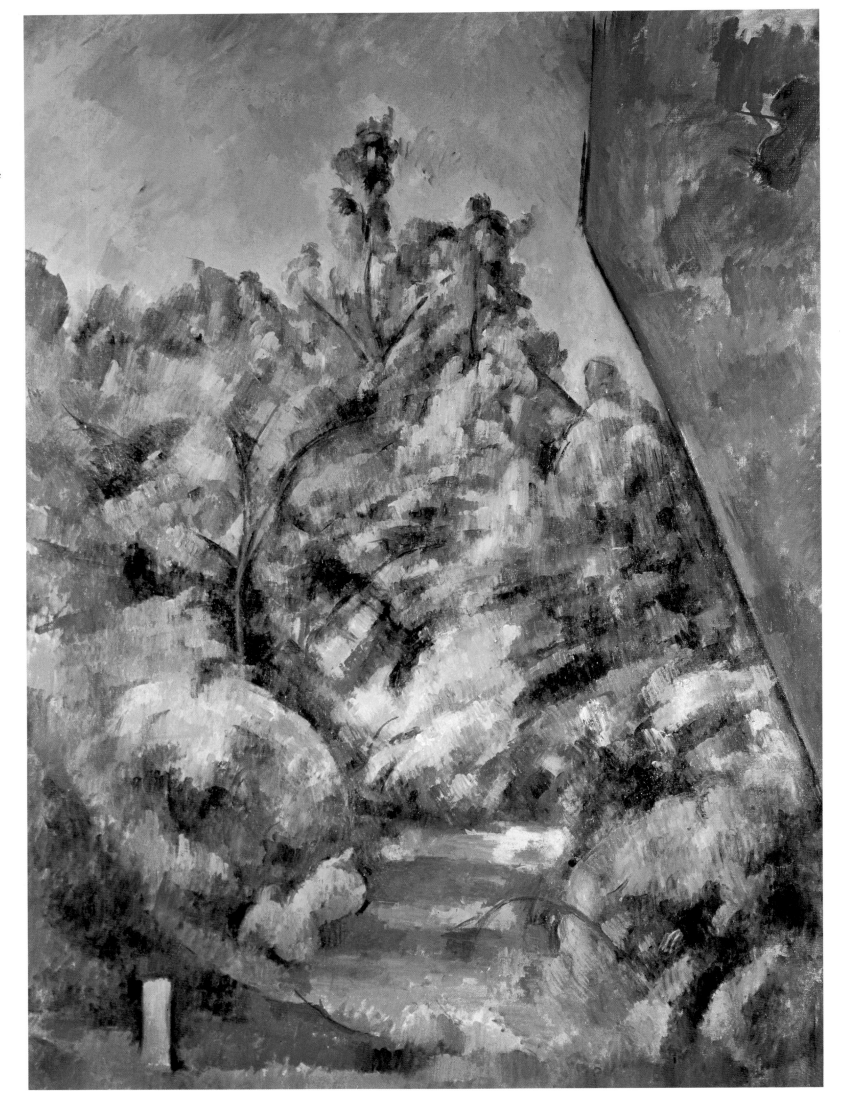

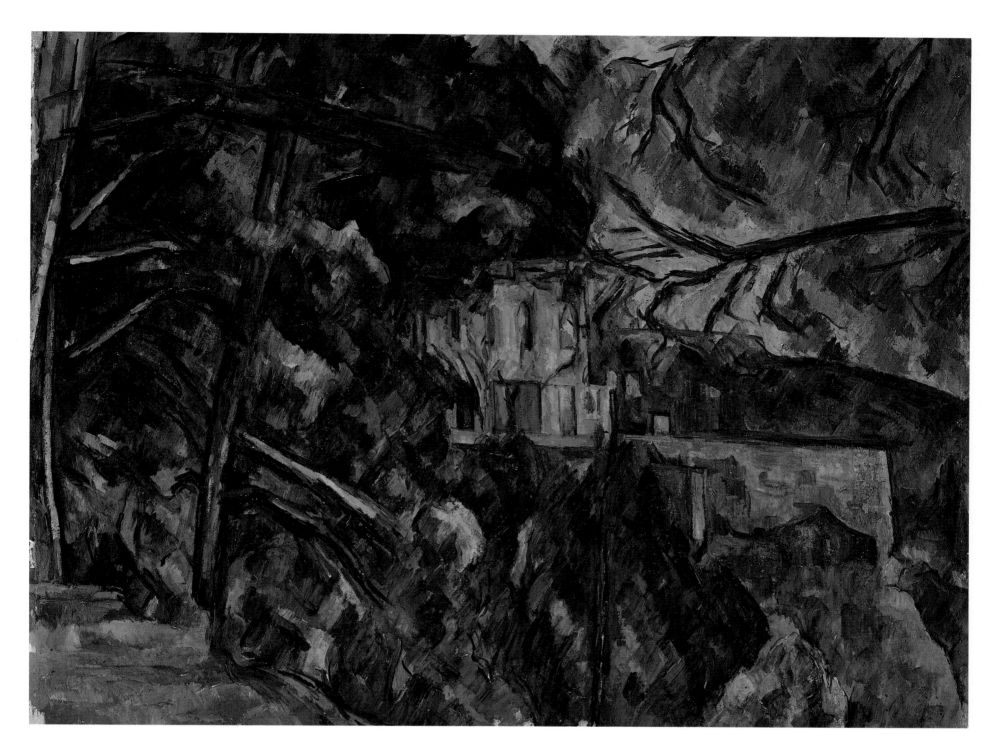

375.
Paul Cézanne
Le Château Noir
1900/1904

PAGE 368
376.
Paul Cézanne
Madame Cézanne in a Yellow Armchair
1893–95

PAGE 369
377.
Paul Cézanne
The Gardener (Vallier Seated)
1905–6

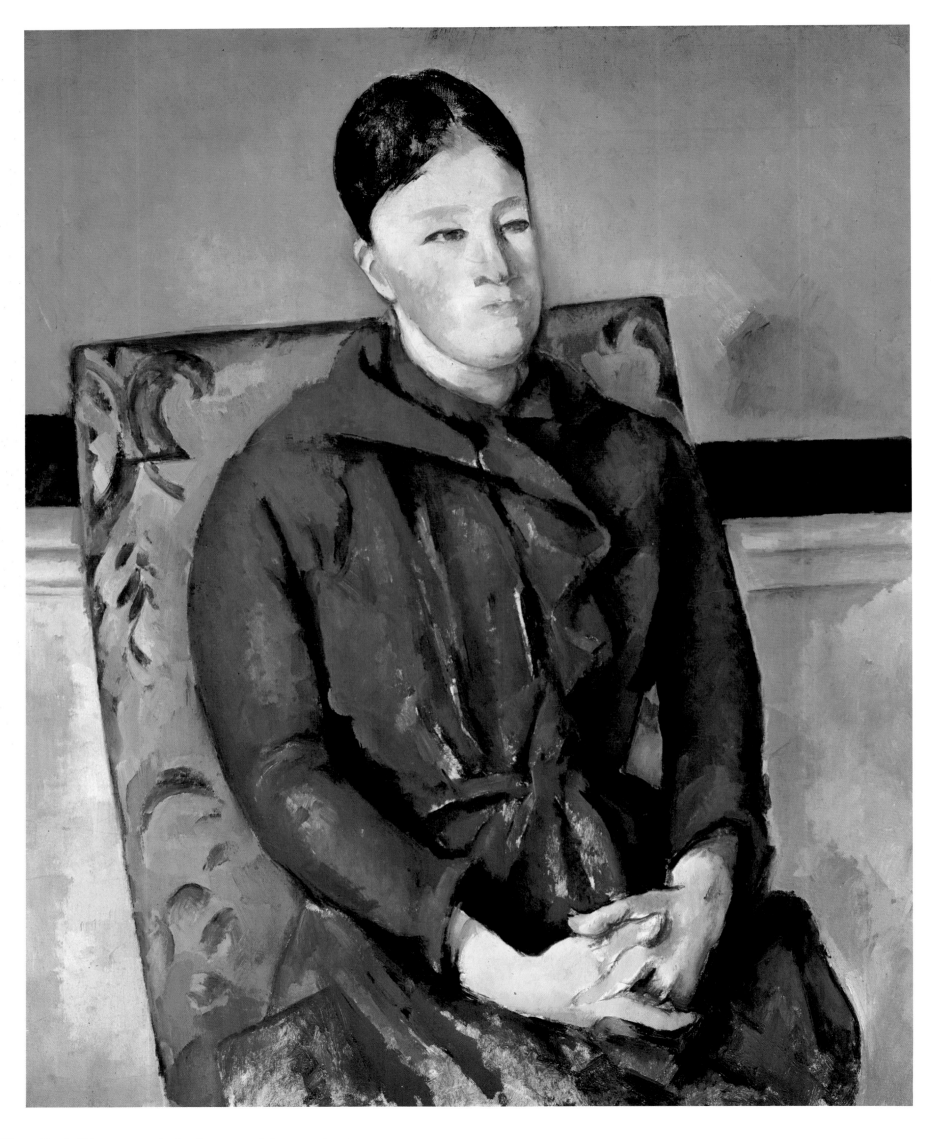

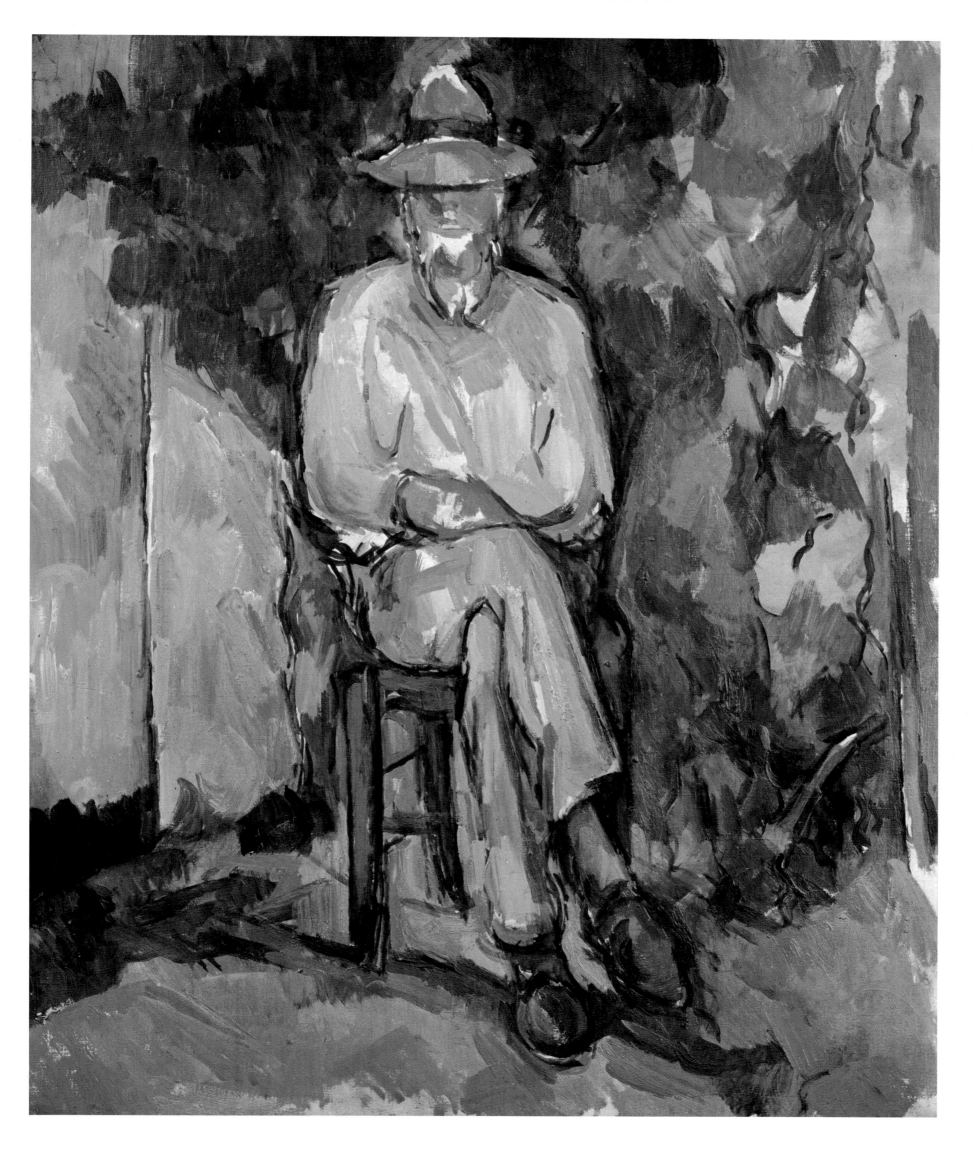

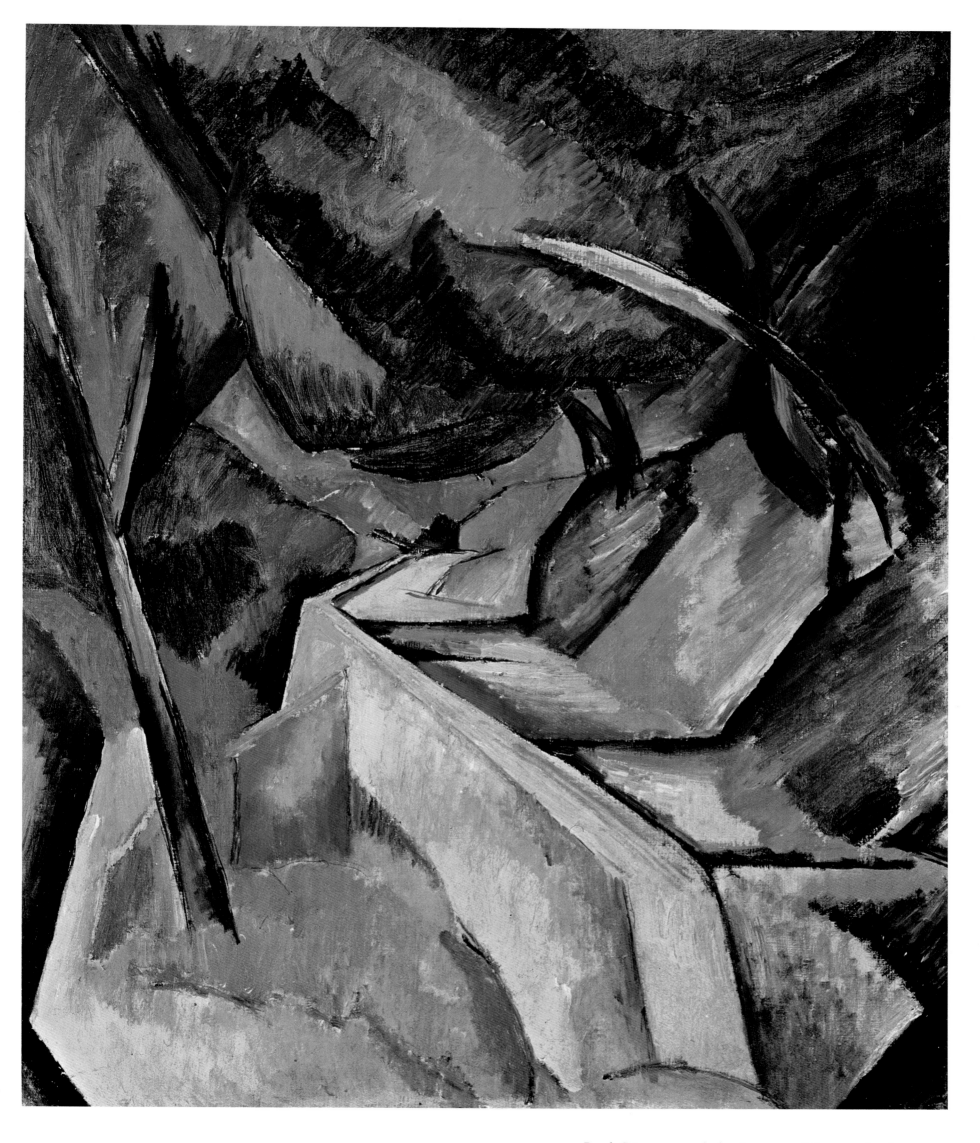

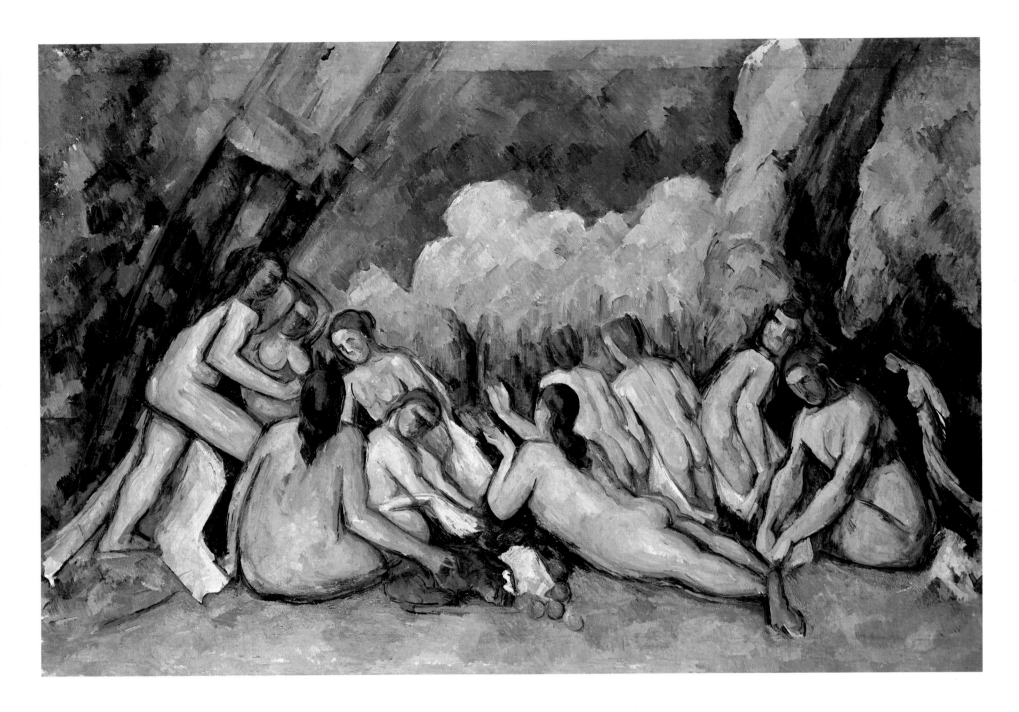

PAGE 370
378.
Paul Cézanne
Pin et Rochers au Château Noir
C. 1910

PAGE 371
379.
Georges Braque
Road near l'Estaque
1908

ABOVE
380.
Paul Cézanne
Bathers
1900–6

While heralding the new language of Cubism, Picasso's ostensible tribute to Cézanne acknowledges both the immediate experience of that painters's many studies of bathers and the entire tradition of the heroic nude which they embraced. In *Demoiselles* we witness a pictorial language in the process of evolution. The tension between flat and solid forms, so often explored by Cézanne, has been replaced by a new concept of space in which the formal integrity of objects is repeatedly violated by the space surrounding them.

381.
Pablo Picasso
Les Demoiselles d'Avignon
1907

OPPOSITE
Detail of plate 5

ABOVE
382.
Paul Cézanne
The Battle of Love
C. 1880

This small canvas may have been painted as early as 1875–76. It constitutes one of the artist's last attempts to do a Renaissance theme, in this case a bacchanal; yet its violent erotic content is far removed from the joyous exuberance and warm color traditionally associated with such a motif. The turbulent mood seen in The Battle of Love, *created by the rippling contours and agitated execution of the figures and landscape, disappeared as Cézanne relinquished mythology and autobiography in favor of an expanded study of the nude. The culmination of his efforts came during the 1890s; while retaining much of the vitality that characterized the earlier work,* Bathers *conveys a more rigorously integrated linear design.*

Cézanne's young friend Joachim Gasquet compared the clarity of this majestic composition to a verse by the classic poet Racine. The architectonic character of the landscape and corresponding nudes conveys a noble intention analogous to that of Poussin, a contemporary and kindred spirit of Racine's. The Large Bathers *is a final recapitulation of the enduring Renaissance motif Cézanne had first addressed some thirty years earlier, a theme which had challenged the imagination of the greatest painters of his century. Because of its scale and subject, the canvas was painted in the studio, and the painter was forced to adjust the requirements of visual truth to the conventions of the theme. Yet it is precisely through this adjustment that Cézanne transcended the physical and emotional limitations of Impressionism to produce a new hybrid vision.*

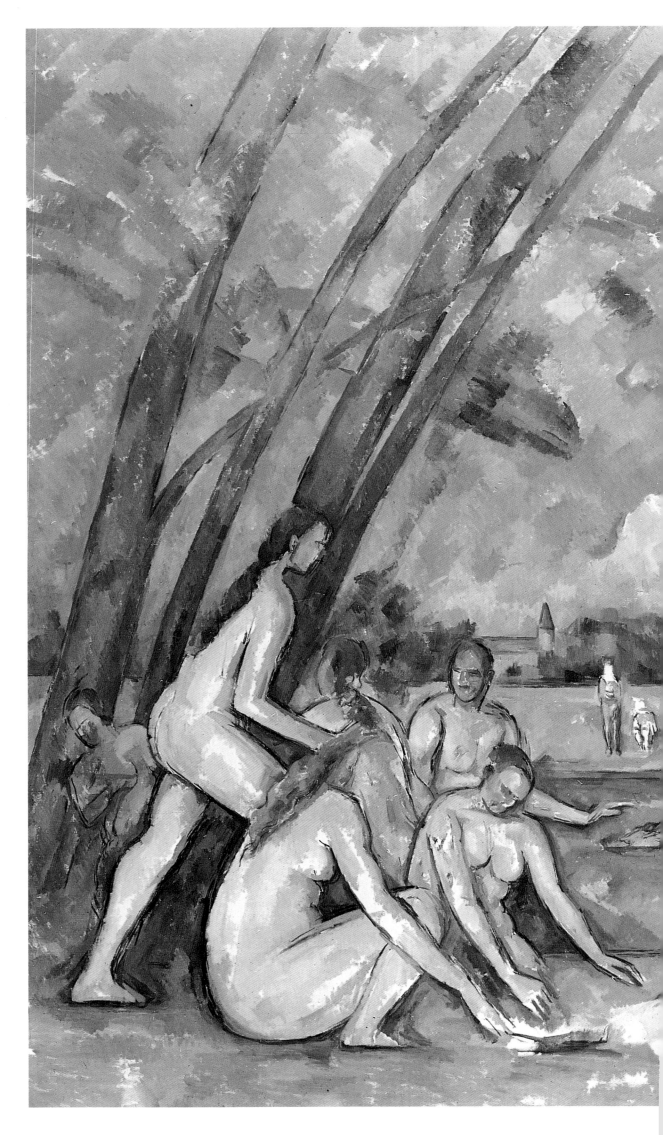

383.
Paul Cézanne
Large Bathers
1899–1905

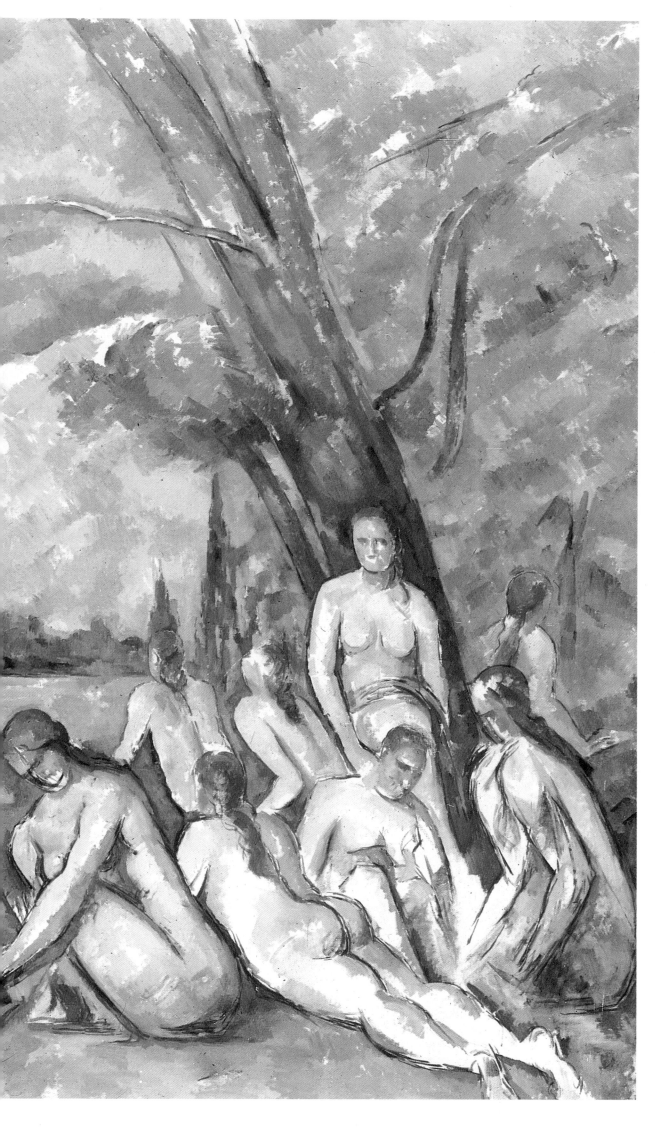

Notes

Chapter 1

1. E. Viollet-le-Duc, "L'Enseignement des arts," *Gazette des beaux-arts* (June 1862), cited in John Rewald, *The History of Impressionism* (New York, 1973), p. 22f.
2. Jonathan Mayne, *The Mirror of Art: Critical Studies by Charles Baudelaire* (London, 1955), n.p.
3. Jonathan Mayne, *Art in Paris 1845–1862: Salons and Other Exhibitions Reviewed by Charles Baudelaire* (London, 1965), pp. 52–68.
4. Charles Baudelaire, *Eugène Delacroix, His Life and Work* (New York, 1947), p. 12.
5. Eugène Delacroix, *Journals* (February 23, 1852), cited in Elizabeth Gilmore Holt, *From the Classicists to the Impressionists: Art and Architecture in the 19th Century* (New York, 1966), p. 162.
6. Walter Pach, trans., *The Journal of Eugène Delacroix*, (New York, 1937), Supplement, p. 730.
7. Mayne, *Mirror of Art*, p. 214.
8. T. J. Clark, *The Absolute Bourgeois, Artists and Politics in France 1848–1851* (Greenwich, Conn., 1973), p. 79.
9. Ibid., p. 80.
10. Robert L. Herbert, *Barbizon Revisited* (San Francisco, 1962), p. 15.
11. Louis Leroy, "L'Exposition des impressionnistes," *Charivari*, April 25, 1874, cited in Rewald, *Impressionism*, p. 320.
12. René Huyghé, G. Bazin, and H. Adhémar, *L'Atelier du peintre* (Paris, 1944), cited in Holt, *Classicists to Impressionists*, pp. 348–49.
13. Rewald, *Impressionism*, p. 17.
14. Jules Champfleury, *Histoire de l'imagerie populaire* (Paris, 1869), p. xii, cited in Rewald, *Impressionism*, p. 20.
15. Théophile Silvestre, *Les Artistes français, études d'après nature* (Brussels, 1861), p. 39.
16. Linda Nochlin, *Realism* (New York, 1972), p. 35.
17. Jules Champfleury, *Les Amis de la nature* (Paris, 1860), ch. 2, cited in Rewald, *Impressionism*, p. 42.
18. Gustave Courbet, letter from the *Courrier du dimanche* (December 25, 1861), cited in Linda Nochlin, *Realism and Tradition in Art, 1848–1900* (Englewood Cliffs, N.J., 1966), p. 35.
19. Pach, *Journal of Delacroix*, pp. 292–93.

Chapter 2

1. Anne Coffin Hanson, *Manet and the Modern Tradition* (New Haven, 1977), pp. 62–63.
2. Charles Baudelaire, "Peintres et aquafortistes," *Le Boulevard* (September 1862), cited in Rewald, *Impressionism*, p. 54.
3. Charles Baudelaire, "Le Peintre de la vie moderne," *Le Figaro*, November 26, 28, December 6, 1863, cited in John Rewald, *The History of Impressionism* (New York, 1973), p. 127.
4. Nils Gösta Sandblad, *Manet: Three Studies in Artistic Conception* (Lund, Sweden, 1954), pp. 20–22, cited in Hanson, *Manet*, p. 68.
5. P. Mantz, "Exposition du Boulevard des Italiens," *Gazette des beaux-arts*, April 1, 1863, cited in Rewald, *Impressionism*, p. 77.
6. Mantz, "Exposition," cited in George Heard Hamilton, *Manet and His Critics* (New York, 1969), p. 40.
7. Ibid., p. 41.
8. Antoine Castagnary, "Le Salon des Refusés," *L'Artiste* (August 1, 1863), reprinted in *Salons 1857–1870*, vol. 1 (Paris, 1892), p. 155.
9. P. G. Hamerton, "The Salon of 1863," *Fine Arts Quarterly Review* (October 1863), cited in Rewald, *Impressionism*, p. 85.
10. Hamilton, *Manet*, p. 44.
11. Jules Claretie, "Deux Heures au Salon de 1865," *Peintres et sculpteurs contemporains* (Paris, 1873), p. 109, cited in Rewald, *Impressionism*, p. 123.
12. Théophile Gautier, *Le Moniteur universel*, June 24, 1865, cited in J. Léthève, "Impressionists and Symbolists and Journalists," *Portfolio and Art News Annual*, no. 2 (1960): n.p.
13. John Richardson, *Manet* (London and New York, 1958), n.p.
14. Zacharie Astruc, "La Fille des îles," cited in Hamilton, *Manet*, p. 69.
15. Paul Mantz, quoted in Max Kozloff, *Renderings* (New York, 1969), p. 35.
16. Preface to *Manet's Private Exposition* (Paris, 1867), cited in Rewald, *Impressionism*, p. 171.
17. G. Poulain, *Bazille et ses amis* (Paris, 1932), p. 83, cited in Rewald, *Impressionism*, p. 172.
18. Emile Zola, "Salon de 1868," *L'Evènement illustré*, cited in Rewald, *Impressionism*, p. 88.
19. Antoine Castagnary, "Salon of 1869," *Siècle*, June 11, 1869, cited in Hamilton, *Manet*, p. 138.
20. Denis Rouart, ed., *Correspondance de Berthe Morisot avec sa famille et ses amis* (Paris, 1950), pp. 25, 31, cited in Hamilton, *Manet*, p. 140.
21. A. Tabarant, *Manet et ses oeuvres* (Paris, 1947), pp. 498–502, cited in Rewald, *Impressionism*, p. 478.

Chapter 3

1. Louis Leroy, "L'Exposition des impressionnistes," *Charivari*, April 25, 1874, cited in John Rewald, *The History of Impressionism* (New York, 1973), p. 323.
2. Steven Z. Levine, *Monet and His Critics* (New York, 1976), p. 14.

OPPOSITE

Detail of plate 383

3. Antoine Castagnary, "Exposition du Boulevard des Capucines—les impressionnistes," *Le Siècle*, April 29, 1874, cited in Rewald, Impressionism, p. 330.

4. Théodore Duret, "Les Peintres impressionnistes" (Paris, 1878), pp. 17–19, cited in Linda Nochlin, *Impressionism and Post-Impressionism, 1874–1904* (Englewood Cliffs, N.J., 1966), pp. 20–30.

5. Emile Zola, "Mon Salon," in *Salons* (Geneva, 1959), p. 131 ff., trans. and cited in Gerd Muehsam, *French Painters and Paintings from the Fourteenth Century to Post Impressionism: A Library of Art Criticism* (New York, 1970), p. 497.

6. Gygès, article in *Paris-Journal* (March 1875), cited in Rewald, *Impressionism*, p. 354.

7. A year after his death in 1898, Chocquet's collection was sold at auction; the inventory included thirty–two Cézannes, eleven Monets, eleven Renoirs, five Manets, and single paintings by Pissarro and Sisley.

8. A. Wolff, article in *Le Figaro*, April 3, 1876, cited in Rewald, *Impressionism*, p. 368f.

9. Edmond Duranty, *La Nouvelle Peinture: A Propos du groupe d'artistes qui expose dans les Galeries Durand-Ruel* (1876), reprint ed. Marcel Guérin (Paris, 1946), pp. 38–47, 53, 55, cited in Nochlin, *Impressionism*, p. 4.

10. Ibid., pp. 5–7.

11. Duranty, *La Nouvelle Peinture*, cited in Rewald, *Impressionism*, p. 377.

12. Leroy, "L'Exposition," cited in Rewald, *Impressionism*, p. 322.

13. G. Jeanniat, "Souvenirs sur Degas," *La Revue universelle* (October 15, November 1, 1933), cited in Rewald, *Impressionism*, p. 380.

14. Paul Valéry, *Manet, Degas, Morisot*, trans. David Paul (New York, 1960), p. 39.

15. Duranty, *La Nouvelle Peinture*, cited in Nochlin, *Impressionism*, p. 6.

16. Wolff, article in *Le Figaro*, cited in Rewald, *Impressionism*, p. 369.

17. Emile Bernard, "Paul Cézanne," *Les Hommes d'aujourd'hui*, vol. 8, no. 387 (1891), cited in Nochlin, *Impressionism*, p. 101.

18. Armand Silvestre, "Le Monde des arts," *La Vie moderne*, April 24, 1879, cited in Rewald, *Impressionism*, p. 421.

19. Pierre-Auguste Renoir, letter of March 1881, cited in Richard Friedenthal, *Letters of the Great Artists: From Blake to Pollock*, trans. Daphne Woodward (New York, 1963), n.p.

Chapter 4

1. Claude Monet, letter to Bazille, July 15, 1864, cited in John Rewald, *The History of Impressionism* (New York, 1973), pp. 110–11.

2. Pigalle, *L'Autographe au salon* (Paris, 1865), cited in Rewald, *Impressionism*, p. 123.

3. Linda Nochlin, *Realism* (New York, 1972), p. 145.

4. Emile Zola, "Mon salon: IV. Les Actualistes," *L'Evènement illustré*, May 24, 1868, cited in *Impressionism, a Centenary Exhibition* (New York, 1974–75), p. 136.

5. Kermit Swiler Champa, *Studies in Early Impressionism* (New Haven, Conn., 1973), p. 62.

6. Camille Pissarro, *Letters to His Son Lucien*, ed. John Rewald (New York, 1943), pp. 355–56.

7. R. Koechlin, "Claude Monet," *Art et decoration* (February 1927), cited in Rewald, *Impressionism*, p. 258.

8. Jules Laforgue, "L'Impressionnisme," *Mélanges posthumes, oeuvres complètes*, 4th ed. (Paris, 1902–3), pp. 133–45, cited in Linda Nochlin, *Impressionism and Post-Impressionism, 1874–1904* (Englewood Cliffs, N.J., 1966), p. 16.

9. Rewald, *Impressionism*, p. 380.

10. Claude Monet, letter to Dr. de Bellio, December 30, 1878, cited in Rewald, *Impressionism*, p. 421.

11. Emile Zola, "Le Naturalisme au salon," *Le Voltaire*, June 18–22, 1880, cited in Steven Z. Levine, *Monet and His Critics* (New York, 1976), pp. 39–40.

12. E. Taboureux, "Claude Monet," *La Vie moderne*, June 12, 1880, cited in Rewald, *Impressionism*, p. 447.

13. Guy de Maupassant, "La Vie d'un paysagiste," *Gil Blas*, September 26, 1886, cited in Rewald, *Impressionism*, p. 517.

14. Joel Isaacson, *Observation and Reflection: Claude Monet* (Oxford, 1978), p. 37.

15. Willem G. C. Byvanck, *Un Hollandaise à Paris en 1891: Sensations de littérature et d'art* (Paris, 1892), p. 177, cited in Levine, *Monet*, p. 134.

16. Isaacson, *Monet*, p. 40.

17. Gustave Geffroy, introduction to *L'Art dans les deux mondes* (1891), pp. 297–98, cited in Levine, *Monet*, p. 122.

18. Levine, *Monet*, p. 122.

19. Lilla Cabot Perry, "Reminiscences of Claude Monet from 1889 to 1909," *The American Magazine of Art* 18 (March 1977): 119–25.

20. Isaacson, *Monet*, p. 42.

21. Georges Clemenceau, "Revolution de Cathédrales," *La Justice*, May 20, 1895, p. 433, cited in Levine, *Monet*, p. 184

22. Claude Roger-Marx, "Les 'Nymphéas' de M. Claude Monet," *Gazette des beaux-arts*, 4th ser. (June 1909), cited in Levine, *Monet*, p. 303.

23. Louis Gillet, *Trois Variations sur Claude Monet* (Paris, 1909), cited in Isaacson, *Monet*, p. 228.

24. René Gimpel, unpublished journal (Paris, n.d.), cited in William Seitz, *Claude Monet: Seasons and Moments* (Garden City, N.Y., 1960), n.p.

Chapter 5

1. C.–L. Moncade, "Le Peintre Renoir et le salon d'automne," *La Liberté* 10, no. 13 (October 15, 1904), cited in Barbara Ehrlich White, *Impressionism in Perspective* (Englewood Cliffs, N.J., 1978), pp. 21–22.

2. Ambroise Vollard, *Renoir: An Intimate Record* (New York, 1925), p. 23.

3. Ibid., p. 25.

4. The remark has been attributed to G.–Albert Aurier.

5. Albert André, *Renoir* (Paris, 1919), p. 8.

6. Georges Rivière, *Renoir et ses amis* (Paris, 1921), p. 81, cited in Kermit Swiler Champa, *Studies in Early Impressionism* (New Haven, Conn., 1973), p. 41.

7. Champa, *Early Impressionism*, p. 47.

8. Vollard, *Renoir*, p. 49.

9. Théodore Duret, *Renoir* (New York, 1937), p. 16.

10. Jean Renoir, *Renoir, My Father* (Boston and Toronto, 1958), p. 157.

11. M. Elder, *Chez Claude Monet à Giverny* (Paris, 1924), p. 70, cited in John Rewald, *The History of Impressionism* (New York, 1973), p. 342.

12. Vollard, *Renoir*, p. 90.

13. M. Robida, *Le Salon Charpentier et les impressionnistes* (Paris, 1958), p. 56, cited in Rewald, *Impressionism*, p. 419.

14. Moncade, "Renoir," cited in White, *Impressionism*, p. 22.

15. Odilon Redon, "Réflexions sur une exposition des impressionnistes" (April 10, 1880), cited in Rewald, *Impressionism*, p. 442.

16. Vollard, *Renoir*, pp. 112, 115.

17. Ibid., p. 101.

18. Ibid., p. 102.

19. Venturi, *Arch. de l'impressionnisme*, vol. 1, pp. 116–17, cited in Rewald, *Impressionism*, p. 462.

20. Vollard, *Renoir*, p. 103.

21. Pierre–Auguste Renoir, letter published in *L'Amateur d'autographes* (1913), pp. 231–33, cited in Rewald, *Impressionism*, p. 461.

22. Vollard, *Renoir*, pp. 118–19.

23. Venturi, *Arch. de l'impressionnisme*, vol. 1, pp. 127–29, cited in Linda Nochlin, *Impressionism and Post–Impressionism, 1874–1904* (Englewood Cliffs, N.J., 1966), pp. 45–47.

24. Barbara Ehrlich White, "The Bathers of 1887 and Renoir's Anti-Impressionism," *Art Bulletin* 55 (1973): 120.

25. Ibid.

26. Ibid., p. 115.

27. Walter Pach, "Pierre–Auguste Renoir," *Scribner's Magazine* (May 1912): 610, cited in White, *Impressionism*, p. 24.

Chapter 6

1. R. H. Ives Gammell, *The Shop-Talk of Edgar Degas* (Boston, 1961), p. 15.

2. Edmond Duranty, *La Nouvelle Peinture*, cited in Linda Nochlin, *Impressionism and Post–Impressionism, 1874–1904* (Englewood Cliffs, N.J., 1966), p. 6.

3. Theodore Reff, "The Pictures within Degas's Pictures," *Metropolitan Museum Journal* 1 (1968): 135.

4. Gammell, *Degas*, p. 36.

5. Reff, "Degas's Pictures," p. 125.

6. Paul Valéry, *Manet, Degas, Morisot*, trans. David Paul (New York, 1960), pp. 81–83.

7. Edmond and Jules de Goncourt, *Journal* (Monaco, 1956), pp. 163–64.

8. Gammell, *Degas*, pp. 38–39.

9. Editors of Réalités, *Impressionism*, preface by René Huyghé (Secaucus, N.J., 1979), p. 204.

10. Daniel Catton Rich, *Degas* (New York, 1951), p. 29.

11. Gerstle Mack, *Toulouse-Lautrec* (New York, 1948), pp. 55–56.

12. Peter Wick, *Henri de Toulouse-Lautrec, Portraits and Figure Studies. The Early Years* (New York, 1946), p. 25.

Chapter 7

1. Gustave Kahn, "Chronique," *Revue indépendante* (January 1888), cited in John Rewald, *Post-Impressionism* (New York, 1979), p. 127.

2. Félix Fénéon, "Le Neo-Impressionnisme," *L'Art moderne*, May 1, 1887, pp. 138–39, cited in Linda Nochlin, *Impressionism and Post-Impressionism, 1874–1904* (Englewood Cliffs, N.J., 1966), p. 110.

3. Nochlin, *Impressionism*, p. 108.

4. Rewald, *Post-Impressionism*, p. 73.

5. Paul Signac, quoted in Nochlin, *Impressionism*, pp. 116–18.

6. Georges Seurat, letter to Maurice Beaubourg, 1890, cited in Nochlin, *Impressionism*, pp. 112–13.

7. Paul Gauguin, letter to Emile Schuffenecker, 1885, cited in Nochlin, *Impressionism*, pp. 157–58.

8. Vincent van Gogh, letter to Theo, cited in Nochlin, *Impressionism*, pp. 139–42.

9. Ibid., p. 142.

10. Vincent van Gogh, letter to Theo, August 1888, cited in Rewald, *Post-Impressionism*, p. 199.

11. G.-Albert Aurier, "The Isolated Ones: Vincent van Gogh," *Mercure de France* (January 1890), cited in Nochlin, *Impressionism*, p. 135.

12. G.-Albert Aurier, "Symbolisme en peinture: Paul Gauguin," *Mercure de France* (March 1891), cited in Rewald, *Post-Impressionism*, p. 447.

13. Paul Gauguin, unpublished document, courtesy of Ir. V. W. van Gogh (Le Pouldu, November, 1889), cited in Rewald, *Post-Impressionism*, pp. 181–82.

14. Paul Gauguin, *Lettres de Gauguin à Daniel de Monfried* (Paris, 1950), p. 70.

15. Paul Gauguin, "Notes on Painting," cited in John Rewald, *Gauguin* (New York, 1938), pp. 161–63.

16. Paul Gauguin, letter to Daniel de Monfried, cited in Pola Gauguin, *My Father Paul Gauguin*, trans. Arthur G. Chater (New York, 1937), pp. 248–50.

Chapter 8

1. Jack Lindsay, *Cézanne: His Life and Art* (New York, 1972), p. 82.

2. Ibid., p. 84.

3. John Rewald, *Cézanne* (London, 1959), p. 82.

4. Judith Wechsler, ed., *Cézanne in Perspective* (New York, 1975), p. 26.

5. Georges Rivière, "L'Exposition des impressionnistes," *L'Intransigeant*, no. 2 (April 14, 1877), cited in Wechsler, *Cézanne*, p. 27.

6. Erle Loran, *Cézanne's Composition*, 3d ed. (Berkeley, Calif., 1963), p. 15.

7. Emile Bernard, "Paul Cézanne," *L'Occident* (July 1904): 17–30, cited in Wechsler, *Cézanne*, p. 42.

8. Paul Cézanne, letter to Pissarro, July 2, 1876, cited in John Rewald, ed., *Paul Cézanne's Letters* (New York, 1976), p. 146.

9. Meyer Schapiro, *Cézanne* (New York, 1952), p. 10.

10. John Rewald, *Paul Cézanne: A Biography* (New York, 1948), p. 129.

11. Wechsler, *Cézanne*, p. 31.

12. Ibid., p. 64.

13. Thadée Natanson, "Paul Cézanne," *La Revue blanche*, December 1, 1895, pp. 499–500, cited in Wechsler, *Cézanne*, p. 35.

14. Maurice Denis, article in *L'Occident* (September 1907), cited in Wechsler, *Cézanne*, p. 52.

15. Ibid., pp. 56–57.

16. Katia Tsiakma, "Cézanne's and Poussin's Nudes," *Art Journal* (winter 1977–78): 131.

17. Rainer Maria Rilke, *Letters of Rainer Maria Rilke, 1892–1910*, trans. Jane Bannard Greene and Herter Norton (New York, 1946), pp. 304–8, 310–11, 313, 314, cited in Wechsler, *Cézanne*, p. 65.

18. Lawrence Gowing, "The Logic of Organized Sensations," *Cézanne: The Late Work*, ed. William Rubin (New York, 1977), p. 70.

19. Paul Cézanne, *Letters*, ed. John Rewald, revised and enlarged (New York, 1976), p. 52.

20. Gyula H. Brassaï, *Picasso and Company* (New York, 1966), p. 79.

21. Bernard, "Paul Cézanne," pp. 19–28, cited in Wechsler, *Cézanne*, p. 78.

22. Emile Bernard, *Souvenirs et lettres* (Paris, 1912), p. 88, cited in William Rubin, "Cézannisme and the Beginnings of Cubism," *Cézanne: The Late Work*, ed. Rubin, p. 201.

23. Jean Royère, "Sur Paul Cézanne," *La Phalange*, November 15, 1906, p. 380, cited in Wechsler, *Cézanne*, p. 48.

List of Illustrations

Color plates are indicated by a dot preceding the title.
*Measurements are given height first, then width. Plate numbers appear in **bold** at the end of each entry.*

Bazille, Frédéric French, 1841–1870
The Artist's Studio, 1870
Oil on canvas, 38 x 50⅝ in. (96.5 x 129 cm)
Musée d'Orsay, Paris **100**

• *Bathers (Scene d'Eté)*, 1869
Oil on canvas, 62¼ x 62½ in.
(158 x 159 cm)
Fogg Art Museum, Harvard University,
Cambridge, Massachusetts; Gift of M.
and Mme F. Meynier de Salinelles **4**

Bonington, Richard Parkes English,
1802–1828
Normandy Coast, 1823–24
Oil on canvas, 17¾ x 15 in. (45.1 x 38.1 cm)
Musée du Louvre, Paris **16**

Boucher, François French, 1703–1770
The Bath of Diana, 1742
Oil on canvas, 22 x 28¾ in. (55.9 x 73.0 cm)
Musée du Louvre, Paris **207**

Boudin, Eugène French, 1824–1898
• *Approaching Storm*, 1864
Oil on panel, 14⅜ x 22¼ in.
(36.5 x 57.8 cm)
Art Institute of Chicago; Gift of Annie
Swan Coburn to the Mr. and Mrs. Lewis
L. Coburn Memorial Collection **1**

The Beach at Trouville, 1864
Oil on canvas, 12⅜ x 18⅞ in.
(31.4 x 47.8 cm)
Musée d'Orsay, Paris **146**

Beach Scene, 1865
Pencil and watercolor, 4½ x 9 in.
(11.4 x 22.9 cm)
Saint Louis Art Museum. Purchase **152**

Braque, Georges French, 1882–1963
Maisons à l'Estaque, 1908
Oil on canvas, 28¾ x 23½ in. (73 x 59.7 cm)
Kunstmuseum, Bern **357**

• *Road near l'Estaque*, 1908
Oil on canvas, 23¾ x 19¾ in.
(60.3 x 50.2 cm)
The Museum of Modern Art, New York;
Given anonymously **379**

Cabanel, Alexandre French, 1823–1889
The Birth of Venus, 1863
Oil on canvas, 31½ x 53 in. (80 x 135 cm)
Pennsylvania Academy of the Fine Arts;
Bequest of Henry C. Gibson **61**

Caillebotte, Gustave French, 1848–1894
Au Café, 1880
Oil on canvas, 61 x 45¼ in. (155 x 115 cm)
Musée des Beaux–Arts, Rouen **117**

Le Pont de l'Europe, 1876
Oil on canvas, 51½ x 71¼ in.
(131 x 181 cm)
Musée du Petit Palais, Geneva **116**

• *Street in Paris, a Rainy Day*, 1877
Oil on canvas, 83½ x 108¾ in.
(212 x 276 cm)
Art Institute of Chicago; Charles H. and
Mary F. S. Worcester Collection **141**

Cassatt, Mary American, 1845–1926
• *The Boating Party*, 1893–94
Oil on canvas, 35½ x 46¼ in.
(90.2 x 118 cm)
National Gallery of Art, Washington,
D.C.; Chester Dale Collection **145**

The Coiffure, 1891
Drypoint, soft-ground etching, and
aquatint, 16 x 22 in. (40.6 x 55.9 cm)
The Metropolitan Museum of Art, New
York; Gift of Paul J. Sachs **118**

• *Lady at the Tea Table*, 1885
Oil on canvas, 29 x 24 in. (73.7 x 61 cm)
The Metropolitan Museum of Art; Gift
of Mary Cassatt, 1923 **144**

• *The Loge*, 1882
Oil on canvas, 31⅛ x 25⅛ in. (80 x 63.8 cm)
National Gallery of Art, Washington
D.C.; Chester Dale Collection **143**

• *Woman in Black at the Opera*, 1880
Oil on canvas, 32 x 26 in. (81.3 x 66 cm)
Museum of Fine Arts, Boston; Charles
Henry Hayden Fund **142**

Cézanne, Paul French, 1839–1906
• *The Artist's Son, Paul*, 1885–90
Oil on canvas, 25¾ x 21¼ in. (65.4 x 54 cm)
National Gallery of Art, Washington,
D.C.; Chester Dale Collection **364**

• *At the Water's Edge*, c. 1890
Oil on canvas, 28⅞ x 36½ in.
(73.2 x 92.7 cm)
National Gallery of Art, Washington,
D.C.; Gift of the W. Averell Harriman
Foundation in memory of Marie N.
Harriman **373**

• *The Basket of Apples*, c. 1895
Oil on canvas, 25¾ x 32 in. (65.4 x 81.3 cm)
Art Institute of Chicago; Helen Birch
Bartlett Memorial Collection **368**

The Bather, c. 1885
Oil on canvas, 50 x 38⅛ in. (127 x 96.8 cm)
The Museum of Modern Art, New York;
Lillie P. Bliss Collection **343**

Bathers, 1895–1900
Oil on canvas, 10⅝ x 18⅛ in. (27 x 46 cm)
Baltimore Museum of Art; The Cone
Collection, formed by Dr. Clairbel and
Miss Etta Cone of Baltimore **355**

• *Bathers*, 1899–1904
Oil on canvas, 20³⁄₁₆ x 24¼ in.
(51.3 x 61.6 cm)
Art Institute of Chicago; Amy
McCormick Memorial Collection **5**

• *Bathers*, 1900–6
Oil on canvas, 51⅛ x 76¾ in.
(130 x 195 cm)
National Gallery, London **380**

Bathers at Rest, 1875–76
Oil on canvas, 39½ x 31¼ in.
(100 x 79.4 cm)
The Barnes Foundation, Merion Station,
Pennsylvania **341**

• *The Battle of Love*, c. 1880
Oil on canvas, 14⅞ x 18¼ in.
(37.8 x 46.4 cm)
National Gallery of Art, Washington,
D.C.; Gift of the W. Averell Harriman
Foundation in memory of Marie N.
Harriman **382**

• *Bibémus Quarry*, c. 1895
Oil on canvas, 25⅝ x 31⅞ in.
(65.1 x 80.8 cm)
Folkwang Museum, Essen **369**

• *Bibémus: Red Rock*, 1897
Oil on canvas, 35⅞ x 26 in. (91 x 66 cm)
Musée d'Orsay, Paris **374**

The Black Clock, 1869–71
Oil on canvas, 21¾ x 29¼ in.
(55.2 x 74.3 cm)
Stavros S. Niarchos Collection, London
339

• *Cardplayers*, 1890–92
Oil on canvas, 25½ x 32 in.
(64.8 x 81.3 cm)
The Metropolitan Museum of Art, New
York; Bequest of Stephen C. Clark **359**

The Cardplayers, 1890–92
Oil on canvas, 71¼ x 52¾ in.
(181 x 134 cm)
The Barnes Foundation, Merion Station,
Pennsylvania **348**

• *Le Château Noir*, 1900/1904
Oil on canvas, 29 x 38 in. (73.7 x 96.5 cm)
National Gallery of Art, Washington,
D.C.; Gift of Eugene and Agnes Meyer
375

Gardanne, 1885–86
Oil on canvas, 31½ x 25¼ in. (80 x 64.1 cm)
The Metropolitan Museum of Art, New
York; Gift of Dr. and Mrs. Franz H.
Hirschland, 1957 **344**

• *The Gardener (Vallier Seated)*, 1905–6
Oil on canvas, 24¾ x 20½ in.
(62.9 x 52.1 cm)
The Tate Gallery, London **377**

• *The Gulf of Marseilles Seen from l'Estaque*,
c. 1884–86
Oil on canvas, 28 ¾ x 39 ½ in.
(73 x 100 cm)
The Metropolitan Museum of Art, New
York; The H. O. Havemeyer Collection;
Bequest of Mrs. H. O. Havemeyer, 1929
362

• *House of Père Lacroix*, 1873
Oil on canvas, 24⅛ x 20 in.
(61.3 x 50.8 cm)
National Gallery of Art, Washington,
D.C.; Chester Dale Collection **138**

House of the Hanged Man, c. 1873
Oil on canvas, 21⅞ x 26¼ in.
(55.4 x 66.7 cm)
Musée d'Orsay, Paris **114**

• *Houses in Provence*, 1880
Oil on canvas, 25 ⅝ x 32 in. (65.1 x 81.3 cm)
National Gallery of Art, Washington,
D.C.; Collection of Mr. and Mrs. Paul
Mellon **361**

• *Jardin des Lauves*, 1906
Oil on canvas, 25 ¾ x 32 in. (65.4 x 81.3 cm)
The Phillips Collection, Washington,
D.C. **372**

• *Large Bathers*, 1899–1905
Oil on canvas, 82 x 99 in. (208 x 252 cm)
Philadelphia Museum of Art; W. P.
Wilstach Collection **383**

• *Madame Cézanne in a Red Armchair*, c. 1877
Oil on canvas, 28½ x 22 in. (72.4 x 55.9 cm)
Museum of Fine Arts, Boston; Bequest of
Robert Treat Paine **365**

• *Madame Cézanne in a Yellow Armchair*,
1893–95
Oil on canvas, 31⅞ x 25½ in.
(80.8 x 61.2 cm)
Art Institute of Chicago; Wilson L. Mead
Fund **376**

• *Marseilles, Seen from l'Estaque*, 1886–90
Oil on canvas, 31 ½ x 38 ½ in. (80 x 97.8 cm)
Art Institute of Chicago; Mr. and Mrs.
Martin A. Ryerson Collection **363**

A Modern Olympia, 1872–73
Oil on canvas, 18⅛ x 21 ⅝ in. (46 x 54.9 cm)
Musée d'Orsay, Paris **340**

• *Mont Sainte-Victoire Seen from Bibémus
Quarry*, c. 1898–1906
Oil on canvas, 25½ x 32 in.
(64.8 x 81.3 cm)
Baltimore Museum of Art; The Cone
Collection, formed by Dr. Clairbel Cone
and Miss Etta Cone of Baltimore **370**

• *Mont Sainte-Victoire Seen from Les Lauves*,
1902–6
Oil on canvas, 25 x 32¾ in. (63.5 x 83.2 cm)
Kunsthaus, Zurich **371**

Mont Sainte-Victoire Seen from Les Lauves,
1902–6
Pencil and watercolor, 14⅛ x 21 ⅝ in.
(35.9 x 54.9 cm)
The Tate Gallery, London **354**

Nudes in Landscape (Bathers), 1895–1906
Oil on canvas, 81 ½ x 52 ⅜ in.
(207 x 133 cm)
The Barnes Foundation, Merion Station,
Pennsylvania **356**

• *Pin et Rochers au Château Noir*, c. 1910
Watercolor, 18⁵⁄₁₆ x 14 in. (46.5 x 35.6 cm)
The Art Museum, Princeton University,
Princeton, New Jersey **378**

Portrait d'Ambroise Vollard, 1899
Oil on canvas, 40¼ x 32½ in.
(102 x 82.6 cm)
Musée du Petit Palais, Paris **346**

Portrait of Gustave Geffroy, 1895
Oil on canvas, 45 ¾ x 34 in. (116 x 86.3 cm)
Musée d'Orsay, Paris **347**

• *Portrait of the Artist's Father*, 1866
Oil on canvas, 78¼ x 47 in. (199 x 119 cm)
National Gallery of Art, Washington,
D.C.; Collection of Mr. and Mrs. Paul
Mellon **360**

Still Life: Apples, Pears, and Pot, 1900–4
Pencil and watercolor, 11 x 18¾ in.
(27.9 x 47.6 cm)
Musée d'Orsay, Paris **351**

Still Life with Apples, 1895–98
Oil on canvas, 27 x 36½ in.
(68.6 x 92.7 cm)
The Museum of Modern Art, New York;
Lillie P. Bliss Collection **352**

- *Still Life with Apples and Peaches*, c. 1905
 Oil on canvas, 32 x 39⅝ in. (81.3 x 101 cm)
 National Gallery of Art, Washington,
 D.C.; Gift of Eugene and Agnes Meyer
 367

- *Still Life with Peppermint Bottle*, c. 1894
 Oil on canvas, 26 x 32¼ in. (66 x 81.9 cm)
 National Gallery of Art, Washington,
 D.C.; Chester Dale Collection **366**

Still Life with Plaster Cupid, c. 1892
Oil on paper mounted on panel,
27½ x 22½ in. (69.9 x 57.2 cm)
Courtauld Institute Galleries, London
349

Three Bathers, 1879–82
Oil on canvas, 19⅝ x 19⅝ in.
(49.8 x 49.8 cm)
Musée du Petit Palais, Paris **342**

Three Skulls, 1900–4
Watercolor over pencil sketch,
18¾ x 24⅞ in. (47.6 x 63.1 cm)
Art Institute of Chicago; Mr. and Mrs.
Lewis L. Coburn Memorial Collection
350

View of Mont Sainte-Victoire, 1885–87
Watercolor, 15¼ x 19⅝ in. (38.7 x 49.8 cm)
Fogg Art Museum, Harvard University,
Cambridge, Massachusetts; Gift of Mr.
Henry P. McIlhenny **353**

Constable, John English, 1776–1837
Cloud Study, 1822
Oil on paper, 18⅞ x 23¼ in.
(47.8 x 59.1 cm)
Ashmolean Museum, Oxford University **17**

- *The Hay Wain*, 1821
 Oil on canvas, 51¼ x 73 in. (130 x 185 cm)
 National Gallery, London **42**

- *Weymouth Bay*, c. 1807
 Oil on canvas, 30 5/16 x 22 1/16 in.
 (77.8 x 56 cm)
 Museum of Fine Arts, Boston; Bequest of
 Mr. and Mrs. William Caleb Loring **41**

Corot, Camille French, 1796–1875
- *Boatman of Mortefontaine*, 1865–70
 Oil on canvas, 24 x 35⅜ in. (61 x 89.9 cm)
 The Frick Collection, New York **46**

The Bridge at Mantes, 1868–70
Oil on canvas, 15⅜ x 22⅞ in. (39.1 x 58 cm)
Musée d'Orsay, Paris **20**

Hagar in the Wilderness, 1835
Oil on canvas, 71 x 106½ in.
(180 x 271 cm)
The Metropolitan Museum of Art,
New York; Rogers Fund **19**

- *The House and Factory of Monsieur Henry*,
 1833
 Oil on canvas, 32⅛ x 39½ in. (81.6 x 100 cm)
 Philadelphia Museum of Art; W. P.
 Wilstach Collection **45**

Courbet, Gustave French, 1819–1877
The Bathers, 1853
Oil on canvas, 89⅜ x 76 in. (227 x 193 cm)
Musée Fabre, Montpellier, France **34**

Burial at Ornans, 1849
Oil on canvas, 10 ft. 3 in. x 21 ft. 9 in.
(3.12 x 6.63 m)
Musée d'Orsay, Paris **33**

- *The Painter's Studio*, 1855
 Oil on canvas, 11 ft. 10½ in. x 19 ft. 7½ in.
 (3.62 x 5.98 m)
 Musée d'Orsay, Paris **52**

Proudhon and His Children, 1865–67
Oil on canvas, 57⅞ x 78 in. (147 x 198 cm)
Musée du Petit Palais, Paris **35**

- *Woman with a Parrot*, 1866
 Oil on canvas, 51 x 77 in. (130 x 196 cm)
 The Metropolitan Museum of Art, New
 York; The H. O. Havemeyer Collection;
 Bequest of Mrs. H. O. Havemeyer, 1929
 51

- *Young Ladies from the Village (Demoiselles
 du Village)*, 1852
 Oil on canvas, 76¾ x 102¾ in.
 (195 x 261 cm)
 The Metropolitan Museum of Art, New
 York; Gift of Harry Payne Bingham, 1940
 50

Couture, Thomas French, 1815–1879
The Romans of the Decadence, 1847
Oil on canvas, 15 ft. 3½ in. x 25 ft. 5 in.
(4.66 x 7.75 m)
Musée d'Orsay, Paris **18**

Cross, Henri–Edmond French, 1856–1910
- *The Golden Islands*, 1892
 Oil on canvas, 23⅝ x 21⅛ in. (60 x 53.3 cm)
 Musée National d'Art Moderne, Paris **7**

Daubigny, Charles François French,
1817–1878
Barge on the River, c. 1865–70
Oil on panel, 8 x 15½ in. (20.3 x 39.4 cm)
Museum of Fine Arts, Boston; Gift of
Mrs. George H. Davenport **24**

Gobelle's Mill at Optevoz, c. 1857
Oil on canvas, 22¾ x 36½ in.
(57.8 x 92.7 cm)
The Metropolitan Museum of Art, New
York; Bequest of Robert Graham Dun,
1911 **25**

- *Soleil couchant*, 1865
 Oil on panel, 15⅜ x 26⅜ in.
 (39.7 x 67.6 cm)
 Musée d'Orsay, Paris **47**

Daumier, Honoré French, 1808–1879
Battle of the Schools, c. 1855
Lithograph, second state, 10⅝ x 8¼ in.
(27 x 21 cm)
Philadelphia Museum of Art; Courtesy of
John Canaday **26**

First-Class Carriage, 1864
Watercolor on paper, 8⅛ x 11¾ in.
(20.6 x 29.8 cm)
Walters Art Gallery, Baltimore **31**

- *The Laundress*, c. 1861–63
 Oil on panel, 19¼ x 13⅛ in.
 (48.9 x 33.3 cm)
 Musée d'Orsay, Paris **49**

*Nadar Raising Photography to the Level of
Art*, 1862
Lithograph, first state, 17 x 8⅝ in.
(43.2 x 21.9 cm)
Museum of Fine Arts, Boston; Bequest of
W.G. Russel Allen **101**

The Republic, 1848
Oil on canvas, 28¾ x 23⅝ in. (73 x 60 cm)
Musée d'Orsay, Paris **30**

Rue Transnonain, 1834
Lithograph, 14⅜ x 21⅝ in. (37.1 x 54.9 cm)
National Gallery of Art, Washington,
D.C.; Rosenwald Collection **27**

The Third-Class Carriage, c. 1860–62
Oil on canvas, 25¾ x 35½ in.
(65.4 x 90.2 cm)
The Metropolitan Museum of Art, New
York; The H. O. Havemeyer Collection;
Bequest of Mrs. H. O. Havemeyer, 1929
32

The Uprising, c. 1849
Oil on canvas, 34½ x 44½ in.
(87.6 x 113 cm)
The Phillips Collection, Washington,
D.C. **28**

Degas, Edgar French, 1834–1917
- *L'Absinthe*, 1876
 Oil on canvas, 37 x 27½ in. (94 x 69.9 cm)
 Musée d'Orsay, Paris **137**

• *Achille de Gas in the Uniform of a Cadet*,
 1856–57
Oil on canvas, 25 ⅜ x 20 ⅛ in.
(65.1 x 51.1 cm)
National Gallery of Art, Washington,
D.C.; Chester Dale Collection **264**

• *At the Milliner's*, 1882
Pastel on paper, 30 x 34 in. (76.2 x 86.4 cm)
The Metropolitan Museum of Art, New
York; The H. O. Havemeyer Collection;
Bequest of Mrs. H. O. Havemeyer **273**

At the Milliner's, c. 1882
Pastel on paper, 27 ⅝ x 27 ¾ in. (70.2 x
70.5 cm)
The Museum of Modern Art, New York;
Gift of Mrs. David M. Levy **253**

• *At the Milliner's*, 1882–85
Oil on canvas, 24 x 29 ½ in. (61 x 74.9 cm)
National Gallery of Art, Washington,
D.C.; Collection of Mr. and Mrs. Paul
Mellon **276**

Au Théâtre, 1880
Pastel, 21 ⅝ x 18 ⅞ in. (54.9 x 47.8 cm)
Durand–Ruel Collection, Paris **247**

The Ballet Class, c. 1880
Oil on canvas, 32 ⅛ x 30 ⅛ in.
(81.6 x 76.5 cm)
Philadelphia Museum of Art; The W. P.
Wilstach Collection **248**

The Ballet from "Robert le Diable," 1872
Oil on canvas, 26 x 21 ⅜ in. (66 x 55.3 cm)
The Metropolitan Museum of Art, New
York; The H. O. Havemeyer Collection;
Bequest of Mrs. H. O. Havemeyer **112**

Ballet Rehearsal, c. 1891
Oil on canvas, 14 ⅛ x 34 ½ in.
(35.9 x 87.6 cm)
Yale University Art Gallery, New Haven,
Connecticut; Gift of Duncan Phillips **252**

• *The Bathers*, 1890–95
Pastel on paper, 44 ⅝ x 45 ½ in.
(113 x 116 cm)
Art Institute of Chicago; Gift of Nathan
Cummings **278**

• *The Bellelli Family*, 1858–65
Oil on canvas, 78 ¾ x 97 ⅜ in. (200 x 247 cm)
Musée d'Orsay, Paris **262**

• *Carriage at the Races*, 1869
Oil on canvas, 13 ¾ x 21 ½ in.
(34.9 x 54.6 cm)
Museum of Fine Arts, Boston;
Arthur Gordon Tompkins Residuary
Fund **134**

Chanteuse au Gant, 1878
Pastel with watercolor on canvas,
20 ⅞ x 18 ⅛ in. (52.9 x 46 cm)
Fogg Art Museum, Harvard University,
Cambridge, Massachusetts; Bequest–
Collection of Maurice Wertheim **256**

• *Cotton Merchants*, 1873
Oil on canvas, 23 x 28 in. (58.4 x 71.1 cm)
Fogg Art Museum, Harvard University,
Cambridge, Massachusetts; Gift of
Herbert N. Straus **136**

The Dancer, c. 1886
Charcoal and pastel on paper,
15 ½ x 10 ⅞ in. (39.4 x 27.5 cm)
Formerly Collection Ambroise Vollard,
Paris **249**

A Dancer Posing, c. 1874
Charcoal and chalk on paper,
18 ⅛ x 12 in. (46 x 30.5 cm)
David Daniels Collection, New York **246**

Dancer Putting on Her Shoe, 1880
Etching, 6 ¹⁵⁄₁₆ x 5 ⅞ in. (17.6 x 14.8 cm)
Smith College Museum of Art,
Northampton, Massachusetts; Gift of
Selma Erving ('27) **250**

• *Dancers at the Old Opera House*, c. 1877
Pastel, 8 ⅝ x 6 ¾ in. (21.9 x 17.1 cm)
National Gallery of Art, Washington,
D.C.; Ailsa Mellon Bruce Collection **270**

• *Dancers, Pink and Green*, c. 1890
Oil on canvas, 32 ⅜ x 29 ¾ in.
(82.2 x 75.6 cm)
The Metropolitan Museum of Art, New
York; The H. O. Havemeyer Collection;
Bequest of Mrs. H. O. Havemeyer, 1929
272

The Dancing Master, Perrot, c. 1875
Black and brown chalk on paper,
19 ½ x 13 ⅛ in. (49.5 x 33.3 cm)
David Daniels Collection, New York **251**

Diego Martelli, 1879
Oil on canvas, 43 ½ x 39 ¾ in. (110 x 101 cm)
National Gallery of Art, Edinburgh **244**

• *Edmondo and Thérèse Morbilli*, c. 1865
Oil on canvas, 46 ⅛ x 35 ⅜ in.
(117 x 89.9 cm)
National Gallery of Art, Washington,
D.C.; Chester Dale Collection **265**

• *Four Dancers*, c. 1899
Oil on canvas, 59 ½ x 71 in. (151 x 180 cm)
National Gallery of Art, Washington,
D.C.; Chester Dale Collection **271**

Foyer de la Danse (The Dancing Class), 1871
Oil on wood, 7 ¾ x 10 ⅝ in. (19.7 x 27.9 cm)
The Metropolitan Museum of Art, New
York; The H. O. Havemeyer Collection;
Bequest of Mrs. H. O. Havemeyer, 1929
111

Jacques-Joseph Tissot, c. 1868
Oil on canvas, 59 ⅛ x 44 in. (151 x 112 cm)
The Metropolitan Museum of Art,
New York; Rogers Fund **242**

Jephthah's Daughter, 1859–61
Oil on canvas, 77 x 117 ½ in. (196 x 298 cm)
Smith College Museum of Art,
Northampton, Massachusetts **238**

• *Madame Camus*, 1869–70
Oil on canvas, 28 ⅝ x 36 ¼ in.
(72.7 x 92.1 cm)
National Gallery of Art, Washington,
D.C.; Chester Dale Collection **267**

Madame Lisle and Madame Loubens,
 1869–70
Oil on canvas, 33 ¼ x 38 ¼ in.
(84.5 x 97.2 cm)
Art Institute of Chicago; Gift of Annie
Laurie Ryerson in memory of Joseph
Turner Ryerson **245**

• *Madame René de Gas*, 1872–73
Oil on canvas, 28 ⅝ x 36 ¼ in.
(72.7 x 92.1 cm)
National Gallery of Art, Washington,
D.C.,Chester Dale Collection **263**

Manet at the Races, c. 1864
Graphite pencil on light brown paper,
12 ⅝ x 9 ⅝ in. (32.1 x 24.4 cm)
The Metropolitan Museum of Art,
New York; Rogers Fund **243**

Mary Cassatt at the Louvre, 1879–80
Etching, 14 ½ x 8 ¾ in. (36.8 x 22.3 cm)
National Gallery of Art, Washington,
D.C.; Rosenwald Collection **255**

• *The Millinery Shop*, c. 1882
Oil on canvas, 39 ⅛ x 43 ⅜ in.
(99.4 x 110 cm)
Art Institute of Chicago; Mr. and Mrs.
Lewis L. Coburn Memorial Collection
275

• *Miss Lala at the Circus Fernando*, 1879
Oil on canvas, 46 x 30 ½ in. (117 x 77.5 cm)
National Gallery, London; Courtauld
Collection **269**

Portrait of Duranty, 1879
Distemper, watercolor, and pastel on linen,
39¾ x 39⅛ in. (101 x 100 cm)
Glasgow Art Gallery;
The Burrell Collection **103**

Portrait of Madame Jeantaud, 1875
Oil on canvas, 27½ x 33 in. (69.9 x 83.8 cm)
Musée d'Orsay, Paris **254**

• *Portraits in an Office: The Cotton Exchange,
New Orleans*, 1873
Oil on canvas, 29⅜ x 36⅛ in.
(74.6 x 91.8 cm)
Musée des Beaux–Arts, Pau, France **135**

• *The Races*, c. 1873
Oil on canvas, 10½ x 13¾ in.
(26.7 x 34.9 cm)
National Gallery of Art, Washington,
D.C.; Widener Collection **268**

Sketch after Ingres's "Bather," 1855
Pencil on paper, 6 x 4⅛ in. (15.2 x 10.5 cm)
Bibliothèque Nationale, Paris **11**

Standing Nude Youth, 1856
Pencil on paper, 12⅛ x 8⅞ in.
(30.8 x 22.4 cm)
David Daniels Collection, New York **237**

Sulking, c. 1871
Oil on canvas, 12¾ x 18¼ in. (32.4 x 46.4 cm)
The Metropolitan Museum of Art, New
York; The H. O. Havemeyer Collection;
Bequest of Mrs. H. O. Havemeyer, 1929
239

• *The Tub*, 1886
Pastel on paper, 23⅝ x 32⅝ in.
(60 x 82.9 cm)
Musée d'Orsay, Paris **277**

• *Uncle and Niece (Portrait of Henri and Lucy
de Gas)*, c. 1876
Oil on canvas, 39¼ x 47 in. (99.9 x 119 cm)
Art Institute of Chicago; Mr. and Mrs.
Lewis L. Coburn Memorial Collection
266

• *Woman in a Rose Hat*, 1879
Pastel, tempera, and oil on canvas,
33¾ x 29⅝ in. (85.7 x 75.2 cm)
Art Institute of Chicago; Joseph Winter-
botham Collection **3**

• *Woman Ironing*, 1882
Oil on canvas, 32 x 26 in. (81.3 x 66 cm)
National Gallery of Art, Washington,
D.C.; Collection of Mr. and Mrs. Paul
Mellon **274**

Woman with Chrysanthemums, 1865
Oil on canvas, 29 x 36½ in. (73.7 x 92.7 cm)
The Metropolitan Museum of Art, New
York; The H. O. Havemeyer Collection;
Bequest of Mrs. H. O. Havemeyer **240**

Delacroix, Eugène French, 1798–1863
• *The Abduction of Rebecca*, 1846
Oil on canvas, 39½ x 32¼ in.
(100 x 81.9 cm)
The Metropolitan Museum of Art, New
York; Wolfe Fund, 1903 **38**

• *Death of Sardanapalus*, 1827
Oil on canvas, 12 ft. 11 in. x 16 ft. 2⅞ in.
(3.94 x 4.95 m)
Musée du Louvre, Paris **36**

• *Liberty Leading the People*, 1830
Oil on canvas, 102 x 128 in. (259 x 325 cm)
Musée du Louvre, Paris **37**

Massacre at Chios, 1824
Oil on canvas, 13 ft. 10 in. x 11 ft. 7 in.
(422 x 353 cm)
Musée du Louvre, Paris **15**

Denis, Maurice French, 1870–1943
• *April*, 1892
Oil on canvas, 14¾ x 24 in. (37.5 x 61 cm)
Rijksmuseum Kröller–Müller, Otterlo,
the Netherlands **9**

The Muses, 1893
Oil on canvas, 66⅛ x 53⅛ in. (168 x 135 cm)
Musée National d'Art Moderne, Paris
310

Diaz de la Peña, Narcisse-Virgile Spanish,
1807?–1876
Forest of Fontainebleau, 1841
Oil on wood panel, 19³⁄₁₆ x 24 in.
(48.7 x 61 cm)
Smith College Museum of Art,
Northampton, Massachusetts; Gift of
Mr. and Mrs. Anthony J. Michel **23**

Fantin-Latour, Henri French, 1836–1904
Homage to Delacroix, 1864
Oil on canvas, 63 x 99⅛ in. (160 x 252 cm)
Musée d'Orsay, Paris **14**

A Studio in the Batignolles Quarter, 1870
Oil on canvas, 80⅜ x 107¾ in.
(204 x 274 cm)
Musée d'Orsay, Paris **66**

Gauguin, Paul French, 1848–1903
• *The Day of the God (Mahana No Atua)*,
1894
Oil on canvas, 27⅜ x 35⅝ in.
(69.5 x 90.5 cm)
Art Institute of Chicago; Helen Birch
Bartlett Memorial Collection **8**

• *Ia Orana Maria*, 1891
Oil on canvas, 44¾ x 34½ in. (114 x 87.6 cm)
The Metropolitan Museum of Art, New
York; Bequest of Samuel A. Lewisohn
337

Locusts and the Ants, 1889
Zincograph, black on yellow paper,
7⅞ x 10⅜ in. (19.9 x 26.4 cm)
Art Institute of Chicago **297**

Les Misérables, 1888
Oil on canvas, 17¾ x 22 in. (45.1 x 55.9 cm)
Rijksmuseum Vincent van Gogh,
Amsterdam **299**

• *Old Women of Arles*, 1888
Oil on canvas, 28¾ x 36 in. (73 x 91.4 cm)
Art Institute of Chicago; Gift of Annie
Swan Coburn **335**

Portrait of van Gogh, 1888
Oil on canvas, 28¾ x 36½ in. (73 x 92.7 cm)
Rijksmuseum Vincent van Gogh,
Amsterdam **298**

Seine in Paris, Winter, 1875
Oil on canvas, 25¼ x 36¼ in.
(64.1 x 92.1 cm)
Musée d'Orsay, Paris **119**

• *Self-Portrait with Halo*, 1889
Oil on wood, 31¼ x 20¼ in.
(79.4 x 51.4 cm)
National Gallery of Art, Washington,
D.C.; Chester Dale Collection **333**

• *Still Life with Three Puppies*, 1888
Oil on wood, 36⅛ x 24⅝ in.
(91.8 x 62.5 cm)
The Museum of Modern Art, New York;
Mrs. Simon Guggenheim Fund **334**

• *Vision after the Sermon: Jacob Wrestling
with the Angel*, 1888
Oil on canvas, 28¾ x 36¼ in. (73 x 92.1 cm)
National Galleries of Scotland, Edinburgh
336

• *Where Do We Come From? What Are We? Where Are We Going?*, 1897
Oil on canvas, 4 ft. 6 ¾ in. x 12 ft. 3 ½ in.
(139 x 375 cm)
Museum of Fine Arts, Boston; Tompkins Collection; Arthur Gordon Tompkins Residuary Fund **338**

The Yellow Christ, 1889
Oil on canvas, 36¼ x 28⅞ in.
(92.1 x 73.2 cm)
Albright-Knox Art Gallery, Buffalo; General Purchase Funds, 1946 **309**

Gérôme, Jean-Léon French, 1824–1904
La République, 1848
Oil on canvas, 22⁷⁄₁₆ x 15¾ in. (57 x 40 cm)
Private collection, New York **29**

Giorgione Venetian, 1478–1511
Concert champêtre, c. 1505
Oil on canvas, 42⅞ x 53⅞ in.
(109 x 137 cm)
Musée du Louvre, Paris **58**

Glaize, Auguste-Barthélémy French, 1807–1893
Picnic, c. 1850
Oil on canvas, 57 x 44⅞ in. (145 x 114 cm)
Musée Fabre, Montpellier, France **150**

Goya, Francisco de Spanish, 1746–1828
"One Can't Bear to Look," from *Disasters of War* c. 1814
Etching, aquatint, and drypoint,
5¾ x 8¼ in. (14.6 x 21 cm)
Courtesy of the Hispanic Society of New York **65**

Third of May, 1808, 1814–15
Oil on canvas, 105 x 135½ in. (267 x 344 cm)
Prado, Madrid **64**

Formerly attributed to Francisco de Goya
Majas on a Balcony, c. 1810
Oil on canvas, 76¾ x 49½ in. (195 x 126 cm)
The Metropolitan Museum of Art, New York; The H. O. Havemeyer Collection; Gift of Mrs. H. O. Havemeyer **67**

Guys, Constantin Dutch, 1805–1892
Coaching, c. 1860
Watercolor with graphite and ink,
10¹¹⁄₁₆ x 17¹¹⁄₁₆ in. (27.1 x 44.9 cm)
Fogg Art Museum, Harvard University, Cambridge, Massachusetts; Grenville L. Winthrop Bequest **59**

Ingres, Jean-Auguste-Dominique French, 1780–1867
Bather, 1808
Oil on canvas, 56¾ x 38¼ in. (144 x 97.2 cm)
Musée du Louvre, Paris **10**

Comtesse d'Haussonville, 1845
Oil on canvas, 51⅞ x 36¼ in. (132 x 92.1 cm)
The Frick Collection, New York **241**

• *Odalisque and Slave*, 1842
Oil on canvas, 30 x 41½ in. (76.2 x 105 cm)
Walters Art Gallery, Baltimore **40**

Odalisque in Grisaille, 1814–46
Oil on canvas, 32¾ x 43 in. (83.2 x 109 cm)
The Metropolitan Museum of Art, New York; Wolfe Fund, 1938 **12**

• *Turkish Bath*, 1862
Oil on canvas, 43¼ x 43¼ in. (110 x 110 cm)
Musée du Louvre, Paris **39**

Jongkind, Johan Barthold Dutch, 1819–1891
Entrance to the Port of Honfleur, 1864
Oil on canvas, 16½ x 22⅛ in.
(41.9 x 56.2 cm)
Art Institute of Chicago; Frank H. and Louise B. Woods Purchase Fund Income **147**

Manet, Edouard French, 1832–1883
The Absinthe Drinker, 1858–59
Oil on canvas, 70 x 40½ in. (178 x 103 cm)
Carlsberg Glyptotek, Copenhagen **53**

• *Argenteuil*, 1874
Oil on canvas, 57⅛ x 44½ in. (145 x 113 cm)
Musée des Beaux–Arts, Tournai, Belgium; Collection H. von Cutson **88**

• *At Père Lathuille's*, 1879
Oil on canvas, 36⅜ x 44⅛ in.
(92.3 x 112 cm)
Musée des Beaux–Arts, Tournai, Belgium **92**

• *At the Café*, 1878
Oil on canvas, 11⅛ x 15 in.
(28.3 x 38.1 cm)
Walters Art Gallery, Baltimore **89**

• *The Balcony*, 1868–69
Oil on canvas, 67¾ x 49¼ in. (172 x 125 cm)
Musée d'Orsay, Paris **82**

• *Le Bal de l'Opéra*, 1873
Oil on canvas, 23⅝ x 28¾ in. (60 x 73 cm)
National Gallery of Art, Washington, D.C. **95**

• *A Bar at the Folies-Bergère*, 1881–82
Oil on canvas, 37¾ x 51¼ in. (95.9 x 130 cm)
Courtauld Institute Galleries, London **93**

La Barricade, 1871
Lithograph, 18⅝ x 13½ in.
(47.3 x 34.3 cm)
National Gallery of Art, Washington, D.C.; Rosenwald Collection **69**

• *Battle of the Kearsarge and the Alabama*, 1864
Oil on canvas, 54⅝ x 51⅛ in. (139 x 130 cm)
Philadelphia Museum of Art; The John G. Johnson Collection **85**

• *Boating*, c. 1874
Oil on canvas, 38¼ x 51¼ in.
(97.2 x 130 cm)
The Metropolitan Museum of Art, New York; The H. O. Havemeyer Collection; Bequest of Mrs. H. O. Havemeyer **87**

A Café Interior, 1869
Pen and india ink on pale tan paper,
11⅝ x 15½ in. (29.5 x 39.4 cm)
Fogg Art Museum, Harvard University, Cambridge, Massachusetts; Bequest of Meta and Paul J. Sachs **72**

Café, place du Théâtre Français, c. 1881
Oil and pastel on linen, 12¾ x 18 in.
(32.4 x 45.7 cm)
Glasgow Art Gallery; The Burrell Collection **71**

Les Chats, 1868–69
Etching, 8⅞ x 10⅛ in.
(22.4 x 23 cm)
Philadelphia Museum of Art; Given by Mr. Carl Zigrosser **68**

Civil War, 1871
Lithograph, second state, 14⅛ x 19⅞ in.
(35.9 x 50.4 cm)
Philadelphia Museum of Art; McIlhenny Fund, purchase from E. Weyhe **70**

• *The Dead Toreador*, 1864
Oil on canvas, 29⅞ x 60⅜ in.
(75.8 x 153 cm)
National Gallery of Art, Washington, D.C.; Widener Collection **78**

• *Déjeuner sur l'herbe (Luncheon on the Grass)*, 1863
Oil on canvas, 82 x 104¼ in. (208 x 265 cm)
Musée d'Orsay, Paris **75**

• *Departure of the Folkestone Boat*, 1869
Oil on canvas, 23½ x 28⅞ in.
(59.7 x 73.2 cm)
Philadelphia Museum of Art; The Mr. and Mrs. Carroll S. Tyson Collection **86**

• *Execution of the Emperor Maximilian*, 1867
Oil on canvas, 75 x 63 in. (190 x 160 cm)
National Gallery, London **83**

Execution of the Emperor Maximilian, 1867
Oil on canvas, 102 x 76¾ in. (259 x 195 cm)
Museum of Fine Arts, Boston; Gift of
Mr. and Mrs. Frank G. Macomber **63**

• *Flowers in a Crystal Vase*, c. 1882
Oil on canvas, 12⅞ x 9⅝ in. (32.6 x 24.4 cm)
National Gallery of Art, Washington,
D.C.; Ailsa Mellon Bruce Collection **98**

• *Gare Saint-Lazare (Le Chemin de Fer)*, 1873
Oil on canvas, 36¾ x 45⅛ in. (93.3 x 115 cm)
National Gallery of Art, Washington,
D.C.; Gift of Horace Havemeyer in
memory of his mother, Louisine W.
Havemeyer **90**

• *In the Conservatory*, 1879
Oil on canvas, 45¼ x 59 in. (115 x 150 cm)
Nationalgalerie, Berlin **91**

• *Le Journal Illustré*, c. 1878–79
Oil on canvas, 24¼ x 19⅞ in.
(61.6 x 50.4 cm)
Art Institute of Chicago; Mr. and Mrs.
Lewis L. Coburn Memorial Collection **97**

• *Lola de Valence*, 1862
Oil on canvas, 48½ x 36¼ in. (123 x 92.1 cm)
Musée d'Orsay, Paris **77**

• *Mademoiselle Victorine in the Costume of an Espada*, 1862
Oil on canvas, 65 x 50¼ in. (165 x 128 cm)
The Metropolitan Museum of Art, New
York; The H. O. Havemeyer Collection;
Bequest of Mrs. H. O. Havemeyer **74**

• *Monet in His Studio Boat*, 1874
Oil on canvas, 32½ x 39½ in. (82.6 x 100 cm)
Der Bayer Staatsgemaldesammlungen,
Munich **102**

• *Music in the Tuileries*, 1862
Oil on canvas, 30 x 46⅞ in. (76.2 x 119 cm)
National Gallery, London **80**

Nana, 1877
Oil on canvas, 59 x 45⅝ in. (150 x 116 cm)
Kunsthalle, Hamburg, Germany **73**

• *The Old Musician*, 1862
Oil on canvas, 74 x 97¾ in. (188 x 248 cm)
National Gallery of Art, Washington,
D.C.; Chester Dale Collection **76**

• *Olympia*, 1863
Oil on canvas, 51¼ x 71¾ in. (130 x 182 cm)
Musée d'Orsay, Paris **81**

• *The Plum*, 1878
Oil on canvas, 29 x 19¾ in. (73.7 x 50.2 cm)
National Gallery of Art, Washington, D.C.;
Collection of Mr. and Mrs. Paul Mellon **99**

• *Portrait of Alphonse Maureau*, c. 1880
Pastel on canvas, 21½ x 17¾ in.
(54.6 x 45.1 cm)
Art Institute of Chicago; Gift of Kate L.
Brewster **96**

Portrait of Emile Zola, 1868
Oil on canvas, 57⅞ x 44⅞ in.
(147 x 114 cm)
Musée d'Orsay, Paris **62**

The Races, 1864–65
Lithograph, 14⅜ x 20¼ in. (36.5 x 51.4 cm)
New York Public Library, Print Division:
Astor, Lenox, and Tilden Foundations **56**

• *The Races at Longchamps*, 1872
Oil on canvas, 17¼ x 33¼ in.
(43.8 x 84.5 cm)
Art Institute of Chicago; Potter Palmer
Collection **94**

The Spanish Singer (The Guitar Player), 1860
Oil on canvas, 58 x 45 in. (147 x 114 cm)
The Metropolitan Museum of Art, New
York; Gift of William Church Osborn **54**

• *Still Life with Melon and Peaches*, 1866
Oil on canvas, 27⅛ x 36¼ in.
(68.9 x 92.1 cm)
National Gallery of Art, Washington,
D.C.; Gift of Eugene and Agnes Meyer **84**

• *The Street Singer*, 1862
Oil on canvas, 68⅞ x 42½ in.
(175 x 108 cm)
Museum of Fine Arts, Boston; Bequest of
Sarah Choate Sears **79**

Millet, Jean-François French, 1814–1875
The Angelus, 1867
Oil on canvas, 21⅝ x 26 in. (54.9 x 66 cm)
Musée d'Orsay, Paris **21**

Faggot Carriers, 1852–54
Conté crayon, 11⅜ x 18⁷⁄₁₆ in.
(28.9 x 46.8 cm)
Museum of Fine Arts, Boston; Gift of
Martin Brimmer **22**

• *The Gleaners*, 1857
Oil on canvas, 32⅞ x 43¾ in.
(83.4 x 111 cm)
Musée d'Orsay, Paris **48**

Monet, Claude French, 1840–1926
• *The Artist's Garden at Vétheuil*, 1880
Oil on canvas, 59⅝ x 47⅝ in.
(151 x 121 cm)
National Gallery of Art, Washington,
D.C.; Ailsa Mellon Bruce Collection **181**

• *Bazille and Camille*, 1865
Oil on canvas, 36⅝ x 27⅛ in. (93 x 68.9 cm)
National Gallery of Art, Washington,
D.C.; Ailsa Mellon Bruce Collection **164**

Beach at Sainte–Adresse, 1867
Oil on canvas, 28½ x 41¼ in.
(72.4 x 105 cm)
Art Institute of Chicago;
Mr. and Mrs. Lewis L. Coburn Memorial
Collection **157**

The Beach at Trouville, 1870
Oil on canvas, 15 x 18¼ in. (38.1 x 46.4 cm)
National Gallery, London **151**

• *Bordighera*, 1884
Oil on canvas, 25½ x 32 in. (64.8 x 81.3 cm)
Art Institute of Chicago; Potter Palmer
Collection **183**

• *Bordighera*, 1884
Oil on canvas, 29 x 36⅜ in. (73.7 x 92.4 cm)
Santa Barbara Museum of Art, Santa
Barbara, California; Estate of Katherine
Dexter McCormick **182**

• *Boulevard des Capucines*, 1873
Oil on canvas, 31¼ x 23¼ in.
(79.4 x 59.1 cm)
Nelson-Atkins Museum of Art, Kansas
City; Acquired through the Kenneth A.
and Helen F. Spencer Foundation **120**

• *The Bridge at Argenteuil*, 1874
Oil on canvas, 23¾ x 31½ in.
(60.3 x 80 cm)
National Gallery of Art, Washington,
D.C.; Paul Mellon Collection **127**

Camille Monet on Her Deathbed, 1879
Oil on canvas, 35½ x 26¼ in.
(90.2 x 67.9 cm)
Musée d'Orsay, Paris **155**

Camille: Woman in a Green Dress, 1866
Oil on canvas, 91 x 59½ in. (231 x 151 cm)
Kunsthalle, Bremen, Germany **153**

Caricature of Rufus Croutinelli, 1856–58
Pencil on paper, 5⅛ x 3⅜ in.
(13 x 8.57 cm)
Art Institute of Chicago **148**

Déjeuner sur l'herbe (Luncheon on the Grass), 1866
Oil on canvas, 48¾ x 71¼ in. (124 x 181 cm)
Pushkin Museum, Moscow **149**

• *Field of Poppies*, 1873
Oil on canvas, 19⅝ x 25⅝ in.
(49.8 x 65.1 cm)
Musée d'Orsay, Paris **175**

• *Gare Saint-Lazare*, 1877
Oil on canvas, 29¼ x 39⅞ in.
(74.3 x 101 cm)
Musée d'Orsay, Paris **178**

• *Grain Stack at Sunset near Giverny*, 1891
Oil on canvas, 28¾ x 36¼ in.
(73 x 92.1 cm)
Museum of Fine Arts, Boston; Bequest of Robert J. Edwards in memory of his mother **185**

• *Grain Stack in Winter*, 1891
Oil on canvas, 25¼ x 36⅜ in.
(65.4 x 92.4 cm)
Museum of Fine Arts, Boston; Gift of the Misses Aimee and Mrs. Horatio A. Lamb **184**

• *La Grenouillère*, 1869
Oil on canvas, 29⅛ x 39¼ in.
(74.6 x 99.7 cm)
The Metropolitan Museum of Art, New York; The H. O. Havemeyer Collection; Bequest of Mrs. H. O. Havemeyer **124**

• *Impression, Sunrise*, c. 1872
Oil on canvas, 18½ x 25¼ in.
(47 x 64.1 cm)
Musée Marmottan, Paris **121**

• *The Japanese Footbridge and the Water Lily Pond, Giverny*, 1899
Oil on canvas, 35⅛ x 36¾ in.
(89.2 x 93.3 cm)
Philadelphia Museum of Art; The Mr. and Mrs. Carroll S. Tyson Collection **191**

• *La Japonaise*, 1876
Oil on canvas, 91 x 56 in. (231 x 142 cm)
Museum of Fine Arts, Boston; 1951 Purchase Fund **173**

• *Jean Monet on His Wooden Horse*, 1872
Oil on canvas, 34¼ x 28¾ in. (87 x 73 cm)
Nathan Cummings Collection, New York **170**

• *The Luncheon*, 1868
Oil on canvas, 90½ x 59 in. (230 x 150 cm)
Stadelsches Kunstinstitut, Frankfurt **171**

The Luncheon, 1872
Oil on canvas, 63 x 78¾ in. (160 x 200 cm)
Musée d'Orsay, Paris **154**

The Manneporte, Etretat (I), 1883
Oil on canvas, 25¾ x 32 in. (65.4 x 81.3 cm)
The Metropolitan Museum of Art, New York; Bequest of William Church Osborn, 1951 **156**

The Palazzo Ducale Seen from San Giorgio, 1908
Oil on canvas, 25⅝ x 39⅜ in.
(65.1 x 100 cm)
Durand–Ruel Collection, Paris **162**

• *Parisians Enjoying the Parc Monceau*, 1878
Oil on canvas, 28⅝ x 21⅜ in.
(72.7 x 54.3 cm)
The Metropolitan Museum of Art, New York; Mr. and Mrs. Henry Ittleson, Jr., Fund **176**

• *Pointe de la Hève at Low Tide*, 1865
Oil on canvas, 35½ x 59¼ in.
(90.2 x 150 cm)
Kimbell Art Museum, Fort Worth **167**

• *Le Pont de l'Europe*, 1877
Oil on canvas, 25⅛ x 31⅞ in.
(63.8 x 80.8 cm)
Musée Marmottan, Paris **177**

• *The Poplars*, 1891
Oil on canvas, 32¼ x 32⅛ in.
(81.9 x 81.6 cm)
The Metropolitan Museum of Art, New York; The H. O. Havemeyer Collection; Bequest of Mrs. H. O. Havemeyer **187**

• *Poplars on the Bank of the Epte River*, 1891
Oil on canvas, 39½ x 25¾ in.
(100 x 65.4 cm)
Philadelphia Museum of Art; Bequest of Anne Thomson as memorial to her father, Frank Thomson, and her mother, Mary Elizabeth Clark Thomson **188**

• *Quai du Louvre, Paris*, 1867
Oil on canvas, 25¾ x 36½ in.
(65.4 x 92.7 cm)
Haags Gemeentemuseum, The Hague **172**

• *Red Boats at Argenteuil*, 1875
Oil on canvas, 23⅝ x 31⅞ in. (60 x 80.8 cm)
Fogg Art Museum, Harvard University, Cambridge, Massachusetts; Bequest– Collection of Maurice Wertheim **169**

• *Regatta at Argenteuil*, 1872
Oil on canvas, 18⅞ x 28¾ in. (47.8 x 73 cm)
Musée d'Orsay, Paris **122**

• *The River*, 1868
Oil on canvas, 31⅞ x 39½ in.
(80.8 x 100 cm)
Art Institute of Chicago; Potter Palmer Collection **168**

Rocks at Belle-Ile, 1886
Oil on canvas, 23⅝ x 28¾ in. (60 x 73 cm)
Location unknown **158**

• *Rouen Cathedral, Portal and Albane Tower*, 1894
Oil on canvas, 42⅛ x 28¾ in. (107 x 73 cm)
Musée d'Orsay, Paris **189**

• *Rouen Cathedral, Sunset*, 1894
Oil on canvas, 39½ x 29¼ in.
(100 x 75.6 cm)
Museum of Fine Arts, Boston; Julia Cheney Edwards Collection; Bequest of Hannah M. Edwards in memory of her mother **190**

• *La Rue Saint-Denis, fête du 30 juin 1878*, 1878
Oil on canvas, 24⅜ x 13 in. (61.9 x 33 cm)
Musée des Beaux–Arts, Rouen, France **180**

• *Saint-Lazare Station: The Arrival of the Train from Normandy*, 1877
Oil on canvas, 23½ x 31½ in. (59.7 x 80 cm)
Art Institute of Chicago; Mr. and Mrs. Martin A. Ryerson Collection **179**

• *Terrace at Sainte-Adresse*, 1866–67
Oil on canvas, 38½ x 51 in. (97.8 x 130 cm)
The Metropolitan Museum of Art, New York; Friends of the Museum Fund **166**

• *Two Grain Stacks*, 1891
Oil on canvas, 25½ x 39¼ in.
(64.8 x 99.7 cm)
Art Institute of Chicago; Mr. and Mrs. Lewis L. Coburn Memorial Collection **186**

• *Water Garden and Japanese Footbridge*, 1900
Oil on canvas, 35 x 36¼ in. (88.9 x 92.1 cm)
Museum of Fine Arts, Boston; Given in memory of Governor Alvan T. Fuller by the Fuller Foundation **192**

Water Lilies I, 1905
Oil on canvas, 35⅛ x 39½ in. (89.2 x 100 cm)
Museum of Fine Arts, Boston; Gift of Edward Jackson Holmes **161**

• *Water Lilies*, 1916–22
Oil on canvas, 6 ft. 6¾ in. x 13 ft. 11⅜ in.
(2 x 4.25 m)
National Gallery, London **193**

• *Water Lilies*, 1919–22
Oil on canvas, 6 ft. 7 in. x 13 ft. 11½ in.
(2.01 x 4.25 m)
The Cleveland Museum of Art; John L.
Severance Fund **194**

• *Woman with a Parasol: Madame Monet and
Her Son*, 1875
Oil on canvas, 39 x 32 in. (99.1 x 81.3 cm)
National Gallery of Art, Washington, D.C.;
Collection of Mr. and Mrs. Paul Mellon **174**

• *Women in the Garden*, 1866–67
Oil on canvas,
100½ x 80¾ in. (255 x 205 cm)
Musée d'Orsay, Paris **165**

Morisot, Berthe French, 1841–1895
• *The Artist's Sister, Madame Pontillon, Seated
on Grass*, 1873
Oil on canvas, 17¾ x 28½ in.
(45.1 x 72.4 cm)
The Cleveland Museum of Art; Gift of
Hanna Fund **133**

The Balcony, 1872
Oil on canvas, 23½ x 19 in. (59.7 x 48.3 cm)
Formerly Collection Henry J. Ittleson, Jr.,
New York **108**

The Cradle, 1873
Oil on canvas, 22 x 18⅛ in. (55.9 x 46 cm)
Musée d'Orsay, Paris **109**

Eté (Summer), c. 1879
Oil on canvas, 18 x 29⅝ in. (45.7 x 75.2 cm)
National Gallery, London **110**

• *The Harbor at Lorient*, 1869
Oil on canvas,
17½ x 28¾ in. (44.5 x 73 cm)
National Gallery of Art, Washington,
D.C.; Ailsa Mellon Bruce Collection **132**

Myrbach-Rheinfeld, Felicien
Austro-Hungarian, 1853–?
Candidates for Admission to the Paris Salon,
n.d.
Drawing, 11 x 18 in. (27.9 x 45.7 cm)
The Metropolitan Museum of Art, New
York; Harris Brisbane Dick Fund, 1947 **13**

Picasso, Pablo Spanish, 1881–1973
Bread and Fruit Dish on a Table, 1909
Oil on canvas, 64½ x 52⅛ in. (164 x 132 cm)
Kunstmuseum, Basel, Switzerland **358**

• *Les Demoiselles d'Avignon*, 1907
Oil on canvas, 96 x 92 in. (244 x 234 cm)
The Museum of Modern Art, New York;
Acquired through the Lille P. Bliss Bequest
381

Pissarro, Camille French, 1830–1903
*Banks of the Oise, near Pontoise, Drab
Weather*, 1878
Oil on canvas, 17 ft. 10½ in. x 21 ft. 5⅞ in.
(5.45 x 6.55 m)
Musée d'Orsay, Paris **106**

Bords de l'Oise (Le Porteur d'eau), 1874
Oil on canvas (mounted on panel),
18 x 15 in. (45.7 x 38.1 cm)
Fogg Art Museum, Harvard University,
Cambridge, Massachusetts; Gift of
Grenville L. Winthrop **107**

La Côte des Boeufs à Pontoise, 1877
Oil on canvas, 45¼ x 34½ in.
(115 x 87.6 cm)
National Gallery, London; Courtesy of
the Trustees of the National Gallery **115**

• *Entrée des voisins*, 1872
Oil on canvas, 18⅛ x 21⅞ in. (46 x 55.4 cm)
Musée d'Orsay, Paris **130**

• *Jallais Hill, Pontoise*, 1867
Oil on canvas, 34¼ x 45¼ in. (87 x 115 cm)
The Metropolitan Museum of Art, New
York; Bequest of William Church
Osborn, 1951 **131**

• *Orchard in Bloom, Louveciennes*, 1872
Oil on canvas, 17¾ x 21⅝ in.
(45.1 x 54.9 cm)
National Gallery of Art, Washington,
D.C.; Ailsa Mellon Bruce Collection **128**

Poussin, Nicolas French, 1594–1665
Burial of Phocion, 1648
Oil on canvas, 46⅞ x 70½ in.
(119 x 179 cm)
Musée du Louvre, Paris **345**

Raimondi, Marcantonio Italian,
1475?–1534?
The Judgment of Paris, after Raphael, c. 1520
Engraving, 11⁵⁄₁₆ x 16¹¹⁄₁₆ in.
(28.7 x 42.7 cm)
The Metropolitan Museum of Art, New
York; Rogers Fund **57**

Renoir, Pierre-Auguste French, 1841–1919
La Balançoire, 1876
Oil on canvas, 36¼ x 28¾ in. (92.1 x 73 cm)
Musée d'Orsay, Paris **113**

The Bather, c. 1917–18
Oil on canvas, 20¼ x 12 in. (51.4 x 30.5 cm)
Philadelphia Museum of Art; Louise and
Walter Arensberg Collection **212**

Bather Arranging Her Hair, 1885
Oil on canvas, 36³⁄₁₆ x 28¾ in.
(91.9 x 73 cm)
Sterling and Francine Clark Art Institute,
Williamstown, Massachusetts **208**

• *Bather Arranging Her Hair*, 1893
Oil on canvas, 36⅜ x 29⅛ in. (92.4 x 74 cm)
National Gallery of Art, Washington,
D.C.; Chester Dale Collection **235**

• *Bathers*, 1887
Oil on canvas, 46⅜ x 67¼ in.
(118 x 171 cm)
Philadelphia Museum of Art **236**

Blond Bather, 1881
Oil on canvas, 32³⁄₁₆ x 25⅞ in.
(81.8 x 65.6 cm)
Sterling and Francine Clark Art Institute,
Williamstown, Massachusetts **206**

Dance in the City, 1883
Oil on canvas, 70⅞ x 35½ in.
(180 x 90.2 cm)
Musée d'Orsay, Paris **204**

Dance in the Country, 1883
Oil on canvas, 70⅞ x 34⅝ in.
(180 x 87.9 cm)
Musée d'Orsay, Paris **205**

• *The Dancer*, 1874
Oil on canvas, 56⅛ x 37⅛ in.
(143 x 94.3 cm)
National Gallery of Art, Washington,
D.C.; Widener Collection **216**

• *Dancing at the Moulin de la Galette*, 1876
Oil on canvas, 31 x 44¾ in.
(78.7 x 114 cm)
Musée d'Orsay, Paris **139**

• *Le Déjeuner*, 1879
Oil on canvas, 39⅛ x 32¼ in.
(99.4 x 81.9 cm)
Städelsches Kunstinstitut, Frankfurt **223**

• *Diana*, 1867
Oil on canvas, 77 x 51¼ in. (196 x 130 cm)
National Gallery of Art, Washington,
D.C.; Chester Dale Collection **214**

• *Girl with a Hoop*, 1885
Oil on canvas, 49½ x 30⅛ in.
(126 x 76.5 cm)
National Gallery of Art, Washington,
D.C.; Chester Dale Collection **234**

• *A Girl with a Watering Can*, 1876
Oil on canvas, 39½ x 28¾ in.
(100 x 73 cm)
National Gallery of Art, Washington,
D.C.; Chester Dale Collection **229**

• *La Grenouillère*, 1869
Oil on canvas, 26 x 31⅞ in. (66 x 80.8 cm)
Nationalmuseum, Stockholm **125**

• *In the Meadow*, c. 1890
Oil on canvas, 32 x 25¾ in.
(81.3 x 65.4 cm)
The Metropolitan Museum of Art,
New York **233**

• *Lady at the Piano*, c. 1875–76
Oil on canvas, 36¾ x 29¼ in.
(93.3 x 74.3 cm)
Art Institute of Chicago; Mr. and Mrs.
Martin A. Ryerson Collection **228**

Lise with a Parasol, 1867
Oil on canvas, 71¼ x 44½ in.
(182 x 113 cm)
Museum Folkwang, Essen, Germany **195**

La Loge, 1874
Oil on canvas, 31½ x 25¼ in. (80 x 64.1 cm)
Courtauld Institute Galleries, London **201**

• *The Luncheon of the Boating Party*, 1881
Oil on canvas, 50¼ x 68⅛ in.
(129 x 173 cm)
The Phillips Collection, Washington, D.C.
221

• *Madame Charpentier with Her Children,
Georgette and Paul*, 1878
Oil on canvas, 60½ x 74⅛ in.
(154 x 188 cm)
The Metropolitan Museum of Art, New
York; Wolfe Fund, 1907; Catherine
Lorillard Wolfe Collection **231**

• *Madame Clapisson (Lady with a Fan)*, 1883
Oil on canvas, 31¼ x 25¼ in.
(79.4 x 64.1 cm)
Art Institute of Chicago; Mr. and Mrs.
Martin A. Ryerson Collection **225**

• *Madame Monet and Her Son in Their
Garden*, 1874
Oil on canvas, 19⅞ x 26¾ in.
(50.4 x 67.9 cm)
National Gallery of Art, Washington,
D.C.; Ailsa Mellon Bruce Collection **219**

• *Mademoiselle Sicot*, 1865
Oil on canvas, 45¾ x 35¼ in. (116 x 89.5 cm)
National Gallery of Art, Washington,
D.C.; Chester Dale Collection **226**

Mother and Children, c. 1874–76
Oil on canvas, 67 x 42⅝ in. (170 x 108 cm)
The Frick Collection, New York **202**

Nude (Study for "Bathers"), c. 1884–85
Pastel and wash, 39 x 25 in. (99.1 x 63.5 cm)
Art Institute of Chicago; Gift of Kate L.
Brewster **209**

• *Oarsmen at Chatou*, 1879
Oil on canvas, 32⅛ x 39⅝ in.
(81.7 x 101 cm)
National Gallery of Art, Washington,
D.C.; Gift of Sam A. Lewisohn **222**

• *Odalisque*, 1870
Oil on canvas, 27¼ x 48¼ in.
(69.2 x 123 cm)
National Gallery of Art, Washington,
D.C.; Chester Dale Collection **213**

• *On the Terrace*, 1881
Oil on canvas, 39½ x 31⅞ in.
(100 x 80.8 cm)
Art Institute of Chicago; Mr. and Mrs.
Lewis L. Coburn Memorial Collection
230

Path through High Grass, c. 1876–78
Oil on canvas, 23⅝ x 29⅛ in. (60 x 74 cm)
Musée d'Orsay, Paris **199**

• *Picking Flowers*, 1875
Oil on canvas, 21⅜ x 25⅝ in.
(54.3 x 65.1 cm)
National Gallery of Art, Washington,
D.C.; Ailsa Mellon Bruce Collection **217**

• *Pont Neuf, Paris*, 1872
Oil on canvas, 29⅝ x 36⅞ in.
(75.2 x 93.5 cm)
National Gallery of Art, Washington,
D.C.; Ailsa Mellon Bruce Collection **140**

• *Portrait of Alfred Sisley*, 1874
Oil on canvas, 25¾ x 21⅜ in.
(65.4 x 54.3 cm)
Art Institute of Chicago; Mr. and Mrs.
Lewis L. Coburn Memorial Collection
224

Portrait of the Artist's Family, 1896
Oil on canvas, 26¾ x 21¼ in. (67.9 x 54 cm)
The Barnes Foundation, Merion Station,
Pennsylvania **211**

La Première Sortie (Her First Evening Out),
c. 1876–77
Oil on canvas, 25⅝ x 19½ in.
(65.1 x 49.5 cm)
National Gallery, London **203**

• *Regatta at Argenteuil*, c. 1874
Oil on canvas, 12¾ x 18 in.
(32.4 x 45.7 cm)
National Gallery of Art, Washington,
D.C.; Ailsa Mellon Bruce Collection **123**

• *Sailboats at Argenteuil*, 1873–74
Oil on canvas, 19¾ x 25¾ in.
(50.2 x 65.4 cm)
Portland Art Museum, Oregon **220**

Self-Portrait, c. 1876
Oil on canvas, 29 x 22¼ in.
(73.7 x 56.5 cm)
Fogg Art Museum, Harvard University,
Cambridge, Massachusetts **197**

Spring Bouquet, 1866
Oil on canvas, 41½ x 31½ in. (105 x 80 cm)
Fogg Art Museum, Harvard University,
Cambridge, Massachusetts **198**

• *Two Little Circus Girls*, 1879
Oil on canvas, 51½ x 38¾ in.
(131 x 98.4 cm)
Art Institute of Chicago; Potter Palmer
Collection **215**

Victor Chocquet, 1876
Oil on canvas, 18⅛ x 14⅛ in. (46 x 35.9 cm)
Collection Oskar Reinhart, Winterthur,
Switzerland **200**

• *Woman in a Park*, 1870
Oil on canvas,
10¼ x 6⅜ in. (26 x 16.2 cm)
National Gallery of Art, Washington,
D.C.; Ailsa Mellon Bruce Collection **217**

• *Woman with a Cat*, c. 1875
Oil on canvas, 22 x 18¼ in. (55.9 x 46.4 cm)
National Gallery of Art, Washington, D.C.;
Gift of Mr. and Mrs. Benjamin E. Levy **227**

• *Young Woman Sewing*, 1879
Oil on canvas, 24¼ x 19⅞ in.
(61.6 x 50.4 cm)
Art Institute of Chicago; Mr. and Mrs.
Lewis L. Coburn Memorial Collection
232

Seurat, Georges French, 1859–1891
• *Bathers at Asnières*, 1884
Oil on canvas, 79⅛ x 118⅛ in.
(201 x 300 cm)
National Gallery, London **314**

• *Le Chahut*, 1889–90
Oil on canvas, 66½ x 54¾ in.
(169 x 139 cm)
Rijksmuseum Kröller–Müller, Otterlo,
the Netherlands **317**

• *The Circus*, 1891
Oil on canvas, 72 x 60 in. (183 x 152 cm)
Musée d'Orsay, Paris **318**

L'Echo, 1882–83
Conté crayon, 12 ¼ x 9 ¼ in.
(31.1 x 23.5 cm)
Yale University Art Gallery, New Haven,
Connecticut; Bequest of Edith M. K.
Wetmore **290**

*Head of a Woman Sewing (Head of Woman
 with a Hat)*, 1884
Conté crayon on Ingres paper,
11 ¾ x 8 ¼ in. (29.8 x 21 cm)
Smith College Museum of Art,
Northampton, Massachusetts **289**

• *Invitation to the Sideshow (La Parade)*,
 1887–88
Oil on canvas, 39 ¼ x 59 in. (99.9 x 150 cm)
The Metropolitan Museum of Art,
New York **315**

Lady with a Parasol, 1885
Conté crayon, 12 ¼ x 9 ½ in.
(31.1 x 24.1 cm)
The Museum of Modern Art, New York;
Bequest of Abby Aldrich Rockefeller **293**

*Landscape with Dog (Study for "A Sunday
 Afternoon on the Island of La Grande
 Jatte")*, 1884–85
Conté crayon, 8⅞ x 12 ¼ in. (22.4 x 31.1 cm)
British Museum, London **292**

*Monkey (Study for "A Sunday Afternoon on
 the Island of La Grande Jatte")*, 1885
Conté crayon, 12¹⁵⁄₁₆ x 9⁵⁄₁₆ in.
(32.9 x 23.7 cm)
The Metropolitan Museum of Art, New
York; Bequest of Miss Adelaide Milton de
Groot, 1967 **294**

The River Banks, c. 1883
Oil sketch on board, 6⅜ x 9⅞ in.
(16.2 x 25 cm)
Glasgow Art Gallery **291**

• *Seascape at Port-en-Bessin, Normandy*, 1888
Oil on canvas, 25⅝ x 31⅞ in.
(65.1 x 80.8 cm)
National Gallery of Art, Washington, D.C.;
Gift of the W. Averell Harriman Fund in
memory of Marie N. Harriman **6**

Seated Boy with Straw Hat, 1883–84
Conté crayon, 9½ x 12 ¼ in.
(24.1 x 31.1 cm)
Yale University Art Gallery, New Haven,
Connecticut; Everett V. Meeks Fund **288**

• *Study for "A Sunday Afternoon on the Island
 of La Grande Jatte"*, 1884–86
Oil on wood, 6¼ x 9⅞ in. (15.9 x 25 cm)
National Gallery of Art, Washington,
D.C.; Ailsa Mellon Bruce Collection **311**

• *A Sunday Afternoon on the Island of La
 Grande Jatte*, 1884–86
Oil on canvas, 81 x 120⅜ in.
(206 x 306 cm)
Art Institute of Chicago; Helen Birch
Bartlett Memorial Collection **313**

• *Woman Powdering Herself*, 1889–90
Oil on canvas, 37½ x 31¼ in.
(95.3 x 79.4 cm)
Courtauld Institute Galleries, London **316**

• *Woman with a Monkey: Study for "A Sunday
 Afternoon on the Island of La Grande
 Jatte"*, 1884
Oil on wood panel, 9¾ x 6¼ in.
(24.8 x 15.9 cm)
Smith College Museum of Art,
Northampton, Massachusetts; Purchased,
1934 **312**

Signac, Paul French, 1863–1935
Application du Cercle Chromatique (theater
 program for the Théâtre Libre de M.
 Henri), 1889
Lithograph, 6⅛ x 7 in. (15.6 x 17.8 cm)
Museum of Fine Arts, Boston; Gift of
Peter A. Wick **295**

Gas Tanks at Clichy, 1886
Oil on canvas, 25½ x 31⅞ in.
(64.8 x 80.8 cm)
National Gallery of Victoria, Melbourne,
Australia; Felton Bequest, 1948 **296**

Sisley, Alfred French, 1840–1899
• *The Bridge at Villeneuve-la-Garenne*, 1872
Oil on canvas, 19½ x 25 ¾ in.
(49.5 x 65.4 cm)
The Metropolitan Museum of Art, New
York; Gift of Mr. and Mrs. Henry Ittleson,
Jr., 1964 **126**

• *Early Snow at Louveciennes*, 1874
Oil on canvas, 21 ¼ x 28 ¾ in. (54 x 73 cm)
Museum of Fine Arts, Boston; Bequest of
John T. Spaulding **129**

The Flood at Port Marly, 1876
Oil on canvas, 23⅝ x 31⅞ in. (60 x 80.8 cm)
Musée d'Orsay, Paris **105**

Village Street in Marlotte, 1866
Oil on canvas, 25½ x 36 in. (64.8 x 91.4 cm)
Albright-Knox Art Gallery, Buffalo;
General Purchase Fund **104**

Titian, Venetian, 1477–1576
Venus of Urbino, 1538
Oil on canvas, 76 ¾ x 65 in. (195 x 165 cm)
Galleria degli Uffizi, Florence **60**

Toulouse-Lautrec, Henri de French,
 1864–1901
• *A la Mie (At the Crumb)*, 1891
Watercolor and gouache on millboard,
21 x 16 ¾ in. (53.3 x 42.5 cm)
Museum of Fine Arts, Boston; Purchase,
A. S. Denio Fund and General Income
for 1940 **280**

• *Alfred la Guigne*, 1894
Gouache on cardboard, 25 ¾ x 19 ¾ in.
(65.4 x 50.2 cm)
National Gallery of Art, Washington,
D.C.; Chester Dale Collection **282**

At the Moulin Rouge, 1892
Oil on canvas, 47½ x 55⅜ in.
(121 x 141 cm)
Art Institute of Chicago; Helen Birch
Bartlett Memorial Collection **259**

Au Salon de la rue des Moulins, 1894
Oil on canvas, 43⅞ x 52⅛ in. (111 x 132 cm)
Musée Toulouse-Lautrec, Albi, France
258

La Buveuse, 1889
Oil on canvas, 18½ x 21 ¾ in. (47 x 55.2 cm)
Fogg Art Museum, Harvard University,
Cambridge, Massachusetts; Collection of
Maurice Wertheim **260**

• *A Corner of the Moulin de la Galette*, 1892
Oil on cardboard mounted on wood,
39½ x 35⅛ in. (100 x 89.2 cm)
National Gallery of Art, Washington,
D.C.; Chester Dale Collection **281**

• *The Englishman at the Moulin Rouge*, 1892
Oil on cardboard, 33 ¾ x 26 in.
(85.7 x 66 cm)
The Metropolitan Museum of Art, New
York; Bequest of Miss Adelaide Milton de
Groot, 1967 **283**

• *In the Circus Fernando: The Ringmaster*,
 1888
Oil on canvas, 38 ¾ x 63½ in.
(98.4 x 161 cm)
Art Institute of Chicago; Joseph
Winterbotham Collection **279**

Jane Avril, from Café-Concert series, 1893
Lithograph, 10⅜ x 8⅜ in.
(26.5 x 21.3 cm)
The Metropolitan Museum of Art, New
York; Harris Brisbane Dick Fund **257**

- *May Milton*, 1895
 Lithograph, 31 x 23½ in. (78.7 x 59.7 cm)
 Art Institute of Chicago; Bequest of Kate
 L. Brewster **287**

- *Quadrille at the Moulin Rouge*, 1892
 Gouache on cardboard, 31½ x 23¾ in.
 (80 x 60.3 cm)
 National Gallery of Art, Washington,
 D.C.; Chester Dale Collection **284**

- *La Toilette*, 1896
 Oil on canvas, 25½ x 20⅞ in.
 (64.8 x 52.9 cm)
 Musée d'Orsay, Paris **285**

- *Yvette Guilbert Taking a Curtain Call*, 1894
 Watercolor and crayon, 16⅜ x 9 in.
 (41.6 x 22.9 cm)
 Museum of Art, Rhode Island School of
 Design; Gift of Mrs. William S. Dareforth
 286

Turner, Joseph Mallord William English,
 1775–1851
- *Houses of Parliament on Fire*, 1834
 Watercolor, 11⅝ x 17¼ in.
 (29.5 x 43.8 cm)
 British Museum, London **43**

- *The Slave Ship*, c. 1840
 Oil on canvas, 35¾ x 48 in.
 (90.8 x 122 cm)
 Museum of Fine Arts, Boston; H. L.
 Pierce Fund **44**

Van Gogh, Vincent Dutch, 1853–1890
 Cane-Bottomed Chair, 1888
 Pencil on paper, 13 x 9¾ in. (33 x 24.8 cm)
 Rijksmuseum Vincent van Gogh,
 Amsterdam **306**

- *Crows over the Wheat Field*, 1890
 Oil on canvas, 19⅞ x 39½ in.
 (50.4 x 100 cm)
 Rijksmuseum Vincent van Gogh,
 Amsterdam **331**

 Cypresses, 1889
 Reed pen and ink over pencil sketch,
 24½ x 18½ in. (62.2 x 47 cm)
 The Brooklyn Museum; Frank L. Babbott
 and A. Augustus Healy Funds **307**

- *Drawbridge near Arles*, 1888
 Oil on canvas, 21¼ x 22⅝ in. (54 x 57.5 cm)
 Rijksmuseum Kröller–Müller, Otterlo,
 the Netherlands **320**

- *Flowering Almond Branch*, 1890
 Oil on canvas, 28¾ x 36¼ in. (73 x 92.1 cm)
 Rijksmuseum Vincent van Gogh,
 Amsterdam **325**

- *Gauguin's Armchair*, 1888
 Oil on canvas, 35¾ x 28¾ in.
 (90.8 x 73 cm)
 Rijksmuseum Vincent van Gogh,
 Amsterdam **330**

- *Haystacks in Provence*, 1888
 Oil on canvas, 28¾ x 36⅜ in.
 (73 x 92.4 cm)
 Rijksmuseum Kröller–Müller, Otterlo,
 the Netherlands **321**

 Les Lavandières, 1888
 Pen and ink on paper, 12⅜ x 9½ in.
 (31.4 x 24.1 cm)
 Rijksmuseum Kröller–Müller, Otterlo,
 the Netherlands **305**

- *The Night Café*, 1888
 Oil on canvas, 37½ x 35 in. (95.2 x 88.9 cm)
 Yale University Art Gallery, New Haven,
 Connecticut; Gift of Stephen C. Clark **323**

 People Coming Out of Church at Nuenen,
 1884
 Oil on canvas, 16½ x 13 in. (41.9 x 33 cm)
 Rijksmuseum Vincent van Gogh,
 Amsterdam **301**

 Portrait of Dr. Gachet (L'Homme à la Pipe),
 1890
 Etching, 7⅛ x 6 in. (18.1 x 15.2 cm)
 Philadelphia Museum of Art; McIlhenny
 Fund **308**

- *Portrait of Madame Ginoux (L'Arlésienne)*,
 1888
 Oil on canvas, 35⅛ x 28⅜ in.
 (89.9 x 72.1 cm)
 The Metropolitan Museum of Art, New
 York; Samuel A. Lewisohn Bequest **328**

- *Portrait of Père Tanguy*, 1887
 Oil on canvas, 18½ x 15⅛ in.
 (47 x 38.4 cm)
 Stavros S. Niarchos Collection, London
 327

 The Potato Eaters, 1885
 Oil on canvas, 32¼ x 44⅞ in.
 (81.9 x 114 cm)
 Rijksmuseum Vincent van Gogh,
 Amsterdam **302**

- *Restaurant Interior*, 1887
 Oil on canvas, 18 x 22¼ in.
 (45.7 x 56.5 cm)
 Rijksmuseum Kröller–Müller, Otterlo,
 the Netherlands **319**

- *Self-Portrait*, 1889
 Oil on canvas, 22⅜ x 17⅛ in.
 (56.8 x 43.5 cm)
 John Hay Whitney Collection, New York
 332

- *Sidewalk Café at Night*, 1888
 Oil on canvas, 31 x 24¾ in. (78.7 x 62.9 cm)
 Rijksmuseum Kröller-Müller, Otterlo,
 the Netherlands **324**

 The Sower, 1881
 Pen and ink on paper, 18⅞ x 14⅜ in.
 (47.8 x 36.5 cm)
 Rijksmuseum Vincent van Gogh,
 Amsterdam **303**

- *The Sower*, 1888
 Oil on canvas, 12¾ x 15¾ in. (32.4 x 40 cm)
 Rijksmuseum Vincent van Gogh,
 Amsterdam **322**

 Still Life with the Bible, 1885
 Oil on canvas, 25½ x 30¾ in.
 (64.8 x 78.1 cm)
 Rijksmuseum Vincent van Gogh,
 Amsterdam **300**

- *Sunflowers*, 1888
 Oil on canvas, 37⅜ x 28¾ in. (94.9 x 73 cm)
 National Gallery, London **326**

 Three Pairs of Shoes, 1887
 Oil on canvas, 19½ x 28 in. (49.5 x 71.1 cm)
 Fogg Art Museum, Harvard University,
 Cambridge, Massachusetts; Collection of
 Maurice Wertheim **304**

- *Van Gogh's Chair and Pipe*, 1888–89
 Oil on canvas, 35½ x 28 in. (90.2 x 71.1 cm)
 The Tate Gallery, London **329**

Velázquez, Diego Spanish, 1599–1660
 Los Borrachos (The Topers), c. 1626–28
 Oil on canvas, 65 x 88½ in. (165 x 225 cm)
 Prado, Madrid **55**

Watteau, Jean–Antoine French, 1684–1721
 Embarkation for Cythera, 1717
 Oil on canvas, 51 x 76½ in. (130 x 194 cm)
 Musée du Louvre, Paris **196**

Whistler, James McNeill American,
 1834–1903
- *Caprice in Purple and Gold, No. 2: The
 Golden Screen*, 1864
 Oil on wood panel, 19¾ x 27 in.
 (50.2 x 68.6 cm)
 Freer Gallery of Art, Smithsonian
 Institution, Washington, D.C. **2**

Selected Bibliography

Pre-Impressionism

Boime, Albert. *The Academy and French Painting of the Nineteenth Century.* New York, 1970.

Bouret, Jean. *The Barbizon School.* London, 1972.

Clark, T. J. *The Absolute Bourgeois: Artists and Politics in France, 1848–1851.* Greenwich, Conn., 1973.

———. *Image of the People, Gustave Courbet and the Second French Republic.* Greenwich, Conn., 1973.

Mainardi, Patricia. *Art and Politics of the Second Empire.* New Haven and London, 1987.

Nochlin, Linda. *Realism.* New York, 1972.

Impressionism and Post-Impressionism

Champa, Kermit Swiler. *Studies in Early Impressionism.* New Haven, Conn., 1973.

Herbert, Robert L. *Neo-Impressionism.* New York, 1969.

———. *Impressionism: Art, Leisure, and Parisian Society.* New Haven and London, 1988.

Loevgren, Sven. *The Genesis of Modernism: Seurat, Gauguin, van Gogh, and French Symbolism in the 1880s.* Bloomington, Ind., 1971.

———. *Post Impressionism: Cross-Currents in European Painting.* London, 1979–80.

Moffett, Charles S. *The New Painting: Impressionism, 1874–1886.* San Francisco: Fine Arts Museums of San Francisco, 1986.

Rewald, John. *The History of Impressionism,* 4th rev. ed. New York, 1973.

———. *Post-Impressionism: From van Gogh to Gauguin,* 3d rev. ed. New York, 1978.

Tinterow, Gary, and Henri Loyrette. *Origins of Impressionism.* New York: Metropolitan Museum of Art, 1994.

Japonisme and Photography

Ives, Colta, F. *The Great Wave: The Influence of Japanese Woodcuts on French Prints.* New York, 1974.

Scharf, Aaron. *Art and Photography.* New York, 1976.

Weisberg, Gabriel P. *Japonisme, Japanese Influences in French Art, 1854–1910.* Cleveland, 1975.

Whitford, Frank. *Japanese Prints and Western Painters.* New York, 1977.

Collections of Documents

Holt, Elizabeth Gilmore, ed. *From the Classicists to the Impressionists: Art and Architecture in the 19th Century.* New York, 1966.

Nochlin, Linda. *Impressionism and Post-Impressionism, 1874–1904: Sources and Documents.* Englewood Cliffs, N.J., 1966.

———. *Realism and Tradition in Art, 1848–1900: Sources and Documents.* Englewood Cliffs, N.J., 1966.

Venturi, Lionello, ed. *Archives de l'impressionnisme, lettres de Renoir, Monet, Pissarro, Sisley, et autres, memoires de Paul Durand-Ruel.* 2 vols. Reprint, New York, 1969.

White, Barbara E., ed. *Impressionism in Perspective.* Englewood Cliffs, N.J., 1978.

Monographs on Individual Artists

Bazille

Daulte, François. *Frédéric Bazille et son temps.* Geneva, 1952.

Frédéric Bazille: Prophet of Impressionism. Brooklyn Museum, 1993.

Caillebotte

Distel, Anne, et al. *Gustave Caillebotte: Urban Impressionist.* Chicago: Art Institute of Chicago; New York: Abbeville Press, 1995.

Varnedoe, J. K., and Thomas P. Lee. *Gustave Caillebotte: A Retrospective Exhibition.* Houston, 1976.

Cassatt

Breeskin, A. D. *Mary Cassatt: A Catalogue Raisonné of the Oils, Pastels, Watercolors, and Drawings.* Washington, D.C., 1970.

Cézanne

Adriani, Götz. *Cézanne Paintings.* New York: Harry N. Abrams, 1995.

Lindsay, Jack. *Cézanne: His Life and Art.* New York, 1972.

Loran, Erle. *Cézanne's Composition: Analysis of His Form with Diagrams and Photographs of His Motifs,* 3d ed. Berkeley, Calif., 1963.

Venturi, Lionello. *Cézanne.* New York, 1978.

Degas

Boggs, Jean Sutherland, et al. *Degas.* New York: Metropolitan Museum of Art; Ottawa: National Gallery of Canada, 1988.

Lemoisne, Paul-André. *Degas et son oeuvre.* 4 vols. Paris, 1946–49.

Manson, J. B. *The Life and Work of Edgar Degas.* London, 1927.

Reff, Theodore. *Degas: The Artist's Mind.* New York, 1976.

Valéry, Paul. *Degas, danse, dessin.* Paris, 1936, 1938.

Gauguin

Andersen, Wayne. *Gauguin's Paradise Lost.* New York, 1971.

Brettell, Richard. *The Art of Paul Gauguin.* Washington, D.C.: National Gallery of Art, 1988.

Wildenstein, G. *Gauguin, sa vie, son oeuvre.* Paris, 1958.

Manet

Cachin, Françoise, et al. *Manet.* New York: Metropolitan Museum of Art, 1983.

Hanson, Anne Coffin. *Manet and the Modern Tradition.* New Haven, Conn., 1977.

Sandblad, Nils Gösta. *Manet: Three Studies in Artistic Conception.* Lund, Sweden, 1954.

Tabarant, Adolphe. *Manet et ses oeuvres.* Paris, 1947.

Monet

Adhémar, Hélène. *Hommage à Monet.* Paris, 1979.

Geffroy, Gustave. *Claude Monet, sa vie, son temps, son oeuvre.* Paris, 1922.

Isaacson, Joel. *Observation and Reflection: Claude Monet.* New York, 1978.

Seitz, William C. *Claude Monet: Seasons and Moments.* Reprint, New York, 1970.

Stuckey, Charles F. *Claude Monet, 1840–1926.* Chicago: Art Institute of Chicago, 1995.

Wildenstein, Daniel. *Monet's Years at Giverny.* New York, 1978.

Morisot

Bataille, M. L., and G. Wildenstein. *Berthe Morisot: Catalogue des peintures, pastels, et aquarelles.* Paris, 1961.

Stuckey, Charles F., and William P. Scott. *Berthe Morisot, Impressionist.* New York: Hudson Hills Press, 1987.

Pissarro

Camille Pissarro. London: Hayward Gallery; Boston: Museum of Fine Arts, 1980.

Pissarro, Lucien R., and Lionello Venturi. *Camille Pissarro, son art, son oeuvre.* 2 vols. Paris, 1923.

Renoir

Daulte, François. *Auguste Renoir: Catalogue raisonné de l'oeuvre peint,* 5 vols. Lausanne, 1971.

Distel, Anne, and John House. *Renoir.* New York: Harry N. Abrams, 1985.

Rivière, Georges. *Renoir et ses amis.* Paris, 1921.

Vollard, Ambroise. *Renoir: An Intimate Record.* New York, 1925.

Seurat

de Hauke, C. M. *Seurat et son ouevre.* 2 vols. Paris, 1961.

Herbert, Robert L., et al. *Georges Seurat.* New York: Metropolitan Museum of Art, 1991.

Homer, William Inness. *Seurat and the Science of Painting.* Cambridge, Mass., 1964.

Rewald, John. *Georges Seurat.* New York, 1943, 1946.

Sisley

Daulte, François. *Alfred Sisley: Catalogue raisonné de l'oeuvre peint.* Lausanne, 1959.

Stevens, Mary Anne, ed. *Alfred Sisley.* London: Royal Academy of Arts; New Haven, Conn., and London: Yale University Press, 1992.

Van Gogh

Hulsker, Jan. *The Complete Van Gogh: Paintings, Drawings, Sketches.* New York: Harry N. Abrams, 1980.

Leymarie, Jean. *Van Gogh.* Paris, New York, 1951.

Tralbaut, M. E. *Vincent van Gogh.* New York, 1969.

Documents, Letters, and Memoirs of Individual Artists

Cézanne

Camoin, Charles. "Souvenirs sur Paul Cézanne." *L'Amour de l'Art* (January 1921).

Cézanne, Paul. *Letters.* Ed. John Rewald. London, 1941.

Gasquet, Joachim. *Cézanne.* Paris, 1921.

Vollard, Ambroise. *Paul Cézanne, His Life and Art.* New York, 1926.

Wechsler, Judith. *Cézanne in Perspective.* Englewood Cliffs, N.J., 1975.

Degas

Degas, Edgar. *Lettres de Degas.* Ed. M. Guérin. Paris, 1945. Eng. ed. Oxford, 1947.

Gauguin

Gauguin, Paul. *Lettres de Gauguin à sa femme et à ses amis.* Ed. M. Malingue, 2d ed. Paris, 1949.

Manet

Hamilton, George Heard. *Manet and His Critics.* New York, 1969.

Moreau-Nélaton, ed. *Manet reconté par lui-même.* 2 vols. Paris, 1926.

Monet

Levine, Steven Z. *Monet and His Critics.* New York, 1976.

Renoir

Renoir, Jean. *Renoir, My Father.* Boston, 1962.

Van Gogh

van Gogh, Vincent, *The Complete Letters of Vincent van Gogh.* 3 vols. Greenwich, Conn., 1958.

Index

NOTE: *Page numbers in italic refer to illustrations. Works of art are listed here by title only if they are discussed in the text. A complete listing of works illustrated in this volume, arranged alphabetically by artist, is provided on pages 382–393.*

Absinthe, L' (Degas), 75, 110, *144*, 248,256
Absinthe Drinker, The (Manet), 61, 62, *62*, 72
Académie des Beaux-Arts, 8, 21
Académie Suisse, 155, 333, 334
A la Mie (At the Crumb) (Toulouse-Lautrec), 256, *278*
A la recherche du temps perdu (Proust), 7
Alfred la Guigne (Toulouse-Lautrec), 257, *280*
Aline (model), 210, 213
Amis de la nature, Les (Champfleury) 34
Andrée, Ellen, 208, 248, 250
Angelus, The (Millet), 27, *29*
Angrand, Charles, 292
Apollinaire, Guillaume, 347
Argenteuil, 73, 110, 161; Manet at, 206; Monet at, 161; Renoir at, 117, 206
Argenteuil (Manet), 73, 74, *91*
Arles, 297–99
Arlésienne, L' (van Gogh), 299, *321*
Asnières, 291
Astruc, Zacharie, 61, 63, 67, 69, 71
At the Café (Manet), 74, *92*
At the Milliner's (Degas), 250, *270, 273*
Aurier, G.-A., 299, 300, 301
Auvers, Cézanne at, 117, 335
Avril, Jane, 257

Balançoire, La (Renoir), 117, *117*, 206
Balcony, The (Manet), 71, *85*
Balcony, The (Morisot), *113*, 114
Bar at the Folies-Bergères, A (Manet), 74, 75–76, *97*
Barbizon School, 11, 27–29; Renoir and, 202; van Gogh and, 296; and water, 109
Basket of Apples, The (Cézanne), 342, *358–59*

Bather (Ingres), 22, 243, 252
Bather, The (Cézanne), 336, *336*
Bathers (Cézanne), 337, *374*
Bathers (Renoir), 213, *240–41*
Bathers, The (Courbet), *34*, 35
Bathers, The (Degas), 254, *275*
Bathers at Asnières (Seurat), 290, 291, *306–7*
Bathers at Rest (Cézanne), *335*, 336
Bathing Nymphs (Girardon), 213
Bathing Nymphs (Poussin), 345
Bath of Diana, The (Boucher), *210*, 213
Battle of the Schools, The (Daumier), 30
Baudelaire, Charles, 29, 74–75; on Courbet, 35; on Daumier, 30–31; on Delacroix, 23, 25; on Manet, 62; Manet and, 63, 67–68
Bazille, Frédéric, 11, 15, 67, 71; Manet and, 66, 69; Monet and, 157, 158; and Salon of 1867, 69; works, *12, 108*
Bazille and Camille (Monet), 157, *170*
Beaux-Arts School. *See* Ecole des Beaux-Arts
Bellelli Family, The (Degas), 244–45, *258–59*
Bernard, Emile, 118, 257
Bibémus: Red Rock (Cézanne), 343, *366*
Bibémus Quarry (Cézanne), 343, *360*
Birth of Venus (Cabanel), 66–67, *67*
Black Clock, The (Cézanne), 334, *334*
Blanc, Charles, 289
Boating (Manet), 73, 74, *90*
Boatman of Mortefontaine (Corot), 26, *52*
Bon Bock (Manet), 72–73
Bonington, Richard Parkes, 23, 25
Bonnard, Pierre, 257
Bonnat, Léon, 255
Bordighera (Monet), 164, *188, 189*
Borrachos, Los (The Topers) (Velázquez), 62, *63*
Boucher, François, 61, *210*, 213
Boudin, Eugène, 15, 107, 155; works, *8, 156, 159*
Boulevard des Capucines (Monet), 7, 109, *123*
Boy with a Horse (Picasso), 346
Bracquemond, Félix, 61, 66, 107
Braque, Georges, 16, 337, 346, 347; works, *346, 371*

Bread and Fruit Dish on a Table (Picasso), 347, *347*
Bridge at Mantes, The (Corot), 26, *26*
Bridge at Villeneuve-la-Garenne, The (Sisley), 113, *132*
brushstroke: Cézanne, 16, 117, 335, 337–38, 345; Manet, 66, 74; Monet, 161, 164; Morisot, 114; Pissaro, 113; Renoir, 117, 202, 206, 208; Signac, 291–92; Sisley, 113
Brussels. *See* Les XX
Burial at Ornans (Courbet), 32, 33, *33*, 35

Cabanel, Alexandre, 21, 66–67, *67*
Café de la Nouvelle Athènes, 115, 120, 248
Café Guerbois, 69, 73, 111, 243, 334
Caillebotte, Gustave, 110, 117, 120, 162, 208; Monet and, 161; Renoir and, 205; works, *119, 120, 148–49*
Camille: Woman in a Green Dress (Monet), 157, *160*
Cardplayers (Cézanne), 341–42
Carriage at the Races (Degas), 116, *140–41*
Cassatt, Mary, 114, 121–22; Degas and, 250; works, *121, 150–53*
Castagnary, Antoine, 34, 61, 66, 108, 157
Cennini, Cennino, 210
Cézanne, Paul, 16, 117–18, 120, 333–47; Gauguin and, 122, 295; and Impressionist group, 107, 118, 337; Manet and, 66; Pissaro and, 113; and Salons, 15, 66, 69; works, *13, 118, 332, 334–37, 339–44, 348–70, 372, 374–78*
Chahut, Le (Seurat), 292, *310*
Champa, Kermit, 158, 204
Champfleury, Jules, 32–33, 34
Chardin, Jean-Baptiste-Siméon, 16
Charivari, Le (publication), 30, 107
Charpentier, Georges, 117, 207
Château Noir, Le (Cézanne), 343, *367*
Chef d'oeuvre inconnu (Balzac), 345
Chevreul, M.-E., 23, 289, 291
Chocquet, Victor, 110, 118, 206, 339

Circus, The (Seurat), 292, 294, *311*
Circus Fernando, 115, 248, *255*
Claus, Jenny, 71
Clemenceau, Georges, 166, 169
color-field painting, 7
color technique and theory, 16, 110; Barbizon School, 29; Cézanne, 337, 338, 345; Corot, 26; Delacroix, 8, 23, 25; divisionism, 292; Manet, 63, 71, 75; Monet, 161, 164; Morisot, 114; Pissaro, 113; Renoir, 213; Seurat, 289, 291; Signac, 291–92; van Gogh, 298
Comtesse d'Haussonville (Degas), 245, *246*
Constable, John, 11, 23, 158; works, *25, 44–46*
Cormon, Félix, 255, 296
Corner of the Moulin de la Galette, A (Toulouse-Lautrec), 256, *279*
Corot, Camille, 11, 21, 25–27, 29, 71, 109; color, 26; Duranty on, 111; Morisot and, 113; Sisley and, 112; works, *26, 50–52*
Courbet, Gustave, 11, 32–35, 68, 69; Cézanne and, 334; Duranty on, 111; on *Olympia* (Manet), 67; one-man show, 32; Renoir and, 202; works, *33–35, 56–59*
Couture, Thomas, 21, 25, 61, 67
Cradle, The (Morisot), 114, *115*
Cross, Henri-Edmond, *17*, 292
Crows over the Wheatfield (van Gogh), 299, *324*
Cubism, 16, 347

Dame aux Camélias, La (Dumas), 67
Dance in the City (Renoir), *209*, 210
Dance in the Country (Renoir), 209, 210, *212*
Dancer Posing, A (Degas), *249*, 250
Dancers at the Old Opera House (Degas), 250, *267*
Dancing at the Moulin de la Galette (Renoir), 117, *146*, 206, 208
Daubigny, Charles-François, 11, 21, 29, 69, 109; Sisley and, 112; works, *28, 53*
Daumier, Honoré, 30–32, 162, 244, 252; works, *29–32, 55*, 108
Dead Toreador, The (Manet), 62, 72, *81*
Degas, Edgar, 67, 107, 115–16, 243–54; and cafés, 75; Caillebotte and, 120; Cassatt and, 121; Gauguin and, 122, 300; and Impressionist group, 15, 107, 122, 254, 287; Manet and, 68; and Salon of 1867, 69; Toulouse-Lautrec and, 255, 256; works, *10, 22, 109*, 115–16, *140–45, 242, 244–53, 258–75*
Déjeuner sur l'herbe (Luncheon on the Grass) (Manet), 15, 66, *78*, 157, 204, 252; Zola and, 334
Déjeuner sur l'herbe (Luncheon on the Grass) (Monet), 155, 157, *157*
Delacroix, Eugène, 8, 23, 34; Cézanne and, 333, 334; on Courbet, 35; Degas and, 243; at Exposition Universelle (1855), 21; Renoir and, 202, 205; Seurat and, 289; van Gogh and, 296; works, *6, 24, 36–40*

Demoiselles d'Avignon, Les (Picasso), 346, *373*
Denis, Maurice, 257, 300, 301; on Cézanne, 342–43, 345; works, *19, 301*
Desboutin, Marcellin, 110, 248
Diana (Renoir), 202, *215*
Diaz de la Peña, Narcisse-Virgile, 27, 29
Diego Martelli (Degas), 246, 247, *247*
divisionism, 287, 292
Doncieux, Camille, 157
Doré, Gustave, 64
Drawbridge near Arles (van Gogh), 297, *313*
drawings, Seurat, 289–90, 291
Dumas, Alexandre, 67
Durand-Ruel, Paul, 107, 110, 208, 301; gallery, 108; Manet and, 72; Monet and, 161, 163, 164; Renoir and, 116, 205
Duranty, Edmond, 107, 111–12, 116, 245; on Degas, 116; Degas and, 248; on *Madame Camus* (Degas), 246
Duret, Théodore, 107, 256; on Monet, 162; on Renoir, 205

Ecole des Beaux-Arts, 21, 67, 202, 289
Edmondo and Thérèse Morbilli (Degas), 245
Education of the Spirit of Colors (Henry), 292
Education of the Spirit of Forms (Henry), 292
Embarkation for Cythera (Watteau), 117, 203
Englishman at the Moulin Rouge, The (Toulouse-Lautrec), 256, *281*
Entrée des voisins (Pissaro), 113, *136*
Esmeralda, La (Renoir), 202
Estuary of the Seine at Honfleur, The (Monet), 155
Eugène Delacroix, His Life and Work (Baudelaire), 23
Execution of the Emperor Maximilian (Manet), 68, 70, *86*

Faggot Carriers (Millet), 27, 29
Fantin-Latour, Henri, 71; Manet and, 61; and Salons, 15, 66, 69; works, *24*, 72
Fauves, 16
Fénéon, Félix, 76, 253, 289, 292
Field of Poppies (Monet), 161, *182–83*
figure painting, 339, 341
Fiquet, Hortense, 338
Flaubert, Gustave, 34
Flood at Port Marly, The (Sisley), *111*, 113
Floor Scrapers, The (Caillebotte), 120
Four Dancers (Degas), *242*, 250, *268*
Foyer de la danse (The Dancing Class) (Degas), *115*, 249
Fragonard, Jean-Honoré, 71
frames, 292
Franco-Prussian War, 72, 161, 205
From Eugène Delacroix to Neoimpressionism (Signac), 292

Gachet, Dr. Paul, 117, 299

Galatea (Raphael), 213
Galerie Durand-Ruel, 108
Galeries Bernheim-Jeune, 346
Gardanne (Cézanne), 337, *338*
Gardener, The (Vallier Seated) (Cézanne), 346, *369*
Gare Saint-Lazare, 161, 164
Gare Saint-Lazare (Le Chemin de Fer) (Manet), 73, *93*, 114, 162
Gare Saint-Lazare (Monet), 161, *185*
Gauguin, Paul, 16, 122, 289, 294–95, 300–301; in Arles, 298–99; Cézanne and, 339; Pissaro and, 113; van Gogh and, 297; works, *18, 121, 286*, 292–93, 300, *326–31*
Gauguin's Armchair (van Gogh), 299, *323*
Gautier, Théophile, 61, 63, 67
Geffroy, Gustave, 161, 165, 166
Geffroy, Louis de, 33
Gérôme, Jean-Léon, 21, *31*, 67
Giorgione, 65
Girardon, François, 213
Girl with a Watering Can, A (Renoir), 207, *232*
Giverny, 16, 163, 164, 166, 168
Glaize, Auguste-Barthélémy, *158*
Gleaners, The (Millet), 29, *54*
Gleyre, Charles, 67, 155, 202
Gogh, Vincent van. See van Gogh, Vincent
Goncourt, Edmond de, 116, 252
Goya, Francisco de, 68, 70–72
Grain Stack at Sunset near Giverny (Monet), 164, *191*
Grain Stack in Winter (Monet), 164, *190*
Grammaire des arts de dessin (Blanc), 289
Grande Jatte (Seurat). See *Sunday Afternoon on the Island of La Grande Jatte, A* (Seurat)
Greek Interior (Gérôme), 336
Grenouillère, La, 109, 158, 205
Grenouillère, La (Monet), 109, *128–29*
Grenouillère, La (Renoir), 109, *130–31*
Group of Independent Artists, 115
Guibert, Maurice, 256
Guillaumin, Armand, 107, 333, 339
Guillemet, Antoine, 71, 333
Guitar Player, The (The Spanish Singer) (Manet), 61, 63, 72
Gulf of Marseilles Seen from L'Estaque, The (Cézanne), 338, *351*
Guys, Constantin, 65

Hagar in the Wilderness (Corot), 26, *26*
Hals, Frans, 116
Hamerton, Philip, 66
Harbor at Lorient, The (Morisot), 114, *138*
Haussmann, Georges, 8, 63, 120
Haystacks in Provence (van Gogh), 297, *314*
Hay Wain, The (Constable), 23, *46*
Henry, Charles, 292
Herbert, Robert, 29
Holbein, Hans, 244
Hoschedé, Alice, 164
Hoschedé, Ernest, 110
Hotel Drouot auction (1875), 110, 206

House and Factory of Monsieur Henry, The (Corot), 26, *50–51*
House of Père Lacroix, The (Cézanne), 118, *145*
House of the Hanged Man, The (Cézanne), 118, *118*, 335, 339
Houses in Provence (Cézanne), 337, *350*
Huysmans, Joris-Karl, 339

Ia Orana Maria (Gauguin), 301, *329*
Ile-de-France, 26, 112–13
Il libro dell'arte (Cennino Cennini), 210
Impression, Sunrise (Monet), 7, 107, 109, *124–25*
Impressionism: philosophy of, 337; as term, 107–8; theory, 208
Impressioniste, L' (journal), 336
Impressionist exhibitions, 15; first (1874), 107, 205, 335; Hotel Drouot auction (1875), 110, 206; second (1876), 110–11, 120; third (1877), 118, 161, 335, 336; fourth, as Group of Independent Artists (1879), 115, 122; fifth (1880), 208; eighth (1886), 287
"Impressionists in 1886, The" (Fénéon), 289, 292
Impressionniste, L' (Rivière), 111
Impressionnistes et Symbolistes (exhibition), 257
Incident in the Bullring, An (Manet), 62
Ingres, Jean-Auguste-Dominique, 8; Degas and, 243; and Delacroix, 23; at Exposition Universelle (1855), 21; works, 20, 22, *41–43*, 246
International Maritime Exhibition (Le Havre), 158
In the Circus Fernando: The Ringmaster (Toulouse-Lautrec), 255, *276–77*
Intimate Journal (Gauguin), 301
Invitation to the Sideshow (La Parade) (Seurat), 292, 294, *308*
irregularism, 212
Isaacson, Joel, 166
Italy, 208, 210, 243

Jacques-Joseph Tissot (Degas), 246, 247, *247*
Jane Avril, from Café-Concert series (Toulouse-Lautrec), 254, 257
Japanese art, 254; Cassatt and, 121; Degas and, 116, 250; Manet and, 63, 73, 74; Toulouse-Lautrec and, 256; van Gogh and, 297
Japonisme, 7
Jardin des Lauves (Cézanne), 344, *364–65*
Jephthah's Daughter (Degas), 243, *244*
Jongkind, Johan Barthold, 66, 111, 155, *156*
Judgement of Paris, The (Raimondi), *65*, 66
Justice, La (newspaper), 166

Kahn, Gustave, 287
Kahnweiler, Daniel-Henry, 347
Kermesse (Rubens), 117

Laforgue, Jules, 161
Lamothe, Louis, 243
landscape painting, 15, 25, 69, 109–10; and Académie des Beaux-Arts, 8; Barbizon School, 27–29; Cézanne, 335, 336; Corot, 25–27; English, 23; Manet, 73–74; Toulouse-Lautrec, 255. *See also* plein-air painting
Large Bathers (Cézanne), 16, 345, *376–77*, *378*
Laundress, The (Daumier), 32, 55, 252
Leenhoff, Ferdinand, 66
Legros, Alphonse, 66, 110, 252
Lehmann, Henri, 21, 289
Le Nain brothers, 62
Leonardo da Vinci, 249
Leroy, Louis, 29, 107, 109, 243; on Morisot, 114
L'Estaque, 118, 336
Les XX (Les Vingt or The Twenty); Cézanne and, 339; Seurat and, 292; Toulouse-Lautrec and, 257
Lhote, Paul, 208, 210
Liberty Leading the People (Delacroix) 6, 32, *38–39*
light, 69, 71; Cézanne and, 118; Monet and, 157; Seurat and, 292
Lise with a Parasol (Renoir), 202, 204, 206
lithographs, by Toulouse-Lautrec, 257
Little Cavaliers (Velázquez), 61
Loge, La (Renoir), 205, *205*, 206
Loge, The (Cassatt), 122, *151*
London, 158, 168
Lorrain, Claude, 26
Louveciennes, 113, 205
Louvre, 118, 289, 333
Luce, Maximilian, 292
Luncheon, The (Monet), 109, *160*, 161, *177*
Luncheon of the Boating Party, The (Renoir), 200, 208, *222–23*

Madame Bovary (Flaubert), 34
Madame Camus (Degas), 245, *263*
Madame Charpentier with Her Children, Georgette and Paul (Renoir), 122, 207, 208, *234–35*
Madame Monet and Her Son in Their Garden (Renoir), 206, *220*
Mademoiselle Sicot (Renoir), 202, *229*
Mademoiselle Victorine in the Costume of an Espada (Manet), 66, 72, *77*
Maître, Edmond, 71
Majas on the Balcony (Goya), 71, 72
Mallarmé, Stéphane, 75, 257
Manet, Edouard, 11, 35, 61–76, 162; at Argenteuil, 110, 206; Cézanne and, 334; Degas and, 248; Duranty on, 111; and Impressionist group, 107; Monet and, 161; Morisot and, 113; one-man show, 15, 69; and the Salon des Refusés, 64, 65; and Salons, 61, 62, 69, 71; Toulouse-Lautrec and, 256; works, *60*, 62–64, *68*, *70*, 73–*105*, *109*

Manet, Eugène, 63, 110, 113, 114
Manet, Gustave, 66
Manette Salomon (Goncourt), 11
Manifesto of Symbolism, 15, 294
Mantz, Paul, 155
Martelli, Diego, 246
Matisse, Henri, 337
Maupassant, Guy de, 163
May Milton (Toulouse-Lautrec), 257, *285*
Mercure de France (magazine), 299
Meurend, Victorine, 63, 66, 73
Millet, Jean-François, 21, 29, 63, 66, 296; works, 27, *54*
Millinery Shop, The (Degas), 250, *272*
Milton, May, 257
Miss Lala at the Circus Fernando (Degas), 248, *266*
Modern Chromatics (Rood), 289
Modern Olympia, A (Cézanne), 117–18, 334, *334*
Moncade, C. L. de, 201
Monet, Claude, 7, 11, 15, 16, 29, 67, 71, 74, 107, 155–69; at Argenteuil, 109–10; Degas and, 254; and Impressionist group, 73, 107, 108–10, 122, 162–63; Manet and, 69; Renoir and, 201, 202, 205, 206; and Salon of 1867, 69; Sisley and, 112–13; works, *2*, *123–26*, *128–29*, *133*, *154*, *156–57*, *159–60*, *162–99*
Monet in His Studio Boat (Manet), *109*, 161
Monet Working in His Garden at Argenteuil (Renoir), 117
Monfried, Daniel de, 301
Montifaud, Marc de, 335
Montmartre, 116, 206
Mont Sainte-Victoire Seen from Les Lauves (Cézanne), 345, *362–63*
Moréas, Jean, 294
Morisot, Berthe, 29, 71, 113–15; and Impressionist group, 107, 110, 113–14, 122, 287; and Salon of 1867, 69; works, *113–14*, *138–39*
Morisot, Edma, 113
Moulin de la Galette, 206
Moulin Rouge, 256
Murillo, Bartolomé Esteban, 61
Music in the Tuileries (Manet), 63, *83*
Myrbach-Rheinfeld, Felicien, *23*

Nabis, 16, 301
Nadar (Gaspard-Félix Tournachon), 107
Natanson, Misia, 256
Natanson, Thadée, 342
Naturalists, 116
Neoimpressionism, 15, 289, 292, 294; van Gogh and, 297
Nieuwerkerke, Count, 11, 29, 64
Night Café, The (van Gogh), 298, *316*
Nochlin, Linda, 157
Nouvelle Peinture, La (Duranty), 107, 116
Nude (Braque), 347

Nude in the Sun, A (Renoir), 117
nudes: Cézanne, 336–37, 345; Degas, 252–54; Renoir, 117, 253
Nymphéas, série de paysages d'eau (Water lilies; a series of water landscapes) (Monet) (exhibition), 16, 168

Oarsmen at Chatou (Renoir), 208, *224–25*
Odalisque (Renoir), 205, *214*
Oeuvre, L' (Zola), 338
Offenbach, Jacques, 63
Old Musician, The (Manet), 62, *79*
Olympia (Manet), *60*, 67–68, *84*, 204, 252; Zola and, 334
Orchard in Bloom, Louveciennes (Pissaro), 113, *134–35*

Pach, Walter, 213
Painter's Studio, The: A Real Allegory Defining Seven Years of My Artistic Life (Courbet), 32, *58–59*
Paris, 7–8; Manet in, 63; Renoir in, 116–17; van Gogh in, 296
pastels: Degas, 248, 254; Toulouse-Lautrec, 256
Pastoral (Cézanne), 334
Pavillon du Réalisme, 32
Peintres impressionistes, Les (Duret), 107
Picasso, Pablo, 16, 337, 346; Cézanne's influence on, 346, 347; works, *347, 373*
Pin et Rochers au Château Noir (Cézanne), 343–44, *370*
Pissaro, Camille, 11, 113, 158; Cézanne and, 117, 333, 335–36, 339, 342; Degas and, 254; Gauguin and, 122, 295; and Impressionist group, 107, 122, 164, 287; Manet and, 66; and Salons, 15, 66, 69; van Gogh and, 297; works, *112, 119, 134–37*
Pissaro, Lucien, 206
plein-air painting, 69, 110, 113; Barbizon School, 29; Duranty on, 112; Gauguin and, 295; Manet and, 73; Monet and, 157, 158, 162, 164; Renoir and, 204, 206, 208. *See also* landscape painting
Plum, The (Manet), 74, 75, *105*, 248
political cartoons, 30–31
Pont de l'Europe, Le (Monet), 161, *184*
Pont Neuf, Paris (Renoir), 117, *147*
Pontoise, 113; Cézanne at, 117, 335; Gauguin at, 122
Poplars, The (Monet), 165, *192*
Poplars on the Bank of the Epte River (Monet), 165, *193*
Portrait of Gustave Geffroy (Cézanne), 339, *339*, 341
Portrait of Madame Ginoux (L'Arlésienne) (van Gogh), 299, *321*
Portrait of Père Tanguy (van Gogh), 297, 299, *320*
Portrait of the Artist's Father (Cézanne), 334, *349*

Portraits in an Office: The Cotton Exchange, New Orleans (Degas), 116, *142–43*, 249
portraiture: Cézanne, 334, 336, 339; Degas, 116, 243, 244, 245–47; Renoir, 117, 206, 207–8; Toulouse-Lautrec, 255; van Gogh, 299
posters, by Toulouse Lautrec, 257
Potato Eaters, The (van Gogh), *295*, 296
Poussin, Nicolas, 16, 26, 337, 345
Première Sortie, La (Her First Evening Out) (Renoir), 206, *207*
Principle of Harmony and Contrast of Colors and Their Application to the Arts (Chevreul), 23
Proust, Marcel, 7, 207
Provence, 118, 337
Puvis de Chavannes, Pierre, 289, 295, 300

railroad imagery, 162
Raimondi, Marcantonio, *65, 66*
Raphael, 208, 213
Réalisme, Le (periodical), 111
Redon, Odilon, 208
Reff, Theodore, 247, 249–50
Rembrandt van Rijn, 61, 116
Renoir, Edmond, 205
Renoir, Pierre-Auguste, 11, 67, 71, 74, 107, 116–17, 201–13; at Argenteuil, 110; and circus Fernando, 248–49; Degas and, 248, 254; and Impressionist group, 15, 73, 110, 164, 208, 287; at La Grenouillère, 109; Manet and, 69; Monet and, 158, 161; Morisot and, 115; and Salons, 69, 122; Sisley and, 112–13; works, *106, 117, 127, 130–31, 146–47, 200, 202–7, 209–41*
Republic, The (Daumier), *31, 32*
Restaurant Interior (van Gogh), 297, *312*
Revue Blanche, La (magazine), 256–57, 342
Rewald, John, 162
Richardson, John, 67
Rilke, Rainer Maria, 345
Rivière, Georges, 111, 202, 206, 336
Road near L'Estaque (Braque), *347, 371*
Roger-Marx, Claude, 168
Rood, Ogden, 289
Rossetti, Dante Gabriel, 158
Rouen Cathedral, Portal and Albane Tower (Monet), 165, *194*
Rouen Cathedral, Sunset (Monet), 165, *195*
Rousseau, Théodore, 27, 29
Royère, Jean, 347
Rubens, Peter Paul, 23, 333, 334
Rue Saint-Denis, fête du 30 juin 1878, La (Monet), 161, *186*
Rue Transnonain (Daumier), *30, 31*
Rysselberghe, Theo van, 292

Sabines, The (David), 30
Sailboats at Argenteuil (Renoir), 117, 206, *221*
Sainte-Beuve, Charles-Augustin, 34
Saint-Lazare Station: The Arrival of the Train from Normandy (Monet), 161, *185*

Salon des Indépendants, 257
Salon des Refusés (1863), 15, 64, 334
Salon of 1845 (Beaudelaire), 29
Salons, 21, 69, 346; Cassatt and, 121; Cézanne and, 117; Manet and, 61, 67, 71, 72–73; Monet and, 122, 155, 158, 162; Renoir and, 204, 208; Seurat and, 290
Schapiro, Meyer, 338
Scholderer, Otto, 71
Secession group (Vienna), 346
Self-Portrait with Halo (Gauguin), 301, *326*
serial painting, 16, 161, 164–68
Sérusier, Paul, 257, 300, 301
Seurat, Georges, 15, 287–94; works, *14, 288–90, 302–11*
Signac, Paul, 287, 291–92; works, *291*
Silvestre, Armand, 108, 113, 122
Silvestre, Théophile, 33
Sisley, Alfred, 15, 67, 112–13; at Argenteuil, 110; and Impressionist group, 107, 110; and independent exhibition, 73; Monet and, 161; and Salon of 1867, 69; works, *111, 132, 135*
Société Anonyme des Artistes, Peintres, Sculpteurs, Graveurs, Etc., 11, 107
Société des Artistes Indépendants, 290, 291
Spanish art, 61–62, 68
Spanish Singer, The (Manet), 61, 63, *72*
Spring Bouquet (Renoir), 202, *203*
still lifes, Cézanne, 334, 336, 342
Still Life with Apples and Peaches (Cézanne), 342, *357*
Street in Paris, a Rainy Day (Caillebotte), 120, *148, 149*
Street Singer, The (Manet), 63, *82*
Studio in the Batignolles Quarter, A (Fantin-Latour), 71, *72*
Sulking (Degas), 245, *245*
Sunday Afternoon on the Island of La Grande Jatte, A (Seurat), 15, 287, 292, *304–5*

Tanguy, Père, 295, 339
Terrace at Sainte-Adresse (Monet), 158, *172–73*, 338
themes: bather, 15; biblical, 300; circus, 115, 255; dance, 249–50; erotic, 334; picnic, 15; urban, 115, 120, 248, 252; visionary, 334
Third of May, 1808 (Goya), 68, *70*
Three Bathers (Cézanne), 336, *336*, 345
Three Skulls (Cézanne), *341*, 342
time, 15, 16; Monet's serial paintings, 16
Tintoretto, 61
Tissot, Jacques-Joseph (James), 116; portrait by Degas, 246
Titian, Tiziano Vecellio, 61, 67, *67*
Topers, The (Los Borrachos) (Velázquez), 62, *63*
Toulouse-Lautrec, Henri de, 75, 255–57, 276–85; works, *254–57, 276–85*
Toulouse-Lautrec in samurai costume, 256, *257*
Tournachon, Gaspard-Félix (Nadar), 107
Tréhot, Lise, 204

Tub, The (Degas), 252, 274–75
Turner, Joseph Mallord William, 23, 158, 162; works, 47–49
Two Grain Stacks (Monet), 164, *191*
Two Little Circus Girls (Renoir), *216*, 248

Uncle and Niece (Portrait of Henri and Lucy de Gas) (Degas), 245, *263*
Uprising, The (Daumier), *30*, 31
urban subject matter, 115, 120, 248, 252

Valadon, Suzanne, 210, 213
Valéry, Paul, 257; on Degas, 116, 250, 252; on Morisot, 114
Valpinçon, Edouard, 243
Valpinçon, Paul, 116
van Gogh, Theo, 296
van Gogh, Vincent, 15–16, 295–300; and *Faggot Carriers* (Millet), 29; meeting with Gauguin, 294; works, 294–99, *312–25*
Van Gogh's Chair and Pipe (van Gogh), 299, *322*
Vauxcelles, Louis, 347
Velázquez, Diego, 61, 63, 68
Velde, Henry van de, 292, 294
Venus of Urbino (Titian), 67
Vétheuil, 122, 162, 163

Vie Moderne, La (magazine), 162, 163, 207
Viollet-le-Duc, Eugène-Emmanuel, 21, 23
Virgin of the Chair (Raphael), 208
Vision after the Sermon: Jacob Wrestling with the Angel (Gauguin), 300, *328*
Vollard, Ambroise, 201, 205, 207, 208, 346; on Cézanne, 341

water: Barbizon School, 109; Monet and, 16, 109, 161, 166, 168
watercolors, Cézanne and, 343
Water Lilies (Monet), 166, 168, 169, *198–99*
Watteau, Antoine, 117, 203
Watts, George Frederic, 158
Where Do We Come From? What Are We? Where Are We Going? (Gauguin), 286, 301, *330–31*
Whistler, James McNeill, 9, 15, 66, 69
White, Barbara Ehrlich, 213
Wolff, Albert, 110, 117
Woman in Black at the Opera (Cassatt), 121, *150*
Woman Ironing (Degas), 252, *271*
Woman Powdering Herself (Seurat), 292, *309*
Woman with a Parasol: Madame Monet and Her Son (Monet), 161, *181*
Woman with Chrysanthemums (Degas), 245, *246*
women, Degas and, 250, 252

Women in the Garden (Monet), 154, 157–58, *171*
Women of Algiers (Delacroix), 205

Yellow Christ, The (Gauguin), 300
Young Ladies from the Village (Demoiselles du Village) (Courbet), 33, *56*
Young Man in the Costume of a Majo (Manet), 66

Zola, Emile, 21, 29, 71, 208, 245; on Cézanne, 118, 120; Cézanne and, 333, 338–39; on Manet, 69; Manet and, 66, 334; on Monet, 109, 157, 158, 162; on Pissaro, 69
Zurbarán, Francisco, 61

Photography Credits

Plate 26, courtesy of John Canaday; plates 42, 110, 114, and 151, courtesy of the Trustees of the National Gallery, London; plate 43, courtesy of the Trustees of the British Museum; plate 117, photo: Giraudon; plate 250, photo: David Stansbury; plate 357, photo: Herman and Magrit Rupf-Schiffung.

Acknowledgments

I should like to thank the following for their contribution to this book:

My former students Penny Green and Talia Gross, who were there when I needed them; my friends and colleagues Susi Bloch and John Daley, whose professional insights and editorial advice facilitated my writing at crucial junctures; John Hochmann, for welcome encouragement; and Patrizia Cavalli, *per simpatia*.

The collective energies of the staff at Abbeville were harnessed to solve problems that arose from the ambitious scale of this project. The center of this collaborative effort was Phyllis Benjamin; more than a sensitive editor, she functioned as a wise godmother to the manuscript and a watchful supervisor over the complex stages of its development. Her levelheadedness and sense of proportion were complemented by a generosity of spirit and a sense of humor that I shall remember with special affection.

In writing acknowledgments, tradition dictates that the author employ that familiar phrase "without whose help this book could not have been written" on at least one occasion, and I have saved that occasion for the end. This book owes its very existence to the unswerving vision and infectious enthusiasm of the late Harry N. Abrams. It was, quite simply, Harry's idea, and the attention he lavished on it persuaded me that it had a special meaning for him. I hope that it will honor his memory and the high standards he set for art book publishing.

—New York, June 1980